EIGHTH EDITION

Children and Their Art METHODS FOR THE ELEMENTARY SCHOOL TOUR COLLEGE HER AVY Kings Hay

Al Hurwitz

MARYLAND INSTITUTE COLLEGE OF ART

Michael Day

BRIGHAM YOUNG UNIVERSITY

THOMSON WADSWORTH

AUSTRALIA · BRAZIL · CANADA · MEXICO · SINGAPORE · SPAIN · UNITED KINGDOM · UNITED STATES

KH

THOMSON

WADSWORTH

Children and Their Art: Methods for the Elementary School, Eighth Edition Al Hurwitz and Michael Day

Publisher: Clark Baxter Acquisitions Editor: John R. Swanson Senior Development Editor: Sharon Adams Poore Assistant Editor: Anne Gittinger Editorial Assistant: Allison Roper Technology Project Manager: David Lionetti Executive Marketing Manager: Diane Wenckebach Marketing Assistant: Alexandra Tran Senior Marketing Communications Manager: Stacey Purviance Senior Project Manager, Editorial Production: Kimberly Adams Creative Director: Rob Hugel Executive Art Director: Maria Epes Print Buyer: Karen Hunt

© 2007 Thomson Wadsworth, a part of The Thomson Corporation. Thomson, the Star logo, and Wadsworth are trademarks used herein under license.

ALL RIGHTS RESERVED. No part of this work covered by the copyright hereon may be reproduced or used in any form or by any means—graphic, electronic, or mechanical, including photocopying, recording, taping, Web distribution, information storage and retrieval systems, or in any other manner—without the written permission of the publisher.

Printed in the United States of America 1 2 3 4 5 6 7 10 09 08 07 06

> For more information about our products, contact us at: Thomson Learning Academic Resource Center 1-800-423-0563

For permission to use material from this text or product, submit a request online at http://www.thomsonrights.com. Any additional questions about permissions can be submitted by e-mail to thomsonrights@thomson.com.

Library of Congress Control Number: 2005936949 Student Edition: ISBN 0-495-00696-3

12/06

Permissions Editor: Joohee Lee
Production Service: G&S Book Services
Text Designer: Marsha Cohen
Photo Researcher: Linda Sykes
Copy Editor: Cynthia Lindlof
Cover Designer: Marsha Cohen
Cover Image: "Cultural Mountain" by Rolland D. Lee (Navajo), age 12, from the book *A Rainbow at Night: The World in Words and Pictures by Navajo Children* by Bruce Hucko. Chronicle Books. 1996. For more information contact Bruce Hucko at bhucko@frontierner.net.
Cover Printer: RR Donnelley/Willard
Compositor: G&S Book Services
Printer: RR Donnelley/Willard

Thomson Higher Education 10 Davis Drive Belmont, CA 94002-3098 USA The authors dedicate this book to the memory of Stevan Brant Day (1963–2002), artist, designer, family man, and devoted child of God.

Life Diver (1992) by Brant Day

Preface / xiii

PART 1

Foundations and Goals for Art Education

<u>chapter</u> **1** FOUNDATIONS OF ART EDUCATION: CHILDREN, ART, AND SOCIETY / 1

Nature of the Visual Arts / 2 Conceptions of the Learner / 5 Early Influences of Philosophy and Psychology 6 Contemporary Views of the Learner 7 Multiple Intelligences 8 Brain Research 8 Values of Society / 11 Public Attitudes in the Schools 12 Change in Art Education / 13 Cizek and Children's Artistic Expression 14 The Teachers of Art 15 The Owatonna Project 16 The Bauhaus 16 Creativity and Art Education 16 Toward Art Content 17 Some Basic Beliefs in Contemporary Art Education / 18

Notes / 18

Activities for the Reader / 21 Suggested Readings / 22 Web Resources / 23

chapter **2**

ART EDUCATION IN CONTEMPORARY CLASSROOMS: ISSUES AND PRACTICES / 25

Art Is Necessary, Not Just "Nice" / 25 A Balanced Program of Art Education / 27 Outcomes of a Quality Art Program 27 Integrating Art with the Elementary Curriculum 29 Influences of Postmodern Thought / 30 Modernism 30 Postmodernism 32 Hyperreality: A Postmodern Condition 37 Summary / 37

Notes / 37 Activities for the Reader / 39 Suggested Readings / 39 Web Resources / 40

chapter 3

PART 2

Children as Learners

CHILDREN'S ARTISTIC DEVELOPMENT: HOW CHILDREN GROW AND LEARN / 43

Stages of Graphic Representation / 45 *The Manipulative Stage (Ages 2–5, Early Childhood)* 47

The Symbol-Making Stage (Ages 6-9, Grades 1-4) 50 The Preadolescent Stage (Ages 10-13, Grades 5-8) 59 vi Why Children Make Art / 60
 Children's Conceptual Development in Art / 63
 Artists and Children's Art / 64

Notes / 65 Activities for the Reader / 66 Suggested Readings / 67 Web Resources / 67

chapter 4

CHILDREN WITH SPECIAL NEEDS: ART FOR ALL CHILDREN / 69

Contributions of Art for Students with Special Needs / 73 Therapy and Catharsis 74 Teaching Children with Intellectual, Cognitive, or Developmental Disabilities / 74 Subject Matter 76 Methods of Teaching / 76 Using Museums 77 Basic Activities 77 Group Activities 79 Other Kinds of Disabilities / 79

Notes / 81 Activities for the Reader / 82 Suggested Readings / 82 Web Resources / 82

chapter 5

TALENTED CHILDREN: THE NATURE OF ARTISTIC GIFTEDNESS / 85

Identifying Gifted Children / 87 Characteristics of Gifted Children 88 Case History of Two Students 91 Artists Examining Their Past 92 Identifying Talented Children / 93 Special Arrangements in Art for Gifted Children / 94 Suggested Art Activities / 95 The Child's Agenda 96 General Activities 97 Painting in Oils and Acrylics 97 Other Media for Drawing and Painting 97 Teaching Gifted Children / 98

Notes / 99 Activities for the Reader / 100 Suggested Readings / 100 Web Resources / 100

PART 3

Content of Art

<u>chapter</u> 6 DRAWING: AT THE HEART OF THE STUDIO EXPERIENCE / 103

The Manipulative Stage (Ages 2–5) / 104 Media and Techniques 104
The Symbol-Making Stage (Grades 1–4) / 105 Media and Techniques 105 Teaching 105
The Preadolescent Stage (Grades 4–6) / 105 Understanding Space 106
The Development of Pictorial Composition / 111 Form and Idea 111 Memory and Drawing 112
Working with Narratives: Storytelling / 113

Notes / 115 Activities for the Reader / 115 Suggested Readings / 116 / Web Resources / 116

chapter 7

PAINTING: AT THE HEART OF THE STUDIO EXPERIENCE / 119

Painting Media and Techniques / 120 Teaching 121 Developing Color Awareness / 122 Color and Art History 124

Notes / 127 Activities for the Reader / 127 Suggested Readings / 128 Web Resources / 128

chapter **8**

SCULPTURE AND CERAMICS / 131

Sculpture: Basic Modes of Forming and Construction / 132 Sculpture with Paper / 135 Box Sculpture 135 Freestanding Forms 137 Sculpture in Plaster of Paris / 139 Media and Techniques 139 Teaching 140 Ceramics: Art from Earth and Fire / 140 Modeling with Clay / 140 Media and Techniques 141 Teaching 142 Making Pottery / 144 Media and Techniques 144 Finishing Processes / 146 Media and Techniques 146 Teaching 147

Notes / 147 Activities for the Reader / 148 Suggested Readings / 148 Web Resources / 149

chapter 9

PRINTMAKING / 151

Rubbings / 153 Monoprints / 154 *Media and Techniques Teaching*Potato and Stick Printing / 156 *Media and Techniques Teaching*Styrofoam, Linoleum, and Woodcut Printing / 157 *Media and Techniques Teaching*Stenciling / 161 *Media and TechniquesTeaching*

Notes / 164 Activities for the Reader / 164 Suggested Readings / 165 Web Resources / 165

chapter 10

NEW MEDIA: IDEAS AND EARTHWORKS-COMPUTERS TO LASERS / 167

New Ideas, New Media / 168 New Media in the Classroom / 171 Creating a Gallery of Self-Portraits 171 Responding to Contemporary Art 171 Art and Nature 172 Polaroid Photography as an Art Medium 172 Art from Everything 173 Fax Friendships 174 Copy Technology 174 Media for Instruction / 175 Projections 176 Experiences with a Camera 177 Storyboards 177 Video 177 Computer Technologies in the Art Classroom 178

Notes / 179 Activities for the Reader / 180 Suggested Readings / 180 Web Resources / 181

chapter **11**

DESIGN: ART LANGUAGE AND APPLICATION / 183

The Elements of Design / 184 Line 185 Shape and Mass 186 Color 186 Texture 189 Space 189 The Principles of Design / 190 Unity 190 Rhythm 191 Proportion 191 Balance 191 Broad Implications of the Design Process 192 Uses of Design / 193 Graphic Design: Art for Communication and Persuasion 194 Design in the Entertainment Media 194 Architecture as One Example of the Uses of Design 195 Teaching Children through Architectural Problems 197

viii Notes / 198

Activities for the Reader / 198 Suggested Readings / 199 Web Resources / 199

chapter 12

ART CRITICISM: FROM CLASSROOM TO MUSEUM / 201

Art Appreciation and Criticism / 202 Postmodern Perspectives for Criticism 203 Teaching Methods to Develop Critical Skills / 203 Studio Involvement 203 The Phased Approach to the Critical Act 204 Description 205 Learning from Art Critics / 208 Working with Language / 210 Dreaming Artworks 211 Writing Art Criticism 212 Further Suggestions for Study / 212 The Artist of the Week 212 Thematic Displays 212 Connecting with Studio Activity 212 Working for Total Group Involvement / 213 Instruments of Engagement and Evaluation 213 Statement Matching 213 Composition 213 What Qualifies as Art? 213 A Pre- and Post-Preference Instrument 215 Sorting and Matching 215 The Picture Wall 215 Teaching Aids for Developing Critical Response / 216 Videos, CDs, DVDs, Filmstrips, and Slides 217 Using Art Museums and Galleries / 217 Activities in Museums 218 Museum Resources 220

Notes / 220 Activities for the Reader / 221 Suggested Readings / 222 Web Resources / 222

chapter 13

ART HISTORY: OTHER TIMES AND PLACES / 225

Art History Content: A Brief Survey of World Art / 226 The Ancient World 227 The Classical Western World 230 The Middle Ages 231 Renaissance and Baroque 234 Modern and Postmodern Art 235 Art in America 238 Contemporary Art 239 The Changing Face of Art History 241 Teaching Art History / 243 Organizing Art Images 243 Integrating Art History 244 Functions of Art History and Methods of Inquiry / 245 Methods of Art Historical Inquiry as a Basis for Teaching 246 The In-Depth Experience 248

Notes / 250 Activities for the Reader / 251 Suggested Readings / 252 Web Resources / 254

chapter 14

AESTHETICS: PHILOSOPHY IN THE ART ROOM / 257

Aesthetics and Theories about Art / 259 Art and Beauty 259 Teaching for the Issue of Beauty 261 Art and Nature: Differences, Similarities, and Fallacies 263 Art and Knowledge: How Much Does One Need to Know? 264 Aesthetics and Media 265 Three Aesthetic Stances: Mimesis, Espressionism, and Formalism / 266 Mimesis: Art as Imitation or Representation of Things as Seen 266 Art as Expression: Emphasis on Feeling and Emotion 267 Formalism: The Importance of Structure 268 The Intentional Fallacy 269 Art and Western Society / 270 Art and Material Values 270 Aesthetics: Politics and Real Life 271 Censorship and Art: A Problem for Aesthetics 271 Examples of Censorship Issues 272 Other Aesthetics Controversies 273 Ways of Teaching: Inquiry and Structured Discussion / 274 NOTES / 277

Activities for the Reader / 277 Suggested Readings / 278 Web Resources / 279

_{chapter} 15

VISUAL CULTURE IN ART EDUCATION / 281

Rationale for Visual Culture in Art Education / 282 Visual Culture in Earlier Times 283
Approaches to Visual Culture in Art Education / 284 Radical Change from Art Education to Visual Culture Education 285 Applied Artists and Their Art 286 Comprehensive Art Education: Visual Culture in the Art Curriculum 286
Applications of Visual Culture in Art Classrooms / 290 Interpreting Denotations and Connotations 290 Cigarette Ad Deconstruction: Deconstructing Advertising 291 Grocery: Corporate Influence in the Community 292

Notes / 293 Activities for the Reader / 294 Suggested Readings / 295 Web Resources / 295

PART 4

Instruction

Methodology / 298 Contexts for Art Teaching 299 Who Should Teach Art? 299 Teaching Practices in Art / 300 Setting the Stage 300 The Sources of Art 301 Motivation for Art Making 301 A Range of Teaching Methods 302 Maintaining a Learning Environment 302 The Art in Teaching 303 Teaching with Technology 308 Organizing for Instruction / 309 Selecting Art Materials and Tools 309 Teacher Talk 309 Teaching in Action: Planning for the First Session / 311 Analyzing the Teacher: Five Phases of Instruction 312

Notes / 314 Activities for the Reader / 314 Suggested Readings / 315 Web Resources / 315

chapter 17

THE SOCIAL DIMENSION: COLLABORATIVE ART ACTIVITIES AND INSTRUCTIONAL GAMES / 317

Social Values in Art Education / 317 The Role of the Teacher in Collaborative Activities / 318 Group Activities: Simpler Forms / 319 Media and Techniques 319 Teaching 320 Puppetry / 320 Murals / 322 Murals and Art History 322 Mural Making 324 Tableau Projects 327 Ecological Themes 328 Blowups 328 Art Games / 329 Art Images for Games 329

Notes / 333 Activities for the Reader / 334 Suggested Readings / 334 Web Resources / 335

PART 5

Curriculum and Assessment

chapter **18**

CURRICULUM: BACKGROUND, PLANNING, AND ORGANIZATION / 337

Influences on Curriculum Decision Making / 338 Readiness of Learners 338 Values of Society 338

Thinking Skills in the Art Curriculum 339 The Community Setting 340 The School Setting 340 Who Designs the Art Curriculum? / 342 The Art Supervisor 342 The Elementary Art Specialist 342 The Classroom Teacher 342 Student Participation in Curriculum Development 343 School District Administrators (Directors of Curriculum) 343 Strategies for Art Curriculum Implementation 343 Key Decisions in Planning an Art Program / 346 School District Philosophy 346 A Balanced Art Program 346 Published Art Curricula 347 Correlating Art with Other Subjects / 348 Relationships within the Arts 348 Social Studies 349 Language Arts 350 Art and Multicultural Understanding 351 Art and Nature 352 Music 353 Mathematics 353 Problems of Correlation 354 Organizing and Writing Art Curriculum / 355 Approaches to Curriculum Development 355 Organizational Categories for Art Curricula 356 The Yearly Plan or Course Outline 358 Unit Plans 358 Lesson Plans 360 Educational Objectives 361

Notes / 365 Activities for the Reader / 366 Suggested Readings / 366 Web Resources / 367

chapter 19

CLASSROOM ORGANIZATION AND EXHIBITION OF STUDENT WORK / 369

Physical Requirements of the Classroom / 370 Basic Supplies and Equipment / 370 Classroom Arrangements / 371 A Primary-Grade Classroom 371 A General Classroom 372 The Art Room 373 Why Exhibit Children's Art? / 375 Selecting Work for Exhibit / 376 Arranging Exhibits in the Classroom / 377 Displaying Two-Dimensional Work 377 Displaying Three-Dimensional Work 379 Teaching 380 Arranging Displays outside the Classroom / 380 Media and Techniques 380 The Exhibition as Community Education / 381

Notes / 382 Activities for the Reader / 382 Successfor Beadings / 382

Suggested Readings / 382 Web Resources / 383

chapter 20

ASSESSING STUDENT LEARNING AND ACHIEVEMENT / 385

Defining Terms / 386 Informal Assessment / 387 Formal Assessment / 388 Concerns about Assessment in Art Education 388 Positive Effects of Assessment in Art 389 Assessment of Student Progress in Art / 389 A Balanced Program of Assessment 389 Some Guiding Principles for Assessment in Art 390 Methods for Assessment of Student Progress in Art / 396 Observation 396 Interview 397 Discussion 397 Performance 398 Checklist 398 Questionnaire 398 Test 399 Essav 399 Visual Identification 399 Attitude Measurement 399 Portfolio 399 Judgment of Student Work 399 Standardized Art Tests 399 Formal Tests Devised by the Teacher 399 Informal Assessments 401 Tools for Assessment of Student Progress in Art 401 Reporting Progress in Art / 401

Notes / 410 Activities for the Reader / 410 Suggested Readings / 411 Web Resources / 411

appendix A

A HISTORICAL FRAMEWORK FOR ART EDUCATION: DATES, PERSONALITIES, PUBLICATIONS, AND EVENTS / 413

appendix **B**

PROFESSIONAL RESPONSIBILITY AND PROFESSIONAL ASSOCIATIONS / 420

______C COMMERCIAL RESOURCES / 421

______ appendix D SAFER MATERIALS FOR ELEMENTARY-SCHOOL ART / 422

Credits / 424 Index / 428

On the occasion of this new edition of *Children and Their Art*, the authors express appreciation to the publisher for unparalleled support over the years. Few texts reach eight editions, and few continue to be published over a period of more than five decades. That *Children and Their Art* has reached this status is a testimonial to the consistent commitment of the publisher, both to the topic of the book and to the authors.

Nearly 50 years have passed since the 1958 publication of the first edition of *Children and Their Art* by Canadian art educator Charles Gaitskell. A dozen years later Al Hurwitz joined Gaitskell as coauthor of the second edition of the book. Hurwitz took the lead role for the third edition, published in 1975, and invited Michael Day to coauthor the fourth edition, which appeared in 1982. Following Dr. Gaitskell's passing, Hurwitz and Day continued to revise and update each new edition in response to changes in the world of art, to trends in the field of general education, and particularly to changes in art education. Day took the lead role for the seventh and eighth editions.

The past half century has produced many significant innovations in the field of art education. In 1958, the field was dependent primarily on the views of Viktor Lowenfeld and a child-centered approach that emphasized art making and exploration of media and materials. During the following decades, art education adopted and adapted a number of new ideas and goals. Some new directions became mere fads, whereas others developed as significant trends. The field moved through notions of curriculum based on the elements and principles of design, art for daily living, and art for creative and mental growth. During the 1980s and 1990s, art education theory transformed from a childcentered approach to a discipline-based approach that emphasized content from the world of art, teaching and learning, and art as an essential subject for all students as a part of their general education. Forms of multicultural education, brain-based education, and visual culture education have asserted major influences in the development of art education as we observe it today.

The field of art education has progressed dramatically as a profession during the past 50 years. The National Art Education Association (NAEA) has emerged as the premier professional organization for art educators at all levels and job descriptions. The NAEA annual conventions are the largest professional development meetings in the world, with hundreds of sessions for the association's approximately 18,000 members. The NAEA publishes a newsletter, a journal, and a research journal on a regular basis; and its publications list consists of hundreds of items, including books, advisories, research reports, and standards documents. State-level professional art education organizations are active in nearly all of the 50 states.

The International Society for Education through Art (InSEA) is an active professional venue at the international level with periodic world congresses and occasional regional congresses held in Europe, Asia, Australia, South America, and North America. InSEA publishes a regular newsletter and an international journal of research and issues. Professional journals of theory and research in art education are published in many countries, often in two or more languages.

Art as a subject in U.S. schools has gained steadily in stature and implementation during the past half century. In 1963, a national study reported that art was taught by art specialists in fewer than 10 percent of elementary-school classrooms and fewer than 20 percent had an art room. Only 54 percent of secondary schools in the United States offered art as a subject, and those schools that offered art enrolled only about 15 percent of the school's student body.

Two reports were published in 2001 and 2002 that provide perspective on the status of art education nationally. The National Center for Education Statistics (NCES) conducted the 2001 study, and the NAEA commissioned the 2002 study. Following are some of the findings:

- Public elementary schools that offer art—87 percent
- Public secondary schools that offer art—93 percent
- Secondary art teachers who are certified—85 percent
- Secondary art teachers who have a master's degree— 55 percent
- Secondary art teachers who indicate that their curriculum is aligned with the National Visual Arts Standards—86 percent
- Secondary schools that require art for graduation— 60 percent

By way of contrast, in 1963, only 8 percent of secondary schools had an art requirement for graduation.

The national infrastructure for art education has also developed dramatically during the past two decades. Following publication of the National Standards for Arts Education and development of Standards for National Board Certification for visual arts teachers in 1994, NAEA published its own Standards for Art Teacher Preparation in 1999. The second National Assessment of Educational Progress in Art was published in 1997. The first Handbook of Research and Policy in Art Education was published in 2004. Each of these items and many others are indicators of the development of art education as a strong profession, one that is much advanced compared to earlier periods in the history of education in the United States. Similar development is taking place internationally.

The authors, Professors Hurwitz and Day, have been actively involved as participants in many of these developments. Their task for this edition of *Children and Their Art* has been to place new developments in perspective, to bring the latest issues to light, and to embrace the many improvements in the field of art education for the benefit of students who are preparing to become teachers of art and for those who are current art educators. Hopefully, the scope of the book also serves the many readers who are directly or indirectly interested in developments and practices in this field.

CHANGES IN THE NEW EDITION

The new edition includes more than 300 illustrations, with well over 100 new images to provide examples of new media and better representation of postmodern art forms and works by women and minority artists.

These are some of the changes that experienced readers of the book will note:

- Addition of a new chapter on visual culture in art education
- Expansion of the chapter on assessment of student learning and achievement
- Increased attention to the use of the computer as a learning tool and as a medium for making art
- Continued attention to the postmodern era in art and implications for art education
- Up-to-date Internet addresses and references following each chapter
- Addition of 120 new art reproductions, examples of child art, and photographs of teaching and learning situations

We have much to learn from countries we have visited—Russia, People's Republic of China, Israel, Japan, France, Netherlands, Germany, Qatar, Austria, Republic of South Africa, Korea, Taiwan, Hong Kong, Canada, Kenya, Jamaica, and Egypt. Even though children in all cultures will create images of their own accord, it is through cultural support, schooling, and teaching that they are able to realize their real potential. We are concerned in this book with assisting teachers to provide the best support for children as they progress in their artistic expression and in their understanding of art.

No one country has all the answers for the ideal art program, nor can any one society be cited for maintaining a full or adequate array of support for the aesthetic development of all its children. To study art education beyond the borders of one's own country is to reaffirm one's sense of mission as an art educator.

ACKNOWLEDGMENTS

It would be impossible to write a book of the range of *Children and Their Art* without the assistance of people who play various roles in art education. We would like to begin by thanking those teachers who were responsible for the examples of student work. Among these are Carolyn

Shapiro Knight, Sharon Slim, Susan Varga, Jim Regan, Catherine Cameron, Joseph Germaine, Derek Smith, and Lynn Whiting. We thank Lorna Teeter and Chi Fan Leung for images of their exciting and well-organized classrooms. We are grateful to all the teachers of students whose artwork appears in this edition. We thank Ron DeLong for his assistance to access the Binney & Smith *Dreammakers* archives of children's art. According to best professional practice we have given the first names and ages of children, when available, in recognizing their work.

Artists made so many valuable contributions, including Hugh O'Donnell, Jim Hennessy, Mansa Nkruma, Larry Santana, Susan Stills, Chen Ming Te, Joan Gaither, and Eugene Grigsby. We thank Jean Patterson of the Huntington Library Collections and Diana Korzenik for the cover of their prize-winning catalog. Helen Hurwitz provided valuable typing skills. Undergraduate art education students Rachel Stratford and Abbey Edelman provided library research assistance. We thank Dr. Sharon Gray for providing a number of art education images and Dr. Tsau Saiau Yue for images from Taiwan. We appreciate the work of colleagues Dr. Donna Kay Beattie and Dr. Marilyn Stewart for their work in assessment of learning in art education. We thank Val Brinkerhoff and David Hawkinson, both professional photographers, for their top-quality works.

Dr. Virgie Day made significant contributions with her discussion of postmodernism in Chapter 2 and editorial support for the entire manuscript. She spent countless hours on the computer to provide all the Internet addresses and references, a major addition to the book. We appreciate the fine work of Dr. Robert Sabol, who reviewed and revised Chapter 20. We thank Bob Steele, Bruce Hucko, Dr. Karen Carroll, Sandra Kaye, Dr. Max Kläger, and Dr. Peter London for their contributions. We would also like to thank Dr. Cynthia Colbert, University of South Carolina; Dr. Victoria Fergus, West Virginia University; Dr. Virgil D. Lampton, University of Tulsa; and Dr. Roberta W. Rice, University of North Carolina–Greensboro for their comments and suggestions.

Finally, we wish to thank the editorial and production staff at Thomson Wadsworth, in particular, John Swansen, acquisitions editor; Sharon Adams Poore, senior development editor; Kim Adams, senior project manager; Anne Gittinger, assistant editor; Diane Wenckebach, executive marketing manager; and Allison Roper, editorial assistant. We also wish to thank Mary Keith Trawick, production services ccordinator, and Linda Sykes, photo researcher. The combined efforts of everyone at Thomson Wadsworth have resulted in the best edition yet of *Children and Their Art*.

ABOUT THE AUTHORS

Al Hurwitz

Al Hurwitz is Chair Emeritus in Art Education at the Maryland Institute College of Art. He taught at the elementary and secondary levels in Miami–Dade County, Florida, before his appointment as art supervisor. He was Director of Visual and Performing Arts for Newton, Massachusetts, schools and taught art education at Harvard University Graduate School of Education; Ohio State University; Teachers' College, Columbia University; Brandeis University; and the Massachusetts College of Art.

He has also written, coauthored, or edited 12 books on art education and served as president of InSEA and the United States Society for Education through Art (USSEA). His national and international awards include the Distinguished Alumnus Award of Pennsylvania State University; the Edmund Ziegfeld Award; the Distinguished Alumnus Award, Maryland Institute College of Art; the Sir Herbert Read and Mahmoud El Bassiouny Awards; and the National Art Educator Award from the NAEA. He received his doctorate from Pennsylvania State University and holds an MFA From Yale Drama School.

Dr. Hurwitz served on the planning committee of the National Board for Professional Teaching Standards (NBPTS), the national certification program for art teachers. He has evaluated programs in art education for the Corcoran School of Art and Teachers' College of Columbia University; and he has conducted workshops for the Hirshhorn, Whitney, and the Los Angeles County Museums of A-t.

The Hurwitz Study Center for Art Education has been created in his name at the Maryland Institute, College of Art.

Michael Day

Michael Day is Professor Emeritus and former Chair of the Department of Visual Arts at Brigham Young University. He taught middle- and high-school art in California and completed his doctorate degree at Stanford University. He served as head of the art education programs at the University of South Carolina and the University of Minnesota. A widely published author and researcher, Professor Day is recipient of the Manuel Barkan Award for published research from the NAEA. He has directed national curriculum development institutes and national professional development seminars for the Getty Education Institute for the Arts. In 1993, he was named the Getty Institute's first Visiting Scholar.

Professor Day has consulted for college art departments and state departments of education and school districts in 26 states. He has served on national panels, editorial boards for national scholarly publications, and art museum boards. He was invited to the former Soviet Union in a scholarly exchange sponsored by the International Research and Exchanges Board; and in 1998 he was one of five scholars invited to Beijing, in a delegation sponsored by the Getty Education Institute and the Ministry of Education of the People's Republic of China. He has taught as visiting professor at the Hong Kong Institute of Art and the National Taiwan Normal University in Taipei.

Dr. Day served as President of the NAEA from 1997 to 1999. His continued interest in art teacher preparation resulted in his 1997 book, *Preparing Teachers of Art*, and in the development and publication in 2000 of the NAEA *Standards for Art Teacher Preparation*, completed under the aegis of his presidency. He coedited with Elliot Eisner the landmark book *Handbook of Research and Policy in Art Education*, published in 2004.

Children and Their Art

FOUNDATIONS OF ART EDUCATION

Children, Art, and Society

One of the most striking features of human societies throughout history and across the globe is a prodigious involvement with the arts.

---Ellen Dissanayake, Homo Aestheticus

Any person who would educate others must consider three fundamental factors. The first basic factor is the nature of those who will learn. Second, every educator needs to consider the content to be taught and learned. And third, the educator cannot ignore the values of the society in which education is to take place.¹ For this discussion, then, the prospective educator needs to consider the dynamic *nature of the visual arts*, various *conceptions of the learner* that will guide education practices, and the *values of the society* in which the educational program exists. These three factors must be addressed whether the educational setting is a

1

Peter Anthony (Sky Eagle), Shuswap, interior British Columbia, Canada, traditional dance regalia. The finest examples of clothing are works of applied art and often express cultural meanings and values. Clothing in most cultures is used to convey cultural roles, establish status in society, and express individual personalities. These aesthetic functions require the skills and sensitivities of artists in their creation. The concept of clothing extends far beyond the obvious needs for covering, protection, and warmth to notions of uniform, fashion, and beauty. The variety of colorful materials and the associations children have with Native Americans make the study of powwow regalia a subject with strong inherent values.

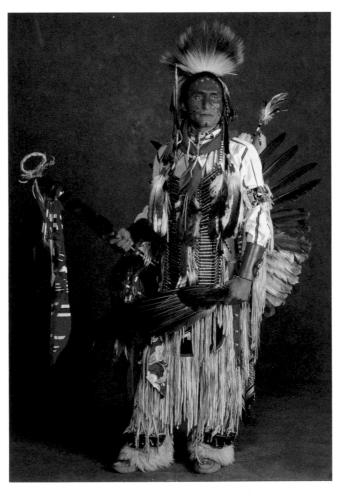

public school district, a private school, a home school, or any setting where formal art education is the goal.

NATURE OF THE VISUAL ARTS

To obtain a basic understanding of art, we might imagine ourselves back in time, even before the age of cave paintings. From this vantage we may recognize the importance of one early achievement: the invention of containers. The seemingly simple realization that a hollow space would allow someone to store water or grain must have been one of the wonders of primitive technology. Eventually, someone must have noticed that if greater attention were given to the *shape* of a vessel and to the thickness of its walls, the container would somehow be more satisfactory. In perfecting the form in order to improve the function, that anonymous fabricator was working on the level of enlightened craftsmanship.

Later, a person making a container, or pot, must have experimented with the *surface* of the vessel, although this had nothing at all to do with its *function*—that is, with how much the pot could carry or how much wear it could survive. Decoration could only make the handling and the seeing of the object more *pleasurable* experiences. This development of the idea of decoration provided the potter with unlimited options for technique and design. Once the object was formed, shapes could be inscribed or painted in patterns that might include swirls, loops, straight lines, or combinations of any of these.

These early craftspeople discovered that decoration could have *meaning*, that signs could stand for ideas. They found that they could communicate their states of mind to other people through these symbols, as well as express fears, dreams, and fantasies.² Cave paintings reflect this function. The animals depicted are more than recognizable shapes taken from the experiences of the group; they probably represent rituals whereby hunters could record con-

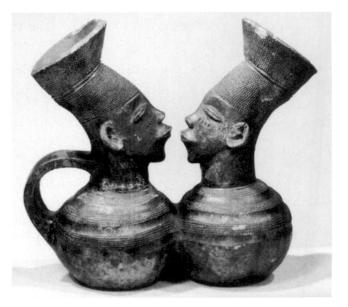

Double-bowled pot, Mangbetu style, Africa (collected about 1910). Ceramic. This exquisite double pot features incised decoration, a beautifully integrated handle, and two sculptured heads with head coverings indicating social or political rank. Ceramic clay is one of the most universal art media. Note the range of time, culture, and place exemplified by ceramic pieces displayed in this book. cern for survival.³ Decoration now moved into the more profound sphere of the image as metaphor, and not every member of the group was capable of making such a transference. Those who could we now call *artists*.⁴

As art moved beyond utilitarian functions and as attention was centered on appearance as well as use, the notion of *aesthetic* response evolved. A painting or a fine vessel might be valued as an investment or for its historical importance, but central to its existence as a work of art is the power to provide pleasure or stimulation as distinctive in its way as musical compositions or poems are. When we view art objects from various cultures, we can respond to the aesthetic "vibrations" of the work despite a lack of knowledge of conditions surrounding the creation of the object. When available, historical and cultural information can extend and intensify our responses to an artwork and greatly increase our understanding of it.

As we discuss the visual arts in this book, we refer to a fascinating array of different art traditions and forms. The traditional *fine arts*, including drawing, painting, sculpture, and printmaking, have existed for many centuries. Today the fine arts embrace a boisterous set of contemporary contenders based in such technologies as photography, video, and computer-generated imagery. The newer concepts of environmental art, performance art, conceptual art, and installation contribute to the diversity of the visual arts.

The *folk arts*, works by naïve or untutored artists, and the *arts of indigenous peoples* emerge in many forms from the vital creative impulses and social functions within culture that only art can satisfy. Included also are the *applied arts* that surround us every day, such as architecture, interior design, weaving, ceramics, fashion design, and a host of other applications. *Popular art* forms in contemporary *visual culture*, such as posters, comics, TV commercials, video games, and movies, add to the vital and dynamic definition of the *visual arts*. This broad, inclusive view of the visual arts is postmodern in scope and is consistent with the postmodern era in which we reside.

As educators concerned with the nature of art, we might study the visual arts of many cultures, including Western European, Egyptian, Asian, African, pre-Columbian, Mexican, Native American, Polynesian, and Islamic. The visual arts from prehistoric to contemporary times, including the ancient, medieval, Renaissance, and modern periods, are worthy of study. Within the ranges of cultures and periods are numerous styles of art, for example, those of the Chinese T'ang dynasty, archaic Greece,

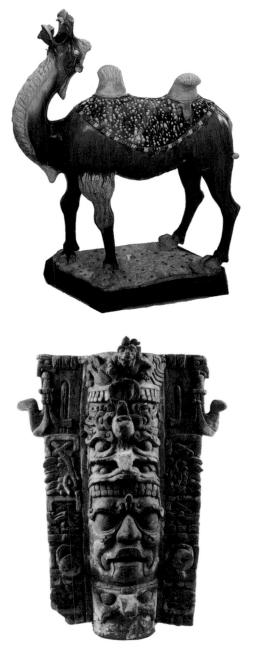

Camel tomb figure, Chinese, T'ang dynasty (618–906 CE). Glazed ceramic, $35'' \times 28'' \times$ 9". From the times of prehistoric cave painters, artists of virtually all cultures, times, and locations have created images of animals. This expressive, beautifully formed, glazed ceramic camel, more than a thousand years old, is one of the prime examples of animal art from China.

Flanged cylinder, Chiapas, Palenque, Mexico (c. 690 CE). Ceramic, 28" high. Many cultures have vanished from the earth, leaving behind artifacts, some of which are works of art, as is this magnificently formed ceramic sculpture from Mexico. Art historians and archeologists study such objects and learn about religious, social, political, and other practices and values of the objects' creators.

African Benin, and Indian Asia, as well as surrealism, pop art, and neoexpressionism, that can provide fascinating insights into the nature of art on a worldwide basis.

Over time, as art has become increasingly complex and diverse, professions have emerged from needs to preserve,

One way to study culture is to note differences in treatment of the same subject across cultures. Compare similarities and differences (clockwise from top left) among these ancient monolithic stone heads: Moai heads, Easter Island (700 CE); Olmec colossal stone head, Gulf Coast, Mexico (1100 BCE); Buddha heads, Temple of Bayon, Angkor Wat, Cambodia (1100 CE); giant statue heads from Nemrut Dagi, Turkey (100 CE). Photographs by Val Brinkerhoff. Courtesy of the Artist.

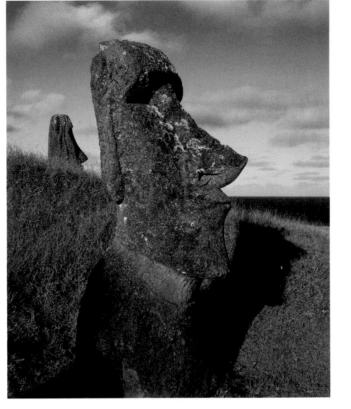

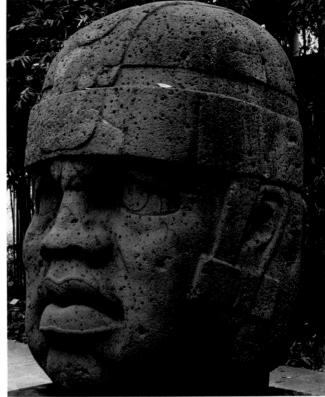

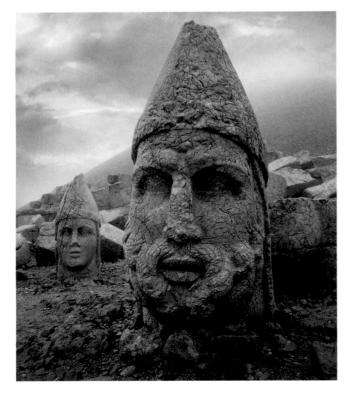

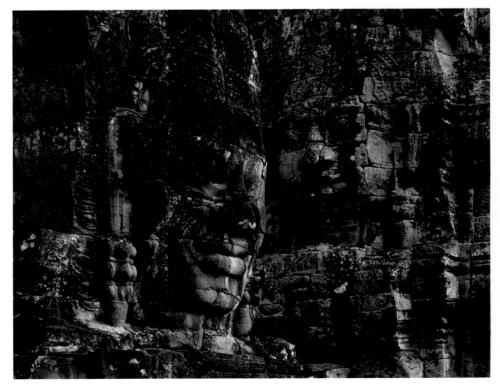

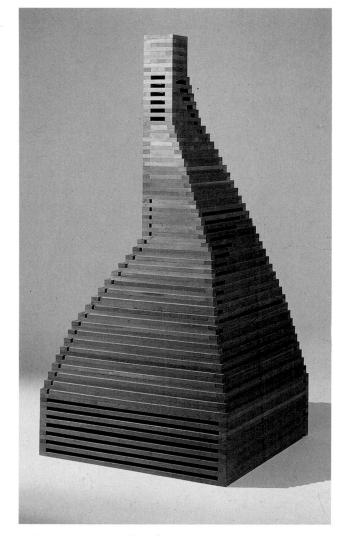

Jackie Ferrara, A207 Recall (1980). Pine wood, 76" high. The artist constructed this sculpture from pieces of pine wood that are glued together. Using only straight lines, she has created a curving structure that allows occasional glimpses of the interior. One might describe this work as a "postmodern chimney."

study, interpret, and judge artworks of today and from the past. A complex system of art museums, galleries, publications, markets, laws, and private and governmental agencies that support and oversee the art community has evolved. This system employs numerous art professionals, such as art educators, gallery directors, art dealers, museum curators, conservators, commercial artists, and producers of art reproductions.

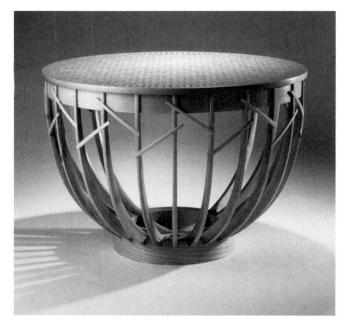

Four art disciplines provide the basic expertises that, in various combinations, endow most art professionals with the knowledge and skills necessary for their specific functions. These are the disciplines practiced by artists, art critics, art historians, and aestheticians. Each of these disciplines or fields reflects many other influences, such as the political, anthropological, social, philosophical, and psychological.⁵

As artists have for centuries, artists today create a wide range of art objects that vary in purpose, quality, and influence. Art critics respond to artworks as they perceive, describe, interpret, and judge them for the professional art world and the lay public. Art historians preserve, study, classify, interpret, and write about important art objects from the past. Aestheticians employ philosophical methods of inquiry and discourse to examine fundamental issues about the nature of art, such as its definition, questions of quality and value, and issues of creation and response to art.⁶

This book explores each of these art disciplines in greater detail (see Chapters 6-13).

CONCEPTIONS OF THE LEARNER

Is the mind of a child a blank tablet waiting to receive the imprint of the teacher? Are learners passive receivers, active seekers, or some combination of both? Does learnMichael Hurwitz, Tea Cup Desk (1994). Ash, maple, marble mosaic, $30'' \times 42''$. Traditional distinctions between fine and applied art can be questioned and discussed in the comparison of Ferrara's and Hurwitz's uses of wood as medium. Does the sculpture qualify as a higher art form because it is free of any constraints other than those created by the artist? Is the 13elegantly designed desk potentially as expressive and meaningful as a sculpture, even though the design of the desk has limitations placed upon it by its functional character?

5

ing take place most efficiently by using all the senses? Are drill and repetition necessary? Are there different learning styles? To what extent does learning transfer from one task or problem to another? Is learning self-determined, or is it the result of influences from the environment? Obviously, the views a teacher holds on these and other issues in learning theory will influence educational practice. Whether the various conceptions of learning are developed by individual educators or are implied by psychological investigation, their practical influence cannot be overlooked.

Contemporary education, like modern art, is not a product of the last three or four decades. Many of the basic ideas found both in aesthetics and teaching theory today may be traced to ideas held by philosophers and teachers who lived long ago, as well as to psychologists of more recent years.

Contemporary art education, then, is a field fed by the

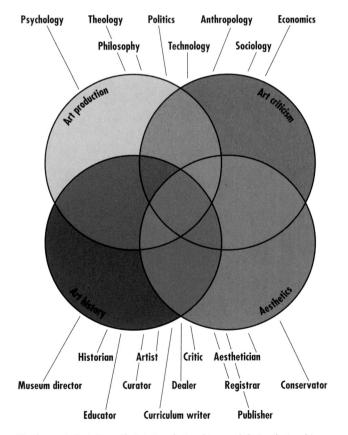

The four art disciplines, their interrelationships, and their relationships with the art professors.

history of art and of general education. The development of current practice in art education is also supported by the investigation of psychologists into learning processes.

Early Influences of Philosophy and Psychology

Jean-Jacques Rousseau, an eighteenth-century philosopher whose ideas influenced early childhood education, advocated that teaching should be related to childhood interests and that education should be concerned with the everyday life of the child.⁷ Let children be children, Rousseau advocated, and let them learn through self-initiated activities.

Rousseau's ideas about the nature of children as learners were carried forth by fellow Europeans, such as Johann Pestalozzi, Johann Friedrich Herbart, and Friedrich Fröbel.⁸ These powerful educators emphasized active engagement by learners in their surroundings; hands-on manipulation of materials, such as the basic geometric forms; and systematic ways to develop plans for instruction. The beginnings of the discourse that shapes the field of art education today can be traced to these pioneers and their many colleagues around the world.

An even stronger influence on education is to be found in the development of psychological thought. Although a detailed discussion is not possible here, these influences are too important to ignore. Interested readers are encouraged to study further what is only suggested on these pages.

Known as the father of progressive education, American philosopher John Dewey became a force in education early in the twentieth century, when children's desks were bolted to the classroom floor in straight rows and rote learning was a standard school activity. Dewey was greatly concerned with the relationship of learners to their environment and to the society in which they live.

Dewey regarded education as the "continuing recreation of experience."⁹ According to Dewey, education involves the direction and control of experience, and a meaningful experience implies active participation and control on the part of learners. Knowledge is not static, he insisted, nor is it gained in a static environment to be used in a static society. Dewey believed that education should be seen not as a preparation for life but as life itself. Many of Dewey's ideas from a century in the past still ring true in today's dialogue in art education.¹⁰

A contemporary of Dewey, psychologist E. L. Thorndike, developed what came to be known as the *stimulusresponse theory*, which held that learning consists of the establishment of a series of connections, or pathways, in the brain resulting from a specific response to stimulus.¹¹ Thorndike's studies led him to believe that learning, to a large extent, was a matter of repetitive drill. Translated to school practice, this would result in the breaking down of a school subject into minute parts to be practiced and learned by students.¹²

Almost opposite in emphasis to this theory, the system of psychology called *Gestalt* has had a strong influence on art education. Gestalt psychologists maintained that wholes are primary and that parts derive their properties and behavior from them. The learner acquires knowledge by achieving "insight"—that is, by understanding the relationships among the various aspects of the learning situation.

Rudolf Arnheim, in his book *Art and Visual Perception* and in other writings, provided art teachers with the clearest and most completely stated view of Gestalt psychology.¹³ Works of art, as Gestalts or complete functional units, must be viewed as wholes. Within works of visual art, each part affects all the other parts simultaneously, so if one aspect is altered, such as the area or brightness of a color, the entire work is changed. In art and in Gestalt psychology, the whole is more than the sum of its parts.

Another influential view of learning in the twentieth century was that of behavioral psychology expounded in the work of B. F. Skinner and others.¹⁴ Behaviorists considered the learner to be a relatively passive organism governed by stimuli supplied by the external environment. Through proper control of environmental stimuli, the learner's behavior could be, to a significant extent, predicted. This study of behavior as an objective science resulted in such developments as programmed instruction, which informed early uses of computers for instruction.

Influences of behavioral psychology on education are significant. In addition to early developments of computerassisted instruction, behaviorism provided foundations for the writing of behavioral objectives for all aspects of the school curriculum, as well as practices of educational evaluation, measurement, and testing. Recurring periods of the accountability movement in education rely on behaviorist concepts. A current application of this approach is the system of high-stakes testing required by the federal government's No Child Left Behind education program. Critics of behaviorism in art education cite the theory's failure to fully account for the idiosyncratic, intuitive, and creative manifestations of human experience.¹⁵ These personal aspects of life and learning, however, are the primary focus of the humanistic psychologists, such as Abraham Maslow and Carl Rogers.¹⁶ The humanists considered the learner free to make choices, and behavior as only the observable expression of an essentially private, inner world of being. The individual exists uniquely within a subjective world of feelings, emotions, and perceptions, many of which may not be acted out in behavior.

Much of the humanists' research took the form of clinical work with individual subjects, to provide therapy and gain understanding. The goal of education, according to Rogers, must be the facilitation of learning, for only the person who has learned how to learn, to adapt, and to change is an educated person. The humanistic view of education resonates with art educators who would emphasize the creative and expressive facets of the human personality.

Contemporary Views of the Learner

The work of Swiss psychologists Jean Piaget and Barbel Inhelder became influential worldwide beginning in the late 1950s.¹⁷ Their theories in cognitive and developmental psychology had an extensive impact on education. Piaget and Inhelder examined such topics as the evolution of language and thought in children; the child's conceptions of the world, of number, time, and space; and other aspects of a child's intellectual development.

Piaget outlined three major stages or *periods* in the child's cognitive development: the sensorimotor period, the period of concrete operations, and the period of formal operations. According to Piaget, the child neither "flowers," as described by Rousseau, nor is "programmed" in the manner Skinner discussed. Rather, the child develops sequentially through Piaget's three stages. Intellectually, a child is qualitatively different from an adult, and this difference varies according to age and to progress within the three stages. For educators, this implies that knowledge of the learner's characteristics is essential to curricular and instructional decision making.¹⁸

Current research in cognitive psychology, as it is applied in education, emphasizes interactions between knowledge and various levels of thinking. Lauren Resnick and Leopold Klopfer point out that "before knowledge becomes truly generative—knowledge that can be used to interpret new situations, to solve problems, to think and reason, and to learn—students must elaborate and question what they are told, examine the new information in relation to other information, and build new knowledge structures."¹⁹ This view recognizes that learners require a certain *amount* of knowledge in order to use knowledge flexibly or creatively and that learning is easier once a generative knowledge base has been established. A rich storehouse of knowledge is essential as students deal with issues raised by the ubiquitous images of visual culture. Educators must address the problem of how to get students started in developing their base of generative knowledge so they can learn more easily and independently.

In art education this view of a "thinking curriculum" correlates well with the use of content and methods of inquiry derived from the four art disciplines. Art teachers can engage students in thinking and reasoning about art and visual culture, questioning ideas, solving problems through active engagement, and being involved in their own creation of, response to, and examination of art objects. The art curriculum also has the potential to engage students in several ways: through refined perceptions of aesthetic qualities of artworks; through analysis and interpretation of meanings, often metaphorical, embedded in works of art and visual culture; through inquiry into social, political, and other contexts that give rise to artistic creation; and through pondering and discussing important perennial questions about the nature of art, art appreciation, and the creation of art.

As contemporary educators continue their pursuit of understanding learners, of how and why they learn, two major areas of scholarly research and theory have captured their attention. Howard Gardner's theory of multiple intelligences, published in 1985, has burgeoned as a topic for educational theory and practice.²⁰ More recently, and concurrently, an explosion of research in neuroscience has had exciting implications for our understanding of learning.

Multiple Intelligences

Gardner's theory is based on knowledge of multiple and differentiated capacities of the brain as well as on scientific observation and analysis of the historical record of the range of human accomplishment. In place of the unitary view of intelligence represented by the intelligence quotient (IQ) scores, Gardner describes eight distinctive intelligences. Each person has all intelligences to some degree, and some people develop one or more intelligences to high levels. The important point is that all eight intelligences are valuable and can be developed within a comprehensive educational program. The traditional emphasis in schools on the linguistic and logical-mathematical intelligences, in Gardner's view, is too narrow and leaves many potentialities undeveloped in students.

During the past decade, many educators and school systems have applied the principles of multiple intelligences (MI) theory in attempts to broaden opportunities of all students to learn and develop.²¹ Gardner encourages applications of his theory but cautions that MI is not a quick solution for problems in education: "Educators who thoughtfully use the theory to support their larger educational goals find that it is a worthy partner in creating schools of excellence."²²

This broader view of intelligence recognizes contributions of the arts for significant learning in schools. Prominent theoretician Elliot Eisner suggests a more comprehensive view of knowledge, and particularly the kind that comes out of the arts: "What we try to do when we take multiple or artistic intelligences seriously is to broaden the array of resources that are brought to bear on topics students study. Varied resources that provide different kinds of opportunities for youngsters with different proclivities (different intelligences) enable them to secure forms of understanding that would not be available without those resources."²³

Brain Research

During the 1970s, research into the functions of the right and left hemispheres of the human brain sparked much discussion among educators. Studies supported the notion that the right and left brain hemispheres are somewhat specialized in their functions, with the left brain as the site of analytic, rational, logical, and linear thinking and the right brain as nonrational, intuitive, and holistic. This research lent support to the belief that the traditional narrow focus of education, with almost exclusive emphasis on logicalmathematical and verbal learning, overlooks significant abilities in students that could and should be developed in schools.²⁴ Through this discussion the notions of multiple intelligences and artistic intelligences were cited in support of more emphasis on the arts, where intuition and the nonrational, nonverbal aspects of thought and expression are valued.

THE INTELLIGENCES, in Gardner's Words

- Linguistic intelligence is the capacity to use language, your native language, and perhaps other languages, to express what's on your mind and to understand other people. Poets really specialize in linguistic intelligence, but any kind of writer, orator, speaker, lawyer, or a person for whom language is an important stock in trade highlights linguistic intelligence.
- People with a highly developed logical-mathematical intelligence understand the underlying principles of some kind of a causal system, the way a scientist or a logician does; or can manipulate numbers, quantities, and operations, the way a mathematician does.
- Spatial intelligence refers to the ability to represent the spatial world internally in your mind—the way a sailor or airplane pilot navigates the large spatial world, or the way a chess player or sculptor represents a more circumscribed spatial world. Spatial intelligence can be used in the arts or in the sciences. If you are spatially intelligent and oriented toward the arts, you are more likely to become a painter or a sculptor or an architect than, say, a musician or a writer. Similarly, certain sciences like anatomy or topology emphasize spatial intelligence.
- Bodily kinesthetic intelligence is the capacity to use your whole body or parts of your body—your hand, your fingers, your arms—to solve a problem, make something, or put on some kind of a production. The most evident examples are people in athletics or the performing arts, particularly dance or acting.
- Musical intelligence is the capacity to think in music, to be able to hear patterns, recognize them, remember them, and perhaps manipulate them. People who have a strong musical intelligence don't

just remember music easily—they can't get it out of their minds, it's so omnipresent. Now, some people will say, "Yes, music is important, but it's a talent, not an intelligence." And I say, "Fine, let's call it a talent." But, then we have to leave the word *intelligent* out of *all* discussions of human abilities. You know, Mozart was very smart!

- Interpersonal intelligence is understanding other people. It's an ability we all need, but is at a premium if you are a teacher, clinician, salesperson, or politician. Anybody who deals with other people has to be skilled in the interpersonal sphere.
- Intrapersonal intelligence refers to having an understancing of yourself, of knowing who you are, what you can do, what you want to do, how you react to things, which things to avoid, and which things to gravitate toward. We are drawn to people who have a good understanding of themselves because those people tend not to screw up. They tend to know what they can do. They tend to know what they can't do. And they tend to know where to go if they need help.
- Naturalist intelligence designates the human ability to discriminate among living things (plants, animals) as well as sensitivity to other features of the natural world (clouds, rock configurations). This ability was clearly of value in our evolutionary past as hunters, gatherers, and farmers; it continues to be central in such roles as botanist or chef. I also speculate that much of our consumer society exploits the naturalist intelligences, which can be mobilized in the discrimination among cars, sneakers, kinds of makeup, and the like. The kind of pattern recognition valued in certain of the sciences may also draw upon naturalist intelligence.

Source: Kathy Checkley, "The First Seven . . . and the Eighth: A Conversation with Howard Gardner," *Educational Leadership* 55, no. 1 (November 1997): 8–13.

Study of the brain has progressed far from these early studies of brain hemispheres. Following a resolution from the U.S. Congress in 1989, President George H. W. Bush officially proclaimed the 1990s the "Decade of the Brain." The promise of this proclamation has been met with an unprecedented explosion of knowledge on how the human brain works. With the aid of new electronic technologies that can map brain activity, "we have learned more about the brain in the past five years than in the past hundred years."²⁵

How can knowledge of brain physiology and function influence education, which is traditionally informed by issues of philosophy, psychology, and economics? Philosophy and psychology often deal with broad questions of human values and potentials, yet historically they have been influenced as well by understandings of human physiology. Neuroscience is a specialized field separate from education, yet the new brain research promises to extend understanding of learning in ways that, at the very least, suggest more efficient and appropriate educational practices for learners of all ages.

Some of the findings of the neuroscientists are particularly relevant to arts educators. The study of music, especially, has proven to be fruitful. The work of researcher Frances Rauscher, for example, made connections between music and spatial task performance.²⁶ Other studies linked music and learning and documented actual changes in brain physiology in professional musicians.²⁷

Four general findings of brain research appear to have implications for learning and, therefore, for teaching, curriculum, and education in general:²⁸

••• *FINDING 1:* The brain changes physiologically as a result of experience. The environment in which a brain operates determines to a large degree the functioning ability of that brain.

For parents, caregivers, and educators, the finding that the electrical activity of brain cells changes the physical structure of the brain is perhaps the most significant discovery of neuroscience. The first three years of a child's life are apparently even more important than many have supposed. Major capacities of each child's brain are shaped and reinforced during the first 10 years of life. These findings underscore the importance of hands-on parenting, of finding the time to cuddle a baby, talk with a toddler, and provide a young child with stimulating experiences.

By the age of 3, a child who is neglected or abused bears marks that, if not indelible, are exceedingly difficult to erase.²⁹ The positive corollary, that a rich and caring environment also makes a difference for children, is encouraging for parents and teachers. Education has a major influence on the learner and, therefore, changes not only the mind but the brain itself. The richness of the educational environment can have a positive effect on each child's capacity to learn.

••• FINDING 2: IQ is not fixed at birth.

At birth a baby's brain contains about 100 billion neurons. But the pattern of wiring between them has yet to stabilize. Up to this point, says neurobiologist Carla Shatz, "what the brain has done is lay out circuits that are its best guess about what's required for vision, for language, for whatever." From birth onward, it is up to neural activity, driven by a flood of sensory experiences, to take this rough blueprint and progressively refine it.³⁰

••• *FINDING 3:* Some abilities are acquired more easily during certain sensitive periods, or "windows of opportunity."

Some of the brain-study findings are truly amazing and will revise our views of the capabilities of very young children with respect to their motor, cognitive, and emotional development. For example, according to neuroscientists, an infant's brain can perceive every possible sound from every language. By 10 months, babies have learned to screen out foreign sounds and to focus on the sounds of their native language.³¹ This window for language development is wide open for infants during the period when they must learn language. Then the window gradually closes, although it will never completely shut.

These windows of opportunity represent critical periods when the brain demands certain types of input to create or consolidate neural networks, such as for acquiring language and emotional control. "Certainly one can learn new information and skills at any age. But what the child learned *during* that window period will strongly influence what is learned after the window closes."³²

The brain's greatest growth spurt declines around age 10, when the balance between synapse creation and atrophy abruptly shifts. Over the next several years, during a period of "use it or lose it," the brain will ruthlessly destroy its weakest synapses, preserving only those that have been transformed by experience. By the end of adolescence, around age 18, the brain has declined in plasticity but increased in power. Abilities that have been nurtured and reinforced are ready to blossom.³³

••• FINDING 4: Learning is strongly influenced by emotion.

Researchers have verified what many teachers already know—that the stronger the emotion connected with an experience, the stronger the memory of that experience. Through chemical processes, the brain recognizes the connection between emotion and learning. When teachers are able to add emotional input to learning experiences to make them more meaningful and exciting, the brain deems the information more important and retention is increased. At the same time, emotions of threat or fear can sidetrack learning.

The role of emotion in learning is another concept that has been discussed for years by educators and psychological theorists.³⁴ At one point, theorists attempted to separate cognition and affect for development of educational objectives.³⁵ Now, brain research has focused attention on the essential role of emotion in learning, and the concept of "emotional intelligence" has entered the discourse of psychologists and educators.³⁶

Researcher Marian Diamond believes that enriched environments unmistakably influence the brain's growth and learning. According to Diamond, an enriched environment for children consists of the following attributes:³⁷

- Includes a steady source of positive emotional support
- Provides a nutritious diet with enough protein, vitamins, minerals, and calories
- Stimulates all the senses (but not necessarily all at once!)
- Has an atmosphere free of undue pressure and stress but suffused with a degree of pleasurable intensity
- Presents a series of novel challenges that are neither too easy nor too difficult for the child at his or her stage of development
- Allows social interaction for a significant percentage of activities
- Promotes the development of a broad range of skills and interests that are mental, physical, aesthetic, social, and emotional

- Gives the child an opportunity to choose many of his or her efforts and to modify them
- Provides an enjoyable atmosphere that promotes exploration and the fun of learning
- Allows the child to be an active participant rather than a passive observer

This blueprint for a happy and healthy learning environment for children reinforces many of the ideas held by educators and psychologists mentioned earlier. Many teachers have come to similar conclusions after years of experience working closely with children and observing how they learn.

Brain research also provides support for the notion of multiple intelligences and definitely underlines the importance of the arts in the education of every child, beginning in the very earliest years. Educator and writer on brain research Robert Sylwester writes: "Evidence from the brain sciences and evolutionary psychology increasingly suggests that the arts (along with such functions as language and math) play an important role in brain development and maintenance—so it's a serious matter for schools to deny children cirect curricular access to the arts."³⁸

Educator and author Eric Jensen asserts that new knowledge about the brain has already changed many school practices. He views education from the perspective of the "brain-based revolution" that has influenced school start times, discipline policies, teaching strategies, lunchroom choices, uses of technology, and "even the way we think of the arts and physical education."³⁹

Brain research is new, exciting, and apparently redolent with heady implications. Nevertheless, as scientists and educators alike caution, the road between the scientific laboratory and the school classroom can be long and winding, with many detours. Educators must always maintain the professional autonomy and integrity that accompany the great responsibility they have to children. This means that educators should carefully and critically assess recommendations that derive from the neurosciences, relying, as always, on their own training, experience, and good professional judgment.

VALUES OF SOCIETY

Educators' concerns with the nature of art and their conceptions of how young people learn are balanced, in the process of education, by the values of society. In a democracy these values are brought to bear on education by the taxpaying public, usually through community school systems, election of school boards, and hiring of school administrators, faculty, and staff to carry out the wishes of the electorate. Public schools in the United States have been responsive also to the needs and values of the larger society, sometimes on a national level. Changes in education brought about by space exploration, the civil rights movement, the need for safe drivers on our streets and highways, the problems of alcohol and drug abuse, and the threat of AIDS are only a few examples of how the needs and values of society influence what occurs in school classrooms.

Art education in the United States has been influenced no less by societal values than by innovations in art or advances in psychology. The programs of art instruction initiated by Walter Smith, for example, were motivated by the business community's need to design goods that could compete on an international basis. Viktor Lowenfeld's emphasis on creativity and self-expression was based on a particular view of child development. The position taken by this book emphasizes a content program based on the works and methods of inquiry of artists, art critics, art historians, and aestheticians.

The art program is an especially appropriate and effective place in the general school curriculum to deal with social issues, problems, and values, precisely because the history of art is replete with the most vivid images of social values, such as Picasso's masterpiece protesting war and violence, *Guernica*; an Indian statue of a contemplative Buddha; Judy Chicago's feminist statement, *The Dinner Party*; or a Navajo wedding basket. The art of any cultural or ethnic group often reveals values held by that group. Understanding of art created within a particular culture requires knowledge of the purposes, functions, and meanings of artworks within the context of their creation.

The history of art education includes significant emphasis on democratic values. The freedom necessary for the success of an aesthetic act cannot be separated from the freedom of thought and action that is the prerogative of individuals living in a democracy. Art educators have been among the pioneers in developing a pedagogy compatible with democratic practices.⁴⁰ They have understood that art cannot be taught successfully unless it is presented in an atmosphere designed to develop individual, and at times possibly nonconformist, expression. It is the emphasis that art education places on personal decision making that often separates art classes from many others.

As individuals we become involved in interpersonal re-

lationships and in social or political events. As citizens we learn to respect and live with our neighbors in various social contexts. Good citizens often improve the quality of everyone's life by taking appropriate actions to affect the broad social and environmental issues confronting the community at large.⁴¹ These broad social concerns are present as themes in many significant works of art and are particularly relevant for analysis of visual culture. They become important whenever art education extends our view beyond the concerns of individuals to the values of society.⁴²

Even aesthetic values have become the focus of social issues. Beginning in the 1920s, critics expressed serious concern about the general level of aesthetic taste in the United States. As early as 1934, Dewey asked, "Why is the architecture of our cities so unworthy of a fine civilization? It is not from lack of materials nor lack of technical capacity . . . yet it is not merely slums but the apartments of the well-to-do that are aesthetically repellent."⁴³

Ouestions like this offered a challenge to education, for such condemnation referred indirectly to the masses of people educated in public schools. The inference was that the art education program was not effective in developing the ability to recognize good design from bad. Art educators continue to seriously consider methods of developing critical thinking and aesthetic sensitivity in children. Aesthetic issues continue to be central to the social and environmental needs of society. The impact of the mass media, the changing faces of cities, the forms of suburbia, and the pollution of natural resources are factors of modern living in all parts of the world and need to be brought to the attention of children. How effective art teachers can be in their attempts to create visual sensitivity is still a matter of speculation. One thing is certain: The future designers and planners who share the task of creating environments that humanize and enhance our lives are students in our schools at this very moment.

Public Attitudes in the Schools

The influences of democracy and freedom are fundamental and have been in operation since the founding of this country. Other values and attitudes toward art perpetuated from early times have not all been beneficial to art education. Unlike citizens of countries with long-standing cultural accomplishments, American pioneers did not grow up in the midst of artistic and architectural traditions. Aesthetic and artistic concerns often were low in priority, because the tasks of survival and practical living required much time and energy. Our thriving democracy produced business leaders and politicians in place of an aristocracy, the traditional patrons of the arts. Because business and politics are often based in practicality, only when the arts could be viewed as making a profitable contributior. were they placed higher in priority. Nevertheless, art education has progressed in theory and in professional practice to the point where enlightened educators view it as an essential rather than as a peripheral aspect of a balanced curriculum.⁴⁴

Recent research reports very significant gains for art as a regular subject in the school curriculum. A 2002 national study by the National Center for Education Statistics (NCES) reported that the visual arts are offered in 87 percent of public elementary schools and 93 percent of secondary schools. The majority of public elementary schools indicated that a specially equipped space is provided for art instruction.⁴⁵

These positive attitudes toward art education might well be the result of the dedicated service of thousands of art teachers during the past 50 years. At least the positive change in attitude toward the arts—as verified by attendance records for art museums, theatres, concerts, and so on—directly correlates with the increased attention paid to the teaching of art in the schools.

The quality of art programs varies widely from state to state and from school district to school district according to the values of legislators, school leaders, and communities and according to varying degrees of financial stability. Art educators often are called upon to advocate support for their programs from parents and from school and community groups. One effect of the seemingly constant need to justify art education is the development of art programs based on well-articulated, convincing rationales.⁴⁶

CHANGE IN ART EDUCATION

The history of art education is a fascinating, ongoing tapestry of interwoven threads that form a complex design. Three of the most prominent threads—the nature of art, conceptions of the learner, and the values of society—have already been discussed. Others represent the works of individual artists, writers, and teachers, and the advances in technology, curriculum projects, and even legislation. It is difficult to gain a clear view of the emerging pattern while the design is still being developed.⁴⁷ The following brief dis-

OBJECTS OF AMERICAN

cussion is an attempt to identify some of the more prominent threads in the historical development of art education.

In the United States, for instance, the origins of art education in the schools are related to the requirements of business and industry or the goals of society in midnineteenth-century New England. American business leaders witnessed how the English had raised their standards of industrial design in order to compete favorably with European business in taste, style, and beauty. England's schools of design were revitalized in the 1850s, and they produced a corps of skilled designers for industry. In the United States, a few shrewd business leaders noted cause and effect and urged skeptical merchants and manufacturers to see the practical necessity of art education for competition in world trace markets. Following the British example, the The history of art education has been chronicled by researchers such as Diana Korzenik, who has collected and studied teaching materials and objects from past eras. This collection is housed in the Huntington Library and is available for study by scholars. Americans recruited Walter Smith, a graduate of England's South Kensington School, and appointed him concurrently director of drawing in the public schools of Boston and state director of art education for Massachusetts. Smith began his monumental task in 1871, just a few months after the Massachusetts legislature passed the first law in the United States making drawing a required subject in the public schools.

Walter Smith approached his work with great vision and vitality and began the development of a sequential curriculum for industrial drawing. Within nine years, he had founded and directed the Massachusetts Normal Art School, the first in the country (now the Massachusetts College of Art and still the only state-supported art school in the country), and had implemented his curriculum in all Massachusetts primary grades up to high school. In addition, Smith's writings and the teachers trained at the Normal School extended Smith's influence across the country. His publications included a series of drawing books for instructional purposes.

Example of a linoleum block print by a student in Franz Cizek's class in Vienna.

Smith's instruction led teachers and children through a rather rigid sequence of freehand, model, memory, and geometric and perspective drawing. Rote learning, copying, and repetition were common aspects of the sequential curriculum.

Smith's method of presenting the content depended upon class instructions and relied heavily upon the use of the blackboard, from which the students copied the problem the teacher drew. Prints and drawings were also copied by the students. Smith justified copy work in two ways: that it was the only rational way to learn, since drawing was essentially copying; and that it was the only practical way to teach, since classes were large and only a very limited amount of time was allotted in the school week to drawing.⁴⁸

Although we would reject this type of art program today, Smith's accomplishments were well ahead of his time. His program broke new ground and gave art education in the United States a firm foundation on which to build, a status the subject had never before had, and a precedent that could never be ignored.⁴⁹

Cizek and Children's Artistic Expression

Until the advent of expressionism or emphasis on children's creative art production, art education remained remarkably aloof from artistic tradition. Expressionism first had its effect on art education largely through the work of one outstanding teacher, Franz Cizek. Cizek, an Austrian, went to Vienna in 1865 to study art. In 1904 he accepted the position of chief of the Department of Experimentation and Research at the Vienna School of Applied Arts. His now-famous art classes for children were developed in this department.

Cizek eliminated certain activities from these classes, such as making color charts and photographic drawings of natural objects. Instead, he encouraged children to present, in visual form, their personal reactions to happenings in their lives.⁵⁰ In the output produced under his guidance much of which has been preserved—the children depicted themselves playing and doing the things that naturally engage the attention and interest of the young. Cizek always maintained that it was not his aim to develop artists. Instead, he held as his one goal the development of the creative power that he found in all children and that he felt could blossom in accordance with "natural laws."⁵¹

Much of the work produced in Cizek's classrooms reveals the charm of expression of which children, under sympathetic teachers, are capable. Some of the output may now seem sentimental, overdirected, and disclosing of pretty mannerisms, such as a profusion of stars in the sky areas of compositions or a stylized expression of childish innocence in the faces. These mannerisms imply that some of the classes may have been highly structured by today's standards and that the artistic development of the children was brought about more by Cizek's teachers than by the "natural laws" that Cizek advocated. Nevertheless, Cizek is an important figure in art education, and his work deserves the widespread admiration it has received. The contemporary belief that children, under certain conditions, are capable of expressing themselves in a personal, creative, and acceptable manner derives largely from his demonstrations in Vienna. Cizek's ideas contrasted completely with those of Walter Smith.

The Teachers of Art

Other threads appear in the warp and weft of the history of art education. Great teachers emerged, such as Arthur Wesley Dow of Columbia University, Walter Sargent of the University of Chicago, and Royal B. Farnum of the Rhode Island School of Design.⁵² Dow was concerned with analyzing the structure of art and sought to develop a systematic way in which it could be taught. He developed and taught what we know today as the elements and principles of design. Within this formalist view, the artist works with line, value, and color, composing these elements to create symmetry, repetition, unity, transition, and subordination, which can be controlled to achieve harmonious relationships. Concepts and language developed by Dow are considered essential fundamentals, and many contemporary art curricula are still organized purely on the basis of a list of design elements and principles.

Walter Sargent's contribution to art education came from his focus on the process by which children learn to draw. He described in acceptable terms three factors that he believed influence children's ability to draw. First, children must want to say something, must have some idea or image to express through drawing. Second, children need to work from devices, such as three-dimensional models or pictures, in making drawings. Finally, children often learn to draw one thing well but not others, so skill in drawing is specific; a person could be good at drawing houses or boats and not good at drawing horses or cows.

It is a tribute to Sargent that these three points are echoed in the literature of art education, such as the work of Brent and Marjorie Wilson: "Individuals employ a separate program for each object which they depict.... In the case of those objects that are well drawn, they have repeatedly played essentially the same program, sharpening their ability to recall the desired configuration easily from memory" ⁵³

Arthur Wesley Dow's debt to

Japanese handling of place-

ment of form in composition

is evident in this illustration

from his book Composition

Following Cizek's focus on creative art activity for young children and the values of the progressive education movement inspired by Dewey, art educators in the United States, such as Margaret Mathias and Belle Boas, were influential in shaping the field through their teaching, writing, and professional activism. Mathias wrote of the natural growth of children's expression through art and also affirmed her belief in the value of art appreciation "for understanding the art of others." In this she anticipated the work of Farnum and others who directed attention to the viewing of art by professional artists. At the same time, Boas projected the earlier work of Dow while she called attention in her book to development of "good taste" and aesthetic judgment in the lives of children through their study of design principles.⁵⁴

Royal B. Farnum was one of the many art educators involved in the *Picture Study Movement* during the 1920s. When it became possible through advances in printing technology to produce inexpensive color reproductions of paintings, many art educators of that era took the opportunity to present children with lessons in art appreciation. It was characteristic that the pictures chosen for study were not contemporary with the time, presented a narrow standard of "beauty," and often carried a religious or moral message. In his book *Education through Pictures: The Practical Picture Study Course*, published in 1931, Farnum lists no works of art by Picasso, Kollwitz, Cézanne, van Gogh, or even Monet or Cassatt.⁵⁵ Instead, the works are chosen from earlier times, with at least 14 of the total of 80 being pictures on religious themes.

Although it is easy to be critical of early attempts at art appreciation, we must recognize the pioneering nature of this type of art education. Nevertheless, as Eisner pointed out, "Until very recently art education as a field has been quite unresponsive to contemporary developments in the world of art. Art education until as late as the middle of the twentieth century was more a reflection of lay artistic tastes than it was a leader in shaping those tastes and in enabling students to experience the work of the artistic frontiers of their day."⁵⁶

The Owatonna Project

The Owatonna Art Project in Minnesota was the most successful of several community art projects funded by the federal government in the 1930s. The object of the Owa-

tonna Project was to create art activities based on the aesthetic interests of community members. The project promoted "home decoration, school and public park plantings [and] visually interesting window displays in commercial areas." 57 The idea was to apply principles of art in everyday life for a richer experience. The Owatonna Project was a successful cooperative effort that involved many sectors of the community, the local schools, and the University of Minnesota. Unfortunately, it was interrupted by the outbreak of World War II and never achieved the impact it might have had under different circumstances. Although art existed in the regular school program, the Owatonna Project was community rather than studio centered. In this regard, it represented a move away from the child-centered approach of Franz Cizek, as Cizek rejected the vocational goals of Walter Smith.

The Bauhaus

Another influence in the late 1930s was the Bauhaus, a German professional art school committed to integrating the technology of its day into the artist's work. As a result of its influence, modern art materials, photography, and visual investigation involving sensory awareness found their way into the secondary school art program. Interest in the technology of art (notably in the communications media), concern for the elements of design, and an adventurous attitude toward new materials are all consistent with the Bauhaus attitude. The Bauhaus stimulated a growing interest in a multisensory approach to art, as well as a tendency to incorporate aesthetic concerns into environmental and industrial design, especially in secondary schools. Teachers who were influenced by the Bauhaus regarded design in a much broader, more inclusive way than did Dow or Sargent.

Creativity and Art Education

Art educators' interest in the development of creativity is well documented by the titles of prominent books published in the field, especially during the 1940s and 1950s. Victor D'Amico's *Creative Teaching in Art*, Viktor Lowenfeld's *Creative and Mental Growth*, and later, Manuel Barkan's *Through Art to Creativity* were three of the most influential.⁵⁸ Long an interest of art educators, creativity was also the focus of considerable attention and study by psychologists. The progressive education movement of the 1920s had laid the groundwork for this interest by relating the free and expressive aspects of art creativity to a theory of personality development.

When the movement declined in the late 1950s, members of the American Psychological Association, acting on the suggestion of their president, J. P. Guilford, assumed leadership in applying more rigorous research techniques to such problems as the analysis of creative behavior and the identification of characteristic behaviors of professionals in both the arts and sciences.⁵⁹ Within a decade, what had formerly existed on the level of a philosophical mystique was replaced by scientific inquiry.

The research tools of psychologists of the time tests, measurements, computers, and clinical methods were brought to bear on the processes of artistic creation. In considering the creative process, psychologists went beyond the visual arts and established commonalities of experience among all types of people involved in solutions to creative problems. Creativity in the schools was no longer the private preserve of the art room. As a result of discovering how the creative process served teachers of other subjects, ideas emerged that would permit art teachers to view their profession with new understanding. Art teachers have long suspected that art, taught under proper conditions, can promote values that transcend the boundaries of the art lesson.

The work of Viktor Lowenfeld emerged as the single most influential force in shaping the field of art education from the early 1950s into the 1980s. Lowenfeld was head of a large doctoral program in art education at Pennsylvania State University. Many of the graduates from his program became established in other colleges and universities around the country and in positions at state and schooldistrict levels. *Creative and Mental Growth* became the classic work in art education, was translated into other languages, and continued to be published in numerous editions, even after Lowenfeld's death in 1960.

Lowenfeld combined a primary emphasis on the development of creativity with his theory of personality integration through art activities. This involved such areas of personality growth as physical, social, creative, and mental. Emphasis was placed almost exclusively on art-production activities, beginning at very early ages and involving a wide range of art materials to encourage children to explore and create. Lowenfeld emphasized the supportive and motivational roles of teachers more than explicit instruction. Teachers were counseled to beware of imposing adult concepts and views on children, who were encouraged to develop their natural creative powers.

Cognitive researchers are currently reexamining creativity. In addition, new insights are emerging from brain research and sociology. Creativity theories are emerging that combine ideas from these three major areas of research.

Toward Art Content

The creativity rationale for art education and the interest in personality development so strongly advocated by Lowenfeld and others dominated the field well into the 1960s. when a new generation of scholars and educators began to suggest, for the first time, that the study of art was intrinsically worthwhile. Attention was focused on art as a body of knowledge that could be learned by children. Justifications for art in the schools arose from art's value to other areas of concern, such as the development of competent industrial designers, the development of perception, achievement of general educational goals, and cultural literacy. Content-centered writers justified the study of art on the basis of what functions art performs in society and why it is important to understand those functions.⁶⁰ This position, as Eisner pointed out, "emphasizes the kinds of contributions to human experience and understanding that only art can provide; it emphasizes what is indigenous and unique to art."61

Many contemporary art programs recognize a body of art knowledge that fosters understanding and response to art as well as activities that result primarily in art making. Students are exposed to the visual arts of the ancient and modern eras through films, slides, and reproductions, as well as through actual art objects in galleries, studios, and museums, when possible. Awareness of the world of art and of the concepts, language, and approaches used in responding to art not only helps students understand and appreciate the art of others but also increases students' sensitivity to their own artwork.

Many art educators today advocate a teaching philosophy that encourages students to think about the relationship of art, ecology, and community, following the earlier work of June King McFee and others.⁶² They emphasize a curriculum that is interdisciplinary, action oriented, and based on social values. Teaching is aimed at fostering awareness of interconnections between community and environment and focuses on concepts of environmental design, ecological art, visual culture, and involvement with community. As we can see, the three fundamental emphases for any program of education—content centered, child centered, and society centered—continue to be advocated and implemented within the diversity of contemporary art education.

SOME BASIC BELIEFS IN CONTEMPORARY ART EDUCATION

Art education today is still very much a composite of what has gone before. It is not difficult to identify the many threads in the pattern that we have discussed. The development of strong professional associations, such as the National Art Education Association (NAEA) in the United States, the Canadian Society for Education through Art (CSEA), the National Society for Education in Art and Design (NSEAD) in the United Kingdom, and the International Society for Education through Art (InSEA) as a world organization (see Appendix B); the publication of an impressive body of literature in the field, including burgeoning research literature; and the emergence of wellfounded teacher-education programs in colleges and universities have led to an enlightened group of art educators. This increased level of professional communication has not resulted in a narrow unanimity of thought about the goals of art education in contemporary society, although some points are agreed on by most art educators.

The development of national standards for the arts was accomplished in 1994 in response to the Goals 2000: Educate America legislation passed by the U.S. Congress and signed by President William Jefferson Clinton. The voluntary standards provide a general guideline for states and local school districts to adapt, adopt, or reject. The introduction to the national standards included the following general statements of values, which were accepted by the national organizations for art, music, theatre, and dance education:⁶³

- The arts have both intrinsic and instrumental value; that is, they have worth in and of themselves and can also be used to achieve a multitude of purposes.
- The arts play a valued role in creating cultures and building civilizations. Although each arts discipline makes its unique contributions to culture, society, and the lives of individuals, their connections to each other enable the arts disciplines to produce more than any of them could produce alone.
- The arts are a way of knowing. Students grow in their ability to apprehend their world when they learn the arts. As they create artworks, they learn how to express themselves and how to communicate with others.
- The arts have value and significance for daily life. They provide personal fulfillment, whether in vocational settings, avocational pursuits, or leisure.
- Lifelong participation in the arts is a valuable part of a life fully lived and should be cultivated.
- No one can claim to be truly educated who lacks basic knowledge and skills in the arts.
- The arts should be an integral part of a program of general education for all students.

In addition to these views about the arts in education, many art educators share the belief that all children possess both innate creative and appreciative abilities that can be nurtured through art instruction.

Of course, views expressed in this book are subjects for dialogue within the teaching profession. Awareness of issues will assist teachers in evaluating their own experiences.

NOTES

- 1. Ralph Tyler, *Basic Principles of Curriculum and Instruction* (Chicago: University of Chicago Press, 1950).
- Ellen Dissanayake has explored in depth the origins and functions of the arts in human culture in her book What Is Art For? (Seattle: University of Washington Press, 1988). She speculates that the arts evolved through

making socially significant activities memorable and special and are therefore essential to human survival.

- 3. Albert Elsen, *Purposes of Art*, 2d ed. (New York: Holt, Rinehart and Winston, 1968).
- 4. Edmund Feldman, *The Artist* (Englewood Cliffs, NJ: Prentice-Hall, 1982).

- Gilbert Clark, Michael Day, and Dwaine Greer, "Discipline-Based Art Education: Becoming Students of Art," in *Discipline-Based Art Education: Origins, Meaning, and Development*, ed. Ralph Smith (Urbana: University of Illinois Press, 1989).
- 6. For discussions of each of these four art disciplines as sources for art curricula, see the essays by Frederick Spratt, Eugene Kleinbauer, Howard Risatti, and Donald Crawford in Smith, *Discipline-Based Art Education*.
- 7. Jean-Jacques Rousseau, *Emile*, trans. Barbara Foxley (London: J. M. Dent and Sons, 1977).
- 8. See Pestalozzi's novel, Leonard and Gertrude (1781), and his book on education, How Gertrude Teaches Her Children (1801). Herbart wrote ABC of Sense Perception to explain Pestalozzi's views. See Herbart's Text Book of Psychology (1816) and Outlines of Educational Doctrine (1835).
- 9. John Dewey, *Philosophy in Civilization* (New York: Minton, Balch, 1931).
- 10. John Dewey, Art as Experience (New York: Capricorn Books, G. P. Putnam's Sons, 1934).
- 11. In 1913 and 1914, Thorndike published his threevolume *Educational Psychology*, comprising vol. 1, *The Original Nature of Man*; vol. 2, *The Psychology of Learning*; and vol. 3, *Work*, *Fatigue*, *and Individual Differences*.
- 12. E. L. Thorndike, *Educational Psychology: Briefer Course* (New York: Teacher's College, 1914), p. 173.
- 13. Rudolf Arnheim, *Art and Visual Perception*, 4th ed. (Berkeley: University of California Press, 1964).
- Examples of B. F. Skinner's writings include Walden Two (New York: Macmillan, 1948); Science and Human Behavior (New York: Macmillan, 1953); and Beyond Freedom and Dignity (New York: Knopf, 1971).
- 15. Frank Milhollan and Bill Forisha, From Skinner to Rogers: Contrasting Approaches to Education (Lincoln, NE: Professional Educators, 1972), p. 46.
- Abraham H. Maslow, "Existential Psychology— What's in It for Us?" in *Existential Psychology*, ed. Rollo May (New York: Random House, 1961); and Carl R. Rogers, *Freedom to Learn* (Columbus, OH: Merrill, 1969).
- 17. See, for example, Barbel Inhelder and Jean Piaget, *The Growth of Logical Thinking from Childhood to Adolescence* (New York: Basic Books, 1958) and *The Early*

Growth of Logic in the Child (New York: Norton, 1964); and Jean Piaget, *Science of Education and the Psychology of the Child* (New York: Viking, 1971).

- 18. Kenneth Lansing, "The Research of Jean Piaget and Its Implications for Art Education in the Elementary School," *Studies in Art Education* 7, no. 2 (Spring 1966).
- Lauren B. Resnick and Leopold E. Klopfer, eds., Toward the Thinking Curriculum: Current Cognitive Research (Alexandria, VA: Yearbook of the Association for Supervision and Curriculum Development, 1989), p. 52; see also Robert Marzano et al., Dimensions of Thinking: A Framework for Curriculum and Instruction (Alexandria, VA: Association for Supervision and Curriculum Development, 1988).
- Howard Gardner, Frames of Mind: The Theory of Multiple Intelligences (New York: Basic Books, 1983), Multiple Intelligences: The Theory in Practice (New York: Basic Books, 1993), and Disciplined Minds: What All Students Should Understand (New York: Simon and Schuster, 1999).
- Carol Reid and Brenda Romanoff, "Using Multiple Intelligence Theory to Identify Gifted Children," Educational Leadership 55, no. 1 (November 1997): 71–74; Andrew Latham, "Quantifying MI's Gains," Educational Leadership 55, no. 1 (November 1997): 84–85; and Linda Campbell, "Variations on a Theme: How Teachers Interpret MI Theory," Educational Leadership 55, nc. 1 (November 1997): 14–19; see also Howard Gardner, "Multiple Intelligences after Twenty Years," address to the American Educational Research Association, Chicago, April 21, 2003.
- Howard Gardner, "Multiple Intelligences as a Partner in School Improvement," *Educational Leadership* 55, no. 1 (November 1997): 20–21.
- Elliot Eisner, "Implications of Artistic Intelligences for Education," in *Artistic Intelligences: Implications for Education*, ed. William J. Moody (New York: Teachers College Press, 1990), p. 37.
- 24. A sample of articles and books includes Madeline Hunter, "Right-Brained Kids in Left-Brained Schools," *Today's Education* (November–December 1976); Elliot Eisner, "The Impoverished Mind," *Educational Leadership* 35, no. 8 (May 1978); and Evelyn Virsheys, *Right Brain People in a Left Brain World* (Los Angeles: Guild of Tutors, 1978).

- 25. Pat Wolfe and Ron Brandt, "What Do We Know from Brain Research?" *Educational Leadership* 56, no. 3 (November 1998): 8–13.
- Frances Rauscher et al., "Music Training Causes Long-Term Enhancement of Preschool Children's Spatial-Temporal Reasoning," *Neurological Research* 19 (1997): 2–8.
- 27. Debra Viadero, "Research: Music on the Mind," *Education Week* (April 8, 1998): 25–27.
- 28. Wolfe and Brandt, "What Do We Know?"
- 29. Madeleine Nash, "Fertile Minds," *Time*, February 3, 1997, pp. 48–56.
- 30. Ibid.
- Shannon Brownlee, "Baby Talk: Learning Language Is an Astonishing Act of Brain Computation," U.S. News & World Report, June 15, 1998, pp. 48–55.
- 32. David Sousa, "Is the Fuss about Brain Research Justified?" *Education Week* (December 16, 1998): 35, 52.
- Renate Nummela Caine and Geoffrey Caine, *Teaching and the Human Brain* (Alexandria, VA: Association for Supervision and Curriculum Development, 1991).
- 34. George Geahigan, "The Arts in Education: A Historical Perspective," in *The Arts, Education, and Aesthetic Knowing: Ninety-first Yearbook of the National Society for the Study of Education*, ed. Bennett Reimer and Ralph Smith (Chicago: University of Chicago Press, 1992); see also Eric Jensen, *Arts with the Brain in Mind* (Alexandria, VA: Association for Supervision and Curriculum Development, 2000).
- 35. Benjamin Bloom, ed., Taxonomy of Educational Objectives: The Classification of Educational Goals, Handbook 1: Cognitive Domain (New York: Longmans, Green, 1956), Handbook 2: Affective Domain (New York: David McKay, 1964); and Robert Mager, Preparing Instructional Objectives (Palo Alto, CA: Fearon, 1962).
- Daniel Goleman, Emotional Intelligence: Why It Can Matter More Than IQ (New York: Bantam, 1995); J. Maree and L. Ebersohn, "Emotional Intelligence and Achievement: Redefining Giftedness," Gifted Education Journal 16, no. 3 (2002): 262–73.
- 37. Marian Diamond and Janet Hopson, Magic Trees of the Mind: How to Nurture Your Child's Intelligence, Creativity, and Healthy Emotions from Birth through Adolescence (New York: Dutton, 1998). This is a practical book on brain research for parents and teachers and

contains an excellent mix of clearly explained scientific research and solid advice on how to create stimulating home and school environments.

- Robert Sylwester, "Art for the Brain's Sake," Educational Leadership 56, no. 3 (November 1998): 31–35.
- 39. Eric Jensen, *Teaching with the Brain in Mind* (Alexandria, VA: Association for Supervision and Curriculum Development, 2005), p. ix.
- 40. Italo De Francesco, Art Education: Its Means and Ends (New York: Harper and Row, 1958).
- 41. June McFee, *Preparation for Art* (Belmont, CA: Wadsworth, 1961).
- 42. June McFee and Rogena Degge, Art, Culture, and Environment (Dubuque, IA: Kendall-Hunt, 1980).
- 43. Dewey, Art as Experience, p. 344.
- 44. Endorsements of art as an essential component in general education are on record from many professional education groups, such as the Association for Supervision and Curriculum Development, the College Board, the National Endowment for the Arts, the Council for Basic Education, the National Art Education Association, and the National Parent and Teachers Association.
- National Center for Education Statistics, Arts Education in Public Elementary and Secondary Schools: 1999– 2000, Statistical Analysis Report (Washington, DC: Office of Educational Research and Improvement, U.S. Department of Education, 2002), NCES 2002-131.
- 46. Illinois Art Education Association, Excellence and Equity in Art Education: Toward Exemplary Practices in the Schools of Illinois (Champaign: University of Illinois Press, 1995).
- 47. Arthur Efland, *A History of Art Education* (New York: Teachers College Press, 1990).
- 48. Harry Green, "Walter Smith: The Forgotten Man," *Art Education* 19, no. 1 (January 1966).
- 49. Foster Wygant, Art in American Schools in the Nineteenth Century (Cincinnati: Interwood Press, 1983).
- 50. Peter Smith, "Franz Cizek: The Patriarch," Art Education (March 1985).
- 51. W. Viola, *Child Art and Franz Cizek* (New York: Reynal and Hitchcock, 1936).
- 52. Stephen Dobbs, "The Paradox of Art Education in the Public Schools: A Brief History of Influences," ERIC Publication ED 049 196 (1971).

- 53. Brent Wilson and Marjorie Wilson, "An Iconoclastic View of the Imagery Sources in the Drawings of Young People," *Art Education* (January 1977): 5, 9.
- 54. Frederick M. Logan, *Growth of Art in American Schools* (New York: Harper and Brothers, 1955); see also Logan's "Update '75, Growth in American Art Education," *Studies in Art Education* 17, no. 1 (1975).
- 55. Royal B. Farnum, *Education through Pictures: The Practical Picture Study Course* (Westport, CT: Art Extension Press, 1931).
- 56. Elliot Eisner and David Ecker, eds., *Readings in Art Education* (Waltham, MA: Blaisdell, 1966).
- 57. Dobbs, "Paradox of Art Education," p. 24.
- Victor D'Amico, Creative Teaching in Art (Scranton, PA: International Textbook, 1942); Viktor Lowenfeld, Creative and Mental Growth (New York: Macmillan, 1947); and Manuel Barkan, Through Art to Creativity (Boston: Allyn and Bacon, 1960).
- 59. J. P. Guilford, "The Nature of Creative Thinking," American Psychologist (September 1950).

- 60. For example, see Ralph Smith, ed., *Aesthetics and Criticism in Art Education* (Chicago: Rand McNally, 1966); and Edmund Feldman, *Art as Image and Idea* (Englewood Cliffs, NJ: Prentice-Hall, 1967).
- 61. Elliot Eisner, *Educating Artistic Vision* (New York: Macmillan, 1972).
- 62. See, for example, Louis Lankford, "Ecological Stewardship in Art Education," Art Education 50, no. 6 (1997): 47–53; Graeme Chalmers, "Celebrating Pluralism Six Years Later: Visual Transculture/s, Education, and Critical Multiculturalism," Studies in Art Education 43, no. 4 (2002): 293–306; Tom Anderson and Melody Milbrandt, Art for Life (New York: McGraw-Hill, 2005).
- 63. Consortium of National Arts Education Associations, National Standards for Arts Education: What Every Young American Should Know and Be Able to Do in the Arts [Reston, VA: Music Educators National Conference, 1994].

ACTIVITIES FOR THE READER

- 1. Visit an art gallery or museum, and find examples of works that are representative of purposes art has served, as discussed in this chapter. See "Nature of the Visual Arts." A textbook in art history or a World Wide Web museum site (see listings under Web Resources) may be used if a museum is not available. Find examples of the following:
 - a. An object created to serve a particular function
 - b. An object enhanced with decorative elements or created in a unique shape to provide a pleasurable experience
 - c. An object whose decoration includes symbols that express ideas or values related to its origin
 - d. An object that elicits an aesthetic response from the viewer
- 2. Examine advertisements from magazines or other publications, and select ads that appear to be well designed or artistically persuasive. This activity can also address television advertisements. Ask probing questions such as these:

- a. What catches your attention: people in the ad? the graphic design? the topic of the ad?
- b. What product does the ad promote? What group is identified as the target audience? What value does the product provide?
- c. What means of persuasion does the ad employ: attractive representation of the product? promise of added value for the purchaser? suggestion of status to be obtained by the purchaser? other strategies to convince purchasers to buy?
- 3. Visit an elementary school, and observe instruction and learning activities in art. From your observations, answer the following questions:
 - a. Is valid art content being taught?
 - b. Is the art learning part of a sequential curriculum?
 - c. Do the children have an opportunity to engage in creative art making?
 - d. Is the art of children displayed in the classroom?
 - e. Does learning include analysis and interpretation of meaning in art?

- f. What evidence is there that children are learning about art history?
- 4. As you spend time observing in an elementary classroom, can you detect if the emphasis is child centered, content centered, or society centered? Or do you note a combination of these approaches?
- 5. Visit a gallery or art museum, and identify examples of art that might be classified according to the discussion in this chapter (see "Nature of the Visual Arts"). Find examples of the following:
- a. Traditional fine arts, such as painting, sculpture, and printmaking
- b. Applied arts, such as furniture, interiors, weaving, pottery, silver, or quilts
- c. Works by indigenous artists from North and South America, Asia, Africa, and so on
- d. Works by naïve or self-educated artists

SUGGESTED READINGS

- Arnheim, Rudolf. *Thoughts on Art Education*. Los Angeles: Getty Center for Education in the Arts, 1989.
- Broudy, Harry S. *The Role of Imagery in Learning*. Los Angeles: Getty Center for Education in the Arts, 1987.
- Dewey, John. *Art as Experience*. New York: Putnam, 1934. The classic text by the great philosopher of education; essential for art educators.
- Dissanayake, Ellen. *Homo Aestheticus: Where Art Comes From and Why.* New York: The Free Press, 1992.
- Dobbs, Stephen M. *Learning in and through Art: A Guide to Discipline-Based Art Education*. Los Angeles: Getty Education Institute for the Arts, 1998. A review of the theory and practice of discipline-based art education.
- Efland, Arthur. A History of Art Education: Intellectual and Social Currents in Teaching the Visual Arts. New York: Teachers College Press, 1990.
- Eisner, Elliot W. *Educating Artistic Vision*. New York: Macmillan, 1972. Reprinted in 1998 by the National Art Education Association. A classic text in art education.
- Gardner, Howard. *Multiple Intelligences: The Theory in Practice*. New York: Basic Books, 1993. Gardner's own explanation of his theory and its implications.
- Kleiner, Fred S., and Christian Mamiya. *Gardner's Art* through the Ages. 12th ed. Fort Worth, TX: Wads-

worth, 2004. Still the best general art history textbook; includes a pronunciation guide to artists' names and an extensive glossary.

- McFee, June King. *Cultural Diversity and the Structure and Practice of Art Education*. Reston, VA: National Art Education Association, 1998. Provides a historical reflection on changing social conditions, cultures, and aesthetic trends and looks at art education practices from a sociology perspective.
- Neperud, Ronald W., ed. Context, Content, and Community in Art Education: Beyond Postmodernism. New York: Teachers College Press, 1995. Various articles that discuss the appropriateness of art education as a means to empower the community and achieve other social goals.
- Russell, Stella Pandell. *Art in the World*. 4th ed. Chicago: Harcourt Brace College Publishers, 1997. An excellent resource for elementary-school teachers and art educators who wish to increase their appreciation of art.
- Smith, Ralph Alexander, and the National Art Education Association. *Excellence II: The Continuing Quest in Art Education*. Reston, VA: National Art Education Association, 1995.
- Yenawine, Philip. *Key Art Terms for Beginners*. New York: Harry N. Abrams, 1995. Attractive reference—not just for beginners.

WEB RESOURCES

Almost every major museum in the world has created a website that provides images of artworks from their collections as well as educational material. The Getty Center in Los Angeles has a useful site, as does the National Museum of American Art at the Smithsonian Institution. Web addresses for these sites are: Education at the Getty: http://www.getty.edu/ education/ National Museum of American Art: http://americanart

.si.edu/

ART EDUCATION IN CONTEMPORARY CLASSROOMS

Issues and Practices

No one can claim to be truly educated who lacks basic knowledge and skills in the arts.

-National Standards for Arts Education

ART IS NECESSARY, NOT JUST "NICE"

Noted philosopher of education Harry Broudy has raised and commented eloquently on the question, "What is the role of art in general education?"¹ He pointed out that if art is an essential component for a balanced education, then there should be no question of its inclusion in the regular curriculum of elementary and secondary schools. If art is only something "fun" or "nice" for the children to have after "serious" schoolwork, then, says Broudy, it has no place in the curriculum. There are numerous nice experiences for children to have, and any of them will do. However, if the state or school-district board of education promises a quality, balanced education for all students, then art must be offered if that promise is to be redeemed. Art becomes a basic subject required within any curriculum of excellence.

The history of art education reveals that sometimes too many promises or claims have been made for art as a subject in school. We can note claims in the literature that art will increase creativity, enhance personality development, improve school attendance, enhance reading skills, and stimulate the right side of the brain. Each of these claims has a valid foundation, sometimes based on educational research. None of these benefits, however, is unique to the study of art; each can be achieved through other areas of the curriculum as well as through art class.

The rationale for art in the schools is based on the essential contributions that come from studying art. Art is taught because, like the study of science, language, and mathematics, the study of art is essential for an educated understanding of the world. Art as well as science provides a fundamental lens of understanding through which we can view and interpret the world in which we live.² Children who do not receive a sound art education are denied a bal-

German youth engaged in painting a mural-size work.

anced, well-rounded general education and are excluded from much of educated discourse. A person who has never seen the Emanuel Leutze painting *Washington Crossing the Delaware*, which has become a cultural icon, will not catch the humor in Gary Larson's cartoon "Washington crossing the street."

The rationale for art as an essential subject is founded on much more than an ability to understand a joke, as noted in the following statements by distinguished writers and scholars.

In saying: "This is who I am," in revealing oneself, the [artist] can help others to become aware of who they are. As a means of revealing collective identity, art should be considered an article of prime necessity, not a luxury.³

—Eduardo Galeano, Uruguayan writer

The goal of the new, more globally inclusive curricula being forged amid heated debate is the perception of Western civilization as one of many worth studying in a multicultural nation, where white students will be encouraged to see themselves as simply another Other.⁴

—Lucy Lippard, critic

Art is humanity's most essential, most universal language. It is not a frill, but a necessary part of communication. We must give our children knowledge and understanding of civilization's most profound works.⁵

> —Ernest Boyer, former president, Carnegie Foundation for the Advancement of Teaching

Arts education is a requisite and integrated component of the entire educational process.⁶

-Nelson Goodman, Harvard Graduate School of Education

What views might we have, then, of the characteristics and outcomes of sound programs of art education? When art is implemented as a regular part of the basic curriculum, what might we expect as outcomes in the lives of the children? What does a sound program of art education look like? How much time in the school week does it require? How does it relate to the rest of the curriculum? Who should teach art? These questions represent the threads that make up the constantly changing tapestry of art education. As the threads change color and texture across the years, the design of the tapestry is altered subtly or drastically, according to the times.

As we have learned from the brief history of art education in Chapter 1, many views about the contributions of art in education and its implementation in schools exist. It is neither possible nor desirable to present single answers to any of the questions just posed. Rather, we present here a view generally accepted in the field of art education, with expectations that there are many valid variations of that view.

A BALANCED PROGRAM OF ART EDUCATION

Art educators, along with colleagues in music, theatre, and dance education, have access to the guidance of national standards. The National Standards for Arts Education provide general directions that have been adopted or adapted voluntarily at the state and local levels. The standards insist that art education is not a hit-or-miss effort but a sequenced and comprehensive enterprise of learning. Art instruction takes a hands-on orientation in that students are continually involved in the work, practice, and study required for effective and creative engagement.

In a classroom where art is taught, we expect to see children's artwork displayed. The work of children reflects the individuality of expression fundamental to art but also exhibits what children have learned in class.

A visitor to a contemporary classroom sees children learning ways to discuss and respond to works of art and visual culture, reading and writing about art (sometimes correlated with language instruction), investigating questions about art (through class discussion, library research, and the Internet), and analyzing uses of art in everyday life, as well as making their own art. Students are enthusiastic and interested in all these learning activities.

Outcomes of a Quality Art Program

Often, children enjoy their overall school experience more because art touches on areas not addressed in other classes. Being able to make art is very important to many children, and some may attend school more regularly when there is a good art program.

It is often during art instruction that children have opportunities to express ideas, opinions, and judgments. either through their own art production or discussion of

THE FAR SIDE" By GARY LARSON

Washington crossing the street

 Gary Larson, "Washington crossing the street" (1986). Cartoonist Gary Larson's humorous takeoff on Leutze's serious painting is an example of parody. Without knowledge of the original image, we simply would not get the joke.

arks

signature

▼ Art images such as Emanuel Leutze's Washington Crossing the Delaware (1851) become cultural referents-the prior knowledge that we need in order to understand everyday experience and educated discourse.

other works. In art class, children are often praised for the uniqueness of their work rather than its conformity to a predetermined standard or response. In art, for example, each student might successfully complete an assignment based on the concept of "landscape," but each student's landscape painting is unique.

A young person who participates in a quality art program throughout the elementary grades will have the following experiences:

 The student will create drawings, paintings, and other artwork from observation, memory, and imagination. The child will progress through stages of symbol for-

Paul Giovanopoulos, *Venus II*. The artist has appropriated the famous image of Botticelli's Venus and rendered it in a number of styles associated with well-known artists or art styles. How many artists and styles can you identify in this work?

mation and elaboration and will develop relatively sophisticated levels of art-making skills. The child will gain an understanding of art as a means for expressing ideas, feelings, and ideals.

- 2. The student will have access to an expanding store of visual art images, referred to by Broudy as the "imagic store." The child will see, during the years from kindergarten through grades 6, 7, or 8, literally hundreds of exemplary works of fine, folk, and applied visual arts. This "imagic store" is a source of imagination.
- 3. The student will gain a basic understanding of the range of the visual arts throughout history and across many cultures. The child will be conversant with art terms and concepts from the history of art, as well as with many particular landmark works and the artists or cultures that produced them. The child will develop preferences for some types or styles of art.
- 4. The student will learn about a range of world cultures through study of artworks, their contexts, purposes, and cultural values. The child will appreciate his or her own cultural heritage and that of many of the distinctive cultural groups of the United States, Canada, and other countries.
- 5. The student will increase his or her awareness of the influences of visual culture in everyday life and develop powers of discrimination regarding the intent, value, and quality of messages conveyed through visual media.
- 6. The student will investigate ways the visual arts are influenced by the contexts of their creation, such as psychological factors in an artist's life, political events, social values, or changes in technology. The child will learn how art expresses cultural values and, in turn, influences society.
- 7. The child will use the library, Internet, and other sources to seek specific information about art and artists.
- 8. The student will discuss the very nature of art, including issues that surround the making, displaying, buying and selling, and interpreting of works of art.

The fortunate children who experience such a program of art will have exercised their creative abilities in art; thought deeply about art; and responded to and learned about art, artists, and their contexts. They will have developed the aesthetic lens of the visual arts that empowers them to view their world with added meaning and significance.

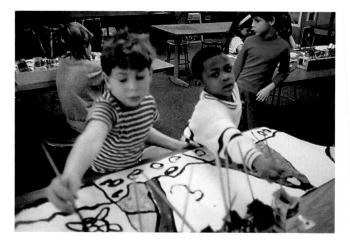

Students can work well together on painting assignments in the classroom setting. These students are working on a large painting made possible by the large tables in the art room. Note the tray nolder for paints and brushes and the stools that give students easy access to exit to the painting area. The expansive hand and arm motions of the two boys are typical when children have opportunity to work on a large scale.

They will be better prepared to negotiate the aggressive world of visual culture. They will have taken one of the essential steps toward achieving a well-rounded, balanced general education that is the right of every child in this society and a requirement for an enlightened citizenry.

Integrating Art with the Elementary Curriculum

Integrating art with other subjects is not a new idea. Leon Loyal Winslow wrote *The Integrated School Art Program* in 1938, and since that time, the topic has reappeared regularly and not without justification. The history of art relates naturally to *historical topics* usually studied at various grade levels. Most history texts, in fact, are illustrated with works of art, providing a ready means for integration. *Social issues* are often expressed by means of powerful images in art and visual culture. Artists of many cultures and eras have dealt with virtually every universal social issue and human value, and teachers have access to the images these artists have produced.

Language instruction can be readily integrated with and enhanced by the art curriculum. Art criticism uses visual concepts and terms (vocabulary) in discussing art. Children learn systematic ways to talk and write about art. Visual art images are intrinsically interesting and provide issues and topics that fascinate children and motivate them to speak and write. Art criticism can take children beyond descriptive use of language to formal analysis and interpretation of meaning in art.

A current concern in general education has to do with *levels of thinking* that are fostered within all subjects in the curriculum.⁷ Too much of children's time is spent with lower levels of thinking involving rote memorization, identification, and recall, and too few complex thinking skills are developed. Some educators are surprised to learn that the art curriculum is one of the easiest and most direct means to engage children in more challenging thinking. Art criticism, for instance, involves forming hypotheses for interpretations of meaning in visual works and discussion, debate, and defense of different interpretations based on visual evidence in the work itself.

Children routinely make judgments about the relationships of each element that they introduce in their own artwork to the totality of the work. A child's tentative decision to introduce hot reds and yellows in a painting that is composed of cool colors requires the child to make sophisticated perceptions, weigh options, interpret implications, and judge appropriateness in relation to intended expression. The child must decide, for example, if red and yellow fit with the overall character of the painting. Few subjects in the curriculum provide such ready means for children to engage in this type of decision making and problem solving.

Children can deal with fundamental issues in art, often using reasor., logic, and careful definition of terms in the process of discourse. Each time a new artwork is introduced in the classroom, an aesthetics issue is introduced. For example, when a teacher shows a slide of a pot by the Native American artist Maria Martinez, the question might arise, "Is a simple clay pot art?" Children often come up with numerous questions that address fundamental issues, such as, "If this pot is art, does that mean that all pots are art?" or "Why is this pot in the art museum and others are not?" When teachers are confronted with these difficult questions and others that inevitably seem to follow, they usually wish to find some way to deal with them in an educationally productive way.

When questions arise in the classroom that address such topics as the nature of art, how quality is determined, or how one becomes an artist, teachers and students become involved in aesthetics discourses at levels appropriate for the age and understanding of the children. This type of discourse is almost always conducted using more complete and challenging levels of thinking so valued by those concerned with general education.

INFLUENCES OF POSTMODERN THOUGHT

Every time we make an educational decision, we carry out a philosophical act that arises from a cultural context and has cultural implications. The more we understand the cultural contexts and implications of educational decisions, the better able we are to create an effective learning environment for all students. Many of the issues educators are involved with today are part of a movement or cultural period known as postmodernism. Postmodernism is now a worldwide movement in all the arts and disciplines, and according to cultural critic Charles Jencks, we are well past the age when we can merely accept or reject it as a new "ism." "It is too omnipresent and important for either approach."8 Rather, Jencks claims, we must understand it before we decide to selectively support or criticize aspects of it. Accordingly, understanding the philosophical ideas of postmodernism provides a context for thinking about current issues and trends in art education. The discussion that follows is necessarily brief; see the Suggested Readings for sources that provide a more in-depth treatment of the subject.

In art and art education, postmodernism is "a new paradigm" that has emerged to challenge ideas that arose during the modern era.⁹ It is therefore best understood by contrasting its premises with those of the modern age—known as modernism. A product of Western European thought, modernism includes the philosophical movement known as the Enlightenment, which occurred from about 1680 to 1780. The modern age continued to about 1950, to be succeeded by what is generally called the postmodern era.

Modernism

Many aspects of modernist philosophy evolved from Enlightenment thinkers who "had the extravagant expectation that the arts and sciences would promote not only the control of natural forces but also understanding of the world and of the self, moral progress, the justice of institutions and even the happiness of human beings."¹⁰ Modernism is a vast and complex phenomenon that covers many beliefs. In time, however, these beliefs developed into "metanarratives," or great themes that some believe influenced the course of history, guided major social movements, and shaped theory in the academic disciplines. The following great themes are among those that have shaped thought in the West:¹¹

- Belief that history is shadowed by logic
- Belief in a universal and coherent foundation of truth
- Belief in reason as a force for a just and egalitarian social order
- Belief in moral progress and the perfectibility of humankind
- Belief in progression of knowledge
- Belief that elimination of worldwide poverty, despotism, ignorance, and superstition is achievable through application of science
- Belief in the power of (Western) art to elevate and refine humanity

A central link among these themes is the idea of *progress*—in knowledge, technology, human freedom, morality, education, and the arts. Time was interpreted as linear and progressive, and history was seen as a series of linear events that eventually would culminate in an end point of perfection. Disciplines of knowledge, even art history and education, were imbued with belief in progress and improvement through change, and change was generally equated with progress.

Another link among modernism's tenets is found in an abiding *faith in science*. Indeed, the belief that nature could be brought under control through the systematic application of science became so powerful that it has dominated modern culture.¹² This belief has influenced thought in all fields of study, including education and art, giving rise to the elevation of empirical science as the premier way of knowing.

Scientific systems of classification were applied to many fields of study, including art. Art historians developed methodologies for classifying art into categories based on historical periods, styles, and formal properties. Eventually, form and formal elements in art were elevated to the position of universals that transcended historical, cultural, or ethnic consideration.¹³ As modernism continued into the twentieth century, it could best be understood as "a cultural movement relating directly to . . . the social condition of living in an urban, fast changing, progressivist world governed by instrumental reason."¹⁴

MODERN ART

Modern theories in art developed sometime after the philosophy of modernism was established. "Artistic modernism" refers both to the styles of art and to the ideologies of art that were produced from about 1880 to 1970. Certain central assumptions or beliefs about art developed as part of modernism:¹⁵

- Belief in progress in the history of art and the belief that art must constantly move toward the new and innovative
- Belief that works exist that are superior representatives of a period, school, or style
- Belief that art has the power to depict and influence social norms
- Belief that content and meaning reside in the work of art
- Belief that quality is a property intrinsic to the work itself
- Belief that art is accessible to all regardless of context or culture and that all persons respond similarly to the visual properties of art

PROGRESS IN ART

Modern art assumed a progressive course in which each generation of artists pushed ahead to find new expressions. Artistic progress was viewed as a series of stylistic revolutions that typically dispatched earlier styles to history.¹⁶ For example, art historians marked progress toward "abstraction" in art through the styles of impressionism, cubism, and abstract expression.

The theory of historical progress in art was established and maintained through university courses and textbooks, and eventually, in school classrooms. In art museums, exhibitions and collections were organized to illustrate the history and progress of art. For this reason, art museums were viewed by some as social instruments used to maintain and reinforce modernism's theories and beliefs.¹⁷

In education and art education, modernism's vision of progress was equated to continual shifting from one paradigm, style, or philosophy of teaching to another. Art education has responded to larger movements and trends in both the field of education and in the art world.¹⁸ Chapter 1 of this textbook describes the various approaches that shaped the teaching of art during the modern era.

THE ROLE OF ART IN SOCIAL PROGRESS

Modernism's assumption that art had the power to depict and influence social norms is reflected in the teachings of philosopher John Dewey. He believed that aesthetic experience had the capacity to influence morality.¹⁹ A belief in the power of art to bring about individual and cultural refinement was widespread in the classrooms of the United States during the Picture Study Movement in the 1920s (see Appendix A).

Many art museums still reflect these goals in their mission statements and education programs. For example, during the 1960s, art museums received government funds to offer museum tours emphasizing masterpieces of Western art to disadvantaged students.²⁰ However, the notion that mere exposure to works of art can confer a moral benefit

Jackson Pollock, *Convergence* (1952). Oil on canvas, 7' 9" \times 13'. Jackson Pollock is recognized as one of the leaders of the abstract expressionist movement that dominated the art world following World War II. Pollock and his fellow artists are credited with establishing the United States, and particularly New York City, as the center of innovation in modern art. Many of the ideas of postmodernism can be best understood in contrast to the basic teness of modernism, which reached its peak in the works of abstract painters and sculptors.

on the viewer has fallen into low repute—a view consistent with postmodernism.

CANON OF GREAT WORKS

A canon is a list of works accepted by scholars and connoisseurs as superior representatives of a period, style, or school and that provides a standard against which new work can be judged.²¹ This is a highly selective list of "masterpieces" that shaped art-world values and influenced the direction of art history. Through formal study the canon of Western art was internalized by generations of artists, art educators, and art historians. The canon became familiar to educated persons who usually were exposed to it in college courses on Western civilization. The canon of traditionally accepted masterpieces received further sanction through its presentation in art history textbooks, museum exhibitions, visual resources (such as reproductions and slides), and art curricula. In this postmodern era, the traditional canon of Western art is only one of many approaches considered in the world of art and in art education.

FORMALISM

Another theory of modernism asserts that it is possible for individuals to reach agreement about the interpretation and judgment of artworks. This assumes that response to art is universal and that the visual aspects of art have the power to move all humans in a similar way.²²

The quest for a universal language that "lies at the core of all understanding" led to the articulation of elements and principles of design or "form." What mattered more than content was form—consequently the label "formalism." Formalism became prevalent in higher-education programs in art and entered the field of art education at the turn of the twentieth century. Knowledge of design and composition was considered foundational to making art that could be experienced aesthetically in any culture, any place, and any time. Prospective art teachers received their art training in studio classes organized around media and processes. The elements and principles of design were assiduously studied and practiced in art schools and art departments.²³ Formalist design content is found even today in many elementary-school art curricula.

AUTONOMY OF THE ARTWORK

Another tenet of modernism held that what is aesthetically relevant about the art is determined by the work itself and not by its context. This belief in the autonomy of the artwork supports the art world's long-held notions that judgments of art's quality are not affected by shifting cultural and social conditions. Art historians and other connoisseurs of art have traditionally claimed the capacity to make objective judgments about the relative worth and visual merit of works of art. From a postmodernist point of view, this practice has come under criticism on grounds that all judgments are subjective and are relative to and conditioned by the social context in which they are made.

MODERN ART AND THE QUEST FOR ORIGINALITY

Although modernist theories began earlier, the actual works that came to be known as modern art date from about 1880 through 1970. Modernism's value of the new and experimental in art resulted in a host of artistic styles, for example, impressionism, fauvism, surrealism, and abstract expression. Modern art was characterized by the imperative to seek new solutions and leave behind the old. The new was constantly being overcome and made obsolete through the discovery of the next new event. Innovation was stressed over all other criteria. Stylistic innovation has defined art in the modernist period, art in the schools, and students' progress in the university classroom.

Additional attributes of modern art included rebellion against the establishment; repudiation of naturalism as a principle of art; and preoccupation with the media and properties of the work, such as color, shape, rhythm, line, balance, and composition. The preoccupation with media and the elements and principles of design dominated art education for decades.

Terry Barrett reminded us that "although Modernism is now old and perhaps over, it was once new and very progressive, bringing a new art for a new age."²⁴ Not all theorists believe that modernism is over. Some even say that postmodernism is simply a continuation of modernism's vision of social emancipation.

Postmodernism

Although it is generally agreed that we live in the postmodern era, the term itself has defied definition. Postmodernism is not a coherent philosophical movement but rather a collective name for a number of philosophical stances and theories.²⁵

Theorists maintain that postmodernism marks a breakdown in the beliefs developed during the modern era. The political calamities and barbarisms of the twentieth century—totalitarianism, genocide, and possible nuclear annihilation—led to a loss of faith in the perfectibility of humankind. Deeply held beliefs in universal justice and equality were challenged by contemporary social structures and the persistent existence of an underclass. The notion of technological domination of nature was shaken by pollution and other environmental ills.²⁶ Much postmodernist thought was aimed at deconstructing the ethnocentrism implicit in the European view of history.²⁷

POSTMODERN THEORY IN ART AND ART EDUCATION

Two particular influences have informed postmodern theory in art and art education. The first is Marxism and the related social movements of feminism and multiculturalism. The second influence comes from linguistic theory and includes structuralism, poststructuralism, deconstruction, and semiotics. The movement for study of visual culture in art education is dependent on postmodern theory.

Marxism was developed in the mid-nineteenth century based on writings of Karl Marx, a German philosopher. Marxist theory addressed issues of social domination and subservience, political inclusion and exclusion, and the economics of a social structure that is characterized as class oppression.²⁸ Contemporary Marxist theory considers, in addition to economics, multiple spheres of domination and power, including religious, aesthetic, ethical, legal, and other cultural systems. Marxist theory holds that societies and their institutions have developed in ways that privilege and benefit particular groups. A major focus, therefore, is to pierce the veils that disguise hidden structures that conceal economic, political, and social elements. This direction is apparent among advocates of visual culture education.

MARXISM AND ART EDUCATION

The term *Marxism* sometimes carries negative connotations, so many scholars use terms for modes of inquiry developed *from* Marxist theory—that is, *critical theory, ideological criticism,* or *social theory.* For the sake of simplicity, this text will continue to use the term *Marxism*.

Contemporary Marxist theory in art is aimed at understanding the role of art in society and the influence of society on art. Institutions, such as museums and schools, are thought to perpetuate the interests of the powerful and wealthy by controlling the kinds of knowledge, skills, and attitudes available to people of different classes.²⁹ Postmodern assumptions based on Marxist theory and prevalent in discussions of education and art include the following:

- Certain groups in any society are privileged over others, and this advantage is most effective when subordinates accept their social status as natural, necessary, or inevitable.
- All thought is mediated by power relations that are socially and historically based.
- Some education practices tend to reinforce systems of class, race, and gender discrimination.

Postmodern critics maintain that power and elitism in the art world were created and maintained during the era of modernism. Two postmodern movements aimed at revealing power structures are those known as feminism and multiculturalism. These movements sought to expose hidden power structures in society, culture, and related institutions that privilege a viewpoint that excluded women and marginalized all but Western European culture.

FEMINISM AND ART THEORY

Feminist scholars questioned the lack of representation of women artists in art history and sought to redefine the discourse of art history. A plethora of new studies and books was published as feminist scholars exposed a dominant masculinist element in traditional art and art history.³⁰ Women's experience, as distinct from men's, became equally legitimate as a subject for art and discourse about art. Traditional masculine ways of depicting women in art were questioned and critiqued by scholars and artists. Feminist scholars, writers, and artists strove to obtain gender equity, or at least a better gender balance, in museum and gallery exhibitions, funding, and scholarly pursuits.³¹

Scholars in art education have sought to offer constructive ways to recognize and incorporate women's contributions and viewpoints into all aspects of art learning. Laura Chapman pointed out that "the persuasiveness of gender bias is not limited to *whose* art has been judged historically important. It extends to the traditional structure of schooling_ and the kind of knowledge valued in schools, museums, and other institutions in society. It influences styles of interacting with students and conventional ways of evaluating learning."³²

This text addresses feminism and art education more completely in the chapters that deal with art content, teaching, and classroom management.

Shirin Neshat, Still from *Passage* (2001). Color video installation with sound. Artist Shirin Neshat typifies the postmodern era in several ways. She is a female artist with a multicultural background (Iran and United States) who deals with women's issues. Her powerful work is primarily in photography and video (with sound and music). Solomon R. Guggenheim Museum, New York. Purchased with funds contributed by The International Director's Council and the Executive Committee Members, 2001.70. Copyright The Solomon R. Guggenheim Museum, New York. Photograph courtesy of the artist.

MULTICULTURALISM

Art history, art museums, and art education curricula too often reflected a Eurocentric bias that appeared exclusionary to many. Cultural groups—Native Americans, African Americans, Latinos, Asian Americans, and others—looked at the art world and education and saw a distorted record of their contributions. Multicultural critics questioned what was portrayed, what was written and communicated, whose voices were included, and whose voices were silenced. Postmodern multicultural theory exposed biased accounts and skewed visual presentations of the cultural histories of non-European peoples. Scholars sought more authenticity in presentation of diverse cultures in schools, museum exhibitions, and history texts. In the art world, redress was sought for artists of color and women, who had not enjoyed the same opportunities and benefits as white male artists.

Multicultural studies challenged modernism's concept of quality in art. Lucy Lippard pointed out that exclusion of women and artists of color "is balanced on a notion of Quality . . . identifiable only by those in power," who claim racism has nothing to do with art judgment.³³ The notion of quality, Lippard claimed, has been the most effective tool in sustaining the homogeneity of Western art.

The field of art education has accommodated multiculturalism in numerous ways. Tom Anderson pointed out that discipline-based art education must be credited for "opening the door" to postmodern approaches in art education that "refocused art educators on the historical, contextual, evaluative, and definitive *content* in art as well as on individual expression."³⁴ The disciplines of art history, art criticism, aesthetics, and educational theory have broadened to accommodate feminist and multicultural viewpoints. Content-based art curricula and educational resources have been created to support art educators in the

Andy Goldsworthy, Yellow Elm Leaves Laid over a Rock, Low Water (1991), Dumfriesshire, Scotland. One of the favorite artists of young students, Goldsworthy creates unique and complex works that might be classified as environmental art. The artist uses no human-made objects or materials, relying solely on nature to provide the materials for his expression. He goes out into nature and creates visually and intellectually appealing works out of leaves, sand, wood, stones, water, ice, snow, sticks, and virtually any natural object he encounters. Although his works return to nature, often he records them photographically so that they can be shared with others. classroom. The official research agenda of the National Art Education Association is inclusive of multicultural and feminist issues.³⁵

COMMUNITY AND SOCIAL VALUES

Awareness of multicultural issues has led to more concern about what community means. Many art educators today advocate a teaching philosophy that encourages students to think about relationships of art, ecology, and community.³⁶ Art making may be interdisciplinary, action oriented, and based on social values. Rather than focus exclusively on form in art, studio teaching often fosters interconnections among art, community, and environment. Working with concepts of environmental design and ecological art "can empower students with the understanding that they, as creative individuals, can have an active voice in protecting their environment and changing current devastating ecological trends."³⁷

A curriculum based on social responsibility requires an approach that broadens the content of art learning as well as pedagogy. Aesthetics may involve consideration of ecological art, created by Andy Goldsworthy and others, as well as appropriateness of local public art. Art criticism learning might focus on environmental design problems, such as the relationship between landscape, ecology, and community. Art making may involve an interdisciplinary and collaborative approach that brings groups of students together to work on projects involving issues of land use, landscape design, and public art.

The *Art in Action* video series, for example, includes a curriculum unit that addresses social and ecological issues.³⁸ *Commentary Islands* is an integrated unit of art curriculum developed by an art teacher. The unit involved students working in teams to create three-dimensional statements about the environment. The sculptural pieces were made on thick Styrofoam bases that would float on the water like islands—thus the title of the unit. On the occasion of launching the "islands" on a nearby pond, students read statements they had written in support of maintaining the natural environment of Earth.³⁹ These students created artworks that conveyed messages about which they cared deeply.

COGNITIVE STRUCTURE OF ART

The second strand of postmodern theory comes from the field of linguistics and includes contemporary methods of inquiry known as poststructuralism, semiotics, and deconstruction. It is not within the scope of this textbook to discuss and define each of these disciplines. See the Suggested Readings at the end of this chapter for more material. However, a brief explanation of semiotics and deconstruction and their relationship to art education is offered here.

Mierle Ukeles, Caremonial Art Honoring Service Workers in the New Service Economy (1988). Steel arch with materials donated from New York City agencies, including gloves, lights, grass, straps, springs and asphalt, $11' \times 8' \times 8.5'$. More than a visual arrangement, this installation carries a strong social message from the artist. Postmode n elements include collaboration, use of nontraditional materials, social theme, and the installation method. Most temporary installations are photographed for purposes of documentation and to make possible the continued impact of the work.

SEMIOTICS

Semiotics is the study of how images, as opposed to words, produce meaning. The essence of semiotic theory holds that the interpretation of an "object" or work of art cannot be accomplished solely on the material nature of the object alone. A work of art has a meaning that has been socially constructed. Interpretation of art images is performed within a cultural and social context. "The meaning of a picture is never inscribed on its surface as brushstrokes are; meaning arises in the collaboration between signs (visual and verbal) and interpreters."40

Semiotic theory rejects the notion that aesthetic values exist as inherent qualities of the work of art. Valuing a work of art is affected by the social and cultural context of the person who is making a judgment. What one period or cul-

Walter De Maria, Lightning Field (1974-77). Stainless steel poles, near Quemado, NM, average height of poles 20.5′, overall dimensions 5,290′ imes 3,300′). As the dark, rolling thunderheads roll across the open New Mexico plains, active lightning flashes can be seen for miles. When the dark clouds pass over Lightning Field, electric bolts arc between earth and sky through the numerous stainless steel poles positioned for that very purpose. This orchestrated display of nature's dramatic power exemplifies several characteristics of postmodern art: It is an installation and a work that cannot become part of the commercial system for buying and selling art. It is an environmental work, utilizing natural forms and phenomena. And it is ecologically harmless in this remote location.

ture finds aesthetically significant or valuable is not necessarily what another culture or period will regard highly. The concept of a universally recognized canon of great art is rejected and replaced with the belief that each generation will value art based on the generation's particular political and cultural interests.

Semiotic theory relates to aesthetic issues in the elementary art classroom. Marilyn Stewart asserted that "those of us who have taught art in the schools know that our students often wonder why certain works have merit and others seem not to."41 Anderson claimed that all art teachers are involved with aesthetic content. "Determining the definitions, meaning, and values of art and deciding how art is to be approached are core issues of aesthetics."42

DECONSTRUCTION

Deconstruction proponents hold that meaning does not exist autonomously in the world to be expressed in language or visual images. Therefore, one can never know an artist's meaning, or accurately interpret the symbols operating in a particular time or place, or understand what a work of art might have meant to a particular audience. Meaning is actually produced by a reader or viewer (interpreter) and therefore exists only as an intellectual construct for each individual.43

Ideas, concepts, and objects are viewed as mental constructs. Deconstruction refers to a mental taking apart or unbuilding of a concept in order to find hidden assumptions. Deconstructionism is generally the careful study of language and meaning. Deconstructionism is a type of interpretation and reinterpretation at a deep level.

The following concepts from deconstruction theory are relevant for art education:

- Greater importance is attached to the viewer and the process of interpretation.
- The notion that the viewer is a passive recipient of knowledge created and served by experts who have discovered the true meaning of a work of art is rejected.
- Interpretation and meaning-making are creative endeavors.
- Meaning exists as an intellectual construct and can be individual or collaborative.

Art educators generally agree that meaning is central to teaching about art and is both unavoidable and desirable. Postmodern notions about the construction of meaning can encourage students to place artworks in a rich context for interpretation. Deconstruction can raise a number of questions for classroom art criticism practice, such as, "Are there ever conclusive meanings about artworks?" "Will meaning change with every viewer?" "How are artworks given social meaning?"⁴⁴ Art criticism is conceived as a creative process resulting in its own linguistic "works of art."

Hyperreality: A Postmodern Condition

A third strand of influence occurring during our postmodern era is the advent of hyperreality. *Hyperreality* is a term used to describe an information society saturated with ever-increasing forms of representation: film, photography, video, CD-ROM, electronic media, and the Internet. These visual media have a profound effect on the construction of cultural narratives that shape our identities. Mechanically produced images collapse the distinction between authentic experiences and those we experience through electronic media.

The computer is so revolutionary that it will eventually affect the way all knowledge is acquired and created. In art, the computer is creating interdisciplinary effects "whose promise we are only beginning to fathom."⁴⁵ The implications for art making are also profound—allowing for interactive multimedia, interactivity with viewers, and collaborative works.

Beyond making art, changes in the relationship between the viewer and the artwork offer a multitude of opportunities to educators. Computer technology in art education makes it possible for a whole range of meanings, related to a single object or artwork, to coexist. Interactive digital media do not depend on a linear or a hierarchical structure and are particularly well suited to both art making and art criticism. Chapter 10 relates digital media to art education and the elementary classroom.

SUMMARY

There is much in postmodernism that is both attractive and disturbing to art educators. Educators generally welcome the broadening of the art world to multiculturalism, exposure of bas in educational materials, placement of greater value on students' interpretations, and connections students have with art they make. On the other hand, it is difficult to give up established traditions that have shaped the meanings of art in the past and contributed to a cultural viewpoint. We learn from postmodernism a measure of modesty about our claims and a sense of the historical character of our understanding of art. The problem for most of us "is not whether to accept modernism or postmodernism. but how to strike the right balance between those approaches and to take from them what is most valuable to us.... Teaching has always been the attempt to pass on our best understanding of the present so that our students will make sense of the future. Postmodernism shows us how important and difficult that task has become."46

NOTES

- Harry S. Broudy, "Arts Education—Necessary or Just Nice?" *Phi Delta Kappan* 60, no. 5 (January 1979): 347–50.
- Harry S. Broudy, *The Role of Art in General Education* (Los Angeles: The Getty Center for Education in the Arts, videotape of Broudy lecture, 1987).
- Rick Simonson and Scott Walker, eds., *The Graywolf* Annual Five: Multi-cultural Literacy (Saint Paul, MN: Graywolf Press, 1988), p. 116.
- Lucy Lippard, Mixed Blessings: New Art in a Multicultura! America (New York: Pantheon Books, 1990), p. 23.
- Ernest Boyer, Toward Civilization: A Report on Arts Education (National Endowment for the Arts, 1988), p. 14.
- Nelson Goodman, "Aims and Claims," in Art, Mind, and Education, ed. Howard Gardner and D. N. Perkins (Urbana: University of Illinois Press, 1989), p. 1.

- Lauren Resnick and Leopold E. Klopfer, "Toward the Thinking Curriculum: An Overview," in *Toward the Thinking Curriculum: Current Cognitive Research* (Reston, VA: Association for Supervision and Curriculum Development, 1989).
- 8. Charles Jencks, *What Is Post-modernism*? 4th ed. (New York: Academy Editions, 1996).
- James Hutchens and Marianne Suggs, eds., Art Education: Content and Practice in a Postmodern Era (Reston, VA: National Art Education Association, 1997).
- Jurgen Habermas, "Modernity versus Postmodernity," in *Postmodern Perspectives: Issues in Contemporary Art*, ed. Howard Risatti (Upper Saddle River, NJ: Prentice-Hall, 1998), pp. 53–64.
- See, for example, Terry Barrett, "Modernism and Postmodernism: An Overview with Art Examples," in Hutchens and Suggs, Art Education, 17–30; Arthur Efland, Kerry J. Freedman, and Patricia L. Stuhr, Postmodern Art Education: An Approach to Curriculum (Reston, VA: National Art Education Association, 1996); and D. Hebdige, "A Report from the Western Front," in Postmodernism, ed. N. Wakefield (London: Pluto Press, 1986).
- Daniel Bell, "Modernism, Postmodernism, and the Decline of Moral Order," in *Culture and Society: Contemporary Debates*, ed. Jeffrey C. Alexander and Steven Seidman (New York: Cambridge University Press, 1990), pp. 319–29.
- 13. Howard Risatti, *Postmodern Perspectives: Issues in Contemporary Art* (Upper Saddle River, NJ: Prentice-Hall, 1998).
- 14. Jencks, What Is Post-modernism? p. 8.
- 15. Terry Barrett, Criticizing Art: Understanding the Contemporary (Mountain View, CA: Mayfield, 1994).
- 16. Efland et al., Postmodern Art Education.
- 17. Donald Preziosi, *Rethinking Art History: Meditations* on a Coy Science (New Haven, CT: Yale University Press, 1989).
- 18. Efland et al., Postmodern Art Education.
- Albert William Levi and Ralph A. Smith, Art Education: A Critical Necessity (Urbana: University of Illinois Press, 1991).
- Barbara Newson and Adele Silver, eds., *The Art Museum as Educator* (Berkeley: University of California Press, 1978).

- 21. Eric Fernie, Art History and Its Methods: A Critical Anthology (London: Phaidon Press, 1995).
- 22. Michael J. Parsons and H. Gene Blocker, *Aesthetics and Education: Disciplines in Art Education* (Urbana: University of Illinois Press, 1993).
- 23. Hutchens and Suggs, Art Education.
- 24. Barrett, Criticizing Art, p. 112.
- 25. Charles Jencks, "The Post-Avant-Garde," in *The Post-modern Reader*, ed. Charles Jencks (London: Academy Editions, 1992).
- 26. Jean-Francois Lyotard, "The Postmodern Condition," in Alexander and Seidman, *Culture and Society*, pp. 330–41.
- Kevin Tavin, "Hauntilogical Shifts: Fear and Loathing of Popular (Visual) Culture," *Studies in Art Education* 46, no. 2 (2005): 101–17.
- Susan M. Pearce, ed., *Interpreting Objects and Collections*, Leicester Readers in Museum Studies (London: Routledge, 1994).
- 29. Carol Duncan, Civilizing Rituals: Inside Public Art Museums (New York: Routledge, 1995).
- 30. For example, see Norma Broude and Mary Garrard, eds., *The Power of Feminist Art* (New York: Harry N. Abrams, 1994); Carol Duncan, "The MoMA's Hot Mamas," in *The Aesthetics of Power: Essays in Critical Art History* (New York: Cambridge University Press, 1993), pp. 189–207; and Guerrilla Girls, *Confessions of the Guerrilla Girls* (New York: HarperCollins, 1995).
- Elizabeth A. Ament, "Using Feminist Perspectives in Art Education," Art Education 51, no. 5 (1998): 56– 61; and Heidi Hein, "Refining Feminist Theory: Lessons from Aesthetics," in Aesthetics in Feminist Perspective, ed. Heidi Hein and C. Korsmeyer (Bloomington: Indiana University Press, 1993), pp. 3–20.
- 32. Laura Chapman, Foreword to *Gender Issues in Art Education: Content, Contexts, and Strategies,* ed. Georgia Collins and Renee Sandell (Reston, VA: National Art Education Association, 1996).
- 33. Lippard, Mixed Blessings, p. 7.
- Tom Anderson, "Toward a Postmodern Approach to Art Education," in Hutchens and Suggs, Art Education, pp. 62–73.
- 35. NAEA Commission on Research in Art Education, Art Education: Creating a Visual Arts Research Agenda to-

ward the 21st Century (Reston, VA: National Art Education Association, 1994).

- 36. Louis E. Lankford, "Ecological Stewardship in Art Education," *Art Education* 50, no. 6 (1997): 47–53.
- 37. Cynthia L. Hollis, "On Developing an Art and Ecology Curriculum," *Art Education* 50, no. 6 (1997): 21–24.
- Getty Center for Education in the Arts, "Episode A: Student Social Commentary," *Art Education in Action*, no. 2 (Los Angeles: The J. Paul Getty Trust, 1995).
- 39. The islands were held by nylon lines to keep them from floating away and polluting the environment.
- 40. Norman Bryson, "Semiology and Visual Interpretation," in *Visual Theory: Painting and Interpretation*, ed. Norman Bryson and K. Moxey (New York: Harper-Collins, 1991), p. 10.

- 41. Marilyn Galvin Stewart, "Aesthetics and the Art Curriculum," *Journal of Aesthetic Education* 28, no. 3 (1954): 77-88.
- 42. Anderson, "Toward a Postmodern Approach," p. 64.
- 43. Ellen Dissanayake, *Homo Aestheticus: Where Art Comes From. and Why* (New York: The Free Press, 1992).
- 44. Sydney Walker, "Postmodern Theory and Classroom Art Criticism: Why Bother?" in Hutchens and Suggs, *Art Education*, pp. 111–21.
- 45. Margot Lovejoy, *Postmodern Currents: Art and Artists in the Age of Electronic Media* (Upper Saddle River, NJ: Prentice-Hall, 1997), p. 160.
- 46. Parsons and Blocker, Aesthetics and Education, p. 65.

ACTIVITIES FOR THE READER

- 1. Write a letter advocating the inclusion of art in the elementary-school curriculum. Use resources from Suggested Readings for this chapter and World Wide Web resources. The reader is directed to websites, which follow.
- 2. Evaluate art education curricula. How are postmodern issues integrated in art history, art criticism, aesthetics, and art making? What evidence is there that the curriculum includes multicultural resources? Are women artists represented? Does the curriculum recognize a diversity of art forms, such as folk art, public art, and visual culture?
- 3. Art Education: The Journal of the National Art Education Association includes a section titled "Instructional

Resources" in each issue; for example, Beth Goldberg, "Art of the Narrative: Interpreting Visual Stories" was published in vol. 58, no. 2 (March 2005). Review "Instructional Resources" in several issues of this publication for features on multicultural art, art made by women, and art in visual culture. Can you recognize postmodern issues discussed in this chapter? University libraries generally subscribe to the journal.

4. Use the World Wide Web to locate curriculum resources on multicultural art and women's art. Make a list of works, and include name and website address (URL). Many sites allow viewers to print copies of art images.

SUGGESTED READINGS

American Association of University Women. *Gender Gaps: Where Schools Still Fail Our Children.* Washington, DC: AAUW Educational Foundation, 1998.

Anderson, Tom, and Melody Milbrandt. Art for Life: Authentic Instruction in Art. New York: McGraw-Hill, 2005. Integrates earlier approaches to art education with content from visual culture.

Blocker, Gene. "Varieties of Multicultural Art Education: Some Pclicy Issues." In *Handbook of Research and Policy in Art Education*, ed. Elliot Eisner and Michael Day,

- Broudy, Harry S. Enlightened Cherishing: An Essay on Aesthetic Education. Urbana: University of Illinois Press, 1972. A delightful philosophical essay on the benefits of arts in education.
- Chalmers, F. Graeme. *Celebrating Pluralism: Art, Education, and Cultural Diversity*. Occasional Paper 5. Santa Monica, CA: Getty Center for Education in the Arts, 1996. Presents a case for multiculturalism as a means to strengthen commonalities of human experience.
- Efland, Arthur, Kerry J. Freedman, and Patricia L. Stuhr, eds. *Postmodern Art Education: An Approach to Curriculum*. Reston, VA: National Art Education Association, 1996. Provides an excellent discussion of postmodern theory and attendant curriculum problems, supplemented with examples of postmodern art curricula.
- Gee, Constance Bumgarner. "Spirit, Mind, and Body: Arts Education the Redeemer." In *Handbook of Research and Policy in Art Education*, ed. Elliot Eisner and Michael Day, pp. 93–114. Mahwah, NJ: Lawrence Erlbaum Associates, 2004.
- Hope, Samuel. "Art Education in a World of Cross-Purposes." In *Handbook of Research and Policy in Art Education*, ed. Elliot Eisner and Michael Day, pp. 115– 34. Mahwah, NJ: Lawrence Erlbaum Associates, 2004.
- Levi, Albert William, and Ralph A. Smith. "Art Education: A Critical Necessity." In *Disciplines in Art Education: Contexts of Understanding*. Urbana: University of Illinois Press, 1991.

- National Endowment for the Arts and Gary O. Larson. American Canvas: An Arts Legacy for Our Communities. Washington, DC: National Endowment for the Arts, 1997.
- National Standards for Arts Education: What Every Young American Should Know and Be Able to Do in the Arts. Reston, VA: MENC, 1994.
- Nochlin, Linda. *Women, Art, and Power and Other Essays.* New York: Harper and Row, 1988. The classic book on feminist art and criticism.
- Sandell, Renee, and Peg Speirs. "Feminist Concerns and Gender Issues in Art Education." *Translations: From Theory to Practice* 8, no. 1 (1999). Written to be helpful to classroom teachers as well as theorists.
- Saunders, Robert J., ed. *Beyond the Traditional in Art: Facing a Pluralistic Society*. Reston, VA: National Art Education Association, 1998. Clarifies multicultural terminology involved in art criticism and aesthetics and provides strategies and help in planning a multicultural curriculum.
- Smith-Shank, Deborah. "Semiotic Pedagogy and Art Education." Studies in Art Education 36, no. 4 (1995): 233-41.
- Young, Bernard, ed. *Art*, *Culture and Ethnicity*. Reston, VA: National Art Education Association, 1990. Addresses the need to focus on the cultural heritage of a multicultural society. Includes discussions related to teaching disadvantaged youth.

WEB RESOURCES

Advocacy

- National Art Education Association, *Publications*: http:// www.naea-reston.org/. Publications and links to other sites.
- National Endowment for the Arts: http://arts.endow.gov. Arts programs, publications, resources for advocacy, and links to other sites.

Multicultural Art and Women's Art Images and Resources

- The J. Paul Getty Trust: http://www.getty.edu/. Curriculum, resources, images, publications, and links to other sites.
- Los Angeles County Museum of Art: http://www .lacma.org

Museum of Latin American Art: http://www.molaa .com/

- National Museum of African Art: http://www.si.edu/ nmafa/nmafa.htm
- National Museum of the American Indian: http://www.si .edu/nmai/nav.htm
- National Museum of Women in the Arts: http://www .nmwa.org
- The Arthur M. Sackler Gallery and Freer Gallery of Art, Smithsonian Institution, The National Museum of Asian Arts for the United States: http://www.si .edu/Asia/
- Smithsonian American Art Museum: http://www .americanart.si.edu/
- UCLA Fowler Museum of Cultural History: http://www .fmch.ucla.edu/

CHAPTER

3

CHILDREN'S ARTISTIC DEVELOPMENT

How Children Grow and Learn

I admire the mind's capacity to derive a pertinent order from the chaos of experience. This dramatic struggle starts at birth, and the art of children is an essential instrument of this need to recognize and create meaningful order.

-Rudolf Arnheim, "A Look at a Century of Growth"

For many years adults have been fascinated with drawings, paintings, and other art objects made by children. Psychologists, educators, parents, and other interested adults have studied children's art from several vantages. Analysis of art products of children has been viewed as a means to look into their young minds and hearts, to learn what they are interested in, what they know, and how they think. Children's art has been studied as an expression of their emotional lives or personality development. Some scholars have used the apparent changes in the ways children draw and paint as they grow older as a basis for theories of mental development. More recently, researchers have studied ways that children understand what art is, how it is made by artists, and how it is judged and valued. This chapter discusses the emotional, developmental, and cognitive aspects of children's development in art and investigates relationships between children's art products and the works of adult artists.

Very young children, even before age 2, enjoy the process of making marks by whatever means are available. The kinesthetic experience of rhythmic movement coupled with the observable results of their actions provides reinforcement for children to draw and paint. As they grow older and develop their cognitive, social, and psychomotor skills, children are able to express their ideas and feelings in their artwork.

As children develop individual symbol systems, their art can become a personal language, although much of what they communicate may not be accessible to others. Indeed, because children of ages 2, 3, and 4 are not concerned with producing an art object, as adults perceive art, they often draw or paint directly over one graphic idea with a subsequent image that may, in turn, suggest a second or

third idea. There may be layers of a child's thought and emotion buried within what to many adults appear to be scribbles or a mess of paint. Researchers who have observed and listened to young children during this process have noted their flexibility in moving from one idea or theme to another, often talking to themselves or singing as they draw, paint, or work with clay.¹

As children grow older, into the preschool and kindergarten ages, the result of their artwork often becomes more readily discernible and easier to interpret, especially as verbal skills increase, so they can explain their images, interests, and intentions. The development of children's abilities to create symbols that represent persons, animals, and objects extends the range of what they can communicate in their art and increases the likelihood that knowledgeable adults can interpret meaning from the art of children.

In the normal course of living prior to formal school experiences, children often relate and explore events in their lives that are emotionally important to them. Relationships with parents, siblings, family pets, or even fantasy characters often are depicted and explored in drawings, paintings, and clay. Children frequently are able to integrate the worlds of imagination, fantasy, and reality in their artistic creations. Sometimes children's understanding of how parts of the real world function can be seen in their artwork, as when they draw family members engaged in activities; when they draw animals, houses, cars, or airplanes; and when they deal with their personal fears or aspirations.

In recent years art educators have paid increased attention to the influences of visual culture in the art products of children. In today's electronic and digital environment, virtually all children experience television programs and advertising tailored to their ages and interests; they have access to shopping malls, video games, movies, and the Internet, among other examples of visual culture. Contrary to the conventional wisdom of earlier eras when images from the culture were viewed as negative intrusions into the natural process of the child's artistic development,² art educators today recognize that children have always learned from their visual environment. Children see and appropriate ideas and images from other children, from the work of adult artists (if they are provided access), and from their everyday visual environment. Rather than ignore these influences, art teachers today include issues, ideas, and images from visual culture as part of their comprehensive art curriculum.3

This painting by a Japanese child illustrates the use of X-ray vision as a means to include more information in a picture. Because young children have naïve abilities to draw and paint about their emotional lives in uninhibited ways, adults understandably have been very interested in their artwork. Children at early ages tend to draw and paint the people and events in their lives—both happy and sad. This seems to be a very natural and healthy practice exhibited by children from all parts of the world. Knowledgeable teachers of art recognize this and encourage children in their natural interests as they gradually assist the children to enlarge their understanding of the world of art.

Some psychologists and educators are especially interested in children's art as a window into their thoughts and feelings, especially those children who might be emotionally disturbed or who have experienced traumas of some sort. The subject matter of drawings, paintings, and sculptures by such children, ways they represent themselves and others in their works, and even the manner by which they create with art materials can sometimes provide clues to their emotional lives. This is the area of special concern for art therapists.

An example of this type of revelation can be seen in the drawings and paintings of refugee children from strifetorn countries who witnessed the horrors and violence of war and later immigrated to North America and entered U.S. and Canadian schools. Similarly, children who experience personal trauma sometimes focus on these topics in their art production and, through the process of dealing with the traumatic event in a safe, nonthreatening medium over which they have control, gain some resolution for themselves. The abilities of children to represent, manipulate, and control their worlds through art, and thus to deal with difficult life situations, are the source of the therapeutic dimension of art. Many art educators emphasize this capacity of art in their educational programs for very young children. Regardless of programmatic emphasis, it would be unwise for teachers to ignore or in any way diminish the spontaneous interest in making art that characterizes children everywhere.

It is not the art teacher's role to attempt to render psychological interpretations of particular children by analyzing their art products. This chapter discusses some of the normal characteristics in children's drawings and paintings. This knowledge will assist teachers in noting gross variations from the norm on the part of particular children. Very unusual art products can be clues that teachers can share with appropriate school personnel, such as other teachers, school counselors, or school psychologists. This information can be useful in helping school officials provide the best educational opportunities for each child.

STAGES OF GRAPHIC REPRESENTATION

Teachers who work with children come to know a great deal about how children behave at particular age levels. A good deal of "teacher talk" or professional shoptalk in faculty lounges is concerned with these behavioral characteristics and with the noticeable gains in maturity as children move from grade to grade. Major proportions of the fields of developmental psychology and cognitive psychology are dedicated to the study of these maturational or developmental changes in children. Educators are concerned with these studies and continuously attempt to make school learning environments more appropriate for the developmental characteristics of children.⁴ For example, the organization of learning centers for use by a few children in the classroom while others are working in reading groups or other activities is very different from earlier practices in which desks were bolted to the floor in rows and all students participated in rote lessons copied from the chalkboard.

Children's capacities to make and understand art develop parallel to changes in the cognitive, emotional, social. and physical dimensions of their lives. The notion that children progress through stages of development in these various areas is central to the field of developmental psychology and the writings of Viktor Lowenfeld, Jean Piaget, Howard Gardner, and others.⁵ Some revisionist thinkers in art education question the developmental structure of art learning. Some claim that in the postmodern era it is impossible to define art, and therefore we are unable to identify the behaviors that might describe artistic development in childrer. Others are convinced that evidence of changes described in stage theory are invalid because of reliance upon pictorial rather than three-dimensional and other forms of artistic expression. The value placed upon children's art, critics argue, reflects Western values and ignores multitudes of cultural settings and political issues.

Some of this criticism is well founded and will be absorbed into existing stage theory. Despite such objections, the view of visual development discussed in this chapter continues to be the most commonly accepted way of describing the nature of change in the art of children and best represents the views of the authors of this work. When we take the position that children should be educated in art, the basic information available through the study of stages or changes in the ways children make and think about art

can be very valuable.⁶ Knowledge of developmental stages in art can provide teachers with insights about what children are attempting in their artwork and how appropriate motivation and instruction can be provided.

Children grow and develop in generally predictable ways, with extensive variations within an age norm or a stage. Just as reading levels vary widely in an average class of 25 or 30 children (and the variation increases with each grade level), so abilities in art vary widely. This means that teachers can come to know, generally, what to expect and plan for when they are preparing their art programs, but they must be aware of the unique educational needs of each child.

We present a simplified version of stage theory that describes three general stages of children's graphic development, known here as the *manipulative stage* (ages 2 through 5), the *symbol-making stage* (ages 6 through 9), and the *preadolescent stage* (ages 10 through 13). Important differences in artistic development are noted among the stages, which are also quite broad.

Some of the characteristics of children's artwork are altered when children are given instruction and when they learn more about the adult world of art. Rather than view these alterations of the natural as negative, we view them as the normal outcome in any area of learning in the school curriculum. When we accept the obligation to provide art education as an essential component in the general education of all children, we accept the fact that education will alter the way children think and act. The moral and ethical requirement for teachers is to assure that changes they bring about in the lives of children are positive, enabling, and life enhancing.

The first stage is one at which children manipulate materials, initially in an exploratory, seemingly random fashion. Later in this stage the manipulation becomes increasingly organized until the children give a title to the marks they make. During the next stage, the children develop a

Children who scribble (preschematic investigation) develop a repertoire of lines and marks they will use later. As these examples show, considerable development is possible even within this stage from the seemingly random and exploratory to an increased sense of organization, use of color, and a more conscious connection between parts of the whole configuration. Children who have opportunity to explore and manipulate materials develop repertoires of mark making that they can call upon when they begin to form graphic symbols.

series of distinct symbols that stand for objects in their experience. These symbols are eventually related to an environment within the drawing. Finally comes a preadolescent stage, at which time the children become critical of their work and express themselves in a more self-conscious manner. The fact that these stages appear in the work of most children in no way detracts from the unique qualities of each child's work. Indeed, within the framework of the recognized stages of expression, the individuality of children stands out more clearly. *Stages of artistic development are useful norms that can enlighten the teacher, but they should not be considered as goals for education.*

The Manipulative Stage (*Ages 2–5, Early Childhood*)

Drawing is a natural and virtually universal activity for children. From infancy onward, children mark, scribble, and draw with whatever materials are available. As soon as they can grasp a marking instrument of some sort—a crayon, a pencil, or even a lipstick or piece of charcoal—children make marks and scribbles. Some adults discourage this behavior in their offspring, especially when it occurs on walls, floors, and other surfaces not intended for graphic purposes, and they are relieved when their children outgrow the tendency to engage in scribbling.

These parents, and often teachers, too, do not realize that what we call scribbling can be a worthwhile learning activity for very young children.7 By scribbling, an infant literally "makes a mark on the world" in one of the earliest examples of personal causation: children come to realize in physical and visual terms that they can exercise control over their environment. Before the age of 2, infants are fascinated by their abilities to make oral noises—babblings, cries, gurgles, and laughs. All these sounds cease instantly on completion. Graphic marks that the infant makes remain, however, and provide evidence of the marking behavior. The child marks and sees the marks with the dawning awareness that he or she can alter them and add to them. This is a significant realization for such a tiny person and, as Elliot Eisner explains, is also a source of pleasure: "The rhythmic movement of the arm and wrist, the stimulation of watching lines appear where none existed before are themselves satisfying and self-justifying. They are intrinsic sources of satisfaction."8

Through their preschematic efforts, children aged 1 through 3 or 4 develop a repertoire or vocabulary of graphic marks, which they create primarily for the kinesthetic rewards inherent in the manipulation of lines, colors, and textures.

Scribbled marks are precursors to the visual symbol system of drawing that each child develops and uses in her or his own way. Children who have opportunities to scribble produce a wide variety of lines, marks, dots, and shapes during the first two or three years of life. This repertoire of graphic marks is utilized later for the invention of visual symbols in the form of drawings. The child who develops a variety of graphic marks during the scribbling years will manifest this visual vocabulary to produce symbolic drawings that increase in richness and sophistication as the child matures. Children who rarely engage in early graphic activities usually exhibit a narrower vocabulary in their drawings and require considerable encouragement to continue drawing.

This initial stage of artistic production is referred to here as the *manipulative stage* and can last through ages 4 or 5 in many children. The term *manipulative* implies a general stage of initial exploration and experimentation with any new materials, including clay, blocks, and so on. Emma, age 4, enjoyed drawing (clockwise from upper left) a horse, a winged dragon, a puppy with a scarf, herself, her older sister, and a rabbit. She counts the number of fingers and toes and is beginning to include all the body parts in her drawings. She has "written" the names of the characters in her drawing, having noticed how older people write.

CHAPTER 3 · CHILDREN'S ARTISTIC DEVELOPMENT

adupe

Once the idea is established, children will use schematic representation in a number of circumstances, retaining some portions as other ideas are included. These two remarkable drawings were created by the same girl at ages 4 and 10. The theme of both works is "Friends." As the child, Maria, has grown and developed perceptually, her schemata have progressed accordingly from early undifferentiated representations of the figure, arms, and face. At age 10 she demonstrates her ability to draw figures in proportion and to create a wide variety of costumes and hairstyles as she depicts her 9- and 10-year-old friends.

The manipulative stage usually lasts until the children are in kindergarten. As time goes on, seemingly random drawings are increasingly controlled; they become more purposeful and rhythmic. Eventually, many children tend to resolve their marks into large circular patterns, and they

learn to vary their lines so they are sweeping, rippling, delicate, or bold.

As they experiment with materials and gain experience, children progress through the manipulative stage. They develop a greater variety of marks and use them in varying combinations. Random manipulation becomes more controlled as children invent and repeat patterns and combinations of marks. Lines of all types are used by children in their marking, including vertical, horizontal, diagonal, curved, wavy, and zigzag lines. Some children will attend to drawing intently for periods of 30 minutes or more and will produce a series of a dozen or more drawings within a brief time.

Children aged 2 to 5 learn about qualities of art materials around them, the multitude of textures, colors, smells, tastes, weights, and other properties. They are interested in art materials because of the intrinsic visual and tactile properties. They can manipulate art materials and can even transform their characteristics. With a brush they can make paint into a line or a shape or various textures. How thrilling it is for the child to learn that colors change when mixed together—and that he or she can make this happen. Similarly, the child can make a piece of clay into a coil or pinch it into small flat shapes or scratch it with an object to create an interesting texture. Children experience the same exploratory process with other media, such as scraps of wood or cardboard boxes. Some parents and teachers introduce preschool children to computer graphics.⁹

Picture making in general comes naturally to children at a surprisingly early age. Some children will grasp a crayon and make marks with it before they are 15 months old. Children's bodily movements are overall movements and result in a broad, rhythmic action. When very young children paint, they do so from their fingertips to the ends of their toes. Not until they grow older and gain control of the smaller muscles do their muscular actions in art become localized to hand, arm, and shoulder.

As well as exhibiting an ability to design in two dimensions, the preschool child often learns to produce three-dimensional designs. By the time some children have reached age 3, they have experimented with sand and sometimes to their parents' horror—mud. They are capable of joining together scraps of wood and cardboard boxes or using building blocks to bring about the semblance of an organized three-dimensional form. The interaction between child and materials is a vital aspect of this stage.

Judith Burton describes three types of conceptual

learning accomplished by children in the manipulative stage. When children are able to grasp the outstanding features of lines, shapes, and textures and when they learn that materials can be organized in many different ways, they have formed *visual concepts*. *Relational concepts* are formed when children can construct relationships of order and comparison and when they can apply these relationships knowledgeably. "For example, when organizing a painting, children make careful decisions about the placement of their lines and shapes, whether they are to be close together or far apart, positioned in the middle, top or bottom of the page, or enclosed within each other."¹⁰

Expressive concepts are formed when children recognize the connections between their actions with art materials and the visual outcomes and sensations these actions cause. Children begin to describe lines as "fast" or "wiggly" and shapes as "fat" or "pointy." The fact the child can control and select the qualities and organize them in ways that express happiness, bounciness, or tiredness represents significant artistic development. It means the child has developed a graphic language with which he or she can begin to express and communicate ideas and feelings.

Up to this point children may or may not have established a theme or expression or given a title to their work. Because drawing is an emotional and social as well as cognitive (intellectual) process, children will often accompany their work with appropriate sounds. Eventually, however, children will lift their eyes from their work and say, "It's me," or "It's a window," or even "That's Daddy driving his car." The manipulative process has at last reached the stage at which the product may be given a title.

We cannot overemphasize the importance of the "naming of ε scribble" in the life and development of a child. Naming—matching a word with an image—can precede the drawing experience when parents read to children from illustrated books. Many parents watch with great anticipation and record the exact age when their child takes the first step; the child's first word is another memorable occasion, but neither is as intellectually significant as the child's own invention of a graphic symbol, for this act places the child far ahead of all other mammals and reveals the tremendous mental potential of human beings.

We do not know precisely how children arrive at such pictorial-verbal equivalents. On the one hand, it has been suggested that the shapes they produce in their controlled manipulations remind them of objects in their environment. On the other hand, the dawning realization that marks or shapes can convey meaning, together with a newly acquired skill to produce them at will, may prompt children to create their own symbols. Perhaps the symbol appears as a result of both mental processes, varying in degree according to the personality of its author. Whatever the process may be, the ability to produce symbols constitutes an enormous advance in the child's educational history. By the first grade, many children have developed their own means of expression and communication.

The first-named scribble is usually a circular or generally round shape. The child sees the shape as it appears After viewing the movie *The Mask of Zorro*, a 3-year-old boy made a distinction between a "pretend" Zorro (left) and the real Zorro (right), who wears a mask. In the center drawing, Zorro loses his knife in the midst of a sword fight.

Illustrating a range in children's degrees of differentiation, the drawing on the left by a 4-year-old Australian shows a family as a series of tadpolelike figures emerging at the end of the scribble stage, whereas the drawing on the right by a 10-year-old Brazilian girl exhibits the stage of realism, around two years in advance of her age level.

among random marks and learns to repeat the shape at will. The production of symbols demands a relatively high degree of precision because a symbol, unlike most of the results of manipulation, is a precise statement of a fact or an event in experience.

On entering kindergarten at the age of 4 or 5, even those children who have had practice at home with art materials and who have produced pleasing designs tend to regress. The causes of such a condition are not hard to find. In the first place, the children are passing through a period of adjustment to a new social setting. Many of them are away from the protection of their parents and their homes for the first time. Unfamiliar faces and situations surround them, including a new and powerful adult in the form of a teacher. Also, many are passing through a new phase of artistic development. From the scribble or manipulative stage they are progressing into the stage of symbols. In the symbol-making stage, marks can no longer be placed at random on a sheet of paper but rather must be set down with increased precision. Not until children feel more at home in their new environment will qualities of spontaneity and directness return. Regressions in ability occur with each child from time to time and may be observed at any level of development. Absence from school, illness, or temporary emotional upsets can be reflected in the artwork of any child.

Although normal children progress beyond it, *no one leaves the manipulative stage entirely*. Even when confronted as adults with an unfamiliar substance or a new tool, we are likely to perform some manipulation before we begin to work in earnest. After buying a new pen, for example, we generally scribble a few marks with it before settling down to write a letter. Artists who purchase a new kind of paint will in all likelihood experiment with it before they paint seriously. Indeed, the manipulation of paint was one of the chief characteristics of abstract expressionist painting. Moreover, the painterly surface is one of the hallmarks of all romantic art, much as the repression of painterly effects is a distinguishing characteristic of classicism. Surface manipulation plays the same role in sculpture. The teacher should realize that manipulation is not a waste of educational time and materials; it is a highly educative process. The interaction between ideas and materials that the children gain through manipulation allows them to enter more easily into the symbolic phase of expression.

Parents and teachers may be tempted to rush a child into the next stage of development prematurely, but children follow their own timetable. It is well to bear in mind that elaboration precedes advancement. Like many artists, children prefer to exhaust the possibilities of one stage before proceeding to the next.

The Symbol-Making Stage (Ages 6–9, Grades 1–4)

When the normal child makes a connection between image and idea, assigning meaning to a drawn shape, the shape becomes a symbol. Initially, this shape is used to stand for whatever the child chooses. A shape designated as "Mommy" might appear very similar to another shape that the child calls "house." The early symbol is, in the terms of psychologist Rudolf Arnheim, *undifferentiated*. It serves the child by standing for many objects. A parallel use in the verbal symbol system is demonstrated when a young child who has learned to say "doggie" in relation to the family pet points to a sheep, cow, or other furry four-legged animal and says "doggie." Adults correct the child and introduce the appropriate term. The child then has a more differentiated symbol to apply: "doggie" for one kind of animal, "sheep" for another, and so on.

A similar process develops with children's drawings. The initial primitive symbol can stand for whatever the child chooses it to represent. As the child's symbol-making ability progresses, the child produces more-sophisticated graphic symbols. This can be seen especially in children's early representations of the human figure. The primitive circular shape stands for "Mommy." Later, a line and two marks inside the shape are "Mommy" with eyes and mouth. The primitive shape is differentiated further by the addition of two lines that represent legs, two lines for arms, and a scribble that stands for hair.

It is at this point that a fundamental misunderstanding of children's graphic representation can occur. Most adults view these early drawings of people as heads with arms and legs protruding, termed "tadpole" figures. The question is asked, "Why do children draw figures this way?" Those who are experienced with children at this level realize that the children understand human anatomy much differently than their drawings would suggest. They know the parts of the body, and they know that arms do not protrude from the head-they are aware of shoulders, chest, and stomach. Why, then, do these early drawings appear to represent heads with arms and legs and no torso? Arnheim's explanation is eminently logical and useful: "Representation never produces a replica of the object but its structural equivalent in a given medium. . . . The young child spontaneously discovers and accepts the fact that a visual object on paper can stand for an enormously different one in nature."11

This means that the child's primitive symbol, the circular shape, stands for the entire person, not just the head. This is a person with eyes and a mouth, a person with hair. It does not represent only the head of a person with inappropriately placed appendages. This interpretation eliminates the apparent discrepancy between what children draw and paint and their understanding of the world around them, especially the human figure. We must recognize that children's symbols are not replicas of the world and that the materials used by children will influence their symbol making. In other words, children at this stage draw what they know, not what they see.

As children grow and develop from this early symbolic behavior into the symbol-making stage, they produce increasingly differentiated representations. The human figure appears with more details, such as feet, hands, fingers, nose, teeth, and perhaps clothing. It is interesting to note again how children create equivalents rather than replicas of their subjects. Hair might be represented by a few lines or by an active scribble. Fingers are often shown as a series of lines protruding from the hands with a "fingerness" quality, but with little regard for exact number.

Eventually a body is drawn with the head attached and with arms and legs in the appropriate location. This more true-to-life figure drawing is usually achieved through a process of experimentation with the medium. Sometimes the space between two long legs becomes the body. Some children add another larger circular shape for the body and draw the head on top. Once the child's representation of the human figure has reached the point where all the body parts are explicitly included, the symbol can be used and elaborated upon in many significant ways. The child can draw mer. and women, boys and girls, and people with different costumes and occupations. Most children also de-

Kya, age 7, who drew these figures is interested in the stories of "Princesses in Love," as she presents Sleeping Beauty, Beauty and the Beast, and Cinderella. These characters are part of popular culture appearing in children's picture books, movies, and Broadway musicals.

velop symbols for other objects in the world, including animals and plants; houses and other buildings; cars, trucks, and other vehicles; and, in general, anything that interests the child. Children observe the drawings of other children and often appropriate useful ideas and images in their own work.

Claire Golomb suggests that children's conventions for representing three dimensions in drawings, such as transparencies and mixed views from front and side, are "a record of the child's problem-solving strategies and also reflect the child's lack of familiarity with the so-called 'tricks of the trade' that create the appearance of three-dimensional space."¹² Golomb's detailed studies of children's work in clay provide useful comparisons between performance in two- and three-dimensional media.

RELATING SYMBOLS TO AN ENVIRONMENT

Whenever pupils produce two or more symbols related in thought within the same composition, they have demonstrated an advance in visual communication, for they have

Alex, age 8, became very interested in the 2002 Winter Olympics. In a complex composition, he is able to depict a hockey game, the bobsled run, and the ski run with moguls. He has included a food venue for each sport. realized that a relationship of objects and events exists in the world. The problems that confront them at this point revolve around a search for a personal means of expressing satisfactory relationships among symbols, ideas, experience, and environment. In striving for such connections, they are engaged in the main task of all artists. This development can occur only if educational conditions are right. Unfortunately, during these delicate developmental stages, problems may result if adults view children's art as a crude version of adult work. Children's work up to this point sometimes appears to the eye of the uninitiated as untidy, disorderly, and often unintelligible. To make children's work neater or clearer, adults sometimes inappropriately use certain "devices," such as outlining objects for them to color or giving them the work of others to copy and trace. The problem with many of these devices is that they are devoid of educational value and ignore the child's point of view. For this reason, adult models can discourage some children from developing their own ideas.

Children may begin relating a symbol to its environment by simple means. They may render in paint, clay, or some other suitable medium two similar symbols for human beings, to which they give the title "Me and My Mother." Soon they begin to put together symbols for diverse objects that have a relationship in their thought. Their work may be given such titles as the following:

- "Our House Has Windows"
- "My Dog Fetching a Stick"
- "I Am Watching Television"
- "I Am Learning to Use a Computer"
- "Riding to School with My Friends"
- "Throwing the Ball to Maria"
- "Mommy and I Are Cooking"

CHILDREN AS STORYTELLERS

Frequently, children weave into one composition events that occur at different times. In a sense, they may treat the subject of a painting as they do that of a written composition. For example, in a painting titled "Shopping with Mother," they may show themselves and their mother driving to a shopping center, making various purchases, and finally unpacking the parcels at home. This becomes a story in three paragraphs with all the items placed on one painting surface.

Expression based on vicarious experiences-stories

told or read to them, events they have seen on television or in the movies—may appear in children's art. Brent and Marjorie Wilson studied the themes of children's drawings and described the surprisingly broad range of thought and feeling depicted by them. In analyzing many children's graphic narratives (story drawings), the Wilsons found about 20 different themes.

Children continually draw *quests* ranging from space odysseys to mountain climbing; *trials* depicting tests of strength, courage, and perseverance; and they show *contests* and *conflicts* in which individuals and groups engage in battles, sports contests, and fights. The process of *survival* is a persistent theme, where children depict evasive actions, but here the characters make little effort to fight back. Little fish are eaten by big fish, and people eat the big fish. Children show *bonding*, love or affection between individuals, animals, plants (and even shoes) in any combination.¹³

Other themes included growth, failure, success, freedom, and daily rhythms; the slice-of-life themes of going to school, going on a picnic and returning, or going to the playground. Although children may first depict nothing but the objects they mention in the titles of their work, when encouraged, they begin to provide a setting or background for objects and even produce graphic narratives.

These topics are universal themes found in all the arts, from poetry and literature to music and the visual arts. Teachers can channel children's innate interests in these themes and ideas toward integrated learning about art as the children make their own art, view works of art by adult artists based on the same themes, and learn about the history and circumstances that caused artists from many cultures to share the same ideas and feelings. As we will note in Chapter 16 on curriculum, themes provide a very useful means by which to organize art learning for school programs.

CHILDREN'S USE OF SPACE

As children's use of symbols broadens and their expression consequently grows in complexity, the task of finding adequate graphic techniques to make their meaning clear becomes increasingly difficult. Their strong desire to express ideas with clarity leads them to invent or adopt many curious artistic conventions. The ingenuity exhibited by children in overcoming their lack of technical skills and in developing expressive devices of their own is fascinating to behold.

Children are confronted with unavoidable spatial problems in their drawings and other two-dimensional work. At first, objects and symbols are not related to each other. There is no up or down or surface on which people or objects are made to stand. For the child, the sheet of paper (picture space) is a place, and all the objects are together. Children often vary the relative sizes of the symbols used in their wcrk. A symbol having emotional or intellectual importance may be made larger. "Mother," for example, may be depicted as being larger than a house; or perhaps more frequently, children-who are generally egocentric at this stage—will delineate themselves as towering over their associates. Children employ this device in connection with all the familiar art materials, but it is especially noticeable in their painting. When children paint, they not only give a greater size to the object that appeals most to them but also may paint it in a favorite color. Color is often chosen for its emotional appeal rather than for its resemblance to a natural object. Soon, of course, the children's observation of the

"Big New York" is the title and the topic of this drawing by Danny, age 11. He has solved the complicated spatial problems that confronted him in depicting high-rise buildings, a street, houses, a river, boats, and a drawbridge.

world affects their choice of color—sky becomes blue and grass, green. When this happens, at about 7 years of age, the paintings tend to lose some of their naïveté.

Even though young children lack technical skills for making art, many are extraordinarily inventive in devising relatively complicated means to present their emotional and intellectual reactions to life. As they grow and learn, children become increasingly aware of relationships among the images they create. They want to make objects or people "stand up" or stand together, and they seek a place that will serve to support them. The bottom edge of the paper often is chosen to perform this function, and people, houses, and trees are lined up nicely along this initial *baseline*. Before long, other baselines are drawn higher on the paper, usually horizontally to match the bottom edge. Sometimes *multiple baselines* are drawn, and objects are lined up on each of them.

Nataya, grade 8, created this spontaneous response to the shocking destruction of the World Trade Center towers in New York City on September 11, 2001. Adults and children alike observed this horrific event as it was depicted many times on television news programs. Children the world over often respond to shock and trauma through their art. She appropriately titled her work "911."

The baseline represents the relationships of objects in the real three-dimensional world, at least for the child at this level of development. At the same stage that children develop baselines, it is not unusual for them to place a strip of color or line at the top of the paper to represent the sky. Between the sky and the ground is air, which it is not necessary to represent because it is invisible. Often accompanying the strip of color as sky is a symbol for the sun, which is frequently depicted as a circular shape with radiating lines. Starlike shapes are sometimes added as a further indication of sky. It is likely that children notice these conventions in the work of other children or in adult art and visual culture. These symbols may persist for years, and the sky does not appear as a solid mass of color touching the earth until the child has developed greater maturity of expression, either as a result of sensitive art instruction or, eventually, because of maturation.

Another spatial problem that young symbol makers must deal with is *overlap*. Because children realize that two objects cannot occupy the same space at the same time, they typically avoid overlapping objects in their drawings. Because the paper is flat, unlike the real world, overlapping appears to be inconsistent in drawings. Nevertheless, children often represent houses with people inside or show a baby inside the mother's abdomen in apparent *X-ray views*. This convention is a logical one to solve a difficult artistic problem—how to represent the interior of a closed object. It is similar to the theatre stage, where one side of the set is open to allow the audience to look in.

As children become less egocentric and more interested in how the world functions, the subject matter of their art often becomes more complex. They encounter numerous representational problems, such as how to include many parts of an event or how to represent a comprehensive view. Children often solve such representational problems by utilizing a bird's-eye view, a foldover view, or multiple views in one drawing or painting. For example, in a drawing of a football game, the symbol-making child might draw the field's yard lines striped from a bird'seye view to depict the space on which the players run. The football players are drawn from a side view, which is more useful for pictorial purposes than the bird's-eye view and is also easier to represent. Even in drawing a single figure, it is not unusual for children to combine profile and front views to best represent the sitting or moving posture of the person.14

After they played circle games, first graders were asked to draw their favorite games. Note the treatment of people in a circle. Note also the range of expression as each child extracted that part of the experience that had the most meaning. To one child, it was a fashion parade; to another child, evicted from the games for misbehaving, it was a time outside the circle. Another child is interested in the problem of shifting views of people standing on the playground. Physical involvement may have destroyed the baseline and expanded the use of space.

In a picture of a hockey game or of people seated around a table, some of the participants may appear to be lying flat or to be standing on their heads. The many children who produce compositions of this type usually do so by moving their picture in a circular fashion as they delineate objects or people. Thus, a child may draw a table and place Mother or Father at the head of it. Then, by turning the paper slightly, the child may place Brother in the nowupright position. This process continues until all are shown seated at the table. As an alternative to moving the drawing or painting surface, children may walk around the work, drawing as they go.

The foldover view is an interesting phenomenon seen in the drawings and paintings of numerous children. Again, it is a logical solution to a difficult representational problem. For example, the child wishes to draw a scene including a street, with sidewalks and buildings on both sides. The child draws the street and sidewalks using a bird's-eye view. The buildings on one side of the street are drawn up from the sidewalk, and the sky is above the buildings. The child then turns the paper around and draws the buildings and sky on the other side of the street up from the sidewalk. The drawing appears to have half the buildings rightside up and the other half upside down. There is sky at the top and at the bottom of the picture. The logic of this can be demonstrated by folding the picture on both sides of the street at the base of the buildings and tipping the buildings up vertically. Now the scene is like a diorama, and a person walking down the street could look left or right and see buildings and sky in proper placement. 55

"Summer Day," a tempera painting by a Russian child, Sherbakovva, age 7, allows us to peer behind exterior walls of a colorful and imaginative house. In the brick house interior by a Chinese child, a similar X-ray view is provided with more detail, even including food on the table. Both children include figures in their work. Teachers should recognize the potential of early schemata for picture making.

Adult artists from various times, places, and cultures have all dealt with these problems associated with spatial representation. Egyptian art is typified by a rigid convention for the human figure, with particular representations of the eye, the profile head, hair, and so on. Chinese artists developed conventional ways to represent mountains rising from the mist, bamboo plants, and the human figure. Renaissance artists developed the conventions of linear perspective, which is one way artists deal systematically with the problems of representing the three-dimensional world on a two-dimensional surface. Artists of every era learn the artistic conventions of their culture and use them, reject them, or develop new solutions to problems, which in turn become another set of artistic conventions. Artists learn the conventions of their cultures and apply them in unique and expressive ways in their own work. This process of learning conventions, applying them, and innovating with them is useful also for children, especially as they approach

adolescence, when their critical awareness becomes more acute.

THE SCHEMA AND THE STEREOTYPE

Symbol-making children develop ways of drawing objects or figures so they become graphic equivalents of what they represent. A *schema* is a drawing (or painting or clay form) that a child develops that *has a degree of resemblance to an actual object*. The arms of a man, for example, are drawn differently from the branches of a tree. Children use these simple drawings consistently again and again to designate the same objects.¹⁵ To create a schema, "the child not only has to fashion a graphic equivalent of objects in the world, but also has to design each solution so as to differentiate the marks from others that she makes."¹⁶ In this sense, schemata are a later form of the principle of differentiation.

Children learn to render the petals of a flower or the parts of people and animals in ways that serve their pur-

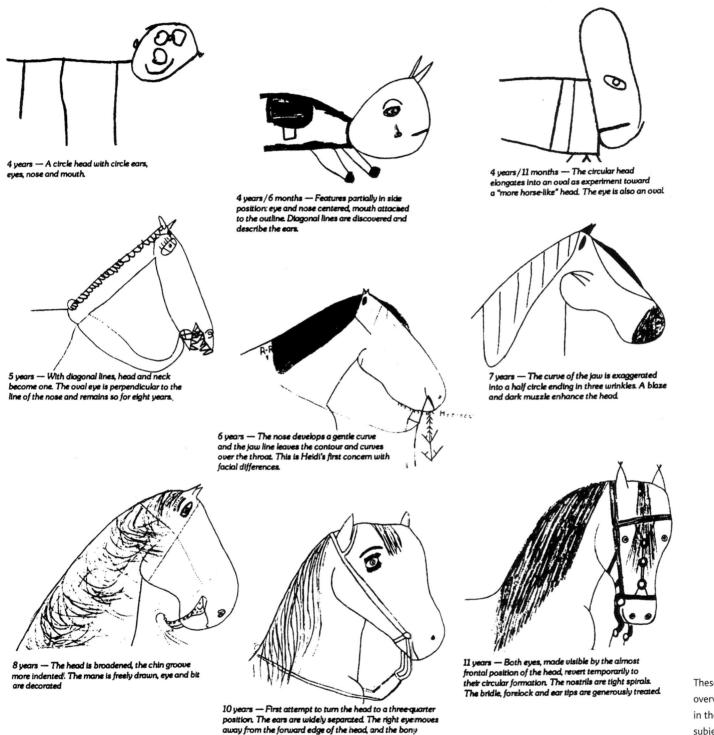

prominence over the left eye is noted.

These drawings present an overview of one girl's changes in the depiction of her favorite subject from symbolic to preadolescent stage. The diagrams below on the left show children's graphic symbols that represent people, trees, and houses, proceeding (left to right) from the simple to the complex. These are the work of kindergarten children.

The drawing (to the right) of a schoolhouse shows a range of ideas in advance of the level of drawing, such as relative sizes of people, an inside-out relationship, subjects connected to each other, filling of the entire space, and the use of smoke to indicate a specific function. poses. Children who develop their own schemata naturally understand them and are able to use them in flexible ways. A child who has developed a schema for the figure of a girl. for example, is able to draw girls with different clothing or different hair or different poses. The basic schema for girl remains fairly uniform, but the child can accomplish reasonable variations. Sometimes children will alter their schema by leaving parts out or by exaggerating significant parts. Drawings are sometimes left unfinished, or some parts are obviously unattended to by the child. These variations should serve to remind adults that children often are more interested in the process of drawing or painting than they are in the result of their efforts as a work of art. The child who draws a picture of his interaction with the neighborhood bully is emotionally more involved with the situation than with the outcome of the drawing as a finished piece. In the child's depiction of the story, it matters little if the fence is not completed—the child knows it is there. The legs that are running and the arm that is throwing are the essential and emotionally significant parts that receive the child's careful attention. Children's art does not so much make visual statements as make experience visible.

Children who continue to make art as they progress through the typical symbol-making ages of 6, 7, and 8 usu-

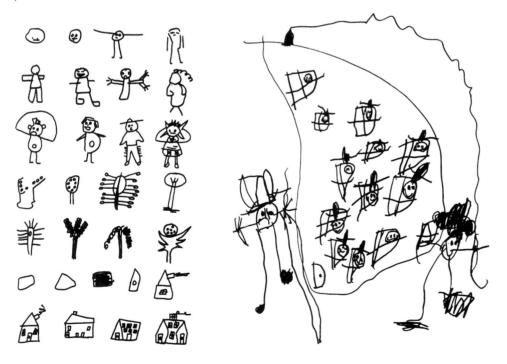

"Knights at a Castle," by a boy, age 4, exemplifies how young children with very basic symbol development can use their symbols fluently and imaginatively. We see figures in the castle, on the ground, and on horses in this action-packed drawing.

ally construct a number of schemata that gain in sophistication and detail as the children's understanding progresses. Some children focus almost exclusively on the human figure; others draw many objects. Because of the time and effort required to develop an advanced schema, most children (and adults) are able to draw some objects much better than others, depending on what each person has developed during the schematic years. This explains why several levels of depiction might appear within a single drawing.

Artistic *stereotypes* are images children repeat from another source without real understanding. Because children do not understand the stereotypes, they can only repeat them inflexibly and often incorrectly or inappropriately. A pervasive example is the looped-V shape that represents birds in flight. This was developed by artists to represent birds in the distance, where the details of body, tail, head, and feet are not distinguishable.

Variations of the looped-V shape and the concurrent understandings are not available to children who pick up the stereotype for flying birds and apply it inappropriately. Children demonstrate their lack of understanding of the meaning and origin of the stereotype in drawings where the looped V is upside down and the birds are apparently flapping their wings upward instead of downward. Sometimes the children's marks look more like the letter *M*.

In any case, bird symbols allow the child to suggest flocks of birds. Were the child to attempt to render a bird with its component parts of head, bill, body, wings, and tail, it would not be possible to give the impression of groups of birds. The child has a need for a shorthand version of a bird image.

Many art images are available to children through television, advertising, and cartoon strips in newspapers and comic books. Others are passed on from child to child. The pervasiveness of adult graphic images in most children's environments suggests that children will be influenced by smiley-face buttons, cartoon characters, and the like, regardless of what adults do or say. When copying tends to stultify or limit individual expression, however, it is harmful. In dealing with children who are involved with copying, the teacher can help them identify what they might learn from their efforts and how they might apply this learning in their own original artwork.

Because it is inevitable that children will be exposed to adult graphic images from visual culture, it makes good sense for teachers to expose children as well to the traditional fine arts. Videos, reproductions, films, and books of great variety are readily available. Just as they do in literature, music, or mathematics, children should become aware of the best the world has to offer in both the fine and applied visual arts. creative, they have learned to be more cautious. Younger children work in art with abandon and will often try anything the teacher suggests in their art. For the younger children practically every art experience is a new one, and they enjoy working on unfamiliar ground. During the years of the preadolescent stage, however, children become more socially aware and sensitive to peer opinion.

The range of topics that interest preadolescent children expands significantly during these years as the children become more conceptually sophisticated and more aware of the teen world. Preadolescent boys and girls increasingly turn to the adolescent culture of popular music; interests in television, movies, and music videos; ways of dressing and grooming; and adolescent language that varies with each new generation. Just prior to adolescence, boys and girls tend to stay separated and often pursue separate interests and activities. As they near the onset of puberty, and for the remainder of their school careers, boys and girls become involved more and more in social interactions between the sexes.

The age range from 10 to 13 is crucial from the standpoint of art education. It is during these years that most children cease to be significantly involved in making art. Indeed, when asked to make a drawing, the majority of adults will refer back to images they made before reaching the teen years. Drawings of human figures made by adults are

"Cultural Mountain" by Rolland D. Lee (Navajo), age 12. Rolland expresses his knowledge and respect for his Native American heritage in this multimedia work. "Cultural Mountain." Cultural concepts and symbols of his Navajo heritage provide subject matter for this imaginative creation. As a preadolescent, he is very interested in central ideas and values of the adult culture, particularly those that sustain his personal identity. Rolland explains, "All the ideas come from both sides of my family, the things they do."

The Preadolescent Stage (Ages 10–13, Grades 5–8)

The preadolescent stage includes children from approximately the fourth to the seventh grades and even into the eighth grade. It is important to acknowledge again the wide variation in rates of maturity among children. This range can be seen quite obviously in sixth- and seventh-grade classrooms, where girls are usually more physically mature than boys, and in the eighth and ninth grades, where some boys have reached puberty and others are still a year or two away from it. Teachers at each higher grade level must deal with the continuously widening intellectual range among students.

The physical, mental, and social changes that occur during these years set preadolescent children apart from younger children in the symbol-making stage. Although preadolescent children are still naturally inquisitive and

Teenage boys and cars are the focus of this drawing, "After School," by Penn, age 11. Preadolescents typically look to their older peers as social models. The differentiation in the sizes of the figures and their overlap with the car and background establish a feeling of depth in the picture. The picture space is completely filled due to the artist's use of cropping, a graphic device appropriated from photography. very often difficult to distinguish from the figure drawings of preadolescent children. The reason is that when individuals give up drawing, their development is virtually arrested at that level. With the development of critical skills at about age 11, children become acutely aware of the qualities of their own art products. If their own drawings and paintings appear "childlike" to them, they become selfconscious and dissatisfied with their artwork and tend to produce less or quit altogether.

With the possible exception of urban graffiti, spontaneous drawing has virtually disappeared at this age. For most students, if art activity is to continue, it will take place in the art class rather than on the playground. This is a time to appeal to students' interests as a point of departure, including comic books, cartoons, videos, or T-shirt designs. The dissatisfaction of 9- or 10-year-children with their own best efforts to make art heralds the beginning of a representational stage, when children desire to become more skillful and competent.

The solution to the problem of decline in art production prior to the teen years seems relatively clear. The preadolescent years are critical in the artistic development of

children. They must make enough progress during this period so that when they become capable of self-criticism, they will not find their own work too wanting. If children are to continue artistic production during adulthood, they must work with diligence, mastering the technical and expressive conventions of adult art that provide a bridge between the art worlds of the child and the adult. As with skills of reading or math, unless instruction is provided, many children will not advance in their own art making and appreciation.

The role of the art teacher changes during students' preadolescent years. Students are more receptive to instruction in competencies of drawing; of color and design principles; of technical skills in painting, printmaking, and sculpture; and of other modes of art making. Children want to know how artists handle the problems of overlap, size, and placement relationships and of convergence of lines for representing space and depth in drawings and paintings. They are receptive to instruction in many technical aspects of art and are motivated to become skilled in making art that passes their own critical judgment and that of their peers. They are ready to learn more about what artists of the past have created and what contemporary artists are doing and why.

Teachers can draw on the full range of the visual arts, including applied arts, such as graphic design and illustration. Students become increasingly interested in social, political, and personal influences in art and respond to themes that will engage them in discussion as well as production. These years can be tremendously rich and exciting for children and for their teachers as the world of art unfolds before them. The child's gaze is directed toward the teen and adult years, and it is there that much of the content of art as a subject lies.

WHY CHILDREN MAKE ART

The virtually universal participation of children in marking and graphic symbol making strongly suggests that basic reasons exist for these behaviors. Children must gain satisfaction from these activities, or they would not engage in them spontaneously. On this topic, however, writers and educators must speculate, because they are unable either to communicate sufficiently well with young children or to recall their own early art experiences. Nevertheless, through lengthy and careful observation of children and

The Figic HTFIL 6 Pounders

A Fresh View of the Presidency. From *The Diary of John Quincy Adams*. Massachusetts Historical Society. In 1780, a 13-year-old John Quincy Adams accompanied his father to Paris. Although an avid sightseer, young Adams found time to fill his journal with drawings. Adams designed his own ships (the *Horrid* and the *Frightful*) and was particularly concerned about the correct way for a flag to unfurl.

through the application of useful psychological theory, it is possible to speculate with some confidence.¹⁷

For children, art is a means to engage all their senses for learning and expression. Creating art heightens children's sensitivity to the physical world and provides a means of expressing both emotional and imaginative states of mind in ways unique to art.

The effects of art activity on children's self-concept

and general personality development can be very beneficial. Art can provide a means for children to develop their inherer.t creative abilities and, in the process, to integrate their emotional, social, and aesthetic selves. Children's art is often seen as instrumental in fostering and preserving each individual's identity, uniqueness, self-esteem, and personal accomplishment.

In addition, some educators claim that art activity contributes to cognitive development. More than 60 years ago, John Dewey expressed his view.

To think effectively in terms of relations of qualities is as severe a demand upon thought as to think in terms of symbols, verbal and mathematical. Indeed, since words are easily manipulated in mechanical ways, the production of a work of genuine art probably demands more intelligence than does most of the so-called thinking that goes on among those who pride themselves on being "intellectuals."¹⁸

Children's early graphic behavior—the making, scribbling, and manipulation of materials—appears to be intrinsically valued. As children move into the symbol-making phase, these psychomotor and kinesthetic rewards are reThis is an illustration for an elaborate story written by Bridgette, age 12, who exercises an active imagination. She has used pencil to draw the characters and scenes of her story, which takes place in Persia and includes a palace with trapdoors, mirrors, and a zoo. Figures are well developed, including detailed fingers, costumes with head coverings and footwear, and natural positions. The animals are easily recognizable.

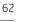

The 4-year-old boy who drew this family group was able to identify and describe the figures.

inforced by children's newly developed ability to conceive and convey meanings. This power to use the images they create as symbols for the world allows children to construct their own knowable world and to convey what they know to others.

As we watch children draw or paint, we are often struck by their concentration and involvement. Children frequently talk as they draw, and it is only through close observation that an adult can gain understanding of what has been created by a particular child. For example, through discussion with her 4-year-old son, a mother learned that his drawing was a picture of the family. The figure on the right with lots of dark hair is the mother; the short figure is the father; next is the child who drew the picture. The small figure next to the boy is his baby sister. When asked by his mother where his brother (a sibling rival) was, the child quickly made the scribble on the left and said, "Here he is; he is hiding behind a bush." In this drawing we see several things:

- 1. The child is developing symbols for the human figure and can make basic differentiations to represent specific individuals.
- 2. The child is able not only to represent figures but also to consider family relationships in his drawing.
- 3. The emotions of the child are important and obvious in his drawing. Mother is most important in his life and is made prominent in the drawing. His own figure is large. The brother with whom he feels competitive is conveniently left out of the picture. Later he is represented only in a hurried scribble.

One of the fascinating and charming aspects of children's art is that it can often serve as a window into the minds and emotions of the children. A series of drawings was done by a 7-year-old girl as a response to her experience at school. The first drawing shows the girl admiring a classmate who has pretty curls and is neat and prim. The child artist is an active girl, her hair is stringy, and she is disheveled. Her classmates note these characteristics and comment unfavorably. This motivates the girl to ask her mother to give her a permanent wave. She has the permanent and puts ribbons in her neat hair. However, after a few hours at school running and playing, her hair is stringy and the ribbons are untied. The pretty classmate is as neat as ever.

This art product reveals the following:

- 1. The child is very aware of peer social relationships at school, and she is concerned about her appearance.
- 2. She is able to reconstruct the series of events in her drawings and to identify her feelings.
- She is able to tell her story with graphic images in a direct and effective way.

This series of portraits provides a spontaneous narrative of a personal experience by Becky, age 7 (described in the text) and shows her awareness of social relationships and the level of her ability to tell a story.

The therapeutic value of making these drawings is not possible to determine. The child was motivated to make them, however, and she did sort out the experience through her art.

In similar ways, children deal with many of life's concerns, joys, and trials through their art. A child is afraid of fire and paints a picture of someone escaping from a burning building. A child is fascinated with sports, invents team players, and draws them in action; the favorite team wins. A child hears a fairy tale or sees a movie and draws a picture illustrating the story. A child visits a grandparent and makes a painting of the experience. The list of possible subjects for child art is as endless as the list of life experiences. Through their art, children can create new worlds as they investigate concepts, relationships, understandings, and models of behavior.

Children can create fantasies and stories through plays and songs as well as through the visual arts, although drawing seems to be a very significant medium for such accomplishments. As children create visual representations, they are required to combine the elements of design into structures with meaning and then to judge the adequacy and quality of their own work. Then they must proceed on the basis of their own judgments. The flexibility of art activity, where even the purpose of the process can change on the basis of the individual's judgment, is very different from activities that emphasize linear thinking and convergent learning, where all students arrive at a single correct answer.

As children enter the preadolescent stage, their interest in art moves from using it solely for personal expression to consciously improving the quality of visual forms. Children become interested in the visual properties of their works—composition, representation—and in the technical aspects of materials and processes. Very few activities available to people of any age allow the personal control from initiation to completion typical of art activity.

Artistic behavior seen from a broad perspective suggests a reciprocal action between art making and responding to art. The imagination can be as intensely engaged in studying artworks as in their creation. The sensory appeal of color as children apply it in a painting can also draw them into a still life by Pierre Bonnard, a color-field painting by Helen Frankenthaler, a fourteenth-century Japanese ceramic figure, illustrations from the Revolutionary War, or costumes from *The Lion King*. The process of engagement with the world of art and visual culture can be as absorbing and satisfying as the process of their creation.

CHILDREN'S CONCEPTUAL DEVELOPMENT IN ART

It is clear that the intellect is involved in the making of art. It is also clear that children progress in their abilities to understand art, to perceive art and respond to it, to relate art to their own life experiences, and to ponder fundamental questions about art. Understanding of art in these areas is not necessarily developed simply through art making. Gardner suggests that "there are separate developmental sagas which govern skills of perception, reflection, and critical judgment" in art.¹⁹

In one study of children's understanding about art, researchers learned that children of different age levels held widely differing views about basic art topics.²⁰ They interviewed children from ages 4 through 16, showed them reproductions of artworks, and asked them questions about where art comes from, how one becomes an artist, what can count as art, how one recognizes quality, and who is able to make judgments about art.

The researchers learned that misconceptions about art were common, especially among younger children. For example, some believed that art could be created by animals

A girl, age 3, drew this exuberant version of her family, "Momma, Daddy, and Me." Her mother is holding her as a baby. or that animals could not paint only because they could not hold a brush. When questions were asked having to do with how works of art are judged for quality and how they are selected for exhibit in a gallery or museum, different misconceptions emerged. Even some teenagers demonstrated limited understanding about the basic notions surrounding the creation of, response to, and judgment of art.

This study encourages teachers to learn more about what their students think and understand about art. Children who are unaware of why original art is different from reproductions, for example, cannot fully appreciate a visit to a museum. They need to discuss questions such as "Who makes TV commercials?" and "Why do commercials feature the arts: music, animation, drama, and dance?" Appreciation of art requires understanding that enriches experience.

Teachers of all subjects in the school curriculum should carefully consider the conceptual levels of their students. For example, very young children have limited conceptions of time; the notion of a decade or a century might not be within their intellectual grasp. The historical fact that Rembrandt was a sixteenth-century artist, therefore, might not be relevant when a teacher is showing students the artist's drawings or paintings. Most often, errors of aiming too high or too low conceptually can be avoided if teachers engage their students in discussions of what they are seeing and

"Tree," by Matthew, age 3, shows his beginning emergence from the manipulative stage to the development of symbols. The medium is watercolor. learning. Beyond simple factual items are basic questions about art that can be discussed fruitfully over and over as students progress from grade level to grade level. One such auestion is. "How is quality in art determined?" This question can be discussed in terms simple enough for a first grader—"Some people (such as art critics or gallery directors) study and devote their lives to judging art"-or for an eighth-grader—"Judgment of quality depends on one's aesthetic position, or beliefs about the nature of art." Teachers should also take care that they do not aim too low in their assessments of what children at particular ages can do. Teachers need to continue to challenge the fastest students in the class in order to keep their interest and involvement, while concurrently accommodating the needs of slower and special learners. Subsequent chapters on curriculum and instruction and evaluation will discuss these issues in greater depth.

ARTISTS AND CHILDREN'S ART

It has been the goal of many adult artists to capture the freshness, spontaneity, and directness so apparent in the art of children. Examples of artistic conventions commonly used by children can be seen in artworks from many cultures and times. Enlargement of important figures in painting and sculpture is a common device in early Christian art. The placement of mountains and trees in Chinese landscapes is similar in many respects to ways children manipulate space in their drawings and paintings. The cubist painters consciously depicted multiple views of objects, flattened space, and distorted images-devices that children typically accomplish in the course of their natural development in art. Such artists as Paul Klee and Jean Michel Basquiat took great pains to eliminate all vestiges of adult conventions from their works in order to achieve the expressiveness associated with children's art. According to Gardner, it is the child's approach to art, "his preconscious sense of form, his willingness to explore and to solve problems that arise, his capacity to take risks, his affective needs which must be worked out in a symbolic realm," that many adult artists wish to emulate.²¹

Is the art of children, then, to be considered in the same way as the work of mature artists. In what ways is it different?

In the case of naïve painters (sometimes referred to as intuitive, or folk, artists), such as Grandma Moses, Horace

Pippin, and Henri Rousseau, whose works contain distinctively childlike qualities, similarities with children's work is unplanned. Naïve artists, by definition, lack professional training and enjoy an independence from the mainstream of art that places them in a situation similar to that of children, who have not yet developed adult conventions and techniques. Nevertheless, as with the work of children, some naïve artists have created works of aesthetic merit, almost always accompanied by strong emotional involvement with the subject matter of the works.

Some mature artists in the Western tradition actively have sought to achieve a semblance of the spontaneity often found in the works of children. These artists, such as Picasso and the cubists or Matisse and the fauvists, were well grounded and expert in the standard art techniques of their times but chose to ignore or reject those techniques in order to achieve expressive purposes. Others, such as Paul Klee, pursued what is seen by the innocent eye, uncorrupted by a technological society. He left us a body of work noted for its remarkable range—humorous, delicate, and mystical—drawing its strength from the shapes and symbols of the 4- to 6-year-old child.

Important differences exist, however, between the art of children and the art of adult professional artists. Small children paint the sky yellow and the tree red because they have not yet developed the conventions of local color; of making objects approximate their appearance; or of controlling the mixing of hues, values, and intensities. Adult artists might disregard the conventions of local color, with which they are quite familiar, for their own expressive purposes. Unlike the child, adult artists have developed considerable facility with materials and techniques; they have trained eye and hand to a sophisticated level; and they have the capacity to plan ahead and follow through over a considerable period of time. Adult artists know the works of other artists, how they were made, and their place within culture and tradition.

Beyond this technical and expressive dimension of art is also the development of the adult artist's personality, which is unavailable to the child because of a lack of experience. Life's events, crises, responsibilities, hardships, and satisfactions are the stuff of which art is made, and it is the person with the most developed feeling for life who is most likely to create art that will speak with significance.

Given these differences, we can celebrate the art of children as well as the art of adults. We can be delighted by the work of children, and we can see in their art production the crucial seeds of future achievement. The value of children's art varies according to the point of view of the observer. The educator may view it as one route to the development of the aesthetic lens; the psychologist, as a key to understanding behavior; and the artist, as the child's most direct confrontation with the inner world of sensation and feeling. But educator, psychologist, and artist all view children's artistic development as a unique and essential component of their general education.

NOTES

- Claire Golomb, "Representational Concepts in Clay: The Development of Sculpture," in *Child Development in Art*, ed. Anna Kindler (Reston, VA: National Art Education Association, 1997), pp. 131–42.
- 2. Viktor Lowenfeld, *Creative and Mental Growth* (New York: Macmillan, 1947).
- 3. Tom Anderson and Melody Milbrandt, Art for Life (New York: McGraw-Hill, 2005).
- Constance Milbrath, Patterns of Artistic Development in Children (New York: Cambridge University Press, 1998).
- Viktor Lowenfeld and Lambert Brittain, Creative and Mental Growth, 8th ed. (New York: Macmillan, 1987);

Jean Piaget, *The Origins of Intelligence in Children* (New York: Norton, 1963); and Howard Gardner, *Artful Scribbles: The Significance of Children's Drawings* (New York: Basic Books, 1980).

- For a discussion of problems inherent in the assumption of untutored progression, see Anna Kindler, "Development and Learning in Art," in *Handbook of Research and Policy in Art Education*, ed. Elliot Eisner and Michael Day (Mahwah, NJ: Lawrence Erlbaum Associates, 2004), pp. 227–32.
- 7. Although the term *scribble* has been accepted by psychologists and art educators in relation to children's drawing, it is in fact a misnomer. Children's scribbles

are not the hasty, careless, or meaningless marks defined in the dictionary. The marks that children make are more accurately described as "presymbolic graphic investigation." As Judith Burton of Teacher's College, Columbia University, has noted, "scribbling" intimates behavior that is not serious or order seeking, behavior that must be overcome as soon as possible so the serious business of symbolization can begin. We err when "we mistake the swirls and swooshes and speeds of presymbolic action as hurried, mindless, and meaningless. Nothing could be further from the truth" (personal correspondence with author).

- Elliot Eisner, "What Do Children Learn When They Paint?" Art Education 31, no. 3 (March 1978): 6.
- 9. Carol Sabbeth, Crayons and Computers (Chicago: Chicago: Chicago Review Press, 1998).
- 10. Judith Burton, "Beginnings of Artistic Language," SchoolArts, September 1980, p. 9.
- 11. Rudolf Arnheim, *Art and Visual Perception* (Berkeley: University of California Press), p. 162.
- 12. Golomb, "Representational Concepts in Clay," p. 141.

- Brent Wilson and Marjorie Wilson, "Drawing Realities: The Themes of Children's Story Drawings," *School-Arts*, May 1979, p. 16.
- Judith M. Burton, "Representing Experience from Imagination and Observation," *SchoolArts*, December 1980, p. 9.
- 15. Betty Lark-Horovitz, Hilda P. Lewis, and Mark Luca, Understanding Children's Art for Better Teaching (Columbus, OH: Charles E. Merrill, 1967), p. 7.
- 16. Gardner, Artful Scribbles, p. 67.
- 17. Claire Golomb, *The Child's Creation of a Pictorial World* (Berkeley: University of California Press, 1992).
- John Dewey, Art as Experience (New York: G. P. Putnam's Sons, 1938), p. 46.
- 19. Howard Gardner, "Toward More Effective Arts Education," in *Art, Mind and Education* (Urbana: University of Illinois Press, 1989), p. 160.
- 20. Howard Gardner, Ellen Winner, and Mary Kircher, "Children's Conceptions of the Arts," *Journal of Aesthetic Education* (July 1985).
- 21. Gardner, Artful Scribbles, p. 269.

ACTIVITIES FOR THE READER

- 1. Collect from a kindergarten and a first-grade class a series of drawings and paintings that illustrate the three types of concepts of the manipulative stage.
- 2. Collect drawings or paintings created by a single child over time to illustrate the development of a symbol, such as that for "person," "toy," or "animal."
- 3. Collect from several children in the first to third grades a series of drawings and paintings that illustrate developments in symbolic expression.
- 4. Collect from pupils enrolled in the third to sixth grades drawings and paintings that illustrate some of the major developments in the preadolescent stage.
- 5. Make one collection of drawings and paintings representative of artistic development from kindergarten to the end of sixth grade. Look for conventions such as baselines, overlap, X-ray views, and foldover views.

- 6. Collect work in three-dimensional materials, such as clay or paper, from the pupils in situations identical with, and for purposes similar to, those mentioned in the first five activities.
- 7. Show children an original painting or a good-quality reproduction. Discuss with each child various questions about the origins, creation, and expressive qualities of the artwork.
- 8. Ask college students or older adults to draw a human figure in a pose of their choice. Observe the developmental level of the drawing, and ask the persons when and where they learned to draw as they did. At what age did each person stop drawing?

SUGGESTED READINGS

- Arnheim, Rudolf. "A Look at a Century of Growth." In *Child Development in Art*, ed. Anna Kindler. Reston, VA: National Art Education Association, 1997.
 - ——. Thoughts on Art Education. Los Angeles: Getty Center for Education in the Arts, 1989.
- Baum, Susan, Julie Viens, and Barbara Slatin. Multiple Intelligences in the Elementary Classroom: A Teacher's Toolkit. New York: Teachers College Press, 2005.
- Boriss-Krimsky, Carolyn. Creativity Handbook: A Visual Arts Guide for Parents and Teachers. Springfield, IL: Charles C. Thomas, 1999.
- Bredenkamp, Sue, and Carol Copple, eds. *Developmentally Appropriate Practice in Early Childhood*. Washington, DC: National Association for the Education of Young Children, 1997.
- Eisner, Elliot. *Educating Artistic Vision*. New York: Macmillan, 1972.
- Engel, Brenda. *Considering Children's Art: Why and How to Value Their Works*. Washington, DC: National Association for the Education of Young Children, 1995.
- Fein, Sylvia. *Heidi's Horse*. Pleasant Hills, CA: Axelrod Press, 1984.

Gardner, Howard. The Arts and Human Development: A Psychological Study of the Artistic Process. New York: Basic Books, 1994.

———. Creating Minds. New York: Basic Books, 1993.

- Kelly, Donna Darling. Uncovering the History of Children's Drawing and Art. Publications in Creativity Research. Westport, CT: Praeger Publishers, 2004.
- Kindler, Anna M., ed. *Child Development in Art.* Reston, VA: National Art Education Association, 1997.
- Koster, Joan Bouza. *Young at Art.* 2d ed. Clifton Park, NY: Thomson Delmar Learning, 2000.
- Lowenfeld, Viktor. Creative and Mental Growth. New York: Macmillan, 1952.
- Milbrath, Constance. Patterns of Artistic Development in Children: Comparative Studies of Talent. Cambridge: Cambridge University Press, 1998.
- Schirrmacher, Robert. Art & Creative Development for Young Children. Clifton Park, NY: Thomson Delmar Learning, 2001.
- Thompson, Christine Marmé, ed. The Visual Arts and Early Childhood Learning. Reston, VA: National Art Education Association, 1995.

WEB RESOURCES

The Art Room, Resources, Young at Art: http://www.arts .ufl.edu/art/rt_room/teach/young_in_art/ International Child Art Foundation: http://www.icaf .org/ National Association for Education of Young Children: http://www.naeyc.org Project Zerc Research Projects, Harvard University: http://www.pz.harvard.edu/

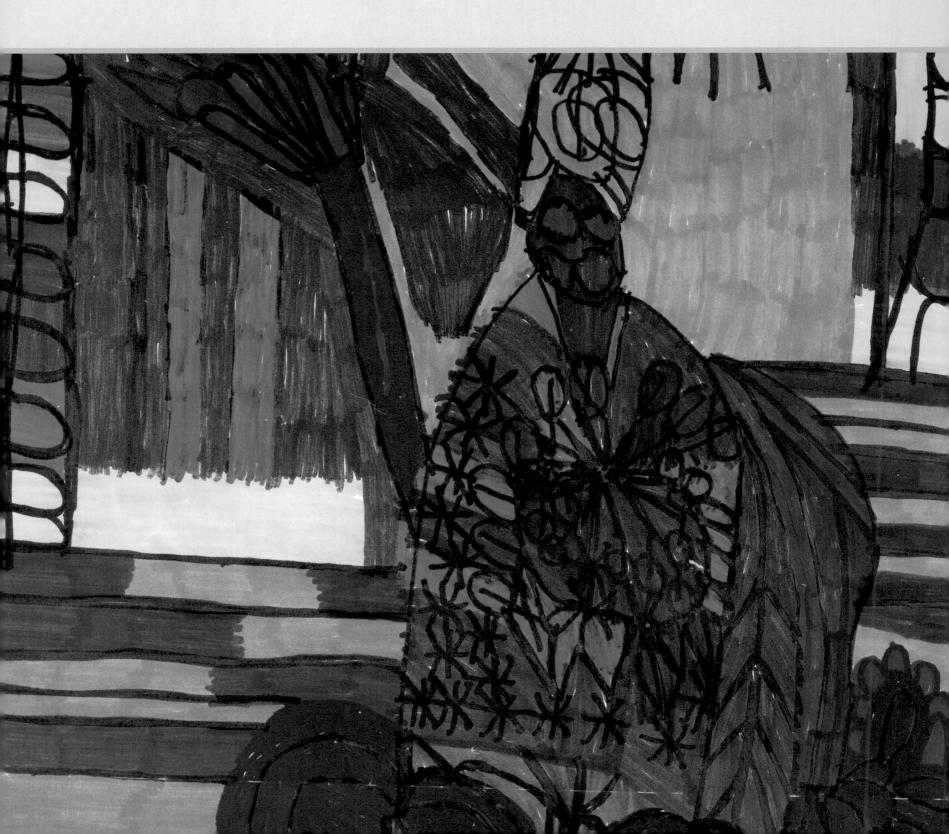

C H A P T E R

CHILDREN WITH SPECIAL NEEDS

Art for All Children

They took away what should have been my eyes, (But I remembered Milton's Paradise).
They took away what should have been my ears, (Beethoven came and wiped away my tears).
They took away what should have been my tongue, (But I had talked with God when I was young).
He would not let them take away my soul— Possessing that, I still possess the whole.

—Helen Keller, "On Herself"

In a middle-class suburban K-5 elementary school (570 students), the first- and second-grade children are gathered in a spacious area outside their open classrooms. They begin their daily assembly this morning with patriotic songs.

Boisterously, if a bit off-key, the group of 100 or so belts out traditional favorites. But they quiet to a hush when [a musical vocal rendition] begins to blare from the stereo, and their 2nd grade teacher announces that they will perform the song in sign language.

Drawing by a German student with mental retardation.

It takes a few lines before most of the students can synchronize their sweeping motions to keep pace with the lyrics, but soon the children are signing the words as passionately as they sang a few moments earlier.

Every student takes part in some way, including a grinning boy with Down syndrome sitting to one side of the group and a girl with cerebral palsy nearby. Toward the back of the group, a boy who uses a wheelchair and computerized audio device to speak cannot lift his arms to sign, yet he follows his schoolmates with his eyes.¹

The scene described here took place at a model fullinclusion elementary school, where students with disabilities spend almost all their days in regular classes and study the same curriculum as their nondisabled peers. The morning's experience in mainstreaming will carry through after the assembly disperses, as nearly all disabled students are taught alongside their nondisabled classmates. And, according to teachers' and administrators' observations and pupils' grades, "not only have the disabled students made noticeable improvement in academic and social performance, but other students also have become more caring and tolerant."²

This is one school's response to the intent of the Individuals with Disabilities Education Act (IDEA), which has been in place in the United States for more than three decades. The goal of this federal legislation is to provide equity in education for all students, a very complicated task given the variations in abilities and learning styles of students. There are approximately 6 million students with disabilities in American schools and 56 million children and adults living with disabilities in the United States.³ This means that all teachers must be ready to teach all children who enter their classrooms in a mainstreamed environment. Art teachers traditionally have accommodated special learners very effectively in their classes.

The language of special education changes as new categories, concepts, and sensitivities emerge in professional discourse. The first distinctions that should be made are between all-inclusive references, such as *challenged* and *disabled*, and those that refer to specific conditions, such as *mental retardation, emotional disturbance,* or *orthopedic impairment*. The accompanying boxed feature presents terms and definitions found in the current IDEA legislation. The term *special needs* has been retained for the discussion in this chapter because it addresses the complete range of learners.⁴ Through classroom experience with many children, teachers come to recognize and respect diversity among students. Some disabilities are permanent, whereas others, such as severe periods of emotional disturbance, may be temporary. In light of the concept of multiple intelligences, teachers note that a child experiencing a disability may excel in other areas of schooling. A child with a specific learning disability, for example, could excel physically or socially.

General education is intended to accommodate the broad range of students who can benefit from regular schooling. This encompasses the entire spectrum of learning types, including children who, for various reasons, are handicapped or challenged learners. Children who are mentally retarded, who are physically or emotionally challenged, or who speak English as a second language (ESL) increasingly are "mainstreamed" in regular classrooms, where they associate with all their peers rather than remain with a limited subgroup related to their particular challenge.

The inclusion of special students in regular classrooms has, in many instances, improved their educational opportunities and broadened their social contacts. At the same time, teachers are challenged by the broad range of learners and special learning needs of their students and must be prepared to educate all children who are assigned to their classes.

When we consider the wide range of learning styles and abilities among learners, the average class size in elementary- and middle-school classrooms, the inclusion of one or more special learners in most classrooms, and the charge to regard each child as an individual, we can gain some appreciation for the complexity of being an effective teacher. School programs typically employ trained experts who work with special groups of students. Classroom teachers rely on these experts for support and assistance with special students. All teachers, however, must gain a basic understanding of the needs of special learners and develop ways to adapt their instructional programs to these needs.

The goals of general education are usually appropriate for all learners, regardless of their special status. For example, we attempt to teach all students to read, although some will learn to do so very slowly and with great difficulty. Reading instruction must be adapted for visually impaired learners or for those who dc not yet speak English, but the goal to teach reading remains unchanged. The same is true with general education goals for writing, mathematics, social studies, and the arts. The goals and learning activities for art education outlined in Chapters 1 and 2 are valid for nearly all students but must be adapted according to the levels and abilities of individual special learners.

Children with all types of special needs should be encouraged to advance as far as their capabilities will allow. An example of this attitude can be seen in the case of Down syndrome children, many of whom have progressed much further educationally than once was believed possible. Organizations such as the Special Olympics and VSA arts have sensitized many people to the needs, capabilities, and contributions of persons with disabilities.⁵ Teachers should be in the forefront of those who are dedicated to assisting learners with special needs to enjoy full and productive lives.

Legislation in the United States has drawn attention to the need for educational programs for the challenged. Federal Chapter 766 mandated the "mainstreaming" of children with special needs into integrated classroom situations with peers of the same age. The goal is to meet the educational needs of every student experiencing disability on an individual basis, while at the same time integrating students into the regular activities of the school day. Research indicates that students with disabilities have made great strides during the past 25 years "with lower dropout rates, an increase in postsecondary enrollment and a higher rate of gainful employment after leaving high school."⁶

Through state-run festivals, teacher-training symposiums, and exhibits, the importance of arts programs for children with special needs is gaining public attention. Research has emphasized the value of arts instruction in special education. Federal and state funding (in Canada, provincial funding) has opened professional opportunities within the public sector in the fields of special education and of art, integrated arts, dance, and music therapy. As these approaches become accepted, their balance of visual, manipulative, and kinesthetic expression aids children whose learning styles are visual, manipulative, auditory, and kinesthetic—as well as verbal.

Doris Guay points to the challenges for art teachers to employ creative problem solving for planning and teaching.

With increased diversity in art class, we can no longer assume that the methods and materials of past practice apply. Teachers must learn to use instructional practices that maximize individual student learning. These include cooperative grouping methods, task analysis, and partial participation. Teachers must also develop effective techniques for individualization,

DEFINITIONS OF DISABILITY TERMS

Autism means a developmental disability significantly affecting verbal and nonverbal communication and social interaction, generally evident before age 3.

Deaf-blindness means concomitant hearing and visual impairments, the combination of which causes such severe communication and other developmental and educational needs that they cannot be accommodated in special education programs solely for children with deafness or children with blindness.

Deafness means a hearing impairment that is so severe that the child is impaired in processing linguistic information through hearing, with or without amplification.

Emotional disturbance is defined as:

- a. An inability to learn that cannot be explained by intellectual, sensory, or health factors.
- b. An inability to build or maintain satisfactory interpersonal relationships with peers and teachers.
- c. Inappropriate types of behavior or feelings under normal circumstances.
- d. A general pervasive mood of unhappiness or depression.
- e. A tendency to develop physical symptoms or fears associated with personal or school problems.

Hearing impairment means an impairment in hearing, whether permanent or fluctuating, existing concurrently with deficits in adaptive behavior and manifested during the developmental period.

Mental retardation means significantly subaverage general intellectual functioning, existing concurrently with deficits in adaptive behavior and manifested during the developmental period.

Multiple disabilities means concomitant impairments (such as mental retardation-blindness, mental retardation-orthopedic impairment, etc.), the combination of which causes such severe educational needs that they cannot be accommodated in special education programs solely for one of the impairments.

Orthopedic impairment means a severe orthopedic impairment, including impairments caused by congenital anomaly, impairments caused by disease, and impairments from other causes.

Other health impairment means having limited strength, vitality, or alertness, including a heightened alertness to environmental stimuli, that results in limited alertness with respect to the educational environment.

Specific learning disability means a disorder in one or more of the basic psychological processes involved in understanding or in using language, spoken or written, that may manifest itself in an imperfect ability to listen, think, speak, read, write, spell, or to do mathematical calculations.

Speech or language impairment means a communication disorder, such as stuttering, impaired articulation, a language impairment or voice impairment.

Traumatic brain injury means an acquired injury to the brain caused by an external physical force, resulting in total or partial functional disability or psychosocial impairment, or both.

Visual impairment including blindness means an impairment in vision that, even with correction, adversely affects a child's educational performance.

Source: "IDEA 1997 Final Regulations: Subpart A-General," Federal Register, September 1998.

Note: To qualify for IDEA, each definition is followed by the phrase "that adversely affects a child's educational performance."

motivation, student empowerment, and classroom management. The creation of normalized opportunities for personal expression and response in art, for a range of student ability, challenges creativity and inventiveness.⁷

CONTRIBUTIONS OF ART FOR STUDENTS WITH SPECIAL NEEDS

The art program in many schools traditionally has been viewed as a particularly favorable setting for educating students with special needs. In art children are able to interact with such materials as paint or clay in direct response to their senses of sight, sound, smell, and touch. The materials of art are sensory, concrete, and manipulable in direct ways that are unique within the school curriculum. All the senses can be brought into interaction, providing opportunities to adapt art-making activities for students who have some sensory or motor impairment. For example, children with visual impairment can form expressive objects with clay. Children with hearing impairment can visually observe a demonstration of color mixing with paint and try the process with immediately verifiable results, and children with motor disabilities can work with finger paints or with large brushes for painting.

Another reason why art class is often a supportive place for special learners has to do with the tradition of personal expression in art. Even when all students are engaged in the same task, such as painting a self-portrait, the outcome for each child can be unique. Each can paint his or her own version of a self-portrait with a stipulated context, yet each cne can express a different mood or point of view. This opportunity for individuality within an assigned task is readily provided by sensitive art instruction.

The comprehensive program of art education we describe in this book is especially adaptable to the needs of learners with special needs (as well as to varying learning styles among all students) because of the wide range of pos-

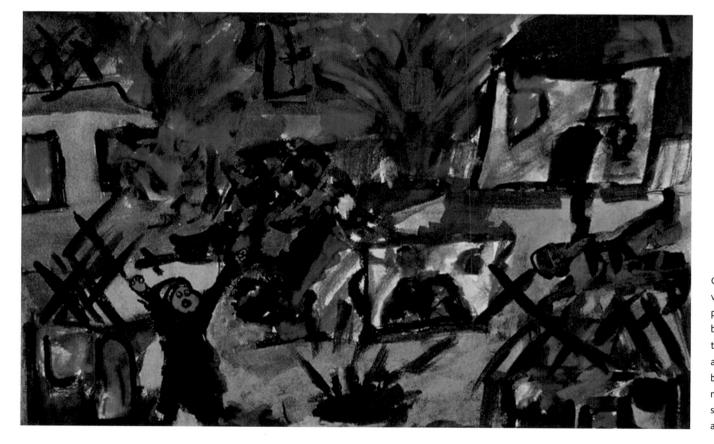

Children often prefer to convey their impressions of experiences that disturb them by drawing or painting rather than by writing or even talking about the event. This example by a Croatian child tells us much about personal expressiveness on both a therapeutic and artistic level. sible art activities. A balanced art program includes the sensory, cognitive, and manipulative activities of art production as well as activities that emphasize visual perception, discussion of artworks, investigation of culture and history, and questioning of fundamental ideas about art. It is unlikely any student will be able to do *all* these activities with equal facility, but it *is* likely that all students will be able to do, enjoy, and learn from many of these activities.

Therapy and Catharsis

Participation in art activities can have therapeutic effects for many learners. Engaging in art production might serve a therapeutic function in a general sense, in fact, for almost any person. The same might be said for any educational pursuit that requires total involvement, such as a scientific experiment, a cooking activity, or participation in a sports event. However, the aspect of art activity that provides so much therapeutic potential is the creative and expressive dimension. Art, according to philosopher Susanne Langer, is "the objectification of human feeling."⁸ Verbal language, says Langer, is inadequate for the expression of the life of feeling all human beings share. These feelings can be adequately expressed only through the arts.

Art therapists are able to engage their clients or patients in arts activities that encourage free expression of emotions. Acts of artistic expression, such as drawing or painting, can result in communication of feelings that goes beyond and is apart from verbal expression. Once the art object has been created, once the feelings have been objectified as an artwork, they can then be viewed and discussed. Thus, art activity assists the therapist and client in two ways. First, creation of the art object can be an expressive release for the patient, providing feelings of profound satisfaction. Second, the object becomes a focus for discussion between therapist and patient, often leading to helpful revelations of the person's emotional life. Trained professional art therapists are capable of helping individuals interpret meanings from their artworks and use this knowledge to improve patients' mental or emotional health.

Therapeutic aspects of art education can occur in classrooms with all students and, more particularly, with students who have fewer or less developed communication skills. Any person with strong emotions and limited ways of expressing them might benefit from artistic expression. In numerous cases of children with intellectual disabilities, of immigrant students with little English capability, of children who have experienced traumatic events, and of others, artistic expression has provided a desperately needed means for expression.

In the words of artist and educator Bob Steele, catharsis in art can be "the alleviation of fears, problems, and complexes by bringing them to consciousness and giving them expression."9 This catharsis can be associated with personal experiences, possibly traumatic, or with the cases of children who have lived through wars and other social upheavals. The art objects these children produce often provide sensitive teachers with insights into the mental and emotional lives of the children. Teachers, however, are not professionally trained art therapists and should not attempt to fulfill that role. Insights that teachers glean through children's art activities and products should be shared with professional school personnel, such as psychologists or therapists. Working together, school teams of counselors, psychologists, administrators, parents, and teachers can best develop and provide the educational opportunities needed for the individual learner.

A distinction is made between exceptional children who receive special schooling and children with special needs who are capable of functioning within normal school situations. As the work of German art educator Max Kläger attests, a sensitive teacher can attain remarkable artistic results with slower learners. His longitudinal studies of several individuals with Down syndrome demonstrated that the subjects' personalities, as well as the visual quality of their work, showed remarkable progress with proper supervision and education.¹⁰

The current policy is to move special-needs children out of specialized schools and into regular schools. As a result, all teachers must be prepared to teach these students. Teachers need to examine each subject area in search of more effective means for dealing with the gifted, the emotionally disturbed, the physically impaired, and the mentally retarded.

TEACHING CHILDREN WITH INTELLECTUAL, COGNITIVE, OR DEVELOPMENTAL DISABILITIES

According to the American Association on Mental Retardation, an individual is considered to have mental retardation based on three criteria: "intellectual functioning level (IQ) is below 70–75; significant limitations exist in two or more adaptive skill areas; and the condition is present from childhood, defined as age 18 or less."¹¹ Mental retardation is 10 times more common than cerebral palsy and affects 25 times as many people as blindness does. Mental retardation cuts across the lines of racial, ethnic, educational, social, and economic backgrounds. It can occur in any family. Approximately 1 in 10 American families is directly affected by mental retardation.

The effects of mental retardation vary considerably among people. According to the Association of Retarded Citizens (The Arc), "about 87 percent will be mildly affected and will be only a little slower than average in learning new information and skills. As children, their mental retardation is not readily apparent and may not be identified until they enter school. As adults, many will be able to lead independent lives in the community and will no longer be viewed as having mental retardation."¹² The remaining 13 percent of the mentally retarded, those with IQs under 50, "will have serious limitations in functioning. However, with early intervention, a functional education, and appropriate supports as an adult, all can lead satisfying lives in the community."¹³

Approximately 1 in 800 newborns has mental retardation caused by Down syndrome (the presence of an extra critical portion of number 21 chromosome). In today's society Down syndrome children commonly go to regular schools, live in families, and gain employment as adults. With good health care and access to current therapies, 80 percent of the Down syndrome adults will live past age 55 (in past decades, only 50 percent lived past age 10). The success and visibility of such people as Chris Burke, a Down syndrome young man who acted in a weekly network television program, has helped increase the general acceptance and understanding of people with intellectual disabilities.

School districts have Individual Educational Program (IEP) committees that determine if a student meets eligibility criteria as a child with disability and then determine if the condition is affecting the child's ability to benefit from education. The arts specialists often interact with these committees to develop the educational plan best suited to each student's needs.

Slower learners enrolled in a regular classroom begin their artistic career by manipulating art materials rather than by drawing or modeling recognizable objects. They are sometimes slower in interacting with the materials given to them and may not initially explore their possibilities fully However, with patience and encouragement, the child will be able to feel more comfortable with new media through repetition of skills. Even so, the child's symbol formation will reflect his or her developmental level. Thus, a child of chronological age 15 whose developmental level is nearer to age 4 can be expected to create symbols appropriate to a 4-year-old child.

Whereas a 5-year-old child might arrive at the symbolmaking stage within three weeks to six months, a 5-yearold slower learner might not reach this stage for a year or more. In time, however, slower learners arrive at the symbol stage in a manner resembling that of nondisabled children. Once the symbol stage has been reached, several symbols may appear in quick succession.

Because of their greater chronological age, children with intellectual disabilities often possess physical coordination superior to that of other children of the same mental age. These physical abilities, of course, help them master drawing skills more readily and allow them to repeat a recently developed symbol without much practice. Children with intellectual disabilities, like all children, will sometimes surprise a teacher with a burst of progress from manipulation to symbol making. As noted earlier, regression from the symbol stage to that of manipulation will sometimes occur as a result of such factors as fatigue, ill health, temporary emotional disturbances, periods of intense concertration, interruptions of various kinds, absence from school, or faulty teaching methods.

Gradually, learners with intellectual, cognitive, or developmental disabilities come to spend more time on their work and thus begin to add details to their symbols. Sometimes they learn to relate their symbols to one another. The progress they make depends largely on the attention they give to their work. Slower learners' attention spans tend to increase with both their chronological age and their mental age. As with all children, slower learners should be encouraged to explore with art materials and to devise their own images rather than rely on stereotypes that have no real meaning in the context of their artwork.

The teacher's attitude in approaching children with special needs is of utmost importance. Patience helps develop trust. Accepting the children as they are and guiding them to progress at their own rate will enable children to work with confidence. An awareness of the particular learning style of each child will aid the teacher in developing a program of appropriate activities. As the teacher helps the child expand and broaden a sensory vocabulary, the child's ability to grasp abstract concepts can deepen.

Learners with intellectual disabilities can benefit from the visual and verbal aspects of a comprehensive art program, as well as from participating in art making. One fourth-grade teacher introduced her students to art criticism by teaching them to name objects depicted in paintings (using good-quality color reproductions). She taught them to name colors, types of lines, and shapes and then introduced visual concepts, such as contrast and balance. At a parents' night at the school, a mother approached the teacher and asked what she had done so successfully to stimulate her Down syndrome daughter's language development. "When Susie comes home after school, she loves to open a picture book, point to the pictures, and describe what she sees. We have encouraged this and have noticed much progress in her language abilities."¹⁴

As indicated earlier, all children who have the aptitude to do so pass through the normal stages of pictorial expression mentioned in Chapter 3 — the manipulative, symbolmaking, and preadolescent stages. Once they progress beyond the stage of manipulation, slower learners discover subject matter for expression in their own experiences. Many of the titles they give to their works are similar to those selected by their nondisabled classmates. The titles describe events that occur at home, at school, at play, or in the community. The following are representative:

"Where I Live"

"Our Class Went to Visit a Farm"

"I Saw a Big Fire"

"My Favorite Foods"

"A Movie I Like"

Subjects such as these are appropriate for the late symbolmaking or preadolescent stage of expression. The titles are concise, and in most of them the children have identified themselves with their environment. The less able the learners, the less inclined they are to relate themselves to the world in which they live.

Subject Matter

The themes that many children with intellectual disabilities select are often closely connected with small, intimate events in life. Many slower learners seem to find constant interest in pictures of this nature, with titles such as "I Sat on Our Steps," "The Birds Are in the Trees," and "Our School Bus."

Children frequently like to depict their reactions to vicarious experience, even though they are more attracted to actual experience. Dramatized versions of familiar stories and events may excite them to visual expression. The teacher should, whenever possible, connect the physical experiences of the children and their drawings. Situations that deal with personal accidents ("falling down" or "bumping my head") make effective sources for drawing, as do activities such as rolling or bouncing balls and using playground equipment.

METHODS OF TEACHING

To teach students experiencing disabilities, a teacher must possess a number of commendable personal qualities and professional abilities. The teacher must above all be patient, for children often progress slowly in their work. The teacher must, furthermore, be able to stimulate children to maximize their potential, but at the same time not hurry them into work beyond their abilities. Finally, the teacher must treat every slow learner as a unique person. A study of their output in art offers a striking illustration of the fact that the personalities of slow learners differ widely.

If the art teacher has in the classroom one or two slower learners who require special attention, this should not create problems. Because all successful teaching in art demands that the teacher treat all pupils as individuals, the fact that learners with disabilities are afforded certain special attention should in no sense make them unique in the eyes of their fellows. Every child in the class, whether disabled, normal, or gifted, will require individual treatment. If the teacher is placed in charge of an entire class of learners with special needs, similar educational principles apply. No two children will react in an identical manner to art. Here, as elsewhere, every child must be offered an educational program tailored to individual needs and capacities.

Step-by-step teaching practices, while rarely of value because they present little challenge, may often give slower learners a valuable and necessary sense of achievement. Frequently, attention to the structure of a lesson may lead learners with special needs into more creative endeavors. Approved teaching methods are effective when used with students experiencing disabilities. Teaching learners with intellectual and cognitive disabilities does not require as much reorientation on the part of the teacher as one might

Top: The illustration for the story of Noah's ark was drawn by the attendant of a boy who was incapacitated in speech and movement. His nurse developed the picture from whatever sounds the boy conveyed. The boy's desire to contribute personally was so strong that a brush was strapped to his wrist so that he could add his own concluding touches in watercolor—an example of the will to create, which cannot be stifled even under the most limiting circumstances.

Bottom: Another version of the Noah story, by a 12-year-old Hungarian child with mental retardation. His conception of God as well as the idea of each person as a victim of his or her own private thunderstorm is strikingly original.

suppose. It can require teaching in sequential concrete terms—hence, the importance of demonstrating art processes, of simplifying, of slowing down verbal instructions, of having the patience to repeat directions, and of breaking down the learning experience into manageable stages.

In her study of accomplished art teachers, Doris Guay

observed a number of strategies that led to success with disabled students.

[Teachers] maintained expectations in a caring classroom atmosphere through the use of verbal praise, hand-over-hand assistance, and the invention of adaptive devices. Teachers generally moved throughout their classroom, providing reinforcement and encouragement. They sought to maintain a calm, personal approach, keeping individuals on task by personal closeness. They never appeared to be rushed. As they found both students with and without disabilities needing assistance, most teachers routinely asked table peers to provide help.¹⁵

The teachers assisted through questioning students' intentions and reminding students of technical concepts taught previously. And, without exception, these teachers revealed an enjoyment of students through their easy humor and quiet laughter.

Using Museums

Innovative approaches, such as taking children with disabilities on field trips, and especially to art museums, have proved valuable in stimulating perceptual awareness and in developing an appreciation of the larger artistic world. Most art museums are barrier free and welcome patrons with disabilities, and many art museums offer learning materials developed especially for schoolchildren. These materials explain the museum's major collections and exhibitions and often include slides or other color reproductions of artworks The art and artists are usually placed in the context of their time and culture. When children are made aware in the classroom of the art they will see at the museum, they often are thrilled when they experience the original versions.

A number of teaching and learning strategies work well with visits to art museums. From the simplest to the most complex, these methods and games are effective with a range of learning styles and abilities. Museum visits are discussed mcre completely in Chapter 12 of this book.

Basic Activities

MEDIA AND TECHNIQUES

In drawing and painting, learners with cognitive disabilities may use the standard tools and equipment recommended for other pupils. Hence, wax and oil-based crayons, tempera paint, the usual types of brushes and papers, and so on may be employed. Most of these pupils also achieve success when cut paper is used as a medium for two-dimensional pictures. Some pupils, however, may begin to build their pictures into three dimensions. Nearly all children enjoy box sculpture, and many seem capable of doing some freestanding paper sculpture. Many slower learners can use molds to make simple masks, and nearly all of them can work successfully with papier-mâché if it is prepared in advance for them.

Carving in wood and other substances might be difficult for some learners with special needs. The tools required in much of this work might be too dangerous for them, and the techniques beyond their abilities. Simple forms of modeling and ceramics, however, are recommended. The direct nature of modeling and the expressive potential of ceramics make this activity highly suitable. Vegetable printing is also a useful technique, largely be-

An example of graphic design combining poetry, printmaking, and typography to create a limited edition of booklets for parents.

cause it is repetitive, whereas stencil and linoleum work could be too difficult for some to master.

With all the basic activities just mentioned, the teacher must modify classroom techniques to suit the abilities of pupils. A step-by-step approach becomes necessary not only in the work itself but also in the selection of tools and media. Some preadolescent slower learners experience difficulty when confronted by a wide range of color or by the problems of mixing tints, shades, and even secondary hues. In assisting students, teachers should provide the least amount of help to effect the greatest learning.

When three-dimensional work, such as pottery or box sculpture, is being taught, the teacher would be wise to analyze the process from start to finish in terms of separate operations. Then, before the pupils begin work, they should be shown a finished object so they know what to expect at the end of their work. After that, however, demonstrations and general teaching might be performed only one operation at a time. The pupils should select the tools only for the one operation, complete the operation, and then return the tools. This process should then be repeated until all the necessary operations have been mastered.

HISTORY AND CRITICISM

Students with intellectual disabilities can participate in all types of art activities if they are adapted to students' ability levels. For example, postcard images of artworks are readily available from art museums and commercial publishers. Children can sort these images according to simple categories, such as subject matter (trees, animals, persons), art mode (picture of buildings, of furniture), color (name hues, distinguish warm and cool), mood (happy, frightened), and many others. Color cards can be made using watercolors and paints and then sorted, mixed, and matched by the children according to basic color theory.

Children can enjoy stories about artists, seeing pictures of them (photographs or self-portraits), hearing stories of their lives and work, and looking at and reading children's books about art. Like most children, students with special needs can enjoy seeing pictures of the people who created the art and learning about them. A balanced art program can provide rich learning opportunities for all children. The full educational resources—including art reproductions, games, films and videos, slides, books, magazines, and objects for handling (such as museum replicas)—should be brought to bear for the art education of all children.

Group Activities

Pupils with mental retardation often have difficulty participating in class or group art activities, largely because of considerable differences in the mental and chronological ages of individual members of the group, even among pupils in special classes. Group activity for students with special needs must be very carefully chosen and supervised, if it is to succeed.

One recommended group activity is puppetry. This activity allows the child to work both as an individual and as a member of a group. Only the simplest of puppets need be made for a successful group performance. Stick and fist puppets are suitable for most slower learners. The child's subjects, cut in cardboard and tacked to sticks, or doll-like creatures made from old socks or paper bags and manipulated with the fingers, will serve as suitable characters for a play. A large cardboard carton provides a simple stage. The spoken lines and the action of the play may be derived from a well-liked story or based on some experience in the children's lives.

Because mural making demands a high level of group cooperation and organization, this activity must be adapted for slower learners. The quasi-group activity, in which the general plan is discussed and decided on by a group but in which each child works independently on a section of the display, is practical for students with special needs, as it is for young children. Some slower learners may not be able to grasp the overall design concept of a mural, but working on a large scale is a pleasurable experience. Many cooperative activities of this type may be carried out in clay or in other modeling or building materials, including empty boxes and odd pieces of wood. A service station, a farm, a village, or a playground are subjects students might be interested in developing.

The gains to be derived for students with intellectual, cognitive, or developmental disabilities working in art may be summarized by the following seven points:

- Through art activity, students often create products that are not noticeably inferior to those of their neighbors. Their efforts need not suffer by comparison. Quality of product, in any case, is of secondary importance.
- 2. The process of concept formation through art takes place for pupils with cognitive disabilities as it does for average and above-average children. Through art,

slower learners can present ideas that may otherwise be denied expression because of limited ability in handling language skills.

- 3. For the trained observer, the artwork may provide diagnostic clues to emotional difficulties that sometimes accompany mental retardation.
- 4. Art activity can function as therapy, providing a unique source of satisfaction and stability to children who have a history of failure or personal tragedy.
- 5. Working in art provides vital sensory and motor experiences that involve the total mental and physical capabilities of the children. The integration of physical and mental operations, in turn, facilitates the union of thought and feeling. In this respect, art serves the same unifying function for children of all abilities.¹⁶
- 6. Artist c activity provides slower learners with experience in decision making and problem solving, which are socially useful skills with transfer value in nonart areas of instruction.
- 7. The art room can provide a nonthreatening atmosphere for the integrated classroom experience.

OTHER KINDS OF DISABILITIES

Although this chapter has focused primarily on art as it relates to students with intellectual, cognitive, or developmental disabilities, teachers may have students with other kinds of disabilities. Teachers cannot become instant authorities on all disabilities, but they can continue to be informed and work with special educators and other experts for the benefit of students with disabilities. Special education authorities urge us to view a disability not as a defect but rather as a difference through which teachers can discover the potential for a specific and unique mode of experience and through which other sensory modes may even be heightened.

As we opened ourselves to their [children with blindness] unique ways of being, we learned to value their otherness, to treasure the ways in which they sensitized us. The children expanded our sensory awareness by referring to "clay that smells like candy," "markers," or "soft paper." They tuned us in to sounds, like Billy, who took intense pleasure in "a marker that squeaks a whole lot . . . that makes a whole lotta noise." Although one would not have chosen a felt-tip marker as the most appropriate tool for a boy with no vision, Billy taught us not to allow our own preconceptions to interfere with what media we might offer children with disabilities.¹⁷

One educator tells how a child with limited vision experienced a "kind of 'color shock'" from the intense hues of tempera paint. "And Terry, a deaf-blind child, literally jumped for joy when she accidentally discovered

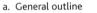

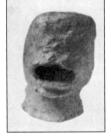

b. Cavity of the mouth is formed

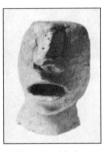

c. Nose is added

d. Eye sockets are hollowed out

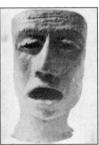

g. Wrinkles are formed

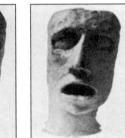

e. Eyeballs are put in

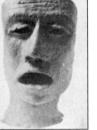

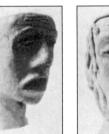

h. Ears are added

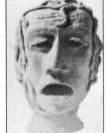

f. Lids are pulled over

i. The head is finished. All features are incorporated into a unified surface. Typical for the visual type.

that wet clay pressed on the white paper made a visible mark. . . . The art program . . . opened our eyes to the need and capacity for joy. . . . The intensity of the children's sensory-motor pleasure in the art experience was inescapable." 18

Children with severe mental retardation make advances in behavior, speech, and language through arts pro-

Children with autism may be extremely withdrawn, rigid, and inflexible in their habits and may also demonstrate impairment in both speech and social relationships. They can also be exceptionally gifted in art. This drawing of Gum's department store in Moscow was drawn by Steven, age 12. Steven, who is as obsessed by architecture as was Nadia with horses (see Chapter 5), began this drawing from observation but completed it from memory.

feld documented the development of a portrait in clay by a 16-year-old girl who is congenitally blind. The project shown here develops from a general outline (a) to the finished head (i). Although known mostly for his work on artistic development, Lowenfeld began his career working with children and adults with special needs to develop this theory of visual and haptic types. These classifications, which he likened to expressionist and impressionist modes of art, are consistent with both normal and specialneeds children.

grams that include other art forms. Through creative drama, children with hearing impairment can shed the fear of using words. Music can help develop a rhythmical sense in children with disabilities, as well as aid them in relaxing their muscles, and movement activities can help children with blindness gain the freedom to extend their sense of personal space.

What a child is not able to do is often offset by a heretofore-neglected area of ability. Once this becomes apparent, the teacher should be certain the parent is informed and the ability noted on the student's record. For example, a student who retreats from working on a large scale may perform very well with a smaller format, or the child who cannot manipulate art materials may excel in responding to art.

We need to keep in mind that the art education program is comprehensive and broad, with a range of learning activities, including reading and writing about art, viewing and responding to art, studying about art and artists, as well as engaging in a rich series of art-making activities. And, as Doug Blandy reminds us, "There can no longer be one type of art education for those who are disabled and another type for those who are not. . . . Environments in which art education takes place will need to become flexible, dynamic, and adaptable to meet the needs of all participants."¹⁹

NOTES

- Joetta Sack, "More Schools Are Educating Students with Disabilities in Regular Classrooms. Are Teachers Ready?" *Education Week* 17, no. 28 (March 25, 1998): 32.
- 2. Ibid., 34.
- American Association of People with Disabilities, 2004 Annual Report, http://www.aapd.com/.
- 4. National Association of Special Education Teachers, *July, 2005 Special Educator e-Journal,* http://www.naset.org/.
- For more information, write to VSA arts, 818 Connecticut Avenue NW, Suite 600, Washington, DC 20006, or go to the VSA website at www.vsarts.org.
- 6. Government Press Release, Students with Disabilities Making Great Strides, New Study Finds, http://www .ed.gov/print/news/pressreleases/2005/07/07282005 .html.
- Doris M. Pfeuffer Guay, "Normalization in Art with Extra Challenged Students: A Problem Solving Framework," *Art Education* (January 1993), p. 58.
- 8. Susanne Langer, *Mind: An Essay on Human Feeling*, vol. 1 (Baltimore: Johns Hopkins Press, 1967), p. 87.
- 9. Bob Steele, *Draw Me a Story* (Toronto, Canada: Peguis Publishers, 1998), p. 50.
- Max Kläger, Jane C.—Symbolisches Denken in Bildern und Sprache (Munchen: Ernst Reinhardt Verlag, 1978).

- American Association on Mental Retardation, Mental Retardation: Definition, Classification, and Systems of Supports, 9th ed. (Washington, DC: AAMR, 1992).
- 12. Association of Retarded Citizens (The Arc), *Introduction to Mental Retardation* (2005), http://www.thearc .org/info-mr.html.
- 13. Ibid.
- 14. This anecdote was related in personal conversation with the authors.
- Doris Guay, "Cross-Site Analysis of Teaching Practices: Visual Art Education with Students Experiencing Disabilities," *Studies in Art Education* 34, no. 4 (Summer 1993): 222–32.
- Eric Jensen, Arts with the Brain in Mind (Alexandria, VA: Association for Supervision and Curriculum Development, 2001).
- 17. Fersonal conversation with authors.
- 18. Judith Rubin, "Growing through Art with the Multiple Handicapped," *Viewpoints: Dialogue in Art Education,* 1976.
- Doug Blandy, "Assuming Responsibility: Disability Rights and the Preparation of Art Educators," *Studies in Art Education* 35, no. 3 (Spring 1994): 184.

ACTIVITIES FOR THE READER

- 1. Visit an art class that includes students with disabilities.
 - a. Compare drawings and paintings of slower learners with those of other students.
 - b. Observe what physical arrangements have been made to accommodate students with disabilities.
 - c. Observe what adjustments have been made in curriculum, materials, and methods to accommodate students with special needs.
- 2. Technology has improved learning opportunities for children with special needs. What assistive technologies might an art class provide for learners with disabilities? Explore the Web Resources list for up-todate information.
- Develop a plan to demonstrate and teach techniques involved in the following activities to a class of children with mental retardation: (a) making a tempera painting; (b) making a clay pot by the coil method; and (c) making a simple weaving.
- 4. Develop a plan to take a small group of students with visual impairment to an art museum. What special accommodations might the museum make to provide access to these students and to enhance their experience with art? Ask the museum education department for information. Surf the Internet to discover resources available to classroom teachers and art educators.

SUGGESTED READINGS

- Benjamin, Amy. Differentiated Instruction: A Guide for Middle and High School Teachers. Larchmont, NV: Eye on Education, 2002.
- Buck, G. H. "Creative Arts: Visual, Music, Dance, and Drama." In Strategies for Teaching Learners with Special Needs, ed. E. A. Polloway and J. A. Patton, pp. 401– 27. Upper Saddle River, NJ: Prentice-Hall, 2004.
- Fitzell, Susan A. Special Needs in the General Classroom: Strategies That Make It Work. Manchester, NH: Cogent Catalyst Publications, 2004.
- Henly, David. Exceptional Children, Exceptional Art. Worcester, MA: Davis Publications, 1992.

Keller, Helen. "On Herself." In *The Faith of Helen Keller*, ed. Jack Belck. Kansas City, MO: Hallmark Editions, 1967. Nyman, Andra L., and Anne M. Jenkins, eds. *Issues and* Approaches to Art for Students with Special Needs. Reston, VA: National Art Education Association, 2005.

- Polloway, Edward, James R. Patton, and Loretta Serna. Strategies for Teaching Learners with Special Needs. Upper Saddle River, NJ: Prentice-Hall, 2004.
- VSA arts. *Express Diversity*! Washington, DC: VSA arts. John F. Kennedy Center. Resource for promoting inclusiveness.
- ———. Start with the Arts. Washington, DC: VSA arts. John F. Kennedy Center. An instructional resource.
- Witten, Susan Washam. "Students with Special Needs: Creating an Equal Opportunity Classroom." In *Middle School Art: Issues of Curriculum and Instruction*, ed. Carole Henry. Reston, VA: National Art Education Association, 1996.

WEB RESOURCES

- American Association for Mental Retardation (AAMR): http://aamr.org/. Provides information regarding policies, research, and effective practices for people with intellectual and developmental disabilities.
- Council on Exceptional Children (CEC): http://www .cec.sped.org/. The largest professional organization dedicated to educating individuals with exceptionalities, students with disabilities, and the gifted. Excel-

lent links to other websites, including those specific to individual disabilities.

- Information Center on Disabilities and Gifted Education: http://ericec.org/osep-sp.html. Provides selected Internet resources for the arts and disabilities and disseminates federally funded special education research for practitioners.
- Internet Resources for Special Children (IRSC): http:// www.irsc.org/. Dedicated to communicating information relating to the needs of children with disabilities and other health-related disorders. Includes educational resources and links to other sites.
- Learning Disabilities Association of America (LDA): http://www.ldanatl.org/. Provides support to people with learning disabilities, their parents, teachers, and other professionals with information on learning disabilities, practical solutions, and a comprehensive network of resources.
- National Arts and Disabilities Center (NADC): http:// nadc.ucla.edu/. A national information dissemination_technical assistance, and referral center specializing in the field of arts and disability and dedicated to promoting the full inclusion of children with disabilities into the visual, performing, media, and literary arts.
- National Association of Special Education Teachers: http://www.naset.org/. For special education teachers and others dedicated to ensuring that all children with special needs receive the best education.
- National Center to Improve Practice (NCIP): http:// www2.edc.org/NCIP/. Dedicated to enhancement of education through technology for students with disabilities.
- National Down Syndrome Society: http://www.ndss.org/. Provides information and resources for education of people with Down syndrome.

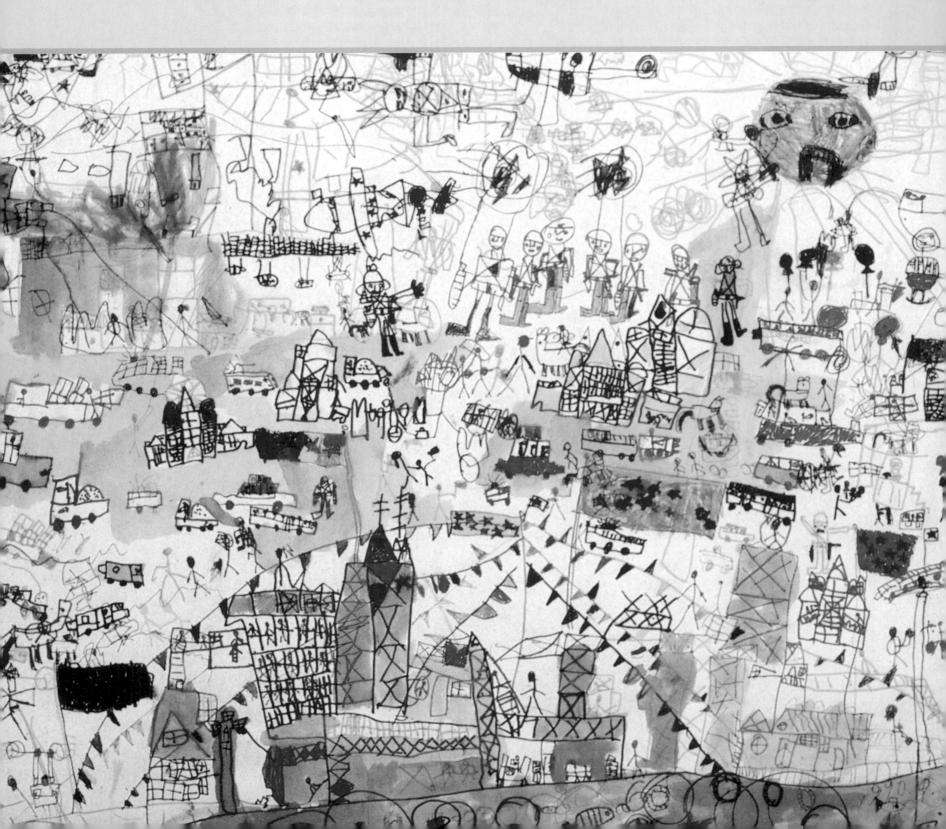

5

TALENTED CHILDREN

The Nature of Artistic Giftedness

It is important that art teachers be sensitive to the needs of artistically talented students and go beyond teaching skills to encouraging independent thought, spontaneity, and originality.

—Gilbert Clark and Enid Zimmerman, Teaching Talented Art Students

Every child has a profile of mental and physical strengths and weaknesses. Some children are physically well coordinated, and others excel in mathematics or learn to read quickly. Some children are musically inclined, are verbally adept, or have an ability to make others laugh. In the area of art, some children can draw well at early ages, and others are especially able to appreciate and understand works of art. Each and every child has a

Drawing by a Chinese student (Shanghai), age 5. Complexity and elaboration, extended concentration, and visual fluency are some of the characteristics of giftedness in art; all are evident in this work.

> combination of the multitude of human abilities and a profile of interests that makes him or her a unique individual.

> Our education system has in the past been more successful with general education for students in the normal range of abilities than it has in providing for the needs of gifted and talented children. Neglect of these students cannot be excused on the grounds that gifted children are able to make satisfactory progress without help. On the con

trary, evidence shows that cases of failure, delinquency, apparent laziness, and general maladjustment easily occur among gifted children as a result of neglect. A major part of this neglect is the failure of teachers to provide challenges that interest fast learners and channel their creative energies in positive directions. The lot of academically gifted children has improved through the addition of special programs, grouping for ability levels, team teaching, and use of paraprofessionals and volunteers. Children who are gifted in art, however, have not been as readily identified or as well provided for.

This chapter deals with three main topics: how to identify children gifted in art, what types of educational programs and practices are needed for their support, and how gifted children can be encouraged to continue in their development.¹

IDENTIFYING GIFTED CHILDREN

However we define art, there are students who are selfdetermined, who set their own agendas, and who pursue encounters with ideas and materials on a more intense level than their peers do. It seems to be more difficult to identify artistically talented children than academically gifted students. With the latter, educators can rely to a large extent on pupils' scores on IQ and other standardized tests, along with reports of their interests, activities, and performance in the area of interest. The identification of artistic talent can be more difficult because few reliable measures exist to judge either art production or appreciation. Whatever beliefs we may hold about a particular child's abilities in art are usually based on personal appraisal rather than on data gathered objectively. Most experts hold that subjective appraisals are not so important in reading, spelling, and number work, where fundamental abilities can be measured fairly accurately and, as a consequence, talent can be identified. We might suspect, however, that the expressive and appreciative aspects of even these academic fields are no more amenable to a reliable measurement than they are in art.

Because most teachers depend on subjective means to identify artistically talented youngsters, their estimate of the children's artistic future can be relied on only with reservations. Nevertheless, the pooled opinion of informed people frequently leads to surprisingly accurate judgments concerning artistic talent. Most researchers agree that there are different ways to be intelligent and different ways that exceptional talent is demonstrated. There is general agreement that children should not be rigidly labeled and that more attention should be focused on the processes of developing potential in children.²

A U.S. Department of Education publication offers the following official definition of children with outstanding talent. This is based on the definition used in the federal Javits Gifted and Talented Education Act.

Kai, the sixth-grade "class artist" in a Shanghai elementary school, displays his love of the American West. His work is true to life, particularly with respect to the horses and the boy's use of size and placement to achieve the appearance of depth.

Nadia (Great Britain), the most celebrated of visually gifted autistic children, drew hundreds of horses. This group was crawn when she was 3 years and 5 months old.

Children and youth with outstanding talent perform or show the potential for performing at remarkably high levels of accomplishment when compared with others of their age, experience, or environment.

These children and youth exhibit high performance capability in intellectual, creative, and/or artistic areas, possess an unusual leadership capacity, or excel in specific academic fields. They require services or activities not ordinarily provided by the schools.

Outstanding talents are present in children and youth from all cultural groups, across all economic strata, and in all areas of human endeavor.³

Research indicates several categories of talented children who are particularly neglected in programs for top students. These include culturally different children, minority and disadvantaged students, females, children with disabilities, underachieving high-potential students, and students with artistic talents.

One school district, typical of many others, has developed procedures for admitting children to gifted programs that combine teacher nominations, test scores, examples of work, and interviews, whereas another relies largely on the judgment of parents and teachers. No tests, reviews, grades, portfolios, or requirements are utilized. Sometimes a system for identifying gifted children is criticized for bias in selecting only certain types of children and eliminating others, possibly from particular ethnic or socioeconomic groups. In some cases resources for gifted programs are limited, and parents are anxious to have their children identified in this category, leading to a competitive atmosphere and potentially hard feelings. For these reasons and others, the best systems for identifying students who might bene-

IDENTIFYING GIFTED AND TALENTED STUDENTS

The U.S. Department of Education urges schools to develop a system for identifying gifted and talented students that:

- Seeks variety—looks throughout a range of disciplines for students with diverse talents
- Uses many assessment measures—uses a variety of appraisals so that schools can find students in different talent areas and at different ages
- Is free of bias—provides students of all backgrounds with equal access to appropriate opportunities
- Is fluid—uses assessment procedures that can accommodate students who develop at different rates and whose interests may change as they mature
- Identifies potential—discovers talents that are not readily apparent in students, as well as those that are obvious
- Assesses motivation—takes into account the drive and passion that play a key role in accomplishment

Source: Pat O'Connell Ross, *National Excellence: A Case for Developing America's Talent* (Washington, DC: U.S. Department of Education, Office of Educational Research and Improvement, October 1993), p. 3.

Maggie, age 8, is clearly aiming to be an artist in the future, as we see in her colorful work, "My Dream Is Being an Artist." Some children, with their intense interests and preoccupation with drawing and other art activities, virtually select themselves as talented students.

fit from special programs for the gifted and talented are usually developed on the local level in response to local needs and resources.

Characteristics of Gifted Children

Several authorities have made the study of artistically gifted children a special concern. One of the earliest efforts to characterize the special capacity for art was made by Norman Meier, a psychologist whose interest in the subject led him to design tests to assess the degree and kind of artistic talent among children. Meier claimed that gifted children derive their artistic ability from superior manual skill, en-

This drawing represents the general level of drawing performance in one sixth-grade class in Taiwan. Because of the consistently high level of the students in this class, one speculates about the relation of talent to instruction. The teacher, who has been selected to give drawing workshops to other teachers, has, it would appear, developed a "system" of instruction that is considered effective in his country. Two questions come to mind in studying the drawings: "How would American children responc to what appears to be such a rigorous approach to drawing?" and "What effect, if any, has the method had on the students' sense of individuality?"

ergy, aesthetic intelligence, perceptual facility, and creative imagination. The lists of characteristics of gifted children vary from one writer to another. Using points on which there is greatest consensus, we might construct a profile of a gifted child as follows: A child gifted in art observes acutely and has a vivid memory, is adept at handling problems requiring imagination, and although open to new experiences, prefers to delve deeply into a limited area. The child takes art seriously and derives great personal satisfaction from the work, is persistent, and spends much time making and learning about art. Indeed, the gifted child may sometimes be obsessive or compulsive about artwork, neglecting other areas of study for it.

As special programs for artistically gifted children have grown in number in both schools and museums, teachers have come to realize that many traits of creative behavior are shared by average or nonartistic as well as gifted children. Attitudes toward art, such as self-direction and commitment, merit attention and are best noted through observation. The following list of characteristics, both general and artistic, has been divided into categories of behavior relevant to artistic talent.⁴

GENERAL CHARACTERISTICS

Precocity Children who are gifted in art usually begin at an early age—in many cases, before starting school and often as early as age 3. A classic example is the highly gifted Chinese child Wang Yani, who at age 4 was able to draw and paint monkeys in scenes and narratives that were much out of the ordinary.⁵

Focus on drawing Giftedness first evinces itself through drawing and, for the most part, will remain in this realm until the child tries other forms of expression or becomes bored with drawing. Drawing dominates not only because it is accessible but also because it fulfills the need for rendering detail.

Rapidity of development All children progress through certain stages of visual graphic development. The gifted child may traverse such stages at an accelerated pace, often condensing a year's progress into months or weeks.

Extended concentration Visually gifted children stay with an artistic problem longer than other children, because they both derive greater pleasure from it and see more possibilities in it.

Self-directedness Gifted children are highly selfmotivated and have the drive to work on their own. They have a strong urge to learn as much and as quickly as possible.

Possible inconsistency with creative behavior The behavior of the artistically gifted is not necessarily consistent with characteristics usually associated with creativity; in many cases the opposite may be true. The success won through long hours of practice is not easily relinquished in favor of journeys into the unknown. Young people's reluctance to appear ridiculous or lose face before their peers tends to instill attitudes of extreme caution when confronting new problems.

Art as an escape Gifted children may use art as a retreat from responsibility and spend more than a normal amount of time drawing. This is often accompanied by the kind of fantasizing reflected in the artwork. No talent, however impressive, is beneficial when used as an escape from other realities, and precocity in and of itself should not absolve a child from fulfilling the same responsibilities required of others.

ART-CENTERED CHARACTERISTICS

Verisimilitude, being true to life Although most children develop the desire to depict people and other subjects from their environment in the upper elementary years, gifted children develop both the skills and the inclination at an earlier age.

Visual fluency Perhaps the most significant of all, this characteristic is most similar to that of the trained artist. Visually fluent children may have more ideas than they have time to depict. Asked to draw a still life, they will include details missed by others; given a story to illustrate, they present many episodes rather than just one. They draw as spontaneously as most

Visual fluency is a marked characteristic of Vladimir, the 9-year-old Russian émigré who made this drawing. As a caricature, this work shows humor without relying upon the context of cartoons. For this child, drawing is a means to an end rather than an end in itself. Like most gifted students, Vladimir has his own way of looking at the world.

people talk, because through drawing they maintain a dialogue with the world.

Complexity and elaboration In their drawings, most children create "schemata" that are adequate to their needs; the gifted child goes beyond these and elaborates on them, sometimes as an adjunct of storytelling or fantasizing and sometimes for the sheer fun of adding details of clothes, body parts, or objects related to the schema. Wholes are related to parts as powers of recollection are tested and transformed into a growing repertoire of images.

Sensitivity to art media Because one of the characteristics of giftedness is the ability to immerse oneself in an art activity, it is logical to assume that through hours of practice the child will master any media of particular interest. Whereas most fourth graders are content to use a color straight out of the jar or tube, a gifted child may become quickly bored with packaged color and combine several colors to achieve desired effects. A child may be instinctively sensitive to what a particular medium can do or may consciously try to attain mastery through practice. Older children (ages 10 to 12) are more apt to do this than are younger ones.

Random improvisation Gifted children often doodle—they improvise with lines, shapes, and patterns; seem conscious of negative areas or spaces between the lines; and are absorbed with the effects of lines. They transfer this interest to subjects such as the human face; like cartoonists, they experiment with the influence of minute changes on facial expression, noting the differences that the slightest shift in the direction of a line can make.

Some psychologists, such as Howard Gardner, believe that educators have accepted a limited view of intelligence that neglects the importance of other mental capacities. Gardner's theory of multiple intelligences includes "logical," "mathematical," and "language" as traits (from which most conventional ideas of intelligence are drawn) but also includes "musical" and "personal" abilities.⁶ "Spatial" intelligence relates to artistic ability. When a teacher engages in a discussion of aesthetics or asks a child to write or talk about art, the child not only extends the subject matter of art but also exercises other modes of intelligence. Artistic or spatial intelligence can also be distributed or divided into categories that draw on other modes mentioned by Gardner (see Chapter 1). Although certain kinds of intelligence are genetic or inherited, all can be strengthened if the desire for improvement is sufficiently strong.

Case History of Two Students

Strong indications of the nature of talent may sometimes be found in case histories of artistically gifted people, but it is often difficult to unearth actual evidence of their early work. A child's art is usually lost, and both parents and teachers are generally unable to recall accurately the child's early behavior. For some cases, however, reasonably detailed and apparently accurate data exist.

Among these cases are the histories of two girls of the same age from upper-middle-class homes. Susan and Mary. These girls showed promise of talent in art very early in their lives. A study of their work shows that both of them began drawing just before they were 1 year old and that they had passed beyond the stage of manipulation before their second birthdays. Around 15 months Susan was naming the marks she was producing in crayons. Mary did the same when she was 16 months old. Around this age Mary began to use some spoken words clearly, but Susan was slower to learn to speak and instead was producing sounds such as "rrr," which consistently stood for "automobile," and "goong" for "duck." When she depicted such objects in her paintings by the use of symbols, she named them in this vocabulary. When 25 months old, Susan produced an attractive montage with sticky tape and colored paper. Around 27 months of age, both girls could delineate many symbols and give them some relationship in the same composition.

Both children led normal, active lives, and during warm weather neglected their art for outdoor games. A study of their work (which their parents carefully dated) reveals, however, that inactivity in art did not seem to interfere with their continuous development. By the time both children were 3 years old, they were overlapping objects in their drawings and paintings, and at 4 Mary seemed to recognize texture as an expressive element of design. By 6, they were skilled in a variety of techniques—mixing colors, devising textural effects, and inventing outstanding compositions. Before she was 7, Mary even gave hints of linear perspective in her work. It is important to note that both girls attended elementary schools that apparently provided progressive and highly regarded art programs. By the time Susan was 10 years old and Mary 10 years and 8 months, their work had lost most of its childlike qualities. Each girl passed through a realistic stage in which objects were rendered rather photographically. Then Susan's work became distinctly mannered in its rhythms, and Mary's output became reminiscent of that of several artists. In quick succession, she went through an Aubrey Beardsley period, followed by one reflecting the influence of Degas and, later, Matisse. When they were 12 years old, the girls met and became friends. They attended the same art classes in high school and produced paintings in a style obviously derived from that of the impressionists.

Fortunately, their secondary school art program proved almost as effective as that of the elementary school. After a time their work became noticeably more personal. Eventually, both girls attended special classes for children with artistic talent, where they remained for four years and where they produced paintings and sculpture in forms that continued to be recognizably personal. Both girls went on to attend ε college of art where, according to their teachers, they gave evidence of outstanding artistic ability.

This drawing of a picnic scene in the park, by Cameron, demonstrates an unusual command of perspective, with conventions of diminishing size, fluency of imagery, and accurate use of overlap, combined for creation of a believable three-dimensional representation. The artist obviously enjoys the activities he has depicted.

There seems to be little doubt that Mary and Susan were talented. What characteristics common to both might identify them as such? First, they expressed an almost lifelong preoccupation with art. Although their interest in art was at times intermittent, their production of art forms was for the most part uninterrupted. Second, both girls came from homes in which the parents enjoyed artistic interests. Both environment and biological inheritance often contribute to talent. Children of musical or artistic parents have the double advantage of both "nature" and "nurture" often denied the children of parents who lack these interests and abilities.⁷

Third, the progress of Mary and Susan throughout the phases of their childlike expression was both richer and more rapid than normal. Although both girls developed skills that were obviously above average in handling tools and materials, neither allowed her skills to assume paramount importance in her output. Again, at one period the girls' artwork apparently was dominated by technique, and the work of other artists whom they admired strongly influenced their output. Fortunately, however, their insight

The class cartoonist may have more wit, inventiveness, and persistence than the "serious" artist. The 10-yearold boy who made this drawing had been interested in cartoons since the age of 6. His drawing shows a keen observation of people, places, and events. These abilities have since been extended into his work as a professional artist.

into artistic processes and their personal integrity, intellectual vigor, and vision were sufficient to overcome these powerful influences, which can be very seductive to the gifted young person who seeks a satisfying means of artistic expression.

Artists Examining Their Past

Another form of case history may be gathered from listening to the earliest memories of adult artists. When asked to reflect on their earliest artistic experiences, artists seem to have remarkable powers of recall. Much of what they describe, however, may on first reading appear to have little to do with conventional views of art.

Milton Glaser, a top graphic designer, is precise about an incident that occurred at the age of 5.

I have a precise picture of the moment I wanted to become an artist . . . it happened when I was five and my cousin, who probably was ten or fifteen years older than I was, came into the house with a brown paper bag, and he said, "Do you want to see a pigeon?" I thought he had a pigeon in the bag and said, "Yes." He took a pencil out of his pocket, and he drew a pigeon on the side of a bag. Two things occurred. One was the expectation of seeing somebody draw a pigeon; and two, it was the first time I had actually observed someone make a drawing that looked like the actual object—as opposed to my own rudimentary drawing. I was literally struck speechless. It seemed a miraculous occurrence, the creation of life, and I have never recovered from that experience.⁸

The noted artist Judy Chicago has recollections that begin even earlier, at age 3, and like many success stories, they begin with the sympathy and support of a parent—in this case, her mother.

When I was three, I began drawing, and my mother, who had wanted to be a dancer, gave me a lot of encouragement. . . . Throughout my childhood, she told me colorful tales about the creative life, particularly when I was sick in bed, and these stories contributed to my developing interest in art, for, from the time I was young, I wanted to be an artist. My father, on the other hand, could never relate to my artistic impulse, so it was to my mother that I brought my artistic achievements and to my father that I brought my intellectual ones.⁹

As the following excerpt reveals, Louise Nevelson knew she wanted to be not only an artist but also a particular kind of artist, a sculptor. I claim for myself I was born this way. From earliest childhood I knew I was going to be an artist. I *fe!t* like an artist. You feel it, just like you feel you're a singer if you have a voice. So I have that blessing, and there was never a time that I questioned it or doubted it. . . . The librarian asked me what I was going to be, and of course I said, "I'm going to be an artist." "No," I added, "I want to be a sculptor, I don't want color to help me." I got so frightened, I ran home crying. How did I know that when I never thought of it before in my life?¹⁰

Were one to generalize about major influences on artistic talent, one might conclude from the sources just cited that the role played by parents, literature (storytelling), and exposure to models of artistic behavior all contribute to the advancement of the creative lives of gifted children.

Many artists have other memories in common—parents who were ignorant of art yet sympathetic to their children's interests; an impulse to copy; and an affinity for realism. First experiences with museums are largely positive, and as with many writers and actors, artists' childhoods were particularly rich in fantasy, daydreams, and love of and pursuit of stories. Faith Ringgold is particularly eloquent in this regard when recalling her childhood in her video *Faith Ringgold: The Last Story Quilt.*¹¹

IDENTIFYING TALENTED CHILDREN

The teacher who suspects a child of possessing unusual artistic talent might be wise to enlist the opinions of others, including artists and art teachers. Opinions of such wellinformed people, furthermore, might be sought over a relatively long period. A sudden appearance of talent may later prove to be merely a remarkable but temporary demonstration of skill. Again, what appears to be artistic talent in early years may disappear as the child develops other interests into which energies and abilities are channeled.

When teachers want information on a particular aspect of talent, they can devise certain tasks to reveal specific skills. Characteristics to be studied in the area of art could include observational ability, color sensitivity, ability to fuse drawing and imagination, emotional expressiveness, memory, handling of space, and sensitivity to media.

Teachers might also notice the interests children have for looking at art, especially original art in galleries and museums, and for reading about art and artists. They might note children who, when encouraged, seem to be adept at discussing works of art, making interesting interpretations of meaning, relating to other artworks, and generally appearing comfortable in the presence of art and talk about art. All children today are very aware of the visual culture that surrounds them on a daily basis. Some children are particularly interested in visual culture in the forms of superherces, characters from comics and popular books, and prominent topics from advertising.

In some special art classes offered to children, a major criterion for admission is commitment to art rather than talent as such. These special classes demonstrate that skill does indeed improve in many instances, once children work in an environment of peers who share their enthusiasm. The classes are specifically designed for those whose hunger for art is simply not satisfied by the amount of activity the normal school could allow. In other words, it is possible to hunger for art without the ability to produce artwork of outstanding quality.

Danny, age 8, demonstrates his wit and humor in this elaborate underwater excursion into the "Sea of Puns." We need to ask how many children of this age understand the concept "pun," to say nothing of being able to translate the literary form into visual form. This boy's fluency and ability to improvise are exceptional for his age.

This drawing by Will, who is 6 years old, shows an advance in execution through the handling of proportion, the use of the profile, and the variety of shapes used in portraying the subject. Such spatial awareness is often overlooked in favor of the subject of the drawing.

SPECIAL ARRANGEMENTS IN ART FOR GIFTED CHILDREN

When gifted children have been identified, a problem arises concerning suitable educational treatment for them. An "enriched" program may be offered by the classroom teacher or art consultant, whereby the pupil is assigned advanced work, given special materials, and allowed to take time from other obligations to work in art. The danger here is that the classroom teacher might not be equipped to provide special help or that excusing the child from nonart activities to work in art might arouse adverse reactions from the rest of the class. We also must bear in mind the negative attitudes many teachers exhibit toward children who are particularly nonconformist in their creative behavior.

Another arrangement for helping the gifted is the "special class," in which only talented children are enrolled. Such classes may be offered during school hours, after school, or on Saturday mornings. Teachers should possess capabilities in special artistic fields. A sympathetic teacher of general education may help a gifted child in art, but a specialist can provide even more assistance. In the special classes the need to provide for individual differences will be even more apparent.

Whatever special arrangements are made for the child with artistic talent, two considerations of paramount importance to the child's future development must be kept in mind. On no account should the child's natural artistic development be unduly hastened into adult forms of expression. In the elementary school, the talented youngster is still a youngster, and artistic growth must occur with due respect for this fact. Even so, every talented child must be provided with sufficient challenge to work to capacity. Unless this condition prevails, the gifted pupil may lose interest in the work, and considerable energies and abilities may be dissipated in less worthwhile ways.

Under what circumstances will talent flourish? First, parents should, at best, encourage an interest in art and, at worst, not discourage it. A sympathetic home environment is extremely stimulating. The home that provides art supplies, art books, and a place to work, together with loving and intelligent parents to admire the work being produced and to discuss and encourage further production, will aid substantially in fostering talent. Next, the schools that the gifted pupil attends should provide a sufficiently stimulating and challenging art program. Finally, somewhere along

"Mean Marvin's Malicious Machine" is an imaginative vehicle driven by a character created from the imagination of Jaimes, a 10-year-old boy.

the line of artistic progress, the gifted pupil should have the opportunity to encounter a supportive teacher who is sensitive to any capabilities that set the gifted child apart from other pupils. Teachers and administrators might ask themselves some of the following questions when identifying and planning for gifted children:

- Have I notified the parents that their child has special talents that deserve support?
- Have I investigated any sources of additional help from the community, such as special classes in museums?
- In dealing with gifted children, am I being overly solicitous—giving more attention than needed?
- Am I adding an appreciative or critical dimension to the activities by showing and discussing artworks related to studio activities?
- Do I have rapport with the children? Do they respect my opinions?
- Has their ability in self-appraisal improved?
- Do I know how to deal with and interpret negative attitudes sometimes displayed by gifted children?
- Am I an effective model for a gifted child? How does my behavior reflect my own love of art?

The word *talent* is a general term covering four levels of ability. There are those with an aptitude for art; those of minimal talent who nevertheless enjoy making art; those whose attitudes and skills set them above their classmates; and those who combine skill, intellect, imagination, and drive on a high level. It is especially important that the teacher has credibility with these students, particularly in the upper grades.

SUGGESTED ART ACTIVITIES

Many gifted children, especially on the higher levels, will have intense personal interests that change over time. A fourth-grade girl may be deeply immersed in personal adaptations of a manga or Japanese novel in comic-book format, then shift to an interest in drawing animals. In such cases, the teacher has certain decisions to make. Shall the student be encouraged to move on to unexplored territory? Shall the teacher enter the world of the student and educate herself or himself in a student's temporary obsession? Can the teacher show the student examples of artists whose work parallels the child's interests and at the same time suggest other directions that can be explored? It is unwise to offer the gifted a curriculum oriented exclusively toward media. The talented child can be challenged by ideas as well as by materials in special classes. Moreover, students should have opportunities to work in one area in depth. A conceptual approach to art activities begins with an idea and then asks the child to use materials as a means of solving a problem. The problem may be stated as follows: "One characteristic of humans is that they design their environment for pleasure and for aesthetic purposes, as well as for function and utility. In creating your own environment, take into consideration purpose.

These two drawings are small segments from a team drawing by two brothers, ages 5 and 7. The complete work has literally dozens of situations and fragments of stories. The sheer number of ideas rather than evidence of conventional drawing skills reflects a high level of fluency. The whole drawing is $18'' \times 24''$ on cardboard and includes hundreds of figures, buildings, imaginary animals, and so on.

scale, and materials." Stating the problem in this manner opens up a number of choices for the student and encourages decision making different from what results when the child is told, "On the table you will find cardboard, pins, knives, and rulers. These are the materials to be used in making a scale model of a vacation home."

The teacher of the special class or the art consultant

Winslow Homer, *Beetle n'Wedge*. Eminent American artist Winslow Homer made this drawing at age 11. Note the four structural studies at the bottom of the page, a member of the Wyeth family among them.

teaching in an after-school program should take an inventory of art activities offered prior to the special class in order to better plan the new program. Thus, a child who is interested in sculpture but has worked only in clay might try a large-scale plaster or wood carving. A problem could be posed from the perspective of illustration: "What do you think this villain looks like? Can you draw or paint him?" Or of graphic design: "What is the best image to use to identify this new fuel-efficient car? How would you communicate this to your audience?" These activities extend the range of the child's experience and compensate for the relatively limited exposure to art in the regular school program.

The Child's Agenda

Highly gifted students have their own agenda, which often reflects a repetition of past successes. When a child has been praised by teachers and peers for the ability to draw in a realistic fashion, why should the student relinquish flattering responses for new and unknown realms of expression? When it comes to openness to new experience, such children may not be as promising as classmates with lesser abilities. A difficult, but necessary, task of the teacher is to make a new material, process, or idea so challenging that the student will be willing to suspend the results that have earned him or her acclaim.

Gifted children are particularly curious about the lives and works of exemplary artists. Children interested in making a wood or clay sculpture, for example, should have access to books, videos, or slides that show how different artists approach this process. They could learn how some artists make preparatory sketches of their ideas for a sculpture, selecting the most promising idea and then assembling the materials needed to carry out the idea. They could learn that other artists make sketches, usually in small scale. from the same materials used for the final sculpture. Gifted boys and girls should learn that women as well as men create sculpture. They should become familiar with sculptural pieces from their own country and time, done by living artists, as well as with the heritage of sculpture from other times and places. They should learn that sculpture can be representational or abstract or nonobjective, depending on the expressive purposes of artists. Gifted children should have experiences that help them understand that artists make sculptures that express meaning and feeling, and they should gain skills in reading meaning from art.

General Activities

Gifted children may demonstrate a number of peculiarities in their selection of art activities. Their interests in such basic types of artwork as cartooning, portraiture, and sculpture develop early, and they appear to find greater challenge and deeper satisfaction in these than they do in some of the crafts, such as weaving a paper construction. Although they may occasionally turn to crafts for their novelty, they generally return with renewed interest to what might be described as the more traditional art forms, possibly because these afford an cpportunity to display the children's special brand of precocity.

Gifted children usually prefer to work at art by themselves rather than to participate in group endeavors. Although as a group the gifted are socially inclined, they seem to recognize in art a subject that demands sustained individual deliberation and effort. They are not entirely averse to participating in art forms requiring collaboration with others, but most are happiest when submerged as individuals in their own artistic agenda.

Painting in Oils and Acrylics

Painting in oils is a good example of a special activity suitable for the gifted. It offers the student an effective means of identifying with "real artists." The oils are rich and sensual in color and are far more versatile than most waterbased paints. The slow-drying quality of oil paint makes it suitable for art projects undertaken over a period of time. By the time they reach preadolescence, gifted children should have had an opportunity to work with oil paint. However, not even the most gifted children can use it effectively until they have had experience with many other types of paint.

Acrylic paints should also be available because they are less expensive than oil paints and have fast-drying characteristics, forcing students to work faster. Both oils and acrylics have excellent characteristics for permanence. Both media are examples of materials that might require special fees. (See Appendix D for possible health hazards involving solvents.)

Other Media for Drawing and Painting

Gifted pupils in the preadolescent stage will find several other challenging media that may not be available in the regular art program. Work with felt pens and pointed brushes can be explored. Charcoal pastels and Conté crayon in black and brown can also be used fairly extensively, either in quick sketching or in more deliberate drawing. Some of this line drawing may lead to more advanced graphic processes, such as serigraphy, lithography, and monctypes.

Some gifted children become proficient in the use of watercolor. In the opinion of many painters, transparent watercolor is one of the most subtle and difficult of media. It must be used with precision and speed, and its "wetness,"

This painting was created by Brittany, age 12, following her study of Japanese samurai. She learned that her family's genealogy goes back to the samurai, and she included her family crest, a peach blossom, on one of the flags in the picture.

or watery character, should be reflected in the finished work. Good watercolor paints, brushes, and especially papers are relatively expensive. The pigments in tubes are more convenient to use than those in cake form. When gifted pupils begin to paint seriously in watercolors, they should be provided with materials of a higher quality than is usually found in the school art program. The many

Unlike many gifted children, 7-year-old Manya, a Russian child, is interested less in realistic depiction than in seeing where her doodles will lead. Her sense of whimsy and her love of improvisation set her efforts apart from those of most of her peers.

acrylic paints on the market offer colors as intense as those of oils, as well as quick-drying properties.

In the contemporary educational climate, with technical innovations becoming increasingly available, it would be a mistake to ignore the creative possibilities of the computer. Many children in today's schools started using computers in preschool. With graphics, painting, and animation programs available in computer software, it is not uncommon for elementary-school children to make art on the computer. Gifted and talented children can benefit immensely through their access to computers, both as a research tool on the World Wide Web and as a medium for creating their own art.

Regardless of the medium, the emphasis should be on the nature of the art problem (more challenging), on the instruction (more specific, where needed), and on the creation of additional time, preferably with a group of their peers. Teachers should require more of gifted children, set higher standards of work, and be more directive when the occasion demands it. Instruction, therefore, differs as much in intensity as in kind.

TEACHING GIFTED CHILDREN

Young gifted children will, of course, make use of the usual materials and perform the basic activities mentioned in earlier chapters in connection with the general art program for all children. Because the gifted may be recognized only over a period of time, they must obviously take part in the art program designed for all until their talent is noted. When it is clear that individuals possess gifts above the ordinary, the teacher should help them progress at their optimum level of accomplishment. Progress in art occurs when the worker keeps producing art. Mere quantity of production or repetition of forms previously created is not progress, but production that leads to improved skill, more penetrating insight, and greater mastery of media can help develop a child's talent.

The principle of teaching in response to the needs of the learner is emphasized throughout this book. The preceding chapter observed that in order to profit from art at all, some slow learners need to follow a step-by-step method of instruction. With the gifted, the reverse is necessary. Here the teacher is faced with the necessity for what might be described as "underteaching." Every attempt must be made to challenge the greater abilities of gifted children. Whenever they can learn a fact or a technique for themselves, they should be encouraged to do so. Assistance must in general be withheld until the children have explored their own avenues for solutions to their problems. Gifted pupils who are given this type of educational treatment thrive on it, and so does their art.

Although artistically gifted children are normally motivated to express themselves with drawing and painting media, they should always have access to authentic works of art in the media of their choice or, failing the actual works, good reproductions of them. The teacher should suggest certain outstanding works for them to study at art galleries and museums. Talented children can be assumed to be capable of extending their passion for creating works of art to the appreciation or criticism of art. *Works of art and visual culture should be discussed—both for their own sake and for the problems they pose within cultural contexts.*

The teacher will have to make special efforts with gifted pupils from underprivileged homes to encourage

them to see the best art and to read books on art. Gifted children from more affluent homes generally have opportunities to add to their knowledge of art. Underprivileged children enjoy fewer such opportunities. Indeed, their gift must often be an especially vital one. In their case, the teacher's duty is to supply the inspiration and sources of knowledge that their home environment has denied them.

Prominent art educator Karen Carroll has noted:

Art teachers should recognize that gifted education in art, whether it be for the academically or the artistically gifted or both—must be as rich in ideas as it is in studio experiences. Likewise, the experiences should emphasize looking at and responding to works of art as well as creating images and objects. What is clearly apparent from practice is that bright students respond quickly and adeptly to art instruction. On the other hand, those with artistic gifts often need to be challenged to use their image-making abilities to think about and explore the world of ideas which reside in the history of art and in the realm of aesthetics.¹²

NOTES

- 1. In much educational writing *gifted* refers to children with a high general intelligence, and *talented* refers to a special capability in one field of endeavor. This differentiation of meaning is by no means universal and has not been adopted here. In this chapter the words are used interchangeably.
- Pat O'Connell Ross, National Excellence: A Case for Developing America's Talent (Washington, DC: U.S. Department of Education, Office of Educational Research and Improvement, 1993).
- 3. Ibid., p. 3.
- 4. Al Hurwitz, *The Gifted and Talented in Art: A Guide to Program Planning* (Worcester, MA: Davis Publications, 1983).
- J. Andrews, "Wang Yani and Contemporary Chinese Painting," in *Yani the Brush of Innocence*, ed. H. W. Ching (New York: Hudson Hills Press, 1989).
- 6. Howard Gardner, *Multiple Intelligences: The Theory in Practice* (New York: Basic Books, 1993).
- 7. Because each girl had highly educated parents who are

especially interested in art, records of their art were preserved. The parents systematically filed the children's work after writing comments about each piece on its reverse side. Both children eventually enrolled in classes for gifted children, at which time the parents disclosed the girls' records. The girls' IQ scores were 120 (Mary) and 130 (Susan).

- 8. Milton Glaser, "Artists on Art," *SchoolArts*, May 1993, p. 60.
- 9. Judy Chicago, *Through the Flower: My Struggle as a Womar Artist* (New York: Doubleday, 1993), pp. 3–4.
- 10. Louise Nevelson, *Dawns and Dusks* (New York: Scribner, 1976), pp. 1, 14.
- 11. Faith Ringgold: The Last Story Quilt, videocassette, prod. Linda Freeman (Chappaqua, NY: L & S Video, 1992), 28 min.
- 12. Karen Lee Carroll, *Towards a Fuller Conception of Gifted ness: Art in Gifted Education and the Gifted in Art Education* (Ph.D. diss., Teachers College, Columbia University, 1987).

ACTIVITIES FOR THE READER

- 1. Make a collection of drawings and paintings by artistically gifted children. Analyze works for subject matter, design, and technique. Compare this collection with works of normal children of the same chronological ages as those in the gifted group.
- 2. Study the home environment of several artistically gifted pupils. Describe the environment in cultural and economic terms.
- 3. Contact several artists, and request that they lend you a drawing from their school days, if one still exists. Ask several artists to recount their earliest recollections of interest in art.

- 4. Compare the entrance requirements of at least two public school programs for gifted and talented children.
- 5. If it were possible to identify levels of giftedness by studying only a portfolio of student work, would you be able to distinguish among characteristics such as talent, attitude, and influences from the school program?
- 6. A fairly significant percentage of college students have been involved in gifted and talented programs during their K–12 education. Interview your classmates and friends who have had this experience, and ask them to describe and evaluate the programs in which they were enrolled.

SUGGESTED READINGS

- Bean, Frances A., and Suzanne M. Karnes, ed. *Methods and Materials for Teaching the Gifted*. 2d ed. Austin, TX: Prufrock Press, 2005.
- Callahan, Carolyn M., and Jay A. McIntire. *Identifying Outstanding Talent in American Indian and Alaska Native Students*. Washington, DC: U.S. Department of Education, Office of Educational Research and Improvement, Javits Gifted and Talented Education Program, 1994.
- Clark, Gilbert, and Enid Zimmerman. *Resources for Educating Artistically Talented Students*. Syracuse, NY: Syracuse University Press, 1987.
 - ------. *Teaching Talented Art Students*. New York: Teachers College Press, 2004.
- Cline, S., and D. Schwartz. *Diverse Populations of Gifted Children: Meeting Their Needs in the Regular Classroom and Beyond*. Upper Saddle River, NJ: Merrill, 1999.
- Gardner, Howard. Intelligence Reframed: Multiple Intelligences for the 21st Century. New York: Basic Books, 2000.

- Golomb, Claire. The Development of Artistically Gifted Children: Selected Case Studies. Hillsdale, NJ: Lawrence Erlbaum Associates, 1995.
- Hurwitz, Al. *The Gifted and Talented in Art.* Worcester, MA: Davis Publications, 1983.
- Kay, Sandra. "Recognizing and Developing Early Talent in the Visual Arts." In *Early Gifts*, ed. Paula Olszewski-Kubillus. Austin, TX: Prufrock Press, 2003.
- Porath, Marion. "A Developmental Model of Artistic Giftedness in Middle Childhood." *Journal for the Education of the Gifted* 20, no. 3 (1997): 201–23.
- Zimmerman, Enid, and David Pariser. "Learning in the Visual Arts: Characteristics of Gifted and Talented Individuals." In *Handbook of Research and Policy in Art Education*, ed. Elliot Eisner and Michael Day, pp. 379– 405. Mahwah, NJ: Lawrence Erlbaum Associates, 2004.

WEB RESOURCES

Council for Exceptional Children (CEC): http://www .cec.sped.org/. The largest professional organization dedicated to educating individuals with special needs, including students with disabilities and the gifted; website provides diverse resources for gifted education, including advocacy material.

- Hoagies' Gifted Education Page: http://www .hoagiesgifted.org/educators.htm. Offers academic resources, teaching guides, reading lists, online articles, and links to organizations and groups focused on gifted and talented education.
- KidSource OnLine: http://www.kidsource.com/ kidsource/pages/ed.gifted.html. Annotated bibliography and other educational resources for gifted and talented education.
- National Association for Gifted Children (NAGC): http://www.nagc.org/. Provides access to programs, resources, and tools for teachers of gifted and talented children.
- Northwestern University, Center for Talent Development: http://www.ctd.northwestern.edu/index.html. Provides online articles, online courses for teachers, an excellent annotated bibliography, and links to other sites.
- U.S. Department of Education and National Library of Education, Educational Resources Information Center (ERIC): http://www.eric.ed.gov. An online searchable database of articles, curricula, digests, fact sheets, and bibliographies, with a new full-text library featuring journal articles, books, and other resources from across the Internet. Includes pertinent links to organizations and programs that support education for the gifted.

DRAWING

At the Heart of the Studio Experience

When a child scribbles on a sheet of paper or makes crude chalk pictures on the sidewalk, a language is beginning to emerge. Young children draw with enthusiasm and meaningfulness, yet this potential language resource is almost universally overlooked in homes and schools.

—Bob Steele, Draw Me a Story

Drawing is probably the most pervasive of all art activities engaged in by children. Through drawing, children participate in the exploration of media, the creation of symbols, the development of narrative themes, and the solving of visual problems. The emphasis in contemporary art education is on the expressive aspects of both responsive and creative experience, with support and instruction by the teacher appropriate for the levels of development of the children.

Children produce drawings and paintings that say something about their reactions to experience and heighten their abilities to observe. Drawing activity is also a precursor to the development of writing skills. The correlation between drawing and lettering is particularly effective in Asian countries such as China and Japan, where practice in calligraphy enlivens the quality of line. Certainly, when taught effectively, drawing and painting activities are universally enjoyed and provide a very flexible and practical means of expression for the young at all stages of artistic development.

This chapter describes tools and materials for drawing and comments on its use at various developmental levels. We also refer to certain problems related to the teaching of drawing, such as dealing with spatial relationships; producing figure, landscape, portrait, and still-life compositions; using mixed media; and exploring the role of memory, experience, and imagination through drawing. Included in our discussions are comments that refer to the historical, critical, and cultural dimensions of art.

Japanese children draw large natural forms in the sand. The beach is a wonderful location for art making.

The chief purposes in encouraging preschool children to draw and paint are to allow them to become familiar

with the materials associated with picture making and to help them develop their own ideas more readily. As previously noted in the chapter on artistic development, children draw and paint for many reasons, and these reasons change as children grow and mature. From the manipulation of materials to the creation of symbols to an emerging interest in aesthetic qualities and meaning in works of art, children make and respond to art in dynamic ways. Very young children may require little or no external motivation to engage in art activities, but as they grow older and become more aware of their capacities and more critical of their abilities, children can benefit increasingly from the guidance of a knowledgeable and sensitive instructor. This chapter provides numerous suggestions to help teachers foster artistic growth in their students.

There are three major categories of drawing: the purely spontaneous work of preschoolers, drawings that are "tutored" once the child enters the influence of school, and independently executed drawings that are heavily influenced by the student's culture and peers.

Good teachers attempt to advance the student, at the same time working from sources relevant to the student. Questionable teaching practice includes making too many decisions for the student and stating conditions for art making with little sensitivity to the student's interests.

THE MANIPULATIVE STAGE (AGES 2-5)

Media and Techniques

In selecting media for children who are in the manipulative stage (grades 1 and 2), the teacher must keep in mind the children's working methods and their natural inclination to work quickly and spontaneously. For beginners, soft chalk and charcoal are dusty and tend to smear and break too easily. These media are more acceptable when the child has progressed well into the symbol-making stage, in about the second grade.¹

Young children who are beginning to draw seem to prefer felt-tip pens, soft lead pencils, and oil-based crayons to other media. The crayons should be firm enough not to break but soft enough for the color to adhere to the paper without undue pressure. Felt-tip pens are especially popular because of their vivid colors and ease of handling. They are available in a variety of sizes, colors, and prices and can be very stimulating for all age groups. Young children will sometimes draw in great detail with fine-point pens and soft pencils and should not be limited to drawing implements with large points.

In general, the size of the point of the drawing implement should be selected for the size of the paper. Small points on large sheets of paper tend to constrict the drawing. All drawings connect to the pivotal areas of the body, from knuckles, to wrists, to elbows, and even to shoulders. Each pivot suggests the thickness of a drawing tool. Probably the most insensitive use of drawing materials is a hard lead pencil on a large $(18'' \times 24'')$ sheet of newsprint paper.

Crayon pastels combine the soft, richly colored qualities of pastels (colored chalks) with the dustless quality of crayons. These are usually more expensive than crayons but are well received as art media by all groups because of the potency of color. Always select safe, nontoxic art materials for use by children.

A wide variety of papers are appropriate for drawing, and a range of sizes and shapes of paper provides interesting alternatives for young artists. Regular $9" \times 12"$ white drawing paper is standard. Manila paper is inexpensive and has sufficient "tooth" for crayon. Newsprint is also suitable, but although it is cheaper than manila paper, its texture is too smooth and it tears easily.

THE SYMBOL-MAKING STAGE (GRADES 1–4)

Media and Techniques

In earlier art sessions, little or no chalk is used, but in the symbol-making stage, with their newly acquired skills, most children will be ready to use soft chalk. "Dustless" chalk, although lacking color potency, leaves less residue on children's clothing. Pressed charcoal in hard sticks is better than the "willow vine" variety, which breaks easily. Chalk and charcoal can be used conveniently on manila and some newsprint papers, which should be large, about $12'' \times 18''$.

Teaching

From primary grades on, drawings and paintings represent subject matter derived directly from the child's experiences in life, as well as imaginative subjects and illustrations for stories, with priority given to the child's interests. Even during these early years, strong influences from visual culture become apparent in students' drawings. Movie and TV characters and situations, as well as topics and figures from current advertising campaigns, find their way into the art expressions of children.

The teacher may from time to time assist the children in recalling the important facts and features of the depicted objects. For example, for children developing symbols for 'man" or "woman," the teacher could draw attention to such activities as running, jumping, climbing, brushing teeth, wearing shoes, combing hair, and washing hands. If the children act out these activities, the concept inherent in the symbol is expressed more completely. These teaching methods, it should be noted, are not suggested for the purpose of producing "realistic" work but rather for helping the children concentrate on an item of experience so their statements concerning it may grow more complete.

THE PREADOLESCENT STAGE (GRADES 4–6)

Preadolescent children are ready to develop specific competencies in drawing and painting activities.² By the time children reach the fourth and fifth grades, they will probaThis imaginative "Family of Aliens" was created by an 8-year-old boy with pen and crayon on heavy cardboard. Subjects taken from the culture of the child need not lead to the use of stereotypes. The subject of aliens from outer space can prove to be a liberating force for the imagination, as shown in this drawing of an alien child and its parents.

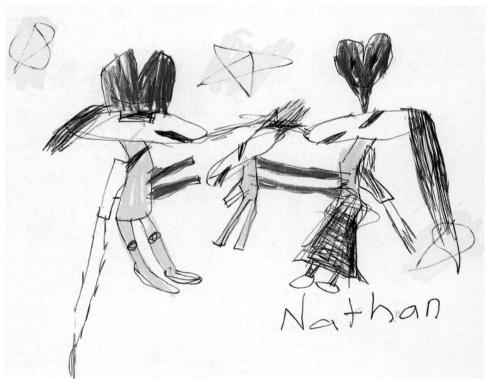

bly have had considerable experience with art media and will have developed many skills in their use. A brush or crayon should now do what the child wants it to do in order to develop an idea. With these developed skills, students can elaborate on ideas that motivate their interests.

Understanding Space

Students in the lower grades accept their handling of space, but sometime around the middle grades, some will become more critical of their efforts. These children are ready for instruction that deals with basic problems of perspective. Following are four conventions of perspective that children can begin to use very early and in which they can gain competency as they grow and progress:

- 1. Overlapping causes one object to appear to be in front of another in space. Draw anything that involves a grouping of objects. You can begin with pieces of fruit or any scene where objects overlap.
- 2. *Diminishing size* of objects gives them the appearance of being farther from the viewer. Draw the same subject as in number 1, making the objects in front larger and the objects that are overlapped smaller.
- 3. If we stand directly in front of a building, the sides will not be visible. When we move to the right or left, the sides begin to appear and the top edges of the *sides* of the building *appear to slope downward*. This is actually a manifestation of diminishing size. Ask students to test this concept at home, in the neighborhood, or at school. A culminating activity for these four principles might be to trace evidence of each directly on a photograph (architectural or home magazines are good sources) or to paint directly on the window of the room if buildings are seen.
- 4. Although *details are less distinct* with distance, do not expect to see this unless great distance is involved. The edges and colors of close subjects, such as the back-yard, are clearer than the mountains on the horizon or the distant view of a city. Have students plan a drawing of overlapping city forms, such as skyscrapers, blurring details with distance to achieve a sense of distance.

Any instruction beyond this point would require a more formal application of the conventions of linear perspective using *horizon lines, vanishing points,* and *guidelines* for constructing the illusion of three dimensions on a twodimensional surface. Students who are ready for this advanced level of instruction and investigation should observe their environment as well as the works of artists who employ the rules of perspective. The suggestions are taken from concepts used in European-based Western art. Different approaches to the handling of space are found in various world cultures.

DEVELOPING SKILLS IN DRAWING FROM OBSERVATION

Many art educators now make a distinction among three categories of activity: *imaginative self-expression, observation,* and *appreciation.* In terms of child development, selfexpression has greater implications for the lower elementary grades, and observation is more relevant to the

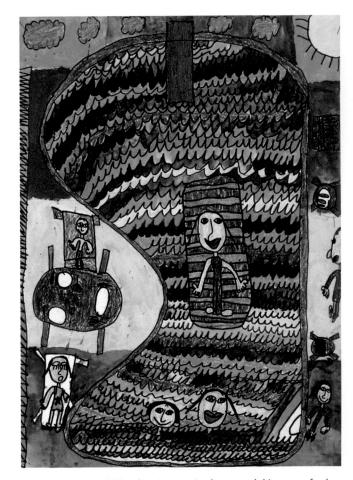

An entire story is told by Christina, age 9, who created this scene of a day at the pool: swimming, sunbathing, cooking, napping, and dining fill the elaborate composition.

capabilities of children in the upper elementary grades. Directed perception satisfies a strong desire among older children to depict subject matter.³

Good drawing occurs when artists select, interpret, and present in a composition those items of experience that move them, regardless of whether or not the presentation is realistic. Weak drawing occurs when the forms used are drawn merely to fill gaps in the pictorial surface with scribbles and stereotypes.

There is little merit in encouraging children of any age to draw with photographic accuracy. But a distinction must be made between requiring children to work for realism in drawing and using certain drawing techniques to heighten their visual acuity. Few teachers who use nature as a model really believe they are forcing their students to conform to photographic realism. This kind of professional skill is impossible to achieve on the elementary level, and there would be very little point to such a goal, even if sufficient time were available.

The question a teacher must inevitably ask is, "What can the child learn from drawing activities?" Drawing activities can fulfill the following goals, even in the limited time school allows:

- 1. To see freshly through close observation
- 2. To exercise imaginative powers
- 3. To develop skills of concentration
- 4. To exercise memory and be able to use recall ability as a basis in drawing
- 5. To provide pleasurable art experiences that allow children to attain a degree of success
- 6. To offer an opportunity to study drawing through works of outstanding professional artists from many cultures
- 7. To provide children with skills that may be employed in other art activities and other subjects, such as science and language arts

SOURCES OF OBSERVATION

Good drawing depends in no small measure on the producer's experience of the things drawn. Such experience depends not only on the eye but also on a total reaction of the artist, involving, ideally, all the senses. Often in the fifth and sixth grades, good drawing may be developed through the use of some time-honored subjects that demand personal reactions to experience. Using familiar sources, the child may produce drawings of the human face and figure,

landscapes, and still-life subjects. According to what subjects, materials, visual references, and motivating forces the teacher selects, drawing can be exciting and pleasurable.

As far as is practical, the children should be responsible for arranging their sources of observation. For example, they should have some control in posing the model for life drawing. The teacher, of course, will have to oversee the lighting and set reasonable time limits for poses. Artificial lighting by one or more spotlights can be used. Models must not be asked to pose for too long (usually 10 minutes is a lifetime). The teacher, of course, should remember the pose in case the pupil forgets it. Chalk marks to indicate the position of the feet often help the model resume the pose after a rest.

In producing life drawings and portraits, older pupils will be assisted by study of both pertinent relationships among parts of the body and approximate sizes of parts of the figure. The pupil who is maturing physiologically often shows an interest in the human body by drawing certain anatomical cetails in a rather pronounced manner. The

107

Taken from three Japanese art guides, these drawings show several stages of development in the contour-line approach to observational drawing. Students were asked to work slowly, press hard with pencil or crayon, look at the subject as long as they could without looking at their drawing, and not erase. teacher should point out the nature of the mechanically independent body blocks—the head, the torso, and the legs.

The human figure lends itself to interpretation. Once the children have closely examined the figure, they could be asked to interpret it in terms of fantasy or qualities of mood—joy, doom, strength, violence. Such subjects can be drawn from observation as well as imagination, for students can be posed displaying these moods.⁴

In still-life work, the pupils should arrange their own groups of objects and also be given the opportunity to become thoroughly familiar with each item. By handling the objects, they may make note of differences in textures and degrees of hardness and softness. Sole dependence on the eye in artwork limits unnecessarily the experience of the creator.

In the selection of still-life material, the teacher also needs to plan a program with the pupils' preferences in mind and to have a challenging variety of objects with contrasting shapes and surfaces, such as the textures found in glass, fur, metal, cloth, and wood. The other elements line, space, light and shade, texture, and color—should be considered for the variety they can bring to a still-life

arrangement. As the objects are assembled, however, they should be brought together into a unified composition.

The inherent interest of the still-life materials is particularly important. Three chairs stacked informally command more attention than a single stool; a saddle and cowboy boots can capture and hold attention more than an apple. A model in full Native American raiment charges the visual imagination in ways that exceeds even the imagery of hip-hop clothing.

Once the objects of the still life have been selected and arranged, the teacher must establish some visual points of reference with which the pupils can work. These might include getting them to use objects that have inherent interest (masks, dolls, toys) and that have simple shapes. The teacher can assist students to improve drawing skills by reminding them of the following points:

- 1. Search for size relationships among various objects.
- 2. Concentrate on the edges of objects (contour drawing).
- 3. Use crayon to indicate shadows.
- Concentrate only on shape by drawing the forms, each on a different-colored paper, cutting them out, and pasting them on neutral-toned paper in overlapping planes.
- Relate the objects to the size and shape of the paper. Students will find they can work on rectangular surfaces (12" × 18"), on squares, and even on circular shapes; they can draw small objects many times their size and reduce large objects to paper size.

In general, landscapes selected for outdoor drawing or for preliminary studies to be finished in the classroom should have a reasonable number of objects in them that can be used as a basis for composition. By having many objects before them, the pupils may select items that they think will make an interesting composition. Children can be sent outside the classroom to bring back sketches of the environment for their classmates to identify.

CONTOUR DRAWING AS A BASIS FOR OBSERVATION

Contour-line drawing, which can be applied to landscape, figures, or objects, is considered by many educators to be a sound basis of perception. *The contour approach requires the children to focus their visual attention on the edges of a form and to note detail and structure; they are thus encouraged to move away from visual clichés to a fresh regard for subjects*

Self-portraits have a strong intrinsic appeal to students. This charming self-portrait was drawn with crayons by a preschool girl who has noticed eyelashes and has a particular interest in depicting them.

One way to instill interest in observational drawing is to create a still life that is rich in color, pattern, and variety of form. Problems of design take care of themselves through the selection of subject. The art teacher in this middle-school classroom loves horses.

they may have lived with but never truly examined. The following teaching session demonstrates how one teacher went about explaining this method of drawing.

TEACHER: . . . I need someone . . . to pose. Michael, how about you? (*Michael is chosen because he is the tallest boy with the tightest pants. He will do very well for the purpose of the lesson. The teacher has him sit above eye level in a chair placed on a table.*) Now listen carefully. First, is there anyone here who is not able to draw a picture of Michael in the air by following the edge of his body with your finger? . . . Then let's try it. (The teacher closes his right eye and slowly follows the outer *edge of the subject in the air. The class follows, feeling fairly certain of success, at least at this stage.*) Very good. That wasn't too bad, was it?

PAUL: But that's not drawing.

TEACHER: Let's wait and see. Now, suppose I had a pane of glass hanging from the ceiling and some white paint. Couldn't you *trace* the lines in Michael's body right on the glass? (*They think about this for a moment.*) After all, it's the next thing to drawing a line in the air, isn't it? ALICE: We don't have any glass.

ALICE: We don't have any glass.

TEACHER: True. I wish we did. But if we did, you could do it, couldn't you? (*All agree they could*.) O.K.—then if you can follow the lines through the glass, you can *see* them. If I ask you to put them on your paper instead, what will your problem be?

ANDY: How can we look at Michael and at our paper at the same time?

TEACHER: Andy is right. We can't do it, so we just won't look at our paper. . . . May I show you what I mean? (*The class heartily approves of this. The teacher goes to the chalkboard.*) Now I'm not going to look at the chalkboard, because I'm more interested in training my eye than in making a pretty picture. I'm going to concentrate just on following the edge. Do you know what the word *concentrate* means? Who knows?

ALICE: To think very hard about something.

TEACHER: Exactly. So I'm going to think very hard—to concentrate-on the outside edges of Michael. We call this contour-line drawing. (He writes it on chalkboard.) Contours are edges of shapes. You don't see lines in nature as a rule. . . . What you see mostly are dark shapes against light shapes, and where they meet, you have lines. Who can see some in this room? (Among those mentioned are where walls meet the ceiling, where books touch one another, and where the dark silhouette of the plants meets the light sky.) Very good; you get the idea. We start with edges-or contours-then. Another example is my arm. (*He puts it up against the chalkboard*.) If I ask you to draw my arm from *memory*, you might come up with something that looks like this (draws several schematic arms—a sausage shape; a stick arm; a segmented form divided into finger, hand, forearm, and upper arm; and so on. The class is visibly amused.) Now, watch this carefully and see what happens when I concentrate on the contour of my arm. (With his right hand he follows the top contour and the underside of his arm. As he removes his arm from the chalkboard, the class is delighted to see a line drawing of the teacher's arm remain on the board.)

VERNON: I used to draw around my fingers that way.

TEACHER: Well, it's kind of hard to trace around every object you'll ever want to draw, and even if you could, would that teach you how to look?

VERNON: But you just did it on the chalkboard.

TEACHER: What was I trying to show you?

- ALICE: You were trying to show what the eye is supposed to do.
- **TEACHER:** Exactly. I showed you what the eye must do *without* a subject to feel. What did the eye show me about my arm? (*The class notes wrinkles, the separation of shirtsleeve and wristwatch and hand.*) I'll bet you didn't

realize there were so many dips and squiggles in just one arm, even without shading—that is, without dark and light. Once a contour drawing is finished, the eye fills in *between* the lines. Now, let me try Michael. (*As he draws, he describes what is happening.*) Now, I'm starting at the top of his head, working down to his toe. I'm going up over the ear, down to the neck, and on to the collar. Now I move away, along the shoulder, and here the line turns down the arm. (*He continues in this manner until the line reaches the foot of the model, then starts the process over again, moving the line down the opposite side of the figure.*)

The discussion points made by the teacher in the dialogue were arrived at after anticipating the kinds of problems children face when attempting contour-line drawing. Their confusion arises in part from the necessity to coordinate eye and hand in analytic drawing skills. Because the contour-line drawing focuses on only one aspect of form that of the edges of the subject—it cannot be expected that the relationship of parts will follow. This problem should be taken up as a second stage in the activity of contour-line drawing. The method described here is recommended for students who suffer from the "I can't draw" syndrome. All students are sincere in their desire to draw; the contour method is an effective way to begin.

DEVELOPING METHODS OF MIXING MEDIA

Children can mix media from an early age, so by the time they reach the higher elementary grades, they may achieve some outstandingly successful results by this means. The use of *resist* techniques, for example, is practical for preadolescents and tends to maintain their interest in their work.

The technique of using resists relies on the fact that waxy media will shed liquid color if the color has been sufficiently thinned with water. A reasonably heavy paper or cardboard having a matte, or nonshiny, surface is required. Crayons or oil pastels are suitable and may be used with watercolor, thinned tempera paint, or colored inks. The last are particularly pleasant to use with this technique. In producing a picture, the pupil first makes a drawing with wax crayon and then lays down a wash of color or colors. To provide accents in the work, the student can use thicker paint or india ink. The ink may be applied with either a pen or a brush or with both tools. In using a scratchboard technique, the pupil scratches away an overall dark coating to expose selected parts of an undersurface. Scratchboard may be either purchased or made by the pupils. The surface of heavy (80 lb) white paper is prepared by covering it with a heavy coat of wax crayons in light colors. A coating of tempera paint or india ink sufficiently thick to cover the wax should then be applied and left to dry. Later, the drawing may be made with a variety of tools, including pen points, pins, scissors, and so on. A careful handling of black, white, and textured areas has highly dramatic effects.

The techniques just described are basic and may be expanded in several ways. For example, white wax crayon may be used in the resist painting, with paint providing color. Another resist technique is to "paint" the design with rubber cement and then float tempera or watercolor over the surface. The next day the cement can be peeled off, revealing broken white areas against the color ground.

Lines in dark ink or tempera work well over collages of colored tissues, and rich effects can be obtained by covering thick tempera paintings with india ink and washing the ink away under a faucet. The danger of mixing media lies in a tendency toward gimmickry, but often the use of combined materials can solve special design problems. We should not consider these techniques as merely child's play. Many reputable artists have used them to produce significant drawings and paintings.

Other forms of mixed media are as follows:

- India ink and watercolor. The child may draw in ink first, then add color or reverse the procedure.
- Watercolor washes over crayon drawings. This is a way of increasing an awareness of "negative space" or background areas.
- Black tempera or india ink over crayon or colored chalk. Here the black paint settles in the uncolored areas. The student can wash away the paint, controlling the amount left on the surface of the colored areas.
- Photocopies of photographs or drawings with addition of inks, markers, watercolors, or other media.
- Color photocopies of collages with a variety of materials. Translations of three-dimensional materials to two dimensions and color are often very satisfactory.

Computer technology has entered into the learning equation for all school subjects, even art. With instruction, students can scan their drawings and import them to a photo program where the drawings can be manipulated in numerous ways. With drawing programs, students can use the computer as a medium.

THE DEVELOPMENT OF PICTORIAL COMPOSITION

Some assistance in pictorial composition must occasionally be offered if the children are to realize their goals of expression. This means that children should be helped toward an understanding of the meaning of design and a feeling for it, largely in connection with their general picture making (see Chapter 11). As they gain experience with the elements of design, children should be praised for any discoveries they make, and any obvious advances may be discussed informally by the class. Works by professional artists, illustrators, and designers should be brought to the attention even of pupils who are still in the early symbol stage. The works of Pablo Picasso, Andrew Wyeth, Helen Frankenthaler, Faith Ringgold, and others may be viewed by children with much pleasure and considerable profit if related to their own acts of expression. Artwork of children's book illustrators can be useful for reference and study, particularly when the literary works are known and liked. The student's everyday experience is filled with examples of visual culture in magazines, on billboards, on television, and in shopping centers. Drawing, design, and composition are found in abundance in these sources and can be the subject of study and learning in art.

Form and Idea

Questions directed at the children are valuable for yielding visual information that can lead to more satisfactory picture making. When this technique is used, the teacher should try to establish the connection between *ideas* and *pictorial form*. This can begin when the children are at an early age by playing a *memory game*. Here the teacher simply draws a large rectangle on the chalkboard and asks someone in the class to draw a subject in the center, say, a turtle. The teacher then draws a second rectangle next to the first and puts the same subject in it. What then follows is a series of questions about the turtle. The children answer the questions by coming up with and adding details to the turtle in the second rectangle. As shapes, ideas, and forms are added, the picture becomes enriched, and the space *around* the turtle is filled as a result of the information acquired. When the picture is finished, the first one looks quite barren by comparison. The questions surrounding the subject might be posed as follows:

- **Q**: Where does a turtle live?
- A: In and around the water.
- Q: How will we know it's water?
- A: Water has waves and fishes.
- **Q**: How will we know there is land next to the water?
- A: There are grass, rocks, and trees.
- **Q**: What does a turtle eat? Wheaties? Canned pineapple? Peanut butter? What does she eat?
- A: She eats insects, bugs.
- A: She car eat her food from a can, too.
- **Q**: Think hard now: Where are there interesting designs on a turtle?
- A: On her shell . . .

Composition is thus approached through the grouping and arranging of forms that give shape to ideas. As each answer provides additional visual information, the picture takes on a life of its own by the relation of *memory* to drawing. The teacher can play this simple game with third graders to provide a way of thinking about picture making. This drawing by a secondgrade child deals with complex problems of space relationships. The child has used several artistic conventions to depict the playground path, fence around the area, and the playground equipment. Several figures are placed in the work by using conventions of perspective, including size reduction and overlap. Above all, the child has been aware of the composition of the picture and was very likely satisfied with the results.

Memory and Drawing

Actors must memorize their lines, musicians their notes, and orchestral conductors a complex array of instrumentation. Writers rely on memory of their own personal histories, dancers display choreographic memory, and artists develop a kind of visual encyclopedia of images and forms they have encountered. Most of us do this casually on the run, so to speak—but the memory of an artist is trained as conscientiously as a pianist practices the scales. It is important that children become aware of the powers of their own memories and gain the insight that memory can give to their own sense of self.⁵ The process of "becoming" is more fulfilling if we retain some sense of continuity with former states of being.

If asked to work in the abstract, children rely on visual judgment, both conscious and intuitive. When asked to

deal with a subject from their own lives, such as a visit to the doctor, they must deal not only with the memory of form but also with its surrounding knowledge. Preschool children are content with graphic symbols, but older children are often frustrated by their inability to capture memory and match it with form as they know it. To be able to recall the shape of a tractor and to describe it is one thing, but to find the right lines and shapes to depict it does not come as easily. Here are suggestions to help children develop memory abilities.

1. Divide the class into pairs, and have the children study their partners closely for two minutes. Everyone then turns around and makes some change or adjustment in clothing, hair, facial expression, and so on. Turning back to each other, the partners are asked to note the changes.

Two examples of art based upon internal sources of the child. (1) Madeline, a 10-yearold girl, visited an elaborate public garden that featured a carousel with horses covered with vines and flowers. (2) Amanda, age 9, followed her interest in family and friends by drawing dog and cat families, including pictures of friends on the wall. She had no real pets in her home.

- 2. Have each child in the class draw a scene from his or her neighborhood to send to a class in a foreign country. Remind the children that those receiving the collection may not read English and that art, as a universal language, will have to tell the story of life in their country.
- 3. Prepare a still life of contrasting shapes, and have the class draw it from observation, putting in as many details as they can. Take the still life away, and ask the children to draw it from memory. Check these drawings against the original. What was not included?
- 4. Take the class outside to study a tree or house. Discuss the characteristics that make the object special. Return to the classroom, and draw the object from memory.
- 5. Have the children close their eyes. Describe a scene with which the class is familiar. Be precise with large things such as buildings and streets, and do not worry about details. Ask the children to build up the picture in their minds as it is described and then to draw it or paint it.
- 6. Show a slide of a painting—one with a strong composition that is not too complex. Let the class study it for three minutes, then turn on the lights, and ask them to draw it. Do this several times with pictures of increasing complexity of design.
- 7. Ask the children to pretend they are on the back of a giant bird that will fly them to school. How many street corners, stores, streets, and the like will they see from the air? Have them draw a diagram of the aerial view just as they would walk it.
- 8. To demonstrate how conscious a process memorization can be, have the children draw the entrance to their house, extending the doorway and its surround-

The title of this drawing by Nate, age 9, "Turbo Toilet 2000," is a tribute to the fourth-grade imagination. The world has never witnessed such a toilet, nor will it ever.

ings to both sides of the paper. Then, ask the children to either draw the same subject from observation or to study it consciously with an eye for another memory drawing the following day.

WORKING WITH NARRATIVES: STORYTELLING

Another approach is exemplified in the studies by Brent Wilson, Al Hurwitz, and Marjorie Wilson.⁶ Their emphasis is on narrative drawing, graphic storytelling, and the cre-

Children like to tell as well as listen to stories. Narrative art encourages both visual and ideational fluency. One picture becomes a beginning for an entire scenario rather than an end in itself, as one image and event set the stage for succeeding ones.

ation of new and exciting worlds by children. Their ideas have centered on the ways children learn to draw from the graphic models of other children, of adults, and of the media, and on the way children use their drawings to tell stories—stories that motivate them to depict people, action, and events.

The five-frame story drawing on this page, collected by the Wilsons, is an example of the influence of stories and images derived from the entertainment media. In response to a request to tell a story with drawings within the frame format, this sixth grader chose to represent a simple vignette based on a television commercial for a fast-food chain. Quite simply, the story deals with the typical advertising theme of initial deprivation and ultimate acquisi-

"War" (p. 13) from *I Dream of Peace; Images of War by Children of Former Yugoslavia* with Preface by Maurice Sendak. Copyright © 1994 UNICEF. Reprinted by permission of HarperCollins. When Harvard psychologist Robert Coles was asked at a PTA meeting why he used so many drawings in his book *Children of Darkness*, he reminded the audience that children often say things in their drawings that are not dealt with in their writing or speaking. This drawing by a boy in Sarajevo not only conveys information about the disastrous effects of war but provides a moving record of an emotional response.

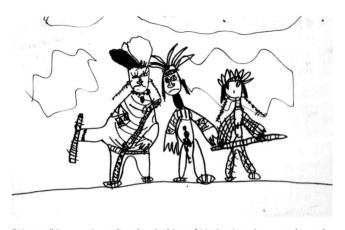

"Kiowas." Bo, age 6, studies the clothing of Native American peoples and makes a "memory" drawing from his sources.

tion—the character in the story is suffering a "Big Mac attack." He breaks through the wall of the restaurant in his haste to obtain and eventually bite into the desired hamburger. Television has also taught the young boy the sophisticated devices of the close-up—witness the lusciously drippy, well-packed sandwich in the second frame—and the long shot—in the next frame—as well as the ability to zoom in and out of the action.

Not all narratives need a succession of comic-strip "frames" to tell their story. Some drawings are more situational than narrative, suggesting stories with a single scene. Drawings can include words, depict humor, and convey action. They can provide a powerful instructional means of developing literacy through visual experience.

The writers have developed several methods for encouraging children to develop graphic skills. These skills are viewed as a graphic vocabulary and grammar, and they assist the child in producing satisfying and meaningful drawings. Following are several of the exercises:

- 1. Ask children to draw as many versions of a single object as possible. Examples might be different types of people, shoes, cars, trees, insects, and so on.
- 2. Ask children to think of a person, such as a dancer, a cartoon character, a sports player, or a superhero, who goes through a lot of motions. On a long strip of paper, show the figure going through its action as it moves from side to side across the paper.
- 3. Ask the children to think about extremities of form

and then to draw people who are very tall or very thin, situations that are too bad or too weird, and so on.

- 4. Using the concept of metamorphosis, ask children to start with one object, such as a car, and to gradually change it in a series of steps until it looks like something else, perhaps an elephant.
- 1. In the use of all art materials and processes, teachers must take care to select safe materials for student use and to explicitly teach safe methods with appropriate health precautions. See Charles Qualley, *Safety in the Artroom* (Worcester, MA: Davis Publications, 1986).
- 2. See drawing books, such as Ted Rose, *Discovering Drawing* (Worcester, MA: Davis Publications, 1990); and Bert Dodson, *Keys to Drawing* (Cincinnati: North Light Publishers, 1985).

5. Ask children to draw a face and then to draw the same face with a series of expressions, such as sad, happy, excited, or frightened. Have them project the face into the future and imagine how age will transform it.

NOTES

- 3. Karl Larsen, See & Draw: Drawing from Observation (Worcester, MA: Davis Publications, 1992).
- 4. See the classic drawing text by Daniel Mendelowitz and Duane Wakeham, *A Guide to Drawing*, 5th ed. (Fort Worth, TX: Harcourt Brace Jovanovich, 1993).
- 5. Bill Martin, *The Joy of Drawing* (New York: Watson-Guptill, 1993).
- 6. Brent Wilson, Al Hurwitz, and Marjorie Wilson, *Teachirg Drawing from Art* (Worcester, MA: Davis Publications, 1987). See Chapter 13 in this book.

ACTIVITIES FOR THE READER

Teachers should be thoroughly familiar with the tools, media, and techniques they will use in the classroom. The following activities are suggested to help them gain this familiarity. Because knowledge of the processes of art, in this instance, is more important than the art produced, teachers should not feel hampered by technical inabilities. Experience with art media is what counts at this stage.

- 1. Select some objects you think are interesting, and use them to make a still-life arrangement. Sketch the arrangement with wax crayons, using light, bright color where you see the highlights at their brightest and using dark-colored crayons where you see the darkest shadows.
- 2. Using heavy drawing pencil, try to draw the following subjects in a strictly accurate, photographically correct manner. (Remember that lines below the horizon line rise to this level; lines above fall to this level; all lines meet at the horizon line.)

- a. A sidewalk or passageway as though you were standing in the center
- b. A cup and saucer on a table below your eye level
- c. A chimney stack, silo, or gas storage tank, the top of which is above your eye level
- d. A group of various-sized boxes piled on a table or on the floor (It is easier to draw if you first paint the boxes one unifying color, such as gray or white.)
- 3. Have a friend pose for you. On manila or newsprint measuring at least $12'' \times 18''$, make a drawing in Conté crayon or heavy pencil. Draw quickly, taking no longer than three to five minutes for each sketch. Do not erase mistakes—simply draw new lines. Make many drawings of this type, based on standing, sitting, and reclining poses.

Now begin to draw more carefully, thinking of places where bones are close to the surface and where flesh is thicker. Heavy pressure with the drawing medium will indicate shadows; the reverse will indicate light areas. Think also of the torso, the head, and the pelvic region as moving somewhat independently of each other. Begin to check body proportions and the effects of clothing on form.

- 4. Place yourself before a mirror for a self-portrait. Study the different flat areas, or planes, of your face. Notice the position of prominent features (especially eyes, which are about halfway between the top of your head and the bottom of your chin). Quickly draw a life-size head in charcoal, crayon, or chalk. When your features have become more familiar to you, try some other media, such as ink or paint. Try a self-portrait that is many times larger than life size.
- 5. Who are the greatest creators of drawings in history? Look for the best examples of drawings by many artists by visiting the library and browsing bookstores. Beginning with cave drawings and rock art, collect drawings from all cultures and times as well as drawings by contemporary artists. Using quality copy and color copy machines, you can compile an excellent collection that

can be used in many teaching situations with all age groups. Does your collection include some of the great women artists?

- Look for examples of good drawing in the world of visual culture: comic books, illustrations for books and magazines, drawings in advertisements, and children's books. Many of today's applied artists are experts at drawing.
- 7. Collect drawings by children of various ages. Ask each child to "draw a person as well as you can." A second request might be to "draw what you draw best." Be sure to label each drawing on the back with the child's name and age in years and months. Bring your collection of drawings to class, and discuss them. Can you and your fellow students arrange the drawings according to age levels of children? What can you learn about individual differences of children of the same age? Can you see the results of art teaching and learning in any of the drawings? Where do children get their ideas for "what they draw best"?

SUGGESTED READINGS

- Brommer, Gerald F. *Exploring Drawing*. Worcester, MA: Davis Publications, 1987.
- Brooke, Sandy. *Hooked on Drawing*. Englewood Cliffs, NJ: Prentice-Hall, 1996.
- Brookes, Mona. Drawing with Children: A Creative Method for Adult Beginners, Too. New York: G. P. Putnam's Sons, 1996.
- Cole, Alison, Tony Rann, and Ann Kay. *Eyewitness Art: Perspective*. New York: DK Publishing, 1993.
- Cox, Maureen V. Children's Drawings of the Human Figure: Essays in Developmental Psychology. Hillsdale, NJ: Lawrence Erlbaum Associates, 1993.

- Edwards, Betty. The New Drawing on the Right Side of the Brain. New York: J. P. Tarcher, 1999.
- Finley, Carol. Art of the Far North: Inuit Sculpture, Drawing, and Printmaking. Lerner Publications, 1998.
- Goldstein, Nathan, *The Art of Responsive Drawing*. 5th ed. Englewood Cliffs, NJ: Prentice-Hall, 1998.
- Steele, Bob. *Draw Me a Story*. Winnipeg, Canada: Peguis Publishers, 1998.
- Steinhart, Peter. *The Undressed Art: Why We Draw.* New York: Alfred A. Knopf, 2004.

WEB RESOURCES

The Art Room: http://www.arts.ufl.edu/art/rt_room/. Developed by art education professor Craig Roland. A great resource for teachers and students. Includes extensive and exciting resources as well as *Drawing Encounters* with ideas for motivating students and advice on teaching kids to love drawing.

- Goshen College Art Education: http://www.goshen.edu/ art/ed/drawingskills.html. Includes drawing lessons, based on a comprehensive approach, developed for elementary schools by art education professor Marvin Bartel.
- Guggenheim Museum: http://www.guggenheim.org/ artscurriculum/lessons/. Provides teachers with curriculum materials to support the use of the museum's exhibitions and collections. Includes a comprehensive range of lessons on art and artists in the collection.
- Kennedy Center Arts Edge: http://artsedge.kennedy -center.org/teach/. Resources include teacher instruction and aids as well as elementary-grade art curriculum. Features interdisciplinary lessons that include drawing and language arts.

- The Metropolitan Museum of Art: http://www .metmuseum.org/. Extensive online teacher and student resources related to one of the greatest collections of art in the world.
- Museum of Modern Art: http://www.moma.org/ education/. The Museum of Modern Art holds one of the most comprehensive collections of twentieth-century drawings in the world. The site features educational resources with teaching materials, online interpretive materials, and online interactive learning programs for students.
- Smithsonian American Art Museum: http://americanart .si.edu/. Teacher and student online resources are extensive and educationally sound. Includes an extensive online database of the collection that allows searches by subject, media, and artist categories.

PAINTING

At the Heart of the Studio Experience

I found that I could say things with color and shapes that I had no words for.

—Georgia O'Keeffe, Beyond Creating

Painting, like drawing, is at the heart of the studio experience, both in terms of children's participation and the history of art.¹ Although there are numerous modes of art production, it seems that even from prehistoric times drawing and painting were practiced. The marks of drawing and colors of painting are found on virtually every natural and fabricated object that provides an appropriate surface, from marks cut into tree bark and paintings on cave walls to painted pottery, painted dwellings, and graffiti found in many of our cities.

Color is exciting for everyone but is especially delightful and interesting for children. As they have opportunity to manipulate, explore, and control color through painting, children learn and grow in their artistic expression. This chapter is organized according to progressively more advanced learning experiences for young painters but does not replicate the discussion of stages from Chapter 6. In general, this chapter discusses children's early explorations and discoveries with painting, the development of painting skills and conventions, the study of paintings from history and other cultures, and older children's empowerment as artists as they conceive of painting in relation to concepts, issues, and communication.

Some children entering kindergarten already have a wide range of experience with art. Some have looked at many good-quality picture books with their parents, other adults, or older siblings. Some have worked with paints and brushes and might even have some skills in identifying and mixing colors. A few children might come from families in which someone is an artist, or they might have visited art museums. Other children will come to the teacher with none of this background. Regardless of their earlier experiences and advantages, nearly all children will be receptive to the delights of pure colors and to the use of paints and brushes on a painting surface.

PAINTING MEDIA AND TECHNIQUES

The most suitable paint for the beginner is an opaque medium usually called *tempera*, which may be purchased in several forms, the least expensive being powder, which must be mixed with water before it is used. (With beginning pupils, the teacher or adult volunteer must mix all the paint.) Powdered tempera, though used less often, has one advantage over liquid tempera: its textural qualities can be varied as desired. The liquid paint tends to go on with a uniform smoothness, whereas the powdered variety can be applied with varying degrees of roughness or smoothness, depending on how much water is mixed with it. Schoolquality acrylic paints are also available.

The broad, muscular fashion in which young children naturally work is even more noticeable with paint than with crayon. Large sheets of paper ($18'' \times 24''$) allow for young painters' large strokes and exuberant movements. The teacher should use a variety of paper and brush sizes

so the children can explore different ways of controlling the paint. Newsprint and manila paper are both suitable, as are the thicker papers such as Bogus and kraft. The children can also use colored poster paper and brown mural paper.

Paintbrushes are usually flat or round, and the coarseness of the bristles varies from very stiff to very soft. Cost is always a factor in purchasing art materials for schools, but it is inconsiderate to ask children to express themselves with materials that even an experienced adult could not control. The poorest-quality brushes, although usually the least expensive, might not be the best value in the long run. With cheap brushes, bristles can fall out in the process of painting and will not stand up to rigorous cleaning. It is better to invest in decent-quality paintbrushes for better service and less frequent replacement. Purchase a variety of brushes, particularly large bristle brushes (10-inch handle, ½-inch flat bristles) for young children. After brushes are used, wash them in water and store in jars with the bristles up to avoid warping.

Very young children are usually anxious to experiment with media and will use whatever crayons, paint, and paper they find within reach. Their attention span is sometimes brief, however, so within five minutes some may exhaust their interest in one kind of work and seek a new activity. The more children experiment with art media, the longer their attention span becomes, and some children remain involved in art activities for extended periods.

When children first use paint, it is wise to offer them only one color. When they have gained some familiarity with the manipulation of the paint, the teacher can give them two colors, then three, then four. By providing children with the primary hues—red, yellow, and blue—plus black and white paints, the teacher can encourage them to discover the basics of color mixing at a very early age. Colors will mix at first by accident (the red and yellow miraculously turning orange can be quite exciting). Accidents with color mixing should be encouraged and explored.

Paint should be distributed in small containers, such as plastic jars, milk cartons, or juice cans. Place these containers firmly in a wire basket or a cardboard or wooden box to prevent accidents. Very young children should have one brush for each color, because they cannot at first be expected to wash their equipment between changes of color. The teacher can give simple demonstrations on how to clean brushes in water and how to mix or lighten colors.

Demonstrating the use of media is an effective way to motivate a class. Watching a concept develop as a process is explained is not only fascinating to children but also arouses a desire to begin seeing for themselves how to handle materials and ideas that are new to them. A demonstration can open the door for personal exploration. As an example, when making a watercolor wash, using an absorbent tissue to subtract color, learning to accept and use inevitable accidents, caring for brushes, and handling details, children observe and learn technical skills.

Teaching

From the beginning of the children's experience with paint, the teacher should attempt to enlarge their color vocabulary. This can occur naturally by naming colors as they are used. Children learn about color most effectively by using it, talking about it, and identifying color terms in their own artwork and in the art of others.

Because many children come to school with a linear orientation to picture making, their first experiments in painting during both the manipulative and symbol-making stages are likely to be brush drawings. Picture making in its early stages is generally a matter of enclosing images with lines rather than the more sophisticated work of placing areas of color next to each other. Even if they begin as painters, children may often complete their work by going over it with black lines to lend greater clarity to the shapes. The teacher should accept whatever strategies the children happen to use but keep an eye on their work habits and handling of materials and get them to talk about their work during the evaluation period.

When the children are familiar with crayons, paints, and brushes, the teacher may try a few simple methods to encourage them and perhaps to help them improve their technique. When certain children in the group make discoveries, such as stipple or dry-brush effects, the teacher might draw the attention of the entire class to these discoveries. When praising or calling attention to a child's work, try to be specific. Comments such as "Isn't Marina's painting great?" do not mean as much as "Look how Marina has not only used green right out of the pan but has also added other colors to make several kinds of green."

One technique used to provide children with a painting direction is to ask them to imagine a scene or an experience that the teacher describes in great detail, such as "riding in a boat, rocking rhythmically on the waves and feeling the spray, smelling the salt air as the bright sun shines down and reflects on the water" (you get the idea).

"Castle That Rules the Sea." Annie, the 9-year-old child from the United States who created this exuberant mixedmedia painting, employed a combination of approaches, with imaginative use of color and pattern applied as observed in nature. She used her imagination to create a fantasy underwater setting.

Then children can be asked to paint their responses to this imaginary experience.

Another technique is to provide children with a reallife experience, such as a walk on the school grounds, during which different types of trees are carefully observed, with attention to the way they are shaped when seen from a distance, how much of the trunk is visible, the fact that the branches are smaller than the trunk, and differences in types of foliage. Children move close to the trees, feel the texture of the bark, put their arms around the trunk, collect and examine leaves, and note how the trees respond to the breeze. With this type of sensory connection as source and motivation, children usually are able to paint more interesting, detailed, and expressive paintings.

The teacher should encourage children to talk about the subject matter of their painting. In so doing, the pupils tend to clarify their ideas. The relation among ideas, language, and images is very intense at early ages and should be encouraged. Whatever learning takes place at the stage of manipulation, however, depends largely on the children. *At this age the teacher's main task is to help children carry out and improve their own ideas*. A pleasant working environment and one in which suitable materials are readily at hand are essential ingredients of a successful program during this stag= of expression. The teacher must give much thought to preparing and distributing supplies and equipment and must work out satisfactory procedures for collecting work and cleaning up after each session.

It is possible to use transparent watercolor for painting, but the teacher must realize that it is more difficult to con-

"Painted Sorrow." A 10-yearold girl, Laurelynn, painted this work spontaneously at home. She used line and watercolor with unusual restraint to capture the intended mood.

> trol than tempera and must proceed accordingly. Watercolors require more instruction and more structured supervision for children to use them successfully. Watercolors have the advantage of convenience of packaging. Their transparency, use of accidents (drips and runs), and ease in cleanup set them in quite a different class from tempera.

> When the children relate the objects in their paintings to the settings, their chief difficulty often arises from an inability to make objects sufficiently distinct from the background of a picture. The following dialogue between a teacher and a third-grade pupil relates to such a problem.

> **TEACHER**: Mark, it looks as if you're about finished. What do you think?

MARK: I don't like it.

TEACHER: What's the matter with it?

MARK: I don't know.

TEACHER: You know, there comes a time when every artist has to stop and look at his work. You notice things you

don't see up close. (*Tacks painting on easel*.) Now look at it hard.

MARK: You can't see it too clear—

TEACHER: You mean the tent?

MARK: It doesn't show up.

TEACHER: What we need is a way to make the tent stand out. What can you do? I can think of something right off.

MARK: I know—paint stripes on it.

TEACHER: Try it and see what happens. You can paint over it if you don't like it.

There could have been other solutions, such as using an outline or increasing the size of the tent. The important point of this dialogue is that the teacher got Mark to discover his own solution without requiring him to give a single correct answer.

As students become older and more experienced, the teacher should provide a wide variety of brushes, ranging from about size 4 to size 10 of the soft, pointed type made of sable or camel hair, and should also make available the bristle-type brush in long flat, short flat, and round types and in all sizes from ¹/₈ inch to 1 inch in width. Because children in upper grades usually can use tints and shades of color, it is sometimes a good idea to provide a neutral-toned paper to make the tonalities of paint more effective.

The discussion that follows will focus on several important techniques that preadolescents are expected to develop—techniques involving facility in use of color, understanding of space, skills in painting from observation, and ability to mix media. Because the teacher's role is central to the process of developing these techniques, comments on how to teach them are incorporated into this discussion rather than set forth in a separate section.

DEVELOPING COLOR AWARENESS

In the early preadolescent stage, children might be concerned with the relationship of background to foreground. This concern, together with their interest in the effects of light and shade, involves them in problems related to color. By learning more about mixing colors, children increase their choices, thereby using a wider range. They also learn how to lower color intensity by adding small amounts of the complementary color and how to lighten color by adding white.²

Once it is decided that pupils will mix colors themselves, the physical arrangements in the classroom for the distribution of pigments must be carefully planned. The "cafeteria" system allows the pupils to select their colors from jars of tempera. They place the desired quantity of each color in a palette or a muffin tin and can mix colors directly in the palettes or tins. Because children sometimes waste paint, the teacher should tell them to take only enough pigment for their painting. They should be cautioned not to mix too large a quantity. By adding stronger colors to weaker, such as blue to yellow to make green, or red to white to make pink, they can save paint.

A variety of ways exist to alter the standard hues. Mixing black with a standard tempera color creates a shade. and adding white to a color produces a tint. If watercolor is used, adding black creates a shade, but the white paper showing through the watered-down pigment creates the tint. Light areas must be carefully planned in advance, but an area can be lightened by dabbing it with a damp towel or by diluting it with more water. The ability to mix tints and shades and thus arrive at different values greatly broadens pupils' ability to use color. Preadolescent children can also alter hues without undue difficulty by mixing the standard hue with its complement. Hence, when a small amount of green is added to red, the character of red is altered; the more green added, the greater the change in the red, until finally it turns a brownish gray. Grays achieved this way have a varied character and are different from those achieved by mixing black and white. When used in a composition, these grays give dramatic emphasis to the areas of bright color.

Children in the upper elementary-school grades are capable not only of looking analytically at how color behaves, as with the color wheel, but also of using what they learn about color in their paintings. This is not as true of children who have not yet reached the preadolescent stage, because young children tend to work intuitively; the works of first graders often exhibit exciting, "painterly" qualities. But the upper grader, being more cautious and less spontaneous in expression, requires stronger and more specific motivation. Color activities built around problems posed by the teacher enable the student to learn more about the interaction of color, as well as to arrive at a more personal, expressive use of color.

Here are some suggestions to develop the possibilities of painting.

1. Questions that sensitize students to color in the environment:

- How many colors can you see in this room?
- Would everyone who is wearing red please stand together?
- Name the colors you see outside the window. Can you grade them according to brightness or dullness?
- 2. Problems relating to color investigation:
 - First make a painting with just three primary colors—red, yellow, and blue. Mix them any way ycu like. In a second painting, add black and white to the three colors.
 - Compare the brown in the paint jar with a brown of your own, made by mixing the primaries. Which do you like better?
 - Mix your own orange, and compare it with the prepared orange in the bottle. Which do you prefer?
- 3. Problems relating to the nature of pigment:
 - What happens when you use color on wet paper?
 - What happens when you use color on black paper?
 - What happens when you combine painting and coLage? Notice how a separation of color and texture appears. How can you bring the painted part and the collage section together?

Paintings by two 6-year-olds, one from the United States. the other from France. Children in the primary grades normally do not fill the pictorial space as completely as they have here. For children at this age, art largely is a graphic-that is, drawing—process. Paintings first emerge as brush drawings, which then may be filled in with areas of color. The teachers of these children have made a conscious attempt to direct attention to certain "painterly" approaches, such as color against color, color and moving lines, and forms that cover the complete surface of the paper.

124

September (2003). Oil on canvas. Chinese American artist Hung Liu was born in China and experienced that country's Cultural Revolution. She came to the United States for graduate study in art and has developed a style that combines historic Chinese imagery, traditional figurative painting, and the expressive paint surfaces of abstract expressionism. Her works include personal symbolism based on her Chinese heritage and her American experience.

- 4. Problems relating to the emotive power of color:
 - What colors would you use for paintings about a hurricane, a picnic, and a carnival?
 - How do advertisers use colors to identify their products? For example, what combination of colors identify 7-Eleven convenience stores?
- 5. Colors differ in relation to other colors:
 - Ask students to clip patches of red (or another color) from magazine pictures and advertisements. Paste the clippings on a poster board, and discuss the numerous variations of a single hue.
 - When the color blue is assigned, have a reproduction of one of Picasso's blue period works, and ask the class to point out the tones that match most closely.

• Try "color day" on a weekly basis, and include white and black to see where variations exist.

Color and Art History

Another way to study color is to use works of art as a frame of reference or as an organizing factor.³ There is *symbolic* use of colors, as in the case of red and blue used for Madonna figures of the Renaissance or of Native American symbols painted on shields; *realistic* color use, based on the actual color of the subject (blue skies, green grass, and so on); *flat* application of color, as in minimal or hard-edged painting; and color directed at specific *moods*, as in the case of theatre set designs. Color can be bold, bright, and painterly, as in the case of the *expressionists*; linked to light, as in the work of the *impressionists*; or limited and restrained, as in the early work of the *cubists*. When discussions of such differences are illustrated with examples, students should be able to identify works by different artists, art movements, and cultures.

STUDYING MASSES AND SHAPES IN SPACE

The problem of rendering space often frustrates the older child, who will require the help of the teacher. Teaching perspective is similar to teaching sensitivity to color, in that in neither case does an intellectual approach assure that learning will follow. Children can have their attention directed to the fact that distance may be achieved through overlapping, diminution of size, consistency of vertical edges, atmospheric perspective or neutralization of receding color, and convergence of lines. This knowledge, however, has only limited value if the children are not able to see the many ways perspective may be used; indeed, effective pictorial expression may occur without recourse to linear perspective. The works of such painters as Vincent van Gogh, Georges Braque, Mary Cassatt, and David Hockney, as well as traditional paintings from China, should be studied as examples of ways artists have distorted, adjusted, and exaggerated the principles of perspective for particular artistic ends. The teacher should have on hand art reproductions (from books, magazines, or other sources) that demonstrate different ways space has been treated by artists, such as these examples from the history of art:

1. Chinese or Persian placement of objects painted in flat tones, which usually disregards the deep, penetrating space of Western art

- 2. Renaissance use of linear perspective, with its vanishing points, diminishing verticals and horizontals, and colors that become pale
- 3. Cubist dissolution of Renaissance-type space, with its substitution of multiple views, shifting planes, and disregard of "local" or realistic color
- 4. Photographic techniques using aerial views, linear perspective, and unusual points of view in landscape subjects
- 5. Renewed interest in spatial relationships by contemporary artists such as David Hockney, who investigates space and color through his use of fragmented Polaroid collages

Space may also be studied by examining color in nonobjective paintings, where no objects exist to distract the viewer from perceiving the artist's use of color in the painting. Children can describe which colors seem to come forward and which recede, which ones "fight" with each other and which are harmonious. Abstract painter Hans Hofmann referred to the tensions of color as a process of "push and pull."

In teaching perspective, as in teaching about color and drawing, the teacher should keep in mind that children may produce successful work without using Western linear perspective. Linear perspective is a system developed during the Renaissance that provides a set of rules or guidelines for rendering objects and buildings with an appearance of three dimensions. There are many guides that provide the accepted diagrams that art students have traditionally used, and children, although eager and able to use such guides, do not always understand the connection between what they copy and what they see in the real world.

With appropriate instruction and time for practice, students can master color theory so they are able to mix whatever hue, intensity, and value they choose in the course of making a painting. They learn to render objects with paint so they appear solid through the use of chiaroscuro. Students can paint a landscape, for example, with a foreground, middle ground, and background, and they can control color value and intensity to make objects in the distance recede and objects in the foreground advance. In the course of learning to paint, students can experiment with abstract and nonobjective painting, try painting moods, and make imaginary (fantasy) paintings.

In the process of learning about painting, beginning in kindergarten, older elementary children have studied and

enjoyed many paintings by mature artists. They have become familiar with major names in the history of Western painting, such as Michelangelo, Rembrandt, Gentileschi, and van Gogh. They have examined paintings from other cultures, including Japanese, Chinese, Native American, Mexican, and African. They are also familiar with names of and werks by contemporary American artists, such as Andrew Wyeth, Romare Bearden, Alice Neel, Willem de Kooning, Faith Ringgold, and Helen Frankenthaler, as well as those of leading illustrators and graphic designers.

At this level of experience and accomplishment, many students have developed what will become a lifelong propensity for aesthetic enjoyment in the appreciation of works of art, most particularly paintings. Many students are ready for another level of accomplishment in their own art production. They are ready, as sixth-grade students or older, to emulate the adult artist as a communicator of concepts, issues, and ideas.

1. Students can study the political and social issues of the day through the newspapers and television and, most appropriately, in conjunction with other studies in their school curriculum. They can view works by

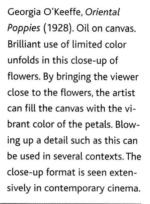

Miriam Schapiro, *The Garden of Eden* (1990). Acrylic on canvas, 95" square. This painting on the origin theme appears to combine the traditional Christian story with Native American patterns and symbols that relate to a different origin story. For a comparison of two works with a similar theme but differing media and approaches, contrast this work by Schapiro with the *Paradise* sculpture by Tolson (see Chapter 8). artists whose subject is related to these issues, such as Käthe Kollwitz's statements about war and suffering, Leon Golub's paintings of poverty and brutality, and Faith Ringgold's quilts/paintings about her experiences growing up in a black community. Students can create their own paintings on social issues about which they have strong feelings or beliefs, possibly environmental pollution, saving the rain forest, or gang violence.

2. A number of universal themes run through the history of art across cultures and across the centuries. One pervasive theme in art is "mother and child," seen in Christian art as Madonna and Child, but noted in virtually every culture that developed art forms by which such a theme could be conveyed. Other themes deal with occupations and work; genre scenes of every-day life; and celebrations of special events, such as

weddings, harvest, war and battle, birth and death. These themes can provide students with much grist for their creative mills.

- 3. Many children are interested in fantasy, or the life of the imagination, which is one of the primary sources for much art. Traditional works by Bosch, Bruegel, Dalí, Kahlo, and other artists can be studied and used as sources of inspiration for fantasy painting. Contemporary fantasy artists illustrate science-fiction books, make movie posters, create fantasy paintings, and do computer animation. The realm of the imagination remains a strong thread in the fabric of world art.
- 4. Students enjoy recognizing styles of painting and can become very accomplished in recognizing historical influences. They can explore art styles in their own work, drawing from historical and contemporary artists and their works. For students at this age level and with appropriate guidance from the teacher, deriving ideas from art and visual culture can be very educational.
- 5. Many artists work from an attitude of introspection, gaining much of their inspiration from their own internal thought processes and moods. The long history of self-portraits is one example of artists turning to their own resources for a subject and idea. Students can be encouraged to examine their own psychological states, moods, preferences, and aspirations as subject for their paintings.

"Rain Clouds." Kya, age 9, observed a natural scene near her home, then translated the memory to create this watercolor and crayon pastel landscape.

- 1. Lucy Micklethwait, A Child's Book of Art: Discover Great Paintings (New York: DK Publishing, 1999).
- 2. Alison Cole, *Eyewitness Art: Color* (New York: DK Publishing, 1993).
- 3. Muriel Silberstein-Storfer, with Mablen Jones, *Doing Art Together* (New York: Metropolitan Museum of Art, 1997).

ACTIVITIES FOR THE READER

- 1. Using a large bristle brush for broad work, paint in tempera an interesting arrangement of color areas on a sheet of dark paper. Try to develop varied textural effects over these areas in the following ways:
 - a. *By using dry-brush:* Dip the brush in paint, and rub it nearly dry on a piece of scrap paper. Then, "dry-brush" an area where the new color will show.
 - b. *By stippling:* Holding a nearly dry brush upright so the bristles strike the paper vertically, stamp it lightly so a stipple pattern of paint shows.
 - c. *By brush drawing:* Select a sable brush, and load it with paint. Paint a pattern over a color area with wavy or crisscrossed lines, small circles, or some other marks to give a rougher-looking texture than is found in surrounding areas.
 - d. *By using powdered paint:* Apply liberal amounts of powdered paint mixed with very little water to your composition to obtain some rough areas. (Add sawdust or sand to liquid tempera if you have no powdered tempera.)
 - e. *By using a sponge:* Paint the surface of the sponge, or dip it into the paint, and rub the sponge on your composition.
 - f. *By using a brayer*: Roll the brayer in paint, and pull it over cut-paper forms. Experiment with the roller by using the edge or by wrapping string around it. Place small pools of color next to each other, and pull the brayer over them, changing directions until you have blocks of broken color that lock into each other.
- 2. The following formal exercises can help you develop technique:

- a. Draw about a dozen 2-inch squares, one below the other. Paint the top square a standard hue; leave the bottom one white. Make a gradation of color areas ranging from the standard hue to white by progressively adding white to the standard hue. The "jumps" between areas should appear even.
- b. Repeat part a, using some other hues. Use transparent watercolor as well as tempera for some exercises, adding water instead of white paint to the watercolor pigment.
- c. Repeat, this time adding the complementary color to the first one chosen. Now the gradations will go from standard to gray rather than to white.
- d. Add black progressively to a standard hue to obtain 12 "jumps" from standard to black.
- e. Try shading about six 3-inch-square areas with Conté crayon, charcoal, or heavy pencil so you progress from very light gray to very dark gray.
- f. Draw textures in four 3-inch-square areas so each square appears "rougher" than the next. Crisscrossed lines, wavy lines, circles, dots, and crosses are some devices to use. India ink and a writing pen are useful tools in this exercise.
- g. Using the side of a crayon, take a series of "rubbings" from such surfaces as wood, sidewalks, rough walls, and so on. Create a design using the rubbings you have collected.
- 3. Using art magazines, color copies, art postcards, or other color art reproductions, begin a collection of paintings that exemplify color concepts you will teach. For example, many artists from various cultures,

times, and places have recognized the power of the primary colors in their work. When viewing an array of adult works by renowned artists, children can see the validity of art concepts and skills they are learning in elementary school. 4. Use your collection of painting reproductions to create teaching aids for a target age level. Children learn visually as well as by making their own art. Teach visually by using the wealth of art teaching resources for virtually any concept you decide to teach.

SUGGESTED READINGS

- Brommer, Gerald. Watercolor & Collage Workshop. New York: Watson-Guptill Publications, 1997.
- Brommer, Gerald F., and Nancy K. Kline. *Exploring Painting*. 3d ed. Teacher's copy. Worcester, MA: Davis Publications, 2003.
- Brown, Maurice, and Diana Korzenik. *Art Making and Education*. Urbana: University of Illinois Press, 1993.
- Carr, Dawson W., and Mark Leonard. *Looking at Paintings*. Malibu, CA: J. Paul Getty Museum, 1992.
- Chaet, Bernard. An Artist's Notebook. New York: Holt, Rinehart and Winston, 1979.
- Fineberg, Jonathan. *The Innocent Eye: Children's Art and the Modern Artist.* Princeton, NJ: Princeton University Press, 1997.
- Jasper, Caroline. *Powercolor*. New York: Watson-Guptill Publications, 2005.
- Kohl, Mary Ann F., and Kim Solga. Discovering Great Artists: Hands-On Art for Children in the Styles of the Great Masters. Bellingham, WA: Bright Ring Publishing, 1997.
- Leclair, Charles. Color in Contemporary Painting. New York: Watson-Guptill Publications, 1997.

- O'Keeffe, Georgia. *Beyond Creating*. Los Angeles: J. Paul Getty Trust, 1985.
- Redeal, Liz, Whitney Chadwick, and Frances Borzello. *Mirror Mirror: Self-Portraits by Women Artists*. New York: Watson-Guptill Publications, 2002.
- Reichold, Klaus, and Bernhard Graf. *Paintings That Changed the World: From Lascaux to Picasso*. New York: Prestel Publishing, 2003.
- Richardson, Joy, and Charlotte Voake. Looking at Pictures: An Introduction to Art for Young People. New York: Harry N. Abrams, 1997.
- Ruch, Marcella, and Pablita Velarde. "Pablita Velarde: Painting Her People." *New Mexico Magazine*, 2001.
- Smith, Nancy R., et al. Experience and Art: Teaching Children to Paint. 2d ed. New York: Teachers College Press, 1993.
- Topal, Cathy Weisman. Children and Painting. Worcester, MA: Davis Publications, 1999.
- Welton, Jude. *Eyewitness Art: Looking at Paintings*. New York: DK Publishing, 1994.
- Yenawine, Philip. Key Art Terms for Beginners. New York: Harry N. Abrams, 1995.

WEB RESOURCES

J. Paul Getty Museum: http://www.getty.edu/art/

- Guggenheim Museum: http://www.guggenheim.org/
- Institute of American Indian Arts Museum: http://www .iaia.edu/museum/. Features contemporary Native American fine art.
- Museum of Modern Art: http://www.moma.org/. Includes "Destination: Modern Art," an interactive program for elementary-age students.

Georgia O'Keeffe Museum: http://www.okeeffemuseum

.org//visit/permanent/index.html. Specializes in the work of O'Keeffe, a major figure in American art, and her contemporaries.

Public Broadcasting System, *Art:21—Art in the Twenty-First Century:* http://www.pbs.org/art21/series/. PBS series that focused exclusively on contemporary visual art and artists in the United States. Includes companion books, DVD set, online lesson library, and educator's guide. Smithsonian American Art Museum: http://americanart .si.edu/. Premier collection of American art with extensive information and educational material.

Tate Britain and Tate Modern: http://www.tate.org.uk. London museums featuring international and modern art and extensive educational resources.

Walker Art Center, Weisman Art Museum, Minneapolis

Institute of Arts and Minnesota Museum of American Art, ArtsNetMinnesota: http://www.artsnetmn.org, and ArtsConnectEd: http://www.artsconnected.org/. These two websites include combined resources of the museums to provide excellent educational resources for teachers and students.

C H A P T E R

SCULPTURE AND CERAMICS

It's almost like dancing, you know. Clay is just a big blob, but the minute you touch a piece of clay it moves. It's plastic. So you have to respond.

-Peter Voulkos, National Museum of American Art

Drawing and painting and printmaking are accomplished primarily on two-dimensional surfaces, usually paper, canvas, or board. Art that extends into the third dimension includes sculpture, ceramics, and other traditional forms such as quilts, furniture, and metalwork. The contemporary (postmodern) forms of earthworks, installation, and video are discussed in Chapter 10.

Japanese children enjoy their sculpture headpieces.

Sculpture and ceramics in some ways overlap as art modes. Some sculpture, for example, is made of fired clay and can be considered ceramic sculpture. Ceramics includes pottery made of fired clay, and even it overlaps with sculpture, as some pots exhibit fine sculptural qualities, some are purposely nonfunctional, and sometimes pots are used as components in sculpture. Ceramic pottery is an ancient art mode and also one of the most universal; pots are found that were created far back in time and in all parts of the world. Sculpture is discussed first in this chapter, with attention paid to media and methods for its creation and with suggestions for teaching children and young people about sculpture. Discussion of ceramics follows, with special attention to the area of pottery, and includes references to historical and critical learning that accompanies the making of ceramics.

SCULPTURE: BASIC MODES OF FORMING AND CONSTRUCTION

When we consider the beginnings of sculpture, we think of very ancient, even prehistoric, examples created before the great sculptures from Egypt that date from nearly 6,000 years ago. Yet the art of sculpture continues today as one of the most highly respected and dynamic of the art modes. Sculpture is often classified as either freestanding or relief. Freestanding sculpture, or sculpture in the round, is the type that can be viewed from many angles, such as a statue of a person or an animal that someone could walk around. Relief sculpture is usually viewed from the front, as a painting is, and is often seen on walls or other surfaces that cannot be viewed from behind.

As is the case with all significant works of art, sculptures reflect ideas, values, and practices of the artists who created them and the societies and cultures to which the artists belong. Ancient Egyptian art, for example, was commissioned by the powerful rulers of the time and served purposes profoundly influenced by the religious beliefs of the culture. In contrast, contemporary art is influenced by the individuality of artists. Yet even the highly individual work of today's sculptors reflects the society in which they live.¹ These relationships can be seen in the carved wooden figures of the Yoruba peoples of Nigeria, the bronze sculptures of sacred bulls from India, and the mobiles (moving sculptures) of Alexander Calder that, incidentally, add another category to sculpture—that which moves while the viewer remains stationary.

Sculpture parks, such as the Storm King Art Center in New York and the Minneapolis Sculpture Garden at the Walker Art Center in Minnesota, are but two of a growing number of outdoor environments for large-scale works designed to be walked around or through. Many viewers experience a heightened level of engagement when they have the opportunity to closely examine large works of art.

Modeling, carving, and constructing are typical processes involved in making sculpture. Modeling involves building up a form from material, such as clay, and then adding and shaping the material. For example, when a head is modeled in clay, the basic form is modeled, and then more clay is added and shaped to develop the nose, hair, ears, and other features. Modeling, then, is usually an additive process. Carving is typically a subtractive process, in which the material, such as wood or plaster, is carved or chipped away until the desired sculptural form emerges. Sculpture also involves a process of constructing, in which the materials are cut or shaped or found and attached together with appropriate materials. Welded metal, nailed or glued wood, and a limitless array of materials, from sheet plastic and glass to driftwood and junk, can all be used to construct sculpture. Constructing is usually an additive process.

Today's art requires a rather broad definition of sculpture, one that takes into account the mixed-media approach and the interrelation of art and technology. "Shaped canvases" can be viewed as painted sculpture or as painting that moves into space. In *assemblage*, artists create unusual contexts for mundane "found objects."² Some sculptors animate their constructions with intricate mechanical devices; others experiment with sound and light as components of the total sculptural experience. Because children respond positively to many of the concepts inherent in sculpture today, problems of both a traditional and a contemporary nature should be considered when planning activities built around forming, shaping, and constructing.

In the traditional sense, carving and modeling are activities in which raw materials from the earth and the forest are directly manipulated by the artist. In modeling, artists may approach clay with few tools other than their bare hands, whereas in carving wood and other media, a tool as primitive as a knife allows artists to pit their skill against the material. If the artist shows respect for it, the primary characteristics of the original material remain in the finished product. Wood remains wood, clay remains clay, and each substance clearly demonstrates its influence on the art form into which it was fashioned.³

Children of all ages can work successfully in modeling

clay. Only older preadolescents, however, are able to carve wood and plaster of paris, because the skills involved are beyond the ability of younger children and some of the tools required are too dangerous for them to use. A 6-yearold might not be able to use carving tools but is capable of building structures by gluing together scraps of wood. It is important when considering the appropriateness of art activities for various grade levels to make a distinction between media and techniques. Instead of arbitrarily relegating any one type of material to a particular grade level, the teacher should examine the material in terms of the specific problem to be explored. Although it is true that the range of manual control varies with the age of children. some techniques associated with a particular medium are within children's capability on every grade level. For instance, even elementary-school children engaged in making animal figures can be encouraged to "pull out the shapes" and to "piece the figure together so the parts don't fall off." They can practice maintaining uniform thickness of the side of a pinch pot and can press patterns of found objects

This very old and beautiful gold cup, made in Iran about 3,000 years ago, is an example of relief sculpture. The gazelles can be seen only from one side, although their heads and horns are actually "in the round." The cup is also an example of a utilitarian object that has been raised to the level of fine art by its decorative and sculptural work.

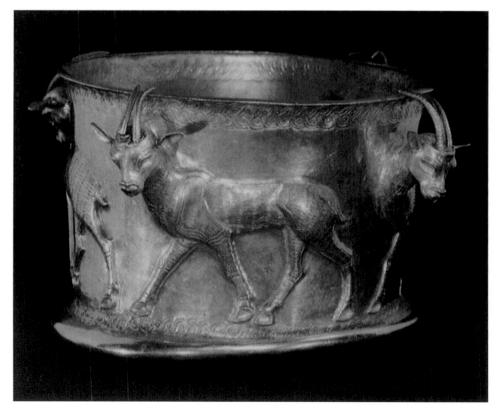

► This stone sculpture is nearly 4,500 years old. The larger figure represents an Egyptian king and the smaller one an Egyptian deity, juxtaposing political authority and religious beliefs in one artwork. Children can learn about such cultural contexts and the purposes of artworks in order to better understand and appreciate them.

▼ Howie Weiss, who teaches a course called "Play" at the Maryland Institute College of Art, uses simple children's toys to make large sculptural constructions. In some classes, students work alone and with others in teams or in small groups. Weiss rented the thousands of LEGO units needed from a recreation department of the city of Baltimore.

into clay tiles. These ideas might be presented to the children with remarks such as these:

- "There are many ways of making sculpture. As all artists do, choose one that is most comfortable for you."
- "Some kinds of modeling [or sculpture] require practice, just like learning a musical instrument or handling a ball. It may be difficult at first, but practice will help you make something you will want to keep."
- "Even a flat piece of sculpture [relief] can be made to catch light. Then it will make interesting surface patterns. Check the coins in your pocket, for example."

Sculpture has a universal appeal, and the problems of creating forms in space and of merging materials and processes with ideas engage the interest of people of all age groups.

Sculpture can be taught using simple materials, such as paper or boxes or wood blocks, or more sophisticated and difficult materials and techniques, such as those required for wood carving. Ceramic clay methods can be taught to all age groups. The following pages deal primarily with techniques for a variety of sculpture media and applications appropriate for children. We do not attempt to present a lesson or unit for each technique but expect that teachers will develop their own learning objectives, themes, and goals with their own students in mind. For more on lesson and unit development, see Chapter 17 on curriculum planning.

SCULPTURE WITH PAPER

Paper is one of the most accessible, least expensive, and most versatile materials for the making of art. Paper is not only used as a surface on which to draw, paint, print, and make collage but is also an art medium in its own right. Paper can be cut into intricate patterns; built into sturdy and detailed sculptures; or folded, expanded, curled, twisted, torn, rolled, laminated, creped, and scored. The art world has undergone a resurgence in the use of paper as a medium of artistic expression.⁴

Because paper has so many uses as a medium of art expression, there are no firm rules about when paper work should be offered in the art program. Paper can be used in sculpture or as part of a mixed-media process. The teacher should encourage children to test paper and to get some sense of its special qualities of strength, tension, and resilience. Children should learn that if they tear paper, it offers little resistance; yet if they pull it, another impressive strength is involved. The many different types of paper, from heavy cardboard to delicate rice paper, and its numerous forms, such as boxes, cans, cups, and cartons, make paper an ideal medium for experimentation by children. More sophisticated paper projects continue to interest children even into their adolescent years. The fact that mature artists use paper as a medium lends validity and integrity to its use in the school art program.

Box Sculpture

MEDIA AND TECHNIQUES

Probably the simplest type of sculpture for very young children is made with paper or cardboard boxes. The only supplies necessary are an assortment of small cardboard containers, masking tape or other sticky paper tape, and possibly white glue. Tempera paint and suitable brushes can also be supplied. The containers should vary in shape and range in size from, say, about 1 inch to 1 foot on each side. If possible, cardboard tubes of different diameters and lengths and perhaps a few empty thread spools should also be provided.

The beginning of this activity is very much like building with blocks. Young children are able to innovate and learn as they stack the boxes and watch them tumble down. Then the children can use masking tape to secure the paper containers and build a permanent structure. For a more stable sculpture, children can glue the boxes and secure them with tape until the glue dries.

Young children delight in gluing containers together to build shapes at random, and later they like to paint them. As might be expected, they first build without apparent plan or subject matter in mind. Very quickly, however, children begin to name their constructions. "This is a bridge," says 5-year-old Peter to his classmates, describing an object that faintly resembles such a structure. "This is my dad's factory," says José, who has placed a chimneylike object on top of a bcx. "I guess it's a castle," says Mary, describing a gaily painted construction. This parallels the naming stage in drawing that occurs at an earlier age.

Soon children begin to make plans before starting their work. One child might decide to make a boat; another, to construct a building and paint it red. Others may enjoy creating forms without any realistic associations. Thus, when working in sculpture, children tend to progress through the usual stages of manipulation and symbolic expression. When sculptures are complete, the students should discuss the choices that await them: to unify the forms by painting them a single color, to decorate the forms in color, or to add additional shapes and textures using paper or cardboard. Edgar Tolson, *Paradise* (1968). Carved and painted white elm with pencil, 12 $7/8'' \times 10''$. This innocent view of Eden includes Adam and Eve, the birds and animals, the serpent, and the fruited tree. Both rural and urban America have produced passionate, though untrained, folk artists. A section of the National Museum of American Art exhibits the delightful and insightful works of naïve artists.

Fifth graders achieved these three-dimensional effects by cutting, scoring, and folding. Above are some ways of developing three-dimensional forms in paper:

- a. Folding and bending
- b. Frilling
- c. Pleating
- d. Stretching
- e. Scoring
- f. Twisting

TEACHING

For children in the primary grades, little teaching is required apart from the usual general encouragement and an attempt to keep the children free of glue and paint. Children should have ample opportunity to discuss their symbols with the teacher and with one another. In this way their work will grow in clarity and completeness. The teacher should encourage children in this stage to add significant details in cut paper and in paint.

Older children construct marvelous sculptural forms using paper containers. These sculptures can become quite large—even taller than the student—and still remain lightweight and easy to move. The teacher can provide motivation by showing pictures or slides of sculpture. Modern, nonobjective, or abstract sculptures interest children and, at the same time, expose them to the real world of art. The sculptural forms of other cultures can be studied—for example, the monumental sculptures of ancient Egypt or the abstract forms of Mark di Suvero and African carvings. The following discussion describes how to implement a paper sculpture project based on the totem poles of the Indians of North America.

The teacher might begin by discussing with students what they know about totem poles—where they are found, how large they are, what they are made of, and what pur-

poses they served within the cultures that created them. Correlation with the social studies curriculum should be considered. As with any cultural studies, teachers must avoid trivializing concepts and practices held dear within respective cultures. Pictures of totem poles can be shown, studied, and discussed. When the children have become sufficiently knowledgeable to understand a related project, the teacher can suggest that they make their poles out of paper and cardboard containers. Depending on the ages in the group and the level of detail desired by the teacher, the children might begin planning totem poles based on ideas learned through their studies of Pacific Northwest cultures. They might give symbolic meaning to each figure and a definite order for the figures from bottom to top, just as real totems have. One of the central goals of such a curriculum unit is to foster knowledge and appreciation of cultures studied. In such a project, it is often desirable to encourage the children to work in groups of three or four.

The students begin construction by gathering a variety of rectangular, round, and unusually shaped containers and

Sculpture with boxes turns into costumes as these 11-year-olds become robots for a school play. The simple processes of pasting, joining, painting, and collage can be used to create sculpture, stage properties, or costumes. Japan, grade 6.

stacking them to create a polelike form. Flexible cardboard can be cut and shaped into tubes, triangular forms, and so on according to need. The pieces are taped together as the pole takes shape. At this point the class should decide what holes and notches to cut with a knife or scissors to make facial features and what shapes to add to make wings, arms, and headpieces fabricated from paper and taped onto the pole.

When the basic pole is completed, surface decorations of cut colored paper can be glued on or tempera paint applied. The entire construction and decoration can follow a traditional Native American theme or can be a contemporary adaptation of the totem concept. When grouped together in vertical structures, the results are often striking and impressive in their size and visual presence. In this type of project, children learn not only about an art medium, design, and technique but also about the art of another culture. A rich selection of visual art teaching resources is available to assist with multicultural art education.⁵

Freestanding Forms

Children in the upper-elementary grades find freestanding forms of paper sculpture challenging. The supplies required for such sculpture include the usual scissors, knife, construction paper, and cardboard; odds and ends of colored paper, tape, and glue; and a vast array of miscellaneous articles, such as drinking straws, toothpicks, and pins with colored heads.

MEDIA AND TECHNIQUES

The chief problem in developing freestanding forms in paper lies in the necessity to develop a shape that will support the completed object. A tentlike form is perhaps the first such shape children will devise. Later they may fashion a paper tube or cone strong enough to support whatever details they plan to add. In constructing a figure, for example, the children might make a cylinder of paper for the head, body, and legs. The arms might be cut from flat paper and glued to the sides of the cylinder. A hat could be made in a conical shape from more paper. Details of features and clothing might then be added with either paint or more paper.

Older children can use rolled paper, such as old newspapers, together with glue, tape, and sometimes wire to construct objects. Children who begin this work obviously must possess some ability to make plans in advance of production. Their plans must include an idea of the nature and size of the object to be fashioned. What will be its general shape? When this is decided, the underlying structure is easily developed. When the students are making a human figure, for example, arms, legs, body, and head may all be produced from rolled newspapers. A chief component, say, the body, should be taped at several places and other sections taped to it. Should one part of the creation tend to be flimsy because of extreme length, the students can reinforce it with wire or strips of cardboard or wood.

When the main structure is complete, the children can strengthen it by carefully wrapping 1-inch-wide strips of newspaper, dipped in art paste, around all parts of the object—until it looks like a mummy. While it is still wet, the children can add details, such as eyes, ears, and nose made of other objects. Art materials suppliers make several products for the paste, including wheat paste. Vinyl wallpaper pastes are generally acceptable.

TEACHING

The teacher will often find it necessary to demonstrate the techniques involved in general freestanding paper sculpture and rolled-paper sculpture. *It is important that teachers always try art projects themselves before introducing them to students.* This is the best way to anticipate problems and the need for demonstrations. As a project progresses, teachers should observe each pupil and be ready to make suggestions so an otherwise impractical improvisation in a paper technique can be successfully altered.

As the pupils gain experience, the teacher must emphasize the necessity of making reasonably detailed plans in advance. The pupils might make sketches of the basic shape of a figure so it can be accurately cut out. Even a sketch of a rolled-paper figure, in which some indication of proportions and reinforcement points is given, is occasionally helpful. In fact, the pupils and teacher together might well go through all stages of using a medium in advance of individual construction.

PAPIER - MÂCHÉ

Papier-mâché, or mashed paper, has been used as a modeling medium for centuries. Chinese soldiers of antiquity are said to have made their armor with this material. Mashed paper is strong and may be put to many uses in an art class. To prepare this claylike medium, tear newsprint into small

pieces. (Do not use magazine paper with a glazed surface, because fibers do not break down as readily into a mash.) Leave the torn paper to soak overnight in water. It is possible to use an electric blender to mash the paper in water, but it is not necessary. Instead, mash the paper in a strainer to remove the water or wring it in a cotton cloth. Four sheets of newspaper shredded will need 4 tablespoons of white glue as a binder. Stir until the pulp has a claylike consistency. If desired, add a spoonful of linseed oil for smoothness and a few drops of oil of cloves or wintergreen as a preservative. This mixture can be wrapped in plastic and stored in the refrigerator. The teacher can also purchase commercially prepared mixtures of papier-mâché that require only the addition of water.

Children can roll papier-mâché, model it, and produce objects such as vegetables and fruits. After the mashed paper has dried—a process that takes about a week—it can be worked with hand tools. The children can sandpaper the dried papier-mâché forms, bore holes in them, or carve and paint them. Acrylic paint is particularly useful, both for its brilliant color and its protective qualities. Objects painted with tempera paints should be shellacked, if possible.

Papier-mâché can also be used as a casting process for anything from balloons to masks that have been modeled in clay. When making a mask, use at least four layers of paper, alternating black-and-white newspaper with color (Sunday comics) to be sure that one layer is completed before beginning another.

Because paper is both versatile and inexpensive, papier-mâché can be used to create large forms. Papier-mâché can be draped or pressed on any surface, from balloons to modeled clay, and can also be squeezed into soft pulp and modeled very much like clay. When dry, it can be lifted off the base and painted. In the most ambitious project ever attempted in this medium, more than 1,000 children in Montreal modeled the subject of a banquet, complete with food, tableware, flowers, and people-their contribution to an international art education conference. Karen Carroll. photographer. (See InSEA in Appendix B.)

SCULPTURE IN PLASTER OF PARIS

For most children in the preadolescent stage, a suitable medium for sculpture is plaster of paris. A child who is capable of using any kind of cutting tool safely can use this material successfully. Plaster of paris can produce sculpted pieces with satisfying qualities either in relief or in the round and can be used with a few readily available tools.

Media and Techniques

The plaster is usually bought in sacks. Mix by sifting handfuls of the plaster into a pail of water until the plaster reaches the water level. Then, activate the mixture by sliding the hand under the plaster and moving the fingers around the bottom of the pail. This attains a creamy consistency without lumps. Waterproof gloves or other protection prevents possible skin reactions to the plaster. If the plaster tends to dry too quickly, slow the rate of drying by adding about a teaspoonful of salt for every 2 cups of plaster.

After it is mixed with water, pour the plaster quickly into a mold to dry and harden. Small cardboard containers such as milk cartons make suitable molds. [Children may also create their own molds by taping sections of heavy cardboard together.) The container is selected according to the type of work intended; a shoe box, for example, might have the right length and height for a plaque on which a relief sculpture could be carved, and a carton that held a large tube of toothpaste would serve as a mold for plaster to be carved in the round. When the plaster dries, which it does with extraordinary rapidity, it contracts slightly so the cardboard is easily peeled away.

Plaster may be combined with other materials, thus allowing for a choice in the degree of density. Students can mix, in various proportions, plaster, vermiculite, sawdust, dirt, and sand. Samples of these aggregates might be prepared and records kept of the degrees of hardness, kinds of texture, and so on that are obtainable with different proportions. Students can also add tempera for color and thus create truly personalized carving media. A number of commercial mixes for sculpture are available from school art suppliers.

The techniques used in cutting plaster are somewhat less difficult for children than those used with wood. Almost any cutting tool may be used on plaster—pocketknives, woodworking tools, linoleum cutters, or even worn-out dentist's tools. No special accommodation is necessary for

this work; the cutting can be done on an old drawing board. When cutting is satisfactorily completed, the children can lightly rub the plaster with fine sandpaper to obtain smooth surfaces where desired.

Another method of working with plaster is to dip surgical bandages or strips of cloth into plaster and drape them over armatures or other substructures. Rolls of plasterinfused gauze used for medical casts are excellent for this method. The sculptor George Segal has been responsible for a whole new direction in art with his plaster body castings placed in complete environments.

Plaster is one of the most versatile and least expensive of all art media. It does require more preparation and cleanup than many other activities, but it lends itself to

George Segal, Walk, Don't Walk (1976). Plaster, cement, metal, painted wood, and electric light, $104'' \times 72'' \times 72''$. Contemporary American sculptor George Segal created the figures in this work by placing wet plaster gauze directly on clothed models, then removing the hardened plaster in sections and reconstructing the complete figures. He placed them on a sidewalk-like pedestal with an actual traffic light. which provides the work's title. Segal has literally frozen a moment in time, presenting viewers of the work with the opportunity to contemplate at their leisure one of life's most common experiences.

working outdoors. Considerable care must be taken to keep the classroom floor clean, preferably with a damp cloth or mop to avoid making dust. If plaster bits are walked on, they are ground into powder that, when stirred up by activity, can cause an unhealthy breathing environment. Students leaving an untidy room after working with plaster can be identified by the trail of white footprints. Plaster and wood are in themselves two very good reasons for separate art rooms in all schools.

Teaching

This elegantly designed ceramic pot was handmade by Native American artists on the Acoma and San Ildefonso Pueblos in New Mexico. The black-on-black pot, from the collection of the National Museum of Women in the Arts, was made by the famous potter Maria Martinez, who, with her family, reinvented the forming and firing processes by studying ancient pottery made by their ancestors. Maria Martinez, Jar, San Ildefonso Pueblo, New Mexico (c. 1939). Blackware, $11^{1/_8''} \times 13''$. Martinez's highly prized pots are displayed in many fine museums and galleries in North America and abroad.

Because of the mixing and hardening processes, it is important for the teacher to carefully plan the demonstrations. Students often require more assistance in preparing the plaster than they do in working with it. The teacher should be sure the children know what their subject matter and technique will be before they mold their plaster. Low relief requires a flat slab, whereas sculpture in the round requires a block of plaster. Obviously, once the plaster is molded, the children are committed to work that suits the shape of the material. As for carving, the suggestions made earlier about wood carving are generally applicable to the problems that arise in working with plaster of paris.

CERAMICS: ART FROM EARTH AND FIRE

The field of ceramics is very broad, including the ancient pottery of many cultures; ceramic sculpture; and contemporary commercial, industrial, and studio pottery. The ce-

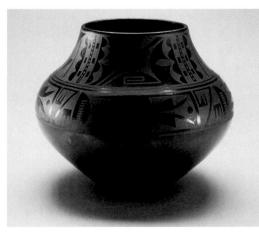

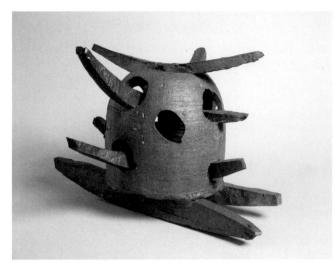

Peter Voulkos, *Rocking Pot*. Voulkos was a leader in making ceramics a fine art form as well as a utilitarian medium. This work exemplifies the artist's emphasis on the intrinsic quality of the clay material and the process of creation, using slab and wheel-thrown clay parts.

ramics industry influences our lives on a daily basis through production of many items, from ordinary cups and plates to fine china and industrial items, such as insulators and tiles used for space vehicles. However, it is the part of the ceramics industry that involves artistic expression that interests us here. Contemporary ceramic artists work with clay to produce sculptures, and studio potters make a wide range of hand-built and wheel-thrown utilitarian items. Taking clay from the earth, shaping it, decorating it, and firing it form a very old and very basic profession often passed down as a legacy within families.

MODELING WITH CLAY

Modeling is an activity in which children of all ages can participate. Clay has been a standard modeling medium in the schools for many years because it is inexpensive and easily manipulated.

Media and Techniques

Clay may be purchased, or it may be found in the ground in some localities, especially along lakes, bays, or small creeks. Any slippery, soapy earth having a red, blue, or

Soldiers from Pit 1, terra-cotta warriors, X'ian, China. Thousands of lifesize, individually sculpted, clay figures were created for Qin dynasty emperor Shi Huangdi and remained buried for more than 2,000 years. Like the Egyptians, this powerful leader created an elaborate tomb for his burial and hid the location, so the contents remained essentially intact.

whitish tinge and adhering tenaciously to the hands is probably clay. Working with the earth, however, will soon reveal whether or not it is suitable for modeling. Natural clay must usually be refined before it can be used as a modeling medium.

When purchased, standard dry clay (always cheaper than prepared clay) is usually packaged in 50- or 100-pound bags. In preparation for use, pour water over about half a pail of clay and mix it in with a spoon or stick. It takes about 5 quarts of warm water to thoroughly soak 25 pounds of dry clay. A tablespoon of vinegar added to the water will neutralize any alkaline content and make the molding process easier on the hands. After the clay has settled overnight, pour off any excess water. Clay also comes in a plastic state, usually in 25- to 100-pound bags. It is more expensive than dry clay because of the shipping charge for the added water content, but it is still relatively inexpensive. One pound of clay makes a ball the size of an adult's fist, and this is a good average amount for a child to work with.

Before modeling can be successfully performed, the teacher should knead and roll the clay on the porous surface until the clay is almost rubbery. When a coil of it can be twisted and bent so it neither breaks readily nor adheres unpleasantly to the hands, it is ready for modeling. A reasonably large quantity of clay for modeling may be prepared in advance and stored for a short time in airtight tins or earthenware containers. Small pieces of clay for each pupil may be subsequently cut away by means of a wire. Used clay can often be reclaimed by soaking it in water for about 48 hours and then placing it on a plaster slab (or *bat*) to dry to a workable consistency.

Before the children work with clay or other modeling materials, protect the working surfaces with newspapers, cardboard sheets, clear plastic, or oilcloth. The children will find it convenient to model the clay on a plywood board placed on the protective covering. While working, the children can turn the board to view the sculpture from all sides. Plaster bats provide both a working and a kneading surface.

Modeling in clay and other materials is essentially an activity fcr the hands and requires few tools. Sets of tools are available to assist children in producing details in their pieces. Tools can be made easily from Popsicle sticks or wooden tongue depressors broken lengthwise and sanded with sandpaper or shaped with a knife or file. Pointed or round-ended tools can be made from dowels. A damp sponge or cloth is useful to moisten the fingers and partially clean them at the close of the activity. The surface of the clay is a record of the children's individuality and should be preserved as part of their total response.

The child's stage of development in pictorial work is reflected in the output in clay.⁶ The youngest and most inexperienced children are satisfied with a short period of manipulation, after which the clay is left in a shape resembling nothing in particular. In a sense, an object made at this stage is a record of an investigation: a kind of scribble in clay. Later, the children may give a name to shapes of this kind. Still later, the symbols associated with drawing and painting may appear in the clay in three-dimensional form. Final y, preadolescents refine their symbols, aiming at greater detail and realistic proportion. Younger children are less concerned about the permanence of their objects than are older ones, who want to see their pieces fired and carried to completion through the use of glazes or paints.

There is no one technique recommended for modeling. Children begin to model naturally with considerable energy, enthusiasm, and, generally, dexterity. Given a piece of clay weighing from ½ pound for kindergarten and firstgrade pupils to 2 pounds for those in higher grades, children will squeeze, stroke, pinch, and pat it to get a satisfactory result. Whereas younger children may pull out their subject from a central mass of clay, they seldom draw this way, preferring to assemble objects out of separate parts. It is recommended that when demonstrating, the teacher offer both an additive method and modeling from a central mass of clay as options.

The finished product in clay must be a solid, compact composition. As they gain confidence in the medium, children attempt to form slender protuberances. These usually fall off, and children quickly learn not to draw out the clay too far from the central mass. They may add little pellets of clay for, say, eyes and buttons, but even these must be kept reasonably flat if they are to adhere to the main body of the clay. It is important to understand that clay shrinks as it dries, so if a wet piece is adhered to a drier piece, the wet one will shrink more in drying and will break off. Pieces to be joined must be similar in moisture content. The use

of watery clay, or *slip*, may help children fix these extra pieces. Slip is prepared by mixing some of the clay used in the modeling with water until the mixture has the consistency of thick cream. The child *scores*, or roughens, the two surfaces to be stuck together with the teeth of a comb, a knitting needle, or a pointed stick and then paints or dabs on the slip with the fingers before pressing the pieces together.

If worked on too long, clay becomes too dry to manipulate. To keep it sufficiently moist from one day to the next, wrap it in a damp cloth, over which is wrapped a plastic sheet, and, if possible, place the whole in a covered tin until it is to be worked again. When the work is finished and left on a shelf to dry, dampen it from time to time with water applied with a paintbrush. This prevents the small protuberances from cracking or dropping off before the main body of the work has dried.

Teaching

The teacher must be concerned with the preparation of the clay, the physical arrangements for handling it in the classroom, and the subject matter selected by the children. For the youngest children, the teacher must prepare the clay. For the older children, the teacher should provide step-bystep instructions and then careful supervision of their preparation of the medium. The students must prepare the clay correctly if the work is to be successful. The room and its furnishings must be adequately protected from clay dust and particles. The teacher should ask each child to spread

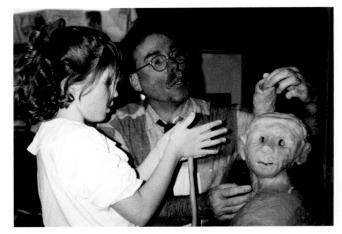

is nearly as tall as the fourth grader who created it! She worked closely with her art teacher, using the coil method and allowing the lower part to become firm before adding additional coils and weight. The child artist, Ashley, studied ancient Etruscan art in conjunction with an exhibit in a local art museum. The costume and pose of the ceramic figure were suggested by a picture from the exhibition brochure. This is an example from a teacher, Mr. Germaine, who encourages students to undertake large and difficult projects that require lengthy periods of work time. The results are memorable for the student. What effect might an accomplishment such as this have on a student's self-esteem?

This glazed ceramic sculpture

newspaper on the floor under the work area. Desks or tables on which the work is performed should be covered with oilcloth, rubber, or plastic sheeting, or with more paper. The teacher should keep many cleaning cloths dampened with water readily at hand and instruct the pupils to use them both when the work is in progress and when it is finished. The pupils must also learn to pick up the protective coverings carefully so clay particles are not left on the tables, desks, or floor.

Good teachers will see that adequate shelves are provided for storing clay work. Teachers should carefully supervise as each child stores the work and should make sure the products are in no way damaged during the storage process.

Subject matter for modeling in clay is somewhat restricted. Usually it involves one person or thing or, at the most, two persons or things resolved into a closely knit composition. Only objects or shapes that are chunky and solid can be successfully rendered. Thus, the human figure and certain animals, such as owls, squirrels, or pigs, which can be successfully stylized into a solid form, are more suitable subjects than naturally spindly creatures, such as giraffes, spiders, and flamingos. Students should discuss and select a subject in keeping with the nature of clay before they begin work.

Working from a posed figure can be a desirable activity for the upper grades. Positioning the human body and interpreting its general proportions can be exciting art experiences when carried through in both the flat and in-theround approaches. Students can establish a basic standing figure without too much difficulty, but to make the figure sit, crawl, sleep, and perform other such activities often requires a posed model.

Modeling in clay can be used to reinforce other learning in art. If fifth and sixth graders sketch the human figure, they can sculpt it as well, working either for heightened observation or for purposes of personal expression. If they are examining texture through collage, children can study texture further by impressing found objects—bark, string, burlap, and the like—into the responsive surface of clay.

LONG-RANGE PLANNING IN CLAY

Children at any age should begin by learning the basic vocabulary of form for clay sculpture: the slab, the coil, and the ball. The following activities provide examples of a sequence based on broad age levels.

A sense of animation can be readily achieved when the human figure is involved in handling an object. Japan, grade 4.

Standing figures can be supported by bottles or rolled-up newspaper. The unglazed examples shown here demonstrate the effect of additive detail and paint. Japan.

EARLY GRADES

- Make a flat slab of clay with the palms of the hands.
- Roll the clay into a thick coil, a thin coil, a big clay ball, and several small clay balls. How closely to a ball can you shape your clay? A square?
- "Pull" a bird out of one lump of clay, using a particular texture for feathers.
- Make a pinch pot out of one small ball of clay, striving for even wall thickness.

MIDDLE GRADES

- Join two pieces of clay together.
- View a video or DVD, or look at books illustrating the clay process and finished clay objects (Degas's ballerinas, Jacob Epstein's portraits, Mary Frank's figures and animals, and so on).
- Make a mother-and-child sculpture of one kind of animal.
- Make a prehistoric creature or dragon, embellishing it with natural textures by imprinting objects such as leaves or fir cones.
- Make a clay figure showing a particular emotional state.
- Make a clay figure showing some action, such as found in pre-Columbian village sculpture.
- A small group of the most advanced students can be responsible for firing clay objects under the supervision of the teacher. Clay need not be fired; it is the modeling experience that is important.
- Press a thick ball of clay onto a piece of wood. Press standing figures or other subjects into the clay. Standing subjects may be made of cardboard as well as clay. This activity works equally well for individuals or groups, all working from a shared theme such as military uniforms and costumes of 1776.

UPPER GRADES

- Make a large coil pot.
- Make a clay container. Decorate it with a pattern consisting of either an incised texture or added bits of clay. Combine slab technique with sections of coils.
- Make a three-dimensional version of a drawing or painting. Try making faces, lips, eyes, and noses.
- Make a ceramic slab wall hanging as a group project.
- Make a portrait that rests on a flat surface (relief sculpture).

 Gather a collection of bones of all kinds, and create bone forms with clay, linking forms in the manner of Henry Moore and Barbara Hepworth, two well-known British sculptors.

MAKING POTTERY

Containers from ancient cultures in China, Greece, South America, and many other parts of the world still exist in museums and private collections. Archeologists learn much about ancient peoples from their artifacts, which in many cases rival or exceed the quality of design and construction of the best work we are able to produce today.

Media and Techniques

Plasticene is an oil-based clay that does not become dry and hard. It cannot be fired and glazed, however, and therefore is not used when permanence is desired. Although more expensive than clay, it can be used repeatedly.

The two most basic hand-forming pottery techniques are the pinch and coil methods. Each of these methods has varying levels of sophistication, and they are often used together by an innovative potter. In the symbol-making stage, children can make pots by hollowing a solid lump of clay. Preadolescents are capable of what are called the coil and slab methods. A simple pinch pot is a good project on which to start a child at any age. Children may begin by shaping the clay into a ball and working the thumb of one hand into the center. They then rotate the ball slowly in the palm of one hand, gently pressing the clay between the thumb and the fingers of the other hand to expand the wall. The wall should be thick and the pot periodically tapped on the table to maintain a flat base. If the walls are thick enough, they may be subsequently decorated by incising lines or pressing hard-edged objects into the surface.

It is useful for children to know and apply a few basic concepts and terms as they make pottery. We have already mentioned that clay shrinks as it dries, so a bowl, cup, or other object should be made about 25 percent larger than the desired size for the finished piece. Children should be reminded to join pieces of clay that have about the same moisture content so they will therefore shrink together about the same amount. Clay that is allowed to dry until it loses most of its elasticity is called *leather hard*. Clay in the leather-hard state is very easy to work with. It is nearly rigid but not brittle. It is strong and can be carved or scraped eas-

Robert Arneson, *Portrait of George* (1981). One of the contemporary innovators in ceramics, Arneson created this 8' high monument to commemorate popular San Francisco mayor George Moscone, who was assassinated. This work was controversial because it contained references to the assassin and the bullets fired to kill the mayor. The commissioned work was returned to Arneson without payment and later sold to a private collector. This is one example of the many artworks that become important in social and political arenas and that often exert public influence.

ily. As the clay continues to dry, it becomes *bone dry*. This is the stage when pieces are extremely brittle and fragile. Bone-dry pieces should not be handled unnecessarily because this is the stage when most breakage occurs. Pots broken at this stage are very difficult to repair satisfactorily. When the pottery or clay sculpture pieces are completely dry, they will not feel as cool to the touch as pieces that still contain moisture, because the evaporation of water from **a** clay piece actually cools it. Only bone-dry pieces should be placed (stacked) in the kiln for firing. Pieces that are very thick, that have air bubbles in the clay, or that are not completely dry will very often explode during firing. A slow firing is best to minimize explosions and fractures. Slow cooling helps avoid breakage caused by uneven contraction between thick and thin parts of a piece of pottery.

Clay that has not been fired is called *greenware*, not because of its color but because of its immaturity. The firing of greenware is called the *bisque firing*, and the fired pieces are labeled *bisqueware*. After firing, the bisqueware is fused and hard and will no longer dissolve when water is applied. It is ready for glazing or other surface decoration. The firing of glazed bisqueware is called the *glaze firing*.

In producing coil pottery, children will find it convenient to work on a small board or plaster bat. They should flatten a ball of clay on the bat until the clay is about half an inch thick and then trim it with a knife to the desired size, usually about 3 to 5 inches in diameter. Next, the pupils produce a coil of clay about half an inch in diameter by rolling the clay. They apply the coil to the edge of the base. which should be scored and dampened with slip so adhesion is assured, and then pinch the coil to the base. Pupils should build a second coil on the first in the same way. No more than four or five coils should be made in one day, lest the assembly collapse under its own weight. After allowing the clay to dry for a day to become leather hard, the pupils may add another four or five coils. Pupils must cover the top coil with plastic and keep it damp so it will adhere well to the additional coils. This process is repeated until the bowl or pot has reached the desired height and shape.

The position of the coils determines the shape of the bowl. Placing a coil slightly on the outside of the one beneath it will flare the bowl; placing it toward the inside will diminish the bowl in diameter. Although a perfectly uniform bowl is not expected, nor indeed altogether desirable, it is necessary to examine the rising edges from all angles to see that the shape of the object is reasonably symmetrical. A *template*, or contour, cut in cardboard may be applied to the side of the bowl, but some teachers frown on this shaping technique for the good reason that it is mechanical and rather extraneous to the process of coil pottery.

When the outlines of the bowl are formed, pupils should either smooth both the inside and the outside with

The coil method of making pottery:

- a. Trimming the base
- b. Rolling the coil
- c. Applying the coil
- d. Smoothing the coil

e. Trimming the lip This technique can also be combined with sections of slabs on flat areas.

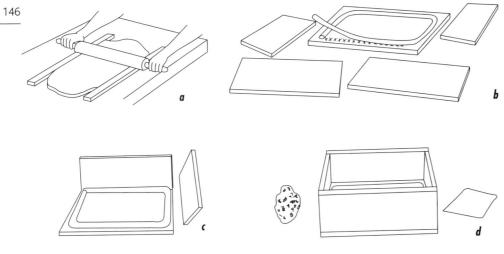

The slab method of making pottery:

- a. Preparing the clay
- Placing the supporting coil on the base
- c. Applying the sides or other vertical forms
- d. Smoothing the sides with sponge and sandpaper

their fingers or smooth just the inside for support and allow the exterior coil texture to show. Dipping the fingers in slip facilitates the smoothing process. Pupils should flatten or taper the lip of the bowl and perhaps trim it with a wire tool or knife. They should then cut the bowl cut away from the slab with a wire and may then gently smooth its edges with the fingers.

FINISHING PROCESSES

Media and Techniques

Several techniques may be used to decorate objects made of clay. These include glazing, incising, pressing with various objects, painting with *engobe* (colored slip), and incising through engobe, a technique known as *sgraffito*.

The successful glazing of clay requires skill and experience. First, the students must very carefully wedge the raw clay to remove air bubbles. Next, after the modeling is done, the object must be dried thoroughly. Then a kiln or oven must be stacked with the pieces for preliminary or bisque firing. When the first firing has been successfully completed, the students must apply the glazes. Always check a prepared glaze to be certain it does not contain lead. Stack the kiln in such a way as to prevent the glazes on one object from touching another, and then complete the second process of firing and cooling. Although it produces lovely results, glazing is a complicated process, and few people learn to do it merely by reading a book on the subject.

Incising involves scoring the clay with various objects. The clay must be partly dry before incising can be done. Students can repeatedly press any one of a number of objects, ranging from nails and knitting needles to keys and pieces of comb, into fairly moist clay to make an interesting pattern.

Engobe, or colored slip, is underglaze pigment. Commercially prepared engobe is available from school supply houses. The engobe is painted on nearly dry (leather-hard) clay with a sable brush. When the painted clay is dry, it must be fired as described earlier. A second firing is required if transparent glaze is applied over the bisque-fired engobe.

Sgraffito combines both incising and painting with engobe. Engobe is painted onto the partially dried object. In

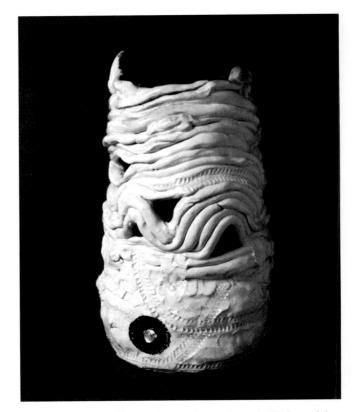

This pot by 12-year-old Brent shows an interesting and skillful use of the coil method.

order to get thorough coverage and to avoid streaks, students should apply two coats—the first by brushing consistently in one direction, the second by brushing consistently in another direction. When the engobe coats have almost dried, students incise lines through them—usually with a stick—to the clay before firing the object.

Some teachers experiment with approaches to surface decoration, which may include acrylics or tempera paint. In the latter case, when the paint is dry, it may be left matte (nonglossy) or covered with a protective coating of shellac. Acrylic paints, unlike tempera, will not come off when the object is handled. Shoe polish gives a pleasing surface tone and may be used in place of paint; it comes in a surprising range of colors. In all cases the clay should be bisque fired before a coating is applied.

Teaching

Sculpture and ceramics, like any art form, should challenge a child within the boundaries of enthusiasm and capability, providing experience in depth and breadth. As in drawing, there is a time to work from observation and a time to work from one's imagination; a time for ideas that move quickly and a time for extended sequential approaches. Children may carve and model as artists have done for ages, or they may combine assembled constructions with light and motion. They may also take a functional form—such as a container—and endow it with some human attribute. When ideas become as important as form, then pottery moves closer to sculpture. In a broad sense, sculpture in particular may be said to encompass many kinds of volumes and masses organized within a spatial context. It can be created with boxes, junk, papier-mâché, clay, or plaster. During the course of six or seven years in an elementary school, a child should have the pleasure of working with many approaches.

Although a conscientious teacher plans for most of the activities, a portion of the program should be left open for the unexpected—a windfall of unusual materials, a trip to a gallery, a magazine article, or an acquaintance with a professional artist could capture the interest of both students and teacher in a new activity.

A fourth-grade class decided to create the environment of a tropical rain forest. They covered the walls with murals, hung vinelike treatments of paper from the ceiling, and attached papier-mâché and stuffed paper sculptures of birds and other animals to both the murals and the ceiling. Such installations can include any and all art forms and media, so long as they are generated by an idea or theme. If the work is idea centered, it is closer to what is known as an installation; if the work's emphasis is on a particular place rather than a concept or an idea, it is an environment. This is an example of the difficulty of categorizing works that overlap in media and intent. Because "Tropical Rain Forest" is a collaborative effort that exists in space and utilizes three-dimensional form, it can also be viewed as an activity that could not have existed at the turn of the century when art education was focused primarily on drawing.

NOTES

- 1. Charlotte Rubinstein, American Women Sculptors: A History of Women Working in Three Dimensions (Boston: G. K. Hall, 1990).
- 2. Cathy Weisman Topal and Lella Gandini, *Beautiful Stuff !: Learning with Found Materials* (Worcester, MA: Davis Publications, 1999).
- 3. Howard Fox, *A Primal Spirit: Ten Contemporary Japanese Sculptors* (Los Angeles: Los Angeles County Museum of Art, 1990).
- 4. Nicholas Roukes, *Sculpture in Paper* (Worcester, MA: Davis Fublications, 1993).
- 5. Crizmac Art & Cultural Education Materials, Inc., Tucson, AZ: http://crizmac.com/.
- Claire Golomb, "Sculpture: Representational Development in Three-Dimensional Medium," in *Handbook of Research and Policy in Art Education*, ed. Elliot Eisner and Michael Day (Mahwah, NJ: Lawrence Erlbaum Associates, 2004), pp. 329–58.

- 1. Survey the district around your school for materials suitable for sculpture and pottery. Can you find any clay, wood, or wire? Test the materials according to the suggestions found in this chapter under the subheadings "Media and Techniques."
- 2. Roll a slab of clay big enough to wrap around an oatmeal box. Press rows of designs into the clay with hard-edged objects, such as seed pods, coins, tools, wood ends, and the like. Keep a balance of large and small shapes and deep and shallow marks. Wrap the slab around the oatmeal box, and seal the joined edges by pinching them. Remove the oatmeal box. Add a clay base, and fire the object. You will have a unique container.
- 3. Visit a local bookstore or library, and find books on ceramics. Browse through books with ceramics work from various countries and cultures, for example, Native American, African, Chinese, and pre-Columbian. Look for examples of ceramic art that suggest teaching and learning activities for you and your students. Make copies, color copies, or slides to begin a file of teaching

resources. Follow the same procedure for sculpture from a variety of times, places, and cultures.

- 4. Make freestanding paper figures of animals or people, based on each of the following basic forms: (a) a tent made with one simple fold, (b) a cylinder, and (c) a cone that may be cut to shape after twisting and gluing. Devise heads and legs by cutting and shaping paper and gluing it in place. Add features and details of clothing by gluing cut-paper pieces to the basic shape.
- 5. Make an object out of rolled newspaper. Roll the newspaper into a tight cylinder for the body, and tie it with string in three or four places. For arms and legs, make thinner cylinders of newspaper also tied with string. Tie the arms and legs to the body. Next, either model the neck and head separately and attach to the body or bend them under as an extension of the body cylinder. Dip strips of newspaper or paper toweling about 1-inch wide into paste, and wrap them around the figure. When the object is dry, add details with colored paper, scraps of fur, and so on. Finish with paint and shellac.

SUGGESTED READINGS

- Bruce, Susan. *The Art of Handbuilt Ceramics*. Wiltshire, UK: Crowood Press, 2000.
- Causey, Andrew. Sculpture since 1945. Oxford History of Art. Oxford, UK: Oxford University Press, 1998.
- Chavarria, Joaquim. The Big Book of Ceramics: A Guide to History, Materials, Equipment, and Techniques. New York: Watson-Guptill Publications, 1999.
- Curtis, Penelope. Sculpture 1900–1945: After Rodin. Oxford History of Art. Oxford, UK: Oxford University Press, 1999.
- Gregory, Ian. Sculptural Ceramics. New York: Overlook Press, 1999.

Kong, Ellen. The Great Clay Adventure: Creative Hand-

building Projects for Young Artists. Worcester, MA: Davis Publications, 1999.

- Nierman, Kevin, Elaine Arima, and Curtis H. Arima. *Kids* 'N' Clay Ceramics Book. New York: Tricycle Press, 2000.
- Potts, Alex. *The Sculptural Imagination: Figurative, Modernist, Minimalist.* New Haven, CT: Yale University Press, 2000.
- Roukes, Nicholas. *Sculpture in Paper*. Worcester, MA: Davis Publications, 1993.
- Rubinstein, Charlotte Streifer. American Women Sculptors: A History of Women Working in Three Dimensions. Boston: G. K. Hall, 1990.

- Smithsonian Institution. *National Museum of American Art.* New York: Little, Brown, 1995.
- Spivey, Richard L., Maria Montoya Martinez, and Herbert Lotz. *The Legacy of Maria Poveka Martinez*. Santa Fe: Museum of New Mexico Press, 2003.
- Topal, Cathy Weisman. Children, Clay and Sculpture. Worcester, MA: Davis Publications, 1998.
- Vincentelli, Moira. *Women Potters: Transforming Traditions*. Camden, NJ: Rutgers University Press, 2004.
- Watson-Jones, R. Contemporary American Women Sculptors. Phoenix, AZ: Oryx Press, 1986.
- Williams, Arthur. Sculpture: Technique, Form, Content. Worcester, MA: Davis Publications, 1995.

WEB RESOURCES

Heritage Preservation, "SOS/4KIDS," *Save Outdoor Sculpture:* http://www.heritagepreservation.org/ PROGRAMS/. Presents online programs that teach kids how to look at sculpture and preserve it.

Hirshhorn Museum and Sculpture Garden: http:// hirshhorn.si.edu/. Includes online artist biographies, object information, and activities related to sculpture.

- Minneapolis Sculpture Garden, Walker Art Center: http://garden.walkerart.org/ Includes collection images, virtual tours, online student activities, and extensive education resources related to sculpture.
- Museum of Modern Art: http://www.moma.org/. A highly creative website that includes interactive programs for students as well as online teaching resources and curriculum.

- Sandy Skoglund Art Site: http://www.sandyskoglund .com/. Focuses on great images of Skoglund's sculptural installations.
- SculpturesitesGR.org: http://www.sculpturesitesgr.org/. Features an impressive collection of modern and contemporary sculpture collected by the city of Grand Rapids, Michigan.
- Smithsonian American Art Museum: http://americanart.si .edu/education/teach_resources.cfm. Includes among the numerous educational resources high-quality online teaching guides and collections of images related to American sculpture.
- Storm King Art Center: http://www.stormking.org/. Site for one of the most important outdoor sculpture collections in the United States.

PRINTMAKING

A fine print may be produced lovingly and patiently, or violently and impetuously dependent upon the "climate" of the printmaker. From a fleeting idea wrested from the complex of human experience, worked through to the final visual image on paper, the print is employed as a medium in its own right.

— Jules Heller, Print Making Today

Drawing, painting, sculpture, and ceramics are very old modes of art, whose origins exist prior to historical records. Printmaking might have occurred when our distant ancestors colored the palms of their hands with pigments and pressed them against cave walls. However, the art of printmaking as we know it today required a technological innovation that is less than 2,000 years old. This innovation was the invention of paper, which is required for the making of prints. Paper, not to be confused with

A block print by a student from Czechoslovakia.

the much older Egyptian material *papyrus*, was invented in 105 CE by a Chinese eunuch, Ts'ai Lun.

The Chinese also invented the oldest form of printmaking, the woodcut. Wood-block pictures and texts existed in China hundreds of years before the first prints appeared in fifteenth-century Europe. The advent of printmaking was a wonderful innovation for artists and for appreciators of art. Now artists could create *multiples* of their work that could be sold at lower prices to collectors. After carefully preparing the woodcut or other printing surface, artists were able to make dozens or even hundreds of signed original artworks instead of only one, as is usually the case with drawing, painting, and sculpture. Because of the lower costs of prints, many more people can afford to collect and enjoy original art.

Four traditional processes continue to be used, some-

times in combination. Each of these processes is used by printmakers in many variations:

Relief process: Woodcut, linoleum cut, stamps, rubbings, and so on. The design area stands out and receives the ink. The rest of the block is cut away so it cannot print when the surface is inked.

Surface process: Lithography. The image is drawn directly on the stone (or metal) surface with a greasy crayon or ink. After treatment of the stone with turpentine and water, ink is applied to the surface, adhering to the greasy drawing, and a print is made.

Intaglio process: Etching, aquatint, engraving, drypoint, and so on. Used in many variations, intaglio is basically cutting or scratching into a surface (usually metal) with tools or acid. The cut areas receive and hold the ink for printing.¹

Stencil process: Silk screen (serigraph), photographic silk screen, paper stencil, and so on. Stencils as used in a school situation consist of cutting out or removing shapes from paper or cardboard and filling in the blank space with paint or ink. Stenciling was a tech-

Rembrandt van Rijn, *The Angel Departing from the Family of Tobias* (1641). This etching is an example of how the artist can achieve fine shading, dramatic contrast of dark and light, and active motion purely through the use of massed line. Rembrandt had a lifelong interest in biblical themes as sources for his drawings, prints, and paintings. Metal etching plates are usually "scored" or destroyed when the print edition is completed to avoid subsequent unauthorized printing.

nique used to make wallpaper and decorate furniture in the nineteenth century.

Newer electronic technologies available in many schools include the regular photocopy machine, color copies, and fax transmissions. At the professional level many artists have their work produced on a computer-controlled printer (IRIS or Giclée), which utilizes a system of very small and accurate color ink jets. Traditional drawings, watercolor paintings, and prints can be scanned into the computer and reproduced in desired quantities on the computer printer. In addition, graphic works of art created on the computer can be printed out. Print editions created through computer technologies are subject to the same ethical and legal conventions of edition number and limitation as are traditional methods.

This chapter discusses variations of these printmaking processes that are within the capabilities of children and the resources of most schools. In all printmaking activities in school classrooms, teachers can relate the process to those used by mature artists, using examples of the best works.² Also, teachers should educate children about printmaking in their everyday lives. These same processes are seen in commercial publications, illustrations, and advertising and on almost every T-shirt with a graphic image.

For preschool children to teenagers, printmaking is a source of fascination and challenge. In contrast to drawing and painting, paper work, and sculpture and pottery, which are largely direct activities, printing is an indirect process; something is done to one substance in order to produce an effect on another substance. Between the child and the finished print, in other words, lie a number of moves with intermediary materials that must be completed successfully before the final image itself appears.³

It is this emphasis on process that intrigues preadolescents so that they often lose their self-consciousness about the quality of the end product. Why worry about accuracy of shape when it is so much fun to gouge the wood, roll on the ink, and transfer the image? Because printing processes exert especially strong influences on the final product, the treatment of subject matter often requires considerable modification to suit the technique. Children will soon discover that details and shading are more appropriate to drawing than to printmaking and that a successful print makes a strong impact through simplification and contrast.

This chapter includes suggested activities for children related to the printmaking processes just mentioned. Ex-

perimental printmaking with such unorthodox materials as corrugated cardboard, collographs, collage, and clay is also discussed. The search for new solutions to traditional problems is as much a part of contemporary printmaking as of painting, and every public school art program should provide for some degree of experimentation in basic art forms.

RUBBINGS

One way to begin printmaking at any level is by transferring a ready-made surface—that is, by making a rubbing. This is an effective way to draw attention to unusual surfaces that may go unnoticed. A gravestone, a coin, a cracked part of the sidewalk, a manhole cover, or a section of grating all have a presence waiting to be revealed by rubbing the side of a crayon on a sheet of paper placed on the sub-

Suzuki Harunobu, *Woman with Mirror* (c. 1770). This beautiful print is a wood block with colored ink on paper. Notice the flat colored areas and the delicate lines possible with the woodcut process. Compare this to Mary Cassatt, *The Bath* (1891). An American impressionist, Cassatt was influenced by Japanese printmaking techniques and style. Notice the ways this print is similar to Harunobu's *Woman with Mirror*. Note Cassatt's use of line, flat color, and pattern in relation to the Japanese print. *The Bath*, however, is not a woodcut but is made with several intaglio techniques: drypoint, etching, and aquatint. Other artists influenced by Japanese techniques include Edgar Degas and Toulouse-Lautrec.

ject. Colors can be changed for different sections of the image, and the paper moved from time to time to create new patterns. Rubbings are not only a way of sensitizing children to the realm of texture but also a means of attuning them to the "skin" of the environment.

The paper should be lightweight so it does not tear easily and light in tone to provide high contrast. (Ordinary printer paper is adequate for small objects.) When they use crayons, students should be encouraged to blend colors. Large primary-color crayons are fine for this activity, but if the budget will allow, Japanese rice paper and crayon pastels offer the most handsome results. In taking rubbings of raised type—as on manhole covers—students can improvise with the image by rearranging the pattern or form, repeating it, or changing the position of the paper. Broken crayons work well for rubbings when applied with the flat side rather than the point.

Maria, the 9-year-old American girl who created this monoprint, gave it the title "Myself in a Garden." She used a bristle brush and a wide range of color to attain the rich texture typical of the monotype process. The print is $17'' \times 24''$.

MONOPRINTS

The printing technique most closely allied to drawing and painting, and to which any child may transfer some picture-making ability, is called *monoprinting*. Although

not as well known as other print forms, monoprinting has a stronger historical background than most teachers realize. Rembrandt used a monoprint technique in making his copper plates. By the mid-1890s, Degas was a leader in this technique. Monoprinting has enjoyed a recent revival of interest among printmakers, some of whom wipe away color from a surface (subtractive method) and some of whom prefer to add color to the plate (additive).⁴

Media and Techniques

The supplies required include a sheet of glass with the edges taped so the children cannot cut their hands. Instead of glass, a piece of linoleum or masonite may be used, measuring about $6'' \times 8''$ and preferably glued to a slab of wood. In the lower-elementary grades, children may use finger paint or tempera directly on the table, because it is easily cleaned with a damp cloth or sponge. They may use brayers, brushes, pieces of stiff cardboard, and fingers, depending on the desired effect. Water-soluble ink and paint in a wide range of colors are available, as are newsprint and other reasonably absorbent papers.

The monoprint process begins with application of paint or printing ink to a flat surface (glass, linoleum, or masonite). Students can apply the paint on the surface evenly or freely using as many colors as desired. If students use glass, they can prepare a drawing and place it under the glass to guide the painting. Use thick glass to avoid breakage, and always make certain the edges are bound with masking tape. When the painted image is complete, cover it with a sheet of paper and apply pressure slowly and evenly with a brayer or the palm of your hand. The three factors that influence the final result are the viscosity of the paint or ink, the pressure applied on the paper, and the paper's degree of porosity.

Students can produce a drawing with almost any implement that can make a strong mark directly into the ink. The eraser end of a pencil, a piece of cardboard, and a broad pen point are but a few of the suitable tools. The drawing, which is made directly in the ink, must be kept bold because the inked surfaces do not show fine details. Only the ink that is left on the surface will be recorded in the final printing.

An interesting variety of prints can be obtained by using printing papers with varying textures. Although newsprint is recommended because it is cheap and absorbent,

Fanny (1985). Perhaps the first prints in history were made by the artist's hands alone, with no other tools. Artist Chuck Close chose to use only his fingerprints and handprints to create this portrait. The work is 10' high and 7' wide. Working from a photograph he took of the elderly woman, Close touched the oil paint, then applied it with his finger to capture this astonishing detail.

other papers should also be tried, such as colored tissue, construction and poster papers, and even the coated stock found in magazine advertisements.

In another method of monoprinting, the pupil covers the glass with ink in the usual manner and then gently places the paper over the inked glass. Next, the pupil draws with a pencil on the upper side of the paper, taking care not to drag the side of the hand on the paper. The resulting print is a composition of dark lines with some imprint of ink on the background areas. Because children have a tendency to over-ink the plate, they should try a test mark on the corner and lift the paper to see if the line is visible.

Drawing in monoprint creates an arresting line quality—soft, rich, and slightly blurred and utterly unique. Because of this, it is particularly appropriate as an adjunct of contour-line drawing in the upper grades.

Another variation of monoprinting is the *paper stop out* method. The pupil cuts or tears paper forms and then places them in a desired pattern on the inked plate. The impression is made by placing fresh paper on the arrangement and rolling it with the brayer. The cut-paper forms beneath serve to "stop out" the ink, and the areas they cover will appear as negative in the finished print.

Teaching

Four main tasks confront the teacher of monoprinting. The first is to arrange tools and supplies so printing may be done conveniently; the second is to see that the ink does not get all over the children; the third is to give stimulating demonstrations and the fourth is to make certain that an area is cleared for wet prints to hang or otherwise be stored until they dry.

Printing should be done on a long table covered with newspapers or oilcloth. At one end or at several points on the table, the teacher should arrange the glass, brayers, and inks. Because it would be uneconomical for each pupil to have a separate set of printing tools, the pupils should be given an orcer in which to work. Those who are not printing should know what other activities are available. As each print is completed, the child should place it carefully on the remaining table space. When all the children have finished, the teacher should encourage them to select the prints they consider most interesting. When wet, the prints can be hung with clothespins on an improvised clothesline and then, when totally dry, pressed between the leaves of a heavy book such as an almanac or a telephone book. When possible, clear a wall on which to mount new prints for drving.

As can be imagined, a large amount of ink comes off on the children's hands. The teacher should make sure that the children either wash their hands often or at least wipe them on a damp cloth. Unless the classroom has a sink, the teacher must provide pails of water, soap, and towels or damp cloths. Make certain all paints or inks are water soluble

The teacher should efficiently demonstrate all methocs of monoprinting. Although the techniques are simple enough, monoprinting can be very messy unless the teacher has had some previous experience with the work.

This colorful print was made by Anna, a 7-year-old who enjoyed experimenting with color selections. She printed with several objects to create repetition, rhythm, and pattern.

Pupils find monoprinting challenging and stimulating. Once they know how to begin, they are eager to discover all the possibilities of this technique. It is a valuable activity not only because it permits spontaneous work but also because it gives children a reasonably accurate idea of the printmaking process in general. Any form of printmaking works well for small groups, especially when they try it for the first time.

POTATO AND STICK PRINTING

All children can produce potato prints, and nearly every child in the primary grades can print with sticks, cross sections of fruits and vegetables, and random objects.

Media and Techniques

For potato printing, children should select pieces with a hard consistency. The pieces should be large enough for the children to grasp easily and should be cut flat on one side or end. All the children need do is dip the flat side of the potato into watercolor, tempera paint, or colored ink and then press it on a sheet of newsprint. The child in kindergarten at first dabs at random but later can create rhythmic patterns. Scraps of sponge may also be used in this type of printing.

The next step is to control the design by cutting into the end of the potato. Students should slice the potato in half and cut the design into the flat side. If a design of a different shape is wanted, they can trim the printing surface into a square. Tempera may then be painted over the designed end, after which printing on paper may begin.

The children may also obtain interesting shapes by using a variety of wood scraps. If the wood is soaked in water for an hour or so, the grain swells and creates patterns. Students may then dip the wood scraps in paint and apply them to the printing surface. In such cases, the design rests on the arrangement of odd shapes and colors rather than on the broken surface of one piece of wood. Students might combine the two techniques. Rubbings can also be applied.

An easily manipulated material to use instead of potatoes or sticks is the square soap eraser. The surface is soft enough to be cut by a pin, yet the edges can hold up for dozens of impressions. The six available sides also allow for a variety of imprints.

Teaching

Because the techniques involved in potato and wood-scrap printing are appealing in themselves, the teacher should have no problem motivating the children. The chief task is to encourage every child to explore the numerous possibilities of the process. The children should be encouraged to find and use many kinds of vegetables and other objects suitable for printing. The teacher should also suggest that background papers for these types of printing can be specially prepared by laying down thin color with a wide brush (see the later section on mixed-media techniques).

Square soap-eraser printing can be made equally challenging. The pupils can use all six sides of an eraser with different designs on each printing surface. Also, combinations of colors should be tested. Backgrounds can also be painted with thin watercolor. Few, if any, problems will arise over subject matter. Only nonobjective or highly abstract patterns can result from this work, and the techniques lend themselves to repeated patterns rather than to picture making. When individual units are used in a random fashion, students can fill in the in-between negative spaces with chalk or crayon.

STYROFOAM, LINOLEUM, AND WOODCUT PRINTING

A good introduction to the relatively complex method of linoleum and woodcuts is the Styrofoam print. Styrofoam is a soft, inexpensive material that can often be obtained by

A sixth grader studies the work of his classmates before beginning his own print.

trimming the sides of food containers. All children need is a pencil to press lines onto the soft surface. The lines will remain incised, and the ink can be rolled over the surface before applying paper for printing. After children make such a print, they understand the process on which more difficult techniques are built.⁵

Media and Techniques

When the linoleum or wood has pieces cut out of it, is inked, and finally, is pressed against a suitably absorbent surface, a linoleum or woodcut print results. The raised parts of the surface dominate the image. Only the more mature students in the upper grades will be capable of this work. Safety precautions should be taught and reinforced regularly.

The usual heavy floor linoleum with burlap backing is suitable for cutting. It may be purchased from furniture and hardware stores or from firms that lay floor cov-

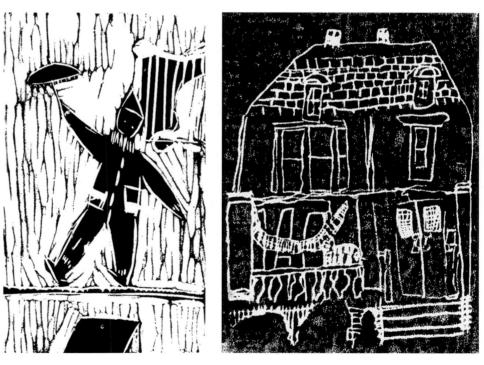

The print of the clown by a Brazilian seventh grader reflects the student's awareness of the capabilities of the medium (linoleum). The house print executed by a second grader on a piece of Styrofoam has been approached as a drawing. Although limited as a print medium, Styrofoam serves as an effective introduction to printmaking through the use of one element—line.

ering. Linoleum should not be confused with vinyl floor coverings, which are synthetic materials. Although less popular today, linoleum is still produced and carried by some home centers. Linoleum comes in large sizes, but scraps of it can often be obtained at a discount. Small pieces may be cut from a larger piece by scoring the linoleum with a knife and then bending it.⁶ Linoleum can be purchased from art supply stores or catalogs, already affixed to wood blocks.

The teacher will need to supply sets of linoleum cutters and short holders for them. These sets consist of straight knives, V-shaped tools, and U-gouges of varying sizes. The knives and gouges are perhaps the most effective tools, although the V-tool is capable of producing some highly sensitive lines and interesting textural effects. It is especially important to keep the tools sharp, and for this purpose the teacher may buy a specially shaped oilstone.

For receiving the impressions, almost any reasonably absorbent paper is suitable, from inexpensive newsprint to the costly but delightful Japanese rice paper. Paper that is

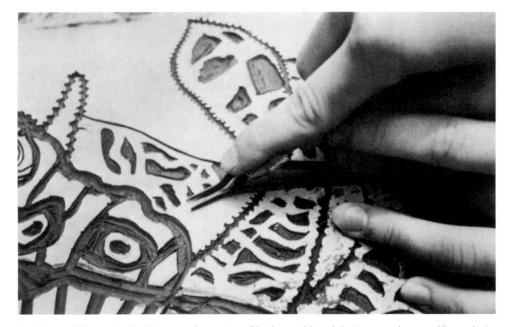

An 11-year-old is cutting his design on a large piece of linoleum. Although basic space, shape, and linear decisions should be made in advance, the scale of the print makes it possible to embellish and enrich the surface. (Note the position of the cutting hand in relation to the supporting hand. Safety precautions are vital whenever sharp instruments are involved.)

thinner than newsprint tends to stick to the block, and paper heavier than 40-pound bond or construction paper does not have enough resilience to pick up all the details of tool marks. Many textiles, including cottons, linens, and silks, will be found practical for printing if their textures are not too rough. For printing on textiles, an oil-based or printer's ink is necessary to obtain a lasting color; otherwise, a water-based ink may be used. A few other supplies are also necessary—rubber brayers and a sheet of plate glass to be used as a palette.

In cutting the linoleum, many people use the V-tool to make a preliminary outline of the main areas of the composition. Various kinds of textured areas may be made by cutting parallel lines, crosshatching lines, or removing "pecks" of linoleum with the V-tool.

Teaching

The chief problems in teaching linoleum printing concern safety precautions, the development of skill in cutting, and the treatment of subject matter. Organization of the classroom is similar to that required of stick printing.

Linoleum and woodcut printing have often given rise to some unfortunate teaching methods concerning the selection of subject matter. Even teachers who have emphasized the importance of developing original subject matter in the direct processes have allowed pupils to copy designs for their work in linoleum and wood so they may concentrate on technique. Such a teaching practice, however, proves in the long run to be as ineffective when applied to cutting as it does when applied to other types of art. No matter what the art form being produced, design and technique must develop in close relationship to each other. At first, children should work directly with the material. Rather than attempt to follow a drawing, they should explore ways of cutting. After becoming acquainted with the cutting methods, they can follow the teacher's suggestion of making some preliminary sketches. By that time they will have insight into the limitations of the medium and will realize to what extent a plan may help them in their work.

In printing, sketches can also be transferred to the plate with carbon paper or by covering the back of the sketch with an even tone from a soft lead pencil. Children should be encouraged to think in terms of the clarity of print qualities rather than of less defined characteristics as-

It is impossible to attain quality of product without adequate time and extended concentration. Ten- and eleven-year-olds can plan highly developed designs on a large scale ($12'' \times 16''$) when the entire printmaking experience is taught in a sequential way. To create her print (above), the fifth-grade girl drew first, transferred the drawing to a plate, and then cut the design and printed it on a variety cf grounds (collage, wet-in-wet color accidents, photomontage, colored tissue paper). The entire sequence is planned for six sessions.

sociated with painting. Because the children are working in media that do not permit a great amount of detail or halftones, their preliminary sketches and planning should be done in a single tempera or ink tone rather than pencil or crayon.

Often a display of the entire process of making a cut is helpful in starting the children to work. After that, further demonstrations of technique may be necessary from time to time. These, however, should be kept to a minimum so children can develop their own methods of working. Lino-

A linoleum-block print by a group of fourth graders. Water-based ink was used on a discarded cotton sheet (which then served as a window curcain). Permanent, washable inks with an oil base may also be used. This is an effective way to utilize an entire class effort for a practical purpose. Every child's pr nt can be used, because pattern and repetition, by their very nature, will flatter any single unit of the design.

leum in particular, unlike some other substances, is a medium that allows many variations of approach to be discovered through experience.

The possibilities for exploration of linoleum are endless. The various types of cuts, the selection of different papers, the use of two or more colors on the same block, the placing of units on textile, and, for sixth-grade pupils, even

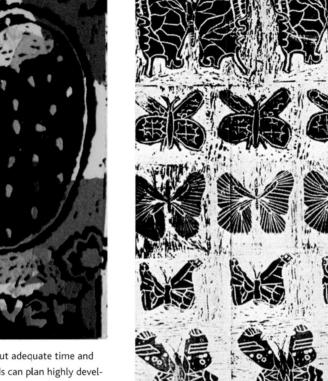

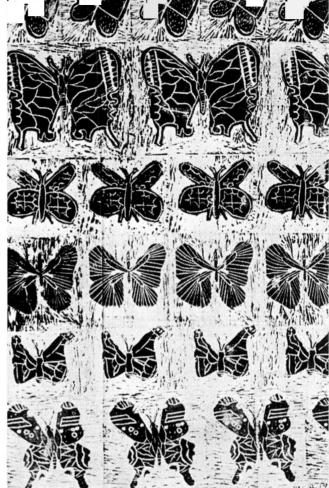

Fifth-grade students of accomplished elementary-art teacher Carolyn Shapiro created these block prints of owls during a unit that integrated art learning with biology and environmental issues. Activities ranged from reading and drawing to examining the bird's pellets to determine its diet. These works are good examples of unique creative responses to a specific assignment. All the owl pictures have certain factors in common, yet each conveys a child's personal expression. The prints measure 12" by 16".

the use of two or more blocks to form a pattern may all be challenging work in this art form.

The preparation of the print surface is an art project in itself. Consider how the following backgrounds will alter a black-and-white print:

Collage of magazine clippings A page from a telephone book Mingling pools of tempera paint on wet paper Marbleized paper Monoprints of tempera or finger paint Handmade paper Collage of colored tissue paper Pages from Sunday newspaper comics

These backgrounds may be used for random effects, or they may be planned with the design of the print in mind.

Some artists whose work in linoleum and wood the children will enjoy are Picasso, the Mexican artist Antonio Posada, and several of the German expressionists. Mexican folk art and medieval and Japanese woodcuts are also rich background sources for appreciation of printmaking.⁷

THE REDUCTION PROCESS

Another variation of the linoleum method is the *reduction* or *subtractive* print. In this method children can begin by printing "an edition" (a dozen or more impressions) in one color. Students remove or reduce a section of the plate. Then they add a second color and print over the first "reduced" position. When this is repeated a third or fourth time, a very rich surface develops, in addition to the added factor of a multicolored print. The original plate is destroyed in the process, of course, but another print form has been created.

In cases where more than one print is made, the student should indicate the number of prints planned for the series and the number of the print within the series. For example, 20/10 would indicate that of the 20 prints executed, this one is the tenth in the series. Numbering prints is one way for students to identify with professional printmakers.

COLLOGRAPHY

The making of collographs involves cutting shapes out of heavy paper or cardboard, gluing them to another board for backing, inking the entire surface, and printing. Collogra-

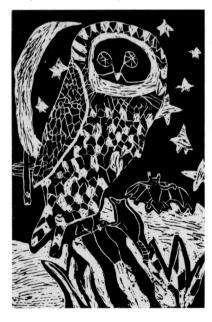

phy provides interesting light areas around the edges of the raised surfaces, where the brayer cannot reach.

Students can produce a collage print by arranging objects, such as string, a piece of wire screen, burlap, or scraps of rough-textured cardboard, on a hard surface. They place newsprint over the arrangement and run an inked brayer over the surface. Literally dozens of prints can be rolled off on such a plate.

MIXED MEDIA

Two techniques can be combined to achieve novel results and encourage a sense of experimentation. A monoprint in finger paint or tempera can overlay other media, such as chalk, watercolor, or paper collage. Linoleum can be printed on collages of newspaper or colored tissue, and string prints can be combined with any of these materials.

When students place a drawing beneath a glass plate to serve as a guide and trail glue slowly on the glass and over the drawing, multiple prints of a single drawing can be produced and each image, in turn, transferred to a monoprinted surface.

Linoleum carving can also be used in conjunction with clay. Because of the firmness of the material, a slab of clay can be gently pressed onto the cut plate. (Oil the surface and indentations to keep the clay from sticking.) When the children separate the slab from the linoleum, it can be fired or glazed, then refired and mounted as a decorative tile.

Corrugated cardboard allows children to work on a large scale, because this material can be obtained in sizes as large as refrigerator cartons. It provides three surface areas to print: (1) the flat exterior surface; (2) the striated pattern of corrugation, which is between the surface "skins"; and (3) the negative areas—sections of the cardboard completely cut away to reveal the paper on which the print is transferred.

STENCILING

Stenciling allows children to print repeated units of design with considerable control. The activity demands a fairly high degree of skill and an ability to plan in detail before production. For these reasons, only the more experienced preadolescents should perform stenciling. In stenciling, shapes are cut out of paper; this paper is placed over a surface, and paint is applied. Only where holes (negative areas) have been cut will paint appear on the undersurface, and thus a controlled design is established. The pieces removed by cutting may also be used as "masks" in the stencil process.

Media and Techniques

Use strong waterproof or special stenciling paper, as well as oak-tag file folders. Hog-bristle brushes may be used to apply the paint, but inexpensive stencil brushes are obtainable. If stenciling is done on paper, tempera and watercolor are suitable. Special stencil paints, however, are available and are very satisfactory to use. Almost any surface, provided it is not too rough, will receive a stenciled pattern. Evenly woven cotton cloth is perhaps the most suitable textile for children to use, and most types of paper for drawing and painting are serviceable.

Students should lay the paper being cut for the final stencils over a glass plate or a piece of hard building board. Care must be taken to be exact in cutting so a cut stops

Physical sensation (elation-fear-excitement) is the motivation for this Japanese student's recollection of his first ride on a roller coaster, captured in a linoleum print.

where it is supposed to stop and joins exactly with another cut. When paper is being stenciled, students should pin it to a drawing board. Textile, on the other hand, must be stretched tightly over newsprint or blotting paper and then pinned firmly in place. The paper underneath the textile will absorb any excess paint that might otherwise run and spoil the work.

The paint should be thick enough not to run, yet not so thick as to form an unpleasantly heavy coating on the painted surface. Tempera paint for printing on paper can be placed in a muffin tin. Students should apply the paint with a stipple brush. After dipping the brush into the paint, students should scrub the brush slightly on scrap paper to rid it of excess paint. They can control the amount of paint picked up by the brush by gently dabbing the brush on the palette.

Students should apply the paint to the holes in the stencil with some care. If the brush is used too vigorously, the stencil may be damaged. For an even spread of color over the entire cutout area, students should apply the paint with a dabbing motion. Stroking from the edge of the stencil into the cut-out area will give a shaded effect.

Teaching

Clean equipment is necessary if smooth work is to result. The brushes, in particular, should be kept scrupulously clean. Although cool water will suffice to wash brushes used with tempera paint and water-soluble ink, turpentine is the solvent for oil-based colors. Brushes that have been cleaned in turpentine should be washed again with soap and cool water. After the brushes have been washed, students should place them in a container with the bristles up. Students should, of course, be taught to clean their palettes after using them. Should students wish to preserve

Erin, age 7, printed the figure six times and added color and texture to create six different versions of smiling friends in the "Springtime."

A black-and-white linoleum print compared with the same print on a surface prepared with watercolor washes. Grade 6.

 Collographs can be torn or cut and made of paper or cardboard.

▲ *Gyotaku*, a traditional fish print on rice paper by a 7-yearold Taiwanese boy. The art of Gyotaku grew out of the desire of fishermen to have visual evidence of the size of their biggest catch.

▲ An example of a work made by pressing the wet edges of cardboard against the paper. The circular shapes are made with flat objects, from a button or poker chip to a cardboard cutout. Is this an abstract work? Or does it represent a truck?

Robert Rauschenberg, *Untitled* (1963). Oil, silk-screened ink, metal and plastic on canvas, $82'' \times 48'' \times 6''$. The artist integrates silk screen—printed photographic images with his own brushwork and drawing to create powerful works of art. You can also see evidence of collage techniques and expressive use of color. How does this print/painting compare to the work of Rembrandt? Can you detect differences that place the works in time and location? Do contemporary artists continue to work in the manner of Rembrandt? How does the work of artists relate to their times and the societies in which they live?

the stencils from one day to another, they should wash the stencils carefully with water or turpentine, depending on the type of paint used, after which the stencils can be suspended from a line strung in a storage cupboard for the purpose.

Finally, the teacher should encourage experimentation, for which stenciling provides many opportunities. Various colors may be used both separately and blended. A good effect is achieved if the stencil is moved slightly when a second color is used. Furthermore, students may use two or more stencils on the same surface.

- 1. Randy Rosen, *Prints: The Facts and Fun of Collecting* (New York: Dutton, 1978), p. 185.
- Jack Cowart et al., Proof Positive: Forty Years of Contemporary American Printmaking at ULAE, 1957–1997 (Washington, DC: Corcoran Gallery of Art, 1997).
- 3. Bernard Toale, *Basic Printmaking Techniques* (Worcester, MA: Davis Publications, 1992).
- 4. See the Joann Moser book/video combination, *Singular Impressions: The Monotype in America* (Washington, DC: Smithsonian Institution Press, 1997).
- 5. For an excellent teaching demonstration of printmak-

ing with fourth-grade students, see Art Education in Action Video Series: Making Art, Episode B: Integrating Art History and Art Criticism, prod. the Getty Education Institute for the Arts, 1995.

- 6. For beginners, pieces measuring $5'' \times 6''$ are satisfactory; later, pieces as large as $10'' \times 12''$ can be used; and for sixth graders, pieces can be even larger. In 1518 Dürer made a woodcut print that was $10' \times 11'$.
- 7. Antony Griffiths, *Prints and Printmaking: An Introduction to the History and Techniques* (Berkeley and Los Angeles: University of California Press, 1996), p. 160.

ACTIVITIES FOR THE READER

- 1. Produce a monotype contour-line drawing by using one color and drawing directly in the paint after it has been applied to a sheet of glass. This is a reverse drawing because the line has been created by paint that has been removed.
- 2. Produce a linear monotype by drawing on paper after it has been laid down over the inky glass. The pressure of the drawn lines will pick up the paint from the glass and transfer it to the paper.
- 3. Produce a nonobjective design in monotype by laying down an arrangement of string, burlap, and cut cardboard on the inky surface before applying the paper for the impression.
- 4. Experiment with a number of vegetables, suitably cut, to produce various printed textural effects on paper. Over these effects, print an orderly design with a potato or carrot into which you have cut a pattern with a knife.
- 5. Use an example of Islamic tessellation (tile patterns) as a historical source for creating sequences of patterns.
- 6. Experiment with a piece of linoleum, making a nonobjective design to obtain many different types of textures. Take several rubbings of your work as you progress. Finally, print it on paper.
- 7. Make a print of the grain of a plank of wood. Use light colors, and overlap the grain or turn the wood to create patterns. If the pattern of the grain suggests anything to you, cut away a few sections of the wood to make the movement of the pattern even stronger.

- 8. Make a collograph by cutting out cardboard shapes, gluing them to a base, inking the surface, and taking a print. The thicker the cardboard is, the greater the play of light around the edges of shapes in the print.
- 9. Obtain a Styrofoam meat tray from the local supermarket. Using a ballpoint pen or blunt pencil, draw on the tray. Then, using a brayer, ink the drawn area and print the image on paper cut to fit the tray.
- 10. Think of ways you can use electronic equipment to make prints: copy machine, fax machine, typewriter, computer. What can you do with a drawing using the capabilities of these machines? Make a color copy of a collograph, a monotype, or a collage. How do the two versions compare? If the work is to your liking, would you consider making a limited numbered series of color copies?
- 11. Browse through several school art supply catalogs, and explore the tools and materials available for elementary-school printmaking. As a class project, order a sample of interesting materials and experiment with them to determine their best uses for elementary students. How do the materials correspond to the skills of children? Are the results acceptable? Are the costs reasonable and feasible for a school art program? Keep records and samples of the best materials and the sources for ordering.
- 12. An experiment that may never happen but deserves to be tried: Paint at least half of the rear tire of your or a

friend's car, and back the car over a sheet of mural paper for some surprising results.

13. Discuss with fellow students: Is there a moral question involved when food is used as art when so much hun-

ger exists in the world? Does the natural beauty of a print made of the cross section of a cabbage indicate a lack of compassion?

SUGGESTED READINGS

- Day, Michael, and Getty Center for Education in the Arts. "Printmaking with a Japanese Influence: Integrating Art History and Art Criticism"; "Art Education in Action: Making Art, Video Footnotes." Santa Monica, CA: Art Education in Action Video Series. 1995.
- Desmet, Anne, and Jim Anderson. *Handmade Prints*. Worcester, MA: Davis Publications, 2000.
- Diehn, Gwen. Simple Printmaking: A Beginner's Guide to Making Relief Prints with Rubber Stamps, Linoleum Blocks, Wood Blocks, Found Objects. Asheville, NC: Lark Books, 2002.
- Heller, Jules. *Print Making Today*. New York: Holt, Rinehart and Winston, 1958.

- Lowry, Glen D., and Museum of Modern Art. Artists and Prints: Masterworks from the Collection of the Museum of Modern Art. New York: Museum of Modern Art, 2003.
- Schminke, Karen, Dorothy Simpson, and Bonny Pierce Lhotke. Digital Art Studio: Techniques for Combining Inkjet Printing and Traditional Artist's Materials. New York: Watson-Guptill Publications, 2004.
- Stobart, Jane. *Printmaking for Beginners*. New York: Watson-Guptill Publications, 2002.
- Toale, Bernard. *Basic Printmaking Techniques*. Worcester, MA: Davis Publications, 1992.
- Westley, Ann. *Relief Printmaking*. New York: Watson-Guptill Publications, 2002.

WEB RESOURCES

- Fine Arts Museums of San Francisco, *Art Imagebase:* http://www.thinker.org/. The site has online education materials as well as an image database that contains hundreds of prints. It is arranged alphabetically and can be searched by artist, title, country, period, or subject matter. Make your own gallery of art by going to http://www.thinker.org/gallery/index.asp.
- Incredible@rtDepartment: http://www.princetonol.com/ groups/iad/. Extensive site that contains many lessons and resources donated by elementary teachers and art teachers. Use the search feature to find printmaking resources.
- Museum of Modern Art: http://moma.org/. To see highlights from the print collection and online print exhibitions, go to http://moma.org/education/ multimedia.html#prints. To see *What Is a Print*? presentation, go to http://www.moma.org/

exhibitions/2001/whatisaprint/flash.html. To visit MoMA's online activity center for educators and students, go to http://www.moma.org/ momalearning/artsafari/.

- National Gallery of Art: http://www.nga.gov/education/ index.shtm. Full of fabulous resources for teachers and students. For printmaking lessons and activities, use the search feature. Many teacher resource packets, slides, films, and so on are available for loan.
- Walker Art Center, Weisman Art Museum, and the Minneapolis Institute of Arts, ArtsConnectEd: http://www.artsconnected.org/. Make your own gallery of prints and other artwork at http://www .artsconnected.org/art_collector/. The program allows image printing and provides information about artists. This site is full of enticing activities and lessons for teachers and students.

NEW MEDIA

Ideas and Earthworks— Computers to Lasers

Art is not possible without technology. Nevertheless, art does not reflect how powerful technology is, but how powerfully it serves the artist's artistic means.

-Mihai Nadin, "Emergent Aesthetics"

The invention of oil paint in the fifteenth century changed the art of painting forever. Before that time artists had to paint on fast-drying plaster (fresco) or use tempera pigments mixed with water or egg yolk. With the new slow-drying oil paints, artists could take time to blend colors carefully and develop images more deliberately. And if properly applied, the oils improved the longevity of paintings.

Quentin Mosely, Ganrinis (1998). Acrylic on wood with neon and argon tubes, $45'' \times 34'' \times 6''$.

Tribute in Light is a commemoration of the 9/11 disaster and loss of the twin towers of the World Trade Center in New York City. The two powerful beams of light rise into the night sky from the Ground Zero Memorial, reminding everyone of the location of the towers and their absence from the skyline of the city. These beams of light appear on anniversaries of the tragic attack. Many other technical advances have greatly influenced what artists attempt and what they are able to accomplish. We mentioned in a previous chapter the invention of lithography and the making of paper as technical advances in the art of printmaking. During the past century, technical advances have occurred at a startling and accelerating rate. Artists today have a range of art media that their predecessors a hundred years ago never could have imagined. Contemporary artists also use materials in new and unusual ways that would not have been accepted or understood in the past. In this chapter we will sample a few of the ideas and media that mark the current art scene, and we will suggest ways elementary-school children might learn about art beyond the traditions of drawing and painting.

NEW IDEAS, NEW MEDIA

The invention of photography in the nineteenth century made a tremendous impact on the visual arts that continues to the present. At first, many artists moved away from realistic representation in drawing and painting because the camera could accomplish that quickly and accurately. In-

stead, artists developed ideas that the camera could not accomplish. The impressionists developed a painterly style, creating images that expressed mood without great detail. The cubists moved in another direction with greater abstraction, using the real visual world only as a starting point and manipulating the concept of reality in art. The fauvists rejected the notion of local or realistic color and painted in ways that the camera could not duplicate.

Later, other artists began using photographic images as reference material for their drawings, paintings, prints, and sculptures. Instead of rejecting the photographic image, some artists began to use the camera to assist them. Gradually, photography became more than a technical process, and photographers entered the realm of art. Photographers found ways to distort images, alter colors at will, print double or triple images, and generally be as expressive as painters. Currently the lines between photography and painting or printmaking are blurred, as artists often combine media. For example, instead of painting, drawing, or sculpting a portrait of the art collector Ethel Scull, Andy Warhol asked her to sit in a coin-operated photo booth and pose for a large number of pictures. He then used a selection of the photographs to make a photoserigraph showing Scull in a variety of views and moods, creating a much more revealing portrait of her than any single view could.

From the beginning days of photography, we have moved ahead to the technologies of cinema, video, and computer-generated images. Each of these technologies has become an artistic medium, and as with photography, new modes of making art have come into being. The entire movie industry has resulted, and many films are considered works of fine art—collected and screened in museums of art. Films are made not only by Hollywood studios but also by a growing coterie of independent filmmakers worldwide. Digital camcorders are becoming common in many households around the world, often to make the equivalent of home movies that were common during the previous generation.

The technology of computer-generated images is developing at a rapid rate. Personal-computer users can purchase programs for "drawing" and "painting" on the computer. A new generation of artists has chosen the computer as its art medium. Most college art departments offer courses that teach students to create expressive art images with the computer. In the commercial art fields, computer art is well established. Many of the images in television advertising are computer generated, as are an increasing number of movies. The tremendous popularity of commercial movies such as *Jurassic Park*, *Titanic*, and *Lord of the Rings* can be attributed largely to the amazing capabilities of computer-generated animation. Technology has advanced rapidly in the computer area, and the computer has become a significant tool for every segment of art making, learning, marketing, and research and for reproduction of art images.

Virtually every innovation in technology makes an impact in the art area as artists appropriate new media to cre-

Christo and Jeanne-Claude's 2005 work, *The Gates*, installed in Central Park, New York City. Christo and Jeanne-Claude raise all the money for their projects by selling their own work to art collectors and museums and by giving lectures. They pay all the expenses for their projects themselves, without any sponsorship. What is the value of works of art such as Christo and Jeanne-Claude's that are tempcrary and cannot be owned, bought, or sold?

ate images previously not feasible. In the area of metals, for example, we have sculptures cast from stainless steel, welded with COR-TEN Steel, constructed of lightweight expanded aluminum, and suspended with high-tensilestrength wire cable. Artists have created light shows, using colored beams of laser light on a large scale at night, often in conjunction with architectural forms. Others, perhaps after a visit to Las Vegas, have made sculpture from neon tubing of different colors and sizes. An entire range of kinetic sculpture has been developed, including sculptures moved by energy produced by water, wind, electricity, gasoline engines, magnets, and so on.

Perhaos as important as new technologies are the new ideas artists continually develop. During the second half of the twentieth century, we witnessed the initiation of conceptual art, environmental art, and performance art. All these new ideas have resulted in an expansion of acceptable materials for art, such as the 3-mile-long work The Gates, Central Park, New York City, 1979-2005, created by Christo and Jeanne-Claude in New York City's Central Park. The Gates consisted of 7,500 rectilinear frames. 16 feet high, hung with saffron-colored fabric panels installed over the park's pedestrian pathways. The installation existed only 16 days in February 2005, after which it was dismantled as planned. Like the artists' other notable works, Running Fence, Surrounded Islands, and Umbrellas. The Gates crossed categories of conceptual art, environmental art, performance art, landscape design, and sculpture. Although controversial among art critics, the installation attracted many thousands of visitors and was generally appreciated by those who experienced the park in a new

The Gates, Central Park, New York City, 1979-2005 installation was viewed by one critic as "nothing less than an unforgivable defacement of a public treasure." Another writer likened the reaction of the crowds of people who visited the scene to "the bright murmur in a theatre, during intermission, when the play is good and everybody knows that everybody knows it." See Note 1. Can you imagine your own reaction if you were walking through The Gates?

Sandy Skoglund, Radioactive Cats (1980). Cibachrome, photography, $30'' \times 40''$. Environments and installations are an important part of contemporary art. Installations are often temporary and are documented with photographs. How does this work relate to ideas from surrealism? Is the artist a sculptor, set designer, photographer, or some combination of these? What mood does the work elicit as you view it? Read a critic's comments about it in the text.

way. One critic wrote, "By artfully altering familiar environments, Christo and Jeanne-Claude repeatedly jolt us out of our habitual patterns of expectation and give us what good art gives—the sense and memory of wonder."¹

Some artists have taken that most basic and ancient of environments, the earth itself, as an art medium. One artist, Walter De Maria, chose a flat, semiarid basin in New Mexico to create the environmental work known as *Lightning Field*. He installed 400 stainless steel poles (2 inches in diameter) in an area known for its thunderstorms, for the specific purpose of attracting lightning strikes. The work covers nearly a square mile with poles installed in rows 225 feet apart. De Maria planned *Lightning Field* as a means to celebrate the power and visual splendor of this aspect of nature.²

Another artist, Robert Smithson, created a spiral of rock and dirt that extended into the Great Salt Lake in Utah. While the *Spiral Jetty* remained in place over the months and years, the colors of the water changed around the spiral as communication with the lake, water depths, and temperatures differed, allowing various types of marine life and chemicals to accrue. The jetty was later submerged

completely as the lake level rose; it recently emerged during a dry spell, encrusted with salt.³ One motivation for artists who create transitory or temporary works is avoidance of the art market, which some believe is a corrupting influence on creative expression. Also, it is a commentary about the lack of control artists have over their works once they are sold and become, in many cases, market commodities.

An example of the use of interior environments is the work of Sandy Skoglund, who creates unusual settings in rooms.⁴ In one piece she painted the entire room—walls, ceiling, and floor—with a flat gray paint. A small table, two chairs, refrigerator, and all other items in the room are painted the same gray. An elderly couple (living models, not sculptures) are posed in the room, the man sitting on a chair and the woman in front of the open refrigerator door; both are dressed completely in the same flat gray, making their skin tones stand out in contrast. Also in the room are many bright yellow green cats (sculptures), each in a different pose. Here is what a critic wrote about this environment, which Skoglund titled *Radioactive Cats*:

In this humorous and horrific scene, an aging couple in a grimly impoverished interior is inundated by mutant green cats, whose lurid coloration reverberates against the neutralized environment. These voracious animals infest every surface in a quest for nonexistent food. This science-fiction fantasy is rendered believable by the veristic nature of photography, which simply records "the truth." Skoglund sculpted the plaster cats herself and readied the set by painting everything in the tiny room a mottled gray. The artist also prepared a version of the tableau as a separate installation, allowing her audience to see both the photography and a portion of the thing photographed.⁵

The artist poses living models in her environments and takes photographs that become the works of art. The actual environments are sometimes displayed in museums and galleries, usually without the living models.⁶

Children are aware of many of these art forms in their everyday lives. Films, videos, computer-generated images in television ads, and for many, music videos are commonly seen. In numerous ways children are more "media literate" than their parents and teachers. We will suggest ways children can participate in art activities based on some of the newer media and ideas. We also suggest that it is worthwhile for children to learn about what contemporary artists are doing and creating and how these artists are changing the art world.

NEW MEDIA IN THE CLASSROOM

Although some of these art media are beyond what is available in typical school art programs, there are classroom activities that children can accomplish under the direction of an interested and energetic teacher.

Cindy Sherman is an artist who dresses herself in different costumes, often complete with wigs, makeup, glasses, and so on, that transform her apparently into a different person. She then photographs herself (self-portrait) as the other person in an actual indoor or outdoor setting. Some of the portraits are humorous, others are tragic, frightening, beautiful, puzzling, ambivalent, and so forth. "In the color work that Sherman began in 1980, she enlarged the scale, backlit the settings, and increased the subtlety cf her female characterizations. As her photographs evolved from costumed melodramas into evocative studies of contemporary women, she explored the edge between art and commerce."⁷

Creating a Gallery of Self-Portraits

Like many children, Cindy Sherman spent a fair portion of her childhood watching television, drawing, and playing "dress-up." With the use of a camera, children in school classrooms can identify characters they would like to represent, assemble the necessary clothes, select the settings, and take the pictures. They can display a gallery of portraits they have created. The teacher can make copies for the children and can save and add to the gallery from year to year.

Ask children to collect photographs of interesting faces that they see in magazines and newspapers. Discuss the moods and feelings the faces convey. Ask if any of the photographs should be classified as art or if they belong in the category of ordinary candid shots that anyone can take. What are the differences between the pictures students believe should qualify as art and those considered ordinary shots?

Responding to Contemporary Art

The history of art is replete with examples of artists who developed new ideas, styles, and uses of media with little recognition by their contemporaries. Sometimes decades or even centuries pass before the artists' contributions are recognized. For example, the impressionists were rejected

during the latter part of the nineteenth century but are well appreciated today. Because of improved education, communication, publication of developments in art, and art reproductions, this time lag need not persist today. Ask students to study the range of newer art media used by several contemporary artists, such as Barbara Kruger, Sandy Skoglund, Christo and Jeanne-Claude, Bill Viola, and others. Have them analyze specific works and try to interpret their meanings. Then, ask them to speculate about which of the artists are most likely to be recognized for their contributions in 30, 5C, or 100 years and why. This activity works well with small learning and discussion groups, with a group recorder to report the discussion to the entire class. Evaluation would focus on the depth of the inquiry and discussion, strength of reasons given in support of choices, Cindy Sherman, Untitled Film Still #5 (1978). Regarded as one of the most influential living American artists, Cindy Sherman became well known for this series of images of contemporary women. Sherman conceived of each "role," costumed and posed herself in a typical setting, and photographed herself, thus combining a number of distinctive art forms. and the quality of class presentations, if these are part of the activity.

Art and Nature

Andy Goldsworthy is a Scottish artist who works exclusively with materials from the natural environment: stone, wood, dirt, sand, leaves, flowers, feathers, ice, snow, and other objects in nature. He usually uses no tools, glues, or human-made materials. All his works are temporary, and nearly all are left in nature to disintegrate and change with the season and the weather. His photographs of the works are the only record of their existence. Goldsworthy speaks little about the meaning of his art. He has said, "I have become aware of how nature is in a state of change, and that change is the key to understanding. I want my art to be sensitive and alert to changes in material, season and weather."⁸

Goldsworthy's approach is eminently available to children, who are always interested in nature and the environment. Following his lead, children might do the following activities:

- Look for leaves with different colors caused by the seasonal changes. Arrange leaves from the same type of tree according to color changes, such as light yellow, yellow, yellow green, green, dark green. Clear a path on the ground, and create a line of leaves that change colors gradually and subtly from one extreme to the other. Make the line several inches wide in a curved or zigzag direction.
- Find an area with sand. Using a tool from nature, such as a stick or rock, make a series of wavy lines in the sand to see how it responds. Is it too dry to hold its shape? Is water available to wet the sand? Create shapes or patterns using repetitions of marks with the natural tools at your disposal.
- Using Goldsworthy's work Yellow Elm Leaves Laid over a Rock, Low Water as inspiration (see this image in Chapter 2), find a location with leaves, rocks, and water. Select and arrange leaves according to colors, and cover one or more rocks with leaves, using the water to hold the leaves in place. Try some variations: several smaller rocks, each a different color; one large rock blended from one color to another; one large rock a single color; or any variation you wish to try.
- Find a location with lots of small, smooth rocks, like a creek bed or gravel pit. Collect a large number of

rocks, and separate them according to sizes and colors. Then, create a series of concentric circles using variations of rock size and color. Stop when you think the design appears complete.

• Remember to bring cameras to the sites, and record your efforts and your finished works of art. The art will remain on site, and the photographs will be your record and your reminder of the beauty you saw in nature. Like Goldsworthy's, your art is a collaboration with nature.

Polaroid Photography as an Art Medium

Prominent artist David Hockney has explored the Polaroid camera as a tool for making art. He is also interested in the cubism of Picasso and Georges Braque, in which multiple views of the same subject are presented in a single painting, producing distortions but also revealing more information than is possible with only one view (note the similarity with Warhol's idea for the Ethel Scull portrait). Hockney has taken this idea and applied it with unusual results using the Polaroid camera.

Polaroid cameras are common, and if not available at the school, one can usually be obtained for temporary use from parents or friends of the school. Ask children to select a scene that they like, such as their own classroom, a local park, or an interesting building. Working in teams according to how many cameras you have or by taking turns with one camera, have the children take pictures of the selected subject from different points of view. When all the pictures are completed, ask the children to select the ones that are most interesting and best express what they feel about the subject. Then they can assemble the pictures and mount them on a firm surface, such as poster board. If they work in teams, they might make several Polaroid works.

When you display the Polaroid "collages," you might include the work of Hockney, along with some information about his life and work. You might even relate the work to the idea of cubism. Statements by the children about what they were trying to capture and communicate in the photographs would add greatly to the display.

Working in a similar way, the children might take pictures of a person (perhaps the principal) and assemble a portrait using Warhol's approach. They might add drawings or paintings of the person to achieve another dimension of insight and interest.

David Hockney, *The Scrabble Game, Jan. 1, 1983 #10* (1983). Photographic collage, $30'' \times 58''$. The artist made multiple images of a scene with a Polaroid camera, then combined the photographs in ways similar to the collages of cubist artists Picasso and Braque.

Art from Everything

It is the attitude of artists that determines what materials they will use to create art. This attitude has changed recently to allow virtually any (safe) materials to be used in the creation of works of art. One example is the sculpture of Nancy Rubins, who has used such diverse materials as old mattresses, water heaters, and parts of airplanes.

Ask children to collect many items that they no longer want or need, such as old toys, dishes, plastic items, or even small appliances or lamps no longer in use. Supplement what they bring with a trip to a local surplus warehouse, yard sales, or thrift store, and purchase (or ask for the donation of) interesting items. Collect wood scraps from the high-school wood shop, from the local lumberyard, or from parents who do woodwork. It is possible to collect cne or more television sets that still work, although sometimes not very well, among the items.

Tell the children they are going to work together to make a sculpture out of the collected materials. They can discuss what mood or political point of view they might want to express: funny, controversial, frightening, exciting, beautiful, and so on. Then they can begin selecting objects and try them together to see if they "work" in interesting ways. The children might need to decide what colors will be best for expressing the subject they have chosen. Individual items might have to be painted before combining them with other objects.

One major problem is how to combine the objects so they do not fall apart. Children might need a hammer and nails, good-quality glue, screws and a screwdriver, clamps, and whatever other means they can devise. Decide in advance if the sculpture will actually have working parts. When the sculpture is assembled and stabilized so it will not fall apart, decide what colors are needed for the final painting. When the work is completed, the students will have a contemporary sculpture, and if they have included

anything electrical that works, they can turn it on and admire the sight, movement, and sound of their work.

Fax Friendships

Artist David Hockney sent an entire mural by fax from California to the Walker Art Center in Minneapolis. The mural image was generated by computer, and each page of printout was a segment of the whole. After Hockney printed out the total image, which required many sheets of paper, he transmitted each sheet across the country by fax. The separate sheets were then assembled on a huge wall in the Art Center, creating the mural. Show students what a fax message looks like, and explain how the fax machine works: Words or images on a sheet of paper are transmitted by telephone as bits of sound, received by another fax machine, and reconstructed on another page at the receiving site in the form of the original image.

Try this activity: Explain that students will work in groups to create messages in the form of graphic art that they will send to selected potential friends in another location. Find a willing recipient of student art messages by fax. These messages could be an exchange with a sister city in another country or with another school in the district, or they could be messages to a politician, the superintendent of schools (one way to promote the art program), a corporation, or a celebrity. Remind students that in order to be transmitted, their work must be of high quality. Tell them to think about it and to enjoy themselves.

Primary assessment would focus on the success of the project: Did students create appropriate and good-quality graphic art messages? Were the messages successfully transmitted and received? Did you receive acknowledgment in response to students' works? In what ways was this a positive experience? Did students become more aware of the uses of technology and art for communication in contemporary life?

Copy Technology

Most schools have photocopy machines, and many have access to color copy machines. Many of the uses for such machines are not very expensive. Using the regular copy machine, children can make drawings that can be duplicated and colored or painted on in different ways without destroying the original. The children can enlarge or reduce

Photocopies of the same

the images. (France)

subject encourage variations

as students work directly on

the drawing and can cut and paste together several versions, as Hockney does with Polaroid shots, to create a collage of multiple versions of a single image drawn by the child. As children experiment with the copy machine, they can learn about the fluency afforded artists with modern technology. They can also learn to manipulate their own ideas in ways that would not be possible without the copy machine.

Good-quality art reproductions can be made with the color copier. Teachers can make color copies to display in the art room, to place in folders for group work, or to use in any types of learning activities as children study and understand works of art. Color copies of children's collages can be very exciting, because the copier translates textured materials into two dimensions. The resultant color copies are much easier to mount, frame, and exhibit, and children can make as many copies as needed.

Artists are beginning to use high-end digital Giclée printers as another addition to printmaking technology. When the artist has created the final drawing, watercolor, or print, it can be duplicated on the machine for whatever edition is wanted. Results are so true to the original that the Giclée print is difficult to discern from the original.

MEDIA FOR INSTRUCTION

The hardware of media is considerably more than mechanical gadgets for presenting information; it is linked to the very shape and structure of the content being imparted and thus represents different modes of learning and expression. Let us consider the many ways instructional media are able to extend students' perceptions of a subject such as painting:

- A CD, DVD, or video about a particular artist can show something of the process of change and maturation in an individual.
- A *comparison of slides* of works of art can lead to a group discussion of likenesses and differences in style and content of art objects.
- Packets of small *reproductions* allow students to investigate at their own pace the visual components of a series of paintings.
- A *live television* art lesson from a public network can bring a professional artist to the class for a single performance.

- A *digital camcorder* can play back a demonstration by a visiting artist recorded for future reference or for classes that could not attend the original performance.
- A *video recording* of an interview with a local art critic can be stored for future reference.
- A *computer* with color monitor and compact disc player can be used to retrieve color images of any artist, style, or work and present them on the screen. A single disc can hold thousands of art images.
- There is no limit in sight for the information about art available on the *Internet*, including museum sites, exhibits of artists' works, commentaries by critics and historians, and color images that can be downloaded. The range of sites extends worldwide. Teachers must be aware of safe practices for children using the Internet.⁹

Teachers might not have access to all these modes of instruction, but with time, knowledge, and equipment, teachers can significantly extend their own style of teaching, the pupils' scope of learning, and the range of subject matter. In all modes of media, limitations are offset by the advantages. Students can learn to use computer graphics programs and eventually gain the skills necessary to create original art that is personally meaningful and expressive. This work by Josiah, age 14, is titled "Em with Thorns." Computer art is now a significant category in many exhibitions of student art.

puter at home.

Even very young children can begin to understand the computer as another medium for making art. This exploratory example was made by Kaebri, age 3, using the family com-

By combining the unique characteristics of several media, in this case tempera paints, large surfaces, and color projections, students can create original, exciting works of art.

Children today are both eager and prepared to engage in media activities. Their visual sense is oriented to motion because of early exposure to television, films, and video and computer games. They accept condensed time-space concepts because they view live coverage of news events, and they have never doubted, for instance, that they could breakfast in one part of the world and lunch in another.

The art teacher should understand that there is no inherent contradiction in goals or philosophy between creating in either the new or the traditional media. Both kinds of materials provide excitement and challenge in the areas of design, including color and drawing; both elicit original solutions on the part of the child and call for a high level of creative ingenuity. Newer media have simply added such increasingly relevant ingredients as time, motion, and light to the elements of color, space, mass, line, texture, and shade. According to one art teacher, "Computers have the potential of expanding the possibilities of creative expression. They provide a playground for ideas and images. . . . Risk taking, experimentation, exploration, and play-are all essential to the artistic process, and are all possible with computers."10 Teachers will be shortsighted should they fail to capitalize on the built-in motivations provided by the excitement of matching sound to light or image to movement. They will also deprive themselves of a logical means of combining other arts, such as music, dance, and choral reading.

The activities that follow range from simple projects that can be carried out in one learning session to more complex operations requiring several sessions. In most cases, the amount of time spent on the project depends on how deeply the teacher wants to probe the subject.

Projections

Most schools still have access to slide and overhead projectors, schools with a drama program usually have transparent color gels, and virtually all schools have digital projectors connected to computers and the Internet. Simultaneous use of projected images combined with handmade slides can be very effective, particularly when used on different subjects, for example, a white sheet draped over a collection of large objects. This form of multimedia is about 30 years old but still allows students to cover large areas with light and color in a relatively short time.

Experiences with a Camera

If a camera is available it can be used as an instrument for observation and personal commentary. The treatment of one subject in two or more greatly contrasted media (as in sculpture, painting, and photography) is an effective way of attuning children to the possibilities and limitations of art media. The following tasks for the beginning photographer are also worth trying in drawing (and writing). Digital cameras are commonly available and provide the most options for classroom use.

- Make a "living comic strip." Tell a story in a series of pictures using real people.
- Photograph an autobiography. Tell about yourself by taking pictures of your favorite things, your family, the place where you live, and yourself.
- Document your neighborhood. Take pictures of people at work and play, people of different ages, and buildings where you and others live, work, and spend time.
- Define a word or a feeling with a picture or series of pictures (happiness, sadness, cold, hot, hard, soft).
- Make a photo essay about a social issue in your school or community.
- Illustrate a song, a poem, or a short story with your own photos.

Storyboards

The storyboard is a transdisciplinary activity that draws in varying degrees on narrative skill, the linking of image to story, and the use of drawing. It can also prepare children to better understand how filnmakers, animators, and even writers of commercials think on paper.

A storyboard is a sequence of pictures that tells a story or relates to a given problem. Some students may choose to draw their sequences; others may compile them or paste them up from news or magazine photos.

The storyboard can be used to plan a film or video, or it can be an activity in itself. Specific homework assignments can be made. For example, children in the upperelementary grades are capable of studying a one-minute television commercial by reducing it to a sequence of storyboard frames, thereby recording the timing of shots, distinguishing among tight shots (very close), long shots (at a distance), close-ups, and so on. In making a storyboard, students can apply the basic vocabulary of film and video to extend their own picture making. Storyboards are the middle ground between the realm of the communications media and the traditional forms of picture making.

A good example of visual narrative that all ages can appreciate is the award-winning children's book *Tuesday*, by David Wiesner.¹¹ This delightful story demonstrates all the techniques of the storyboard.

Video

The portable camcorder is gaining popularity in the schools at a rapid rate. We must admit that the camcorder is a truly revolutionary instrument. To children, it means that they can, in a sense, control the very technology that for so many years has dominated their leisure hours of TV watch-

						0			O He M		0
						O He H	0	O Kalu	CO HE HE		O HO H
						O KA					O
					C HAN	O H	O He V	O K			0
	O KAN			O H							0
	O Ki	0 H			O					0	
0	O H	O	0	0	0	O		O K	O He M	0	O K)

Nam June Paik, *Vⁱdeo Flag Z* (1986). Television sets, videodisc players, videodiscs, Plexiglas modular cabinet, $74'' \times 133'' \times 18''$. In this work, the artist combined multimonitor VCRs in a wall installation with 84 TV screens programmed in the configuration of the American flag. Images on the screen move constantly, providing a dynamic version of the flag. The viewer can see the entire display as a unified work or concentrate on each screen individually. Nam June Paik is considered the father of video art, having developed this new direction dur ng a period of four decades. His integration of technology and visual art exemplifies one major thrust of the postmodern era. Dozens, or even hundreds, of video monitors in Paik's works are computer programmed with video sequences, sometimes projecting independently, sometimes in sequences, and sometimes in unison. The result is a series of dynamic works that seem to have a life of their own.

ing. The tables are suddenly turned, and, no longer viewers, they are in command, becoming producer, director, or actor. Their new domain is a television studio in miniature, consisting of camera, television monitor, and computer. It is now possible for formerly passive observers to control the camera, create the image, and get immediate feedback on the monitor. Nor do they have to limit their activities to the school; they can extend their control to the play-ground, the neighborhood—anywhere the camcorder can be carried.

As with photography, technical aspects of video cameras are best learned in a workshop. It is, however, worth noting some of the ways one art teacher with special training went about building a sequence of activities around the camcorder. During a summer workshop, the children, working in rotating groups, did the following:¹²

- Designed and presented their own commercials. This involved designing the package, writing copy, and delivering the "message," as well as recording the entire experience on a camcorder.
- Designed and assembled several settings for short plays, which were developed from a series of improvisations. Sets were constructed of large sheets of cardboard and included cast-off furniture.
- Studied the effects of light and change of scale by examining miniature sets on camera.
- Critiqued commercial programming viewed on the monitor.
- Role-played various social situations derived from their school and home experiences.
- Acted as television art teachers by demonstrating a simple process such as potato printing, stenciling, or collography.
- Took turns as camera operator, director, performer, designer, and producer. They also learned the basic operation and nomenclature of the equipment.

The use of video in the art program has become commonplace in many schools. A review of the activities just listed might make a curious teacher speculate about the many possibilities offered by the camcorder as a means of extending the children's visual awareness.

With the current quality of digital video cameras (camcorders), very high-quality videos can be achieved. After students shoot video segments, scenes can be fed into a personal computer with editing software. The higher-level cameras and software programs allow for all types of editing, special effects, titles, and sound. Digital video cameras and personal computers are becoming increasingly common in homes in the United States as well as in schools.

New technology is available; the problem is to get it into the classroom—or to get the students to the equipment.

Computer Technologies in the Art Classroom

The range of art learning and teaching that can be accomplished through uses of computer, video, CD, and DVD technologies is truly mind-boggling. Virtually anything we can think of to do as teachers can be done now, and computer capabilities are still rapidly developing. Moving from the simple to the more sophisticated uses, it is now possible for students to do the following:

- Create black-and-white or color artwork on computers in the art classroom, using school computers and readily available graphics software packages.
- Experiment with their art images, altering the color, form, and composition of their work while saving the

Elementary and middle-level schools are making computers more accessible to students. Some schools have computer labs that are used by different classes according to a schedule, similar to use of the library or gymnasium. Students in this classroom use laptops. Basic graphics programs are increasingly available for making art and design work with computers, and color printers are becoming more common in schools.

original image in case they "ruin" an experimental version.

- Print out their computer drawings or paintings in black and white or color.
- Transfer images from a video camera to the computer screen, where they can be altered and transformed by using graphics software packages.
- Take photographs with a hand-held digital camera and cownload them to a computer to view on a color monitor. Selections of images can be burned to a CD. Some teachers keep digital portfolios of student work.
- Transfer virtually any image, including their own drawings and paintings or photographs, to the computer screen, where they can alter them or incorporate them in their artwork.
- Gain access to color images of entire museum collections on CDs and browse through the collection, calling up images of works by artist, style, title, or other keywords.

The interconnection of the major electronic devices, including telephone, cellular phone, satellite access, telefax, radio, television, camcorders, and computers will do nothing but increase the potentials of newer media for teaching and learning. And electronic network systems will open the art classroom windows for innumerable learning programs and opportunities.

However, as with all technological innovations, these tools will be only as effective as the teacher who selects and organizes them in an art curriculum with clear direction and valid goals. It will be even more important for teachers to distinguish between what content will be educationally significant and what will be merely entertaining.

Teachers interested in developing computer skills often have access to classes in computer operation through

This middle-level art teacher uses laptop computers as an integral part of her art curricu um. Students can do online research on art topics, write essays, make **a**rt, and create visual reports with computers. Storage and security of the computers are made easy with this handy cart. The computer skills students gain in art class are applied across the curriculum, enhancing their learning and preparing them for the world outside school.

school districts, adult education programs, and college or university classes. In addition, some computer companies offer regular workshops and intensive two- to five-day seminars for increasing computer skills and knowledge of specific software programs. Teachers seeking information about hardware and software have many published sources that address computer applications for elementary, secondary, and higher education. Such publications discuss educational applications of all forms of advanced electronic technologies. Some states have developed written materials available to all school districts and teachers for the purpose of encouraging computer use in all subject areas, including the arts.

NOTES

- 1. Paula Harper, "Financing 'The Gates,'" Art in America, September 2005, p. 59.
- 2. For more on *Lightning Fields* and De Maria, see John Beardsley, *Earthworks and Beyond*, 3d ed. (New York: Abbeville Press, 1998).
- 3. For more on *Spiral Jetty* and Smithson, see Beardsley, *Earthworks and Beyond*.
- 4. A photograph of *Radioactive Cats* and information about th€ artist appear in Randy Rosen, Catherine Brawer, et al., *Making Their Mark: Women Artists Move*

into the Mainstream, 1970–1985 (New York: Abbeville Press, 1989), p. 86.

- 5. Ibid., p. 84.
- 6. For more on this artist, visit www.sandyskoglund.com.
- 7. Rosen et al., Making Their Mark, p. 138.
- 8. Beardsley, Earthworks and Beyond, p. 206.
- 9. Craig Roland, The Art Teacher's Guide to the Internet (Worcester, MA: Davis Publications, 2005).
- 10. Deborah Greh, Computers in the Artroom: A Handbook for Teachers (Worcester, MA: Davis Publications, 1990), p. 10.
- 11. David Wiesner, *Tuesday* (New York: Clarion Books, 1991).
- 12. This special workshop for fifth and sixth graders was offered by the Newton Creative Arts Summer Program, Newton, MA.

ACTIVITIES FOR THE READER

The chapter itself describes many activities to try with the instruments of light, motion, and nature. Here are some others.

- 1. Work with colleagues to create simple "how to" instructional videos on such topics as pulling a print, wedging clay, mixing colors, doing formal analysis of a painting or library research on an artist, or others. Make each video segment brief and easy to understand, and make sure it works with the intended age group of students.
- 2. Any series of still pictures will give the illusion of motion when viewed in sequence. Create a sequence of "flip cards" by working on one side of a group of index cards. By slightly changing the position of the image from card to card, it is possible to create the illusion of a ball flying off the page, a ship sinking into the sea, a smile appearing on a face, or Dr. Jekyll turning into Mr. Hyde.
- 3. Using a simple computer animation program, try the "flip-card" activity described in suggestion 2.

- Using a computer graphics program such as Power-Point, make teaching aids for concepts of color, design, art history, and other topics in the curriculum for elementary grades.
- 5. Use photographs in combination with art materials, such as colored markers, colored pencils, paints, or inks, and create a collage or poster with the goal of making a color photocopy as the final product. Note how versatile the photocopy medium is.
- 6. Wrap two students in muslin or a cotton sheet, and project a picture of a well-known painting or building upon the wrapped figures. See how this transforms a familiar image.
- 7. Plan an installation in a school space that combines electronic media and accumulated items and that makes a statement about a contemporary social issue.
- 8. Search for living artists who have nontraditional ways of using art materials or who use nontraditional materials for their art. How can their new ideas be transformed for use in the art classroom?

SUGGESTED READINGS

- Beardsley, John. *Earthworks and Beyond*. 3d ed. New York: Abbeville Press, 1998.
- Bidner, Jenni. *The Kid's Guide to Digital Photography: How* to Shoot, Save, Play with & Print Your Digital Photos. Asheville, NC: Lark Books, 2004.
- Burnett, Ron. *How Images Think*. Cambridge, MA: MIT Press, 2004.
- Gordon, Bob, and Maggie Gordon. *The Complete Guide to Digital Graphic Design*. New York: Watson-Guptill Publications, 2002.
- Greene, Rachel. *Internet Art.* World of Art. London: Thames and Hudson, 2004.
- Greh, Deborah. New Technologies in the Artroom. Worcester, MA: Davis Publications, 2002.

- Lucie-Smith, Edward. Art Nature Dialogues: Interviews with Environmental Artists. Albany: State University of New York Press, 2004.
- Malloy, Judy, ed. *Women, Art, and Technology*. Cambridge, MA: MIT Press, 2003.
- Nadin, Mihai. "Emergent Aesthetics—Aesthetic Issues in Computer Arts." *Leonardo* (Supplemental Issue, 1989), p. 47.
- Patmore, Chris. *The Complete Animation Course: The Principles, Practice, and Techniques of Successful Animation.* Hauppauge, NY: Barron's Education Series, 2003.
- Patterson, Freeman. Photography and the Art of Seeing: A Visual Perception Workshop for Film and Digital Photog-

raphy. 3d ed. Toronto, ON, Canada: Key Porter Books, 2004.

- Paul, Christine. *Digital Art*. World of Art. London: Thames and Hudson, 2003.
- Rush, Michael. *New Media in Art.* World of Art. 2d ed. London: Thames and Hudson, 2005.
- Schoch, Elizabeth T. *Everything Digital Photography*. Devon, UK: David and Charles, 2004.
- Sollins, Susan. Art: 21. Vols. 1 & 2. New York: Harry N. Abrams, 2003.
- Wallis, Brian, and Jeffrey Kastner. *Land and Environmental Art: Tnemes and Movements*. New York: Phaidon Press, 2005.

WEB RESOURCES

- Guggenheim Museum, Internet Art at the Solomon R. Guggenheim Museum: http://www.guggenheim.org/ internetart/internetart_index.html. The Guggenheim Museum commissions, collects, displays, and preserves Internet art. Its website also features virtual art exhibitions.
- Museum of Computer Art: http://moca.virtual.museum/. Features works by artists working in digital art. Includes reviews, critiques, essays, and articles on computer art.
- Museum of Contemporary Art, Los Angeles: http://www .moca.org/. Features online exhibitions of contemporary art. Go to resources for teachers and students to access a curriculum guide, *Contemporary Art Start*.
- Museum of Modern Art, *Red Studio*: http://redstudio .moma.org/. MoMA created this program to explore issues and questions raised by students about modern art and today's working artists. Check out the other online teacher resources.
- Walker Art Center, *Gallery 9: New Media Initiatives Departmen*^{*}: http://gallery9.walkerart.org/. Gallery 9 is the Walker Art Center's online exhibition space and one of the most recognized online venues for the exhibition and contextualization of Internet-based art. Features curated online exhibitions and dialogue about art and technology.

C H A P T E R

DESIGN

Art Language and Application

What is expressed in art is reinterpreted in terms of form and style, and is a public idea rather than a private state of mind.

-Michael Parsons, How We Understand Art

The term *design* refers to "the overall visual presentation of an artwork, including both composition and style."¹ The design of an artwork is its organization, the arrangement of the elements available to the artist for the purpose of expression. The word is also used as a verb, such as to *design* some object. Clothes, cars, buildings, and gardens are designed or arranged for practical and aesthetic purposes. A number of art professions take on the term: fashion design, interior design, graphic design, and others.

Jonathan, grade 4, from the United States, combines imagination with a riot of bright color in this painting. He used pencil, ink markers, crayons, and tempera paint in this fantasy work of flowers, butterfly, and bees.

As we note from the opening quotation by Michael Parsons, the message a creative person wishes to convey is made apparent by the formal organization of any work of art, whether by a child or an adult. A piece of clay sculpture by a child in the first grade, a Chinese stoneware vase, a painting by Mary Cassatt, or a video installation by Bill Viola all involve design, structure, and the relation of subsidiary elements to a unified whole.

Design, therefore, is presented in all art forms and may be intuitively achieved or consciously dealt with. One function of art education is to develop a child's awareness of design. In this chapter we will discuss design as it applies to visual forms of expression, including an analysis of the parts, or elements, that make up design and an outline of the methods employed by artists to use these elements coherently. The teacher without a knowledge of design is limited when the need arises to instruct and assist children with their own artwork and with understanding the work of others. The information in this chapter is presented as professional background knowledge with suggestions for practical classroom applications.

THE ELEMENTS OF DESIGN

Design is the organization of parts into a coherent whole. Visual design is the organization of *materials* and *forms* for a specific *purpose*. The designs of accomplished artists should convey the feeling that nothing in the designs could be changed without violating their structure. All the elements of design in use should make a complete and harmonious whole.

The act of designing is common to all human beings. Early peoples brought order and coherence to their environments while constructing their villages. Families follow the desire for order in arranging their living spaces, and gardeners bring order to their gardens. Because the desire for order is universal, artistic acts—which demand that a form, composition, or design be achieved—have potential significance for us all.

A distinction can be made between designers who begin with practical functions and use the principles and elements of visual organization to make their solutions as aesthetically pleasing as possible and artists who use the same elements in nonfunctional ways for purely aesthetic purposes.

Those who have attempted to isolate the elements of design for definition have reached only partial agreement. Nevertheless, nearly all agree that the elements of design include *line, shape, color, texture,* and *space.* Design in three dimensions includes the element of *mass,* which is analogous to two-dimensional *shape.* The term *form* has two major meanings in art and design. Form is (1) the underlying structure or *composition* in a work of art and (2) the shape or outline of something.

These elements of art are, in effect, the building blocks of all visual art; they are all the artist has to work with. The vocabulary of form is the foundation of the formal analysis process and provides student and teacher with the language needed to discuss the work of artists as well as students.

Each element discussed can be seen in both nature and art. It is the teacher's task to assemble the sources to teach children to recognize the elements and principles and to reinforce students' understanding with art activities derived from those sources.

Contemporary artists, such as Frank Stella and Judy Pfaff, have worked against what they feel are static effects, for example, symmetry, balance, and classic proportion. Instead, they have placed a premium on accident, on spontaneity of execution, and on deliberate avoidance of a "closed" image. The design elements exist in all styles, and for purposes of elementary instruction, we can use design vocabulary in referring to both the child's work and the work of professionals. The language of design provides a basis for discussing the work of students, which can begin as soon as a child understands—through use and recognition—the meaning of the vocabulary.

Design also has another meaning worth noting. Design as a verb can refer to the planning of useful or decorative objects, such as fabrics, appliances, automobiles, or interiors. We can therefore design a container or create a painting wherein elements and principles of design operate effectively. The *principles* of design refer to generalizations in the structure of forms, be they from fine arts or commercial design.² When elements interact, they make up prin*ciples*. Because it is important to convey to young children the meaning of the elements (line, shape, color, texture, and space) as well as the principles, this chapter will discuss both sets of terms. The danger in planning activities related to the design elements is that too often teachers neglect the second, vital stage of making the connections between principles and elements. The ultimate goal of design education is to become aware of this important interaction, in both the children's work and that of professional artists. Teacher and pupil must share some common language, and the terminology of design constitutes the beginning of a mode of discourse that can be referred to during the entire span of the elementary art program.

Line

Most of us have entered the world of art through the lines we have created. *Line* is the path traced by a moving point and is perhaps the most flexible and revealing element of design. If we are angry and doodle a line, our anger is clearly revealed in the marks we make. If we are placid, calm, or pleased, our line takes on a different character. Artists readily express their feelings by means of line. In communicating protest of brutality in general, an artist may use slashing, angular, abrupt lines; presenting feelings about the beauty of a summer landscape, the artist may use lines that are gently undulating and flowing.

Line may be used strongly and directly. German artist Käthe Kollwitz, who lost a son in World War I and a grandson in World War II, used line as a primary means to achieve her end; the strong, powerful line supports both her rage against war and her compassion for its victims. The sensi-

Käthe Kollwitz, *Germany's Children Are Starving* (1924). Kollwitz's use of bold, emph**at**ic lines for the lithograph reinforce the tragic content of her subject, which refers to the suffering of children as a result of World War I.

tively drawn lines of Inuit printmakers define objects, figures, and an mals and lead the eye around the picture. The quality of line is integral to the meaning of both works. Artists may alsc imply line—that is, convey it indirectly—by forming edges of contrasting tones that move from one part of a painting to another.

Line has sometimes been called the "nervous system" of a work of art. For most of us, linear experience is our first contact with art—if only because of the availability of pencil, pen, or crayon. The study of line is particularly effective with elementary-school children, because they usually have experienced a number of ways of drawing lines with a variety of tcols, such as pencils, crayons, and felt-tip pens. Children will often find their own words to distinguish among "scratchy" lines, "funny" lines, or the "squiggly" character of some lines. This sort of discussion provides a Pitseolak Ashoona, Winter

Camp Scene (1969), Cape

Inuit artists have depicted

scenes of life in the frozen

from stone blocks. Line is a

Dorset, Northwest Territories.

North in sensitive prints made

basis on which to build the vocabulary of art. The study of line need not be limited to drawing or painting, for line can be observed and enjoyed in architecture and sculpture, as well as in nature, when we observe cracks in a sidewalk or branches against a sky.

Shape and Mass

The term *shape* refers to the general outline of something. Shapes can be drawn with lines, painted, or cut out of paper or other two-dimensional materials. They can be categorized as geometric or natural. Geometric shapes include squares, rectangles, circles, and triangles; whereas natural or organic shapes are those found in nature, such as rocks, trees, clouds, and the shapes of animal and plant life. Geometric shapes are also found in nature, as in honeycombs, some seashells, and cellular structures. Artists such as Barbara Hepworth or Henry Moore, for example, use shapes that suggest natural forms without making specific reference to shapes that occur in nature. Also, the shape of a pyramid in silhouette is a triangle, but the same shape may exist beneath the outward form of a Madonna and Child. *Mass* is the three-dimensional equivalent of shape, although it may be found in artworks that give an illusion of mass, such as Michelangelo's paintings in the Sistine Chapel. The cube, pyramid, and sphere are the threedimensional equivalents of the geometric square, triangle, and circle. *Mass* refers to the volume or bulk of objects in a work of art, and *space* refers to the areas that surround mass. The aesthetic effect of mass is most readily grasped in architecture and sculpture. The great mass of an office building and the delicate mass of a church spire have the power to move us in different ways. A sculpture can affect us by the weight, shape, and balance of the masses created by the sculptor.

Color

Because of the complexity of *color*, both artists and scientists have for years tried to arrive at a theoretical basis for its use. Edmund Feldman has noted:

Color theory provides speculative answers to questions which are not often asked in the course of examining works of art. Some color systems seem related to the physiology of perception more than to the aesthetics or psychology of perception. Others may have evolved from industrial needs for the classification and description of dyes, pigments and colored objects. At any rate, artists work with color—pigment, to be exact—more on an intuitive than a scientific basis.³

In teaching children about the nature of color, the teacher may vary the methods, using intuitive approaches in the primary grades and gradually introducing color terminology and its application in the middle and upper grades.

Color is a powerful element, and it serves to emphasize the extent to which all the elements are interdependent. Although the elements have been discussed here separately, in reality they cannot be dissociated. The moment we make a mark on paper with a black crayon, line and space are involved. If paint has been applied, color is present. As soon as a shape is drawn, it interacts with the space around it. Only for the sake of convenience have we treated these elements as separate entities.

Color functions on two levels. On the cognitive level, color conveys information in purely descriptive terms, as in leaves changing color in the fall, and in symbolic terms, as in flags or traffic signals. On the level of feeling (or affective level), color evokes psychological associations and thereby

PARTIII · CONTENT OF ART

creates moods and feelings. As any industrial design consultant or theatre designer is aware, color affects us emotionally as well as psychologically. Indeed, so pervasive are color's effects that the vocabulary of color theory can be used metaphorically in a wide variety of contexts—such as in music, when we refer to tone color, or in writing, when we speak of "purple prose."

Color also has been used symbolically within and sometimes across cultures, from early Renaissance paintings to Navajo weavings. Color can be based on real events (green leaves and blue skies) or used expressively, as in the still-life paintings of Janet Fish and the landscapes of April Gornik.

THE LANGUAGE OF COLOR

Scientists may define color as an effect of physical forces on our nervous system through impact on the retina. To painters, however, color is far more complex: it is a vital element closely related to all the other design elements. The sensitivity with which painters use color can convey a personal style and the meaning of a particular work. Ultimately it can influence the varied responses of viewers to a work of art.

The painter's color terminology also differs from the physicist's, whose primary reference is light rather than pigment. In art, a consistent terminology has come to be accepted as a means of discussing and using color, both in looking at works of art and in producing them. The following definitions provide some guidelines for instruction in painting, design, and the appreciation of art.

Hue is another word for color as in the phrase "the varied hues of the spectrum." Scientifically, a hue is determined by the wavelength of light reflected from an object. As the wavelengths change, we note those distinct qualities that we call hues. Hues, therefore, are identifiable segments of light waves even though everyone may not see or receive them in exactly the same way. Computers have actually expanded our conception of color. Computers can generate subtle variations of color that result in an almost unlimited number of color choices for the graphic artist.⁴

To the painter working with pigment, the primary colors are red, yellow, and blue. Most children can recognize and work with the painter's primaries, as well as violet, green, and orange (secondary colcrs) because they can be created by mixing the primaries. The tertiary colors result from mixing primary and secondary colors and may be more difficult for children to achieve, because they require a greater control of paint (see the diagram of the color wheel). The use of tertiaries can provide richer hues than the simple mixing of black and white will yield.

Value refers to the degree of darkness or lightness of a hue—the lighter a color, the higher its value; the darker the color, the lower its value. Hence, if white is added, the value is heightened; if black is added, the value is lowered. When most of the pigment is white, the resulting color is called a *tint*. The addition of black produces *shades*. Hues may also be changed by the use of a *glaze*, or a veil of thin transparent color, which is brushed over the hue. This method of changing a color was much favored during the Renaissance.

Chiaroscuro is the technique used in drawing and painting tc create the effects of light and shadow in the natural world. This entails shading objects from light to dark to give the appearance of three dimensions. In Rembrandt's work, the light appears to glow from within the subject. Monet bathes his haystacks in light, and contemporary abstract painter Helen Frankenthaler uses veils of color for dramatic emotional effects.

Architects and sculptors control the light-and-dark composition of their work, not by mixing pigments as in painting or shading with pencil or crayon as in drawing but by planning the way light and shadow interact. A building may be designed with deep recesses to produce shadows in contrast to a facade that catches the light, and sculptors take great pains to control the "hollows" (negative areas) and "bumps" (positive areas) they make so light and shade are used to their best advantage. A portrait sculptor, for example, in order to achieve the very dark center of the human eye, makes a deep recess that becomes dark shadow.

Intensity, or brightness, indicates the ultimate purity of a color. Any hue that has not been mixed with another color is considered to be at its maximum intensity. Paints for school use come in the highest intensities because it is not usually possible to make a color brighter. Students can lower the brightness of colors by mixing them with complementary or opposite colors. Children have much greater expressive control of their paintings when they learn to lower intensity and alter value of colors. Without this knowledge, children tend to use all high-intensity colors cirectly from the paint containers.

Complementary is a term that refers to the relationship between primary and secondary colors on a color wheel. On the wheel, these colors are in opposition to one another, as red is to green, blue to orange, and yellow to violet. The complementaries are antagonistic in the sense that A color wheel is a useful visual aid for teaching color-mixing theory with watercolor, tempera, oil, acrylic, pastels, or other forms of pigments. Students who learn about the relationships of colors (hue, value, intensity) and their effects when mixed or juxtaposed greatly enhance their technical and expressive capabilities with painting media. neither color in a pair possesses any property in common with the other. Complementary pairs, however, are complete in the sense that together they contain all three primaries. For example, the complement of red is green, which is made of yellow and blue. Browns and blacks are obtained by mixing the three primaries in some ratio. Mixing two complementary hues has the same effect as mixing the primaries. Artists make great use of the fact that complementary pairs neutralize each other, creating a wide range of grays, which are potentially more interesting than grays composed of black and white.

Analogous colors are intermediate hues on the color wheel and may be explained to children in terms of families of color. Analogous colors can be likened to a family in which a red man and a blue woman produce a violet child.

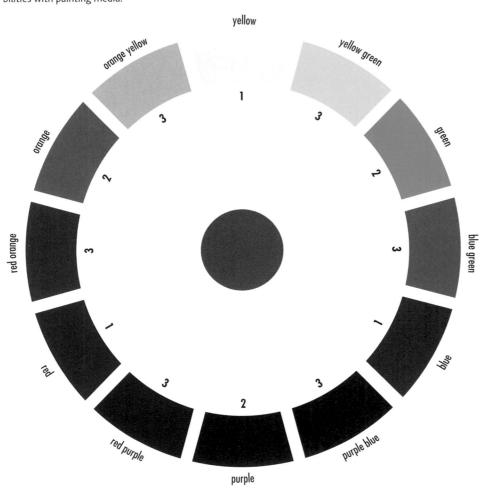

Rebecca, age 11, combined a sensitive use of color with an imaginative radial design for her rendition of a "Fashionable Fan." She chose areas of analogous colors, both warm and cool, and included areas of contrast to create this delightful painting. Notice symbols in the work: smiling faces, hearts, and frowning faces.

Analogous colors always get along; it is the complementary colors that often disagree.

Warm and *cool* refer to the psychological properties of certain colors. We normally call reds, yellows, and oranges warm colors, which we generally perceive as coming forward, or "advancing," in a field of color. Blues and greens are usually identified as cool and "receding" colors. The movement forward or backward of any color, however, depends entirely on its relationship to the surrounding hues. Experimentation with recession and advancement of color is of special interest to the hard-edge and color-field painters.

Color wheels are useful guides to understanding the terminology of color relationships. Teachers should not restrict pupils to the schematized set of relationships shown on the wheel. The purpose of color wheels is to expand students' understanding of color relationships and to assist them in developing skills for painting and drawing with color. Teachers are discouraged from requiring pupils to create elaborate and time-consuming color wheels.

Many art forms are produced in which color is lacking—black-and-white films, some forms of sculpture, many of the etching processes, and drawings in which black-andwhite media are used. Color, then, is a complex element at once dependent, powerful, and moving in its sensual appeal. As for the interests of children, teachers will discover that color has an appeal far in excess of the other elements of design.

Texture

Texture refers to qualities of surfaces. Every surface has a texture; a pebble on the seashore, a veined leaf, a cat's fur, a brick wall, and a sheet of glass all display varying kinds and degrees of texture. We derive a sensuous enjoyment from texture. We like to run our hands lightly over the surface of a tweed jacket or a silk scarf; we enjoy holding a smooth stone lightly in our hands or gently stroking a baby's hair. We enjoy textures visually as well, and artists use both tactile and visual textures in their works. Architects plan surface textures for visual contrast, variety, and unity; painters create visual equivalents of various textures.

Texture appeals to people for both aesthetic and sensuous reasons, although it is doubtful if the two can be entirely separated. The texture that artists use may be actual or simulated. Paper for watercolor paintings is carefully chosen for its textural qualities. Some painters create effects with gesso on a surface before painting on it with tempera or oils. The paint itself may be applied with careful regard for its textural effects. Paint applied thickly has a degree of roughness, but it can also be put on with silky smoothness. In drawing and painting, artists represent textures as well as employ them with roughened painting surfaces or impasto. Richard Estes is known for the photorealistic quality of his city scenes, in which he represents concrete buildings, plate-glass windows with reflective surfaces, asphalt pavement, shiny automobiles, brick facades, and natural textures such as foliage and grass. Sculptors work directly with textures inherent in the materials of their art. Deborah Butterfield has created a series of horses in materials ranging from plaster and bronze to sticks, mud. and wire. The materials she selects often determine the textures of the sculptures and the moods they express.

Children delight in surface qualities in drawing, painting, sculpture, and collage activities. Teachers can assist children in exploring the possibilities of expression through the use of textures in their own artwork. And teachers can help children develop visual and tactile sensitivity by discussing the treatment of texture and surface in such objects as a Japanese tea bowl, a monumental Egyptian sculpture, a Native American woven basket, a modern automobile, and paintings by Hans Hofmann (textured surface) and William Harnett (realistic illusion of objects of varied surfaces). Because texture is a major avenue of aesthetic awareness for sightless students, some museums now have special collections of "please touch" objects that children are encouraged to handle.

Space

In art there are two types of space: actual space and pictorial space. Actual space is either two dimensional, as in drawings, paintings, or prints produced on flat surfaces, or three dimensional, as in sculpture, architecture, or ceramics. Artists have learned to be as sensitive to the organization of space as they are to line and shape. As soon as a line or a shape is placed on paper or canvas, it interacts with the surrounding space. When a second line or shape is added to the composition, other spatial relationships are created. Two shapes can be close together or far apart, above and below, side by side, or crowded in a corner. The possibilities multiply as each new shape or line is added to the composition.

Sculpture is three dimensional and exists in actual space as it relates to surrounding areas. The sculptor is aware of these relationships and makes purposeful decisions to pierce space with sculptural forms and to cause forms to move in space—as with mobiles or kinetic sculpture.

Pictorial space is the flat surface of the paper, canvas, or other material and is known also as the *picture plane*. On this surface artists often create the illusion of threedimensional space. For example, a landscape picture often has a *foreground* of objects that appear near to the viewer, a *middle ground* farther away, and a *background*, such as the sky or distant hills, that is behind most of the objects in the picture. To achieve this illusion, the artist can overlap objects in the background and make them smaller than similar objects in the foreground.

Linear perspective is a system developed by artists of the Renaissance that approximates the visual phenomenon of apparently diminishing size of objects as their distance from the viewer increases. This system, which utilizes a horizon line and one or more vanishing points, is rarely learned spontaneously and usually requires instruction and practice for mastery. Pictorial space is not limited to linear perspectives and can also be created in a totally abstract and nonobjective painting through the use of shapes and colors that recede or advance.

Whatever line or shape is placed on the picture plane immediately creates a figure-ground relationship, in which the mark or shape is the "figure" and the surrounding area is the "ground." With three-dimensional works of art, the object is the figure, and the space behind or around it is the background, or just the ground. The placement of any figure in a pictorial space shapes the ground. All shapes and masses are surrounded by the element of space. As an example of the use of space in architecture, consider the courtyards separating the buildings in a modern housing development. Here the architect has carefully planned the amount of space that should be provided between one building and another. If the space had been planned to be smaller, the buildings might appear huddled together; if the space had been planned to be wider, the buildings might not appear to belong to a coherent plan.

All the elements of design are included in this collage by Ruth, age 8. Contrast of darks and lights, patterns, and textures, handled with an eye for balance, make this composition work.

The artist working in two dimensions must also regulate the spaces between shapes. Children can learn to appreciate these qualities when they create designs by pasting pieces of dark paper on a white background.

Tension is a design concept that does not fall easily into

the categories of elements or principles. In a Cézanne painting of an apple on the edge of a table, the artist's use of tension is easy for children to sense, but when portions of a work are intended to convey tenseness or a sense of straining between opposing forces, the tension is too difficult for an untrained, immature student to understand—particularly if the work is abstract.

Children should be made aware of the interactions that take place among all elements of an artwork. These formal properties of art are employed by all types of artists; painters, sculptors, architects, graphic designers, weavers, illustrators, and landscape designers all study and develop skills for expression through design.

THE PRINCIPLES OF DESIGN

It would be convenient to offer a formula for the production of satisfactory designs, but, of course, if designs were subject to rules and regulations, art would cease to exist. Every good design is different from every other good design, and all artists have unique ways of using the elements and principles of art.

Artists in non-Western societies may not be aware of the elements and principles as described here, but these artists still make use of design concepts. When an Aboriginal artist creates a bark or rock drawing, line is the dominant aspect; and when a Dogon sculptor carves rows of marching figures on a granary door, then repetition becomes an outstanding factor in the door's design. We will now discuss individually those principles mentioned earlier—*unity, rhythm, proportion,* and *balance*—in which the elements have a role to play.

Unity

We have already mentioned the integrated nature of design. We described design in terms of order, coherence, and expressive power. These are the most obvious characteristics that result from a successful art form, whether musical, dramatic, literary, or graphic. Each element is so arranged that it contributes to a desirable oneness or wholeness. In a drawing, a line ripples across a certain area to be caught up elsewhere; shapes and spaces set up beats and measures in a kind of visual music. Colors, textures, and areas of light and shade all contribute to the orchestration of the visual pattern. This oneness or wholeness we call *unity*.

Without oversimplifying or intellectualizing a process

that is largely one of feeling, we may analyze to some extent how unity is achieved in a visual design. Three aspects of design that contribute to the unity of a work of art are the rhythms, the balances, and the proportion established.

Rhythm

The controlled movements to be found in many good designs are called *rhythms*. Artists may establish rhythm through the use of any of the elements of design—lines, areas of light and shade, spots of color, repetitions of shapes and spaces, or textured surfaces. For example, in a particular work of art, a line may ripple in one direction, then undulate in another. This movement may be momentarily halted by an obstructive, brightly colored shape before it darts away along a pathway formed by areas of light and shade. Artists use rhythm to give movement to the manner in which our eyes move over a work of art and to control the pace at which our gaze travels.

At least two main types of rhythm appear to occur in works of art. The first has the character of a flow and is usually achieved either by lines or the elongation of forms. (The work of El Greco is an outstanding example.) The second type has the character of a beat. An element may be used in one area of a work and repeated elsewhere, either as an exact duplication of the original theme or motif or as only an echo of it. In traditional paintings we are more likely to find reminiscences than duplications of an original motif. The undulating-stripe paintings of Bridget Riley offer examples of visual rhythm and visual beat. In many crafts, such as weaving or pottery, repetition often is used purely for decorative purposes.

Proportion

The size relationships within a composition refer to its *proportion*. Proportion often involves an ideal relationship that the artist strives for. Things that are "out of proportion" are often awkward or disturbing, such as an oversized sofa in a small room, a tiny painting hung alone on a broad expanse of wall, or a part of a figure or other object that is too large or small for the other parts. The ancient Greeks developed an elaborate system of proportion by which they built temples and other edifices.

The proportions of a classical Greek temple . . . were rigidly prescribed in a formula that can be stated mathematically as

a:b = b:(a + b). Thus, if *a* is the width of a temple and *b* the length, the relationship between the two sides becomes apparent. Similar rules governed the height of the temple, the distance between columns, and so forth. When we look at a Greek temple today, even without being aware of the formula, we sense that its proportions are somehow supremely "right," totally satisfying. The same mean rectangle that determined the floor plan of the temple has been found to circumscribe Greek vases and sculpture as well.⁵

Some artists adhere to systems of proportion to achieve their expressive aims. Others convey ideas and feelings by distorting proportion or controlling it in other ways. To children, proportion is largely a matter of appropriate size relationships.

Balance

Closely related to the aspect of proportion in design is *balance*. When the eye is attracted equally to the various imaginary axes of a composition, the design is considered to be in balance.

Writers have attempted to explain balance in terms of physics, usually referring to the figure of a seesaw. However, the concept is not quite accurate, because physical balance and aesthetic balance, although related, are not synonymous. Balance in aesthetics should be considered

It is difficult to imagine any program of art education without referring to art's early sources-be they the cave walls of Altamira or, as in the case of this illustration, the bark drawings from northern Australia. Such images record our earliest interests in the use of pictographs with magical associations. Although survival played a part in the creation of symbolic images, the pleasure given to both artist and viewer was surely a part of the process. Aboriginal bark paintings (Australia) provide exceptionally clear references to art terms, such as symmetry, line, repetition, and rhythm.

as attraction to the eye, or visual interest, rather than as simple gravitational pull. Aesthetic balance refers to all parts of a picture—the top and bottom—and not only to the sides, as the seesaw analogy suggests. The sizes of the shapes, although having some influence on aesthetic balance, may easily be outweighed by a strong contrast of elements. A small, bright spot of color, for example, has great visual weight in a gray area, as does an area of deep shade next to a highlight.

Many books on art discuss "formal" versus "informal" balance. The arrangement of a composition with one welldefined figure placed centrally and with balancing elements placed on either side of this center, as in a front view of a Haida totem pole, is called *formal* or *symmetrical* balance. All other arrangements are called *informal* or *asymmetrical*.

Attraction to one kind of balance or another is also dictated by the ebb and flow of artistic fashion. The history of art shows us that most civilizations (including the Hindu, Aztec, and Japanese) have gone through a symmetricaldesign phase. The artists of the High Renaissance prized symmetry and were followed by the mannerists, who rejected the limitations of two-point perspective. The dadaists of the 1920s and abstract expressionists of the 1950s discarded all semblance of conventional visual order; yet during the 1960s, many hard-edge painters and pop artists revived it for the simplicity and directness of its impact on the viewer. Neoexpressionist artists opt for more dynamic, informal compositions.

Broad Implications of the Design Process

It is possible to produce a design that has all the attributes of unity but is neither interesting nor distinguished. A checkerboard, for example, has a rhythmic beat and a balance, but as a design it is unsatisfactory because it is monotonous and lacks tension and a center of interest. Likewise, a picket fence, a line of identical telephone poles, and a railway track are as uninteresting as the ticking of a clock. A stone wall, however, might have great design interest because of the variety of its units. Even though shapes are similar in a brick wall, people generally prefer the random colors, tones, and textures found in old, used brick.

Although the perceptual process seeks closure, or completeness, educated vision demands that in art, at least, a degree of complexity be attained if our attention is to be held. Every element, therefore, must be employed to bring about a desirable variety within unity.

Sensitivity to the nuances of form can begin with sorting exercises such as sorting pebbles and stones for specified visual characteristics.

This variety within unity is, in fact, an expression of life. Philosophers have postulated that design, or form, is a manifestation of our deepest and most moving experiences. In the designs they produce, people are said to express their relationship to the universe. In *Art as Experience*, John Dewey mentioned the mighty rhythms of nature—the course of the seasons and the cycle of lunar changes—together with those movements and phases of the human body, including the pulsing of the blood, appetite and satiety, and birth and death, as basic human experiences from which design may arise.⁶

Sir Herbert Read, commenting on Platonic doctrine, tells us that

the universality of the aesthetic principle is Plato's philosophy: the fact that it pervades not only man-made things in so far as these are beautiful, but also living bodies and all plants, nature and the universe itself. It is because the harmony is all pervading, the very principle of coherence in the universe, that this principle should be the basis of education.⁷

Dewey, Plato, and Read would, then, seem to assert that the search for order, which the design impulse seeks to fulfill, is important not only for an individual's artwork but also as a reflection of that person's larger integrative relationship with life itself and can indeed be viewed as a metaphor for life.

USES OF DESIGN

The language of design provides us with a vocabulary to talk about art more effectively. When *design* is used as a verb, as in "*design* a house," the term implies using the principles and elements for practical purposes (we do not say to a painter, "design a painting"). Design, in its broadest sense, deals with the organization of the elements of art for functional purposes. In the "living" or "applied" arts, design shows us its practical side. This can be better understood by studying the diagram that follows, which likens design functions to a concentric scheme, with the individual at the center and the community at its outermost layer.

- 1. Individual uses: clothing, jewelry, tattoos, uniforms
- 2. Objects used by individuals: appliances, automobiles, tools
- 3. The interiors we live in: furniture, fabrics, wall coverings
- 4. Dwellings: apartments, houses, houses of worship
- 5. Neighborhoods: from established urban areas to housing developments
- 6. New towns and cities: Columbia, Maryland; Seaside, Florida; Brasilia, Brazil

7. Visual worldwide culture entering our lives: in the form of television, computers, and multimedia

Environmental design, such as landscaping, has its own parameters and extends through circles 4, 5, and 6.

Although this book addresses the personally expressive side of art—that is, art that exists for what it can provide by way of pleasure or intellectual stimulation—we must also keep in mind that art for most people exists to serve other human needs. Something basic to our nature makes us designers. An object as simple as a toothpick has undergone so many changes that an example from the turn of the twentieth century looks quite different from one purchased today.

Of course, interesting crossovers occur from one function to another, as in one-of-a-kind buildings, articles of clothing, furniture, or jewelry that not only serve practical needs but also are cherished for their high aesthetic value. When a museum prefers to add a table by George Nakashima to its collection rather than the dozens of paintings

An imaginative photographic artwork depicts a work of contemporary architecture. Barbara Kasten's 1986 cibachrome photograph *Architectural Site 10* provides an exciting and colorful interpretation of architect Arata Isozaki's Museum of Contemporary Art, Los Angeles. Does this museum structure seem appropriately contemporary to house the art of today? Earl Keleny, Obesity in Men Linked to TV Viewing (1989). Watercolor and oil on paper. Humor and art have long been companions. This is the image of the ultimate "couch potato" (notice the spots on his shirt). Who is the woman making ready to dislodge the long pole that supports his head? What will happen then? How can art be used to convey a serious point through a whimsical image? Can you find other examples of humor in art? and sculptures that have been offered, then the line that traditionally separates useful art from fine art has been blurred.

A wide range of applications of design exists, much too broad to discuss here. The following (partial) list of careers in the applied arts will provide a hint of the extent of these fields.⁸

- architecture crafts design editorial design and illustration fashion design film and television
- graphic design industrial design interior and display design photography theatre and stage design

Keep in mind that each of these fields of design has numerous parts and permutations involving many other careers. For example, under graphic design we will find these options, among others:

advertising designer CD, DVD jacket designer computer graphics designer corporate art director graphic designer layout artist letterer, calligrapher, type designer outdoor advertising designer website designer

We will briefly discuss the fields of graphic design, design for entertainment, and architecture; the latter will be the subject of suggested classroom applications.

Graphic Design: Art for Communication and Persuasion

The means used to persuade consumers to use one product over another involve every sort of print and digital media, from posters to websites and from billboards to TV ads. Sometimes graphic designers also produce public symbols promoting civic responsibility, as in the case of traffic and safety hazard signs.⁹ Two goals are uppermost in the minds of the graphic designer: to communicate quickly and to find the proper match between word and image-hence, the importance of typography. In some ways the task of the art teacher is similar to that of the poster designer. The teacher must be wary that the art program not end up as a service pursuit, producing posters for PTAs, community causes, national campaigns, and school functions. One thing is clear: As long as methods of reproduction on a mass scale are available, graphic designers will produce for a mass market. The more underdeveloped the society is, the less is the need for the graphic designer.

When we consider the extent to which both children and adults are exposed to the influences of graphic design, and the general pervasiveness of the applied arts in our lives, we can gain an appreciation of the importance of including design fundamentals in a comprehensive school art program. When young people become familiar with the principles, practices, and motives behind much of graphic design, they will, it is hoped, become more selective rather than be manipulated by such influences.

Design in the Entertainment Media

Artists and designers in the electronic media occupy a category of their own. The role played in our lives by television alone is as influential as that of graphic design. Artists in film, video, and stage design usually work in concert with other artists and technicians. In live theatre, set designers, lighting designers, and makeup and costume designers work with writers, directors, musicians, and actors to create the final presentation. In television, advertising designers often include visual graphics, animation, music, drama, and dance in a 30-second commercial.

The field of music videos is another example of collab-

oration and of how hazy the line is between the fine and applied arts. Many music videos are artworks in their own right and might become a contemporary version of the type of collaborations inherent in opera, which some view as the ultimate art form.

The applied arts, including the design areas, are sometimes considered as separate from the fine arts. Russia, for example, would be unlikely to hold an art exhibit on a national level without including the works of theatrical, film. and book designers. In the United States it is less likely that the work of such artists would appear in a similar situation. Illustrators and graphic designers have their own recognition and award systems that often result in yearbook publications of the best works in the various fields. The design fields in the entertainment and advertising industries each have their own cultural histories, and because such works can be examined for their social and philosophical contexts, they have a legitimate place in a balanced art program. To include areas other than drawing, painting, and sculpture in the art program, teachers require access to visual resources, along with an adequate background of understanding of the applied arts.

Architecture as One Example of the Uses of Design

Architecture not only has good coverage from a design point of view in the available books and slides but also has a powerful human function that can be studied in every society and in every historical epoch. To include architecture in the curriculum, let's begin by defining it. One good working definition is that *architecture* is "the art and science of enclosing space for human needs." Architecture has an aesthet:c as well as a practical dimension and, in some cases, achieves a symbolic significance. To expand our understanding of the term, we must search for concepts related to architecture that can suggest student activities, historic examples, and points of emphasis when introducing activities. Examples of some basic architectural concepts follow.

FUNCTION AND FORM

Architectural design starts with the needs of the user. Architects do not begin with a set of columns or windows but with such questions as "Who will use it?" "What func-

Frank Gehry, Guggenheim Museum, Bilbao. Art critic Robert Hughes has labeled Gehry's Bilbao Museum "the first great building of the 21st century," even though it was completed in 1997. The organic structure of Gehry's building was made possible through the use of computer animation and three-dimensional computer modeling. The fact that the architect is also a sculptor enables him to create a building that holds all the fascination of a giant sculpture. The large Jeff Koons sculpture Puppy sits in front of the museum, facing the city of Bilbao and offering a friendly welcome to residents and visitors alike. The huge Puppy is completely covered with large, colorful, living flowers.

tions must the building perform?" and "What are the constraints of cost?" Structures from toolsheds to museums begin on this level. This is known as form following function. Postmodern architects sometimes reverse this formula and opt for emphasis on form (see the work of Frank Gehry).

ENVIRONMENT

Architects capitalize on the setting and environment of the structure, such as the average weather and the local materials of the setting. Designers in Florida will therefore be more likely to use coral stucco and concrete block than wood, which is a material more congenial to the Pacific Northwest.

ENGINEERING

Architects must be familiar with the engineering or structural demands of the building. (The medieval designers whose cathedrals collapsed after decades of work learned the hard way that flying buttresses were needed to support increased height.) Similarly, architects who work

This "breakaway" approach to interior design by a Japanese student, grade 4, requires the student to consider five areas of a given space. Wall sections can then be folded vertically to reinforce the illusion of the setting. in earthquake zones need to know more about buildingstabilization engineering than do most of their colleagues.

SPACE

The architect must be something of a psychologist because sensitivity to the effect of space on the individual is critical. The effects of space must be considered in the choices architects make when dealing with such issues as height, isolating or joining living areas, and utilizing the space that surrounds the structure.

ELEMENTS OF DESIGN

Architects may consciously utilize the vocabulary of basic design. Paintings use line, texture, repetition, rhythm, light, color, symmetry, shape, and volume for different purposes. Architects can and do find ways of using such elements in the design of a building, always considering the practical implications of their use.

GROUP PLANNING

If an assignment is complex, as in the case of an arts center, architects, unlike most painters, will plan as a group, brainstorming and sharing their special areas of expertise. Frank Gehry, for example, works with a technical staff that creates 3-D computer models of his architectural ideas. He consults in the design process with craftspeople who will actually build the structure he designs. And, of course, he regularly checks on the aspirations and needs of his clients in relation to the location, budget, and time constraints of the project.

CAREERS

The architect may begin working with a drafter and later may call on such specialists as model makers or landscape architects. Architects also require the services of such specialists as electrical, heating, and plumbing engineers. A wide range of careers in architecture require an understanding of applied design, for example:

city planner/environmental designer home designer landscape architect marine architect playground designer theme park designer

Teaching Children through Architectural Problems

Following are suggested activities that will introduce children to concepts, practices, and problems associated with the field of architecture.

MATERIALS INVESTIGATION: STRUCTURE

Students can test materials by making structures of clay or paper, exploring the possibilities of the medium. For example, when paper is torn, it has little strength; when it is pulled, it has great tensile strength. Problem: What would be required to turn one $12'' \times 10''$ sheet of 60-pound paper into a bridge that spans two tables to hold a 5-pound weight?

BRAINSTORMING THROUGH SCHEMATIC DRAWING: GROUP PLANNING

Divide the class into groups, and give each group a large sheet of paper. Assign an architectural design problem to each group (a special kind of school, an airport, a store), and ask them to role-play architects by engaging in visual brainstorming, listing and transposing human needs into a flowchart of symbols, such as bubbles, squares, and arrows. The teacher can then translate the class suggestions onto the chalkboard.

SCALE MODELS (CAREERS)

If there is a school or department of architecture or an architectural firm nearby, ask for any scale models that may be discarded after use. These can be an introduction to the use of scale and the variety of materials used in models, such as sandpaper (roofs and driveways), dyed bits of sponge (trees and bushes), and balsa wood (walls). Of course, working to scale integrates learning in mathematics and art.

HOMEWORK (HISTORICAL)

Copy a facade of a building from another country or historical period, and mount it on a time line. Or ask students for small drawings, and mount them alongside a map of the world with arrows leading to the point of origin.

STREET MAKING (BRAINSTORMING)

Have everyone bring in one box to be turned into a house. (Changes or additions to the basic rectangle may be added.) Group the boxes together, and see what it would take to turn them into a neighborhood.

RECONSTRUCTION THROUGH MEMORY

Ask the students to suppose they are birds flying from home to school. What would the earth look like? How many streets can they remember? Can students draw their route home?

FORM ANALYSIS (DEVELOPING CRITICAL SKILLS)

Show an architectural slide that is out of focus, and ask the students to use the sides of small pieces of crayon to indicate the shadow areas of the volumes of form. Increase the focus two more times, and ask them to use the point of the crayon.

For all these architecture activities, see the Web Resources listed at the end of the chapter. These and other sites will provide images and information that will enrich student learning. Model community. For upper grades, the factor of accurate scale is dealt with, bringing art closer to mathematics. In this example, class members used the community in which they live as a point of reference.

Students working with blocks. Begin with group blocks to establish basic relationships among elements, such as living and commercial areas versus private spaces.

- 1. Philip Yenawine, Key Art Terms for Beginners (New York: Harry N. Abrams, 1995), p. 95.
- Steven Heller and Anne Fink, Less Is More: The New Simplicity in Graphic Design (Cincinnati, OH: North Light Books, 1999).
- 3. Edmund B. Feldman, Art as Image and Idea (Englewood Cliffs, NJ: Prentice-Hall, 1967), chap. 9.
- 4. Charles Stroh, "Basic Color Theory and Color in Computers," *Art Education* 50, no. 4 (July 1997): 17–22.
- Marjorie Elliott Bevlin, *Design through Discovery* (New York: Holt, Rinehart and Winston, 1977), p. 130.

- 6. John Dewey, *Art as Experience* (New York: Capricorn, 1937). See Chapter 1 in this book.
- 7. Herbert Read, *Education through Art*, rev. ed. (New York: Pantheon, 1958), p. 64.
- 8. The Consortium for Design and Construction Careers: fheitzma@triton.edu. Other Internet sources provide additional information regarding the many careers in art and design.
- 9. Kevin Gatta, *Foundations of Graphic Design* (Worcester, MA: Davis Publications, 1991).

ACTIVITIES FOR THE READER

- 1. Study the paintings and sculpture of such recognized American artists as Edward Hopper, Georgia O'Keeffe, and Jackson Pollock. Make a linear analysis of one of the works. Such an analysis should emphasize the main flows of line in the composition rather than copy the objects themselves. Pen and ink, soft lead pencil, and crayon are suitable media.
- 2. Find a small object, such as a piece of popcorn, a bit of crumpled paper, or some nuts and bolts. Using a brush and ink or markers, try to blow up the detail on a sheet of mural paper that measures at least $3' \times 4'$. Consider the space between the lines and how the figure (the object) relates to the ground (the surrounding space).
- 3. Cut some rectangular shapes and strips from paper of various tones but generally neutral in color. Move these shapes on a piece of white cardboard until a satisfactory arrangement of the shapes and spaces has been found, and then glue them in place. Find similar shapes, and drop them from above the cardboard so they fall in an accidental pattern. Continue this procedure until you come upon an arrangement that pleases you. Compare the "found" design with the planned one. Which do you prefer, and why? Does the accident offer an element of surprise that the planned design seems to need?
- 4. To investigate line and space, try the "exploding" design. Divide a sheet of dark paper into sections, and place the sections on white background. Observe how pulling the sections apart creates everything from a thin white line to a dominant segment of white. Do this also with curving lines that bisect the paper. Use this process to design a poster on a selected topic.
- 5. Create a collage that changes texturally in one direction from glassy smoothness to extreme roughness. Feel it with your eyes closed, and compare it with those of your classmates.

Vary the feel by adjusting the size and location of your textural samples. Visually disabled children will enjoy touching these. How might this idea be applied by an interior designer? A garden or landscape designer?

- 6. Dampen a sheet of heavy white drawing paper, and drip tempera paint or watercolors so different hues run and blend. Note the new colors so formed. View paintings by Morris Louis and Helen Frankenthaler, and note their use of running and blending colors.
- 7. Join the class in bringing in a swatch of color you think is red. When placed next to one another, the swatches of reddish paper, paint, and cloth will produce a surprising range of tone and value in a subtly modulated monochromatic collage. Try other colors as well, including black and white. Notice in each case how the surface texture contributes to the effect of the color. Each week, choose a particular "color."
- 8. Collect for study pictures of similar objects, such as automobiles, chairs, yachts, and kitchen equipment. Compare one brand with another from the point of view of function. How does a Porsche, for example, compare with a Cadillac or a Hummer in this respect? What concessions have the manufacturers made to style at the expense of function? Why have they done so? To what extent are they justified in doing so? Start a scrapbook that concentrates on the most poorly designed products.
- 9. List some of the kinds of graphic design that are part of the world of the child. Start with children's picture books, children's TV programs, comics, and other items of popular culture.
- 10. Exercising preference and judgment: What is the least attractive building in the community? The most attractive? Is

there a very ugly building in your town? What makes a building ugly? Bring photographs to class and discuss, noting differences of opinion.

11. A room of your own is being added to your apartment or home. What will it offer in the way of convenience of work or leisure, hobbies, and so on? What will it look like? Draw each wall separately on cardboard, and then stand them vertically on a clay base.

12. Design a doghouse or a birdhouse that relates to the identity of its occupants. Think of a Chihuahua, a dachshund, or a Great Dane, and use your imagination.

SUGGESTED READINGS

- Carpenter, William, and Dan Hoffman. *Learning by Building: Design and Construction in Architectural Education*. New York: Van Nostrand Reinhold, 1997.
- Carter, David E. *The Big Book of Logos 4*. New York: Harper Design, 2005.
- ———. The Big Book of New Design Ideas. New York: Harper Design, 2003.
- Conway, Hazel, and Rowan Roenisch. Understanding Architecture: An Introduction to Architecture and Architectural History. New York: Routledge, 1994.
- Frohardt, Darcie Clark. Teaching Art with Books Kids Love: Teaching Art Appreciation, Elements of Art, and Principles of Design with Award-Winning Children's Books. Golden, CO: Fulcrum Publishers, 1999.
- Gatto, Joseph A., Albert W. Porter, and Jack Selleck. *Exploring Visual Design: The Elements and Principles*. Worcester, MA: Davis Publications, 2000.
- Lauer, David, and Stephen Pentak. *Design Basics*. New York: Wadsworth Publishing, 2004.

- Miller, Anistatia R., and Jared M. Brown. *Graphic Design Speak: A Visual Dictionary for Designers and Clients*. Cincinnati, OH: North Light Books, 1999.
- Norman, Dcnald A. *The Design of Everyday Things*. New York: Basic Books, 2002.
- Parsons, Michael. How We Understand Art: A Cognitive Developmental Account of Aesthetic Experience. New York: Cambridge University Press, 1987.
- Resnick, Elizabeth. Design for Communication: Conceptual Graphic Design Basics. Hoboken, NJ: Wiley Publishers, 2003.
- Thorne-Thomsen, Kathleen. Frank Lloyd Wright for Kids: His Life and Idecs. Chicago: Chicago Review Press, 1994.
- ——. Greene & Greene for Kids: Art, Architecture, Activities. Layton, UT: Gibbs Smith Publishers, 2004.
- Ulrich, Karl T., and Steven D. Eppinger. *Product Design and Developmert*. 3d ed. New York: McGraw-Hill, 2003.
- Williams, Robin. *The Non-designer's Design Book*. 2d ed. Berkeley, CA: Peachpit Press, 2003.

WEB RESOURCES

- Center for Understanding the Built Environment (CUBE), Architectural Activities: http://www.cubekc.org/architivities.html. Provides information for educators about architectural design, preservation, and planning. Teachers can adapt curriculum for any grade level. Among the curriculum units are Box City, Frank Lloyd Wright, and Women in Architecture.
- Museum of Modern Art, *Architecture and Design Online Collection:* http://www.moma.org/collection/depts/arch_design/ index.html. Visit the online exhibition *Tall Buildings*.
- National Building Museum, Education Resources Packets: http:// www.nbm.org/Education/Educator/workshops.html. Provides curriculum pertaining to architecture and city design that may be downloaded, as well as online exhibitions and images.
- National Gallery of Art, NGA Classroom for Teachers and Students: http://www.nga.gov/education/classroom/. Provides resources by curriculum, artist, or topic. The architecture curriculum features noted architect I. M. Pei.
- Public Broadcesting Service, *Frank Lloyd Wright: Life & Work:* http://www.pbs.org/flw/. Includes teacher resources, student activities, curriculum, and a lesson on urban planning.
- Smithsonian Institution, *Smithsonian Education:* http://www .smithsonianeducation.org/educators/index.html. Multitude of resources for educators and students that include lessons on design and architecture. The site is rich in information and images.

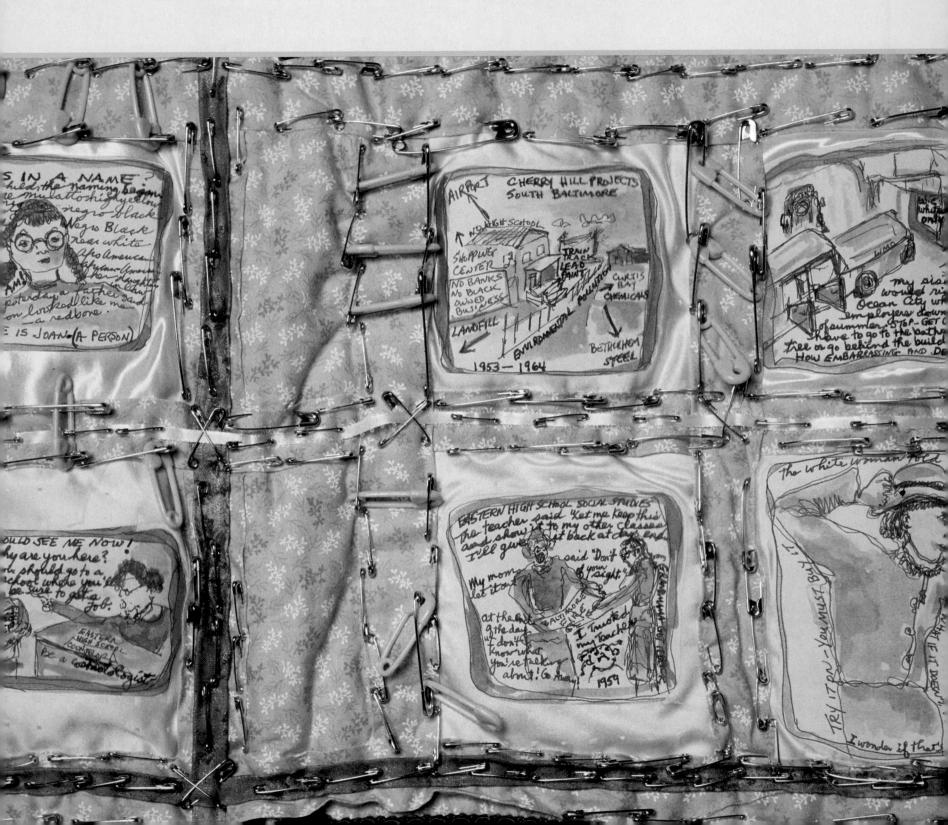

CHAPTER

2

ART CRITICISM

From Classroom to Museum

Works of art are mere things until we begin to carefully perceive and interpret them then they become alive and enliven us as we reflect on, wonder about, and respond to them.

—Terry Barrett, Interpreting Art

Up to this point, we have considered problems arising from creating art forms. We now turn to another aspect of art education, that of developing the pupils' critical skills, their abilities to reflect, wonder, and respond to works of visual art.

ART APPRECIATION AND CRITICISM

The word *appreciate* means "valuing," or having a sense of an object's worth through the familiarity one gains by sustained, guided study. Appreciation also involves the acquisition of knowledge related to the object, the artist, the materials used, the historical and stylistic setting, and the development of a critical sense. If we agree that critics as well as artists can be models for artistic study, we must think about how critics operate. There are journalistic critics who write for the general public, and there are critics who work for art journals who are knowledgeable in history and aesthetics and use language in such a way that criticism itself becomes an art form. Critics focus primarily on contemporary art created by artists of the present day or the near past. Their task is to assist viewers to better understand, interpret, and evaluate art and visual culture.

When we utilize a knowledge base in art, we deal with information surrounding a work (names, dates, places) as well as facts concerning physical details taken from the work itself (subject matter, media, colors). Knowledge also

James M. Flagg, "I Want You" recruiting poster. This classic recruiting poster for military service has a firm place in American history. Children can learn about the events that led to the creation of this poster, its use during World Wars I and II, its place as an American icon, and the way that images become icons. They can interpret the emotional qualities of the image and what ideas it conveys, and they can debate whether this image should be considered art. Students can discuss the social issues of today in relation to this poster and its history.

includes those concepts of design, technique, and style that the teacher feels can enable the student to "read" a painting. The cultural context of art and its function within that context is another essential component for understanding. Being able to recognize these factors in an artwork begins in our natural, untrained powers of perception but requires guided experience in order to make them operable.¹

Appreciation can begin in a spontaneous, intuitive reaction, but it does not end there. One way to arrive at a

A student contemplates a work by American abstract artist Sam Francis in the Norton Simon Museum of Art in Pasadena, California. Museum visits allow patrons to view original works of art and enjoy an aesthetic experience that reproductions do not allow. deeper level of response is to understand the difference between looking and seeing. In order to do this, we can employ a process used by professional art critics. A goal of criticism is to be able to respond more fully to an artwork and to defend one's opinion regarding it.

Knowledge, however, is not a precondition for deriving pleasure from works of art—if it were, people would not collect art about which they know little but which nevertheless has the power to capture and hold their attention.

Criticism focuses our attention on the kinds of knowledge that can be obtained from the art object itself as well as on the circumstances that surround it. What a person is emotionally, intellectually, and socially will influence the nature of his or her response.

One German literary critic sums it up as follows:

Criticism ranges from journalism to scholarship, and in rare moments of glory, it becomes literature in its own right. Above all, the task of criticism is to *mediate*. The critic stands between author [artist] and reader [viewer], mediating between art and society. In this regard the critic's function is primarily educational. The objection often made in regard to the critic—that he or she has a touch of the schoolmaster is absolutely justified. Whom do critics wish to instruct? . . . The critic wants to instruct the readers, to point out to them what is good and why it is so. By the same token this means that a critic is obliged to point out what is bad and why.²

Postmodern Perspectives for Criticism

In his book *Postmodern Perspectives: Issues in Contemporary Art*, Howard Risatti emphasizes the plurality of approaches common in postmodern criticism.³ Among the most prominent approaches we find traditional formalist criticism, feminist criticism, ideological or Marxist views, and psychoanalytic criticism based on concepts originating with Sigmund Freud's work. A good deal of emphasis is placed on the context of the work: when, where, and how the work was created; its function within the culture of origin; relationships with other prominent works or movements in art; and values of the society from which the work emerged. The study of context includes details of influential events in the artist's life that might shed light on his or her artistic creations.

In addition to these four prominent approaches to art criticism, numerous others can be pursued, including economic, religious, and technical perspectives, each of which might illuminate our understanding of the work(s) in question. Postmodern approaches as well lend credence to the views of individuals as they bring their unique backgrounds of experience to the encounter with art. Criticism becomes more democratic and less authoritarian than was perceived in the writings of modernist critics, such as Clement Greenberg and Harold Rosenberg, who helped establish abstract expressionism as the dominant art movement in the United States following World War II.

TEACHING METHODS TO DEVELOP CRITICAL SKILLS

The freshness, honesty, and directness that characterize the artwork of primary pupils, and the imaginative and intuitive capabilities of most children on the elementary level, combine to provide a positive learning climate for the students' critical-appreciative activities. The increased verbal skill of children in the upper-elementary grades can also compensate for the self-consciousness some may feel in certain studio activities and can often provide highly verbal children with an opportunity to excel in activities that are not studio oriented.

When we ask children to verbalize, to use linguistic as well as visual forms of expression, we are using skills developed in the language arts program for our own ends. Whereas children may engage in art activities for an hour a week, they will have had two hours of reading and writing on a daily basis since the first grade. Critical activities are the meeting ground between art and language arts, and it is because of the students' familiarity with the latter that they take so readily to applying language to the understanding of artworks.

Studio Involvement

Critical skills also can be developed in close relationship to art activities. According to this method, a teacher seizes every practical opportunity to introduce the subject of appreciation, not only of drawing and painting but also of three-dimensional work, such as sculpture, pottery, and architecture. This studio- or activity-centered method is based on the belief that one should not divorce expression from appreciation. When working with a medium, we become conscious of the problems, needs, and goals that have influenced our own expressive acts.

Past	Present
Rarely went beyond immediate reactions to a work of art.	Defers judgment until the art object has been examined.
Instruction was primarily verbal and teacher centered.	Instruction may be based on verbalization, contextual and perceptua investigation, studio activity, or combinations of these.
Instruction relied primarily on reproductions of fine art.	Utilizes a wide range of instructional media—slides, books, reproduc- tions, videos, films, and most important, original works of art, visits to museums and galleries, and visits from local artists.
Based primarily on painting, because of its "storytelling" qualities.	May encompass the complete range of visual form from fine arts (painting, sculpture) to applied arts (industrial design, architecture, crafts, print media, television, advertising, films), and other forms of visual culture.
Used literary and sentimental associations as basis for discussion. Concentrated on such elements as beauty and morality to the exclusion of formal qualities and social issues.	Bases discussion on formal qualities of the artwork. Recognizes beauty and other sensuously gratifying qualities as only one part of the aesthetic experience; also recognizes abrasive and shocking im- ages as legitimate expressions of psychological and political motives.
Neglected the contributions of women artists and representa- tives of growing minority populations, such as African American, Hispanic, and Asian.	Utilizes references to the past; shows respect for artistic efforts of all epochs. Strives for gender balance. Is no longer exclusively Western European in its sources.
Spent much time in anecdotal accounts of artist's life.	Minimizes life of the artist and concentrates instead on the work in its societal context.
Concentrated on a "great works" approach, to the exclusion of "lesser" works that have a special contribution to make.	Adopts a broader view of art objects and can include craft, illustra- tion, media, or industrial arts, as well as comic books and fine arts. Plays down "great works" approach.

In commenting on the reciprocity between the creative and critical processes in art instruction, Manuel Barkan and Laura Chapman stated:

The most sensitive making of art cannot lead to rich comprehension if it is not accompanied by observation of works of art and reflective thought about them. Neither can observation and reflection alone call for the nuances of feeling nor develop the commitment that can result from personal involvement in making works of art. The reciprocal relationship between learning to make art and learning to recognize, attend to, and understand art should guide the planning of art instruction.⁴

The Phased Approach to the Critical Act

The method that follows is a form of response related to the distinctions that critics make in writing about art. Awareness of formal structure requires children to be acquainted with the components of artworks and the teacher to be sensitive to children's perceptual, linguistic, and creative capabilities. It includes processes whereby students may engage in studio, historical, and critical activities, gaining relevant information while discussing works of art, and suggests deferring judgment and interpretation until the work has been examined and discussed.

One of the goals of critical activity is the development and use of the language of art. Children will not compare a photo-realistic work and a Willem de Kooning abstract painting in terms of "painterly" textures unless this term has been pointed out to them. Even fourth graders are capable of such distinctions if their attention has been directed specifically to nuances of surface or if they have been brought to discover it for themselves. Consistent examples should be selected for art terms that you expect children to learn.

Description

Although the descriptive level focuses on aspects most of us generally perceive commonly, it can also lead to some heated discussions, because what you see as red, your neighbor may see as orange; one person may see square shapes, and another, trapezoidal. In any case, it is through description that we make language more precise.

From the middle grades on, the teacher should make a distinction between *objective* description, items with which no one will disagree (such as a house, two people walking, a sky that takes up more than half the space, and so on), and *personalized* or *evocative* description ("sloppily" painted may be described by someone else as "loosely" painted). A scientist may describe a horse by Orozco as a four-legged quadruped; a critic or a poet may note its "noble bearing" or observe that it "moves like the wind." Evocative description usually involves adjectives. It can be imaginative in nature, and although evocative description should be encouraged, the teacher should make the students aware of the difference between the two approaches.

Even description, the most straightforward phase of art criticism, can become controversial if students are sufficiently confident to assert their own views. The perceptions of a group of viewers always results in interesting observations that no one person would make on his or her own. Criticism lends itself to group discussion and students learning from one other.

FORMA_ ANALYSIS

Prior to formal analysis, teacher and students will recognize the art object for what it is: a poster, watercolor, installation, or other form. They will also have an initial emotional response to the object and will recognize the general context and purpose of the piece. A ceramic portrait bust, for example, is a different kind of object with a purpose different from a poster for a rock concert.

Although formal analysis also has a perceptual basis, it takes the descriptive stage a step further by requiring the child to discuss the structure or composition of an artwork. The child who can distinguish between symmetry and asymmetry, identify the artist's media, and be sensitive to the qualities of color and line can discuss the form of an artwork or how it is put together. This is the stage in which the teacher discovers whether the children can use the language of design discussed in Chapter 11.

Once students are able to identify elements and principles, they can move on to search for the ways in which the elements of art (or design) interact. A student can easily point to a circle of red but may not be aware of the role the circle plays in relation to the rest of the composition. The discussions initiated at both descriptive and formalanalytic stages bring about that intense, sustained visual concentration necessary for the critical act. They also set the stage for the development of the interpretation that follows. Description and analysis do not accept premature judgments, requiring instead that the student defer certain opinions until they can be handled with that degree of detachment we call "distancing." When we "distance," we put a temporary hold on our emotions and our judgments.

INTERPRETATION

In the interpretative stage, the student moves to more imaginative levels and is invited to speculate about the meaning embodied in a work or the purpose the artist may have had in mind. To do this, the child is asked to establish some connection between the structure that can be discerned and the direction in which the artist is taking him or her. For example, if the class has agreed that Orozco in his *Zapatistas* used sharp contrasts of dark and light and strong directional forces, the question that follows is, 'To what end?" Would the meaning have been as clear had the artist used the more delicate colors and softer brushwork of impressionism? At this point, the class is getting at the painter's use of compositional elements for a specific end—in *Zapatistas*, compositional elements reinforce Orozco's attitude toward the revolution in Mexico. How does Renoir's sensuous and pleasing color relate to *his* feelings regarding motherhood and courtship? How do de Kooning's fragmented shapes and strident colors tie in with his attitudes regarding certain types of women? Such questions characterize discussion in the interpretative stage, which is open—a time and place without right and wrong answers.

JUDGMENT AND INFORMED PREFERENCE

The critical process normally ends with a judgment—that is, a conclusion regarding the success or failure of an artwork and its ranking with other artworks. Judgment, in this sense, is more the province of professional critics and connoisseurs than elementary students. Judgment, in the mind of a child, is often synonymous with preference.

It is useful to recognize the distinction between preference and judgment in response to works of art. Preferences are not subject to correction by authority or persuasion because one's personal liking or disliking of an artwork is an aspect of one's individuality. Such reactions as "like/ dislike," "it stinks," and "awesome" are psychological reactions and by their very nature discourage further discussion. Judgment, however, is subject to argumentation and persuasion.

When someone makes a statement such as "That is a

The Family (1968). Oil on canvas. Contemporary artist Eugene Grigsby Jr. was asked the question, "What would you like children and their teacher to discuss when viewing this painting?" The box on page 207 contains his response.

very strong painting" or "That is a poor example of raku pottery," it is reasonable for someone else to ask, "Why do you say that?" and request some justification for the judgment. If the justification is weak or controversial, then the floor is open to discussion. One goal of critical activity is to move students from closed to open minds, from instantaneous preference to a state of deferred judgment.

It is perfectly reasonable to say, "I know this drawing is not of high quality, but I like it nevertheless." Conversely, it is appropriate to remark, "I know this is an excellent sculpture, but I really don't like it." In most instances, however, we are more apt to like a work of art if we understand it and have spent some time with it. In most cases we prefer works that we judge to be of high quality to those that we judge to be of low quality. Another goal of art appreciation is accepting that preference and judgment are not

José Clemente Orozco, *Zapatistas* (1931). The striking contrasts of light and dark in this work can be a starting point for a discussion of ends in painting. In addition to formal analysis, students might search the context of this work during a time of political unrest and civil strife in Mexico. What message did the artist convey with this painting?

THE FAMILY by Eugene Grigsby Jr.

The Family, oil on canvas, $34'' \times 46''$, was painted in 1968. This painting grew out of a number of drawings and studies of family groups. It reflects my interest and concern about my family and families in general. I have been concerned about and interested in the family unit for many years. This image shows a family of mixed race, the design reflects the influence of my studies of African design, especially that of the Kuba who live in the Congo. This enabled me to use a variety of colors, textures and geometric shapes, to represent a universal family.

When traced back in history, families are a mixture of many cultures, races and religions. In many tribal cultures there is a different way of looking at the self in relation to other members of the community. In Western cultures we say "I think, therefore I am." In tribal cultures the thinking is "I am because we are" or "It takes a village to raise a child." A family grouping in a tribal community is the nurturing relationship that extends beyond immediate family to those in the surrounding community.

The family unit is the basis of our democracy. Not only democracy as we conceive it. Throughout history, the family unit has been the basis for humanity. Although the Christian holy family introduces us to humanity, similar family units are found in other religions and societies. Some families are large. Religion, poverty, and culture often determine family size. Some are small. Poor families, especially farm families, need many children and siblings to help with farm chores.

Some can trace ancestry for decades or longer. The origins of my family have been traced to Africa. Most American families, other than those of the Native Americans, can be traced to other countries. What about your family? How large is it? Where did it originate? A family is like a tree. It has roots and branches; some produce fragrant flcwers, and seeds and pods to plant and insure its future existence. Can you describe your immediate and extended family and trace it for several generations?

It would be fun to draw members of your family from imagination, or as you remember them. Many African tribal cultures worshipped ancestors and gave much respect to elders, called "griot," who kept the family and tribal histories.

My nuclear family is small; my mother, father, two brothers and a sister, but extended to many uncles, aunts, and cousins. My current family begins with myself, my wife, and two sons, plus their wives and two children and one great grandson. Ancestors provide background for family; both my paternal and maternal ancestors provide strength, hope, and ambition. It has lasted many years. The maternal branch held its 100th reunion in August, 2005. Eugene Grigsby Jr.

Phoenix, 2005

finite, that they can change over time. Even the greatest critics maintain their personal likes and dislikes. We find, however, as we learn more about art, that our tastes change and expand as our acceptance of artworks increases.

The stage of informed preference is the culminating and most demanding phase of formal criticism. It invites students to render their opinions regarding the worth of an object, provided their opinions are based on what they have learned in the previous stages. Such questions as the following are asked: "Are you moved by this work of art?" "Does it make a powerful statement?" "Would you like to own it or hang it in your room?" "Does it leave you cold?" "Do you dislike it?" "Why?" Most viewers instinctively begin at the level of preference: The process of criticism as set forth here attempts to *defer preference until the matter has been given sustained thought and attention.*

Children view criticism as a visual-verbal game and will participate with enthusiasm if the discussions are not too lengthy (a half hour seems to be an outside limit). Works with strong themes, interesting subject matter, and a clear compositional structure seem to elicit the most positive responses.

How Much Longer? (2003). Quilt. Artist Joan Gaither gave this response to the question, "What would you like children and their teacher to discuss when viewing your work?" She places her quilt in the context of racial discrimination (see the box on page 209).

In essence, the four stages are related to four basic questions:

- 1. What do you see? (description)
- 2. How are things put together? (formal analysis)
- 3. What is the artist trying to say? (interpretation)
- 4. What do you think of the work, and why? (informed preference)

Initially, the phases of criticism should be used in the order described, but when students are familiar with the process, *they can begin critical activity at any stage*. The roles of studio activity and historical information will depend on the teacher's knowledge and sense of timing.

The critical approach just described is not the only way to deepen our understanding of art. Tom Anderson has developed a model that includes the categories of reaction, perceptual analysis, personal interpretation, contextual examination, and synthesis, which involves resolution and evaluation.⁵ Anderson has also commented on a crosscultural approach to art criticism. It is important to note that with any model for critical response we might employ with children and young people, there is no need for a lockstep sequence from one phase or stage to another. In ordinary discourse about art, critics and students alike often move from one topic and stage to another and back again according to the dictates of their interests and the dynamics of discussion. In any approach, carefully chosen, specific artworks provide the primary impetus for learning.

LEARNING FROM ART CRITICS

Art criticism, art history, and aesthetics, as we approach them here, are inventions of Western civilization and have been applied as disciplines most readily in the context of European and American art. Yet today in the United States, art and artists from every culture compose the dynamic body of contemporary art. In the multicultural mix of the American population, many artists create works that convey ideas and values from their cultural heritages. Additionally, artists from around the world are drawn to this country much as they were attracted to Paris in the nineteenth century. Contemporary art from around the world enriches the American art environment as we enjoy the works in museums, galleries, and art publications.

Art critics, those who write about today's art, have contributed to the exciting array of ideas about art and have helped shape new directions and form new values in contemporary art. Much can be learned from the works of the art critics. Suzi Gablik, for example, questioned many of the assumptions of modern art (*Has Modernism Failed*?)⁶ and offered a more personal and relevant vision for the return of art to earlier traditions of spiritual, religious, and cultural values (*The Reenchantment of Art*).⁷

Linda Nochlin has informed our perceptions of gender issues in art (*Women, Art, and Power*).⁸ She has examined the history of gender discrimination and has revealed for readers the status of this issue today. Nochlin and her fellow art critics initiated the movement that recognized and examined feminist issues in art.⁹ The feminist movement in art has been carried forth by artists such as Judy Chicago

The Guerrilla Girls is an art activist group that uses "a rapier wit to fire volley after volley of carefully researched statistics at art world audiences, exposing individuals and institutions that underrepresent or exclude women and artists of color from exhibitions, collections, and funding."

(*The Dinner Party*)¹⁰ and feminist activists such as the Guerrilla Girls (*Confessions of the Guerrilla Girls*).¹¹

In her landmark book, *Mixed Blessings*, Lucy Lippard informed the issue of racial equality in the world of art.¹² By focusing exclusively on artists of color, many with cul-

HOW MUCH LONGER? by Joan Gaither

How Much Longer? is a quilt that highlights selected moments of being on the receiving edge of racial intolerance over time, and points to a need, in this artist's mind, for learning tolerance and education. *How Much Longer*? represents only a portion of the journey. However, once the idea of the quilt journey has begun, there is no set path. My sketchbooks are filled with word lists, sketches in pencil and watercolor, and fabric swatches reflective of early memories concerning issues of identity.

While not apparent initially, the use of no threads gives way to the safety pins and straight pins that hold this quilt together and highlights the consequences of racism for those who have been marginalized. The pins exist as a metaphor for the lingering pain and fragility of long-term confrontation with incidents based on racial hatred that denies one's person. The 24 squares of selected memories are chronologically organized from early childhood memories to the date of the quilt's creation 2003.

If *How Much Longer*? were to be discussed in school, I would hope that the teacher and students would search for the work's meaning by posing questions such as the following:

What comes to mind when you first see the quilt?

What do you notice about this quilt that may be different from a traditional quilt used on a bed?

How does the choice of format size, fabric colors, and textures affect your initial response to the quilt?

How does the photo transfer technique differ from traditional quilting?

What personal concerns are evidenced in the emotional, social, and political mini-stories contained within the work?

What is the significance of the baby spoons and baby diaper pins?

Did you notice that several of the safety pins have been left unfastened? How does this affect the meaning?

In addition to discovering how diverse materials can be used to embellish and elaborate upon an idea in quilting from the soul, consider ways in which you might brainstorm other ideas related to a series of events that have a lifelong effect on who you have become. tural, ethnic, and gender issues central to their work, Lippard alerted the art world of the significant connections between contemporary art and life in society. Howard Risatti assisted readers in making sense of the confusing situation of art in the postmodern era (*Postmodern Perspectives*),¹³ and Arthur Danto provided a shocking, but logical, thought that we might have observed the end of art as we know it (*After the End of Art*).¹⁴ Fortunately, we learned that Danto meant the end of one of the grand narratives in art, the one that culminated with Pollock and the abstract expressionists. To date, postmodern art has developed no grand narrative.

Judy Chicago, *The Dinner Party* (1979). Judy Chicago highlighted women's history and contributions to society with her mixed-media depiction of famous women, both historical and legendary.

The ideas from these and many other books and ar-

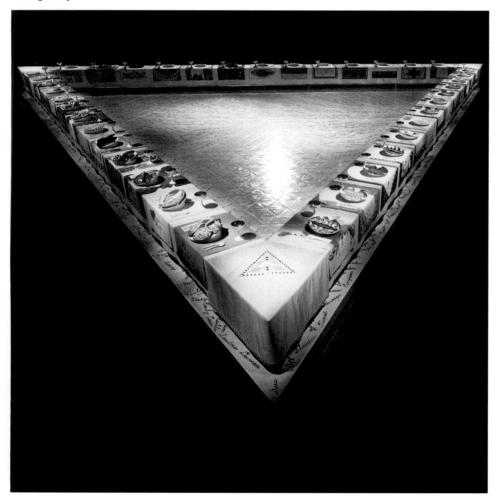

Cover from *Mixed Blessings, Art in a Multicultural America* by Lucy R. Lippard. According to the author, this book "deals with the ways crosscultural activity is reflected in the visual arts." Artists featured in the book belong to the Native, African, Asian, and Latin American communities.

ticles by art critics continue to inform our understanding of contemporary art and our regard for the artists of today and the significance of their works. As teachers, we will find ways to bring some of the relevant ideas of contemporary art into our classrooms in ways that meet the needs and abilities of the students we teach. We will assist our students in becoming familiar with contemporary artists and the ideas they communicate in their work, and we will observe how readily students of today's world respond to and understand the works of today's artists.

WORKING WITH LANGUAGE

One approach to fostering students' use of critical language begins by listing art terms that are to be learned by lesson, by unit, and by year. Try to avoid using any word unless it has a clear equivalent in an artwork. This can be accomplished with students at any age, as long as the concepts can be clearly illustrated in an artwork. Once having learned a word, students should be expected to use it from then on, whenever it is exemplified in a work under discussion.

New critical language also provides the teacher with a way to evaluate learning. The following words suggest three levels of complexity. Terms may overlap categories and can include formal qualities, subjects, media, and even emotional states or qualities of feeling.

LEVEL I: LOWER ELEMENTARY

portrait	color	sketch
still life	line	sculpture
landscape	contrast	contour
cartoon	paint	
shape	art	

LEVEL II: MIDDLE ELEMENTARY

abstract	advertising	contour
realism	print	graphic design
nonobjective	painterly	composition
modeling	assemblage	culture
watercolor	collage	texture

LEVEL III: UPPER ELEMENTARY AND MIDDLE SCHOOL

style	theme	social issue
proportion	perspective	installation
aesthetics	crosshatch	variation
interpretation	environmental art	genre
illustration	dominance	fantasy
expressive	subject	
symbols	art criticism	

Teachers can construct their own lists of terms, suggesting increasing complexity, sequenced instruction, and cumulative learning. After a word is learned on one level, it is then added to the ones on the next. This also opens the door to making variations of key words. As an example, the author showed a group of seventh graders a reproduction of a painting by Jackson Pollock and asked someone to point to the presence of lines. The immediate reaction was to deny the existence of lines. The class was urged to keep looking until the use of line was detected. Within a few minutes, it was discovered that Pollock used several ways to create lines; he dripped, he brushed, and he painted them. Pollock's method was then related to his general approach to painting, which, in turn, emerged as a key to understanding the movement known as abstract expressionism. One term—*line*—thus provided an entry into a major style of this century, or to put it another way, the *microcosmic* opened the door to the *macrocosmic*.

Dreaming Artworks

To get the students' imaginative juices flowing, ask each one to select a painting from an array of examples and write a few paragraphs beginning with the sentence "Last night I had the strangest dream."

One variation is to have the class respond to the same artwork. This will call attention to students' individual respenses. "Dreaming" can be used in classrooms with art reproductions, but it is more effective with original works in museums or galleries. Younger children who cannot write can participate in an oral version of this activity. Jenny Holzer, Untitled (1989– 1990). Selection from "Truism: Inflammatory Essays, The Living Series, The Survival Series, Under a Rock, Laments and Mother and Child text." Artist Jenny Holzer is noted for her use of language in her art. This installation is in the Guggenheim Museum in New York City. Holzer's provocative phrases deal with social and personal issues.

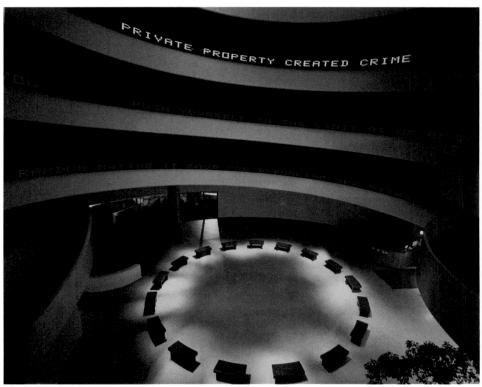

Bring an original work to the art room, or do this during a gallery visit. Ask students to write a personal response to the designated work (or one from a designated selection). They might follow the phased approach or strike out in their own way. Each brief essay should include interpretation of the meaning or feeling of the selected work.

FURTHER SUGGESTIONS FOR STUDY

The Artist of the Week

A lesson need not take up the full art period. An effective learning situation can occur in 5 to 10 minutes. Each art class could begin with an introduction to the "Artist of the Week," the teacher providing some interesting information about the artist and his or her work; posing some questions of a descriptive, analytic, or interpretative nature; and displaying the picture as part of an expanding exhibit.

Andrew Wyeth, *Christina's World* (1948). Tempera on gessoed panel, $32^{1}/4^{"} \times 47^{3}/4^{"}$. Questions of interpretation the teacher might pose: "What is Christina's relationship to the house?" "Does it mean something special to her?" "Does her position on the ground or her infirmity bear on these questions?"

Choose contemporary artists in line with the emphasis of art criticism.

Thematic Displays

Teachers can teach critical skills visually as well as verbally by displaying works that are connected to each other in some way. For example, three female faces are placed on the bulletin board: the face of a fashion model from a magazine, a woman's face by Andrew Wyeth, and a female face from a Romare Bearden collage. After the pictures have been on display for a few days, the teacher asks, "What have you learned by looking at these three heads?" Discussion might include concepts of beauty, the idea of portraiture, differences in style, similarities, and interpretations. The teacher could also try a parallel version with male faces.

Connecting with Studio Activity

Whenever possible, teaching for art appreciation should take place in conjunction with studio art projects. When students are working on a visual or technical problem in their own art, they are more receptive to learning from other artists who have confronted similar problems. For example, children are working on a collage and several are using pictures and fragments of pictures from magazines, so the teacher might show them collages by Romare Bearden and the story quilts of Faith Ringgold.

Aware of their apparent interest in fantasy, the teacher can show the children pictures of works by artists who specialize in fantasy, such as Salvador Dalí, René Magritte, or Frida Kahlo. Children can thus gain empathy by explicitly trying what artists have tried. In another example, the teacher's goal is to help the children understand why the impressionists are called "painters of light"-that is, why and how they captured so much sunlight in their work and why their colors are "broken" rather than "solid." The teacher takes the students outdoors on a sunny day to do landscape pictures with cravon pastels and encourages the children to capture the colors they see in sunlit areas. When they return to the classroom, they discuss how working outdoors is different from working in the classroom. Then they view and discuss the impressionists' works a second time and share insights.

It is through a studio experience that students can roleplay the artist. Although copying is not creative, it can enable a student to empathize with an artist's technique and expressive content. An attempt to duplicate a drawing by Seurat can for the moment place the student in Seurat's presence.

WORKING FOR TOTAL GROUP INVOLVEMENT

Instruments of Engagement and Evaluation

Teaching for critical skills, however, poses distinct problems. Although verbalizing about art is central to criticism, nonverbal activities must also be considered. Because children vary in their inclinations and abilities to speak about art, class discussions are too often dominated by the articulate and outgoing students. Moreover, as there is rarely enough time for each member of the class to give his or her opinion, the teacher may use one or more of the verbal and nonverbal instruments (task sheets) described in the following sections that suggest how to achieve total class involvement. Each sheet should be related to what may reasonably be expected of children in the area of art criticism, and each of the instruments attempts to reach one of four goals:

- 1. To enable the children to discuss artworks with a knowledge of art terminology and to be able to identify the design, meaning, and media as these elements function in particular works of art
- 2. To extend the students' range of preference or acceptance of artworks
- 3. To clarify for students the various purposes and functions of art and visual culture in society
- 4. To develop the students' abilities to speculate, to imagine, and to form plausible interpretations based on what has been observed

Statement Matching

One way a teacher can involve a full class in working toward the first goal is to have them respond to multiplechoice questions while they progress through a series of slides or reproductions. The questions should be based on the terminology and concepts the teacher deems valuable. Notice that some questions given are purposely more open ended than others to permit more extended discussion after the test. Thus, as the children see their first Andrew Wyeth painting, the teacher may want to emphasize the uses of composition and placement of objects, for example: This painting is called *Christina's World*. You notice that the artist has used a high rather than a low horizon line [point to line]. Now study it carefully. If you think he did it because the house just happened to be located there, write *A*. If you think he did it because it allows for more space between the girl and the house, write *B*. If you think he did it because it would look that way if the scene were photographed by a camera, write C. All right, how many wrote *A*? *B*? C? How many wrote more than one reason? Paul, I notice you didn't raise your hand at all—can't you decide? Mary, you voted for *B*. How about trying to convince Paul why you voted that way.

Composition

Another way to involve the whole class in identifying components of design is to give each child a reproduction or photocopy of the same painting and a sheet of tracing paper. The students place the paper over the reproduction, and the teacher asks the class to seek out and define such compositional devices as balance, center of interest, directional movement, and "hidden" structure. This method of searching fcr what lies beneath the form of a subject or composition will be most effective if first demonstrated on an overhead projector.

A variation of this method is to project a slide of an artwork on mural paper or on the chalkboard. The teacher begins by chalking a directional line directly on the projected image. Every child must then come up and add his or her own "invisible" line, such as rectangular-shaped buildings in an Edward Hopper painting or a prominent curve in a Georgia O'Keeffe flower painting (colored chalks may be used to make the final effect more vivid). When the lights are turned on, the class is confronted with the "skeleton," or substructure, of the work, which has been reduced to an abstraction of the original.

What Qualifies as Art?

The Solomon R. Guggenheim Museum featured "The Art of the Motorcycle" in 1998. This show included more than 110 motorcycles in a museum known for its collection and exhibition of great works of art.

The following questions might be used to initiate a classroom debate.

- Are motorcycles works of art? Why or why not?
- Why might an art museum deviate from the types of art that it usually displays?

Mary Cassatt, Breakfast in

Frida Kahlo, Self-Portrait with Monkey (1938). Oil on canvas, $16'' \times 12''$.

Edgar Degas, Little Dancer Aged Fourteen (plaster statuette). Model 1879–1881, cast ca. 1921, 41" imes 19" imes 20".

Dale Chihuly, Seaform (1981). Free-blown and expanded mold-blown and

Jaune Quick-to-See Smith, Osage Orange (1985). Oil on canvas, 48" × 72".

tooled glass, $9'' \times 20''$.

Children look at groups of artworks in postcard form or as reproductions displayed on a wallboard, read captions, and look carefully to answer questions such as these:

- 1. Which artworks are three dimensional? (Chihuly glass piece, Degas bronze)
- 2. Make a list of the different art media used for these artworks. (oil paint, collage, caste bronze, blown glass) Which media have you used?
- 3. Which artworks feature the human face or figure? (all but Chihuly) Of these, which one is most realistic? Which is most abstract?
- 4. What parts of the world are represented? (Mexico, France, United States)
- 5. Which work do you think is most emotional or expressive? Explain why you think so. What can you find out about each artist and the context of his or her work? How do these selected works relate to other examples by each artist?

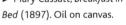

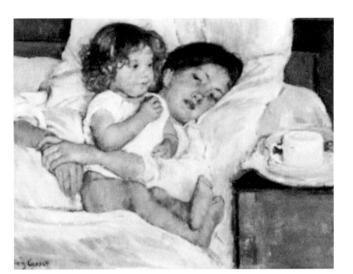

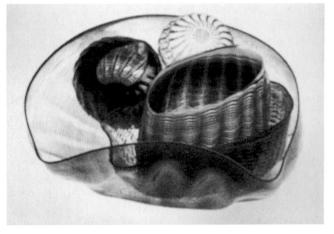

Romare Bearden, *Serenade* (1969). Collage and paint. Bearden's work can be interpreted formally as well as in relation to its historical context and expressive quality.

- If a motorcycle is a work of art, what other kinds of things can be considered art?
- How might the way a motorcycle is displayed help viewers think of them as works of art?¹⁵

A Pre- and Post-Preference Instrument

In order to assess the degree and nature of change in children's preference of artworks, the teacher can use a simple assessment based on all the reproductions to be used during the course of the year. This is a simple questionnaire that requires children merely to check off the phrase that best describes their reactions to the artworks placed before them. Using the children's style of speech, the responses to be checked might run as follows:

- 1. I like this painting and would like to hang it in my own room.
- 2. This painting doesn't affect me one way or the other.
- 3. I don't like this painting.
- 4. This painting bothers me; as a matter of fact, I really dislike it.

Initially, most children will gravitate toward the familiar—that is, to realistic treatments of subjects that appeal to them. By consistently exposing children throughout the year to works that range across cultures and from the representational to the nonobjective, a competent teacher can open their eyes to a wider range of art. This does not place a premium on any one particular style but aims at noting changes in taste from whatever point the child begins. If the preference test is given at the beginning and at the end of the course, the teacher should be able to determine how the class has changed—both as a group and as individuals.

Sorting and Matching

Another way to develop the children's critical skills is to have them work from a set of reproductions used by every class member. The sets may be compiled from inexpensive museum reproductions, which come in manageable sizes. Six seems to be a number of reproductions children can handle; more than this tends to be overwhelming, and occasions may arise when only two or three are appropriate. Whatever the number of pictures, children should examine them and be asked to make certain decisions. Such study also allows children to proceed at their own rate and to find the viewing distance most convenient for them. Spreading the pictures out on the floor or on a table is preferable to flipping through them—the pictures are more easily compared when seen simultaneously. Each collection a student uses should be accompanied by a set of questions designed to focus attention on a particular subject, idea, or term.

The Picture Wall

It is surprising how available art reproductions are once we begin looking for them. They now appear in popular magazines, calendars, posters, and, of course, in museums and One section of a room can be designated as a picture wall to provide the teacher with a ready reference for comparisons, identification of artists, styles, subjects, and art vocabulary. The picture wall can be assembled from museum cards, magazines, or commercially prepared reproductions. It should be used flexibly, from making comparisons and creating connections to studying cross-cultural and chronological contexts. card shops. Examples of applied arts and visual culture are readily available in popular magazines. As your collection grows, carry them with you in a large envelope, or find a place on the wall of the classroom, adding contributions from friends and students. The picture wall provides a variety of instructional aids, because each image will reflect categories of words (moods, styles, social issues) and help with identification of subjects, artists, and historical periods. The picture wall, because it is not encumbered by size or frames, is flexible; sections of it are meant to be shifted about; differentiation by selection encourages fluid thinking. One child selects some that deal only with landscape, another selects advertising, another chooses only nonobjective works, another the work of Faith Ringgold, and so on.

TEACHING AIDS FOR DEVELOPING CRITICAL RESPONSE

Among the teaching aids required in any program of art appreciation are prints, videos, CDs, DVDs, filmstrips, and slides dealing with a variety of art topics, as well as some actual works of art in two and three dimensions. No matter what field of art may be engaging the child's attention—

This poster, "Save Our Earth," provides much for viewers to discuss. The conservation theme is explicit, opening a number of contemporary political issues for analysis and debate, and the aesthetic dimensions of the work are worthy of additional interpretation.

pottery, textiles, drawing, or painting—it will be necessary to have on hand suitable works for reference and study that illustrate as many aspects of art as possible: contemporary, historical, national and foreign, and art that reflects the visual culture familiar to students.

The selection of the images is crucial. The teacher must not only consider the appropriateness of the artwork to the goals of instruction but must also reflect sensitivity to the ages and natural preferences of children.

Videos, CDs, DVDs, Filmstrips, and Slides

Technology for instructional art materials has changed over the past decade. Once the primary technology for teaching art criticism and art history, slides are being used less and less. Digital technologies continue to develop, and CDs, DVDs, and camcorders in connection with computers are the current technology leaders. Given the dynamic nature of the computer field, we can expect new technologies and new terms to emerge. Each year sees worthwhile additions to a growing library of acceptable videos designed for the young. Many of these videos are intended both to stimulate children to produce art and to assist them in mastering various techniques.

The teacher who uses videos must understand what constitutes a good program. Before using a video with the class, the teacher obviously must preview it and then decide how effective it may be. What criteria should be used in selecting videos to be shown to young children?

- 1. The video should be of high technical and artistic quality. Young children see expertly made movies in theatres and on television. Similar high-quality work by producers of children's videos should be standard.
- 2. The video must be suitable to the children's vocabulary, understanding, and level of maturity.
- 3. The video should be closely related to the curriculum. No matter how excellent a video may be in itself, it tends to be a poor educational device when shown out of context.
- 4. When a video is of the "how-to-do-it" variety, it must not only stimulate the children but also leave some room for them to use their own initiative. Try to use videos that attempt to stimulate production, focus attention on design, and give a few basic hints about technique and leave children with challenges to solve independently.
- 5. Teachers should feel free to turn down the sound and make their own comments, because they know the language level of their particular class.

Through a prior acquaintance with the video, the teacher can better time its introduction during the art sessions, as a preface to a topic, as an aid in teaching a topic, or as a summary for a series of experiences with a topic. Sometimes the teacher may need to comment on the video to the class before it is shown; on other occasions a discussion might take place afterward. Because obtaining a video for a specific art class is often difficult, the projector and a screen, as well as the video, must be scheduled, sometimes weeks in advance. Therefore, as much advance planning as possible must be done so the video will suit the type of art activity in progress.

Filmstrips and videos are an excellent value: they take up little space, are usually accompanied by lecture notes (of varying usefulness), and are flexible with regard to timing. They are inflexible, however, in that the images are set in a fixed crder.

USING ART MUSEUMS AND GALLERIES

Although we may obtain a reasonably accurate idea about many works of art by consulting reproductions, nothing can actually replace the work itself. How often we feel we

This teacher takes time to orient and inform her students during their visit to an art museum. Students often learn more if visits are structured around art concepts and selected works of art, and they usually are excited to see original works they have studied in the classroom prior to the museum visit. know a work of art through a study of reproductions, only to be overwhelmed on first seeing the original! Colors, brushstrokes, textures, and sometimes the scale of the work are never adequately conveyed by a reproduction. It is most desirable, therefore, for children to have the opportunity from time to time to observe original works of art, no matter how familiar they may be with reproductions or objects of visual culture, which are almost always replications. The most obvious sources of originals are galleries and museums, local artists, and collectors. Schools situated near art institutions would be remiss indeed not to make use of them. Even if a relatively long journey is necessary, the time and effort required may be considered well spent if children are properly prepared for the experience.

Before a class pays a visit to a museum or gallery, however, the teacher should visit the museum to become acquainted not only with the building and the collections but also with such mundane but important matters as the location of restrooms for the children and the special rules of the institution, especially concerning younger visitors. At the same time, the teacher can make any special arrangements with museum officials concerning the program for the children's visit and the length of time it will take.

Activities in Museums

Museums, according to one dictionary, are institutions devoted to the procurement, care, study, and display of objects of lasting interest or value. Museum staffs also engage in scholarly work, ranging from creating a definitive catalog on a neglected artist to sponsoring an archeological dig. Museums originated as collections of art assembled by wealthy individuals; today, the thousands of museums that dot our country have gone beyond the arts into such areas as farming, street cars, electricity, and so on. To the art teacher, museums are places where teachers can foster aesthetic experience and cultural understanding in a way that is impossible in the school.

Remember that museums are unnatural settings for art, in that they display works out of context, stripped of their original function. Remind students that the African mask they are admiring was meant to be actually worn by someone under certain conditions, that a particular portrait was meant to be hung in a certain kind of house, commissioned by a merchant who sought the approval of posterity through its purchase. Objects should be placed in context whenever possible.

Making youngsters feel at home in museums can be a very useful form of life preparation. Your students should not be among those who feel they must plod dutifully through galleries or museums but should instead welcome the experience as a result of an effective art program.

Here are some suggestions for you and your students to get the most out of your museum visit.

GUIDELINES

- Prepare for your visit. Build up suspense and anticipation by specific activities, such as timing the visit to coordinate with a particular part of your curriculum. Pay particular attention to those factors that cannot be appreciated in a reproduction, such as size, and other subtleties that do not register in reproductions.
- If you want to teach your class in a museum setting, be sure to get permission in advance. Some museums, of necessity, have a policy against unannounced group visits. If you are not allowed to use the artworks yourself, request the services of a guide to help you with a particular problem; for example, you may want such terms as *allegory*, *symbol*, or *metaphor* explained in relation to specific works. Because you may be requesting a service outside the normal duties of the staff, state the reasons for your requests.
- Inquire about the availability of canvas folding chairs. If there is a cafeteria, students will surely want to use it, so schedule your trip accordingly. Invite at least two parents to assist.
- Time the viewing. Have you ever thought about the amount of time given to viewing? Using one gallery, ask students to time viewing patterns among museum-goers. What is the shortest length? The longest? Average? What work receives the most viewing time?
- As you walk through a museum, try to see its contents as sources for your curriculum. New forms of contemporary art, such as installations and video art, works that challenge our thinking, art with personal messages, and dozens of other subjects, all have high interest value for children and teenagers.
- Be sensitive to "museumitis," and plan for breaks. When children are tired and hungry, very little appreciation will take place.

- Be sensitive to viewing habits. Team viewing does have its advantages. It is good to work in pairs, because four eyes may see more than two. On the other hand, nearby responses by others may get in the way of an individual's own response. Students should be encouraged to determine their own pace and to find their own viewing space. (For example, how close or how far should one be when viewing an object?)
- Catalogs are useful for showing pupils what they will see during their museum visit. Catalogs often mean more *after* a visit than before, because it is then that we know what the writers are discussing.
- Guided tours have their value, but they do pose one problem, especially for younger students—the distracting nature of what the viewers see peripherally. Why is it that the next gallery so often seems more tempting than what is under discussion?
- Some subjects invite very close scrutiny. For such cases, magnifying glasses will come in handy.
- Follow up all museum visits with class or individual discussions. Consider including student drawings from the museum visit with your next student exhibit. The prestige value of art museums will enhance the community's opinion of both the teacher and the program.

SUGGESTED LEARNING TASKS

- Think of artworks as aesthetic magnets. Because all artworks cannot and will not "speak" to each individual, encourage children to go on to the ones that have holding power, that draw them into their presence. They should stand in the center of a gallery and slowly take in its contents, allowing the images to "talk" to them, responding by moving to the ones that have something to say to them.
- One way to help focus attention is to ask students to concentrate on one item as rendered in a number of works, such as hands, background, portraits, or handling of light sources. Many times just one work can provide enough information for study.
- Ask everyone to bring a sketchbook, and assign one or two exercises based on work done in class. If you have taught action drawing, ask students to draw a complex composition in a free, loose, gestural style. In the case of sculpture in the round, draw it from three different points of view.

- Try to have enough funds to purchase for each student at the end of the visit one postcard that the students have selected for themselves. This will put them in the position of thinking before selecting.
- Prepare a study sheet or visual "treasure hunt" based on the example shown, and give each student a copy to work on independently. This will allow you to focus their attention on a few works that you want to discuss later.
- Visit the museum in advance of the class visit, and learn one story related to a particular work; tell the

William Christenterry, *Alabama Wall* (1985). Metal and tempera on wood, $45^{3}/_{8}" \times 50^{1}/_{2}"$. The artist has created a striking visual form using materials that are typically cast off by others: old license plates, vintage signs, and rusted corrugated steel. He says, "I am fascinated by how things change, how one of these signs, for example—it was once in mint condition, an object put there to sell, advertise a product—takes on a wonderful character, an aesthetic quality through the effect of the elements and the passage of time."

MUSEUM TREASURE HUNT

CONTEMPORARY ART Rooms 7 and 8

CAN YOU FIND IT?

Can you find each of these items in works by contemporary artists in Rooms 7 and 8 of the museum? As you find each one, write the name of the artist and the title of the work.

- 1. A video installation
- 2. A work about the rain forest
- 3. A lighthouse
- 4. A newspaper
- 5. A work made of glass
- 6. A work that includes words

A "treasure hunt" or study sheet that students can use to independently observe artworks in a gallery or museum.

story to the class later in the presence of the art object. This advance visit should also include information of historical interest.

• Find out the estimated value of one of the museum's most precious works. Ask students why they think it costs so much. What would this amount buy in the nonart world? What are the social and political issues related to the economics of art?

Museum Resources

Many art museums provide excellent programs, materials, and support for school art programs. Virtually all of these museums have websites (note some in the Web Resources at the end of this chapter), and they make special arrangements for school visits. Art museum educators belong to a division of the National Art Education Association and meet annually to share programs and ideas at the NAEA convention. Millions of children, young people, teachers, and parents visit the nation's art museums each year for learning and enjoyment.

NOTES

- 1. For an excellent book of art criticism essays, see Theodore Wolff, *The Many Masks of Modern Art* (Boston: Christian Science Monitor, 1989).
- 2. Marcel Reoch-Ranicki, in an interview for Lufthansa's *Germany* magazine, vol. 33, February 1988, p. 26.
- Howard Risatti, Postmodern Perspectives: Issues in Contemporary Art (Englewood Cliffs, NJ: Prentice-Hall, 1998).
- Manuel Barkan and Laura Chapman, Guidelines for Art Instruction through Television for Elementary Schools (Bloomington, IN: National Center for School and College Television, 1967), p. 7.

- Tom Anderson, "Defining and Structuring Art Criticism for Education," *Studies in Art Education* 34, no. 4 (1993): 199–208.
- 6. Suzi Gablik, *Has Modernism Failed*? (New York: Thames and Hudson, 1984).
- 7. Suzi Gablik, *The Reenchantment of Art* (New York: Thames and Hudson, 1991).
- 8. Linda Nochlin, *Women, Art, and Power and Other Essays* (New York: Harper and Row, 1988).
- 9. Norma Broude and Mary Garrard, eds., *The Power of Feminist Art* (New York: Harry N. Abrams, 1994).
- 10. The Dinner Party is considered one of the most signifi-

cant works for its pioneering place in the feminist art movement and for the beginning of installation as an art form.

- 11. Guerrilla Girls, Confessions of the Guerrilla Girls (New York: HarperCollins, 1995).
- 12. Lucy Lippard, Mixed Blessings: New Art in Multicultural America (New York: Pantheon Books, 1990).
- 13. Risatzi, Postmodern Perspectives.
- 14. Arthur Danto, *After the End of Art* (Washington, DC: National Gallery of Art, 1997).
- 15. Denise Stone, *Using the Art Museum* (Worcester, MA: Davis Publications, 2001).

ACTIVITIES FOR THE READER

- 1. Clip examples of art criticism from the newspaper or from an art journal, and paste them on sheets of paper, allowing at least 3-inch margins. Indicate in the margins the various ways the respective critics deal with the subject. Can you identify description, analysis, and interpretation? Does the critic place the work(s) in context? Does the context include works of other artists? Does it include discussion of other works by the artist?
- 2. Go to a library, and gain access to the art journals in the periodical section. How many art journals do you find? Spend an hour or more browsing through the journals that seem most interesting to you. Which journals would you order for the school library when you have your first teaching position? Which journals do you regard as the best for conducting research on contemporary art and art criticism? Do you see a journal to which you would like to subscribe? Why not go ahead and subscribe and begin your own collection as a resource for future teaching?
- 3. Browse through several catalogs of art teaching resource materials, such as CRIZMAC or Crystal Productions (see Appendix C). Identify books, CDs, DVDs, videos, and other materials you would like to use for teaching art. If you had a budget of \$300 for your art program, which items would you order?
- 4. Begin a file system for collecting art reproductions and articles from magazines. Use regular file folders and a

file box with hanging files. Develop a filing system that suits your interests and that will be of most benefit for your teaching. Begin collecting and filing items such as these:

- a. Journal articles about contemporary artists
- b. Pictures of their art and the art from advertisements and gallery catalogs and so on
- c. Postcards from art museums featuring the works in their collections
- d. Copies from art textbooks on topics of interest for your teaching
- e. Color copies of art from books and magazines that you cannot tear up for your files
- f. Examples of popular culture, such as advertisements aimed at children and young people, advertisements that are "takeoffs" of well-known works of art; well-designed commercial objects such as motorcycles, furniture, and digital devices such as cell phones, music players, and cameras
- 5. Go with a group of classmates to a local museum or art gallery. Agree on the selection of one work of art on exhibit. Set a time limit (30 minutes) for each person to write a critical response to the work, including an interpretation of the meaning conveyed by the work. Then take turns sharing your writing, and note differences in the interpretations. Did you learn from one other's views? Did the group arrive at a richer view as a result of hearing multiple perspectives?

Art Criticism and Art Appreciation Readings

- Atkins, Robert. Art Speak. New York: Abbeville Press, 1997.
- Barrett, Terry. Criticizing Art: Understanding the Contemporary. 2d ed. Mountain View, CA: Mayfield, 2000.
 - ——. Interpreting Art: Reflecting, Wondering, and Responding. New York: McGraw-Hill, 2003.
 - —. *Talking about Student Art.* Art in Education Practice Series. Worcester, MA: Davis Publications, 2004.
- Douglass, Scott. *The Museum Experience*. Belmont, CA: Wadsworth/Thomson Learning, 2004.
- Feldman, Edmund. *Practical Art Criticism*. Englewood Cliffs, NJ: Prentice-Hall, 1993.
- Hurwitz, Al, Stanley S. Madeja, and Eldon Katter. *Pathways to Art Appreciation*. Reston, VA: National Art Education Association, 2004.
- Nochlin, Linda. *Representing Women*. New York: Thames and Hudson, 1999.
- Raczka, Bob. Art Is . . . Brookfield, CT: Millbrook Press, 2003.
- _____. More Than Meets the Eye: Seeing Art with All Five Senses, Brookfield, CT: Millbrook Press, 2003.

Wolff, Theodore F., and George Geahigan. Art Criticism

and Education. Disciplines in Art Education. Champaign: University of Illinois Press, 1997.

Museum Readings

- Falk, John H., and Lynn D. Dierking. *Learning from Museums: Visitor Experiences & the Making of Meaning.* Lanham, MD: AltaMira Press, 2000.
- Knapp, Ruthie, and Janice Lehmberg. Off the Wall Museum Guides for Kids: Modern Art. Off the Wall Museum Guides. Worcester, MA: Davis Publications, 2001.
- Pitman-Gelles, Bonnie. *Presence of Mind: Museums and the Spirit of Learning*. Washington, DC: American Association of Museums, 1999.
- Sheppard, Beverly. *Building Museum and School Partnerships*. Washington, DC: American Association of Museums, 2000.
- Stone, Denise. Using the Museum. Worcester, MA: Davis Publications, 2001.
- Wilkinson, Sue, Sue Clive, and Jennifer Blain. *Developing Cross Curricular Learning in Museums and Galleries*. Staffordshire, UK: Trentham Books, 2001.

WEB RESOURCES

Art Critics and Art Criticism

- College Art Association (*caa.reviews*): http://www .caareviews.org/. Publishes current scholarly and critical reviews of art exhibitions, publications, films, and digital productions.
- Metropolitan Museum of Art, *Explore & Learn* and *MuseumKids:* http://www.metmuseum.org/explore/index.asp
- New York Times, *Arts* (*Daily Arts* and *Arts and Leisure*): http://www.nytimes.com/yr/mo/day/artleisure/ index.html. Features commentary and criticism from contemporary art critics about current art and museum events.

North Texas Institute for Educators on the Visual Arts,

Curriculum Resources: Art Criticism: http://www.art .unt.edu/ntieva/artcurr/crit/index.htm. Comprehensive curriculum resources for teaching art criticism. Includes curriculum, art criticism activities, instructions on using art reproductions in the classroom, instructions on using Internet resources, and museum activities.

Museums with Extensive Online Education Resources

Art Institute of Chicago: http://www.artic.edu/ Dallas Museum of Art: http://www.dallasmuseumofart .org Guggenheim Museum, New York: http://www .guggenheim.org/new_york_index.shtml

- Los Angeles County Museum of Art: http://www.lacma .org/
- Metropolitan Museum of Art: http://www.metmuseum .org/
- Minneapolis Institute of Arts: http://www.artsmia.org/
- Museum of Fine Arts, Boston: http://www.mfa.org
- Museum of Modern Art: http://www.moma.org/ education/
- National Gallery of Art: http://www.nga.gov/education/ classroom/

- Philadelphia Museum of Art: http://www.philamuseum .org/education
- San Francisco Museum of Modern Art: http://www .sfmoma.org/education/edu_overview.html
- Smithsonian American Art Museum: http://www .americanart.si.edu/index2.cfm
- Smithsonian Institution, National Museum of African Art ard National Museum of the American Indian: http://www.smithsonianeducation.org/
- Walker Art Center: http://learn.walkerart.org/index.wac

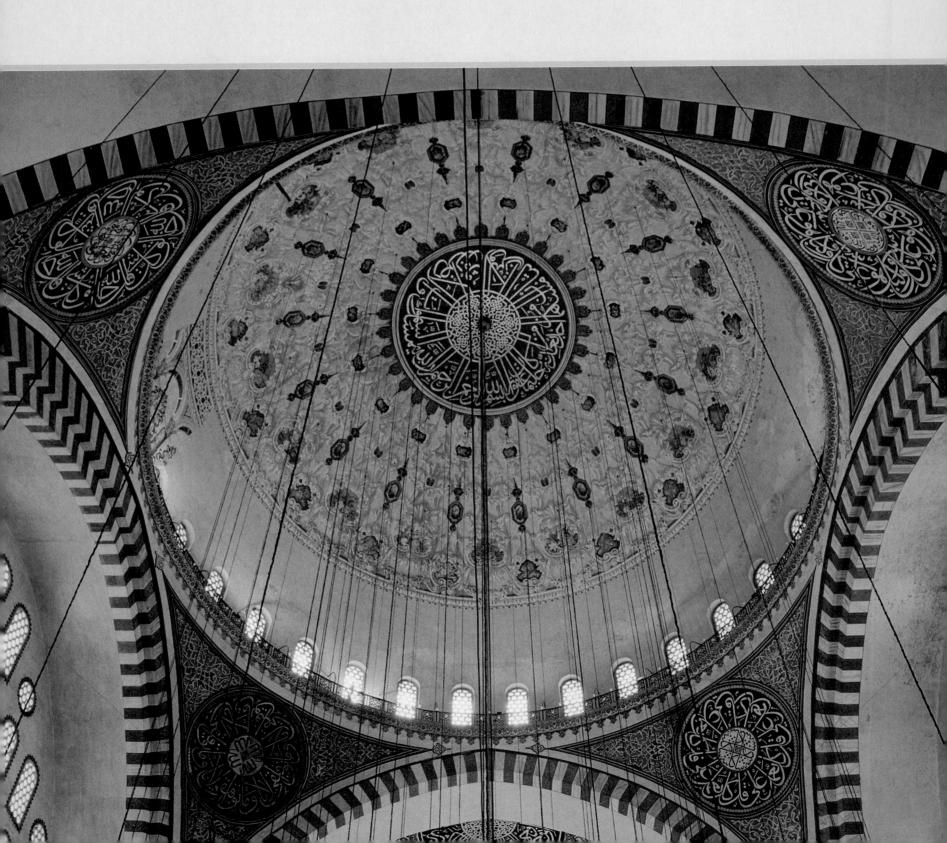

ART HISTORY

Other Times and Places

Art history is a keystone enterprise in making the visible legible.

-Donald Preziosi, The Art of Art History

The first account of art history in the Western world was written by the Florentine architect and painter Giorgio Vasari, whose contemporaries included the great Italian artists Raphael, Andrea del Sarto, Leonardo da Vinci, and Michelangelo, with whom he was well acquainted. Vasari tells the story of how he happened to undertake the task of writing *Lives of the Artists*. He was involved with a painting commission for the church in Rome under the patronage of Cardinal Farnese. In the evenings he would often join the cardinal for dinner and conversation with other men of arts

© Val Brinkerhoff

and letters. During these evenings the idea was initiated that a catalog of all the artists and their works would be a marvelous possession of great interest, and it was suggested that Vasari, who had for years filled his notebooks with drawings of great art and notes about the artists, undertake the project. Vasari wrote:

This I readily promised to do, as best I could, though I knew it was really beyond my powers. And so I started to look through my memoranda and notes, which I had been gathering on this subject since my childhood as a pastime and because of the affection I bore towards the memory of our artists, every scrap of information about whom was precious to me.¹

A highly trained art conservator cleans the figure of the Libyan Sibyl, part of the great fresco painting by Michelangelo on the ceiling of the Sistine Chapel in the Vatican, Rome, 1508-12. The entire mural was cleaned of years of grime, candle smoke, and air pollution, revealing colors brighter and more vivid than anyone had imagined. Conservators applied all the scientific and artistic knowledge and skill at their disposal to assure that the masterwork would not be harmed in any way.

With this book Vasari began a tradition that has been multiplied in importance, complexity, and participation by thousands of professional art historians, many of whom share Vasari's love of art and affection for the memory of great artists. As we can see from the quotation at the beginning of this chapter, the contemporary field of art history ranges far beyond the scope of Vasari's relatively simple beginning. Art historians today employ technical tools from the physical sciences and methods of inquiry from the social sciences that were unknown in the sixteenth century.

Vasari wrote of the lives of Italian painters, sculptors, and architects from the time of Cimabue, born in 1240, to Michelangelo, who died in 1564. Art historians today study art and artists from all continents of the world, from a multitude of cultures, and from a range of art modes, including printmaking, ceramics, decorative arts (including furniture design), and photography, cinema, and video, which have emerged only during the past century.

ART HISTORY CONTENT: A BRIEF SURVEY OF WORLD ART

The intent of art history, especially as we approach it in art education, is to provide information and insights that will enlighten our understanding and appreciation of artworks and their significance and meaning. Often this means learning about the peoples and cultures from which the artworks came and the purposes of the art within those cultures. Art historians have studied the art of the world created not only since Vasari's time but also back into prehistory and the several thousand years of Sumerian and Egyptian culture. One of the contributions of art historians has been their categorization of art into styles and historical periods, providing us with conceptual handles to grasp meaning and significance in the art we see. We find art history organized in numerous ways, each of which presents a different emphasis and provides a different insight. For example, art historians have studied and written about art according to periods (the Middle Ages, the age of baroque), styles (romanticism, cubism), cultures (Egyptian, Native American), religions (Christian, Islamic), locations or countries (royal Benin art, art of the Andes), themes (the figure, nature), purposes (images of authority, imaginative art), and other categories. More recently the field of art history has broadened to include approaches that emphasize cultural, political, economic, and social issues. New insights are also

gained from writers who employ post-Marxist, feminist, and psychoanalytic methods and perspectives. Educators can follow and benefit from this range of approaches and should adapt different approaches for different educational goals.

The following very brief survey of world art is only a suggestion of the vast and rich content for the study of art. It is necessarily incomplete and simplified and is included here to demonstrate the range of content for systematic study appropriate for children in a regular art program. The massive body of world art from prehistory to contemporary times can be almost overwhelming for curriculum organizers. Questions of emphasis, theme, culture, mode, period, works, and artists for study become very difficult when every decision to include one item means the elimination of many equally valid competing items. The scope and balance of art content from different cultures and times might vary according to local resources, populations, and educational goals. The traditional emphasis on Western European art in North American schools has evolved in many locations to a more balanced study of the arts from many cultures. Recognition of excellence in art contributions from many cultures seems appropriate for a democracy with a multicultural population. Some teachers believe that art history should begin in their own communities, with the buildings and monuments that exist in the immediate world of the students.

This survey has been organized according to historical periods often used by art historians: the ancient world, the classical world, the Middle Ages, Renaissance and baroque, the modern world, and contemporary art. Because of the great complexity of art and its relationship to culture, this system of organization, like any other, has certain limitations. For example, the arts of China cross many of these chronological periods, whereas Byzantine art resides within a narrower time frame. Some teachers prefer to relate art history content to the topics of social studies curricula in their schools. References to art objects can extend students' art learning and integrate art with their other studies.

The Ancient World

PREHISTORIC ART

The earliest art provides the major part of our knowledge of prehistoric humans. Although cave paintings and other artifacts that have survived are extremely old, some dating back more than 50,000 years, some are surprisingly sophisticated and rich in aesthetic as well as cultural value. *Paleolithic art* is the art of the last ice age, the time when massive glaciers covered much of Europe and North America. Cave paintings of animals and humans have survived in France and Spain, as have small stone sculptures of female figures, such as the well-known *Venus of Willendorf*. The great stone monument at Stonehenge in England was created primarily during the *Neolithic* period, which ranged from 180C to 1400 BCE.

THE ART OF EGYPT

When we think of the art and culture of Egypt, it is usually in the context of very ancient times. Indeed, in discussing Egyptian art, we speak in terms of many centuries, going

This painted limestone sculpture of Queen Nefertiti typifies the simplified form of Egyptian sculpture. back 5.000 years. Early wall paintings date to 3500 BCE, and the latest (New Kingdom) period lasted until nearly 1000 BCE, a span of 2,500 years of clearly recognizable Egyptian artistic style. When we consider the pace of contemporary life, with amazing events occurring in all parts of the world, scientific advances that significantly influence our lives within a generation, and political events that drastically alter systems of government for entire continents, all of which become known to us almost instantaneously via television, it is difficult for us to comprehend the continuity of Egyptian culture. When we compare this continuity to changes in more recent periods-such styles as impressionism, which began about 150 years ago, or pop art, which emerged about 50 years ago-we gain some perspective. Life in Egypt evidently changed very slowly, and time was a plentiful commodity for Egyptian leaders, who envisioned grand accomplishments that took decades to complete.

The familiar monuments of Egyptian art—the great pyramids at Giza, the Great Sphinx, the magnificent lifesize sculptures of royalty, the monumental sculptures of Ramses, the beautiful head of Queen Nefertiti, and the amazing gold coffin cover of Tutankhamen—all must be considered and understood in the light of religious beliefs and political practices of the culture. Virtually all Egyptian art is religious in nature, relating to beliefs about life after death, especially for the pharaoh, his family, and his retinue. The pyramids were actually tombs and monuments, and the sculptures and paintings had religious purposes related to the afterlife. Because the pharaoh was considered to be a god as well as a king, the political and religious aspects of art were interrelated.

THE NEAR EAST

The Mesopotamian region, in the valley between the Tigris and Euphrates rivers, developed civilizations with writing and arts almost concurrently with Egyptian advances. The very early arts of the Sumerians (2800–1720 BCE) include impressive examples of architecture and sculpture, many of which were motivated by religious beliefs.² The Sumerians built impressive temples atop their *ziggurats*, massive stepped platforms that rose like mountains above the flat plains. Some of the small ziggurats are probably older than the Egyptian pyramids.

The Assyrians (1760–612 BCE) followed the Sumerians as rulers of the region and creators of great art. They left behind marvelous examples of fresco paintings, sculpture (especially graceful relief sculptures), and architecture, including elaborate walled cities. They were followed by the Babylonians for a relatively brief period before the region was ruled by the Persians (539–465 BCE). The Persians worshipped in the open air and thus developed almost no religious architecture, but they did construct huge and impressive palaces. For example, the audience hall of King Darius had a wooden ceiling supported by 36 columns, each 40 feet tall.³

ART OF AFRICA

Many scientists believe that human life began in Africa, where the oldest human remains have been discovered. The continent of Africa is three times as large as the United States, with nearly a thousand different languages spoken among its peoples. Many distinctive styles of art have developed in Africa, some with traditions that have persisted for a thousand years.⁴

The art of Africa, like the art of China, crosses chronological categories from ancient times, through the Middle

Figure group, Yoruba peoples, Oyo region, Nigeria (early–mid twentieth century). Wood, indigo pigment, 15" high.

Ages, and into this millennium. For example, in West Africa the kingdoms of Yoruba and Benin peoples date back to the twelfth century and have produced impressive works of architecture, sculpture, personal adornment, costume, and religious objects. Royal Benin sculptural pieces of bronze, cast copper alloy, iron, and ivory are examples of a particular African artistic style among the many styles created by the peoples of the continent.

As in most traditional societies, art in Africa plays an integral role in the daily lives of the people:

African art is pottery for carrying water; it is textiles, leatherwork, and jewelry for wearing; it is sculpture for use in ceremonies and rituals. An African object viewed in isolation, compelling as it may be, loses some of its meaning and visual impact. An African mask, for example, is worn as part of an entire costume that covers the wearer from head to foot. The wearer of the mask participates in a performance that could include music, dance, song, and storytelling.⁵

Much of the history of African art is unknown, as the peoples of past centuries left no written records. African art history is reconstructed by studying oral traditions, European and Arabic documents, languages, and archeological discoveries. African art influenced European artists near the turn of the twentieth century and remains a strong factor in American art today, as well as continuing on the African continent.

THE ART OF ASIA

Civilization flourished along the Indus River in India as early as 3000 BCE. Like much of world art, the art of India was motivated and directed to a large extent by religious beliefs. The Buddhist religion emerged in the sixth century BCE, and much of the architecture and sculpture were created in honor of Buddha. Over the centuries many Buddhists came to believe that Buddha was divine. They built cave temples and carved freestanding statues showing him teaching or in meditation: "His gentle smile and halo suggest saintliness. His long ear lobes show how attentively he listens to the secrets of the cosmos and are a symbolic reflection of his pre-Nirvana existence, when he wore the heavy jewelry of a prince. . . . The figure is serene, far beyond sensual pleasure and other attachments."6 As Buddhism spread to Southeast Asia and north to Tibet, China, and Japan, painters and sculptors adapted this Indian concept of the Buddha with their own modifications in local imagery.

Buddh:sm became a major world religion, but it did not persist as strongly in India, where the Hindu religion gained prominence. Hindu art and architecture developed into magnificent forms, with structures often completely covered with relief sculpture "of intertwining human, animal, and floral motifs expressing the rhythm of life."⁷

Chinese art maintained a pattern of characteristic forms For nearly 4.000 years, developing fine traditions of architecture, pottery, ceramic and bronze sculpture, jade carving, painting, and printmaking.⁸ Although art in China began in very ancient times, the study of Chinese art takes the scholar across time periods, through the Middle Ages and into modern times. Art historians have studied the different developments and emphases in Chinese art across the several reigns or dynasties (for example, Shang dynasty, 1766–1045 BCE; Zhou dynasty, 1044 BCE–256 CE; T'ang dynasty, 618–907 CE; Song dynasty, 960–1274; Ming dynasty, 1368–1644; and Qing dynasty, 1645–1912).

Japanese art also ranges from prehistoric periods to contemporary times. Following the evolution of art in China, Japanese art is similar yet distinctive, with many masterworks worthy of note. For example, the Japanese excelled in the areas of landscape design and gardening with plants and natural materials, and they achieved greatness in the areas of pottery and wood-block printing, to name only a The art of China is such a large and magnificent body of works that it is difficult to select a single example for this brief survey. This work by Ma Yuan, *Bare Willows and Distant Mountains* (thirteenth century), is an example of the almost ethereal style of landscape painting that differs so markedly from Western styles.

Suzuki Kiitsu, Reeds and Cranes (nineteenth century). Japanese artist Suzuki Kiitsu used graceful, delicate lines to paint the green reeds against a gold background, with darker grav tones near the bottom of the panels, part of a sixfold screen. The cranes are equally graceful and curvilinear, with high contrasting black-and-white feathers and a bright red accent on their heads. The artist has placed each crane in a different natural position, but none overlaps the others.

few accomplishments. Highlights include the great figure sculptures of Unkei from the Kamakura period (1185–1333 CE) and the wonderful polychrome wood-block prints of Katsushika Hokusai from the Edo period (1615–1867 CE).⁹

The Classical Western World

The traditions of art most influential and best known in contemporary North America come from Western Europe, beginning with the art of Greece (800–100 BCE). The monuments and masterpieces of European art are much too numerous to mention in this brief survey. North Americans are especially aware of Greek architecture and sculpture, with the Greek temple known as the Parthenon heading the list. The *Discobolus* (discus thrower), *Venus de Milo, Nike of Samothrace,* and *Horsemen* from the frieze of the Parthenon, and the *Laocoön Group* (now thought to be a

Roman work done in a Greek style) are among the bestknown sculptures. The Greeks developed red clay pottery to a high level with distinctive forms for specific purposes (to hold water, wine, oil, and so on) and painted with black figures on a natural red background or red figures on a black ground. Much of Greek art depicts gods and goddesses, mythological figures and events, and athletes and leaders with idealized versions of the human figure.

Attributed to the Methyse Painter, *Red-Figure Volute Krater* (455– 450 BCE). Painted ceramic vessel. This exquisite Greek vessel is functional and decorative but also provides a surface for a highly developed painting style. The shape and size of the vessel, style of decoration, and content of the painting all have cultural significance. This object demonstrates some of the contradictions that occur when critics or aestheticians attempt to make distinctions between craft and art.

According to one author:

No other culture has had as far-reaching or lasting an influence on art and civilization than that of ancient Greece. . . . Unlike some other cultures which flourished, died, and left barely an imprint on the pages of history, that of Greece has asserted itself time and again over the 3,000 years since its birth. During the fifteenth century, there was a revival of Greek art and culture called the *Renaissance*, and on the eve of the French Revolution of 1789, artists of the *neoclassical* period again turned to the style and subjects of ancient Greece. Our forefathers looked to Greek architectural styles for the building of our nation's capital, and nearly every small town in America has a bank, post office, or library constructed in the Greek Revival style.¹⁰

Rome conquered Greece and most of the Western world beginning about 30 BCE and maintained the Roman Empire until nearly 500 CE. Roman art followed closely the traditions of Greek art but related more to the political and military aspects of the culture than to religious beliefs. Architecture on a grand scale produced the Colosseum, the Pantheon, the Arch of Constantine, and many beautifully proportioned Roman villas. Roman sculptures of human figures were often startlingly realistic, rather than idealized as Greek figures were.

The Middle Ages

CHRISTIAN ART

Dominating Europe for centuries, Christian art began during the fourth century. Early *Byzantine* art blended influences from the Roman traditions with Eastern conventions from Constantinople (Byzantium or modern Istanbul). One of the monuments of the Byzantine era (400-1453) is the church of San Vitale in Ravenna, Italy. This spacious and well-lit church was built on an octagonal plan different from that of most European cathedrals and is noted for the beautiful mosaics that decorate its walls and ceilings.

Romanesque architecture emerged as an important style "quite suddenly when a medieval prophecy foretelling the end of the world in 1000 failed to come true."¹¹ Christians set out to show their gratitude by building churches across Europe in Italy, Spain, Germany, and France. The Romanesque style was a revival of Roman forms of architecture, as churches were built with a central nave and side aisles. Because of the need to build strong walls to support the broad vaults, the churches were quite dark, with few small windows. *Gothic* cathedrals were then built with even higher walls and arches. Exterior buttresses to support the high walls made large stained-glass windows possible and led to the exquisite development of this art form. Notre Dame cathedral in Paris and Chartres cathedral are two prime examples of the glories of Gothic architecture still in existence.

ISLAMIC ART

Islam is the religious faith of Muslims, who accept Allah as the sole deity and Muhammad as prophet. Islam also represents the civilization erected upon the Islamic faith. Mecca in Saudi Arabia is the birthplace of Muhammad, who died in 632, and is a holy site for Muslims and a desti-

Forest of treelike columns. Great Mosque at Cordoba, Spain (756 CE). A Roman temple was originally built on the site where the Great Mosque of Cordoba now stands. Construction began on the Great Islamic Mosque about 756 and was mostly completed about 785. Cordoba then became the capital of the Spanish Islamic dynasty. For the next 200 years changes and additions were made to this unique Islamic structure. making it the third-largest building anywhere in the Muslim world. The massive building is primarily known for its prayer hall (23,400 square meters) containing 514 palm tree-like columns. Photograph © Val Brinkerhoff.

nation for pilgrims in the Islamic world. While Europeans were struggling with the domination and eventual dissolution of the Roman Empire as the dominant political force, Muslims were known for their accomplishments in algebra, geometry, astronomy, optics, and literature, as well as for the creation of great universities and libraries. Islam ex-

panded greatly during the centuries from 600 to 1300 CE from Spain in the west to Agra, India, in the east.

The Koran is the book composed of sacred writings accepted by Muslims as revelations made to Muhammad by Allah. The Koran forbids the representation of human beings and animals; thus, Islamic religious art did not develop traditions of painting and sculpture. Instead, Islamic artists created marvelous and complex symbolic art and architecture based on geometry, mathematics, and the beautiful calligraphy of the Arabic text of the Koran itself. Islamic culture has produced fine rugs, ceramics, enameled glass, highly embellished metalwork, and fine manuscript illumination in addition to the distinctive architecture.

The most important and distinctive Islamic building is the mosque, a place for worship, prayer, scripture reading, and preaching. Throughout the Islamic world, the Muslims built mosques, and from the minarets, or towers, the faithful are called to pray five times daily. Mosques are built

▲ Taj Mahal, commissioned by Shah Jahan, Agra, India (1623–43). One of the world's best-known buildings, the Taj Mahal was created as a memorial and symbol of the shah's love for his deceased wife. It demonstrates how architecture can be personally and culturally significant as well as metaphorically expressive, just as other modes of art are.

■ Dome, Suleimaniye Mosque, Istanbul, Turkey (1557 CE). Designed by the great Ottoman architect Sinan, the Suleimaniye Mosque and its complex of tombs and educational buildings stand on a prominent site in Istanbul. Here the great circular dome, probably representing the dome of heaven, rises above a four-cornered base, likely symbolizing the four corners of the earth. Photograph © Val Brinkerhoff. with the best materials, design, and architectural expertise. Three of the best examples of Islamic architecture are pictured here: the Great Mosque at Cordoba, Spain; the Suleimaniye Mosque in Istanbul, Turkey; and the Taj Mahal in Agra, India.

The aesthetic attitudes developed in Asia and the forms and conventions of Eastern artistic creation differed significantly from those common in Western art. Eastern and African art influenced European artists greatly in the late nineteenth and the twentieth centuries.

THE ART OF OCEANIA

This diverse category includes the art of Australia, New Zealand, New Guinea, and major Pacific island groups. Because warfare among the island peoples was frequent, numerous groups devised distinctive war clubs made of wood, stone, and seashells. Many of the decorated objects relate to religious ceremonies, including masks, costumes, and body decoration used in conjunction with dancing. The Maori people of New Zealand created a distinctive style of the sculpted human figure with curvilinear designs and overall patterns. Intricate carvings and decorations are found on huts, canoes, coffins, staffs, and facial tattoos.

The famous monoliths of volcanic stone on Easter Island in Polynesia remain a puzzle. These large, brooding sculptures, originally set on ceremonial stone platforms, were discovered on an Easter Sunday by nineteenth-century missionaries. More than 600 of these huge heads and halflength figures survive, some of which are up to 60 feet tall (see photograph in Chapter 1). Because the people who created these sculptures left no records, archeologists speculate that they symbolized the spiritual and political power that chieftains were thought to derive from the gods.

PRE-COLUMBIAN ART

The Native Americans of Mexico, Central America, and South America shared knowledge needed to cultivate such crops as maize, squash, beans, cotton, and tobacco; they used irrigation systems in agriculture and developed weaponry, metalwork, featherwork, basketry, and textiles. Several groups became proficient in astronomy and developed the calendar, mathematics, metallurgy, hieroglyphic writing, amazingly precise architecture, and painting and sculpture. Evidence shows that some peoples accomplished surgery. The Mayan peoples, the Incas, and the Aztecs were three major cultures that left behind a wealth of marvelous art objects, including their extensive cities and magnificent temples. As with many early cultures, a major impetus for pre-Columbian art was religious belief (see photograph in Chapter 1).

The plentiful availability of gold and silver, which eventually contributed to the decline of these peoples at the hands of Spanish conquerors, is evident in many pre-Columbian objects. Following is a commentary about a tapestry tunic with golden spangles from the Chimu culture, woven about 1200:

It may seem unnecessary to our eyes to have added the gold to this tawny-toned tapestry tunic, such is the charm of the tapestry design itself, but perhaps the gold carries status which no texcile design could equal. The representation is a row of trees with monkeys in the limbs above plucking fruit for the aide below who holds the bag. . . . The technique of the textile is slit tapestry with alpaca weft and cotton warp, with the golden-toned autumn colors which are characteristic of the fabrics from the north coast of Peru.¹²

It is apparent that very sophisticated and accomplished cultures have disappeared in the jungles of Mexico and Central and South America, leaving behind intriguing evidences of their thought and customs.¹³ Archeologists are conducting excavations on a number of sites in hopes of learning more about the arts and sciences of these early civilizations.

Native North American art is similar in many ways to that of Central and South America, except that most natives in the northern continent were nomads and did not build permanent cities. Some of the exceptions to this are the communities of the Hopi mesas in Arizona, which are among the oldest continuously inhabited dwellings on the continent. They were inhabited before Europeans came to this land. Also in Arizona, Colorado, and New Mexico, in the Canyor de Chelly and other locations, are the ruins of cliff dwellings that the Anasazi, the "ancient ones," built in small communities high in the steep canyon walls. Very old Native American cultures painted and carved petroglyphs, similar in some ways to the prehistoric cave paintings of Europe, that are still found in many isolated canyons in Arizona, Colorado, and Utah.

Many cf the points made in the discussion of African peoples apply as well to Native American arts and culture. This is a large continent, and the various tribal nations lived in very different climatic, political, and social conditions. The Navajos and Hopis of the Southwest lived in a hot, dry, and, in many ways, inhospitable climate; the Sioux, Plains Indians of the Dakotas and Nebraska, roamed on horses, taking their dwellings with them to follow the buffalo; the Tlingits of the Northwest Coast lived in a humid, wet, coastal environment and depended a great deal on the sea and their skill with boats; and the Algonquin, Cree, and Ojibwa peoples of Alaska, Canada, and the northern United States lived at the opposite extreme of the Navajos, in the frigid north. Different conditions, languages, and lifestyles among the more than 150 major Indian tribal nations in North America have resulted in a wide range of art forms.

The Northwest Coast Native Americans, for example, carved beautifully designed wooden utensils for everyday use and developed the idea of totem poles as culturally significant symbols of family lineage and characteristics. Navaios are noted for exquisitely designed and woven wool blankets and silver-and-turquoise jewelry. The Pueblo peoples have developed highly prized pottery that is collected and exhibited in art museums. Sioux nations created beautiful clothing, including wedding garments, from tanned and decorated leathers. A number of these objects incorporated designs and symbols that expressed spiritual values and beliefs held within respective cultures, many of which recognized the importance of the sun, the sky, the earth, and of unity between nature and the people. Unfortunately, much of the best art of Native Americans has been lost over the years, and many of the craft forms are not being continued within cultural groups. However, the good news is that in some areas, notably the Southwest. traditional art and craft forms are maintained with vital and creative results, such as the woven blankets, pottery, and silver jewelry of the Hopis and Navajos.¹⁴ The National Museum of the American Indian, Smithsonian Institution, in Washington, D.C., was created to preserve and exhibit the heritage of Native Americans and to provide the public with access to knowledge about indigenous American cultures through its education program. The museum publishes the periodical Native Peoples, which is "dedicated to the sensitive portrayal of the arts and lifeways of native peoples of the Americas."15 The Canadian Museum of Civilization in Hull, Quebec, performs a similar function in Canada.

Renaissance and Baroque

The *Renaissance* began in Europe about 1400 and continued for approximately 200 years. This period marked an increased interest in classical learning, philosophy, and art, hearkening back to the thoughts of Greece and Rome.

With beginnings in Italy, the spirit of the Renaissance moved throughout Europe, with notable effects in the Netherlands and Flanders. The pantheon of great artists associated with the Renaissance and the list of masterpieces of art from this period are extensive, including works by Michelangelo (the ceiling of the Sistine Chapel, Pietà, David), Leonardo (The Last Supper, Mona Lisa), Sondro Botticelli (Birth of Venus), Jan van Evck (Giovanni Arnolfini and His Bride), Raphael, Sofonisba Anguissola, Brueghel, Albrecht Dürer, and Albrecht Altdorfer. Numerous artworks during the Renaissance employed symbolism, often expressing Christian concepts or beliefs. For example, van Evck's painting of the Arnolfini wedding portrays the Italian silk merchant and his shy Flemish bride in a room surrounded by objects with subtle symbolic meanings. The couple standing with shoes off signifies that they stand on sacred ground (the sacred institution of marriage). The dog signifies fidelity: miniature figures of Adam and Eve, the first couple, are carved in the bench; the single candle burning in the chandelier represents the light of Christ; and the convex mirror, symbolic of the all-seeing eye of God, reflects the entire scene.

The small medallions set into the mirror's frame show tiny scenes from the Passion of Christ and represent van Eyck's ever-present promise of salvation for the figures reflected on the mirror's convex surface. These figures include not only the principals, Arnolfini and his wife, but two persons who look into the room through the door. One of these must be the artist himself, since the florid inscription above the mirror, *Johannes de Eyck fuit hic,* announces that he was present.¹⁶

Following the Renaissance, during the seventeenth and eighteenth centuries, came the age of *baroque* art, with painting and sculpture featuring dark and light contrasts, exaggerated emotions, and dynamic movement in composition. Such artists as Artemisia Gentileschi (*Judith and Maidservant with the Head of Holofernes*), Caravaggio (*David with the Head of Goliath*), and Rembrandt (*The Night Watch*) extended the use of light and chiaroscuro for dramatic effect to the same high degree that perspective was earlier developed during the Renaissance. Later, French artists created the intimate *rococo* style with a profusion of curved ornamentation and intricate decoration. The rococo, as the baroque, was manifest in painting, sculpture, architecture, and interior design and in the crafts areas of furniture, tapestry, porcelain, and silver.

Modern and Postmodern Art

Rococo art was replaced in popularity by the *neoclassical* movement, which emphasized straight lines and classical ornamentation in architecture, and by balanced formalism, precise linear drawing, and classical subjects in painting, such as Jacque-Louis David's *The Death of Socrates*. Neoclassicism became entrenched in the French Academy and was the style against which the impressionist painters rebelled late in the nineteenth century.

The nineteenth century in Europe was a period of many artistic styles, beginning with the subjective orientation of *romanticism*, which suggested a personal, intensely emotional style. In France, Eugène Delacroix (Liberty Leading the People) and Théodore Géricault (Raft of the Medusa) exemplified the romantic movement. Rosa Bonheur's monumental The Horse Fair lifted animal painting to a high level. The leading landscape painters of England, John Constable (The Hay Wain) and J. M. W. Turner (The Burning of the Houses of Parliament), expressed the fascination of romanticism with untamed nature, country folk in natural settings, and the picturesque or exotic. Turner's huge paintings were prophetic of the monumental nonobjective canvases of abstract expressionism. The following excerpt from a book about Turner demonstrates how art historical research and writing can enlighten us with respect to an artist's expression.

The old man's [Turner's] request was a strange one. Aboard the steamboat *Ariel*, out of Harwich, preparations were afoot for a bad storm that was brewing. The passenger was persistent. Others might want to go below; he wanted to be lashed to a spar on deck. He was a little man, almost gnomelike, and plainly battered by time. But his sharp gray eyes were impelling, and the crew, in the English tradition of tolerance of eccentricity, complied with his wish. Tied to his perilous post for four hours, Joseph Mallord William Turner, England's leading painter, absorbed and observed the onslaught of the elements.¹⁷

It is certain that this storm, experienced by the artist in all its force and fury, provided the raw material for some of his bombastic paintings of nature's power, such as *Rain, Steam, and Speed*.

During the second half of the century, *realism* and social protest followed the French and American revolutions. Artists depicted social themes, the dignity of working people, and the unfairness of some social institutions

▼ Jan van Eyck, *Giovanni Arnolfini and His Bride* (1434). This unique portrait was commissioned by an Italian busiressman to serve as a record of the couple's marriage and as a kind of wedding contract. Art historians often discuss it as an example of Christian symbolism in painting.

Rosa Bonheur, *The Horse Fair* (1853). Oil on canvas, 8' $'4'' \times$ 16' 7'/2''. French painter Rosa Bonheur employed high contrast, linear movement, and dynamic poses of horses and handlers to create this dramatic, exciting scene from the nineteenth century. Bonheur is admired for her ability as a painter but also for her perseverance in achieving success and recognition in an arena that was male dominated in the nineteenth century.

and practices. Jean-François Millet (*The Gleaners*), Honoré Daumier (*Third Class Carriage*), Berthe Morisot (*In the Dining Room*), and Jean Courbet (*Burial at Ornans*) painted ordinary people with a stark realism that was quite different, both in presentation of subject and paint application, from the neoclassical style of Jacques-Louis David and Ingres.

Many innovations or movements in the modern era began in revolutions against accepted artistic tradition or, in many instances, academic dogma. So it was that a group of French painters, including Manet, Morisot, and Renoir, rejected the narrow aesthetic views of the state academy of artists and developed new purposes and images in painting. These artists, dubbed *impressionists* as the result of a critic's sarcastic remark, responded to the invention of the camera as a recording device that surpassed the painter in accuracy and to the new scientific knowledge of optics. They began to concentrate on the creation of images the camera could not achieve as they emphasized mood and visual impression.

The impressionists abandoned traditional hierarchical organization of subject matter in favor of a relatively mod-

ern preoccupation with light and color. They avoided flat tones and clear edges in favor of small strokes of color and indefinite contours, both of which tended to convey a sense of diffuse and often sparkling light. Artists moved their studios outdoors, and such painters as Monet found themselves doing multiple studies of a particular subject as they focused on the light of early morning, high noon, and twilight in relation to a cathedral, a bridge, or a haystack.

The more immediate forebears of twentieth-century art were a group of painters known as the *postimpressionists* because of their close relationship to the earlier impressionist movement. Vincent van Gogh, Paul Cézanne, Suzanne Valadon, and Paul Gauguin, all highly individualistic, contributed their own distinctive perception of art to those who were to follow. The vivid, emotionally charged works of van Gogh left their mark on the expressionists; the broad, flat tones of Gauguin were to find their echoes in the work of Henri Matisse; the unidealized female nudes of Valadon are reflected in contemporary figure painting; and the construction of forms in terms of planes undertaken by Cézanne opened the door to cubism, perhaps the most revolutionary of twentieth-century styles. Cézanne refused to limit his vision to the forms given by the tradition of painting and thus examined the structure beneath the outward aspects of objects. He invited the viewer to study his pictorial subjects from multiple points of view, and he made the space between objects as meaningful as the objects themselves. Cézanne rejected the hazy softness of impressionism and applied his paint in clearly articulated flat strokes of color, which appeared literally to build his paintings as one small passage led to larger areas.

The fauvists may be represented by Matisse and André Derain. Matisse was the leader of this group of painters in France who extended the new use of color created by Gauguin and van Gogh, carrying it to such a point that the group earned the critically derisive term fauves, or "wild beasts." The art-viewing public at the turn of the twentieth century, having just begun to accept the radical innovations of the postimpressionists, could not cope with the fauvists' strident use of pure color, their free-flowing arabesques, purely decorative line, and total disregard of local color (the specific color of a natural object). They were trying to paint according to Derain's clarion call: "We must, at all costs, break out of the fold in which the realists have imprisoned us." The fauvists were creating their own reality. and they conceived of painting as a vehicle for expression that was totally autonomous, wholly independent of the viewer's perception of the world.

It was in 1907, when he painted *Les Demoiselles d'Avignon*, that Picasso took Cézanne's ideas one step further toward what is now known as *cubism*. *Les Demoiselles* combined the simultaneous perspective of Cézanne with the simple, monumental shapes and sharply faceted surfaces of traditional African and Iberian art. As Picasso developed his ideas along with Georges Braque, the forms of cubism moved continuously away from photographic realism. By 1911, cubist compositions grew in complexity as planes overlapped, interpenetrated, and moved into areas of total abstraction. Space and form were now handled with a minimum of color, in contrast to the rich hues of fauvism and expressionism. Historian Werner Haftmann commented on cubism's lack of interest in color and light in favor of a more intellectual concern for order.

Cubism embraces all the aspects of the object simultaneously and is more complete than the optical view. From the information and signs conveyed on the rhythmically moving surface, the imagination can reassemble the object in its entirety. . . . Cubism corresponds to that new modern conception of reality which it has been the aim of the whole pictorial effort of the 20th Century to express in visual terms.¹⁸

Within cubism can be found many of the central concepts of modern art: manipulation and rejection of Renaissance perspective, abstraction to the point of nonobjectivity, emphasis on the integrity of the picture plane, introduction of manufactured elements in collage, and experimentation with different conceptions of reality.

The precursors of surrealism were such artists as Paul Klee, Giorgio di Chirico, and Marc Chagall, all of whom dealt with fantasy, dreams, and other states of mind. We may add to these influences the dada movement, whose anti-art theatrics and demonstrations challenged the most basic assumptions about art. André Breton, a poet, first used the term surrealist in his own publication, thus reflecting the close connection between an art movement and a literary one, a common situation in the history of art. The artists who were ultimately to be identified with the movement—Salvador Dalí, Joan Miró, René Magritte—all shared Breton's interest in Freud's ideas regarding dreams. psychoanalysis, and the relation of conscious and subconscious experience as the subject matter for art. They strove to divorce themselves from rational and logical approaches to art. Breton, who admired and encouraged the painting

Pablo Picasso, *Les Demoiselles d'Avignon* (1907).

Two 10-year-olds produced these paintings in a unit on expressionism. Their work was preceded by a discussion of attitudes and visual characteristics shared by German expressionist painters.

of Frida Kahlo, wrote, "Surrealism: the dictation of thought free from any control of reason, independent of any aesthetic or moral preoccupation . . . rests upon a belief in the superior reality of certain forms of association hitherto neglected, in the omnipotence of the dream, in the disinterested play of thought." ¹⁹ Influences of surrealism are especially evident in many contemporary music videos.

Expressionism, generally speaking, places emphasis on emotions, sensations, and ideas rather than on the appearance of objects. Expressionist artists convey their views in a form that is almost invariably a pronounced distortion of photographic realism. Characteristics of expressionism often include heightened use of color, extreme simplification of form, and distortion of representational conventions for expressive purposes. Themes of expressionism differed radically from the French preoccupation with form and style, as such artists as Käthe Kollwitz focused on social, emotional, and political subjects. Kollwitz, who lived through both world wars, commented powerfully in her drawings and prints on themes of political corruption, the suffering of women and children, revolution, and the horrors of war. The expressionist stance, like realism, seems to have a universal appeal, as evidenced by the emergence of abstract

expressionism worldwide in the 1940s and of neoexpressionism in the late 1970s.

One of the most revolutionary developments in European art of the early twentieth century was the shift toward what was at first called *nonobjective* art. Vasily Kandinsky, a Russian who lived in Germany and France, is considered the father of nonobjective painting.²⁰ The concepts subsumed under this term are now usually referred to as *nonrepresentational* and cover a much wider range of styles than originally. Nonrepresentational art now refers to many of the artistic styles that developed in the United States after World War II, when the center of the avant-garde in art shifted from Paris, which had been occupied during the war, to New York City.

Art in America

Art and architecture in the United States during the colonial period and westward expansion largely reflected European styles and tastes. Government and public buildings and the homes of the wealthy were built according to a series of revival architectural styles. Near the turn of the twentieth century, American architect Louis Sullivan expressed ideas (for example, "form follows function") that were the foundations for design of the American skyscraper. Sullivan's student, Frank Lloyd Wright, developed an architectural philosophy and form that became intrinsically American. Wright gained worldwide attention for his blending of nature and modern architectural form in a series of homes built in several states around the country, notably the Robie House in Chicago and the Kaufman House, Fallingwater, built over a waterfall in Bear Run, Pennsylvania.

Early American painting and sculpture reached points of excellence but contributed little to the avant-garde development on an international level. Such artists as Albert Bierstadt painted magnificent landscapes of the Rocky Mountains, Yosemite Valley, and the great American West, motivating even more westward migration. Charles Russell and Frederic Remington chronicled the taming of the "Wild West" with their paintings of cowboys, Native Americans, cavalry, and life on the frontier. George Catlin focused his attention on the life and culture of Native Americans and painted many authentic portraits and group pictures. The list of great early American artists is a long one that includes Winslow Homer, Thomas Eakins, Frederic Church, and many others.

In the nineteenth century, such artists as James McNeil Whistler and Mary Cassatt left the United States for Europe to further their artistic education and to enjoy the more sophisticated ambiance of European culture. In the first decade of the twentieth century, a group of artists known as the "Ash Can school" abandoned European traditions to record the seamier side of urban life in America tenement life, backyards, alleys, prize fights, and children at play. The Ash Can artists' interest in their immediate environment was repeated several decades later when artists turned their eyes not to the urban scene but to rural and small-town settings in the Midwest.

The Armory Show of avant-garde European art in New York City in 1913 was a landmark event for American art. This exhibit brought cubist, fauvist, and other newly developed twentieth-century art styles to audiences in the United States for the first time. Although many traditional American artists and critics openly derided the abstract forms of modern art, the show was extremely popular, attracting large crowds, and sales of the European art were excellent. The impact of the Armory Show is difficult to assess, but no one doubts it initiated change in American art.

Contemporary Art

The other event that contributed most significantly to change in American art, and to the eventual preeminence of New York City as the center of world art, was World War II. Because of the impending war, a number of influential European artists immigrated to America, including Hans Hofmann, Willem de Kooning, and Josef Albers. Paris had been the magnet for artists until the war, but because it was devastated and occupied, most artists fled to other countries. The United States emerged after the war as the most powerful country in the world, and New York City acquired the same drawing power for artists that Paris, Rome, and Florence had enjoyed in the past. During the 1940s, 1950s, and 1960s, art styles in America followed the pace established in France during the first half of the century.

Frank Lloyd Wright, Fallingwater, Kaufman House (1936–39). To design this house in Bear Run, Pennsylvania, the architect utilized a cantilever construction to place part of the house over the natural waterfall, an example of Wright's approach that wedded structure and environment.

Frederic Remington, On Southern Plains (1907). Compare this painting of the American West with Picasso's landmark cubist painting, Les Demoiselles d'Avianon, painted the same year. The extreme differences in subject and style explain why the New York Armory Show of 1913, which displayed modern European art for the first time in the United States, was such a controversial event. Remington was one of the excellent artists who recorded the American "Wild West."

Jackson Pollock, de Kooning, Joan Mitchell, and other artists created *abstract expressionism*, the first unique American art style. This style became one of the most dominant, monolithic art movements in history. Following the direction of earlier artists that moved toward abstraction in art, the abstract expressionists, or "action painters," developed a visual art that approached the abstract purity of music. This art was nonobjective, meaning that it did not attempt to represent objects that exist in the real world. It was "presentational" rather than representational. The source of content for painting existed within the sensibility of the artist.

The *pop art* style followed relatively soon after abstract expressionism and also became influential on an international scale. Younger artists of the time, such as Andy Warhol, Jasper Johns, and Roy Lichtenstein, who received their art education during the heyday of abstract expressionism, predictably rebelled against the strict prescriptions that attended the supposedly most creative style. Rather than search their own inner emotional states for expression in painting, the newer generation of artists insisted that the modern world of urban living, mass media, and commercial imagery was the real subject for art. They painted the banal and mundane aspects of contemporary life. The pop artists seemed to challenge the viewer, who was uneasy about accepting an art style that celebrated soup cans and

soap boxes, by stating boldly: "This is your world! Don't blame the artist if you don't like what you see."

The development of op art in England and the United States was also a response to the spontaneous, painterly, personalized application of paint by the abstract expressionists. Op artists, such as Richard Anuszkiewicz and Bridget Riley, staved with the nonobjective approach but celebrated the geometric precision characteristic of a highly technological society. They used knowledge of human optics to produce images that forced viewers to respond on an autonomic level. For example, the human eye is incapable of focusing on large and small shapes simultaneously. By painting high-contrast lines that graduated from large to very small, the artists created artworks that no one can view completely at a single moment. The cool, depersonalized, precise forms of op art are responses to the "expressive brushstrokes" of abstract expressionism, as well as expressions of a society preoccupied with science and technology.

Realism is one of the oldest and most enduring styles of art. Photo-realism, the most recent manifestation of our love for the realistic-appearing image, is appropriately associated with photography. Not only do artists in this stylistic group, such as Chuck Close and Richard Estes, use photographic technology for production of their works but the images themselves can be obtained only through photography. Common photographic conventions, such as cropping, unusual angles, and soft focus caused by shallow depth of field, are consciously included in the paintings. It is also accurate to view the return to realism, this intensified photo-realism in which the camera reveals more than the natural eye, as yet another incident in the rejection of total abstraction in art. Other realists, such as Janet Fish and Claudio Bravo, remain more traditional and use photographs sparingly or not at all.

Neoexpressionism is another manifestation of the basic expressionistic approach seen earlier in German expressionism during the 1920s and in abstract expressionism during the 1950s. It signaled a return of initiative in avantgarde art to Europe, although a strong contingent of proponents practice in this country. Neoexpressionism is typified by crudity of rendering, violent and cynical themes, and a nihilistic point of view. It is a pervasive and influential world art movement led by artists such as Anselm Kieffer, Georg Baselitz, and Francesco Clemente.

The current *postmodern* era in art began with the decline of abstract expressionism as the dominating art movement and represents a rejection of formalism and nonobjectivity.²¹ The postmodern stance tends to emphasize social and political issues related to feminism, Marxism, civil rights, sexual orientation, censorship, ecology, AIDS, and other prominent topics.²² Contemporary artists work in a wide range of traditional as well as highly technological media, including lasers, computers, facsimile machines, and film and video. The range of art modes has increased to include environmental art, performance art, conceptual art, site-specific installations, found and collected objects, temporary art, and the prominent use of letters and words in art, as in the works of Barbara Kruger, Jenny Holzer, and Edgar Heap of Birds.

Today the influences of world art are intermingled because of the ready availability of good-quality art reproductions, the Internet, and the improvement of communications in general. Much credit for the availability of information about the arts of world cultures must be given to the many art historians who have laboriously and carefully researched, categorized, analyzed, interpreted, and written about art.

The Changing Face of Art History

Art history has changed in its scope and emphasis since the time of Vasari. The discipline continues to change as new scholars with different points of view criticize the field and suggest, even demand, improvements. The field of art history has responded to issues, such as an overdue *recognition of the contributions of women artists*. Fortunately, this oversight is being corrected through scholarly research and publication of such books as Nancy Heller's *Women Artists: An Illustrated History* and more inclusive histories of art, such as Fred Kleiner and Christin Mamiya's *Gardner's Art through the Ages.*²³

Women are now in the mainstream of drawing, paint-

▶ Janet Fish, Kara (1983). Oil on canvas, $70^{\frac{1}{4}''} \times 60^{\frac{1}{2}''}$. The style of realism has maintained a central place in the visual arts for many centuries. Although much of twentieth-century Western art history is a record of movement toward increasing abstraction in the styles of impressionism, cubism, and abstract expressionism, the representation of objects from the visual world has made a strong resurgence in art in recent decades. Janet Fish and other artists use photography as a tool for their detailed paintings. ing, and sculpture; and forms of expression that have been developed primarily by women, such as quilting, are being recognized for their contributions to traditional and contemporary art. Art periodicals, such as *ARTnews* and *Art in America*, recognize, present, and discuss art by women artists on a regular basis. We are seeing exhibitions of art by women in museums and galleries more frequently, providing more of the equity that has been absent for so long. Unfortunately, this process is not as rapid or as easy as might

Roger Shimomura, *Diary*: *December 12, 1941* (1980). Acrylic on canvas, $50^{1/4''} \times 60''$. Shimomura's "Diary Series" of paintings was inspired by the daily journal kept by his grandmother, who emigrated from Japan in 1912. The artist gives visual form to events that deeply affected the Japanese American community during World War II. Art in the postmodern era often refers to social issues and events. be desired or expected. Another area that art historians and other art professionals are attending to is *recognition of non-Western art.* The Western tradition in art has been the primary focus of art historians.

Americans of color and of various ethnic roots have contributed significantly to contemporary art, including such well-known names as Henry Ossawa Tanner, Romare Bearden, Maria Martinez, Frida Kahlo, Diego Rivera, Isamu Noguchi, Nam June Paik, and Maya Lin. Many of the following artists are featured in art writer Lucy Lippard's influential book *Mixed Blessings: New Art in a Multicultural America:* Jacob Lawrence, Faith Ringgold, Howardena Pindell, Jean-Michel Basquiat, Fred Wilson, Luis Jimenez, Ana Mendieta, Jaune Quick-to-See Smith, James Luna, Robert Haozous, James Joe, Kay WalkingStick, Fritz Scholder, and Margo Machida.²⁴

Art historians have responded to what some have viewed as an *overemphasis on the formalist tradition* of art. All art disciplines have changed during recent years in the direction of broader applications of perspectives from such fields as psychology, politics, sociology, and anthropology. We can read the writings of art critics and historians who apply perspectives of psychoanalysis, feminism, Marxism, and cultural anthropology. Formal analysis of artworks for many is decidedly secondary to the psychological and social

Howardena Pindell, Autobiography: Water/Ancestors, Middle Passage/ Family Ghosts (1988). Acrylic, tempera, cattle markers, oil stick, paper, polymer photo transfer. In recent decades, artists have turned to social themes and cultural contexts as subjects for expression. This multimedia work includes a sewn insertion of the artist's body silhouette, the blank white shape of a slave ship, and references to the artist's African ancestors and the abuse of female slaves.

issues that surround art. These perspectives influence judgments made about entire styles of art, with formalistic styles, such as abstract expressionism and op art, sliding down the scale and art with social content, such as neoexpressionism, gaining respect. For art education in the schools, an overemphasis on formalism can be seen when curricula fail to go beyond superficial teaching of the elements or principles of art, when the social significance of artworks is ignored, and when functions of objects are ignored and they are viewed exclusively for their aesthetic properties.

Another issue in art history and art education is a perceived *overemphasis on the fine arts* to the exclusion of crafts and decorative arts, of folk arts, and of applied arts, especially their commercial applications. The very old debate that centers on distinctions between art and craft, the elitist view that finds little significance in applied arts, and the lack of recognition of art in everyday experience are attitudes that are losing prominence.

TEACHING ART HISTORY

Children are fascinated with the content of art history and with art images when teachers can engage them at levels appropriate for their abilities and interests. Traditional teaching methods that university art history instructors use (projecting slides and lecturing) are not appropriate for most elementary classes. Showing art images and providing information can be useful in brief sessions, though it is rarely effective for more than 10 or 15 minutes. Children often learn more and perceive more carefully when they are engaged in active tasks that relate to the art being studied.

Organizing Art Images

A visual time line and a world map provide useful reference points for art history. Although young children do not have sufficient concepts of time to comprehend such lengthy periods as centuries and decades, they can understand the implications of relative differences in distance from "now" on the time line. Similarly, many children in primary grades are not able to conceptualize the distances involved in world geography and cultures, but they can see different locations on a globe or world map, and their understanding will grow as they mature and as they learn more in social studies. Show children postcards or larger reproductions of artworks that are culturally distinctive, such as an Egyptian sculpture, an African mask, or a Rembrandt painting, and ask them to identify where each artwork belongs on the world map and on the time line. Display the art reproduction on the bulletin board, and string a length of yarn from the picture to the correct world location and point on the time line. Repeat this process as you teach about different periods and styles of art. Eventually the children will be able to associate differences in art styles with different cultures and their locations.

To increase their understanding of art modes, write terms, such as drawing, painting, sculpture, and ceramics, on strips of cardboard, and place them at the heads of columns on the bulletin board. Using reproductions collected from magazines (or on postcards and so forth), ask the children to categorize the art objects according to mode. They can include examples of their own work as well, placing their artwork in the correct columns. This categorization activity can continue to whatever level of sophistication the age group can achieve; for example, they can group sculptures according to materials and landscape paintings according to artist. The teacher can purchase postcards with a wide range of art reproductions at nearly every art museum or order them from many museums. Some museums publish books of postcards for very reasonable prices. A collection of postcard art images can be one of the art teacher's most versatile resources. The teacher can also collect very inexpensively small reproductions of art images by cutting pictures of art from art magazines. A magazine might yield a hundred good-quality art reproductions, most in color, appropriate for teaching.

In another exercise, design a bulletin-board display of a different artist (Mary Cassatt), culture (African masks), theme (struggle with death), or other art topic every month or more often. Use good-quality reproductions, pictures of artists if available, titles, concepts, names, dates, and whatever information is appropriate for the age levels and interests of the children and your art curriculum. With all these display strategies for teaching art history, provide the information you want children to receive according to your teaching goals. Engage students with questions and discussions about the visual displays, the artists, and the historical contexts. You will note that many will absorb much information and ask for more. They will become able to discuss art with levels of knowledge and understanding that many adults will envy.

Marcel Duchamp, Nude Descending a Staircase, No. 2 (1912). Oil on canvas, 4' 10" × 2' 11".

Integrating Art History

DEFINING PURPOSES OF ART

Organize the children in small groups of three or four, seated together preferably at tables. Display four or five art reproductions or photographs of objects at the front of the room where all can see, or provide smaller reproductions for each group. Ask each group to speculate as to the purpose of the object when it was created. You might include a Greek vessel for holding water, a painting of a king in full royal regalia, a Navajo silver-and-turquoise necklace, or a cathedral. Adapt the difficulty and complexity of the tasks to the abilities of the grade level. This activity can lead naturally into as much historical content as you wish, as well as into art criticism and aesthetics. The idea that there are different purposes to art is a simple but important idea basic to aesthetics.

RESEARCHING PROBLEMS

Collect articles, books, pictures, filmstrips, and other materials on a topic, such as Canadian Haida totem poles. Organize a folder with such materials on as many topics as you choose (you can add one or two each year to your files). Divide your class into groups of four or five (this will work best with upper-elementary or middle-school students). Provide each group with a file, access to whatever audiovisual equipment is needed, and a study sheet asking questions such as these: Who were the people who created totem poles? Where did they live? What materials and tools did they use to make the totems, and why? When did they begin doing this? When did they stop, if ever? Why did they make totem poles? What did the totems mean to the people? and How could we make totem poles in art class?

After appropriate class time (and homework?), ask each group of students to briefly report to the class on their topic. When reports have been given (and perhaps displays mounted), let the class vote on which of the reports they would like to pursue with a studio activity. When they choose, expand the discussion of how this might be done, what materials will be needed, how students might help to collect materials, and what they might learn from the activity. The groups might design, construct, and paint their own artworks and display them with descriptions of the meanings and symbols they used in their creations. This type of activity is obviously an in-depth project requiring a number of class periods to complete.

UNDERSTANDING THROUGH STUDIO ACTIVITIES

Children become more interested in art historical topics when they are involved with related studio activities. If students are working with the idea of forms in motion, they will likely be very interested to see what the futurists accomplished with the concept. A child struggling with the notion of distortion for expressive purpose can become quite involved in reading about Modigliani and looking at his works. Students who are struggling with composition in their paintings are usually very receptive to a five-minute viewing of examples of good composition. In all these situations, the art historical content can be purposefully emphasized by the teacher, or it can emerge naturally in the course of discussions and conversations with individual students and later shared with all class members.

Eliot Elisofon, *Marcel Duchamp* (1952). Forty years after *Nude Descending* a *Staircase* was painted, photographer Elisofon captured multiple images of artist Duchamp stepping down a staircase, giving us another example of the illusion of motion on a flat surface.

FUNCTIONS OF ART HISTORY AND METHODS OF INQUIRY

Noted art historian Heinrich Wölfflin related the story of a young artist who, with three of his friends,

set out to paint part of the landscape, all four firmly resolved not to deviate from nature by a hair's-breadth; and although the subject was the same, and each quite creditably reproduced what his eyes had seen, the result was four totally different pictures, as different from each other as the personalities of the four painters. Whence the narrator drew the conclusion that there is no such thing as objective vision, and that form and color are always apprehended differently according to temperament.²⁵

For the art historian, there is nothing surprising in this observation.

Wölfflin made the point that among artists there is no such thing as objective vision. In recent years we have come

to realize that the same thing might be said about historians in general and art historians in particular. Art historians have at their disposal today such a range of methods of inquiry that they are able to provide us with many points of view about particular artworks, artists, styles, and periods. We are much richer for this diversity.

Contemporary art historian Eugene Kleinbauer discusses two primary modes of art historical inquiry, the *intrinsic* and the *extrinsic*.²⁶ Using intrinsic methods, art historians focus on the artwork itself, identifying materials and techniques, establishing the authenticity and attribution, iconography, subject matter, themes, and functions. In order to perform these operations, art historians must learn a great deal about the artwork and its context, and they must develop the eye of a connoisseur in order to make fine distinctions. Art professionals employ a number of scientific tools that reveal important facts to assist art historians.

Extrinsic methods of inquiry involve studies of conditions and influences associated with the creation of the

Thomas Moran, The Grand Canyon of the Yellowstone (1893-1901). Oil on canvas, 8' imes 14'. The tremendous scale and colorful grandeur of the West impressed artist Thomas Moran during his travels in Wyoming and Montana. This monumental painting of Yellowstone Park established Moran as one of America's premier landscape painters. Compare this landscape with the work of contemporary landscape painter Wolf Kahn (see painting in Chapter 18).

246

artwork, including artistic biography, patronage, and the history of the period. Art historians also apply methods derived from psychology and psychoanalysis and other approaches to learn more about religious, social, philosophical, cultural, and intellectual determinants of the work. The closer we get to extrinsic methods, the closer we are to a postmodern view of both history and criticism (see Chapter 2).

Here is an example of some questions and problems that art historians face: A Rembrandt painting is made available for sale at a reputable New York City auction firm. A museum of art is looking to purchase a Rembrandt painting, which very rarely becomes available, and this work is exactly what the museum director has in mind. There is a question, however, of the authenticity of the painting. Some authorities suggest that it is by a student of Rembrandt, done in the master's studio under his direction, but it is not of the hand of Rembrandt. Should the museum purchase the painting? How can the museum establish the painting's authenticity and attribution to Rembrandt? If the issue is not clearly resolved, how will doubt influence the price to be offered for its purchase?

In a memory exercise, a group of upper-elementary students observed the *Mona Lisa* for one minute and were then asked to draw the Leonardo painting from memory.

All the skills and methods of art historians are brought to bear on such questions, often resulting in definitive information that makes answers to these questions obvious.

For example, while investigating the provenance, or history of ownership, of the painting, a scholar discovers a gap of 50 years when the painting was apparently lost. The circumstances of its recent rediscovery suggest that it might be a forgery. The art history scholar, an expert on Dutch painting and Rembrandt in particular, closely analyzes the details of the painting, noting brushstrokes and other painting techniques that are subtly different from Rembrandt's. Scientific analysis of the paint reveals an element that was not available in oil paint until a century after Rembrandt's death. The experts who have examined this painting are able to determine that it is not of the hand of Rembrandt or from his studio, but it is, rather, a copy from a later date or a forgery created with intent to defraud. Art historians apply methods such as these not only in conjunction with the art market but also for the purpose of improving our understanding of art and the meaning and significance of artworks.

Methods of Art Historical Inquiry as a Basis for Teaching

Teachers can organize classroom art activities based on art historians' methods of inquiry. Following are some examples.

STYLE RECOGNITION

Using postcard reproductions (or images from magazines), place about 10 paintings on the display board or arrange them on a table. Place a number beside each reproduction. Tell the students that 6 of the paintings are by the same artist and 4 are by other artists. (You might use 6 landscapes by van Gogh and other landscapes by Gauguin, Monet, and so on. To make the activity easier, select the 4 to be very different, such as a Japanese landscape, a cubist landscape, or a Grandma Moses landscape.) Ask the children to identify which ones are by the same artist and which are not. Can they recognize and name the artist who created the 6? Can they identify the artist(s) who painted the other 4? How did they know? Older children can respond with pencil and paper. All ages can enjoy discussing the results and justifying their answers.

VIEWING THEMES IN ART HISTORICALLY

Using available art reproductions—from books, slides, postcards, and so on—organize a series of artworks on a theme, such as animals in art or people working. Ask chil-

This parade of historical cats resulted from the transference of an artistic style to a subject cherished by children.

dren to group the reproductions and identify the theme. For example, with the theme of animals in art, the works might include such items as a Robert Rauschenberg sculpture with a stuffed chicken on top, a Marino Marini bronze sculpture of a horse, a Chinese carved jade dragon, a Japanese wood-block print of kittens, and a Rosa Bonheur painting of horses. (There are thousands of artworks on this theme; other themes include mother and child, art that protests against war, beauty in nature, and portraits of authority.) Depending on the age level of the children, you might ask them to do the following:

- 1. Determine, if possible, the materials and processes of each artwork.
- 2. Determine each artwork's origin and artist.
- 3. Determine where the artwork was created and where it is now located.
- 4. Determine who owns the work now.
- 5. Discuss for what purpose the work was created.
- 6. Interpret the meaning or expressive properties of the artwork.
- 7. Compare the artworks according to dates of creation.

Very often some of this information is available on the back of a postcard or in written materials that accompany reproductions. If children can read and use an art dictionary and library resources, the activities can move in that direction.

WHICH ARTWORK CAME FIRST?

Again using an array of art reproductions (possibly a selection of six slides projected on a screen), ask children to speculate on which artwork was created first in time, which one was created next, and so on. You can control the difficulty of this activity by your selection of artworks. Even very young children can place a Rembrandt portrait earlier in time than a Warhol portrait of Marilyn Monroe or an Alice Neel portrait of Andy Warhol. This activity is related to the dating processes of art historians.

ARCHEOLOGICAL PUZZLES

Some art historians use archeological techniques to learn more about art objects from very old cultures, such as Egyptian or Native American. They sometimes find artifacts of artistic merit through digs, and they become skilled in piecing broken objects together. For this activity, obtain pictures of three or four Pueblo pots, cut the pictures in pieces with scissors or a blade, and place the pieces together in a bowl or box. A small group of children can work together to arrange the pieces, restoring the pictures of the pots. Ask the children how they knew which pieces fit together (according to color, pattern, size, texture, and so on). Provide information about the pots for the children after they have completed the puzzles. Relate this activity to the work done by art historians who study the arts of very old cultures.

READING ART HISTORY

Reading is a very important activity for virtually all art historians. Increasing numbers of good-quality books about art history are written for children. School librarians should be encouraged to purchase books about art. A wide range of art magazines is available, many of which would be appropriate for elementary-school classrooms. Teachers might wish to peruse art magazines before making them available to children, checking for items that might be offensive according to the standards of the local school system and community. A selection of children's books about art is offered at the end of this chapter.

Older children can do library research on art history topics and can write essays on these topics. Much can be learned through this traditional approach, which is similar to research done by art historians. Older elementary students can also participate in firsthand research. Newspapers, newsmagazines, and television news programs report on major art events. For example, the 2005 installation by Christo and Jeanne-Claude, *The Gates*, *Central Park*, *New York City*, 1979–2005, was widely covered in the national media, not only in art journals but also on the national news programs. *The Gates* became an event that ordinary people knew about and discussed.

The In-Depth Experience

Spending a prolonged time with a single artwork or artist offers children an opportunity to get at the heart of a work through extended probing below the surface. This requires teachers to become authorities through their own research so information about the period, the artist, and the general cultural setting can be added to the discussion. Some ideas can emerge through questioning, whereas others, such as the meaning of symbols or autobiographical references, must be provided by the discussion leader.²⁷ When indepth approaches go beyond a single work and are applied

The humor in this magazine cover is dependent on the viewer's knowledge of Georges Seurat's painting technique, known as pointillism, and recognition of the three figures from Jean-François Millet's famous work *The Gleaners*. Instead of gathering leftover grain and straw, these gleaners collect the painted dots near a figure from *A Sunday Afternoon cn the Grande Jatte*, the large Seurat painting featured in the contemporary musical *Sunday in the Park with George*. Original drawing by J. B. Handelsman.

In this collaborative approach

to the study of a Renaissance

Japanese students create an

installation by extending the

boundaries of a work that has

been "blown up" to cover a

painting, a group of sixth-grade

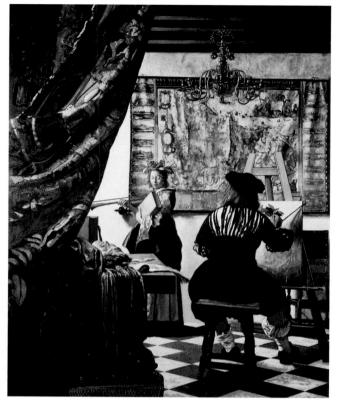

George Deem, New York Artist in Studio (1979). Contemporary painter George Deem looks at the works of artists from the past, appropriates their images and concepts, and reconfigures them in creative new ways. Deem has a particular respect for Vermeer, and in this diptych, we see his version of Vermeer's seventeenth-century work The Art of Painting on the right and a contemporary version of the scene on the left. Notice how Deem has maintained exactness of composition in his New York version but has introduced many items that were not found in Vermeer's time.

to an artist, a movement, a style, or a subject, a basis for a unit exists.

One elementary school organized a "Georges Seurat Week," during which all grades studied the life and works of Seurat. Bulletin-board displays about Seurat and his art were placed around the school; children learned about pointillism and painted pictures using that technique (or approximations of the technique). One teacher wrote lyrics about Seurat to be sung to a popular tune. The culminating activity was a school assembly to watch a local theatre group perform part of the play *Sunday in the Park with George*, which they were presenting in a local theatre at the time. Then everyone sang the Seurat song, to the enjoyment of all.

DRAMATIZING ART HISTORY

Children can often relate better to historical art concepts through dramatization activities. They can collect clothes and props for costumes, scenes, and sets to portray an artist or art event. For example, have children choose an artist and dress in a costume appropriate for the artist, and then have the class try to guess which artist each child represents. This can be expanded by using a "20 questions" approach, during which the child dressed as the artist will answer students' questions about the artist's life and art. This means that the students portraying the artists will have to familiarize themselves with this material.

Here are more dramatization activities:

- The letters of van Gogh when read aloud and supported by slides of his artwork can be an exciting source for a dramatic reading for an assembly, a PTA meeting, or parents' night.
- Sixth-grade students and their teacher produced a videotape featuring paintings by Mary Cassatt of mothers with their infants or children in various intimate and affectionate poses. They recorded the song "Baby of Mine," sung by Bette Midler, as accompaniment to the series of visuals of the paintings. The result was a delightful and emotionally powerful video for classroom use. Copyright issues were cleared with

the district office and presented no problem because of the exclusively educational use of materials. Always check on copyright practices and procedures when using visual or musical artworks for such productions to learn if permissions must be sought.

Study of art history is not intended to be a separate entity in the art program; at best it is integrated with art making, design, aesthetics, and art criticism and with the broader curriculum. Many opportunities are available at any grade level to correlate and integrate art history learning with language arts, social studies, and other subjects across the curriculum. Art history has unique and fascinating content that can enliven the curriculum and engage the students.

NOTES

- 1. Giorgio Vasari, *Lives of the Artists*, trans. George Bull (1555; repr., New York: Penguin, 1981), p. 13.
- 2. Dates of artistic periods vary according to different published sources. Such differences sometimes occur as scholars select different historical events to mark the beginnings and endings of periods. Estimates of dates associated with historical periods of art have been taken from several sources, including the very clear chronology in Rita Gilbert and William McCarter, *Living with Art*, 2d ed. (New York: Alfred A. Knopf, 1989).
- 3. H. W. Janson, *History of Art* (New York: Harry N. Abrams, 1963), p. 65; see also 4th ed., 1991.
- For a brief general survey of world art, including the art of Africa, see Stella Pandell Russell, *Art in the World*, 3d ed. (Chicago: Holt, Rinehart and Winston, 1989).
- National Museum of African Art, The Art of West African Kingdoms (Washington, DC: Smithsonian Institution Press, 1987), p. 5.
- 6. Russell, Art in the World, p. 221.
- 7. Ibid.
- 8. Mary Tregear, *Chinese Art* (New York: Oxford University Press, 1980).
- 9. Joan Stanley Baker, *Japanese Art* (London: Thames and Hudson, 1984).
- Lois Fichner-Rathus, Understanding Art, 2d ed. (Englewood Cliffs, NJ: Prentice-Hall, 1989), p. 260.

- 11. Russell, Art in the World, p. 266.
- 12. Henry La Farge, ed., *Museums of the Andes* (New York: Newsweek, 1981), p. 147.
- 13. See, for example, Walter Alva and Christopher Donnan, *Royal Tombs of Sipan* (Los Angeles: University of California, 1993), a beautifully illustrated account of excavations that revealed much information about the Moche people of ancient Peru, whose civilization dates back nearly 2,000 years.
- 14. Detailed information about Native American crafts is available in such sources as Sandra Corrie Newman, *Indian Basket Weaving* (Flagstaff, AZ: Northland Press, 1974), and Louise Lincoln, ed., *Southwest Indian Silver from the Doneghy Collection* (Austin: University of Texas Press, 1982). More art museums in the Southwest and other regions of North America are taking an active role in preserving and documenting this precious art.
- 15. *Native Peoples*, published in affiliation with the National Museum of the American Indian, Smithsonian Institution, and other associations and museums by Media Concepts Group, Inc., Phoenix, AZ.
- 16. Horst de la Croix and Richard Tansey, *Gardner's Art through the Ages*, 7th ed. (New York: Harcourt Brace Jovanovich, 1980), p. 592; see also 12th ed., 2004.
- 17. Diana Hirsh, *The World of Turner* (New York: Time-Life Books, 1969), p. 7.

- 18. Werner Haftmann, *Painting in the Twentieth Century* (New York: Praeger, 1965), p. 80.
- 19. Herbert Read, A Concise History of Modern Painting (New York: Praeger, 1959), p. 132.
- 20. For an account of his ideas, see Vasily Kandinsky, Concerning the Spiritual in Art and Painting in Particular (New York: Wittenborn, 1964).
- 21. Suzi Gablik, *Has Modernism Failed*? (New York: Thames and Hudson, 1984); see also Gablik's *The Reenchantment of Art* (New York: Thames and Hudson, 1991).
- Howard Risatti, Postmodern Perspectives: Issues in Contemporary Art, rev. ed. (Englewood Cliffs, NJ: Prentice-Hall, 1999).
- 23. Nancy Heller, Women Artists: An Illustrated History, 4th ed. (New York: Abbeville Press, 2004); Abby Remer, Pioneering Spirits: The Lives and Times of Re-

markable Women Artists in Western History (Worcester, MA: Davis Publications, 1997); Fred S. Kleiner and Christin Mamiya, *Gardner's Art through the Ages*, 12th ed., 2 vols. (Belmont, CA: Wadsworth Publishing, 2004).

- 24. Lucy Lippard, Mixed Blessings: New Art in a Multicultural America (New York: Pantheon Books, 1990).
- 25. Hein-ich Wölfflin, Principles of Art History, 7th ed., trans. M. D. Hottinger (Germany, 1915; repr., New York: Dover, 1950), p. 1.
- Eugene Kleinbauer, "Art History in Discipline-Based Art Education," in *Discipline-Based Art Education*, ed. Ralph Smith (Urbana: University of Illinois Press, 1989).
- 27. Al Hurwitz and Stanley S. Madeja, *The Joyous Vision* (New York: Prentice-Hall, 1977).

ACTIVITIES FOR THE READER

1. Review the brief introduction to art history in this chapter. Note that due to the necessary brevity, there was no mention of many important artists, styles, and periods. Where do each of the following names and terms belong in this art historical outline?

Aegean art	Hudson River school
American impressionism	mannerism
Ash Can school	Mantegna
Brunelleschi	Marin
Carolingian art	Neel
El Greco	Rodin
Etruscan art	Rubens
Frankenthaler	Valadon
Goya	Velázquez
Hellenistic art	Vigée-Lebrun
Malas a list of atlast in the state of the	

2. Make a list of other important names, styles, and periods that you believe should be included in the brief survey of art history. If you as a teacher decided

that no student would be allowed to pass without being able to identify a specified number of artworks, you would be creating your own canon. Plan a canon of 20 important works of art for upper-elementary children.

- 3. Consult several art history texts, most of which will include a photograph and discussion of van Eyck's *Giovanni A*nolfini and His Bride*, and compare each interpretation. Do all the accounts agree, or do interpretations differ? Which interpretation do you believe is most authoritative (accurate)? What did the historian write to convince you of that interpretation?
- 4. Select any art style or genre from the history of art, such as Japanese landscape, Pueblo pottery, Rodin sculpture, or cubist painting. Analyze the topic you have selected with the goal of developing a teaching unit for children. What would you like for children to know about the topic, the artist(s), major artworks,

and cultural influences? Analyze the formal properties of the art. What are the major stylistic characteristics, media, processes for creation, and themes? Decide which important points, artists, works, and ideas you would like children to learn about. Decide what classroom learning activities will help children learn about and experience this art form.

- 5. Consult several art history textbooks. Look at the table of contents of each book, and compare the categories used to organize historical content. How do these outlines differ? How are they the same? Do all of the texts cover the same periods, styles, and artists? Compare the ways several texts or encyclopedias treat the same artist or movement.
- 6. Choose a topic in non-Western art, such as the architecture of India or the pottery of Japan. Using the library, see how many books are available on the topic. Browse through the books to familiarize yourself with the range and depth of content on this topic.

- 7. Become an authority on a single painting. (There are at least three books written on Picasso's *Guernica*.)
- 8. Visit two museums, if they are available, and compare the kinds of information on artwork labels. Do labels represent a philosophy on the part of the museum regarding the nature and degree of communication between the museum and the public?
- 9. If there is a museum in your vicinity, visit its bookstore and make a list of the art books you think would be interesting to children (see Suggested Readings).
- 10. On your museum visits and during your readings in general art history textbooks, note which women artists are represented. What proportion of works on display or in publication are by women? How prominently are they featured? How does this proportion relate to numbers of artists by gender? What conclusions or implications can you draw from the data of your study?

SUGGESTED READINGS

- Addiss, Stephen, and Mary Erickson. Art History and Education. Introduction by Ralph A. Smith. Urbana: University of Illinois Press, 1993.
- Arnason, H. H., and Peter Kalb. *History of Modern Art.* 5th ed. New York: Harry N. Abrams, 2003.
- Brommer, Gerald F. *Discovering Art History*. 3d ed. Worcester, MA: Davis Publications, 1997.
- Buser, Thomas. *Experiencing Art around Us* (with CD-ROM). 2d ed. Belmont, CA: Thomson Learning, 2006.
- Chanda, Jacqueline. *African Arts & Cultures*. Worcester, MA: Davis Publications, 1993.
- ——. *Discovering African Art.* Worcester, MA: Davis Publications, 1997.
- Craven, Wayne. American Art: History and Culture. New York: McGraw-Hill Professional, 2002.

- D'Alleva, Anne. Native American Arts & Cultures. Worcester, MA: Davis Publications, 1994.
- Doss, Erika. Twentieth-Century Art. Oxford, UK: Oxford University Press, 2002.
- Farrington, Lisa E. Creating Their Own Image: The History of African-American Women Artists. Oxford, UK: Oxford University Press, 2005.
- Fichner-Rathus, Lois. Understanding Art. 7th ed. New York: Wadsworth Publishing, 2004.
- Getty Center for Education in the Arts, Michael D. Day, et al. "Art History and Art Criticism." In *Art Education in Action.* Santa Monica, CA: The Getty Center for Education in the Arts, 1995. 5 videocassettes. Video footnotes by Michael D. Day.
- Haruch, Tony. *Discovering Oceanic Art*. Worcester, MA: Davis Publications, 1997.

- Heller, Nancy. *Women Artists: An Illustrated History.* 4th ed. New York: Abbeville Press, 2004.
- Kleiner, Fred S., and Christin J. Mamiya. *Gardner's Art through the Ages, Volumes I & II.* 12th ed. Belmont, CA: Wadsworth Publishing, 2004.
- Lazzari, Margaret, and Dona Schlesier. *Exploring Art: A Global, Thematic Approach* (with CD-ROM). 2d ed. Belmont, CA: Thomson Wadsworth, 2005.
- Lucie-Smith, Edward. *Latin American Art of the 20th Century*. 2d ed. World of Art. New York: Thames and Hudson, 2004.
- Mittler, Gene, Rosalind Ragans, Lisa Wihos, and Donna Banning. *Understanding Art, Student Edition*. New York: Glencoe/McGraw-Hill, 2004.
- Nochlin, Linda. Representing Women: Interplay, Arts, History, Theory. London: Thames and Hudson, 1999.
- Paul, Stella. Twentieth-Century Art at the Metropolitan Museum of Art: A Resource for Educators. New York: Metropolitan Museum of Art, 1999.
- Pointon, Marcia R. *History of Art: A Students' Handbook.* 4th ed. London and New York: Routledge, 1997.
- Preziosi, Donald, ed. *The Art of Art History: A Critical Anthology*. New York: Oxford University Press, 1998.
- Remer, Abby. *Discovering Native American Art*. Worcester, MA: Davis Publications, 1997.
- Stokstad, Marilyn, Stephen Addiss, and David Cateforis. *Art History* (with CD-ROM). Rev. ed. Saddle River, NJ: Prentice-Hall, 2004.
- Uecker, Jeffry. *History through Art Timeline & Guide*. Worcester, MA: Davis Publications, 2000.

Art History Books for Children

- Acton, Mary. *Learning to Look at Paintings*. New York: Routledge, 1997.
- Arnold, Caroline, and Richard Hewett. Stories in Stone: Rock Art Pictures by Early Americans. New York: Clarion Books, 1996.
- Beckett, Sister Wendy. The Duke and the Peasant: Life in the Middle Ages. Adventures in Art. New York: Prestel Publishing, 1997.
- Bolden, Tonya. Wake Up Our Souls: A Celebration of Black American Artists. New York: Harry N. Abrams, 2004.
- Brooklyn Museum of Art, Missy Sullivan, and Deborah

Schwartz. The Native American Look Book: Art and Activities for Kids. New York: New Press, 2000.

- Chertok, Bobbi, Goody Hirshfeld, and Marilyn Rosh. *Teaching American History with Art Masterpieces*. New York: Scholastic Professional Books, 1998.
 - ——. Teaching the Middle Ages with Magnificent Art Masterpieces. New York: Scholastic Professional Books, 2000.
- Duggleby John. Story Painter: The Life of Jacob Lawrence. San Francisco: Chronicle Books, 1988.
- Fritz, Jean. *Leonardo's Horse*. Books for Young Readers. New York: Penguin Putnam, 2003.
- Hollein, Nina, and Max Hollein. *Matisse: Cut-Out Fun with Matisse*. Adventures in Art. New York: Prestel Publishing, 2003.
- Holub, Joan, and Brad Bucks. *Vincent van Gogh: Sunflowers and Swirly Stars*. Smart about Art. New York: Grosset and Dunlap, 2001.
- Holzhey, Magdalena. *Frida Kahlo: The Artist in the Blue House*. Adventures in Art. New York: Prestel Publishing, 2003.
- Issacson, Fhilip M. A Short Walk around the Pyramids & through the World of Art. Reissue. Notable Children's Book. New York: Alfred A. Knopf, 1993.
- Kelley, True. *Pablo Picasso: Breaking All the Rules*. Smart about Art. New York: Grosset and Dunlap, 2002.
- Lauber, Patricia. *Painters of the Caves*. Hanover, PA: National Geographic, 1998.
- Lawrence, Jacob, and Augusta Baker Collection. *The Great Migration: An American Story*. New York and Washington, DC: Museum of Modern Art, Phillips Collection, and HarperCollins, 1995.
- Leach, Debra F. *Grant Wood: The Artist in the Hayloft*. New York: Frestel Publishing, 2005.
- Macaulay, David. Cathedral: The Story of Its Construction. New York: Houghton Mifflin, 1981.
- ——. Mosque. New York: Houghton Mifflin, 2003.
- O'Conner, Jane, and Jennifer Kalls. *Mary Cassatt: Family Pictures*. Smart about Art. New York: Grosset and Dunlar, 2003.
- Scleszka, Jon, and Lane Smith. Seen Art? New York: Penguin Bcoks, 2005.
- Sills, Leslie. Inspirations: Stories about Women Artists: Georgia O'Keeffe, Frida Kahlo, Alice Neel, Faith Ringgold. Niles, L.: A. Whitman, 1989.

Thomas, David, and Elizabeth Lemke. *Marc Chagall: What Color Is Paradise*? Adventures in Art. New York: Prestel Publishing, 2000. Turner, Robyn. *Faith Ringgold*. Portraits of Women Artists for Children. Boston: Little, Brown, 1993.

WEB RESOURCES

Museum Websites

The following websites are among many that provide extensive art history resources of interest to art educators. Museum education programs produce CDs, slides, and videos to accompany curriculum. Many have developed online activities for students, multicultural curriculum online teacher packets in addition to those that can be purchased in the museum's bookstores. In addition to their own large image databases, the museum sites have excellent hyperlinks to other museums.

Art Institute of Chicago: http://www.artic.edu/ Guggenheim Museum, New York: http://www .guggenheim.org/new_york_index.shtml Metropolitan Museum of Art, New York: http://www .metmuseum.org/ Minneapolis Institute of Arts: http://www.artsMIA .org/ Musée du Louvre: http://www.louvre.fr/ Museum of Modern Art: http://www.moma.org/ National Museum of Women in the Arts: http://www .nmwa.org/ Philadelphia Museum of Art: http://www.philamuseum .org/ Smithsonian American Art Museum: http://www .americanart.si.edu/index2.cfm Smithsonian Institution. National Museum of African Art and National Museum of the American Indian: http://www.smithsonianeducation.org/

Walker Art Center: http://www.walkerart.org/index .wac

Art History Web Resources

- artnet: http://www.artnet.com/library. An excellent research site for information and images of individual artists.
- The British Museum, *children's* COMPASS: http://www .thebritishmuseum.ac.uk/world/world.html. Online learning for teachers and students includes lessons, activities, and exhibitions about the world's major civilizations—their cultures and art.
- Delahunt, Michael R. "Art History," *ArtLex:* http://www .artlex.com/. Visual arts dictionary for artists, students, and educators in art production, criticism, history, aesthetics, and education. Definitions of terms, along with numerous illustrations, pronunciation notes, great quotations, and links to other art history resources on the web.
- Educational Web (Eduweb) Adventures: http://www .eduweb.com/company.html. Develops creative and interactive content for teaching art history. Check out "A. Pintura: The Case of Grandpa's Painting." Is the painting by Raphael? van Gogh? Titian?
- Egyptian Center for Documentation of Cultural and Natural Heritage, *Eternal Egypt:* http://www.eternalegypt .org/. Brings to life 5,000 years of Egyptian civilization and includes interactive, multimedia experiences for learning about Egyptian cultural artifacts, places, and history. The website includes high-resolution images, three-dimensional reconstructions of Egyptian monuments and antiquities, and virtually reconstructed environments.

Incredible@rtDepartment: http://www.princetonol.com/ groups/iad/. Great source for lesson plans, activities, images, and links to other art history sites.

Wadsworth Publishing, *Arts and Humanities Resources* and *Special Features:* http://www.wadsworth.com/ art_d/. The publisher of *Children and Their Art* provides online resources for teachers and students. World ORT, *Learning about the Holocaust through Art:* http://art.holocaust-education.net/. Includes teacher's guides, student activities, and study resources for teaching young people about the Holocaust through art.

255

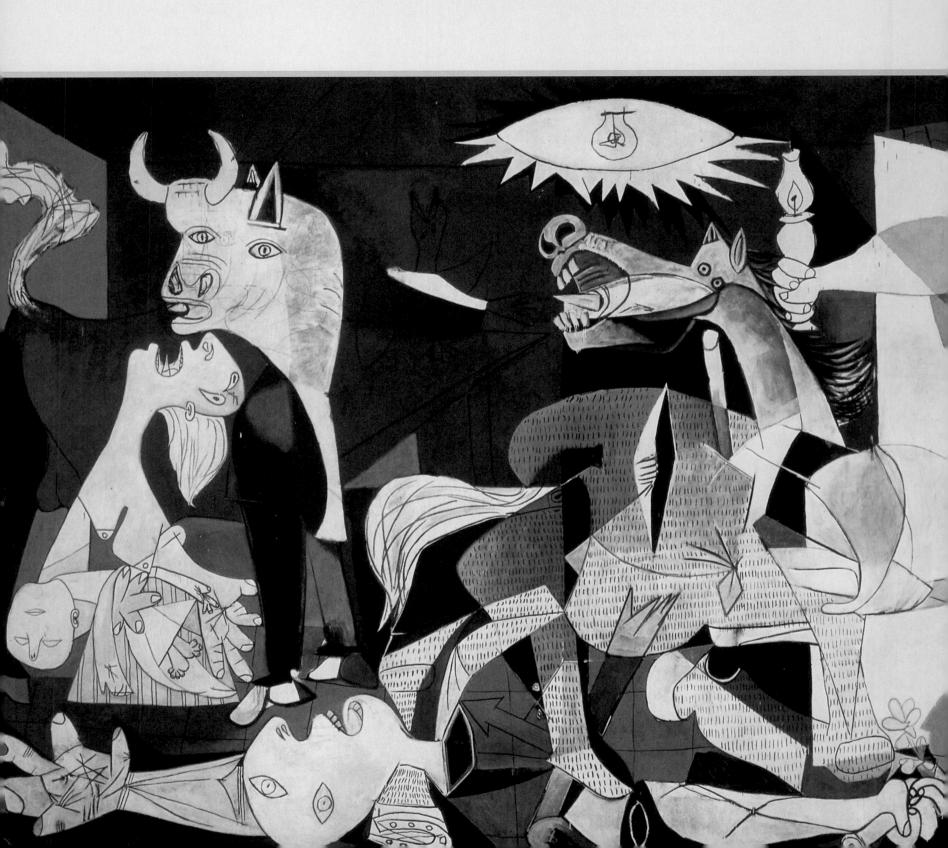

AESTHETICS

Philosophy in the Art Room

Philosophical inquiry is not something separate from the day-to-day experiences in the artroom; rather, it is an integral part of being a reflective, involved student of art, who thereby learns skills that can enhance the overall character of life.

---Marilyn Stewart, Thinking through Aesthetics

Aesthetics is a body of writing by philosophers that poses such recurring questions as these: What is a work of art? How does it differ from other objects? What purposes does art serve? Can art be judged, and if so, how? What responsibility does the artist have to society? Can *nature* be art? What makes an experience aesthetic? Can a mass-produced object be a work of art? How do institutional settings, such as museums, galleries,

Detail from Guernica by Pablo Picasso, 1937.

and art magazines, define art? What is the relation between emotion and aesthetic experience? Why are some artworks labeled masterpieces? These questions are not uncommon, even among children who, during an art museum visit, might ask, "Who decides what to put in the museum?" "Is everything in this museum art?" "Why is that chair art? Is it better than the chairs at school or at home? Can comic

books be art? Why?" Such questions are inevitable from lively children in a stimulating environment, and they require thoughtful responses from teachers at levels appropriate to children's capacities of comprehension.

In his writings about the nature and purpose of art, Russian novelist Leo Tolstoy expressed his view that art should be "accessible to the whole people." 1 This view, as with any view given to define art, raises additional questions. Does Tolstoy mean by accessible that art should be available to all people or understandable to all? If he means understandable to everyone, does this mean that the viewer has no obligation to bring anything to the viewing experience other than a spontaneous reaction? If this is true, then is there any point in acquiring a knowledge base for the art one is likely to encounter in a museum or art gallery? If popular art forms used in advertisements, illustrations, and other sorts of graphic design are understood more readily than a work by Picasso or other fine artists, does that mean that popular art is better? At what point does fine art cease to become serious and turn commercial? Are serious artists, whose works are appreciated by relatively few, fulfilling their role in society, and does an artist have an obligation to the community where he or she lives? The Mexican muralists certainly believed the latter. Others, however, feel an artist's sole obligation is to himself or herself.

Aesthetics can be described as a question-centered subject, where we delve beneath the surface of long-held assumptions. Aesthetics asks us to withhold opinions as the search for answers goes on—where the process of probing is as valuable as the conclusions reached. In this respect, aesthetics questioning is similar to the critical process that asks us to defer judgment of an artwork until we have studied the evidence.

◄ Balcony House, Mesa Verde National Park, Colorado. Photo by Val Brinkerhoff. This architectural ruin of the Anasazi, the "ancient ones," dates from the thirteenth century. The circular kiva and two-story ruins are at the top of a large canyon alcove in the mountains of southwestern Colorado. Though more than 1,500 feet from the canyon floor below, a sacred source of springwater emerges from one of the walls behind the ruin. This precious source of water continues to run today. Compare the building materials, organic design, and relationship of the structure to its environment with Frank Lloyd Wright's Fallingwater and Frank Gehry's Bilbao Museum. By what criteria can quality in architecture be judged? What role do time, place, technology, and purpose play in making judgments? What is good and true in art? As a subject for study, *aesthetics* is a noun. When it is used as an adjective—as in *aesthetic education*—it is used to qualify or describe something else. Thus, *aesthetic response* refers to the nature of our reactions to art, and *aesthetic education* to a multiarts curriculum. When aesthetics is seen as a way of uncovering the essence of a problem through discussion and questioning, it is referred to as *aesthetic inquiry*. Aesthetic inquiry, in turn, may follow a systematic, logical structure known as the *Socratic method*, or it may be more in the nature of a freewheeling discussion.²

In this chapter we discuss several traditional, but persistent, issues centered on the relationships between art and beauty, art and nature, and art and knowledge. As we will see, each of these larger issues relates to numerous more specific, sometimes even practical, questions.

Next, we present three well-established theories of art, or *aesthetic stances*, that we use as the foundation for making judgments of value and quality with respect to art. These stances, known as *mimesis*, *expressionism*, and *formalism*, provide us with insights for judging art and for understanding how others value art.

We will also discuss some of the questions and issues having to do with art and society, art and money, art and censorship, forgery of art, and other social and political aspects of art. Through this discussion we reiterate that aesthetics questions are not merely esoteric exercises but are raised in everyday life and are often both urgent and controversial. They are almost always complicated, requiring the type of reasoned thought and communication that the discipline of aesthetics is known to employ.

Finally, we present suggestions for integrating aesthetics into art teaching in ways that are interesting for students and teachers alike. Several cases or "puzzles" about art are provided and discussed, along with suggested resources and instructional methods of practical use for teachers.

AESTHETICS AND THEORIES ABOUT ART

Because this book is neither an anthology of theoretical writings nor a textbook solely on aesthetics, the following section will review only those theories about art that hold promise for the classroom. Some of these ideas have held the attention of writers since classical times; others could have arisen only in the past century. We will begin by examining one question in depth: What do we mean by the word *beautiful*?

Art and Beauty

When aesthetics first appeared as a separate area of study in the middle of the eighteenth century, generations of philosophers had already pondered the concept of beauty. The view that art in general must be identified with concepts of beauty has little relevance to aestheticians and artists today.

Despite the fact that many artists have relied on beauty as a basis for expression, it is merely one of many possible approaches. Goya, for example, found inspiration in the *lack* of beauty, in the horrors of war; Daumier found themes for expression in political revolution; Toulouse-Lautrec, in the degradation of the body and soul. Art, in fact, embraces all of life, not only that small segment of it that may be considered ideally beautiful.

Beauty, to the uninitiated in art, is most often identified with execution as well as subject matter. Thus, in the world of the art academies of the nineteenth century, no-

Prehistoric pictographs and petroglyphs are found in many locations around the world. Hundreds of examples of rock art remain intact in the inaccessible canyons and desert regions of the American Southwest. What importance do we give the issue of artist's intent when viewing this work? Photo by Val Brinkerhoff.

bility and virtue were associated with technical virtuosity; later, high-blown sentiment was associated with "realistic" rendering, particularly in Victorian times.

Beauty is a good place to begin a discussion on aesthetics. The fact that other interests have superseded the issue of beauty, and that it has undergone revision, in no way invalidates our interest in the ideal of the beautiful, usually defined as something possessing characteristics with the capacity to excite and stimulate pleasure in the viewer. Two traditional points of view exist regarding the nature of the phenomenon of pleasure engendered by beauty.

A *relativist* position states that conceptions of the beautiful will vary from person to person for any number of reasons, the major one residing in the nature of the respondents—their shared values and their makeup as individuals

within a culture. This may explain why critics, however knowledgeable, are still conditioned by their own time and have often failed to appreciate art forms in advance of existing styles. The relativist view of beauty respects the varieties and shifts of tastes during one's own lifetime regarding a particular work and takes into account the influence of one's culture. Beauty, then, exists not so much in the object as in the mind of the beholder.

Does this mean that no standards exist in attempting to determine the conditions of a work of beauty? Not at all, say the *objectivists*, whose roots lie in classical Greek thought. Writers such as Alberti, the Renaissance scholar, have regarded beauty in terms of canons or standards of perfectibility, using such criteria as connectedness and harmonious treatment of design principles such as rhythm, color, hue, and balance. Beauty, they say, is *in* the artwork and is available to the perceptions of the beholder. In our time, greater attention is paid to the *content* of the work that is, the *ideas* that forms convey—than to the forms themselves. Children will have very limited comprehen-

Aristide Maillol, female figure *La Nymphe*. Bronze, cast before 1952. How would you answer the following questions about the Maillol sculpture?

- Does it make sense to spend money on art when homeless people need assistance? Are the arts immoral if there is need among the people?
- Does this work honor, celebrate, or degrade women? Will different factions in society respond differently to this question?
- Is art from previous periods relevant in contemporary times?
- Is this an ideal figure? Do such ideals change according to time and culture?
- · Can a static figure convey a sense of movement?
- What types of value can art possess? Aesthetic? Cultural? Monetary? Societal?
- What questions and issues are raised by the nude figure in art? How does your community respond to these issues?
- In what ways does this sculpture transcend political, social, and ethnic boundaries?
- Is representational art such as this Maillol superior to abstract or nonobjective work?
- What might be appropriate and inappropriate settings in which to install this sculpture?

Look at these questions again, and speculate on possible responses from various members of society, such as a businessperson, an art critic, a 6-year-old child, a manual worker, a politician, a historian, an art teacher, or people with other points of view.

CHILDREN'S BELIEFS ABOUT ART

Children have beliefs about art and often raise philosophical questions about art. As we acquire language. we acquire concepts. As children learn to use the term "art," they learn how the term is most often used within their language community. They may not be aware that they have beliefs about art, but they bring their beliefs to bear upon the comments they make and the questions they ask. For instance, when a child worries that her artwork is too much like another child's and is therefore not good, she probably holds the belief that an artwork is good to the extent that it is original or unique. The origin of this belief cannot be specifically identified; it is the sort of assumption that we learn indirectly from being in a particular language community. Most teachers of art have experienced the situation in which students wonder why a certain work of art or a certain kind of art is thought to be good. They ask, "Why is this art?" and make comments such as "Even I could have done that!" When students raise such issues, they typically subscribe to certain beliefs about what art is and also what good art is. These beliefs become more meaningful when they have been examined and their implications made explicit.

Source: Marilyn G. Stewart, *Thinking through Aesthetics* (Worcester, MA: Davis Publications, 1997), p. 9.

sion of what objective standards of beauty mean unless they can be shown specific examples. For example, 6- and 7-year-olds can learn to identify balance, line, and contrast but have greater difficulties with rhythm, tension, and harmony, which are more advanced attributes. Children are also very quick to make judgments based on personal associations and are likely to think that a poor rendering of ice cream is more beautiful than a still life containing a dead fish that may be more beautifully rendered.

When a teacher reads a dictionary definition after a class discussion, children will quickly see how limited is the authority of books. Consider the following, taken from *Webster's Collegiate Dictionary:* "Beauty: the quality in a thing

that gives pleasure to the senses or pleasurably exalts the mind or spirit."³ Such a definition does well by the impressionist painter but falls short when applied to Goya's *Disasters of War*, a series of etchings that consciously avoids grace and charm while gratifying our aesthetic sense. If we accept "gratify" as the key condition, then we can be moved both by the sensuousness of a Renoir portrait and the human testimony in a pair of worker's shoes by van Gogh far from beautiful in the traditional objectivist sense but highly gratifying from another point of view.⁴

The concept of beauty is persistent in art, however, as indicated by a 1999 major exhibition on the topic. *ARTnews* reported that "beauty is back on the agenda: The Hirshhorn Museum and Sculpture Garden is celebrating the institution's 25th anniversary with the exhibition 'Regarding Beauty.'"⁵ The exhibit featured a wide range of works by contemporary artists and a catalog with 29 essays on beauty and art by top writers.

Teaching for the Issue of Beauty

The following is an edited transcript of a lesson unit on beauty taught by an art teacher to a class of sixth-grade students. In this case, a slide of a painting was shown as a reference point during the discussion. The following section is limited to the *interpretative* phase of the critical process. Domenico Ghirlandaio's *Portrait of an Old Man with a Young Boy* was selected as the focal point for an introduction to the relativist point of view toward beauty.

- **TEACHER:** This picture was painted about the time that Columbus "discovered" America. Let's just take a few moments to look at it. Before you tell me what you *think* of it, see if you can tell me what's happening. Suppose you had to describe the subject to someone who couldn't see—what would you say?
- MARK: It's a picture of a boy looking at his father—or grand-father.
- **TEACHER:** That's right! As you read the title, you know that this is an Italian man and his grandson. I think the artist is pretty clear about how the man feels about the boy. What do you think?
- SARAH: I think he loves him. He is looking at the boy and holding him on his lap.
- TEACHER: And how does the boy feel about his grandfather?
- SARAH: He loves him, too—he is facing the grandfather, and he has his arm on his shoulder.

Domenico Ghirlandaio, *Portrait* of an Old Man with a Young Boy (1480). The subject matter of this painting is so powerful that it is difficult to maintain aesthetic distance. When we learn that the man is the boy's grandfather, the poignancy of the work increases.

TEACHER: Do you all agree to this? (*murmurs of assent*) We began with a description of the painting, and now we're talking about the relationship between the two. We could also talk about their clothes and about the scene behind them, or a doctor might be interested in the medical term for the man's nose—but that's not really what the painting is about. What is it really about? What? (*silence*) Come on—you already said it, Sarah.

SARAH: Love.

- **TEACHER:** Of course; it's about love. Love between young and old, between family members. What other kinds of love are there?
- PAUL: My dog loves me—
- **TEACHER:** Right—animals—what else? **SUE:** My mother loves to walk.

TEACHER: We can also love things, as well as people, although I think "like" is probably a better word. Love is a stronger word, and since people are the most important, I use "love" for people. You know you haven't mentioned one very important part of this painting. (*silence*) I know you can see it—do you feel uncomfortable talking about it?

LORI: His nose—

TEACHER: What about his nose?

LORI: It's gross.

TEACHER: Any other way to describe it?

- **PAUL:** It's ugly—it looks like a cartoon. It's like it has bumps and pimples. . . .
- **TEACHER:** Of course, today someone with a nose like that could go to a doctor—a plastic surgeon—and have it fixed. Tell me, could you love someone with a nose like that? (*general discussion—pro and con*)

LORI: I couldn't look at it. . . .

- **TEACHER:** Let's suppose someone saved your life, was very generous to you, loved you very much—suppose it was someone you loved *now*; would it make that much difference?
- MARK: If it was my father or mother, it would be different. I wouldn't marry someone like that. . . .
- **TEACHER:** The nose would still be ugly, but that wouldn't make your parent ugly as a person—do you see the difference? Let's look at it from an opposite direction. Can you think of someone who is nice looking on the outside but ugly on the inside?
- **SUE**: The woman on [famous TV series]—the mean one.
- **TEACHER:** Right. Would you agree that there are two kinds of beauty? The beauty we see, and . . . come on . . . you know.

MARK: What's inside. What a person is really like.

- **TEACHER**: There's an old saying—"All that glitters is not gold." There's another saying—"What you see is what you get." True? Not true? You're right about the actress—that is, the character she plays. Remember, she's an actress; she isn't really that way. She glitters, all right, but don't let that fool you. How does this discussion relate to art? Why do you suppose the artist painted this man?
- **ALLISON:** Maybe the man paid him to paint the picture. Maybe he did it for the money.
- **TEACHER**: Yes, that's very likely, as we have discussed earlier. When the artist saw the man's nose, what do you sup-

pose he thought? That he was being asked to paint an ugly picture?

- JUAN: He might not have liked that. But the picture didn't turn out ugly anyway, so it doesn't matter.
- ALLISON: I think the artist might not have liked the nose, but he could see how the man and boy loved each other, so he painted that.
- **TEACHER**: And what does all this tell us about art and beauty?

AN AESTHETICS QUESTION

In what ways are artworks special? What makes some artworks better than others?

Responses from 8th-grade students:

SAMYRA:

Artworks are special because they can show somebody something; they might make people feel like doing something or inspire them. . . . Art serves many purposes: to make people feel good, to inspire, to entertain, to amaze, and to fool, as in optical illusions or 3-D pictures. . . .

JASON:

Art is made special by the thoughts the piece expresses, not by the quality of craftsmanship by the artist. Some art makes people sad, some art makes people happy, but the best art is the art that makes people stop and think about the art's meaning—really good art will have you thinking at any range from days to the rest of your life.

MICHELLE:

All artwork is special in its own way. Some tell you stories, some show moods, and some just pull you into their own little world. I think those are the most interesting. . . .

Source: Marilyn G. Stewart, *Thinking through Aesthetics* (Worcester, MA: Davis Publications, 1997), p. 54.

From this point the class discussed art and beauty and, with guidance from the teacher, viewed artworks from other cultures and compared different conceptions of beauty expressed by the works.

This discussion took about 10 minutes of class time. It included writing Ghirlandaio's name on the board and learning how to pronounce it. The teacher also pointed out that the work was painted in oils on a wooden panel and, in reply to one question, gave the value of around \$1 million. It was also mentioned that the painting was commissioned—that is, painted and paid for by the subject, Sr. Fasettei "the man with the nose," as the students thereafter referred to him.

Art and Nature: Differences, Similarities, and Fallacies

The language of art can be applied to natural as well as created forms; indeed, the best way to alert children to line, texture, colors, and so on is to begin with parallel references between art and the natural world:

- Lines exist in naked branches seen against the sky, as well as in drawings.
- Varieties of green can be discerned in spring foliage, as well as in a woodland scene by an impressionist painter.
- Contrast exists between foliage set against white buildings, as well as in the paintings of Georgia O'Keeffe.
- Broad **rhythms** can be seen in the overlapping of mountain ranges and in patterns of freshly plowed fields.

When artists rely on specific elements of design to reinforce their subjects, the connections are easiest for children to discern. The same elements, however, also exist in purely abstract works. If we are moved by and derive pleasure from the existence of design in both art and nature, then why make an aesthetic distinction between the two? Isn't a real lighthouse as significant as one painted by Edward Hopper? If Hopper has added nothing to the subject of lighthouses, then the answer is yes; but because Hopper goes beyond natural phenomena by endowing his work with the stamp of his personal vision, then the difference between the art st's eye and the subject of the artist's attention (the lighthouse) is so critical that comparing one with the other is like using apples as a standard for judging an orange. See if you can discover the aesthetic fallacy

in the following lines from Joyce Kilmer's famous poem "Trees": $^{\rm 6}$

I think that I shall never see A poem lovely as a tree . . . Poems are made by fools like me But only God can make a tree.

Art and Knowledge: How Much Does One Need to Know?

Study Sandro Botticelli's *Primavera*. Without taking the time to describe or analyze its structure, think about your intuitive response to it. If you are like most people, your re-

actions will be positive; this is one of the most reproduced, hence most popular, images of Western European art. As one writer states: "Its complete meaning is as elusive as the remote and wistful elegance of the almost transcendental scene which Botticelli sets before our eyes. This is a picture with layers of meaning, layers that shimmer like the diaphanous veils of its dancing figures."⁷ In this bit of evocative description, the writer has already taken a stand on the relative importance of knowledge and appreciation. In order to sense "wistful elegance" and shimmering "diaphanous veils," we do not need knowledge, but if we are to probe the painting's layers of meaning, we are going to need some historical facts that have little or no relation to the realm of intuition. Here are just a few to consider:

- Sandro Botticelli's work represents a late rather than an early Renaissance style of painting. The painting is executed on wood, rather than on canvas, and bears no signature or title.
- More than 40 different plants can be identified in the painting, all of which are significant for their placement.
- The setting is in a sacred grove, known to everyone who is familiar with Dante's *Divine Comedy* as the boundary between heaven and purgatory.
- The figures in the painting each have their own identity. They are known by their attributes or objects with which they are associated: Cupid with his bow, the myrtle bush and its aphrodisiacal powers with Venus, Mercury with winged heels, and so on. Fewer agree on the meaning of the main figures. Some say one group represents chastity, beauty, and love; others see them as splendor, youth, and happiness.
- The *Primavera* also possesses a musical analogy to some historians. The concept of harmony in human affairs is embodied in the mathematical basis of the use of intervals and in the ratios of smaller to larger units of harmonic relationships. "The figures string out across the painting like the notes of an octave. Mercury and Zephyr are the tonic notes. All those in harmony with them face the same way while the discords, the second and seventh notes, turn the other way."⁸

The writers from whom this brief listing of facts was taken spent a year in Florence studying five paintings, among them the *Primavera*. This dedication to deciphering the layers of a work is what distinguishes historians from

Edward Hopper, *Lighthouse and Building*, Portland Head, Cape Elizabeth, Maine (1972). Comparing the photograph showing the source of the artist's subject to the watercolor itself, one can see how the artist transformed nature. Did the artist improve on nature's version?

Sandro Botticelli, *Primavera* (1477). This painting serves to show that a viewer can have both an intuitive and a knowledge-based appreciation of an artwork, both of which are unique and valid reactions to viewing the painting.

aestheticians. The aesthetic questions posed are "How much must one know in order to fully appreciate a work of art?" and "Has the knowledge gained by reading about the *Primavera* in any way affected your relation to it, and if so, how?" Of the thousands of visitors who yearly come to the Uffizi to see this painting, many seek information about the work and the artist, and others do not feel they need any-thing beyond what they bring to the work.

A work of art, as demonstrated by the *Primavera*, can reach us on several levels. The first level is accessible to anyone with an open eye and mind, but to reach succeeding levels or layers of appreciation, we may have to call on the insights of historians or anyone who can shed light on the work from the perspective of his or her discipline. Some artworks are like puzzles waiting to be solved.

Aesthetics and Media

The medium selected by an artist is a critical factor not only in the success of a work but also in its material value. Why is it that oil paintings generally enjoy more prestige than the same subject executed in watercolor, and what circumstances could serve to equalize such a discrepancy? For no other medium are aesthetic issues raised more than printmaking; the director of one print workshop poses the following questions:

Is a computer print an original? Should it be considered alongside etching, lithographs, wood blocks and screenprints? Some would say no, it lacks the 3-D quality of layering that distinguishes "hand made" prints from mechanical reproduction. And is it mechanical? Just because you cannot distinguish the texture because of the superfine resolution, does that make it any less mechanical? Is the act of originality simply choice and are the means of producing the image irrelevant?⁹

THREE AESTHETIC STANCES: MIMESIS, EXPRESSIONISM, AND FORMALISM

Mimesis: Art as Imitation or Representation of Things As Seen

Must art match what we see? Plato argued that it did not matter how skillful artists were in portraying the physical world; they could never render the true reality—the essence of objects. Artists were therefore imitators or mimics and, because of this, were inherently inferior to poets and musicians. In the beginnings of Western art, people admired the skill it took to create visual equivalents of the world they knew. The notion of art as imitation or representation of life becomes more complicated as one studies it and discovers related movements and theories, such as the realism of Courbet, who once stated, "Show me an an-

Romare Bearden, *Quilting Time* (1986).

gel, and I'll paint you one." The idea of realism has also taken the form of *social realism*, which dealt with particular social-consciousness subject matter (the working class); *naturalism*, which overlapped into literature; and *trompe l'oeil* painting, where meticulous handling of detail could deceive the eye. Techniques for imitating nature range from the *illusionistic* devices in perspective developed in the Re-

Henry Ossawa Tanner, *The Banjo Lesson* (1893). Oil on canvas, $36'' \times 48''$. Tanner and Bearden are recognized for their powerful and sensitive portrayals of everyday experiences in African American communities. Themes of building, working, creating, playing music, family, and intergenerational relationships can be observed in these works. What media were used for each of these works? Compare these works with art by other artists on the same themes. Find other works in this book by African American artists. Which aesthetic stances best apply to each of these works?

naissance and used by both scene designers and painters to the contemporary photo-realists' reliance on photographic veracity. Behind all variations of "art as imitation" lies the assumption that art is most meaningful when it can provide some sort of match between the personal experience of the viewer and the work of the artist. As in all aesthetic theories, the questions that inevitably arise are "Is that all there is to art, and if not, what are the alternatives?" and "What lies beyond our immediate experience?"

The major alternative approach to the imitation or *mimesis* theory is the expressionist view.

Art as Expression: Emphasis on Feeling and Emotion

The idea that expression can be considered a major function of art creates a distinction between what we *feel* about something and what we *know* about it. Tolstoy believed that the expressive power of art reached its highest form only when an artwork could successfully communicate its meaning to the *viewer*. The emotive power of art was one of the main ideas behind the movement of *expressionism* that began in Germany during the early decades of the twentieth century. The term has since been applied to any movement or artist whose work puts a high priority on feeling and emotion, and it has also come to be associated with the formal *means* used by the artist to achieve it, such as spontaneity of execution, heavily applied paint, the use of accidents, and, as in the cases of van Gogh and de Kooning, even to certain kinds of brushes and implements for applying paint. The key element is transmission of feeling—the assumption that for the artwork to be effective, the viewer must receive the feelings of the artists. As Tolstoy described it, "Art is a human activity . . . that one man consciously . . . hands on to others . . . feelings he has lived through so that other people are infected by them and also experience them."¹⁰ This is also related to *empathy*, which we will discuss later.

It is, of course, possible to transmit deep feeling and emotional conviction *without* stressing the formal aspects just listed; indeed, romantic realists such as Rosa Bonheur also direct our emotions through subject matter as well as specific painting techniques. Picasso's *Guernica* is an example of how abstraction treated with a minimal use of color and surface manipulation can also arouse our feelings. Regardless of where one throws one's allegiance, arousing and conveying emotion in the spectator must be taken as a universal condition of the expressive function of art. The

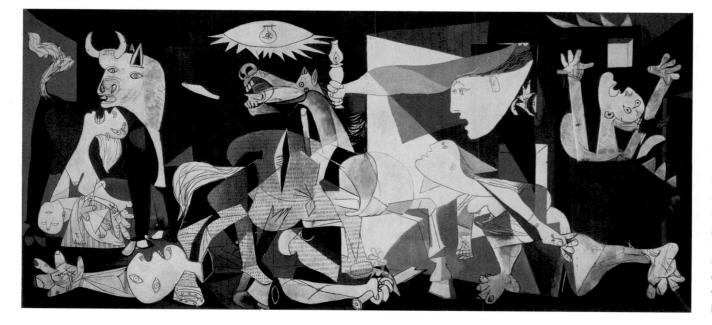

Pablo Picasso, Guernica (1937). This painting is one of the most famous works of art created to protest war. Picasso was living in France prior to World War II when Hitler's dive-bombers practiced on the Basque village in Spain, killing innocent people and their livestock. Spain's leader sanctioned the attack as a political gesture of control. Angered with this brutal outrage, Picasso spent months making sketches, drawings, and different versions of the work. Does the work convey the message intended by Picasso?

current worldwide neoexpressionist movement in art demonstrates again the relevance of this aesthetic stance.

Formalism: The Importance of Structure

Formalist aesthetics asserts that the value of an artwork lies not in its relation to real life or to subject matter—as in a landscape or portrait—but in its use of color, space, rhythm, harmony, and so on. To ask of any artwork that it remind the viewer of something in his or her life rather than be valued as the work itself, say the formalists, is to place a limitation on the work. A love of nature, for example, can only partially prepare us to appreciate a Chinese landscape, a Tiffany scene in stained glass, or an Inuit carving. We must be able to respond to the sensory and formal properties of art as well as to subject matter. The critics who developed the formalist theory thought that a picture representing a subject in a recognizable way is essentially an arrangement of colors and forms and must be judged on this basis.

The formalist artist or critic looks for unity and internal consistency in artworks. Whether the object is a painting, pot, or chair, all parts must relate in a unified way to every other part. In terms of balance, emphasis, and variation, to mention only a few principles, the art object must express the artist's intelligent decisions. When a work is lacking in some aspect, the informed viewer or critic can point to the weakness, because it is apparent in its lack of consistency with the expression of the complete work. The notion of craftsmanship, artistic skill, or competency in technique is often included within the formalistic viewpoint. The formalist keeps his or her eye on this arrangement, whereas the expressionist is interested in the feelings or emotions the artist wants to convey.

Although the aesthetic stances discussed here were developed primarily in response to Western art, they are useful as well for viewing art from any culture or natural phenomenon. However, they are not central to the way art is regarded within many other cultures. Richard Anderson has compared philosophies of art within nine cultures separate from the Western tradition, including the San people of southwestern Africa, Eskimo or Inuit peoples of the Arctic, Aboriginal Australian peoples, inhabitants of the Sepik region of New Guinea, Navajos of the American Southwest, Yoruba people of West Africa, pre-Columbian Aztecs, peoples of early India, and peoples of Japan.¹¹ An-

Stuart Davis, Swing Landscape (1938). Oil on canvas, 86'' imes172". One of the most original artists. Stuart Davis combined concepts from cubism with his unique American vision. Davis's work provides a transition between French cubism and the nonobjective painting of Pollock and the abstract expressionists. Many of Davis's works made reference to musical forms such as swing, jazz, and boogie-woogie. How would this work be regarded by a person who adhered to the mimetic aesthetic stance? To the expressionist stance? What is your response?

The context of an artwork can change the meaning and the aesthetic response of the viewer. These two examples of metalwork from the same period reflect the violently contrasting social conditions that surrounded their creation. The silver tea service cannot be regarded in the same light when shown in the presence of the slave shackles.

derson's studies provide a sample of the range of views, purposes, and functions of the visual arts among the diverse peoples of the world.

The Intentional Fallacy

The fallacy of artistic intention is interesting because of the sharp division it has created among critics, philosophers, and artists. Everyone seems to agree that any artist has some purpose in mind when beginning a work, but from this limited-consensus point on, opinions diverge. The intentionalist critics say that if the goal of the artist is not taken into consideration, we may be looking for the wrong things or expecting more than the artist can deliver. Others argue that we must deal only with what we see, because the artists might not be around to question; and even if they were present, artists are not always articulate with respect to their work. The fallacy lies in the belief that it is necessary to know the artist's intention before we can appreciate his or her work. When an intentionalist points to an artist such as Jackson Pollock, whose decision to rely on accidents precludes a clear intention, the opposing side will say that when Pollock decided *not* to plan ahead, that decision in itself is a statement of intent. Both sides would have to admit that in most cases, there is always some element of surprise or discovery even when the artist's intentions are formulated in advance. Artists will often comment on the things people see in their work that have little to do with what they had in mind.

Some artists object when asked to explain the meaning of their work and take the position that if they could explain the meaning, there would be no reason to create the artwork, that the work must speak for itself. Other artists are not articulate and have no interest in speaking and writing about their art or the work of other artists. They feel that they should not be burdened with interpreting their own work. Probably all artists are, to some extent at least, culture bound, in that they are unable to detach themselves from the influences and conventions of the society in which they live. The idea that only the artist can provide the real meaning of a work of art is, basically, impractical for these reasons and also because many artists are no longer living and able to answer our questions. Intentionalists and non-

Anna Hyatt Huntington, *Fight-ing Stallions* (1950). Aluminum, $15' \times 12' \times 6'$ 4". Compare this sculpture with other images of horses in this book. What is the most pervasive feeling conveyed by this work? What is the role of the figure riding the horse? Why is the figure nude? How would the meaning of the work change if the figure were clothed?

Bettye Saar, *The Liberation of Aunt Jemima* (1972). Mixed media, $11^{3/4''} \times 8'' \times 2^{3/4''}$. This work challenges a pervasive racial stereotype and represents the current emphasis in art on social issues. Saar appropriates and controls in her work the image she wishes to "liberate" or reveal as a stereotype. Which is more important in a work of art, its form or its message? Must art be beautiful? Must art speak truth?

intentionalists differ primarily in the emphasis each places on artists' interpretations of their own work.

ART AND WESTERN SOCIETY

Art and Material Values

All visual arts, Western ones in particular, exist within a social setting that includes an economy of valuation. Historically, artists have been supported by political rulers, church leaders, wealthy gentry, and business leaders. Much of our legacy of great art was created by artists who were entirely supported by or commissioned by one of these powerful groups. Unless they are independently wealthy or supported by family money, many artists today are individual entrepreneurs who make their living from selling their work. Commercial artists, designers of all types, architects,

Jaune Quick-to-See Smith, Rainbow (1989). Oil and mixed media on canvas, 66" \times 84". Quick-to-See Smith's colorful painting of a rainbow combines a number of postmodern elements: The work relates a contemporary ecological theme that is also tied to the artist's Native American heritage. She uses words in the work, as well as pictographs, and is apparently well acquainted with conventions of modern painting, including emphasis on the flat picture plane and paint quality and texture. The combination of ideas, images, and styles is typical of many postmodern works.

and others work within the business community and are paid for their creative production. A large number of artists support themselves by teaching art to others, a noble tradition that goes back many centuries. The relationships between art and material values are many and complex, including the amounts of money artists receive for their work.

A month rarely goes by without some transaction involving an enormous sum of money being paid for an artwork. In 1987, an Australian collector purchased van Gogh's *Irises* for a record \$53.9 million. This is for a work by an artist who sold only one painting during his lifetime for a very small sum. The question that immediately comes to mind is "How can any single artwork be worth that much?" This same query raised considerable heat some years ago when Australian tax money was expended (only \$1 million in this case for Jackson Pollock's *Blue Poles*). On May 5, 2004, Picasso's painting *Boy with a Pipe* sold at Sotheby's public auction for \$104 million, a new record at the time.

People may only shake their heads in disbelief when a private party spends his or her own money but will become vociferous in their objections when public funds are involved. In any case, we cannot deal with the question of dollar value without considering the value of an artwork as a unique, one-of-a-kind phenomenon for which there can be no exact counterpart. Questions such as these often arise: How does one arrive at the monetary value of a work of art? Who sets the standard, what are the criteria, and how do we go about getting such information? Ask students, "What could you do with \$104 million to support art in your community?" One student might discover that an entire museum could be built for that sum; another, a community art center; and another may discover that an entire collection of contemporary art can be purchased for this same price. Whatever the solution, it will require some research demonstrating differing philosophies on the part of students. Dealing with implications of a news item leads us to the bridge that connects theory and speculation to the real world of tomorrow's headlines.

Aesthetics: Politics and Real Life

Aesthetic problems posed by *headline aesthetics* (current news items that pose aesthetics questions) may come from any number of traditional concerns, such as the question of beauty or the artist's responsibility to society. We can also call this *practical aesthetics*, because it can involve us on a personal level, such as the expenditure of public tax monies. Newspapers and magazines, the main source of headline aesthetics, also possess an aura of authenticity more compelling than any textbook. Following are some typical examples of controversy that occurs when aesthetic ambiguity meets the American public:

- Richard Serra sues the General Services Administration when it decides to move his sculpture *Tilted Arc* to a site other than the one for which it was designed because of public hostility to the work.
- A mural in Aberdeen, Maryland, is cut up and reassembled. The artist, William Smith, charges the Marriott Corporation with lowering the monetary value as well as with violating the artistic integrity of the painting.
- Sculptor David Smith disowns one of his works whose paint has been stripped away by a collector. The practice continues even after his death, and the executors of his estate are involved in litigations.

- A Pittsburgh man changes the color of an Alexander Calder mobile from black to green and gold because these are the county colors.
- An art supervisor is asked by the secretaries' association to take down an exhibition of teachers' work because drawings of nudes are found offensive.
- A group of major American artists writes a letter to the *New York Times* complaining about architect Frank Lloyd Wright's design for what is now the Guggenheim Museum.

Censorship and Art: A Problem for Aesthetics

Art exhibitions in publicly supported art museums sometimes raise a high degree of controversy. An example is an exhibition at the Corcoran Gallery of Art in Washington, D.C., in 1989.¹² Works by photographers Robert Mapplethorpe, Andres Serrano, and others proved to be disturbing to a large constituency of citizens. Outraged citizens' protests led to proposals in the U.S. Senate that nearly resulted in the demise of the National Endowment for the Arts. Another exhibit, titled "Sensations," caused a sensation at the Brooklyn Museum of Art in 1999. The mayor of New York City called the exhibit "sick" and threatened to cut the city's funding of the museum.

These two instances of attempted censorship have raised many questions in the minds of museum directors, politicians, and the general population. Censorship of art by persons with questionable art expertise, exemplified by these incidents, is certainly not new to art educators, particularly to supervisors whose job it is to schedule exhibits of various kinds in public places.

Is the aesthetic issue at stake here the freedom of the artist? Censorship is as much a problem today as it was to Plato, who recommended censoring poets (and doubtless artists as well) because of the potential conflict between artistic freedom and the good of society. Some typical questions that emerge from these controversies follow:

- Should the museum directors remove questionable photographs and other art that might be offensive to some members of the public? Would this have been an "honorable" compromise?
- Is the issue one of spending public funds on art, or is it an issue of art judgments being made by persons not qualified as art professionals? Should politicians, with the dual responsibilities to promote and support the arts and to spend public monies wisely, have the op-

tion to judge the quality and significance of the art they support? Can politicians perform this function, or should they commission professional critics to make such decisions?

- What problems arise when politicians or other bureaucrats take upon themselves the function of judging the quality and significance of art? Is this practice consistent with the freedom of speech guaranteed in the Constitution of the United States? Are there historical precedents for this practice? What can we learn from these precedents?
- When works of art supported by public funds appear vulgar, disrespectful of some group or institution, or beyond standards of decency held by most people, do public officials have an obligation to display those works? Are standards of community morality and decency separate from standards of artistic quality? If they are separate, which standards take precedence in these

Dorothea Lange, Migrant Mother, Nipomo, California (1936). Photographer Lange was driving across rural California during the Depression years and was drawn to a migrant workers' camp, where she discovered this mother and her children. There was no work because the vegetable crop had frozen. One of the most memorable pictures of the twentieth century, this photograph expresses the anguish of extreme poverty, concern for family, and stoical endurance. Is this photograph a work of art? Does it matter that Lange took many pictures of the family and selected this one to publish? Why is this image so enduring?

cases? Should the artworks be displayed because of their artistic excellence attested to by knowledgeable art professionals, or should they be removed from display because they offend a large number of viewers, including politicians?

As with many problems in life, there are no easy answers to many aesthetic issues. It seems that each question raises even more questions. Nevertheless, these are real issues that must be resolved in real life, one way or the other. In some ways the study of aesthetics is one of the most useful things we can ask students to do, because it gives them valuable experience in thinking carefully and logically about very "messy" real-life problems and in learning to evaluate different points of view, each of which might have some merit.

Examples of Censorship Issues

- If you examine the surface of the Washington Monument, you will see that the color of the stone changes around a quarter of the way up. The reason is that some people were so enraged by its design that they dumped hundreds of slabs of stone into the Potomac River. The monument was completed some 40 years later when the furor subsided, but by then it was impossible to match the original colors of the stone.
- In San Diego, California, the city council voted down funds for a park that featured a sculpture composed of airplane fragments. Who should make the judgments about art that is funded by the public for public display? The city council? Park officials who will see the work every day? Ordinary citizens who will visit the park? A panel of art professionals who can judge the quality of the proposed artwork?
- One of the most contentious and widely observed controversies about a work of public art occurred when a blue-ribbon panel of art experts selected the proposal of Maya Lin, then an undergraduate art student at Yale University, for the Vietnam Veterans Memorial on the Mall in Washington, D.C. A vocal contingency of veterans objected to her proposal, which some interpreted as a demeaning memorial unworthy of the veterans' service and sacrifice. Even though her work was selected by a highly qualified panel in a blind process, politicians and interest groups forced additional

hearings. The compromise that resulted included a second work, a realistic sculpture of three ethnically diverse soldiers, which was installed on the same site, along with a flagpole and the American flag.

These examples show how truly important aesthetics can be in practical matters. Censorship is a particularly effective topic to introduce problems of aesthetics, because at some point all of us must deal with the conflict between reason and emotion. Aesthetics thus has a way of answering one question by posing another. If you can get students to accept this, then they are exercising that "tolerance of ambiguity" that is one characteristic of the sophisticated mind.

Other Aesthetics Controversies

The following example of real-life aesthetics is centered on the nature of the art object. We'll call this example "The Question of the Missing Nose."

Situation: Go into any museum that collects classical art, and you will find portrait busts minus their noses. This is understandable because protuberances from any basic form are vulnerable, especially when one considers the hazards of being buried for centuries under debris, dirt, and archeological fragments.

Problem: As a curator of a museum, you have received a classical sculpture of a portrait bust from a donor. There is one condition attached to the gift, however. The donor insists that the missing nose be repaired so viewers can see it exactly as did the Roman citizen at the beginning of the Christian era. Not all of your staff is overjoyed at the conditions under which the gift is offered. Some flatly reject it on the grounds that no person under any condition has the right to tamper with a work of art, whereas others say, "Why quibble? Don't look a gift horse in the mouth; our collection needs this work." What does the class think?

This is a good adversary situation and lends itself to a formal debate. One could also simulate a courtroom setting in which two lawyers argue their case before a jury composed of their classmates. The curator, who has accepted the terms of the gift, could also act as the defendant on trial for aesthetic misdemeanors. "The Question of the Missing Nose" has its counterpart in an incident that actually occurred.

A hammer-wielding vandal damaged Michelangelo's

Pietà, dest-oying the Madonna's nose, breaking her arm, and chipping her eye and veil. Several possibilities for restoration exist, and you, as museum director, must select one:¹³

- 1. Do nothing to repair the damage other than clear away small amounts of rubble from the base of the statue.
- 2. Working from photographs and drawings of the *Pietà* made prior to the incident, restore the nose, arm, eye, and veil to their original contours, using a plaster ma-

Maya Ying Lin, Vietnam Veterans Memorial, Washington, D.C. (1982). Composed of 150 polished and engraved black granite panels 40" wide, height from 18" to 10' 9". Maya Lin's design for this memorial comes from the context of contemporary minimal sculpture. The abstract quality of the black marble "Wall," as opposed to traditional memorials featuring realistic sculptures of combatants, made this work controversial when it was dedicated in 1982. Since then, two traditional sculptures have been added, one of three soldiers, another of female military medical personnel caring for the wounded. The Wall has subsequently gained stature as a unique and effective memorial. Visitors to the Vietnam Veterans Memorial stand before the reflective surface, viewing their own images as they see the thousands of names of fallen veterans engraved in the stone.

terial lighter in color than the original marble so it is immediately obvious to any viewer which portions have been restored.

- 3. Using a technique that involves grinding identical marble (including much of the rubble) to form a resinbound plaster that will dry to a color and texture indistinguishable from the original, restore the nose and elbow to their original contours. The restoration will be undetectable to visual analysis.
- 4. Do number 3, but incorporate a tracer dye in the marble plaster to permit X-ray identification of the restored portions.

Maya Ying Lin, *Civil Rights Memorial*, Southern Poverty Law Center, Montgomery, Alabama (1990). Curved, polished black granite wall, 9' high and 40' long, and a circular table of black granite, 11' 6" in diameter, 30" high, on a base of 20", water. The use of water that slides down the wall in a thin sheet and wells up onto the circular table is suggested by the quotation from Martin Luther King Jr. inscribed on the wall: "Until justice rolls down like waters and righteousness like a mighty stream." The names of men, women, and children who lost their lives in the struggle for civil rights in the United States appear on the round table, covered by a thin sheet of water. Both of Lin's memorials demonstrate how art can communicate social ideals, values, and beliefs in ways that transcend the power of words.

"THE CASE OF THE DOUBTFUL PICASSO": THE AESTHETICS OF FORGERY

As one delves into the problems of choice, other questions begin to emerge that, in turn, lead to other quandaries, such as the relationship of forgeries to authentic art.

Problem: You have recently come into an inheritance and have reached the conclusion that one of the safest wavs to hold onto your money and ensure its growth is to invest in art. You decide to begin educating yourself rather than rely exclusively on the advice of dealers. You begin to do some serious museumgoing. You have decided to limit your collecting to European painters between World Wars I and II. You read books and journals, study catalogs, go to auctions, and talk to people who seem to know about art. One day you hear of a Picasso that another collector has to sell in a hurry. Despite the fact that Picasso is not one of your favorites, you go to the owner's home to see the painting, and to your surprise, you like it. Possessing the collector's mixture of greed and love, you buy it. Two years later, it comes to light that your painting may be a forgery. What should your reaction be?

- 1. Sell it as quickly as you can to another collector.
- 2. Keep it, because you still love it.
- 3. Sell it as an example of superb fakery.

What are the pros and cons of each of these solutions? Does the fact that someone else painted it lessen your enjoyment of it? Would you have purchased it if it had been painted by a relatively unknown artist? What is the relationship between the intrinsic value of the work and its dollar value?

WAYS OF TEACHING: INQUIRY AND STRUCTURED DISCUSSION

Some form of inquiry lies at the heart of each of the art disciplines, including aesthetics. When any discussion goes beyond informal sharing of opinions, it begins to verge on what is called *inquiry*—the search for the best answers through the questioning process. When we interpret art, when we study a work for its meaning by digging beneath the surface of some long-held assumption, we are practicing inquiry. If a student comments that abstract painting is "a put-on" or says, "I could do this stuff when I was in nursery school," then inquiry is in order. Every teacher of social

CLASSROOM CLIMATE FOR PHILOSOPHICAL INQUIRY

Teachers generally want their artrooms to be safe places—places where students feel comfortable sharing their ideas, concerns, fears, and dreams. Students need to know that they are valued, that what they have to say will be heard. They need to trust that they will not be put down by their peers. If students are to feel comfortable raising philosophical questions about art, the artroom must be such that they know their ideas are valued. They need to know that they are free to voice their concerns and their beliefs—that their opinions *matter*.

Source: Marilyn G. Stewart, *Thinking through Aesthetics* (Worcester, MA: Davis Publications, 1997), p. 34.

studies who has heard students make unsupported generalizations about nationalities or ethnic groups knows that in such cases the rational examination of an idea should be encouraged. If inquiry is at the heart of philosophy in general, the ability to withhold opinions as we venture into uncharted waters lies at the heart of inquiry. Underlying the inquiry process is an assumption that lecturing is the least effective way to discover meaning in art.

When inquiry is structured so it follows certain accepted rules of logic, it is called a *dialectic* approach, a form of structured conversation. Plato's *Republic* is really a series of such student-teacher dialogues; succeeding philosophers have had their own ideas as to how such dialogues should be conducted.

Immanuel Kant thought that the best way to begin is to make a false statement and invite the student to examine it for its logical weakness—for example, "Everyone is an artist" or "Art serves no practical use in society." The German philosopher Georg Hegel believed that any premise or *thesis* will do as long as it is followed by an antithesis or counterargument. Both thesis and antithesis, however, must conclude with a *synthesis* that rejects the limitations of the two previous stages and preserves what is reasonable in both of them. These are Hegel's *triads* of discussion. Whether one wishes to follow an orderly structured approach or a more freewheeling one, the same guidelines for discussion apply to both. The following suggestions are not necessarily listed in order of importance.

- 1. Build your lesson around a few key questions embodied in the concepts you wish to teach. If you wish to stress the concept for third graders that "art is humanmade, not a creation of nature," show them a photo of a city scene and a painting by Edward Hopper and ask, "Which is the painting, which is the photograph, and what is the difference?" Try to stick to your key question; and to maintain your conceptual focus, resist the temptation to go off into side issues. (This is not always easy with imaginative primary graders.) Although informal brainstorming and free association do have their place, they are not to be confused with the process of inquiry.
- 2. Try to avoid yes-or-no questions, because these have limited value and do not open further discussion.
- 3. Rote definitions repeated from text or a dictionary can obscure understanding, because they give the impression that only one answer is correct. Because rote answers represent very little struggle on the student's part, they are also the most quickly forgotten.
- 4. Complex answers take time; obvious ones do not. Obvious answers do serve one purpose, however—they can get things rolling and involve the shy or reluctant participant. No one likes to keep saying, "I don't know."
- 5. Avoid asking questions that contain their own answers. For example, "Isn't Barbara Hepworth terrific in the way she simplifies natural forms?"
- 6. Encourage the role of devil's advocate by having students present counterarguments even when these arguments go against their convictions.
- 7. Do not get carried away by the brilliance of your question. The longer and more involved the query, the quicker the point will be lost. Be as clear and precise as you can in your questions, because the nature of a question often determines the kind of answer you will receive.
- 8 Wait for the moment when it is the teacher's job to sum up—to clarify. The summation, a form of Hegel's third stage of *synthesis*, sets the stage for what is to follow

AESTHETICS SKILLS

Students will develop the following skills during aesthetics dialogue:

- Listen carefully to others
- Identify and raise questions
- State their own views carefully
- Provide reasons for what they believe
- Use words carefully
- Make distinctions
- Uncover assumptions
- Offer cogent arguments
- Be respectful of others' views
- Reflect on their own beliefs and reasons for holding them
- Imagine alternative solutions to issues
- 9. Play one student's answer off another's. ("Do you agree with Susan? No? Why?")
- 10. Move the discussion around the room instead of concentrating on a few bright lights. Above all, do not neglect those in the back row, and never underestimate the role that seating plays. Proximity to windows, to friends, or to the teacher can all affect the attention of students.
- 11. There is no point in asking a question if you do not take time to listen to the answer. Try the "pair-share" method as part of your inquiry. Divide the class into teams, and allow two or three minutes for participants to think about an answer. Then, have representatives of each group share their answers with the class.
- 12. Although the truth does not necessarily lie in consensus, try an occasional survey to see what kind of consensus exists. ("How many agree with Bruce? You seem to be in the minority. George, because you don't agree with Bruce, can you come up to the picture and identify what you are referring to?")
- 13. Because inquiry cannot proceed without guidelines, get the class involved in setting down a few rules be-

fore you begin. These may range from the general ("Try to be open to a point of view that's different from yours") to the more specific ("When possible, give some clear evidence, such as pointing to a flaw in an argument to support your statement").

- 14. Although aesthetic discussions can proceed on what is said rather than on what is seen, the ideas selected for discussion should, whenever possible, relate to artworks. Can you imagine how much would be lost in a discussion of formalist or expressionist philosophies of art without comparing works of artists such as Piet Mondrian (a formalist) and Oskar Kokoschka (an expressionist)?
- 15. The general goal of any program of aesthetic inquiry is to develop in students the ability to deal with disagreement and uncertainty, to value ways of viewing a problem that differ from their own.

Never underestimate the desire of children to talk about art, particularly in the primary grades. The fact is, the younger the child, the more eagerly discussion will be welcomed. Any idea presented as a puzzle or a quandary or that uses a case history has immediate appeal as a means of provoking discussion.

QUESTIONS FROM 5TH GRADERS

- How can you tell scribbles from abstract works? What is a scribble, exactly?
- Does it matter how much time a work took to make?
- Does the artist need to have skill? What is skill? Is it using tools well or is it thinking out things to do?
- Does it matter if an artist makes a mistake? How can mistakes sometimes be good?
- Can earthworks be artworks? Can you walk in or on artworks?

Source: Michael Parsons and Gene Blocker, Aesthetics and Education (Urbana: University of Illinois Press, 1993), p. 177.

NOTES

- 1. Leo Tolstoy, *What Is Art?* (Philadelphia: Henry Altemus, 1898), p. 281.
- Margaret P. Battin, "Cases for Kids: Using Puzzles to Teach Aesthetics to Children," in *Aesthetics for Young People*, ed. Ronald Moore (Reston, VA: National Art Education Association, 1995).
- 3. Merriam-Webster's Collegiate Dictionary, 10th ed. (Springfield, MA: Merriam-Webster, 1997).
- 4. An excellent sourcebook for aesthetics discussions is Margaret Battin, John Fisher, Ronald Moore, and Anita Silvers, *Puzzles about Art: An Aesthetics Casebook* (New York: St. Martin's Press, 1989).
- 5. William Feaver, "Reawakening Beauty," *ARTnews* 98, no. 9 (October 1999): 216.

- 6. Louis Untermeyer, ed., *Modern American Poetry, Modern British Poetry: A Critical Approach* (New York: Harcourt Brace, 1936), p. 391.
- Richard Foster and Pamela Tudor-Craig, *The Secret Life of Paintings* (New York: St. Martin's Press, 1986), p. 41.
 Ibid.
- 8. ID1d.
- 9. Dennis O'Neil, *Lasting Impressions*, catalog, Susquehanna Art Museum, 1993, p. 32.
- 10. Tolstcy, What Is Art? p. 281.
- 11. Richard L. Anderson, *Calliope's Sisters: A Comparative Study of Philosophies of Art* (Englewood Cliffs, NJ: Prentize-Hall, 1990).
- 12. Smithsonian, October 1989, p. 2.
- 13. Battin et al., Puzzles about Art, pp. vi-viii.

ACTIVITIES FOR THE READER

- 1. A painting of a black circle could be interpreted as the artist's mood, the Black Hole of Calcutta, or just left-over black paint. Apply multiple meanings to Andrew Wyeth's *Christina's World* as you try to account for the subject's relation to her house. Is your interpretation as valid as Wyeth's?
- 2. Select a common object, and endow it with meaning beyond itself. (Warhol did this with his Brillo boxes.) What can you do to transpose the object of your choice? Consider its setting, the lighting of the object, and possible changes of color. Would you use written material to alter the object's meaning?
- 3. Select a well-known artwork such as Picasso's *Guernica*, and write reactions to it from the following points of view: a historian, an art historian, an art critic of the last century, and a survivor of the bombing of the Basque village after which the painting is titled.
- 4. Review the discussion about artist's intent in this chapter. Discuss the following case with a friend or colleague. Vincent van Gogh's *The Starry Night* is widely

appreciated and highly regarded by professionals in the art field. It is considered to be one of his masterworks and, according to the current art market, is worth many millions of dollars. What if an art historian uncovered a lost letter by van Gogh to his brother, Theo, indicating his dissatisfaction with his recently completed painting titled *The Starry Night*? He wrote in the letter that it just did not turn out the way he *intended*, and he considered it to be a failure. Would such a revelation of the artist's intent and his negative evaluation of the painting change the way we respond to it and regard it?

5. Prepare a bulletin board for an ongoing display titled "Big Questions about Art." When a question comes up through class discussion or studio activities, such as "Is a pot art?" (or a chair, car, building, African mask), bring in pictures of examples under discussion. Place each picture on the bulletin board under YES, NO, or MAYBE. Students might bring such items as a postcard from a natural history museum that pictures embroidered fishskin boots from Siberia, a *National Geographic* picture showing jewelry and body scarification in an African tribe, a comic book, or a picture of a beautifully designed modern toaster. Move pictures from one category to another as more information is gathered. A beautifully shaped piece of driftwood might be moved from the YES category to the NO category after it has been decided that natural objects are not considered art. The driftwood, however, may remain in the NO category until someone discovers Marcel Duchamp's "readymades."

- 6. Try to locate a cheap "airport art" reproduction of a piece of sculpture being sold as African in origin. Take your purchase to a museum or to any collector who has authentic examples. Compare the two, and search for any factors that separate a clumsy fake from what is authentic (nature of material, surface, evidence of age or newness, and so on). Some clever fakes are made of the same materials used in authentic works. Try to locate an example of a work that is difficult to categorize as authentic or imitation.
- 7. Should the objects depicted in a work be taken literally, at face value, or can we assume that the artist is using unpleasant subject matter to get at an idea that exists beyond what is seen? Set up a debate centered around the withdrawal of financial support of a museum because the public finds certain works offensive.
- 8. The tradition of political cartoons persists in many Western societies, where virtually any topic can be-

come the subject of satire and humor. Early in 2006, several cartoons featuring images of the Islamic prophet Muhammad appeared in a Danish newspaper. Because the Islamic faith forbids any visual depiction of the prophet, many Muslims were offended by the cartoons. Many felt that their beliefs had been insulted. Riots occurred in a number of cities, and embassies were torched in a number of countries. Some deaths resulted from the riots and fires. Many issues are raised by this event, including the power of visual imagery and art in contemporary life, freedom of speech, responsibility and freedom, and sensitivity to religious beliefs of others.

It is difficult to recall a stronger or more farreaching reaction to any work produced in the history of art. To those interested in the nature of art, questions arise on both psychological and aesthetic grounds. What is there about visual art that can arouse people in such powerful ways? Are there other examples of words, performances, or even cinematic works that have moved people with such intensity? What responsibilities and cultural sensitivities should be applied by makers of visual art? What is the role of art educators in assisting students of all ages to understand and respect the visual arts of world cultures? Whatever one's notions or beliefs, these questions merit discussion in any art class that purports to deal with art in a serious manner.

SUGGESTED READINGS

- Adams, Laurie S. *The Methodologies of Art: An Introduction*. New York: HarperCollins, 1996.
- Anderson, Tom, and Sally McRorie. "A Role for Aesthetics in Centering the K–12 Art Curriculum." *Art Education* 50, no. 3 (1997): 6–14.
- Csikszentmihalyi, Mihaly, and Rick E. Robinson. *The Art of Seeing: An Interpretation of the Aesthetic Encounter*. Los Angeles: J. Paul Getty Trust Publications, 1991.
- Danto, Arthur. The Abuse of Beauty: Aesthetics and the Concept of Art. Peru, IL: Open Court Publishing, 2003.

Diaz, Gene, and Martha McKenna, eds. Teaching for the

Aesthetic Experience: The Art of Learning. New York: Peter Lang Publishing, 2004.

- Eaton, Marsha M. *Basic Issues in Aesthetics*. Belmont, CA: Wadsworth Publishing, 1988.
- Eisner, Elliot. "Aesthetic Modes of Knowing." In *Learning* and Teaching the Ways of Knowing, ed. Elliot Eisner. Chicago: The National Society for the Study of Education, 1985.
- ———. *The Arts and the Creation of Mind*. New Haven, CT: Yale University Press, 2004.
- Getty Center for Education in the Arts and Michael Day.

Art Education in Action, Aesthetics: Episode A: "The Aesthetic Experience"; Episode B: "Teaching across the Curriculum." VHS video. Viewer's Guide by Michael D. Day. Santa Monica, CA: Getty Center for Education in the Arts, 1995.

- Lankford, Louis. *Aesthetics: Issues and Inquiry*. Reston, VA: National Art Education Association, 1992.
- McRorie, Sally. "On Teaching and Learning Aesthetics: Gender and Related Issues." In *Gender Issues in Art Education: Content, Contexts, and Strategies,* ed. Georgia Collins and Renee Sandell, pp. 30–38. Reston, VA: National Art Education Association, 1996.
- Moore, Ronald, ed. *Aesthetics for Young People*. Reston, VA: National Art Education Association, 1995.
- Parsons, Michael J., and H. Gene Blocker. *Aesthetics and Education: Disciplines in Art Education*. Urbana: University of Illinois Press, 1993.
- Perkins, David. The Intelligent Eye: Learning to Think by Looking at Art. Los Angeles: J. Paul Getty Trust Publications, 1994.
- Smith, Ralph A., and Alan Simpson, eds. *Aesthetics and Arts Education*. Urbana: University of Illinois Press, 1993.
- Stewart, Marilyn G. *Thinking through Aesthetics*. Worcester, MA: Davis Publications, 1997.

WEB RESOURCES

Resources for the Study of Aesthetics

ArtsNet Minnesota, ArtsConnectEd, *What Is Art?*: http:// www.artsconnected.org/artsnetmn/whatsart/index .html. Includes many superb resources for educators as well as a curriculum on aesthetics. Incredible@rtDepartment: http://www.princetonol.com/ groups/iad/. Includes lesson plans, resources, art games, and links to other great websites for teachers and students.

North Texas Institute for Educators on the Visual Arts, *Aesthetics: Questioning the Nature of Art:* http://www .art.unt.edu/ntieva/artcurr/aes/. Includes an introductior to aesthetics, curriculum, and resources.

VISUAL CULTURE IN ART EDUCATION

Education in and through the visual arts is needed to support, and sometimes challenge, the increasingly sophisticated visual culture that has developed in postindustrial environments.

-Kerry Freedman, Teaching Visual Culture

Visual culture is a very broad concept that, like postmodernism, has resisted definition. One scholar defines visual culture as "all that is humanly formed and sensed through vision."¹ Another says, "Visual culture is concerned with visual events in which information, meaning, or pleasure is sought by the consumer in an interface with visual technology."² A third writer describes visual culture as "the study of all the social practices of visuality."³ The literature of visual culture and associated topics, critical theory, critical pedagogy, visual studies, and popular culture is vast.⁴

Movie poster for The Incredibles

Visual culture has become a topic for discussion in art education because the contemporary world of electronic and print media has become so prevalent in the United States and a few other countries. Since the invention of photography in the mid-nineteenth century, visual images have become more ubiquitous and more influential in the everyday life of people of all ages. Children and young people often become more involved than adults with uses of newer media such as computers, cell phones, music videos, computer games, movies, the Internet, and combinations of these technologies. Nearly all of these sources of vi-

sual culture embody an agenda or purpose that is intended to entertain or influence viewers.

RATIONALE FOR VISUAL CULTURE IN ART EDUCATION

Because students are so involved in visual media, including magazines, billboards, shopping malls, and amusement parks, and because the images projected for their consumption can be so influential, art educators have recognized a responsibility to educate students regarding the contemporary visual world in which they live. Students need to gain the perceptual and conceptual tools needed to analyze meanings and motives of commercial imagery.

One writer summarizes the rationale as follows:

During an average viewing experience, teenagers will view thousands of often negative ideas about how they should look, act, think, and feel. . . . In order to provide an art education that is relevant to students today, art educators must address issues related to the visual arts students regularly encounter as well as teaching them about the visual arts they rarely see.⁵

This poster by Choctaw artist Jerry Ingram encouraged Native American citizens to participate in the 1990 U.S. census. This is a prime example of interpretation of denotation and connotation in an item of visual culture.

Megatron, by the recognized "father of video art," Nam June Paik, might serve as an icon for the electronic information age. This work is composed of more than 200 video screens. The video monitors are organized in two groups displaying video clips, digital distortions, and animated sequences. The images are selected from all areas of visual culture internationally. Art educators generally agree that children need to be aware that they are targets for commercial and political influences. All the arts are used as means by those who would influence, and the visual arts are particularly persuasive. Children and young people need to learn how to recognize and deconstruct these influences in order to be better prepared as citizens and for their own personal well-being. Teachers need to determine how much of their art curriculum should be devoted to lessons on visual culture.

Visual Culture in Earlier Times

The recent discussion of visual culture in art education has already made a positive impact. By means of published articles, professional conferences, and teaching practice, the discourse about visual culture has contributed in several ways:

- It has raised awareness of the visual environment in which students live and by which their lives are influenced.
- It has placed an important emphasis on works of contemporary art and artists.
- It has emphasized the work of applied artists who create much of what we know as visual culture.
- It has revived interest in more student-centered pedagogies. Teachers are encouraged to be more sensitive and aware of their students' daily experiences and their interests.
- It has provided another alternative approach that art educators may choose according to the educational needs of their students in local settings.
- The emphasis on contemporary art and visual culture provides many opportunities for teachers to connect with art students' life experiences in positive educational encounters.

None of these ideas are new to the field of art education, but educators can benefit from renewed attention to the personal lives of their students, particularly within a school environment preoccupied with high-stakes assessment and national testing.

Although the term was not in use, the thread of visual culture can be found in the history of art education going back at least 80 years. In the late 1920s, art educators developed a practical approach that focused on "art in everyday life." They sought to educate young people to apply art principles in the way they dressed, decorated their rooms at home, and experienced their environment. Art teachers encouraged students to note in their communities such things as landscaping, displays in store windows, and public art. The goals of this school and community approach were to help students view art as relevant and applicable in their daily lives and to raise the general aesthetic level of the entire community.

In 1941, prominent art educators Edwin Ziegfeld and Ray Faulkner published a widely used college text, *Art Today: An Introduction to the Visual Arts*, which included many of these ideas.⁶ In 1944, Ziegfeld published *Art for Daily Living: The Story of the Owatonna Art Education Project.*⁷ The "art for daily living" movement might have gained more lasting attention in art education if not for the advent of World War II, which resulted in the demise of the Owatonna Project and many other worthwhile endeavors in education.

Following World War II, television came upon the scene and captured the attention of everyone, first in black and white, then in color. In some ways, TV was the beginning of the ubiquitous presence of visual culture in the lives of childrer and young people that we witness today.

Art teachers in the 1960s and 1970s engaged students with studio projects such as designing album covers for

This Soninke woman, Silla Camara, from Mauritania in West Africa, continues the long tradition for women of the family households to paint designs on the earthen sides of their homes. The paintings, made from natural pigments, are washed away each rainy season and painted anew at the beginning of the dry season. The decorative and symbolic paintings contribute significantly to the visual environment of Soninke and other African peoples who follow similar traditions. Improving the visual environment for daily living is a very old and persistent idea.

their favorite music, tie-dyeing T-shirts and other items of apparel, and making animated films with colored markers applied directly to clear 16 mm film. During the "psychedelic" years, students in art classes created light shows in conjunction with rock music, using overhead projectors shone through theatre gels, moiré patterns, and colored dyes in water and oil. In the 1970s and 1980s, many students worked with animation using 8 mm movie cameras capable of single-frame shots. Students created simple, brief, animated movies using actors, drawings, and clay figures. The Claymation process had its beginnings during those decades and has persisted as an animation technique, even though computer animation has emerged to dominate the art form.⁸ Art classes often were called upon to make posters, flyers, logos, and other applications of

The clay figures in this series of animated programs must be moved by hand in tiny increments and photographed frame by frame to achieve moving images. With the necessary equipment, this is a technique that can be used in the elementary school. The award-winning animators of Wallace and Gromit use a selection of lips that they place in sequence on the faces to make the figures articulate words.

graphic design and illustration for school programs, events, and announcements.

The advent of personal computers in school and at home at first resulted in minimal changes in the lives of students. The decade of the 1990s, however, saw rapid advances in computer applications with new graphic design and image-making capabilities, animation, color printers, and a host of innovations that found their way into classrooms, which now included computer labs. With development of the Internet, e-mail, instant messaging, live journals, and the combined capabilities of cell phones, digital cameras, text messaging, and so on, we now have a student population that is very much "connected" to the digital world. Parents and teachers will add the phrase, "for good and for ill."

At this writing, the latest research indicates that 87 percent of youths ages 12 to 17 years use the Internet and half say they go online every day. Instant messaging is used by 75 percent of the wired teens. About 45 percent of this age group have cell phones.⁹ Within a year all of these numbers will move upward, and we know that the younger brothers and sisters of this age group are not far behind in their access to digital products. When we consider the time spent by children and young people with all the sources of visual culture—comic books, magazines, TV, movies, video games, visits to the shopping mall, cell phone, computer, Internet, and more—we gain appreciation of the need to address this aspect of their experience in art education.

APPROACHES TO VISUAL CULTURE IN ART EDUCATION

When interest in multicultural art education became prominent in earlier decades, the field of art education developed several approaches that teachers could apply according to their local needs (see Chapter 18). Likewise, several approaches are available for teaching visual culture in art education, for example: (1) a radical change in art education with new aims or goals for the field and the ascension of visual culture as the primary subject for study—the primary aim of this view is social reconstruction that promotes democracy, liberty, and justice; (2) a traditional approach that features study of various applied art forms, such as illustration, graphic design, and fashion design, with emphasis on art making; (3) comprehensive art education, the approach expressed throughout this book that recognizes four art disciplines, places visual culture as one component within a broad art curriculum. The definition of *visual culture* as "everything visual" is rejected; the term is defined for art education as "contemporary applied arts."

Radical Change from Art Education to Visual Culture Education

Some educators advocate a "paradigm shift" in art education that would radically change the field, with new aims and goals, new terminology, and new subject content. This approach utilizes visual culture education for the purpose of social reconstruction. Sometimes known as "visual culture art education," this approach emerged from writings on critical theory, visual studies, critical pedagogy, and visual culture.¹⁰ The primary purpose of this approach is to educate children and young people according to a social and political agenda based on concepts such as democracy. power, oppression, global capitalism, liberation, and justice. These concepts are defined and taught according to the premises of the critical theorists. For example, one advocate of this approach explained: "Critical pedagogy . . . focuses on lived experiences with the intention to disrupt. contest, and transform systems of oppression."11 In this view, the school classroom becomes a site for political struggle, and winning the minds of children is the goal. According to one proponent of visual culture, the problems caused by "corporate capitalism" are "the primary incentive for educational intervention. We need to win for the future critically aware and active citizens."12

In this radically different approach, art is defined as a subset of visual culture, a larger concept. Thus, visual culture subsumes all of what we know as art. Students respond to objects of visual culture in their environment, such as advertisements, TV programs, and video games, and deconstruct the images that they encounter. This deconstruction is intended to provide students with abilities to recognize the political and commercial agendas of those responsible for the objects of visual culture. According to Tom Anderson and Melody Milbrandt:

A frequent result of critiques of visual culture is social reconstruction. That is, the critiques examine a given concept that represents social power; deconstruct the assumptions, values, and mores at the heart of these privileged constructions in order to find contradictions, disjunctions, and dysfunctions; and thereby move them out of their positions of power. Then other values, mores, and institutions are moved from the periphery to the center.¹³

Although this approach has gained support in recent years, particularly at the university level, many art educators are concerned about the implications of a change so extreme that it would require a renaming of the field of art education. Elliot Eisner articulated his concern with "the tacit and not so tacit political thread that appears to run through the study of visual culture." He viewed visual culture education as "a form of pluralism that relativizes the value of art into the political analysis of anything visual."¹⁴ Concerns have been expressed that art education might become another version of social studies, that the political agenda of this approach might serve to reduce demand for art education, and that the concept of students engaged in

Bot Fighters is an advanced video game of violence between robots. Many video games feature different types of violent behavior, fighting, shooting weapons, and in some way overcoming an opponent. Educators, parents, and psychologists have expressed concerns about the extent to which children are exposed to these behaviors in video formats and in relation to children's cartoon programs on TV. Fortunately, video game creators have developed more positive scenarios and activities for children. Wise parents monitor the amount of time chilcren spend playing video games as well as the types of video games they play.

Mariko Mori, *Star Doll* (1998). 10" high. *Star Doll* was created as a work of art in an edition of 99 dolls. The title refers to a persona developed by Mori, a former fashion model and fashion designer who lives in New York and Tokyo. Like the famous toy Barbie doll, this work raises questions of personal identification for girls and young women. Is this a cool way to look? Is this a model for children to emulate? Is this figure realistic as a goal for females?

creative art making might be lost or at least severely diminished within a visual culture emphasis.

Applied Artists and Their Art

A second approach to visual culture in art education attends to the creations of applied artists such as graphic designers, interior designers, illustrators, and animators. The term and the concept of visual culture are not featured prominently within this approach, which has existed in art education for many years and is found most prominently at the middle-school and high-school levels but also can be part of the art curriculum in elementary schools. The purpose of this approach is to inform students about the various types of artists, what they create, and how they work. Students usually engage in making objects of applied arts. This approach also identifies the many careers in the visual arts that students might consider later in their schooling.

Examples of this approach are found in many classrooms as art teachers engage students in art projects such as creating CD covers for their favorite musicians, posters for school events, or illustrations for narratives from history or social studies. For example, see Chapter 18 of this text for children's illustrations of Gray's Raid, a historical event that occurred in the locality of the elementary school. In the same chapter, note a student's sensitive illustration of a traditional narrative from her Navajo heritage.

Other examples of the work of applied art in elementary and middle-level curriculum can be found in commercial art curricula, such as Art: A Personal Journey.¹⁵ A lesson on package design suggests to students that they design a package for "a music CD, a shoe box, or a department store shopping bag." The teacher is encouraged to bring to class examples of package designs for students to examine and discuss. Students are asked to discuss questions such as "To what audience were the artists directing the design of these packages?"; "What type of artists design packages, advertising, and printed materials?"; and "What are some questions that graphic designers must answer before creating a package design?"¹⁶ In this same student textbook, similar lessons appear that focus on fashion design, interior design, and illustration. These lessons are integrated with units of instruction on traditional art modes such as drawing, painting, and printmaking, as well as units on contemporary art and artists.

Comprehensive Art Education: Visual Culture in the Art Curriculum

The third and final approach that we will discuss places the concept of visual culture within the larger realm of art. Visual culture is considered a part of contemporary art, and both fine and applied arts are given high priority for teaching and learning. Contemporary art is recognized for its postmodern characteristics, which often address social and

Creating a Package Design

Marketing in Three Dimensions

Studio Introduction

Design in the Studio

As you walk down the cereal aisle of your grocery store, which packages catch your eye? Have you ever noticed that the bright and colorful designs of some cereal boxes are directed toward young people? They seem to send a message that says "If you buy this cereal, you will have fun!" Other cereal box designs send messages about how healthy you can be if you eat the cereal inside.

Businesses depend on graphic designers —artists who plan the lettering and artwork for packages, posters, advertisements, and other printed material—to help market and sell their products. Many people will select one item over another because the package design appeals to them. With so much product competition, package designs must be as visually appealing as possible.

Studio Background

Designers at Work

In this day and age, there are millions of products and hundreds of stores from which to buy them. Graphic designers have the unique challenge of creating packages that will sell a specific product or promote a specific store. For example, they must try to make one kind of shampoo, one brand of cold medicine, or the corporate image of a particular store stand apart from all the rest. They often create designs to fit a standard container, such as a coffee can, perfume box, or shopping bag. They sometimes custom-design packages that have unusual forms.

Graphic designers need to answer several questions as they create a package design. 1. What size and shape should the package be? What materials should be used? If the product is heavy, the designer must construct a package that will hold the weight.

 What message should the design communicate? The designer must know the important characteristics of the product or store, and figure out a way to tell the buyer about them through the design.
 Who is the buying audience? Some messages are aimed at the general public. Others are aimed at

138

Fig. 3–24 Why is this a successful example of graphic design 7 Green Stripe 7 reads 1 for 1 f

4. What kind and style of graphics wil best communicate the message? The style may be serious, fun, realistic, or abstract. Lettering scyles can also help send messages. Creative use of the elements and principles of design can also attract attention and send the right message. In this studio experience, you will create a package design for a product or store of your choice. Pages 140 and 141 will tell you how to do it. Choose a product or kind of store for which you would like to design a package. For example, you may want to design a case for a music CD, a shoe box, or a department store shopping bag. Use line, shape, color, and pattern to send a message about your product or store.

Fig. 3–26 This student artist used simple shapes and just a few colors to express his message. Barry Knapp, *Barry's Pro Shap*, 2000. Cut paper, pipe cleaners, height: 16 1/4* (41 cm), Jordan-Ethridge Middle School, Jordan, New York.

Artists as Designers

139

political issues. Visual culture is included as an important component within a comprehensive art curriculum.

Consistent with postmodern attitudes about art, this comprehensive approach recognizes a variety of art forms and a plurality of art styles. The popular paintings of Thomas Kinkade, the ultimate art marketer; the mixedmedia creations of naïve artist Thornton Dial; and the video installations of Bill Viola are all candidates for study and critical response. This approach presents visual culture within a comprehensive art curriculum. This is "art education" as distinct from "visual culture education," which deals with all visual images. This approach is also distinct from "visual culture art education," a misnomer used to describe the radical version discussed previously.¹⁷

Several principles describe the status of art and visual culture within the comprehensive approach to art education. First, teachers should pay attention to the aspects of visual culture relevant to art, forgoing the huge domain of nonart visual experience. Second, when the irrelevant is discarded, visual culture is recognized as a component within the realm of art. Third, contemporary art, including visual culture, receives consistent emphasis in the curSeveral commercially produced art curricula are available for elementary and middle levels. Most are published with the elementary classroom teacher in mind but can also be used to good advantage by elementary-school art specialists (see Appendix C). Architect Frank Gehry is also a well-known sculptor. *Standing Glass Fish* is a postmodern work made from atypical materials. It is located in the outdoor sculpture garden at the Walker Art Center in Minneapolis. Compare this work to Gehry's sculptural buildings.

riculum along with art from past cultures, sites, and eras worldwide.

VISUAL CULTURE RELEVANT TO ART EDUCATION

From the perspective of art education, much of everyday visual culture is irrelevant. In and of themselves, bathroom fixtures, medical X-rays, and TV monitors hold little interest for the art classroom. It is when such items are selected and incorporated into art that they gain relevance. When Marcel Duchamp selected a porcelain urinal, titled it *Fountain*, and entered the object in an art exhibition, the bathroom fixture became relevant for art study. When Robert Rauschenberg included a medical X-ray of his body as part of *Self-Portrait*, the X-ray took on new meaning. When Nam June Paik accumulated hundreds of video monitors of all sizes for his installations, such as *Megatron*, these particular video monitors became art media. Artists can select objects of all kinds from the material world to use in the creation of their work. Another example of this transfor-

Some cultural critics predict that the Disney Concert Hall in Los Angeles will become the new icon for the city, replacing the old HOLLYWOOD sign on the hillside. Architect Frank Gehry is also a sculptor, which might explain why this work looks more like a monumental sculpture than a traditional building.

mation is seen in the work of Thornton Dial, known as a naïve artist, outsider artist, or yard artist, whose work is exhibited in the Museum of Fine Arts, Houston.¹⁸ For many years Dial has made art from cast-off objects that most people regard as junk. Everything is not art, yet anything might be transformed into art.

In addition to the works of untutored artists such as Dial, the objects of visual culture relevant to art education are created most likely by graduates of the same departments and colleges in which art educators are prepared. Visual culture can be regarded as the works of applied artists, such as architects, interior designers, graphic designers, and animators, some of the various professionals who create TV ads, magazine design, fashion in clothing, and animated movies. These applied artists are educated in the hundreds of private schools of art or departments of art in colleges and universities across the United States. They study alongside fellow students who will become painters, sculptors, printmakers, art historians, and art educators.

VISUAL CULTURE IS A SUBSET OF VISUAL ART

For the purposes of art education, visual culture is placed within the overall definition of art. This definition includes the traditional fine arts, the applied arts of which visual culture is composed, the tribal and folk arts, and works by highly motivated naïve artists who have forgone formal training as artists. The National Association of Schools of Art and Design (NASAD) is an organization that serves to accredit many U.S. schools that educate artists, including those who create most of visual culture. NASAD recognizes BA, BFA, MA, and MFA degrees in the following programs: 19

- Drawing .
- Printmaking 0
- Illustration .
- Fashion design .
- Photography
- Art history
- Painting

- Industrial design
- Animation .
- Textile design
- Art education •
- . Sculpture
- Graduates of these degree programs nationwide create a major proportion of contemporary art and visual culture. They create most of the visual culture relevant for art education. Graduates of these programs also create video games, websites, action figures, greeting cards (career fields that are not listed as majors), and all sorts of objects that make up our visual culture environment. It is difficult to identify objects of visual culture that were not made by some combination of the contemporary artists represented in the NASAD list.

•

Graphic design

Film/Video

• Theatre design

Interior design

Weaving/Fibers

Each of these degree programs requires that the history of the art discipline be taught along with the studio skills. There is a history of illustration, for example, and a history of animation. Each art discipline has a system for recognizing quality work within its arena. Each year various professional publications recognize the best work in photography, interior design, animation, and so forth.²⁰ There are many competitive exhibitions for contemporary fine artists, including regional, national, and international shows. Each discipline has critics and historians, and philo-

The Incredibles is one in a growing number of full-length feature films created entirely on computers. This technique, or artistic medium, became possible only upon development of very powerful computers and sophisticated animation software programs. The film is an example of popular culture that reaches millions of young learners.

- - Ceramics

Movie still from *Monsters, Inc.* These creatures are from an animated movie about monsters whose job it is to scare children. Creator Peter Docter observes, "People generally think of monsters as really scary, snarly, slobbery beasts. But in our film, they're just normal everyday 'Joes.' They clock in; they clock out. They talk about donuts and union dues.... Scaring kids is just their job" (*CyberArts 2002*).

sophical questions abound in all categories. The applied arts can be studied within the format of comprehensive art education.

TODAY'S ART FOR TODAY'S STUDENTS

Contemporary art includes the art created in the life span of the viewer. For persons born in 1980, the art created after that date is contemporary art. Art that relates to the current postmodern era is considered contemporary by most people. Without being too concerned about when a work of art was created, each of us experiences artworks of many types. We experience many objects of contemporary fine art as photographs or reproductions, such as the pictures in this book. We might never be in the presence of the original works, yet we can be moved by them and we can learn from them.

Art created for visual culture is usually reproduced in large multiples, and we never see the original. An illustrator or graphic designer is concerned primarily with how the work will look on billboards or in magazines or corporate reports. Sometimes an applied artist's work is available in the original, such as Norman Rockwell's paintings that appeared on magazine covers. Rockwell died in 1978, so most of today's college students are not contemporary with him, and his art might not fit their conceptions of "contemporary." Rockwell's paintings, created as applied art, have achieved fine art status with their exhibition in top U.S. art museums, which emphasizes that many former definitions and boundaries of art have been discarded in the contemporary world. The exhibition of Thornton Dial's work in a major museum reinforces this observation.

APPLICATIONS OF VISUAL CULTURE IN ART CLASSROOMS

Interpreting Denotations and Connotations

We have already seen some applications of visual culture in art education. Art educator and critic Terry Barrett has provided us with additional examples for different age levels. With the simple, but telling, distinction between *denota*- *tions* and *connotations* of meaning in visual images, Barrett engaged college students in a group interpretation of a cover of *Rolling Stone* magazine. The magazine cover featured a provocative photograph of the singing group Destiny's Child and numerous written references to items of popular culture. The interpretation developed by college students involved adult-level sexual, social, and political issues that were denoted and connoted in the cover.²¹

Following a similar procedure with seventh-grade students, Barrett explained the meanings of his terms: "*Denotations* are what you literally see in a picture; *connotations* are what the things and words imply or suggest by what they show and how they show it." This group of students viewed and discussed the athletic sweatshirts and T-shirts they wore to class. Many of these garments represented local rival football teams. Teacher and students discussed and interpreted logos and symbols on the apparel, lettering styles, school colors, and meaningful departures from school colors. "By the end of the discussion, we were all impressed with how many different kinds of denotations the shirts bore and how many different connotations common items like school logo-shirts can carry."²²

In another school setting with a group of kindergartners, Barrett explained the task but avoided the terms and definitions. He brought a variety of cereal boxes to the classroom and requested that the children sort the boxes into two groups: cereals for adults and cereals for children. After sorting the boxes, the class was asked to explain how they made the choices.

From this discussion, Barrett learned that the kindergartners attended to the connotations of the imagery on the boxes. They pointed to cute bears with honey dippers, cartoonlike tigers, and three little people with cute faces and charming clothes that the kindergartners identified as Snap, Crackle, and Pop. They identified pictures of toys that could be retrieved from within the boxes. In contrast, the adult cereal boxes displayed bowls filled with flakes, fresh fruits, and milk; coupons to save money; and smiling women with slim waists. The children learned that the boxes were designed to appeal to different groups of people and they involved images intended to persuade.

What Barrett demonstrated in this sequence of sessions with a range of learners is that given a strategy, children and young people are able to interpret implicit messages in the visual culture of their environment. He asserted that it is "immensely important that we interpret the images and designed objects with which we live. Images and objects present opinions as if they were truth, reinforce attitudes, and confirm or deny beliefs and values."²³

Cigarette Ad Deconstruction: Deconstructing Advertising

Virtually every educator agrees that cigarette smoking is a bad choice for students. Art educator Sheng Kuan Chung developed a curriculum unit for middle-level students that engaged them in analysis, interpretation, and creative production in response to cigarette advertisements. The unit was implemented with 12 students during four Saturday sessions; each session lasted three hours. Computers were instrumental for instruction and for student creative production.²⁴

Chung provided extensive background on the issue of tobacco company advertising that targeted the "youth market." An initial activity for students was to respond to a cigarette ad provided by the teacher. The ad and a worksheet for student responses were available on computers. Students were asked to analyze the ads "in terms of visual components, advertising techniques, and intended and implicit messages." Chung reported that "students seemed to have no trouble articulating the intended and implicit messages of a cigarette ad."²⁵ One student interpreted the intended message of an ad that featured an attractive young woman as the primary image: "If you smoke [brand name] cigarettes, you will look young, slim, and beautiful." Another student interpreted the intended message of a different cigarette ad: "I think the ad would make people think that smoking is 'cool.' Make people feel fit-in, and look mature."26

The art curriculum unit also engaged students in making comparisons of graphic design techniques and strategies used by activist artist Barbara Kruger and the activist group The Guerrilla Girls. Students analyzed ways that these artists use slogans, logos, design principles, lighting, and associations of images in their works. With this perceptual and conceptual preparation, students were ready for the studio assignment.

Students were asked to redesign the cigarette ads they had deconstructed, "using their aesthetic sensitivity and a sense of social responsibility." Continuing with their use of computers, students applied graphic design software to reconstruct the ads with a different intended message. The students' new versions of cigarette ads included gloomy environments, skeletal images, unhealthy references, and explicit texts about the hazards of smoking. One student's ad featured in bold lettering: "Smoking causes vision problems, hair loss, yellow teeth, wrinkles, gum diseases, and osteoporosis."²⁷ The connotations of the students' ads were equally difficult to misconstrue.

Students then critiqued one another's ads, interpreting the new messages. Finally, students' redesigned cigarette ads were exhibited in a gallery. Chung reported that many parents voiced their support for such a socially meaningful art project.

Grocery: Corporate Influence in the Community

Chiang Hsiu-Chi, of Taiwan, developed a curriculum unit based on the impact of visual culture in the lives of her middle-level students. Chiang identified and selected a work of art, titled *Grocery*, featured at the Taipei Museum of Fine Art. It is the work of Chen Ming-Te and winner of the 2002 Taipei Arts Award given to young contemporary Taiwan artists. Chen's three-dimensional installation features a section of a traditional Chinese grocery store on one

This sculptural installation, *Grocery*, by Chen Ming Te, won the 2002 Taipei Arts Award for young emerging artists in Taiwan. Many postmodern works have serious social messages.

A 7-Eleven franchise store in Taipei. Many young people like the store because they can rely on quality and a standard stock of items.

side and a corresponding section of a 7-Eleven franchise convenience store on the other side.

Their analysis and interpretation of Chen's *Grocery* raised a number of issues for Chiang and her students. Why are the 7-Eleven stores popular in Taiwan? What attracts young shoppers to the 7-Eleven? What are some of the social and cultural implications of an international franchise from the United States replacing local businesses? What is the future of locally owned family grocery stores? How do local groceries contribute to neighborhood life? Do international franchises such as 7-Eleven make similar contributions?

Chiang and her students conducted a great deal of research in developing this art curriculum unit. They explored topics such as changes in consumer society; systems of corporate identification; and one titled "Why women and girls must fight the addictive power of advertising." The teacher provided many images for her students, including photographs she took in her own neighborhood. She provided a detailed history and background of the 7-Eleven franchise, which had more than 24,000 stores in 17 countries and total sales in excess of \$33 billion in 2002.

Through their studies and observations, students learned how huge business franchises can change the social system in local neighborhoods. What happens to the small family markets when a franchise moves into the neighborhood? What is gained in the neighborhood, and what is lost? These questions led students to learn more about marketing systems, display design, logos, and corporate identity through graphic design. The range of learning can be broad, and students have opportunity to follow their own interests in relation to the larger study. Finally, students created their own designs for markets that they believe will best serve the community. They were able to apply social and business concepts as well as design principles to their own work. This approach to visual culture in the art curriculum began with a work of postmodern contemporary art, Chen's *Grocery*. The social issues conveyed through the work suggested subsequent studies of the visual culture of the large grocery franchise.

The study of visual culture in art education can be exciting and meaningful for students of all ages. Teachers have opportunity to exercise their own creativity and apply their knowledge of the social world as they develop art curriculum and engage their students in the art of today by the artists of today.²⁸

This is a photograph of a typical grocery in a neighborhood of Taipei. Stores such as this are run by families who often live over the store or nearby. The store serves people of the neighborhood as a source of needed items and also as a community center for social interactions and news.

NOTES

- 1. Kerry Freedman, *Teaching Visual Culture* (New York: Teachers College Press, 2003), p. 1.
- 2. Nicholas Mirzoeff, An Introduction to Visual Culture (New York: Routledge, 1999), p. 3.
- 3. W. J. T. Mitchell, "Showing Seeing: A Critique of Visual Culture," *Journal of Visual Culture* 1, no. 2 (2002): 241.
- 4. For examples of the variety of the literature, see Zoya Kocur and Simon Leung, eds., *Theory in Contemporary Art since 1985* (Malden, MA: Blackwell Publishing, 2005); Deborah Smith-Shank, ed., *Semiotics and Visual Culture: Sights, Signs, and Significance* (Reston, VA: National Art Education Association, 2004); Stuart Sim, ed., *The Routledge Companion to Postmodernism* (New York: Routledge, 2001); John Walker and Sarah Chaplin, *Visual Culture: An Introduction* (New York: Manchester University Press, 1997); and Richard Cary, *Critical Art Pedagogy: Foundations for Postmodern Art Education* (New York: Garland Publishing, 1998).
- Kerry Freedman, "Please Stand By for an Important Message: Television in Art Education," *Visual Arts Re*search 28, no. 2 (2002): 24.

- Ray Faulkner, Edwin Ziegfeld, and Gerald Hill, Art Today: An Introduction to the Fine and Functional Arts (New York: Holt, 1941).
- 7. Edwin Ziegfeld, Art for Daily Living: The Story of the Owatomna Art Education Project (Minneapolis: University of Minnesota, 1944).
- 8. At this writing, the top-grossing movie in America is an animated feature film featuring the Claymation figures Wallace and Gromit.
- 9. "Internet Use Up for Young and Old," USA Today, September 7, 2005. This was a report of the Pew Internet and American Life Project.
- Joe Kincheloe and Peter McLaren, "Rethinking Critical Theory and Qualitative Research," in *The Handbook of Qualitative Research*, ed. Norman Denzin and Yvonna Lincoln (Thousand Oaks, CA: Sage Publications, 1994).
- Kevin Tavin, "Wrestling with Angels, Searching for Ghosts: Toward a Critical Pedagogy of Visual Culture," *Studies in Art Education* 44, no. 3 (2003): 198.
- 12. Paul Dur.cum, "Theorising Everyday Aesthetic Ex-

perience with Contemporary Visual Culture," Visual Arts Research 28, no. 2 (2002): 14.

- 13. Tom Anderson and Melody Milbrandt, Art for Life (New York: McGraw-Hill, 2005), p. 54.
- 14. Elliot Eisner, "Should We Create New Aims for Art Education?" *Art Education*, September 2001, p. 9.
- Marilyn Stewart and Eldon Katter, Art: A Personal Journey (Worcester, MA: Davis Publications, 2002), p. 139.
- 16. Ibid.
- 17. The misnomer occurs because the title uses "visual culture" and "art" as modifiers of "education." In this approach visual culture as a concept includes art.
- 18. Edward Gomez, "You Pick It Up and Make Art Out of It," *ARTnews*, October 2005.
- 19. NASAD, *Handbook 2004–2005* (Reston, VA: National Association of Schools of Art and Design, 2004).
- 20. See, for example, Applied Arts: Canada's Visual Communications Magazine, December 2004. This issue

features the year's best work in photography and illustration.

- 21. Terry Barrett, "Interpreting Visual Culture," Art Education, March 2003, pp. 7–12.
- 22. Ibid., p. 11.
- 23. Ibid., p. 12.
- 24. Sheng Kuan Chung, "Media/Visual Literacy in Art Education: Cigarette Ad Deconstruction," Art Education, May 2005, pp. 19–24.
- 25. Ibid., p. 21.
- 26. Ibid.
- 27. Ibid., p. 22.
- 28. Michael Day, "Teaching Cultural Understanding within Comprehensive Art Education," *The International Journal of Arts Education* 3, no. 1 (July 2005): 37–53.

ACTIVITIES FOR THE READER

- 1. Examine the poster *Listen to the Drum* depicted in this chapter. Using Barrett's distinctions of denoted and connoted messages, discuss this work with several classmates. Notice the slogans, font styles, colors, and logos as well as the images. Develop a detailed interpretation of this poster's message.
- 2. Identify a type of product that interests children and youth of a particular age group. This will vary according to their age group, gender, location, and so on. Some examples are sneakers and athletic shoes, sports drinks, electronic devices, breakfast foods, candies, toys, and action figures. Begin a collection of the advertising that targets the age group you have selected. Analyze the strategies and graphic devices used by the advertising. How might this type of activity work with school students?
- 3. Look through this book for images that address social issues or problems. Select two or three, and discuss each with your fellow students. Can you find images that comment on gender equity, population control, conservation of the environment, or violence?
- 4. Interview students of various ages, asking them questions about their interactions with visual culture. How

much time, on average, do they spend watching TV, playing video games, walking in the shopping mall, and so forth? Tailor your questions, and interview children of the age group you are most interested in teaching.

- 5. Following the example of Chiang Hsiu-Chi of Taiwan, note a local franchise of any large corporation. This could be a grocery store, fast-food establishment, clothing outlet, or home-improvement store, for example. Do research and conduct interviews to determine what impact the franchise has on local business, culture, and everyday life. What are the positive outcomes? Are there negative outcomes? How is this business's image created and conveyed to the community and to potential customers?
- 6. Develop a lesson on cigarette advertising and the hazards of smoking for a selected age group. What age is too early for this type of education? How will you tailor your lesson for the age group you have selected? This is an issue about which there is no controversy. How do you handle issues that are controversial? What policies do school districts have regarding controversial issues?

SUGGESTED READINGS

- Barnard, Malcolm. *Approaches to Understanding Visual Culture*. New York: Palgrave Macmillan, 2001.
- Cary, Richard. Critical Art Pedagogy: Foundations for Postmodern Art Education. New York: Garland Publishing, 1998.
- Courtney-Clarke, Margaret. *African Canvas*. New York: Rizzoli International, 1990.
- Elkins, James. Visual Studies: A Skeptical Introduction. London: Routledge, 2003.
- Ferguson, Marjorie, and Peter Golding, eds. Cultural Studies in Question. London: Sage Publications, 1999.
- Freedman, Kerry. *Teaching Visual Culture: Curriculum, Aesthetics and the Social Life of Art.* New York: Teacher's College Press, 2003.
- Freire, Paolo. Pedagogy of the Oppressed. New York: Continuum, 1970.
- Gaudelius, Yvonne, and Peg Speirs, eds. Contemporary Issues in Art Education. Upper Saddle River, NJ: Prentice-Hall, 2002.
- Holly, Michael Ann, and Keith Moxey, eds. Art History, Aesthetics, Visual Studies. Williamstown, MA: Sterling and Francine Clark Art Institute, 2002.
- Hooper-Greenhill, Eilean. Museums and the Interpretation

- of Visual Culture. Museum Meanings. Oxford, UK: Routledge, 2001.
- Leopoldseder, Hannes, ed. CyberArts 2002. New York: Distr_buted Arts Publishers, 2002.
- Mirzoeff, Nicholas. An Introduction to Visual Culture. Oxford, UK: Routledge, 1999.
- Moore, Ronald. "Aesthetic Experience in the World of Visual Culture." *Arts Education Policy Review* 105, no. 6 (2004): 15–22.
- Rose, Gillian. Visual Methodologies: An Introduction to Interpretation of Visual Materials. Thousand Oaks, CA: Sage Publications, 2001.
- Schwoch, James, and Dilip Gaonkar, eds. The Question of Method in Cultural Studies. Oxford, UK: Blackwell Publishing Professional, 2005.
- Sturken, Marita, and Lisa Cartwright. Practices of Looking: An Introduction to Visual Culture. Oxford, UK: Oxford University Press, 2001.
- Van Camp. J. "Visual Culture and Aesthetics: Everything Old Is New Again . . . or Is It?" *Arts Education Policy Review* 106, no. 1 (2004): 33–37.
- Zelizer, Barbie, ed. Visual Culture and the Holocaust. Piscataway, NJ: Rutgers University Press, 2000.

WEB RESOURCES

The following websites contain links to institutions and programs that provide differing levels of theory and information about visual culture. Continue to check these and other lists for teaching resources related to application of visual culture in the elementary classroom.

- Aesthetics and Visual Culture: http://pegasus.cc.ucf .edu/~janzb/aesthetics/. This meta-website, developed by philosopher-professor Bruce B. Janz and hosted by the University of Central Florida, provides well-organized links to sites related to study and research in visual culture and aesthetics.
- Aristos: An Online Review of the Arts: http://www .aristos.org/index.htm. Edited by Louis Torres and Michelle M. Kamhi and features online critiques, reviews, and discussion of exhibitions, contemporary

art issues, and publications including visual culture. A great feature is a searchable archive of past issues.

- Incredible@_tDepartment: http://www.princetonol.com/ groups/iad/. Use search feature to find visual culture resources.
- University of Colorado at Denver, School of Education, *Critical Pedagogy:* http://carbon.cudenver.edu/ ~mryder/itc_data/crit_ped.html. Links to articles on critical theory and pedagogy from the educator's point of view.
- Washington State University, Program in American Studies, *Popular Culture: Resources for Critical Analysis:* http://libarts.wsu.edu/amerst/. Includes content to support introduction to the theory and application of visual culture studies

METHODS FOR TEACHING ART

Classroom Practice

Teaching is intellectual and ethical work. It requires the full attention—wide awake, inquiring, critical—of thoughtful and caring people if it is to be done well.

---William Ayers, Tc Become a Teacher

How does one go about teaching art? A 10-year-old child watches in fascination as an artist-in-residence throws a pot, the sensuousness of the clay in motion nearly driving him to distraction as he anticipates his turn on the wheel. The attention of a fifth-grade girl is held by a slide of a Mayan temple and by the teacher's account of the rituals that occurred on various occasions, and a second grader is proud to have been chosen by the teacher to help distribute the supplies needed for the first painting session of the year. When children are engaged in situations like these, someone has made a decision regarding the means of learning—one way of defining what is known as *methodology*, or that drier term, pedagogy. We noted in Part 2 that all children are unique individuals and that we encounter a wide range of learning styles and abilities among the children in our schools. We discussed in Part 3 the extensive content for instruction within a balanced, comprehensive art program. Given the diversity of learners and the breadth and depth of the subject, art teachers need to develop and employ a repertoire of teaching methods. Indeed, the type of art program outlined in previous chapters requires a variety of teaching methods. For example, art teachers demonstrate skills for art making, show slides or prints of artworks, and lead discussions about works of art. In this chapter we will discuss some of the issues and practices for teaching art in elementary- and middle-school classrooms, and we will review the range of teaching strategies that might be appropriate for different teaching situations.

METHODOLOGY

Methodology is not a rigidly prescriptive series of stepby-step directions on the "how" of teaching. Certainly a teacher can and should use a multitude of methods or strategies. If curriculum deals with the content of instruc-

Working outdoors with mosaic materials (United States).

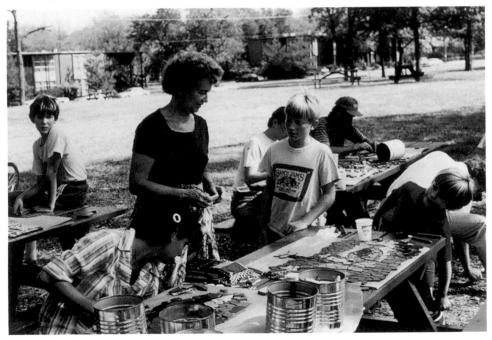

tion, methodology concerns itself with the most effective means of moving students toward realization of curriculum goals. A program can be well planned and resources plentiful, but if a teacher is unaware of processes for getting children to move in a productive way, then the art program the teacher (and students) envision will probably never materialize.

Methodology brings to mind certain principles and techniques of motivation and control that can be studied, observed, and reflected on. If we concede that methods are determined by the varying nature of the children and the task, then methodology invites an eclectic approach. Here are three general styles of instruction:

- 1. The *directive* method is appropriate for transmitting skills, techniques, or processes.
- 2. The *Socratic* or questioning method, employed with groups or individuals, is used to *guide* students in finding answers. This method requires certain skills of the teacher and takes more time, but it is particularly appropriate for aesthetics or any realm of instruction that deals with ideas, theories, interpretation, and analysis.
- 3. *Discovery* is the method in which the teacher sets the stage for lessons that are open ended, speculative, and problem solving.

As an example, after demonstrating the processes of monoprinting, the teacher shows students a painting and monotype by the same artist (Degas) and asks them to describe differences between the two works. The students then make a monoprint, being attentive to the viscosity of paint, the porosity of the paper, and the transfer of paint to paper. In this lesson the teacher has touched on the three modes of instruction just described.

The three general approaches suggest different problems and therefore different methods of presentation, motivation, and styles of pupil-teacher relationships. The problem the teacher faces is to determine appropriate times to use each approach. The introduction of a new medium can be either directive or discovery centered, a discussion of the meaning of an artwork can be Socratic, and calling attention to safety factors should be directive. The approach recommended is flexibility: a teaching style that draws on a number of strategies or methods of instruction suitable for a particular child, material, or idea.

The approaches discussed thus far are general. Another level of methodology deals with the specific aspects of instruction. When teachers suggest a particular way of

developing a painting ("Begin large, then work small, and choose your brushes to match the problem," or "Before you mix a color, think of the amount of paint you will need to cover the space"), they are working at the most immediate level of methodology. When two teachers discuss the most effective way of teaching watercolor or when a teacher plans to introduce a new tool in such a way as to minimize waste or accidents, this is directive methodology operating at both immediate and practical levels. In a broad sense, discussions of teaching methods might include such questions as these: How does a teacher assist students to become more aware of symbols in works of art? What do teachers say or do to open students' eyes, to heighten their perceptions of the aesthetic dimensions of their environment? How do teaching methods relate to motivation and discipline problems? Before dealing with the specifics of such questions, we must turn our attention to more general contexts for instruction.

Contexts for Art Teaching

Art, like any other subject, no matter how intrinsically interesting and attractive, can be poorly taught. Teachers have failed when students learn to dislike the subject and avoid contact with it in later life. Teachers must never become so concerned with emphasis on subject content that they ignore students' attitudes and feelings about the subject. In general, students will respond positively to art instruction when teachers are well prepared, have learning goals clearly in mind, and are able to explain the goals to children at their levels of understanding.

When art is taught well, children are enthusiastic about learning; and when such is the case, art can influence the whole atmosphere of a school, and other fields of study seem to benefit by its good effects. Thinking becomes livelier. and children take a greater interest and pride both in their school and in themselves. School halls, classrooms, and the principal's office are changed from drab areas into places of real visual interest, and children proudly bring their parents to school to see exhibitions of work. Principals report a greater degree of cooperation not only among the children themselves but also among members of the teaching staff and between the public and the school. Most of all, successful teachers bring the student to believe that art matters. They also help parents understand why art is worth the time and money required, that it occupies a justifiable position in general education.

Who Should Teach Art?

The National Art Education Association states that "art instruction shall be conducted by qualified teachers of art."¹ Advocates for art instruction by specialists at the elementary level argue that most classroom teachers have not had the benefit of a fundamental art education and therefore are not qualified to teach art. Art teachers are specially prepared to implement art instruction. They point out that classroom teachers already carry a heavy burden of instructional responsibilities and do not need another subject to concern them.

Some states discourage the employment of art and other subject specialists at the elementary level. Advocates of both sides of the issue appear to agree that art special-

In this method of group instruction in a Japanese school, (1) the entire school gathers on the playground to receive instructions after which (2) each child completes a line drawing of his or her own plant. After this, the work will be critiqued in each classroom, and some will develop their drawings into more complete works using watercolor or mixed media. ists, as a rule, can teach art better than classroom generalists, but some point out that other factors must be considered. In some cases, the objection to specialists is a financial one; in other instances, the argument is philosophical. Some educators argue that for art to be integrated with the rest of the curriculum, for art to become part of the basic curriculum, it is best taught by classroom teachers. They point to art programs in which art teachers move from school to school with hundreds of pupil contacts, preventing them from learning the names of children or developing meaningful relationships with them as individuals. In some cases, art programs are limited by what art specialists can bring to classrooms on a cart.

Because some school districts have more autonomy than others, the issue of who teaches art to elementary children becomes a local decision. In some districts, some of the elementary schools employ art specialists and others do not. There are districts in which art instruction is accomplished cooperatively by art teachers and classroom teachers. Statistics indicate that 87 percent of public elementary schools in the United States offer visual arts instruction. In 55 percent of classrooms, art specialists teach art; and in 26 percent, classroom teachers teach art. In the remaining 19 percent of classrooms, a combination of art specialists and classroom teachers teach art. The employment of elementary art specialists varies widely in different regions of the country. In the West, 57 percent of schools report art instruction by classroom teachers, whereas in the Northeast, only 7 percent of schools do not include visual arts specialists on their teaching staffs.²

The art teacher constantly battles for instructional time with the students. On the average, elementary students receive about 44 hours of art instruction during the school year.³ Considering time required for classroom management and cleanup, the time for real teaching and learning is severely limited. The problem of selection and justification of art learning activities is obviously very important.

The teacher who has sufficient ability, tact, and liking for children to teach language, arithmetic, or social studies is capable of conducting an art program. Like any other subject, art requires of the teacher some specific knowledge and skills—such as a knowledge of design, an acquaintance with professional artworks, and some ability to use materials such as paint and clay. With the support of a well-written art curriculum, a competent teacher may gain the knowledge and master the skills associated with art education. The problems in teaching art, including classroom management and control, discipline, presentation of lessons, assistance of pupils, and appraisal of the success of the program, are, broadly speaking, similar to those in the general school program.

Teachers do not have to be accomplished artists, critics, or historians in order to know how to initiate classroom art activities. If they can handle basic materials and have the aid of a sound art curriculum, classroom teachers can provide children with an art program of value, if not of the same quality as art specialists. Basically three types of teachers can offer some degree of art instruction:

- 1. The classroom teacher with limited preparation who encourages children to use art by assigning problems and conducting what has been called a laissez-faire program
- 2. The classroom teacher with preservice preparation who has taken the time to complete an in-service course and to study on his or her own and who is able to implement a balanced art curriculum
- 3. The professional art teacher who, through training in education as well as art, has the knowledge to develop and implement a comprehensive art program

This book is intended to serve all three of these types of teachers.

TEACHING PRACTICES IN ART

A good teacher begins where the child's natural interests and abilities end. We recognize that much of what children do on their own without guidance, motivation, or special material is repetitive and not a clear indication of the children's true capabilities. If children are to be challenged, their levels of development should be regarded as plateaus from which the children advance. The teacher, weary of seeing the same array of rainbows, cartoon characters, and other stereotypes, obviously must teach for the capability of the child. A good teacher realizes that one does not take away without giving something in return—that it is possible to build even on stereotypes. Even secondhand images can provide a starting point for original thinking.

Setting the Stage

Methodology begins before the students enter the art room. Classroom teachers send out cues by the way they prepare their rooms. Some teachers display reproductions of artworks and natural objects, such as flowers, driftwood, or plants. Others create a visually exciting setting with posters, magazine clippings, and objects of popular culture. Art teachers with their own rooms can create an environment rich in visual stimulation, well organized, and reasonably clean and orderly. When students first enter, they should receive cues about the potential excitement that awaits them in an art room. The teacher who stands at the door and greets the children, who does not begin the class until order is established, who has a pleasant expression, is teaching. The questions all teachers must ask themselves are quite simple: "If I were a child, what set of circumstances in this room would direct my thinking and my attitudes?" "What will a child feel like in this space?"

The Sources of Art

Children can be motivated by their experiences to produce and respond to art. As children live from day to day, they have many experiences that arise from life at home, at play, at school, and in the community in general. They bring to each new experience the insight they have acquired from previous experiences. The majority of experiences children enjoy do arouse their intellect and stimulate their feelings and so may be considered suitable subject matter for artistic expression.

When teachers respect the memories, the imagination, and the life experiences of children, they set the stage not only for studio activities but also for an awareness of history and criticism. To cite an example, when a 7-yearold child wants to draw his or her family, the family pictures and sculptures of Picasso, Mary Cassatt, or Romare Bearden might be of special interest to the child. Themes in art based on everyday life and universal human experiences, such as family, love, conflict, fantasy, and fear, are evident in art from many cultures. The most powerful art often relates directly to the experiences we share as human beings.

A major source of motivation, then, is the life of the child, both internal and external. Because the *total* makeup of the child provides sources for motivation, the teacher can go beyond lived experience and probe for what might be called the *inner vision*; that is, the dream worlds, fears, desires, and reveries. A very real function of the art program is to provide visual objectification for what is felt and imagined as well as for what is observed and directly experienced in the world.

Motivation for Art Making

In general, the teacher makes a distinction between *extrinsic* motivation, which consists of forces external to the child (such as contests and grades) that influence the child's level of motivation, and *intrinsic* motivation, which capitalizes on internal standards and goals the child recognizes as having value (such as the desire to perform well). The teacher should avoid striving for the short-term gain of the former and concentrate on intrinsic sources, which are far more valuable in the long run to the child's development.

The teacher, having decided on the source of motivation, must consider this question: "What are the most effective means of getting the children to use their experiences for making art with the materials I have provided?" At this point the teacher must be sensitive to the variables of the situation, linking subject to materials with techniques capable of capturing the attention of the class. The teacher may decide to focus on the excitement of untried materials, may introduce the lesson with a new video, or may set up a bulletin board using materials from outside the classroom. The teacher may engage the class in a lively discussion or bring in an animal or unusual still life, plan a field trip, invite a guest speaker, demonstrate how a particular skill might be used, or use an artwork to build the students' art vocabulary. At times the teacher will seek direction from students in determining the direction for learning.

In an example of media as motivation, pulling the first print provides a special excitement that is never quite achieved in other stages of the print process. When the print is completed, the student must decide on the size of the edition, the choice of paper, the ground or support—shall it be white or colored, collage or montage?—and the color of the ink itself. In each of these stages, the teacher should try to lead the child toward solving the problem independently.

When a discussion is planned to provide the basis of motivation, the teacher should involve more children than the usual bright extroverts. She or he should know when to let the class members do most of the talking until *they* have come up with the points to be emphasized.⁴ The teacher may find it wise to increase interaction by seating the children close together or by dividing the class into small groups, each with their own task or question to discuss. In this kind of instruction, the teacher's personality, enthusiasm for the task, acceptance of unusual ideas, and flair for communication all play an important role. When the energy level is low and the class has to be brought up to a productive level, the motivational phase can be enhanced by a touch of showmanship. This is where creativity and imagination come into play.

It is important to remember that children do not normally connect their experiences with artistic acts. If a teacher asks children to paint a picture of an experience that appeals to them or to do whatever they like, the results are usually disappointing. Under such circumstances, the children are often at a loss about where to begin. A well-known cartoon of children looking up at a teacher and asking with rueful expressions, "Do we have to do anything we want to?" illustrates the point. It is not that children are incapable of expression but rather that they might have difficulty connecting total freedom with expressive acts.

A Range of Teaching Methods

It is not possible to discuss teaching methods without referring at the same time to educational goals, curriculum, and evaluation, because they are all interrelated and each influences all the others. The broad range of art content in the art curriculum suggests that a variety of instructional methods should be used. Evaluation, if it is not to appear as an afterthought, must be considered during the curriculum development process. As teachers conduct instruction in their classrooms, they are aware of curriculum goals, content for instruction, activities intended to foster learning, and evaluation processes that will assist teachers to assess student learning. With this point in mind, we will focus attention here specifically on teaching methods, with occasional references to these other interrelated topics. By the same token, the chapters on curriculum organization and evaluation will refer to some of the ideas in this discussion.

Maintaining a Learning Environment

Every successful art teacher develops ways to maintain a good learning environment in the classroom. Following are a few suggestions taken from experienced teachers during a discussion of discipline in the art classroom.⁵

- Make expectations for behavior in the art class clear to students as early as possible, preferably the first day. Rules might be prominently posted and should be uniformly enforced.
- If feasible, involve students in the rule-making process, but let them know that the nonnegotiable goal is a safe and encouraging learning environment.
- Seat students according to the needs of the lesson activity. A semicircle is good for eye contact. If students are seated at tables, the teacher will need to move around to make eye contact.
- Learn names of students immediately. Calling a rambunctious student by name sends a message that the teacher knows the student and cares enough to learn names.
- A seating chart for each class with assigned seats is one way to learn names. Another is to take photos of each student and make picture files for each class. Some teachers use a digital camera; others use a Polaroid camera for the pictures.
- When giving demonstrations or discussing art images, try to avoid turning your back to the group, but maintain eye contact as much as possible.
- If a behavior problem is developing, move to the trouble area, relying upon your presence to prevent problems from occurring.
- A direct question to an unruly student, using the student's name, is a way of diverting attention.
- Some students act out in order to get attention. The teacher who overreacts is reinforcing the unruly behavior. Sometimes it is best to ignore the problem if it is not disturbing the learning environment. The next step is to quietly invite the student for a private discussion.
- It is possible to make personal contracts with students that state performance levels, criteria for assessment, dates for checking work, and the nature of work to be presented. The contract method asks students to commit to a final grade using the agreed-upon criteria.
- Treat students with dignity and respect, and they are more likely to reciprocate with respect in the teacher-student relationship.

One first-year teacher was having difficulty controlling student behavior in his art classes. He spent more and more class time maintaining discipline. Why did students act out in his classes more than in other classes? After consulting with several experienced teachers in the school, he came to the conclusion that he was "expecting" bad behavior from the students and somehow they seemed to know this. He decided to change his expectation and go to classes with an attitude that "I have something valuable and exciting to share with my students, and they are going to enjoy learning in my classes." The result was very positive, and the teacher went on to enjoy a successful year with his students. His teaching skills were sound, and the change in his expectations of student behavior, tacitly conveyed to students, allowed him to express his talents as a caring and competent teacher.

The Art in Teaching

Teaching can be considered an art form; although much progress has been made toward improving teaching and learning in the schools, it certainly is not a science with specified actions that guarantee certain responses or reactions. When we observe a great teacher in action, it is not uncommon for us to remark, "She is an artist in the classroom!" or "He handled that situation beautifully," or "What a creative teacher!" These comments are always meant as compliments for a person who has developed into a great teacher. Like artists (actors, poets, dancers, musicians, and visual artists), teachers develop a repertoire of meaningful behaviors and apply them as they see fit according to their experience and goals. One of the differences that marks novices in art or in teaching from those who are masters is the range of their repertoires. For this discussion we will review a range of teaching methods that many excellent teachers are able to use fluently and flexibly, according to their teaching purposes and the needs of their students.

Following are a number of methods good teachers use with varying degrees of emphasis:

demonstrations	student reports
assignments	games
audiovisual presentations	field trips
lectures	guest speakers
individual work	dramatizations
group activities	visual displays
portfolios and journals	discussion

Many of these methods have been mentioned in previous chapters in conjunction with suggested activities for teaching art history, criticism, aesthetics, visual culture, or any of the different modes of art production. They are not listed in any order of effectiveness, and the list is not exhaustive. It is not unusual to observe a good art teacher using several methods during a single class period.

DEMONSTRATIONS

When the children are prepared to paint with brushes, tempera paints, water containers, paper towels, and old shirts worn backward for smocks, the teacher demonstrates how to dip the brush into a color, to brush color on the painting surface, to rinse the brush in water, to blot on a paper towel, and to dip into another color. Children like watching demonstrations that are, in a way, performances and particularly enjoy observing the teacher use the markerboard or chalkboard; indeed, it is almost impossible to ignore the line that is moving on paper or markerboard. The ability to draw an example can give a teacher added credibility in a relatively short period of time.

Outside the studio classroom, the teacher can show students how to use the resource books in the library to find information on the art history topics they have selected to study. The teacher can show students how to use an encyclopedia, a dictionary of art terms, and a handbook on art and artists.

ASSIGNMENTS

After many ciscussions of puzzles about art over their years of art instruction, the sixth-grade students are ready to write a paragraph on their own. The teacher gives them a description of a difficult art situation and assigns them to write their response to the puzzle, stating reasons for their decision. This is the situation:

There is a famous painting by a master artist from the seventeenth certury that has hung in a great museum for many years, where it has been seen by thousands of art lovers. The painting has been photographed and reproduced as beautiful art prints sold in the museum shop. Thousands of people have these prints hanging in their homes. During a routine cleaning of the painting, the art conservator discovered by means of an X-ray that the famous painting was painted over another painting by the artist. This happened when the artist was poor and could not afford a new canvas. Experts agree that the newly discovered painting is probably as good as the famous familiar work. Should the museum director

- a. Authorize the removal of the famous work in order to uncover the one never seen before? This would destroy the famous painting but would provide the world with another great painting by the master.
- b. Keep the famous work as is and leave the underpainting where it is, never to be seen?

For homework, children can be asked to bring a clipping about art from a magazine or newspaper. The clippings can then be placed on the bulletin board and used for discussions of what is happening in the world of art. The chapter on aesthetics provides other suggestions.

AUDIOVISUAL PRESENTATIONS

Children often become bored watching instructional videos or lengthy slide lectures. Audio and visual presentations need not be uninteresting to children if teachers adapt them to children's capacities for instruction and attention. Rather than show an entire video, for example, teachers often preview and select only one segment that focuses on the concept, skill, or understanding relevant to the art lesson. Brief audiovisual presentations interspersed with discussion or studio activities can also be effective.

Interrupting their work on a collage assignment, the teacher can show examples of surrealist paintings, then allow children to resume their work. This need not take more than five minutes.

Or children can watch a 10-minute segment of a video on the stained-glass windows in Gothic cathedrals. After the video presentation, the teacher can hand out worksheets asking questions about the topic. Demonstrations and brief talks can be combined to enhance motivation.

LECTURES

Before starting the class on a ceramics project, the teacher can give the students a brief lecture about handling clay, including the health hazards and safety precautions that need to be understood when working with clay, glazes, and clay tools. The kiln in the art room should be discussed, and the teacher should preview the firing process, explaining the high temperatures inside the kiln. Lectures can also be combined with demonstrations.

In another lecture, the teacher may show slides of African masks and tell the children about the uses of masks in African societies. Although lectures are often associated with higher education, this method can be effective with all age groups if teachers will control duration and content and use visual aids in conjunction with their lectures, avoiding a boring style of delivery.

The lecture method should be used sparingly unless it includes student discussions or participation of some sort. Brief talks, however, can be effective to review a topic or to emphasize a particular point. Teachers will soon become sensitive to the attention span of the class and how this relates to their ability to control the attention of the group.

INDIVIDUAL WORK

As with other school subjects, most art learning activities involve individual work by students. When children are involved in their own art expression, when they are working on individual reading or writing assignments, or when they are using learning centers during spare time in class, they work as individuals. Good teachers often try to vary the amount of individual work with group activities, providing variety for children in the class. Individual work will always be primary, however, because each child needs opportunities for individual artistic expression, as well as individual response to the artworks of others.

After participating in an art criticism session, for example, each student might be given a worksheet with several questions about a painting displayed at the front of the room and asked to discuss his or her personal response to the work. Each student then completes the worksheet and gives it to the teacher, who, after reading the papers, will provide general comments.

During a visit to an art museum, children take a tour led by a museum guide. After the students have completed the tour and have asked questions, the art teacher can ask each child to take 10 minutes to select his or her favorite work (in a large museum, this assignment might be restricted to one or two galleries), suggesting that the children copy the information from the label by the work, make brief notes or sketches describing the work, and be prepared to tell why they chose it.

GROUP ACTIVITIES

Children can be organized into groups to work on a mural that will be designed and painted on a wall in the school neighborhood. A delegation of children and the teacher will need to identify the wall and to obtain the necessary permission from the owner and the city to paint on the wall. Each group has a task. One group will do library research on murals, especially contemporary murals in community settings. (The teacher can direct attention to the tradition of mural making by the Mexican muralists Diego Rivera and José Clemente Orozco and by contemporary artists in the United States.) Another group can be assigned to plan the background, another to work on the buildings, another to work on the vehicles (cars, buses, trucks, and so on), and another to draw and paint the figures.

In the art museum, children can be divided into groups of three or four assigned to particular works of art. The task for each group is to discuss the work by using strategies that they have learned in class and to report on the work to the rest of the class when they are back at school. The teacher can show the slide of the work while each group reports.

REPORTS

The method of fostering learning by assigning reports has been mentioned in conjunction with other methods. Teaching methods are often integrated, although they might also be used separately. The same is true of learning activities that integrate content from art history and art production or other combinations of the art disciplines.

In preparation for a unit about architecture, the teacher may ask the children to notice some things about the buildings where they live. Each child is to notice if her or his home is in a one-story, two-story, or more than two-story building. Each child should be given the opportunity to report this information at the next class meeting.

A fifth- or sixth-grade class can be given a library research assignment, in which they select an artist's name from a list provided by the teacher, spend a period in the library, and write a two-paragraph report about the artist. This assignment could be in conjunction with a unit in language arts.

If an evening or weekend television program is scheduled that is art related, students can bring in a report that describes the program, their reactions to it, or both. Another form of report is the personalized autobiography of an artist.

GAMES

Games represent the play instinct transferred to art learning situations. Games can be rule governed or open ended. They may be commercial games or games created by art teachers. Art games are used largely for motivation but can also serve as the main body of the lesson. Students can learn to develop their own art games. There are times when a game format overlaps conventional styles of instruction and learning.

If a fourth-grade class has been learning about color primary and secondary colors — the class can be divided into four groups and assigned to four locations in the classroom. The teacher should provide in each location an assortment of art postcards from museums. The first group to select works of art that match each color category on their worksheet receives a reward (for example, first group out for lunch).

Teachers often invent learning games based on quiz shows or other well-known games. Art games are available commercially, and many promote worthwhile learning as well as the inherent fun of social interaction.⁶ Art museums often produce gamelike activities for gallery visits, many of which are adaptable for classroom use (see Appendix C).

FIELD TRIPS

Most teachers are convinced of the value of field trips, but many are faced with limited financial support from the districts where they teach. Whenever possible, however, students should have opportunities to learn about the world away from school. For the art program, field trips to art galleries, museums, or other sites such as a graphic design studio, are especially beneficial because children are able to experience original works of art of high quality and to obtain a needed frame of reference that will help them better understand what the slides and prints they see in school actually represent.

Teachers learn about supervising children on trips through experience and sharing with one another. Books about visits to museums are also available.⁷ Following are a few brief suggestions that might fall under the category of teaching methods in relation to field trips (other suggestions are listed in the section on using museums in Chapter 12):

- When possible, visit the museum, gallery, or studio ahead of time in preparation for the planned field trip to note possible problems, such as parking, limited space for your purposes, and so forth. If possible, arrange for a guided tour. Learn about the services offered to school groups. *Schedule your visit!*
- Select several artworks you want all children to see. One problem with museums is that there is too much to see unless the teacher can provide some focus for

the children. You can discuss works seen after you return to school.

- 3. If possible, obtain images of selected works. You can show some of the works to the children before the trip. This establishes an anticipatory mood and provides the works with "celebrity status."
- 4. Note such things as where the bus will stop, where students will enter, where they will place their coats, where the bathrooms are located, and so forth. Decide where the group will meet before and after the visit. Are there clocks in evidence so everyone will know what time it is?
- 5. Draw a map (some museums provide maps), and show these items to the children in the classroom before leaving on the trip. Talk the class through the entire trip, using the map to show where everything is, what the time schedule is, and how they should handle any problems that might arise, such as becoming separated from the group (this should never happen, of course, but sometimes does, regardless of precautions).
- 6. Children may "act up" much more when they are nervous and uneasy because of strange surroundings and situations. By providing all this information, you will place the children more at ease and help them enjoy the experience and learn from it.
- 7. Follow up the museum visit with discussion and sharing back in the classroom. Try to consolidate learning that has taken place. Help children realize what they have learned. Report the successful trips to parents.
- 8. Enlist the aid of parents as assistants.
- 9. Always follow safety guidelines for off-campus excursions.

Field trips can also be taken in the neighborhood with little or no expense. The art teacher may take the class for a walking architecture tour in the neighborhood, noting some basic features of buildings that relate to the study of architecture, such as how the buildings relate to each other and to the environment, what materials are used in their construction, how old they appear to be, and for what purposes they were built.

GUEST SPEAKERS

It is a common practice to invite artists into schools. When the goal of the art program is for children to learn more about the world of art, this makes a great deal of sense. Children have opportunities to see a professional artist at work, to talk with the artist and ask questions, and to observe the materials and methods used to create works of art. It also makes good educational sense to invite other art professionals into the classroom, such as art historians, art critics, and aestheticians (probably more difficult to locate). Often a parent or community figure is happy to help, if asked.

For example, the third-grade teacher wants the students to see what oil paints are like; to smell the paint, linseed oil, and turpentine; and to see an artist's palette and easel. The teacher asks the class if any of them knows of a person who paints. One little girl says her mother's friend is a painter. The teacher contacts the mother, learns the artist's name, and invites the woman to visit the class and demonstrate with her oil paints on a stretched canvas. Although the artist is not a professional, her tools and materials are authentic, and the children learn a great deal from the artist's visit and enjoy it very much.

DRAMATIZATION

This teaching method can make experience more vivid for children, who often remember dramatizations for many years. This does not mean the teacher has to be an actor and dramatize classroom presentations, although some teachers have abilities in dramatics and use their talents effectively with children.⁸ Rather, this is a method whereby teachers assist children to act out, or dramatize, situations that are educationally meaningful with respect to the art curriculum.

For example, a teacher asks for a volunteer from the class each month to dress up as his or her favorite artist and to present the artist's autobiography as if he or she were addressing the class. One boy chooses Piet Mondrian and, with help from the teacher and from home, develops a costume with primary colors and black vertical and horizontal lines. Another boy chooses Jackson Pollock and has a great time splattering some old clothes with multicolored tempera paints to create his costume. A girl chooses Georgia O'Keeffe. She dresses in black and white like a photograph of the artist and somehow finds a bleached cow skull. Another girl chooses James McNeill Whistler and dresses and poses like the painting known as Whistler's Mother (titled Arrangement in Gray and Black by the artist). As each new month begins, students are asked to guess the name of the artist being dramatized. The child doing the dramatization, having studied the artist's life and works, answers classmates' questions. Some of the artists are more

difficult to guess than others. In every case, students are more interested to learn about the artist after the dramatic presentation.

A sixth-grade teacher engaged her students in an aesthetics discussion based on a real-life art controversy reported in the news. The issue revolved around a sculpture that was installed near a county jail, raising questions of use of public money for art versus other needs, appropriateness of the sculpture site, and opinions of the work itself. The teacher assigned groups of class members to represent the points of view of the artist, members of the public, prison guards, prisoners, and state legislators.⁹ Students entered their roles enthusiastically and put on a class skit (with many ad-libs) that was videotaped in the classroom. The issues were clearly stated, and students had the opportunity to examine several valid but competing points of view. Students enjoyed viewing their performances on the video monitor.

VISUAL DISPLAYS

One advantage that art teachers have is the visual nature of the subject. Many children learn visually, and art teachers can see visual evidence of the effectiveness of their instruction in students' art products. We can accomplish much instruction and foster learning with minimal class time, simply through the means of visual displays.

One teacher always includes explanatory material as a component of exhibitions of students' artwork. When she teaches a unit based on a theme or an art style such as cubism, this teacher displays material about the concepts, skills, and instruction that children have received and images they have studied, along with examples of their own work. As other teachers, parents, administrators, and students pass the room, they observe what is being taught and learned by students in this teacher's class. This is the art teacher's way to educate the community.

DISCUSSION

Although some people think of a teacher as a solitary figure controlling a class from a space between desk and markerboard, teachers also work on a one-to-one basis or move from group to group in cooperative learning situations, where four or five mixed-ability groups work together toward a common goal. Small groups can collaborate on murals or dioramas, or they can focus on problems posed by a phase of criticism, such as analysis or interpretation. When five groups each work from the same reproduction and are asked to deal with the same problem, a lively mixture of ideas is likely to occur. One writer has noted:

Cooperative learning involves every class member. The most skillfully conducted class discussion cannot eliminate the reluctance of the shy and the disinterested to participate. In a class of thirty, the constraints of time may not allow for student input on an individual basis. Cooperative learning makes it easier for a student to state a point of view as a member of a team than as a member of a class.¹⁰

In many cases, a team of four or five members sharing the same image can delve deeply into such tasks as these:

- Taking a sensory walk through a painting
- Searching for the artist's intent in an artwork
- Comparing two or more treatments of the same subject

Children enjoy various forms of debates because a factor of suspense is present. When dealing with ideas rather

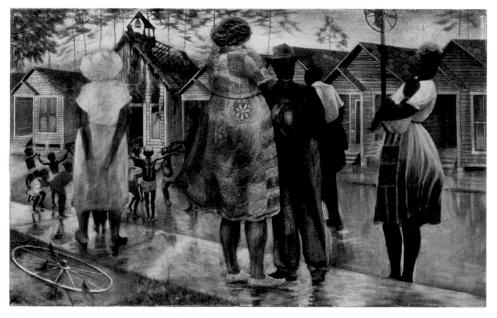

John T. Biggers, *Shotgun*, *Third Ward #1* (1988). Oil on canvas, $30'' \times 48''$. This painting depicts a scene from the Houston community where the artist lived, with the row of "shotgun" houses next to the church, which was burned. Reacting to the calamity, the residents gather in the street. The man with a hat holds a lighted candle in a glass, symbolizing a ray of hope for the burned church, which will be restored and continue to serve as a source of inspiration for the community. The circle of children might be seen as the next generation of leaders, the continuing "cycle" of the community. Disasters in art might be a theme for study; disasters are always with hur ankind: for example, floods, hurricanes, earthquakes, tsunamis, volcanic eruptions, tornados, and droughts.

than studio activity, teams can develop a defense for a particular point of view regarding an aesthetic issue. As an example, one table of students can develop a case for total freedom for the artist, and another can be asked to play devil's advocate for a number of issues involving artistic freedom, such as the need to respect public mores of a group or community, the relation of freedom of speech to freedom of artistic expression, the need to define art before rendering decisions, and so on. Small-group learning encourages children to learn from one another as well as from the teacher. It operates on the assumption that two or three opinions may be better than one and that the interaction that takes place through listening and contributing possesses both social and educational value.

Teaching with Technology

Computer technology and the availability of the World Wide Web on the Internet, the "information superhighway," has changed education significantly and permanently. Internet users worldwide are estimated in the hundreds of millions, with many new online users every day. Current estimates indicate up to 8 billion pages on the Internet with as many as 7 million new pages each day. These numbers will be obsolete within a year due to the rapid growth of Internet users and online pages.¹¹

The children of the twenty-first century need to be computer literate in order to compete academically and in their future occupations and to be knowledgeable citizens in a democratic society. But beyond this new literacy requirement, computers can be exciting, stimulating tools for learning in art as well as across the school curriculum. According to art educator Phillip Dunn, "Art teachers who are technologically literate are uniquely positioned to play a major role in their schools' attempts to restructure in the face of an ever-changing global marketplace."¹²

With computers, students of all ages can create visual images, download works from the world of art, access information about these artworks, engage in critical analysis and discussions, and compare and contrast the aesthetics of a wide variety of cultures. On the web, students can visit the Louvre and other great art museums of the world and view selected works from the collection in full color. Students can access websites of many contemporary artists, read about their ideas, and view their current work.

Working on the web can help students develop criticalthinking and problem-solving skills and do so at their own

TWELVE GOOD REASONS TO USE THE INTERNET IN THE ART CLASSROOM

Once your art classroom is connected to the Internet, you can do the following:

- 1. Network and share ideas with other art educators around the globe
- 2. Collaborate with other art teachers on student art exchanges and joint classroom projects
- 3. Participate in professional development courses and workshops offered over the Internet
- Download and incorporate online tools, images, and curricular resources in your lesson presentations
- 5. Promote your art program on a global scale by posting curriculum materials and student work on your school's website
- 6. Take your class on a virtual field trip to art museums or other public art sites around the world
- 7. Promote student research into art and visual culture using online tools and resources
- 8. Foster student dialogue and collaboration with their peers from other schools
- 9. Build connections to other subject areas in the school curriculum
- 10. Expose students to a variety of viewpoints and ways of visually representing the world
- 11. Allow students to learn online from artists and other art professionals
- 12. Empower students to use the Internet as a medium for personal expression, communication, and lifelong learning

Source: Craig Roland, *The Art Teacher's Guide to the Internet* (Worcester, MA: Davis Publications, 2005) p. 16.

pace. Computers offer interactive learning programs, some commercially produced, some created by art museums, and others available on the web. With basic computer graphics programs, even very young children can make their own art on the computer and print it out in color (see Chapter 10). As with any new and perhaps novel tool, however, teachers and students need to take care that real learning is the central activity rather than mere entertainment.

ORGANIZING FOR INSTRUCTION

Most of the time during the art program the children will engage in the process of making art. Teachers can increase the amount of time available for productive activities by organizing tools and materials for efficient use. Effective teachers devise ways to organize and store art tools, such as brushes, water containers, and clay tools. They label and color-code drawers and cupboards so everyone knows where things go and where things are. Children are taught to assist with the distribution of art tools and materials, with cleanup, and with the collection and careful storage of students' artwork. Children often enjoy helping and can become very efficient in performing these tasks. (Organization of a room for art instruction is discussed in Chapter 19.)

Selecting Art Materials and Tools

Different types of media suit various stages of physical development of the pupils. At certain stages, for example, children have difficulty using soft chalk and require instead a harder substance, such as oil-based cravons. Too hard a medium, however, makes it difficult for children to cover paper readily and will interfere with their expression. Very young children, who have not learned to use their smaller muscles with dexterity, may require large surfaces for painting or assembling large objects. Yet children of all ages periodically have a desire to render detail, and occasionally pencils should be permitted for small-scale work, in which case the lead should be soft and the paper not too large. As children mature and gain greater muscular control, they can work with smaller surfaces and objects. Others, however, may wish to work on a large scale no matter what stage of muscular development they have reached.

Children will show marked preferences for a particular medium. One child may find greater satisfaction in using clay than in using cardboard; another may prefer watercolor to tempera paint. Unless these children are given reasonable, although, of course, not exclusive, opportunities to employ the media of their choice, their lack of enthusiasm may be reflected in their work.

Children may also have preferences in tools. A certain size and type of brush may suit one child but not another, and a fine pen point may appeal to some. Teachers should

This second-grade girl has just enjoyed the opportunity to work large as she made her drawing on an easel.

be sensitive to the relationship between tools and paper size, bearing in mind that small tools (pencils and crayons) inhibit design on paper larger than $12'' \times$ by 8" and that large brushes limit detail and observation on smaller sizes of paper.

The teacher who makes an effort to provide a variety of materials and tools is following an accepted practice in art. Nearly every artist develops preferences among the many media and tools available, but this does not prevent exploration of further choices of favorite materials or testing of new materials. If the budget is limited, the teacher will have to expand content rather than variety of media. The many approaches to drawing, for example, can keep a class going for a semester. Limited supplies can sometimes be an advantage because it forces the teacher to think in depth rather than breadth.

Teacher Taik

One of the most important factors in instruction is student– teacher dialogue or, to put it simply, "teacher talk." Attending any exhibition of children's work, we are struck by either shared characteristics or the lack of common attributes within groups of children's artworks from different teachers. These group differences are caused not only by materials and subject matter (one teacher prefers clay to other materials, whereas another may stress observational drawing) but also by the kind of language each teacher uses. Although teachers communicate much to their students through the way they dress, their attitudes, and their personalities (little is missed by even the youngest child), their language probably has the most direct influence on how the work of their students develops.

The quality and level of student discussion can be shaped by the art vocabulary the teacher has been able to develop with each lesson. Every new experience should include new words derived from both studio and critical experiences. Based on classroom observations, the following conversations are typical of teachers who attempted to tread a fine line between direct and indirect teaching.

SIX LEVELS OF ART TALK

FIRST GRADE: FLOWER PROBLEM IN TEMPERA

TEACHER: I like your shapes; they move all over in so many ways. Tell me about this—it isn't a flower, is it?

STUDENT: It's a bug—yes, a bug.

- **TEACHER**: Does it have a name?
- **STUDENT:** A grasshopper.
- **TEACHER:** Grasshoppers are long and skinny, aren't they? How about a different-shaped bug? Can you think of one?
- **STUDENT**: I can paint a snake—

TEACHER: Well, a snake isn't a bug, but a snake is very nice.

SECOND GRADE: "MY PET," DRAWING IN FELT-TIP PEN

TEACHER: That's a good rabbit, but he looks awfully small. **STUDENT:** It's a girl rabbit.

TEACHER: Yes, well, it looks kind of lonely by itself. What can we add to keep it company—you know, to make the picture bigger?

STUDENT: It has a cage.

TEACHER: Cages are good; where do you keep your cage? **STUDENT:** Outside, on the porch.

TEACHER: Well, if it's outside, there are other things to draw, aren't there? You put them in, and let me see if I can tell you what they are.

THIRD GRADE: CLAY ANIMAL

STUDENT: It doesn't look like a dog; it's all lumpy.

- **TEACHER**: I think you are going to have to decide what kind of a dog—
- **STUDENT:** A German shepherd. I like German shepherds. My uncle has one.
- **TEACHER**: What makes a German shepherd different from, say, a beagle?

STUDENT: The ears stick up.

TEACHER: Okay. Then let's begin there. Pull its ears up, and I think you can smooth out some of those lumps.

FOURTH GRADE: BOX SCULPTURE

- **TEACHER:** Having trouble, Chuck? You don't seem very happy.
- **STUDENT**: I hate it; it's not turning out.

TEACHER: What seems to be wrong?

- **STUDENT**: I don't know; it's a mess. Nothing seems to go together; I wanted this neat truck—
- **TEACHER**: Well, I think you've been a little careless in joining the sections together (demonstrates joining process with tape). See what I mean?

STUDENT: Yeah, I don't know. It still won't look like a truck.

TEACHER: Look, Chuck, try to think ahead. You have a cereal box and a medicine carton, and they both have pieces of letters and different colors showing. Why don't you join it, then paint it; I think you'll like it better.

FIFTH GRADE: LINOLEUM PRINT

STUDENT: It won't work.

TEACHER: What won't work?

STUDENT: The tool; it keeps sliding and slipping.

TEACHER: Let me try. No, the blade's okay. Here, try standing and let your weight press the blade, and, for goodness' sake, keep your left hand out of the way of the blade, or your mother will be calling me tonight about an accident, okay?

STUDENT: Okay.

TEACHER: Say, I haven't checked your drawing. Can I see it before you continue?

SIXTH GRADE: LANDSCAPE PAINTING

TEACHER: Very nice, John, very nice. **STUDENT:** It all looks the same.

TEACHER: What do you mean?

STUDENT: Well, there was more color—

TEACHER: You mean more kinds of green in the trees—? **STUDENT:** Yeah, that's right.

TEACHER: Look, you keep using the same color green. Come on; you know how to change a color.

STUDENT: It will be messier.

TEACHER: You've got your palette set up; try out some mixtures, add yellow, try a touch of black—

STUDENT: Black?

TEACHER: Why not? Try it; it won't bite you. You can always paint over it.

Each teacher in these dialogues had to be sensitive to the range of vocabulary, the nature of the assistance needed, and the tone of address. The role of language is complex and plays a vital part in art education. The best way to learn how to use language more effectively is to observe good teachers in action, either in an art or general classroom situation. It should be borne in mind that the highest form of instruction occurs when teaching becomes a series of conversations about art.

TEACHING IN ACTION: PLANNING FOR THE FIRST SESSION

All teachers must plan for the first meeting with their pupils. The taped dialogues transcribed here represent two approaches to this first meeting. The first conversation depicts a teacher's attempt to deal with a basic question of aesthetics: a grass-roots definition of art from disadvantaged children in the third grade. The second transcript demonstrates how a first planning session with middle-class children might appear.

FIRST DIALOGUE

TEACHER: Do any of you know who I am? (*pause*) **TOMMY**: You an art teacher?

TEACHER: That's right. I am your art teacher. Now, can anyone tell me what an artist does?

SARAH: He paints you pictures.

TEACHER: Very good. What other kinds of artists are there? (*longer pause*)

FLORENCE: Are you going to let us draw pictures?

TEACHER: Certainly, we'll draw pictures, but we'll do things that other kinds of artists do, too. Can you think of

other things we can do that other artists do? (*pause*) Well, think of going shopping with your mother. Can you think of the work of artists in a shopping center?

TOMMY: (*suddenly*) I know! He can paint you a sign.

- **TEACHER**: (*enthusiastically*) Yes, yes, sign painters are artists, too—what else?
- **TOMMY:** (*picking up the enthusiasm*) And if you had a butcher shop and you had a good—I mean a *good* artist, $h \in could$ paint you a pork chop on the window.

The above conversation is a fragment of a discussion held during the first meeting with a group of third graders in an inner-city school. The purposes of the teacher's discussion were to (1) learn the children's concept of art. (2) establish the kind of rapport that comes only through a relaxed exchange of ideas, and (3) prepare the children for the program she had planned for the year. As a result of her discussion, the teacher was wise enough to set aside quite a few activities she had planned, because she realized they were inappropriate for the children. A skilled and experienced teacher would be sensitive to the range of differences among children and would understand that they all come to the art class with their own ideas of what constitutes an artist. To scme, art represents part of social studies; to others, it means carrying out school services. For one child it is the high point of the week, and to another it is a traumatic period during which the student is constantly cautioned against making a mess.

SECOND DIALOGUE

Let us examine a planning session taking place at a meeting of the author and some pupils. These pupils are fifth graders in a middle-class neighborhood. A content analysis of the pupils' comments is provided in the margin.

MR. H: Good morning. My name is Mr. H. I'm an art teacher as well as your art supervisor, and I'd like to talk with you about some of the things you're going to be doing this year with Ms. G, your regular art teacher.

SUSAN: You mean you're not going to be our art teacher?

- MR. H: No, but I hope I'll be coming in now and then to see what Ms. G is doing, and perhaps later on I'll take a few classes myself.
- MARK: What are we going to do today?
- MR. H: Well, as I said earlier, I'd like to take this time to talk about what you'd like to do this year.

susan: Will Mr. S be back?

Analysis of Pupil Comments in Second Dialogue

This remark may be interpreted as a sign of disappointment that Mr. H will not be their regular teacher.

Mark is ready to go to work. In his eyes the art period (there are so few of them) is not a place to talk but to make things.

"Mr. S" was a participant in the Creative Arts Council's program designed to bring performing artists of all kinds into the schools. The children's interest in observing professionals at work thus opens the door for potters, printmakers, painters, and the like to step into the art curriculum.

Marcia's mention of the raccoon allows the teacher to emphasize as much drawing from observation as he feels is appropriate. Should he decide to have the children do contour-line drawings from a posed figure or brush drawings of animals or use any of these as a basis for subject matter or for making a point, he has Marcia's suggestion to which he may refer.

Paul and Barbara's suggestion has given the (continued on p. 312) (continued from p. 311) teacher the opportunity to plan additional field trips—or a first lesson in art appreciation based on the Dutch school.

In setting up categories, the teacher hopes to get the children to begin making distinctions within the arts.

This is a technique that will be developed further in the informational part of the art program.

The teacher does not skirt David's dislike of painting. By acknowledging it publicly, he hopes to create a threat-free environment in which differences of opinion are discussed openly.

The discussion of the function of clay results in adding sculpture to the list of activities.

Now that the teacher has rapport with the class, he can contribute his own ideas. Others that eventually followed were activities in architecture (redesigning the school playground) and design ("making a picture"). Sculpture was also broken down into several media, and printmaking was added.

- MR. H: I don't know. Who is Mr. S? (great commotion) One at a time—could we please use our hands? Deirdre? (*The children had prepared name tags.*)
- **DEIRDRE:** Mr. S illustrated books, and he showed us how he did his pictures.
- **OTHERS**: Yeah—he was cool. Boy, could he draw!
- MR. H: (going to the chalkboard) Well, we have our first request. You'd like to meet a real artist (writes this on board). Anything else?
- MARCIA: The raccoon—the raccoon?
- MR. H: The raccoon?
- **OTHERS:** Yes—Ms. G brought in this raccoon. We petted him. It climbed up the bookcase.
- MR. H: All right—let me see—how shall I put it? How about "Drawing from Live Subjects"—that way we can use live fifth graders as well as other kinds of animals. (*laughter*) Very good. I think drawing from nature is
 - a great idea—it would be even better if we could get a baby elephant in here—(*laughter—other animals are suggested that are equally unrealistic*)—all right, now, keep going—ves, Barbara?

BARBARA: I liked the field trip to the Museum of Fine Arts. **MR.H**: Oh, what did you see?

- BARBARA: It was Rembrandt.
- **PAUL**: No it wasn't (others join in quick argument).

MR. H: Does anyone remember the exact title of the show? PAUL: I know! "The Age of Rembrandt"; that's what it was. MR. H: Okay. Let's put in "Field Trips." I'll write it under

"Visiting Artists" rather than "Drawing." What else? **SUSAN**: Are we going to paint?

MR. H: Certainly—what's an art class without painting? DAVID: I don't like to paint.

MR. H: Why not?

DAVID: I don't know. I like making jewelry.

- MR. H: Well—we can't like everything, can we? You must feel about painting the way I feel about lettering. Let me put down "Crafts," David. That'll hold the door open to other materials. Who'd like to name some?
- POLLY: Clay.
- PAUL: Clay is sculpture.
- **POLLY**: Bowls are clay and . . .

PAUL: Clay is more sculpture.

- MR. H: Actually, clay can be either. Say—I've got one for you. How about movies? We can make a movie.
- **OTHERS**: Movies? How?

PAUL: I took pictures with my father's camera.

MR. H: Well, I had in mind another kind, something we

could all do together. We can scratch designs right on the raw film, put all the pieces together, and put it to music. How does that sound?

The important thing to note in the second dialogue is that the teacher knew in advance what the rough content of the year's work would be. In communicating with the pupils, he could have tried these approaches:

- 1. He could have doled out the projects on a piecemeal basis as the year progressed, without attempting to communicate the overall structure. This would be an *improvised*, teacher-directed approach.
- 2. He could have described the entire year's activities to the class, providing a *planned*, directed program.

Instead, the teacher chose a third approach:

3. He involved the class in the planning. In so doing, many of the teacher's own ideas were made to seem to originate in the class. By engaging the students' participation, he ensured a climate of acceptance for new ideas that normally might not be well received.

Analyzing the Teacher: Five Phases of Instruction

Teaching art is far more complex than many new teachers realize. The following list is composed of significant factors that could bear on the conduct of a teacher. It is an evaluation instrument with which teachers can get a "profile" of their own style. Note that this form is not judgmental; it merely asks whether any of the factors listed were present, not present, or present in some exemplary way. Description of any one item could be elaborated if desired. The lesson is divided into five segments: preparation, presentation, the class in action, evaluation, and teaching style. Obviously, no one lesson could possibly encompass all the items listed. The list also provides some indication of the possible variables that occur in teaching.

PREPARATION FOR INSTRUCTION AND CLASSROOM MANAGEMENT

- 1. Display areas:
 - a. Display pupils' work
 - b. Relate materials to the art curriculum
 - c. Relate materials to current events in art, school, community
 - d. Show design awareness in the arrangement of pupils' work

- 2. Supplies and materials:
 - a. Organized so the room is orderly and functional
 - b. Organized so the room is orderly but inhibiting
 - c. Organized so the room is disorderly but functional
 - d. Organized so the room is disorderly and nonfunctional
 - e. Distributed systematically
- 3. Resource materials (aids, art books, art magazines, file materials, live art, videos, and other audiovisual support):
 - a. Provided by school system and school
 - b. Not provided by school system and school
 - c. Derived from teacher's reference file
 - d. Not provided by teacher
- 4. Nonobservable data:
 - a. (Pupils' work) Kept in portfolio for reference
 - b. (Reference file) Made available for student use

PRESENTATION OF LESSON

- 1. Objectives clearly stated
- 2. Objectives arrived at through dialogue
- 3. Discussion related to topic or objective
- 4. Discussion related to levels within group
- 5. Interaction between pupils and teacher:
 - a. Teacher interrupts pupils
 - b. Teacher welcomes disagreement
- 6. Demonstrations oriented toward multiple solutions
- 7. Demonstrations convergent on single solution
- 8. Class is flexible:
 - a. Chairs reorganized for viewing demonstrations
 - b. Children able to come to teacher freely for additional material
 - c. Several projects in operation at same time
 - d. Children able to move freely from project to project

THE CLASS IN ACTION

- 1. Teacher:
 - a. Listens to pupils when asking questions
 - b. Asks open questions
 - c. Asks closed questions
 - d. Praises work of pupils in general terms
 - e. Praises work in specific terms relevant to the problem
 - f. Uses other forms of verbal reinforcement
 - g. Is able to reach pupils who request consultation
 - h. Talks at length to some pupils

- i. Relates comments not only to objectives but to pupils' frame of reference
- j. Motivates those who have become discouraged
- k. Remotivates those with short attention span
- 1. Is flexible in permitting deviation from assignments
- m. Uses art vocabulary
- n. Is competent in handling discipline problems
- 2. Pupils:
 - a. Are self-directive in organizing for work
 - b. Are self-directive in organizing for cleanup
 - c. Use art vocabulary

EVALUATION PERIOD (FOR FINAL GROUP EVALUATION)

- 1. Evaluation relates to goals of lesson
- 2. Pupils encouraged to participate
- 3. Pupils do participate as a group
- 4. Only one work evaluated
- 5. Several works evaluated
- 6. Range of evaluation devices used
- 7. No final evaluation given
- 8. Pupils not embarrassed or threatened by public evaluation

This teacher is well organized and is engaged in instructional activities with students. Note visual displays in the classroom, storage facilities, and materials in use by students.

TEACHING STYLE (PERSONALITY)

- 1. Teacher takes positive attitude toward instruction
- 2. Teacher shows rapport with pupils' age group
- 3. Teacher demonstrates sense of humor
- 4. Teacher has sense of pace: controls flow of lesson
- 5. Teacher is innovative in following respects: a. c.
- 1. See the NAEA's brochure *Quality Art Education* (Reston, VA: National Art Education Association, 1984).

d.

- National Center for Education Statistics, Arts Education in Public Elementary and Secondary Schools: 1999– 2000, NCES 2002-131 (Washington, DC: U.S. Department of Education, 2002), p. 20.
- 3. Ibid., p. 18.

Ъ.

- 4. For examples of classroom dialogue, see the seven case studies of art programs in Michael Day, Elliot Eisner, Robert Stake, Brent Wilson, and Marjorie Wilson, *Art History, Art Criticism, and Art Production*, vol. 2 (Los Angeles: Rand Corporation, 1984).
- Frank Susi, "Behavior Management in the Classroom," in *Instructional Methods for the Artroom: Reprints from NAEA Advisories*, ed. Andra Nyman (Reston, VA: National Art Education Association, 1996).
- 6. See, for example, art learning games in the CRIZMAC catalog (Tucson, AZ: CRIZMAC Publications, 2005).

6. Teacher is aware of language (vivid phrasing, imagistic speech, clarity of expression)

If a teacher wishes to have an objective profile of her or his performance, an administrator could be requested to use the instrument during an observation period. This may hold some surprises for the teacher, as well as educate the administrator regarding what is involved in conducting an art program.

NOTES

- 7. See, for example, Jean Sousa, *Telling Stories in Art Images* (Chicago: The Art Institute of Chicago, 1997).
- 8. See a teacher accomplished in dramatization, Art Education in Action, Aesthetics, Episode A: "The Aesthetic Experience," Richard Harsh, art teacher, videotape (Los Angeles: Getty Center for Education in the Arts, 1995).
- 9. Art Education in Action, Aesthetics, Episode B: "Teaching across the Curriculum," Evelyn Sonnichsen, art teacher, videotape (Los Angeles: Getty Center for Education in the Arts, 1995).
- 10. Al Hurwitz, Collaboration in Art Education (Reston, VA: National Art Education Association, 1993), p. 12.
- 11. Craig Roland, The Art Teacher's Guide to the Internet (Worcester, MA: Davis Publications, 2005), p. 41.
- 12. Phillip Dunn, "More Power: Integrated Interactive Technology and Art Education," *Art Education* 49, no. 6 (November 1996): 6–11.

ACTIVITIES FOR THE READER

- 1. Describe any situation you have experienced in which children disliked art. Explain how the dislike arose, and indicate the means you might use to alter the children's attitude.
- 2. Describe the traits of a personal acquaintance whom you consider to be an effective teacher of art.
- 3. Observe some art lessons given by expert teachers, and note especially (a) the motivational devices employed, (b) the manner in which themes are defined, (c) the way in which goals are established, and (d) the problems that arise and the means by which a solution to them is found. Can you add any items to the analysis instrument at the end of this chapter?
- 4. Describe how you would motivate a class for a lesson

in increased sensitivity to color, based on fall colors in nature.

- 5. Take a close look at your personality, and try to project your teaching "style" from it. Apply your style to a specific teaching situation—demonstration, evaluation, or selection of topic. In what ways does your style suggest limitations?
- 6. Describe the steps you might take to improve the following situations: (a) a third-grade art class whose members are outrageously untidy and wasteful of materials, (b) a group of sixth-grade boys who think art is "sissy," and (c) a group of children whose parents or older brothers and sisters have given them formulas for the drawing of objects.

- 7. Observe an art teacher in action, and document the methods used by the teacher. How many methods mentioned in this chapter did you observe? Was the teaching effective? Did you observe ways that instruction might be improved through the use of a wider variety of teaching methods?
- 8. Select two of the teaching methods listed in this chapter. Develop lessons that utilize each of these, and try them out in a classroom situation with students. Repeat this process with one or two more methods until you have developed a repertoire of teaching methods on which you can rely as situations arise in your teaching position.

SUGGESTED READINGS

- Ayers, William, ed. *To Become a Teacher: Making a Difference in Children's Lives.* New York: Teachers College Press, 1995.
- Barrett, Terry. *Talking about Student Art.* Art Education in Practice Series. Worcester, MA: Davis Publications, 1997.
- Bates, Jane K. *Becoming an Art Teacher*. New York: Wadsworth Publishing, 2000.
- Beetlestone, Florence. Creative Children, Imaginative Teaching. New York: Open University Press/McGraw-Hill, 1998.
- Crockett, Tom. The Portfolio Journey: A Creative Guide to Keeping Student Managed Portfolios in the Classroom. Westport, CT: Libraries Unlimited, 1998.
- Delacruz, Elizabeth Manley. Design for Inquiry: Instructional Theory, Research, and Practice in Art Education. Reston, VA: National Art Education Association, 1997.
- Dobbs, Stephen M. Learning in and through Art: A Guide to Discipline-Based Art Education. Los Angeles: Getty Education Institute for the Arts, 1998.

- Eisner, Elliot. *The Arts and the Creation of Mind*. New Haven, CT: Yale University Press, 2004.
- Fisher, Robert, and Mary Williams, eds. Unlocking Creativity⁻ Teaching across the Curriculum. London: David Fulton Publishers, 2005.
- Gollnick, Donna, and Phillip C. Chinn. *Multicultural Education in a Pluralistic Society*. New York: Prentice-Hall, 2001.
- Greh, Deborah. *New Technologies in the Artroom* (CD-ROM included). Worcester, MA: Davis Publications, 2003.
- Henry, Carole, and National Art Education Association. Middle School Art: Issues of Curriculum and Instruction. Reston, VA: National Art Education Association, 1996.
- Nyman, Andra L., ed. Instructional Methods for the Artroom: Reprints from NAEA Advisories. Reston, VA: National Art Education Association, 1996.
- Roland, Craig. *The Art Teacher's Guide to the Internet*. Worcester, MA: Davis Publications, 2005.
- Walker, Sydney. *Teaching Meaning in Artmaking*. Worcester, MA: Davis Publications, 2001.

WEB RESOURCES

- *Arts & Activities* magazine: http://www.artsandactivities .com/. Provides an archive of former issues and some online activities.
- the @rt room: http://www.arts.ufl.edu/art/rt_room/ index.html. Developed by Dr. Craig Roland, a professor of art education, this site is full of resources for classroom teachers.
- Crayola.com: http://www.crayola.com/. Created by Binney & Smith, the site features ideas and lessons plans for teaching art.
- CRIZMAC Art & Cultural Education Materials: http:// www.crizmac.com/. This company, created by an art teacher, provides great materials for teaching multicultural art. CRIZMAC has developed art curricula and CD-ROMs as well as other resources.
- Davis Publications: http://www.davisart.com/. Davis publishes *SchoolArts* magazine and other great resources for elementary teachers, including curricula, textbocks, and art images in many forms. The *School-Arts* page includes online free lessons. Scroll down to find excellent art education links.
- National Art Education Association: http://www.naea -reston.org/. Provides extensive resources, training, and tools designed to support teaching and learning in art.
- Scholastic, *The Scholastic Art and Writing Awards:* http:// www.scholastic.com/artandwritingawards/. Many online resources for teachers. Navigate the site, and discover lesson plans and student activities.

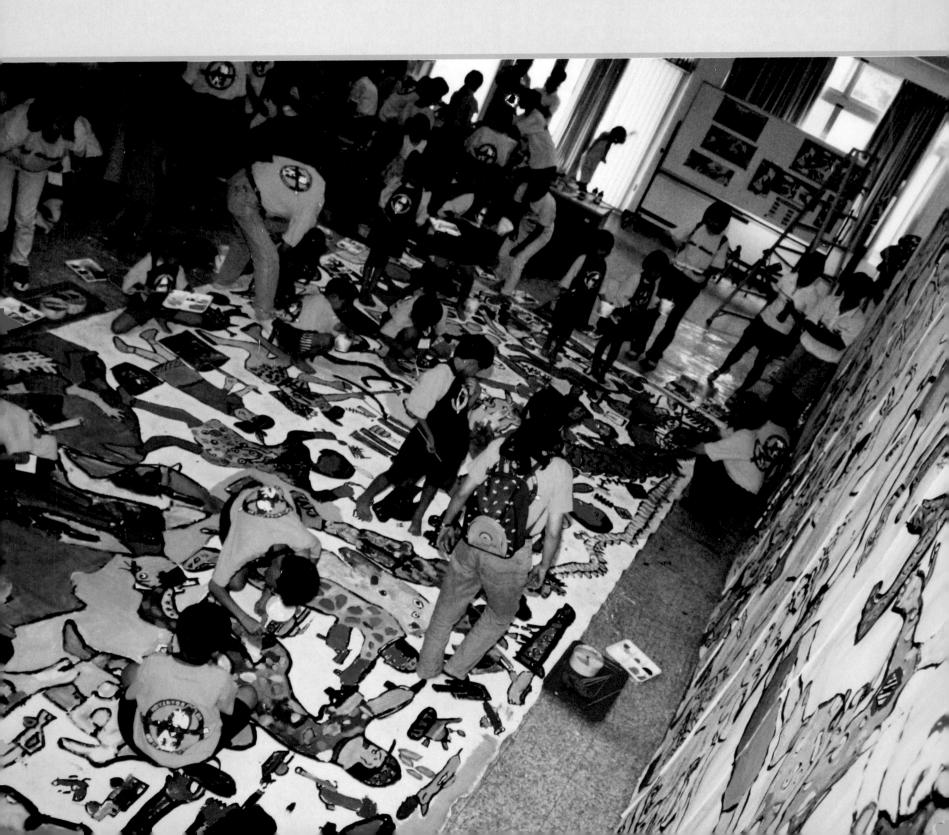

THE SOCIAL DIMENSION

Collaborative Art Activities and Instructional Games

Children's artistic development is enhanced within a supportive community of peers and knowledgeable, caring adults. Art is a form of speaking; sincere and crafted speaking. For that you need community; someone with something to say, someone willing to listen. Shared art is art's purpose fulfilled.

—Peter London

SOCIAL VALUES IN ART EDUCATION

Many art educators today advocate a teaching philosophy that encourages students to think about relationships of art, ecology, and community.¹ They emphasize a curriculum that is interdisciplinary, action oriented,

and based on social values. Teaching is aimed at fostering awareness of interconnections between community and environment and focuses on concepts of environmental design, ecological art, and involvement with community.² Community and ecological issues "can empower students with the understanding that they, as creative individuals, can have an active voice in protecting their environment and changing current devastating ecological trends."³ Cooperative learning and collaborative activities can play a central role in such a curriculum.

In this chapter we discuss the expanded role that art education can play in helping children understand social processes as they increase their comprehension of art. We shall describe some art activities that are especially suitable for the development of children's social insights and discuss concepts of art that have emerged in recent years, as well as more traditional forms, such as puppetry and mural making. We will also provide examples of children learning about art through participation in a variety of educational games.

Students engaged in a group critique of bronze sculpture at the Ringling Museum, Sarasota, Florida.

THE ROLE OF THE TEACHER IN COLLABORATIVE ACTIVITIES

Group art can be likened to an amoeba; although outward forms are in a constant state of flux, the essence remains constant. One difficulty in categorizing group activities lies in the ways in which styles borrow from each other. There is really only one condition which must be shared; namely, that two or more participants be brought together to create an object or event which, in some way, exists beyond the effort of a single person.⁴

While realizing the desirability of including group activities in an art program, the teacher may have certain questions concerning the mechanics of this technique. How does group activity work? How should the activity be chosen? What should be its scope? What is the role of the teacher?

Group activities, like those of an individual, must begin with some end in mind. This sense of purpose supplies the drive necessary to complete the project. Moreover, it is the children who should share a role in the "purposing." The teacher, of course, may make suggestions, but before these suggestions can be effected, the children must accept them wholeheartedly. Both the "planning" and the "executing," which are outcomes of the purposing, must also be controlled by members of the working group. Finally, the children themselves must ask the general and the specific questions concerning the outcome of the activity: Did they do what they planned? What was learned in the doing? What mistakes were made? How could the activity be done better next time? Children, in other words, should also be involved in evaluating the experience.

In the collective life of the school or classroom, occasions requiring group effort in art invariably arise. "Let's have a play," the children say. "Let's run a puppet show. . . . Let's make a big picture to go in the hallway." Very little suggestion need come from the teacher to set in motion a desirable group project. The children themselves are often the first to suggest to a teacher that a group activity be considered.

It is in this area that the classroom teacher has an advantage over the art teacher, who may see a class for only 50 minutes a week. Children quickly learn that some activities are inappropriate for the typical art schedule and do not even suggest time-consuming group activities. If art teachers are skillful, however, they can sustain interest from one week to the next so a class is able to paint a wall, build a miniature city, or convert a section of the art room into an art environment or installation. There will always be some children who want to continue working on such a project after school, and release time may even be possible for others to come to the art room as a large project nears completion.

Before encouraging children to proceed with a group project, the teacher must judge not only whether it is sufficiently challenging to occupy the attention of several people but also whether it may be too large for successful completion by a group. In their enthusiasm for art, children are sometimes willing to plunge into a task they could never complete. Once fired with the idea of a mural, for example, a group of fifth graders might cheerfully embark on the enormous task of designing murals for all four walls of a school gymnasium. A group activity in art that comes to a halt because the children have lost interest or lack competence to complete it reflects not only on the group techniques but also on the teacher's judgment. When failure looms, the teacher must help the pupils alter their plans so they can achieve success.

Having a greater maturity and insight into group processes, the teacher must fill the role of counselor with tact, sympathy, and skill. As soon as the need for group work in art is apparent, the teacher must urge the children to elect leaders and establish committees necessary for planning and executing to take place. The teacher should see that as far as is practical, the children control these steps. Although teachers have the power of veto, they should be reluctant to use it. If at times the children's decisions seem to be wrong, the teacher should nevertheless allow them to proceed, unless, of course, their chosen course of action would only lead to overwhelmingly disastrous results. It is part of the learning process for people to make mistakes and, profiting from them, subsequently to rectify them.

Because group procedures depend for success largely on the maximum contribution of each participant, the teacher must see that every child in the group is given an opportunity to make a suitable contribution to the project. A good group project should include a wide enough range of tasks to elicit participation from every member of the class.

GROUP ACTIVITIES: SIMPLER FORMS

Media and Techniques

A group activity for primary grades may be based on any theme that interests the pupils and may make use of any medium and technique the children are capable of handling. If a kindergarten class happens to be talking about the subject of spring, for example, each child who has reached the symbol-making stage may select one item of the season to illustrate. The children may draw and paint symbols of flowers, birds, trees, and other springlike objects. After drawing cr painting each item, the children cut away the

Public mural pair ting is a popular activity in Mexico, where group activities are often part of neighborhood festivals. This popularity is due in part to the legacy of the great Mexican muralists of the twentieth century— Diago Rivera, José Clemente Orozco, and David Alfaro Siqueiros—who became world leaders in the art of mural painting.

unused paper around the symbol and then assemble the drawings and paintings.

Many other suitable topics could be treated in a similar fashion, for example:

- 1. *Shopping:* Various stores may be drawn and painted, together with people and automobiles. This subject also could be handled as an interior scene showing the articles on display in a supermarket.
- 2. *Where I Live:* Pictures of houses are eventually assembled to form a street or neighborhood.
- 3. *My Friends:* The outlines of boys and girls are assembled to form a crowd of children.
- 4. *Spring in the Garden:* Forms associated with gardens, such as bugs, butterflies, flowers, and trees, are gathered.
- 5. *Above and Below:* Sky shapes (clouds and birds), trees and flowers, and imaginative treatment of what lies below the earth's surface, such as root systems and animal homes, are included.
- 6. *A Story Everyone Loves:* Solicit participation to create a story by the group, and then work in teams to illustrate the story.

Diagrams of stick puppets (A and B), a puppet made from a paper bag (C), and a puppet made from an old stocking (D).

Three-dimensional output also lends itself to group activity for early grades. For example, the children can assemble modeling clay and paper constructions on a table to depict such scenes as "The Farm," with barns, cows, and so forth; and "The Circus," with clowns, elephants, and the like.

One of the simplest and most effective group projects is the "chalk-in," which can be executed on a sidewalk or parking lot. This can be done randomly or with sections marked off in a grid, with parts of each section touching adjacent ones at some point.

Teaching

A "group" may be defined as a team ranging from three students to a complete class, depending on the nature of the project. Small groups work very well on dioramas, middlesized groups can work in the sandbox, and larger groups can take on constructions like model shopping centers and housing communities. Other projects could include decorative maps or a mural that transforms the entire classroom into a medieval environment, complete with mullioned windows and stone walls.

PUPPETRY

Although puppetry is generally not taken seriously as an art form in the United States and Canada, it occupies a very high position in many other cultures. In Moscow, the national puppet theater is intended for adults rather than children; and in Spain and Italy, no public park is complete without an adult puppet theatre. In Indonesia, Japan, and other Asian cultures, puppeteers begin their careers in childhood as apprentices, learning not only the intricate processes of construction and operation but also the roles to be enacted, many of which date back many generations. These plays recount the myths of creation and the battles between good and evil carried on by warriors and figures of royalty. Puppetry has its own history and its unique function as an educational and socializing factor in both developing nations and European societies. Puppetry, from hand puppets to marionettes, has a legitimate place in a balanced art program. Perhaps some of the most effective group activities lie within this art form.

Because it is more complex than most art activities, puppetry is often seen as a threat to other priorities in the curriculum. It is therefore neglected in favor of art experiences that require less time and planning and fewer materials. However, properly conducted, puppetry can carry the children into language arts and history as they gather information, prepare scenarios, and plan and construct a theatre and sets. Work in puppetry is a natural focal point for accommodating various learning styles.

To produce a successful puppet play, the group as a whole must reach decisions, and each member of the group, although maintaining a personal identity, must give full cooperation if the enterprise is to succeed. Puppets range in technical complexity from the very simple to the very intricate, so groups of children at any particular stage of development may select techniques compatible with their capabilities. Marionettes are unrealistic because of the complexity of the joints.

MEDIA AND TECHNIQUES

Simple stick puppets—the type operated directly with one hand—may be produced in a variety of ways. The beginner can draw a figure on cardboard and later cut away the excess background. The cut-out figure is then attached to a stick. The pupil may use, in place of a cut-out figure, a bag stuffed with paper or absorbent cotton, decorated with paint or cut paper, and tied to the stick.

A paper bag may also be used for a puppet that moves its head. The children tie a string around the middle of a paper bag, leaving just enough room for inserting the index finger above the middle. They then paint a face on the closed upper portion of the bag. To operate the puppet, the child thrusts his or her hand into the bag up to the neck and pushes the index finger through the neck to articulate the head.

An old stocking, appropriately decorated with buttons for eyes and pieces of cloth or paper for hair, ears, and other features, also makes an effective puppet when slipped over the hand and arm. Animals such as snakes or dragons may be formed by this means. They become especially fearsome if a mouth is cut into the toe of a sock and cloth is stitched to form a lining to the throat thus formed. Both top and bottom jaws should be stuffed with a material like absorbent cotton. The children work the jaws by inserting the fingers in the upper section and the thumb in the lower. The students can enhance the attractiveness of this creation by making a lining of a color contrasting with the sock or by adding teeth or a tongue made from bright materials.

Students may construct a fist puppet from a wide variety of materials. Some of the modeling media mentioned in earlier chapters, including papier-mâché, are suitable for the construction of heads; plastic wood may also be used. The students may make the bodies of the puppets from remnants of most textiles. These more advanced fist puppets should be capable of articulation in both the head and arms. The thumb and little finger are usually employed to create movements in the arms, while the index finger moves a modeled head.

To model a head, children should first cut and glue together a stiff cylinder of cardboard (preferably light bristol board) large enough in diameter to fit their index finger loosely. The modeling medium, which tends to shrink the cylinder slightly, is then worked directly around the cardboard until the head, including all features, and the neck are formed. The neck of the puppet modeled over the lower part of the cylinder, or "fingerstall," should be increased slightly in diameter at its base to hold in place the clothes, which are attached by a drawstring. When the modeling medium is dry, the children should smooth it with sandpaper and then decorate it with poster paint. They can add an attractive sparkle to eyes, lips, or teeth by coating them with shellac or, better still, clear nail polish. In character dolls, attention can be drawn to outstanding features by the same means. Most puppets tend to be more appealing if the eyes are considerably enlarged and made conspicuous with a shiny coating. Students can paste or glue in place hair, eyebrows, and beards made from absorbent cotton, yarn, cut paper, or scraps of fur.

The clothing covers the child's hand and arm and forms the body of the puppet. The outside dimensions of the clothing are determined by the size of the child's hand. The hand should be laid flat on a desk, with the thumb, index, and little fingers extended. The approximate length of the puppet's arms will be indicated by the distance from the tip of the thumb to the tip of the little finger, and the neckline should come halfway up the index finger. To make clothing, fold a single piece of cloth in two, make a cut in the center of the fold for the neck, and then sew the sides, leaving openings for the fingers. Small mitts may be attached to the openings to cover the fingertips. If children wish their puppets to have interchangeable costumes, a drawstring can be used to tie the clothing to the neck. If

A puppet head modeled over a cardboard fingerstall. The puppet can be manipulated by placing the fingers as shown.

they plan on designing only one costume for their puppets, the pupils can glue it into place and tie it for extra security.

Lively puppet costumes can be made with bright textiles; men's old ties are valuable for this purpose. First, remove the lining of the ties and iron the material flat before being folding it over and sewing it to make a garment. Add buttons and other decorations as required.

When children make puppets, they expect to use them in a stage production. In presenting a fist-puppet show, the operators work beneath the set. This means that the stage must be elevated so the puppeteers can stand or crouch under it while the show goes on. A simple stage can be constructed from a large topless cardboard carton with two opposite sides removed and an opening for the stage cut in its base. The carton is then placed on a table with the opening facing the audience. The puppeteers stand or crouch behind the table and are concealed from the audience by the carton and a curtain around the table legs. Teachers can capitalize on the popularity of television's Muppets but should avoid using commercially manufactured hand puppets, because children may see these as competing with their own efforts.

The stage settings should be simple. In most cases they may be approached as large paintings, but they should have strong "carrying" power and be rich in a decorative sense. Students should design costumes and backdrops to provide a visual contrast with each other. Because the stage has no floor, the background is held or fixed in position from below or hung from a frame above. On it the children may pin significant items, such as windows and doors. They may prepare separate backdrops for each scene. Likewise, they must design stage properties—tables, chairs, and the like in two dimensions. Spotlights create striking effects and bring out the features of the presentation. Occasionally, it may be worthwhile to experiment with projected materials like slides.

The manipulation of fist puppets is not difficult; the pupils can teach themselves the technique merely by practice. They should remember, however, that when more than one puppet is onstage, the puppet that is "speaking" should be in continual movement so the audience will know exactly which puppet is the speaker. The other puppets should be still.

Children have been raised in a video and television environment in which the Muppets and other puppet characters on TV are an important part of their culture. Puppetry activities allow children to become producers and creators rather than passive consumers.

MURALS

Murals and Art History

The tradition of making murals, or very large paintings on walls, as art forms dates back to Egypt, Greece, and other early cultures. One might even claim that the prehistoric cave paintings are murals. During the Renaissance, murals in fresco were very popular, and two of the world's most famous works are murals in churches done during that period: Michelangelo's ceiling of the Sistine Chapel and Leonardo da Vinci's Last Supper. Marc Chagall painted magnificent murals on the ceiling of the Paris Opera House, and American artists such as Thomas Hart Benton painted murals for the federal government as part of an assistance program during the Great Depression. Diego Rivera is perhaps one of the most well-known mural artists; the great Mexican artist painted numerous murals, many of them on highly charged social and political themes, in the United States and Mexico. Hispanic American artists in contemporary communities such as Los Angeles have continued under Rivera's influence with striking public murals on building exteriors.

Although elementary-school children cannot use oil paints or fresco, they can gain familiarity with the terms used in discussing these media. They can also observe how mural materials have changed with advancements of technology: muralists now use such materials as welded metals, fired enamel plates, illuminated glass, ceramics, and concrete. David Siqueiros, for example, used automotive lacquers as well as other industrial materials in his murals. Muralists today are as likely to be sculptors as painters; children who are exposed to their work may want to participate in a relief mural rather than a painting for their class activity. Children involved in mural-making activities will benefit from learning about these great traditions, and teachers will note that children often demonstrate greater interest, have more ideas, and create better murals when they have been taught them.

The contemporary mural is also a vital means of multicultural expression in inner-city neighborhoods, building community and cultural identity, as well as conveying frustration with existing conditions. Walls are designed and

◀ Diego Rivera, Man, Con-323 troller of the Universe (1934). This fresco was originally painted as a commission for the lobby of the RCA Building in Rockefeller Center, New York. The patron, Nelson Rockefeller, approved of Rivera's theme for the painting, which contained a critique of intolerance and militarism on the left, contrasted on the right by a celebration of the possibilities of science and technology for a new and better future. However, Rockefeller insisted that Rivera remove the face of the Communist ideologue Lenin, portrayed as a positive leader for the future. When Rivera declined to do so, Rockefeller paid the full commission for the work and had the mural destroyed. Rivera re-created the painting in a government building in Mexico City.

◀ Thomas Hart Benton, City Activities, from the America Today mural series. Thomas Hart Benton was a famous American artist known for his murals of American life, some of which were created in public buildings for President Franklin Roosevelt's WPA projects during the Great Depression of the 1930s. Jackson Pollock worked for him on a number of murals and later acknowledged that he learned much from Benton, who provided strong ideas about art against which Pollock reacted.

executed by one artist, by teams of artists, or by nonprofessionals working under the direction of artists. For *The Great Wall of Los Angeles*, Chicana artist Judy Baca used more than 200 rival gang members from Latino and African American communities to create a 1,700-foot-long mural. In the artist's words, "Murals belong to no one, therefore to everyone."⁵ Funding for this impressive urban project came from a multitude of sources, including the National Endowment for the Arts, the juvenile justice system, and the Los Angeles Department of Recreation and Parks.

Mural Making

Although the term *mural* in its strictest sense refers to a painting made directly on a wall, in many schools it has come to denote any large picture. We have adopted that meaning for this discussion. Murals can be painted or constructed on exterior or interior walls, and we can find examples of both done by children in their schools and neighborhoods. For example, a school in an industrial part of

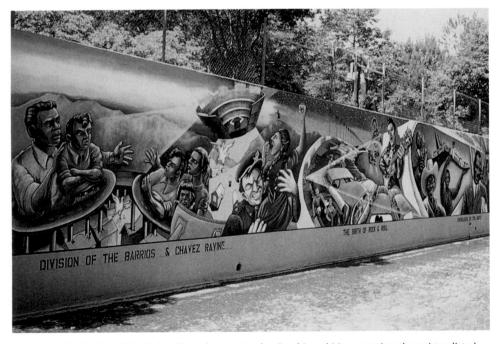

A section of Judith F. Baca's "mile-long" mural in Los Angeles. For this ambitious creation, the artist enlisted the aid of rival youth gangs and, in the process, established a system for assisting the participants in their school studies. Known as *The Great Wall of Los Angeles*, the mural is a visual record of the city's history and the personal and social concerns of its citizens. Baca is currently working on restoration of the mural.

town may be near an abandoned factory surrounded by concrete walls that are an eyesore for the community. With proper permissions, art classes could transform the ugly walls into objects of beauty and community pride.

MEDIA, TECHNIQUES, AND SUBJECT MATTER

When a school group decides to paint a mural inside the school, it should be considered as part of the scheme of interior decoration and integrated with it. The new work should echo the color relationships already established by the interior where the mural is placed. Furthermore, because door and window openings create a design in a room, the mural should be placed so it does not violate the architectural arrangement of these elements but tends to maintain the existing plan or even improve on it. The architectural limitations of classrooms are so consistently severe that most murals will probably be no larger than $4' \times 8'$. Composition-board backing, which can be purchased at lumberyards or building-supply stores, may be used as a light, portable background for direct painting or as a backing for mural paper.

Despite the technicalities involved in the successful production of a mural, most children find that the activity is generally within their capabilities and find the experience happy and rewarding. Children in the primary grades will have difficulty preplanning their work and will probably see mural making as an activity that allows them to paint spontaneously on any vertical surface.

The subject matter for murals may be similar to that used in individual picture making, or it may derive from a broader frame of reference, such as social studies or language arts. The most successful murals reflect the children's own experiences and interests. A subject such as the "Westward Expansion," though not a part of the child's personal background, can be worthwhile if attention is given to motivation by creating the environment of the early settlers with folk music, old prints, posters, and films. Ideas might come from observations of billboards, large signs, or other items of visual culture in the community. Whatever subject is chosen must be sufficiently broad in scope to allow several pupils to elaborate on it. A still-life composition, for example, would not be an appropriate subject for a mural.

The distinction between a painting with a limited focus of attention and a mural with multiple focuses must be made. A subject in which there are many objects of related but differing appearance, such as houses, factory buildings, or crowds of people, would be most suited to group activity. An example of a subject that offers a great variety of shapes is "At the Circus." Members of a third-grade class included both circus performers and spectators in their mural. The following are examples of themes that elementaryschool pupils have successfully developed:

FROM THE EXPERIENCE	FROM OTHER AREAS
OF THE CHILD	OF THE CURRICULUM
Our School Playground If I Lived in Baghdad Playing Outside in Winter Shopping The Seasons Change	The Next <i>Star Wars</i> The Rain Forest Books I Have Liked Our Town (Neighborhood Acting My Age in Ancient Greece

Most of the picture-making media can be used in mural production. The paper should be sufficiently heavy and tough to support the weight of the finished product. Kraft paper, the heavy brown wrapping paper that comes in large rolls, is suitable. Many school-supply houses offer a gray mural paper that is pleasant to use. When ordering paper. a 4-foot width is recommended. The most effective coloring medium for young children is tempera paint, applied with the same wide range of brushes suggested for picture making. Some especially wide brushes should be available for painting the large areas of the mural. In applying tempera paint, students should avoid excessive thickness, because the paint will flake off when the mural is rolled up for storage. Students may use chalk, but it tends to be dusty and to smudge badly when several children are working at one time. Colored cut paper also yields effective results from the first grade on; the cut paper can also be combined with paper collage. Wax crayons are not suitable because they require too much effort to cover large areas, but crayons may be used in some areas as a resist with thin tempera.

The technique of planning and executing the mural varies with the nature of the group. The kindergarten child may begin by working side by side with classmates on the same long strip of paper. Beginners all paint on the same topic suggested by the teacher and use the same medium, but each child actually creates an individual composition without much reference to the work of the others. Not until they reach the third or fourth grade are some children able to plan the mural cooperatively. When they develop this ability, they may begin by making sketches lightly in chalk on the area allotted for the mural. Considerable discussion and many alterations may occur before the design satisfies all the participants.

By the time they reach the fifth or sixth grade, many pupils are ready to plan a mural on a reduced scale before beginning the work itself. They prepare sketches on paper with dimensions proportionate to those of the mural. These sketches are made in outline and in color. Later, when the pupils have laid the mural paper over a large table or

Lily Ann Rosenberg is an artist who divides her time between studio and community. To create her ceramic murals, the artist has students generate ideas that are mounted as they work; then the students and leader organize the ideas into an overall composition. They convert these into flat forms such as tiles or slabs, then color, fire, and glaze them. The "ground" is prepared by fastening chicken wire to plywood, and the various sections are separated by "walls" of clay so that individual sections composed of tiles, sand, shells, and so on can be pressed into sections of wet, colored cement.

pinned it to tackboard, the final sketch is enlarged on the mural surface. Usually this is done freehand, but sometimes teachers suggest that the squaring method of enlargement be used. By this method, the sketch and the mural surface are divided into corresponding squares. A pupil redraws in the corresponding area of the mural what is in a specific area of the sketch. Such a procedure, though common practice with professional muralists, may easily inhibit children and should be used with caution. Only the most mature children are capable of benefiting from this technique.

After the drawing (or "cartoon," as it is sometimes called) has been satisfactorily transferred to the mural surface, pupils apply the colors. If tempera paint is to be used, it is usually mixed in advance in a relatively limited number of hues. Tints and shades are also mixed in advance. All colors should be prepared in sufficient quantity to complete all areas in the mural where they are to be used. In this way time and paint are saved, and the unity of the mural created in the sketch is preserved in the larger work. If colored chalk or cut paper is used, of course, the class is not likely to run out of a color. Acrylic paint is advisable for murals because it is waterproof; does not flake off if rolled up; and allows sand, paper, and other objects to be embedded in it while the paint is still wet. When pupils use cut paper, the technique for producing a mural is less formal than when paint or chalk is used. The pupils can move areas of the colored paper around on the mural to find the most satisfying effects. Thus, plans may undergo even major revision up to the final moment when the colored paper is stuck to the surface. Colored construction paper is recommended for the main body of the mural, because it gives the background areas added interest.

In carrying out the plan of a mural, the pupils quickly

Children from the class work on a panel of a large mural. The artist's visit provided stimulus for a four-lesson unit that was part of a larger unit on "Cultural Diversity and Identity." The lessons were also designed to fulfill four of the National Standards for the Visual Arts.

The art teacher has invited a visiting artist from Nigeria, who is seen here introducing herself, her country, and her art. A visiting artist from another culture can do three things: inform students about the way artists work; provide a valued addition to the study of another country for social studies; and add interest to the art program and a rich form of motivation for art activities.

discover that they must solve problems of design peculiar to murals. Because the length of a mural in relation to its height is usually much greater than in paintings, the technical problem arises of establishing satisfactory centers of interest. Although only one center of interest may be developed, it must not be so strong that the observer finds it necessary to ignore portions of the work at the extremities of the composition. On the other hand, if a series of centers of interest are placed along the full length of the composition, the observer may consider the result jumpy and spotty. In general, the composition should be dispersed. the pupils being particularly careful about connecting the rhythms they establish so no part of the mural is either neglected or unduly emphasized. The balances in a mural made by children, furthermore, have a tendency to get out of hand. Not infrequently children become intrigued with subject matter in one section of the work, with the result that they may give it too much attention and neglect other sections. Profuse detail may overload a favored part, while other areas are overlooked. The teacher can call attention to imbalances in the composition as the mural develops.

TEACHING

As with puppetry, it is not difficult to interest children in making murals. Showing a video, DVD, or CD with images of murals or going to see a mural in a public building are two ways to arouse their interest. Children are also motivated by seeing the murals other children have made. Perhaps the most effective method is to discuss with the class the needs and benefits of making murals as decorations for specified areas of the school, such as the classroom, the halls, the cafeteria, or the auditorium.

Although in puppetry enough work often needs to be done to permit every member of the class to participate in the endeavor, this is not so in mural making. The pupils may all discuss the making of murals, including the various media, the most suitable subjects, and the probable locations where the work might be placed, but eventually the pupils must divide into small groups, probably not to reunite until the final evaluation period. In the elementary school, the small groups may comprise from 3 to 10 pupils each, depending on the size of the mural.

Preadolescents should be able to organize their own mural making. First, all the pupils in a class interested in mural making assemble to discuss what the theme should be. After the pupils' suggestions for the main theme have been written on the chalkboard, each pupil selects some aspect to work on. Those interested in the same aspect form a team to work on that particular mural. If too many students elect one aspect, two teams can be created, each to work separately on the same subject. The teams are finally arranged, and each elects its chairperson.

Discussion then takes place within each team regarding the size and shape of its particular mural, the medium, and possible techniques. Sketches are then prepared, either cooperatively or individually. The teams can either choose the individual sketch most liked by all or prepare a composite picture, using the best ideas from the several sketches. They then draw the cartoon, usually with the chairperson supervising to see that the chosen sketch is reproduced with reasonable accuracy. Next, the teams add color. This process goes on until each team's mural is completed. Finally, all the mural makers meet to review their work and to discuss the usual topics that arise in critiquing the works.

During these proceedings the teacher acts as a consultant. If the pupils have previously made individual pictures, the teacher need give few demonstrations. The teacher's tasks consist for the most part in seeing that a working area and suitable materials are available, providing the initial motivation, outlining some of the technical requirements of a mural, and demonstrating the "squaring" method of enlarging, if it is to be used.

A completely different approach allows the children to develop the mural spontaneously. In this approach the children can choose colors prepared beforehand in order to assure color harmony. The group then gathers around all four sides of the paper placed on the floor and begins to paint. If the group is too large to do this comfortably, it is divided into smaller units. The first children paint whatever comes into their minds, and succeeding groups try to relate their shapes and colors to those that have preceded them. The entire experience should be as open, and the children as immediately responsive, as possible.

Tableau Projects

In the late Middle Ages and into the Renaissance, many artists were called on to design entertainments for their patrons. Even Leonardo da Vinci designed many such projects for the Duke of Milan. Included among the entertainments was the production of *tableaux vivants* (living pictures), in which participant-actors dressed and posed in legendary or historical depictions. Such tableaux could provide an unusual assembly program. is that of the itinerant community artist-activist who serves as an energizer as he or she works with people of all ages within a neighborhood. This photo shows part of a serpent, executed in cement surfaced with mosaic, created by the artist Pedro Silva in Nashville's Fanny Mae Dees Park. Seating places for the public are designed into the sculpture.

An emerging profession in art

Students working in teams should choose a work of art and "become" the work of art through creating a setting and costumes and posing the figures. They should be encouraged to use the simplest materials, the emphasis of the project being the understanding of the visual aspect of the work they have chosen to portray. A tableau can also provide an opportunity to use the grid method to enlarge the background of the painting in which the figures pose. Or the image can be projected and outlined for an accurate enlargement.

The members of the group can include an oral presentation of background information on the artist, on the original work, or on the historical context. At the time of the presentation, an image of the original work can be shown so the spectators can compare it with the tableau.

Ecological Themes

An example of a collaborative art project with a theme based on social values is the Commentary Islands unit taught by Sharon Seim of Nebraska.⁶ During this fourweek (12-session) art unit, students studied works by several artists who use contemporary landscape forms to make comments about the world in which they live (see Christo, Andy Goldsworthy, and Robert Smithson in this book).

Then they formed teams of five and wrestled with decisions about social issues upon which their islands would comment.

The size and shape of the islands were restricted only by the size of the Styrofoam slab each team received. The artworks were created on these bases, which would float and therefore appear as islands on the pond near the school. Students were asked to prepare a written dedication speech (with music or dramatic accompaniment) that would be given on the occasion of launching the islands. Their speeches focused on such themes as "Destruction of the Rain Forest," "How the World Is Solving Pollution," "Urban Sprawl," "Endangered Animals," and "World Peace."

As the islands were launched in an emotionally moving ceremony, they floated out into the pond and moved together in the sunlight. Then they were retrieved with the fishing line attached to each work and taken back to the classroom. It is very likely that all the students who worked in teams and as an entire class to achieve this collaborative effort will fondly recall this experience for years to come. Subjects such as this lend themselves to art integrated with other subjects in the curriculum.

Blowups

"Blowups" are another simple, and most manageable, way to begin a mural, because each child works on her or his own section in her or his own space. First, select an interesting image. (Photographs of the facades of older buildings, group portraits, city views, and well-known artworks are good subjects.) Then the master photo should be divided into as many squares as there are students. Each class member should have his or her own section of the photo to enlarge according to scale (a $1'' \times 1''$ square represents a $1' \times 1'$ square, and so on). They then transfer the small segments to the larger space, heeding whatever problem or technique the class has selected for attention. This is an excellent way to apply a particular skill in color, collage, or pencil. In studying color, children can work in flat tones, blend the tones, or try to match the original color purely as an exercise in color control. When the segments are assembled according to the original, nothing quite goes together; the viewer must accomplish the process of making things "fit" via perceptual reconstruction. When this occurs, the viewer becomes a more active participant in studying the final image.

When making blowups, randomness moves closer to

control. In this situation, students work strictly on their own but within certain limitations, knowing that a surprise awaits them. For example, an art teacher in a junior high school wanted to commemorate Washington's birthday in an unusual and memorable way. He cut a reproduction of Emanuel Leutze's Washington Crossing the Delaware into 1-inch squares. Each student received a square and a large sheet of paper cut to a proportionate size. The class then "blew up," or enlarged to scale, the small segments and transferred them to the large paper. No attempt was made to match colors, because Day-Glo paint was used instead of the standard tempera, watercolor, or chalk. Individual students used whatever colors they wanted without regard for Leutze's painting or the choices of other students. A wall was selected for mounting the project. When the completed pieces were assembled in proper order and fixed in place, a black light was turned on the wall and the effect was overwhelming. The teacher's goal was reached: "Neither teacher nor students will ever forget Washington's birthday."

Selecting the proper work to be expanded is important. The facade of a cathedral, as an example, is relatively easy because of the geometric structures in the facade, whereas a battle scene that includes multitudes of subjects is far more difficult. Picasso's large painting *Guernica* would be relatively easy because it lacks color and is largely composed of flat tones. It is also an important artwork in protest of war and would be easily integrated with history, social studies, or even current issues.

ART GAMES

Group art activities can be conceptual, visual, and verbal as well as creative. Art games can be a very effective means to get children involved in art content and ideas. Game activities can teach cultural and historical content and philosophical and aesthetic concepts and skills in enjoyable ways. Open-ended games can raise questions and issues about art that students love to discuss and debate. Many games can be played in small groups or by individuals.

Art Images for Games

Art games usually require the use of art images—that is, reproductions of artworks. Teachers can obtain a wide selection of small, good-quality art reproductions by purchasing such art magazines as *ARTnews*, *Art in America*,

or *American Artist* and by clipping the reproductions from the pages. We recommend that you record all the pertinent information about each artwork, mount the picture, and place the information on the back. You can collect pictures of paintings, sculpture, prints, architecture, product design, and all modes of art. Another excellent source for small, manipulable art images is the postcards sold in art museums. One of the sources of income for art museums is the sale of reproductions of the works in their collections. Most of these postcards sell for very reasonable prices, and some museums sell postcard portfolios, which result in even lower costs per card. Some games can be played with larger prints, such as those available from companies that sell reproductions.

ARTISTS' NAMES AND STYLES

An elementary-school art teacher can organize and involve students in learning art history by using names of artists, styles, or cultures. For example, when students enter the room and sit down, the teacher directs them to look beneath their seats, where a card is taped. Each child finds a card that has an artist's name and possibly biographical information and a picture of a work by the artist. In preparing the cards, the teacher can create any type of category, such as impressionist painters, living artists, or African sculpture. Or the categories might be related to art modes, such as drawing, painting, sculpture, ceramics, or architecture, or to examples of art from various cultural

These Chinese children are playing a game using postcardsize art reproductions. This game is designed to challenge and expand the concept of "landscape" in traditional and contemporary art.

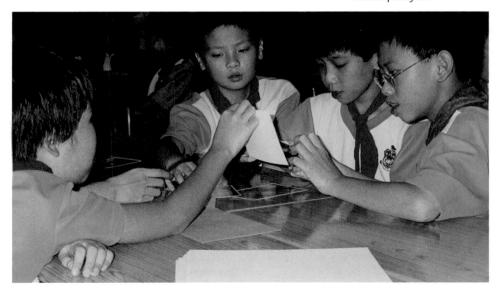

groups. The teacher can also use images from visual culture that convey ideas in the form of logos, corporate identity, or advertising.

The teacher can use the card designators in a variety of ways. "Now students, look at your card, and make sure you know who you are. Where is Pablo Picasso? Where is Mary Cassatt? Where is Helen Frankenthaler? I see you notice that your name can be a man's or a woman's; you can trade around later if you want to. The important thing to recognize is your style of painting. I would like all the cubists to sit at this table, the impressionists over at that table, the fauvists here, and the abstract expressionists at the table by the door."

The teacher can use these categories for cleanup and monitor assignments, for dividing groups for games or studio projects, for dismissing at the end of the class period, or for making cleanup tasks more interesting: "Folk artists, please empty the trash cans." The teacher can also reshuffle the groups at any time by using other information on the cards. "Will all of you artists please look one more time at the painting on your card. If you used mostly warm colors, sit here; mostly cool colors, sit there . . ."; and so forth, using such categories as color selection, dates of birth or death, or the subject matter of paintings, such as still life, figure, or landscape.

The teacher can also use these card designators to encourage class participation. The teacher displays one of Monet's water lily paintings and addresses the class: "Everyone please look at this large print I am showing. Now, which one of you painted this?" A boy raises his hand. "Please tell us a little about yourself. What is your name, where are you from, and how did you come to paint this?" The level of these questions and the student's responses will depend on how much instruction has been given and on what information is included on the cards.

ART COLLECTOR

Simple children's card games such as Art Rummy can be altered to use images of art and visual culture. One teacher has devised card games using postcard-size art images. The goal of one of the games is for the players to obtain entire "art collections" of four matching artworks, such as four by Emily Carr, four portraits, or four sculptures. The cards are shuffled and dealt, and the deck is placed face down for drawing. Each card in a collection has the titles and artists' names of the other three in the collection. Children then ask each other for cards they need for a collection. "Do you have *Waves at Matsushima*, by Sotatsu?" If the child who is asked has the card, he or she gives it to the asker, who then gets another turn. If not, the child draws a card. The next child asks, "Do you have *The Letter*, by Mary Cassatt?" or "Do you have *The False Mirror*, by René Magritte?" As with most of the games, children become increasingly familiar with art images, styles, modes, subjects, and names of artists. Similar games are available for purchase in some museums and bookstores.

The following games were devised by the authors and have been used with success in classroom situations. Some will appeal more to older elementary students, but each game can be adapted by teachers to meet the levels of their students.

GUESS THE THEME

Using small reproductions or postcard art images, organize five or six artworks according to some theme or idea. For very young children, this might be very simple, such as five paintings of babies or five sculptures of horses. For older children, themes can be more difficult to detect, such as six works from different cultures, in different art media, all representing some form of violence (which is, unfortunately, very common in history and in art).⁷ A theme such as this might also raise questions about what art should depict and what artists should create about the world around them. The number of themes is almost limitless. Some interesting examples might be people at work (using different cultures), mother and child, people with authority, flowers in art, relationships between two people, hats, cityscapes, and so on. Themes can relate to topics in the grade-level curriculum, such as "The Sea" or "The Westward Expansion."

For a variation of this, place the complete collection in one place and have students pick out a thematic set from the whole collection. The teacher may suggest or students can assemble a group of artworks whose theme the class is asked to identify.

COMPARE AND CONTRAST

For this game, select two artworks that are similar in some ways, the more obvious for the younger children. Give the two reproductions to a group of three or four children, and ask them to discuss (to list, if they can write) ways the two artworks are similar and ways they are different. In making the comparisons, children should be encouraged to look at information on the backs of the cards that will give them more of a basis for deciding on similarities and differences. For example, comparing the portraits of two American presidents, George Washington and Franklin Delano Roosevelt, students can point to both paintings as portraits of men who held the same office, who have dark suits and white shirts, who are looking at the viewer, and who have similar neutral brown backgrounds. From the backs of the postcards, students will learn that both artists are Americans who lived in different times, as did the presidents depicted. They may learn that both paintings are in galleries in Washington, D.C., both are owned by the people of the United States, both are oil paintings on canvas, and both are approximately the same size.

Older children might be able to make comparisons of the two men and their records as president. The contrasting styles of the artists and the differences in level of formality of pose might be related to the different times during which these men served as president. These paintings would provide teachers with opportunities to relate art to history and social studies, as well as politics.

The comparisons that teachers can organize are limitless, including ideas from architecture, applied design, art materials, and cultures.

HOW ARE THESE THE SAME?

In this game the children are given a series of art images that have something in common, either obviously or more subtly, depending on the teacher's goals and the children's abilities. For example, the six or seven artworks might all be made of bronze, be utilitarian art objects, be watercolors, or be nonobjective art. This activity can be used to push children beyond observation into other means of investigation. For example, a series of seven cards seems to have almost nothing in common on observation of the artworks. One is a traditional portrait painting, another is a nonobjective wood sculpture, another is a floral abstract, another is a watercolor of the sea, and so on. Only by investigating the information on the backs of the cards will the students be able to make the connection that all the works were created by women artists. Other categories might include artworks that are all religious objects, all are in the same museum, or all are characters from comic books.

IS THIS ART?

Postcard images are arranged in small packets of six or seven. The teacher selects these images to raise questions about definitions of art: "What objects can be counted as art, and why?" This game works best with small groups of children discussing the question and reporting what they decide and why to the entire class. For example, one packet might contain a photograph of an ordinary chair, a picture of a tree, a painting of a tree, a picture of an animal, a picture of a building, and a photograph of a sculpture. The primary questions about art in this packet asks, "Are natural objects works of art, or does art have to be made by humans? If art has to be made by humans, which objects should be considered art and which are ordinary objects?"

Another packet contains art images that are suspect in the minds of some people. For example, among images that are generally acceptable, such as a Rembrandt painting or a Greek sculpture, the teacher places one of the graffiti paintings by Keith Haring, an installation by Sandy Skoglund, and an image of Barbie, the famous doll. The variety possible for this game is unlimited, and the teacher can direct it to correlate with curriculum goals and objectives.

WHERE AND WHEN?

The teacher displays (perhaps permanently) a large world map and a large time line on the wall or bulletin board. On the game table or in a box are several packets of postcards pasted on envelopes (the more substantial envelopes wear better). The information usually found on the back of the postcard, including when and where the works were created, is typed on a card inside each envelope. The task for children is to try to place each art object on the correct continent or island group and/or to place it approximately on the time line. One image might be of an African mask, another a Native American eagle-feather bonnet, another an Egyptian sculpture, another a fashion advertisement, and so on. Children can look on the card inside the envelope to see if they were correct. The packets of postcard images are arranged according to difficulty. Examples from Asian or Middle Eastern artworks could parallel Western-based time lines, which are more linear.

Art games can be fun for children and teachers, provide variety in teaching and learning, motivate and stimulate interest, and inspire a great deal of learning. Teachers can use games to raise issues of aesthetics and to teach about history and criticism. In the hands (and minds) of good teachers, art games become another component in the instructional repertoire. As we have seen in the section on puppetry, there is an aspect of collaborative activity that moves easily and naturally toward theatrical performance. This series of photos records some of the high points of a drawing event that involved parents, teachers, and students in an elementary school and was part of a communityschool art program.

Top left: The group leader, author Al Hurwitz, introduces the event, which includes four parents who serve as guest artists.

Top right: A section of fifthand sixth-grade students begin to work. Parents have covered the entire gymnasium floor with protective paper.

Bottom left: Everyone draws the same subject: a teacher dressed in authentic regalia of an Iroquois chief. The subject was selected because it has strong visual interest and correlated with a social studies curriculum unit on Native Americans.

Bottom right: An exhibition is mounted on the walls of the gymnasium as the session progresses. The drawings reflect a wide range of responses. This example by a sixth grader reveals a loose, sketchy style.

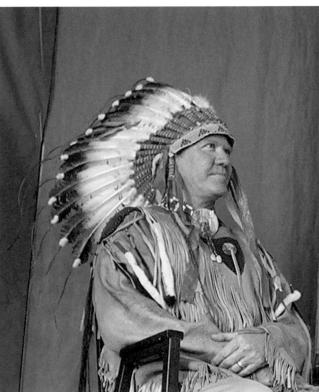

The student who created this work used a contour drawing approach learned in an earlier lesson. Two sessions were offered to accommodate the entire school. The exhibition of drawings became large, diverse, and very interesting. The session culminates with a discussion of the drawing exhibition.

Dr. Hurwitz demonstrates and explains his gestural abstraction approach to the group.

- Louis E. Lankford, "Ecological Stewardship in Art Education," Art Education 50, no. 6 (1997): 47–53.
- Ronald W. Neperud, "Art, Ecology, and Art Education: Practices and Linkages," *Art Education* 50, no. 6 (1997): 14–20; and Theresa Marche, "Looking Outward, Looking In: Community in Art Education," *Art Education* 51, no. 3 (1998): 6–13.
- 3. Cynthia L. Hollis, "On Developing an Art and Ecology Curriculum," *Art Education* 50, no. 6 (1997): 21–24.

NOTES

- 4. Al Hurwitz, Collaboration in Art Education (Reston, VA: National Art Education Association, 1993), p. 3.
- 5. The Annenberg CPB Collection, *Judy Baca*, videotape (South Burlington, VT: Annenberg, 1997).
- Art Education in Action, Episode A, "Highlighting Studio Froduction and Student Social Commentary," videotape (Los Angeles: Getty Center for Education in the Arts, 1995).
- 7. For example, this set might include such artworks

as The Burning of the Sanjo Palace, thirteenth-century Japanese; Battle between Zanga and Awkhast, fifteenthcentury Persian; The Martyrdom of St. Hippolytes, fifteenth-century Flemish; The Crucifixion, Tiepolo, Italian, 1700; *Echo of a Scream*, Siqueiros, Mexican, 1937; and an untitled drawing showing two men in business suits struggling, by Robert Longo, contemporary American, 1986.

ACTIVITIES FOR THE READER

- 1. Describe three group activities not mentioned in this chapter.
- 2. Make three fist puppets: a simple stick puppet, a more complicated paper-bag puppet, and a cloth puppet of an animal whose jaws will move. Improvise dialogue around a situation with a fellow student's puppets.
- 3. Practice manipulating each of your puppets. When skillful, give a short performance for some of your younger friends and see how they react.
- 4. Study any professional murals in your locality. Make a note of their subject matter in relation to their location, their design, and the media used.
- 5. Design a small-scale mural suitable for the interior of your local post office, the foyer of a local theatre, or the entrance of the local high school. Choose subject matter of local interest.
- 6. Try some of the art games described in the chapter. Look for art games in museums and bookstores. Begin your own collection of reproductions, and list the ways they could be categorized for filing.
- 7. Collect a large number of art postcards or art magazine cutouts, and invent art games using the images. Make games that will be useful for teaching art concepts, skills, and history.

SUGGESTED READINGS

- Alger, Sandra L. H. *Games for Teaching Art*. Portland, ME: J. Weston Walch, 1995.
- Angeletti, Roberta. *The Cave Painters of Lascaux*. Glenview, IL: Crystal Productions, 2004.
- Barnet-Sanchez, Holly, and Eva Sperling Cockcroft, eds. Signs from the Heart: California Chicano Murals. Albuquerque: University of New Mexico Press, 1993.
- Bryan, Esther. *Quilt of Belonging: The Invitation Project*. Erin, Ontario, Canada: Boston Mills Press, 2005.
- Congdon, Kristin. Community Art in Action. Worcester, MA: Davis Publications, 2005.
- Currell, David. *Puppets and Puppet Theatre*. Wiltshire, UK: Crowood Press, 1999.
- Hurwitz, Al. Collaboration in Art Education. Reston, VA: National Art Education Association, 1993.

- Hurwitz, Al, and Stanley Madeja. *Pathways to Art Appreciation*. Reston, VA: National Art Education Association, 2004.
- Rochfort, Desmond. *Mexican Muralists*. San Francisco: Chronicle Books, 1998.
- Rosenberg, David. Art Game Book. New York: Assouline Publishing, 2003.
- Scicoff, Rochelle, and Janet Braun-Reinitz. *The Mural Book: A Practical Guide for Educators*. Glenview, IL: Crystal Productions, 2001.

WEB RESOURCES

- Chicana and Chicano Space: http://mati.eas.asu.edu/ ChicanArte/index.html. Presents thematic, inquirybased art education resources related to Chicano art and culture. Go to Inquiry Learning and then to Mural Making Tools, Materials, and Processes.
- Incredible@rtDepartment: http://www.princetonol.com/ groups/iad/. This site is aptly named. Search for group art activities.
- Museum of Modern Art, Art Safari: An Adventure in Looking, for Children and Adults: http://artsafari .moma.org/. Art Safari presents the painting and sculpture collection of the Museum of Modern Art in the context of an interactive website activity. This site encourages learning about art by looking and sharing interpretations.
- Museum of Web Art (MOWA), "Kids Wing": http://www .mowa.org/about.html. The Museum of Web Art was founded to provide a context for new electronic art. The site is patterned after traditional museums. "Kids Wing" is designed as an interactive experience for groups or individuals and includes games, art activities, puzzles, and a display of children's electronic art.

- National Gallery of Art, NGAkids: http://www.nga.gov/ kids/kids.htm. Check out the Art Zone for interactive activities.
- PBS, *The Art of the Mural:* http://www.pbs.org/ americanfamily/mural.html. Includes the history of murals and how to incorporate mural making into your curriculum.
- Sanford Art Supplies: http://www.sanford-artedventures .com/play/play.html. *A Lifetime of Color ArtEdventures* features interactive online games for teachers and students.
- The Social and Public Art Resource Center (SPARC): http://www.sparcmurals.org/sparcone/index. Created by mural artist Judy Baca and colleagues, SPARC is an arts center that produces, preserves, and conducts educational programs about communitybased public artworks. The site includes information for teachers who want to involve students in school and community mural projects.
- The Virtual Diego Rivera Web Museum: http://www .diegorivera.com/index.php. Features Diego Rivera's great mural paintings. Contains links to additional resources for teachers.

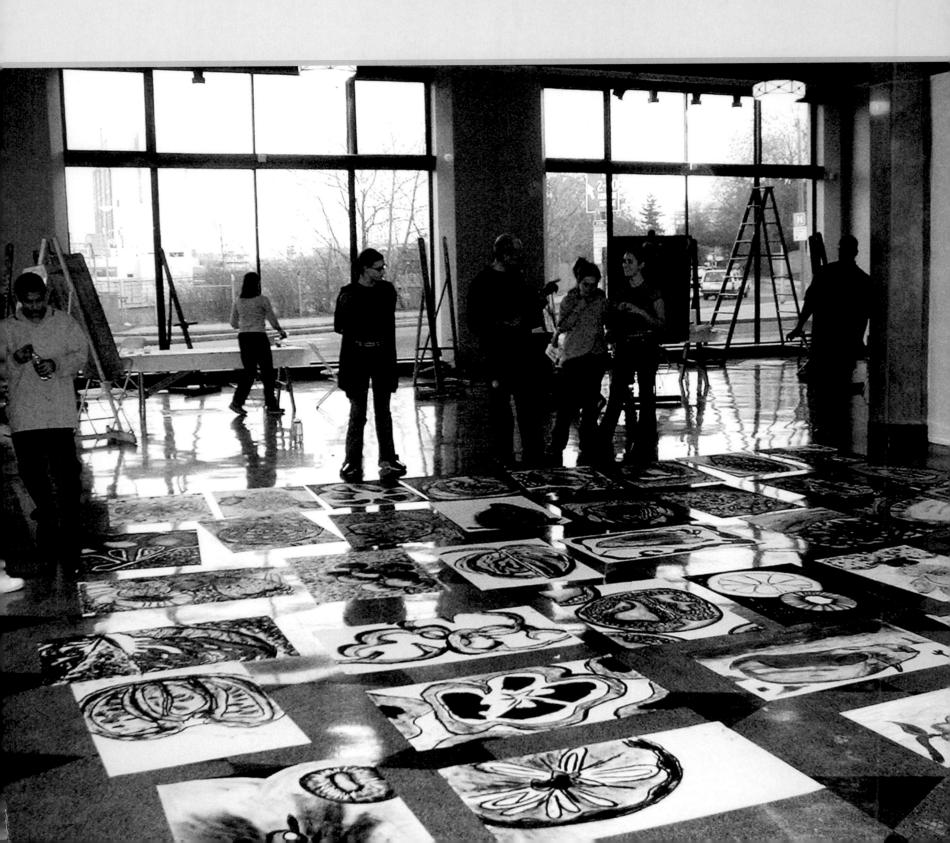

CHAPTER

CURRICULUM

Background, Planning, and Organization

> Educators help shape minds, and the curriculum we provide is one of the most important tools we use in this process.

> > ---Elliot W. Eisner, The Kind of Schools We Need

The term *curriculum* is used to refer to several aspects of the educational enterprise, depending on who is using the term and in what context. For some, the curriculum is the organized content that is planned for students to learn; for others, curriculum refers not to the written plans for learning but to actual instruction as it takes place in the classroom. Other educators might indicate that curriculum refers not to what teachers teach but to what students learn. Still others see the curriculum as the entire experience of children in and out of school. All these connotations are worth considering whenever we set out to plan a program of art education for children and youth. This chapter will focus on organizing art content and on planning art activities to promote learning about art.

As we discussed in Chapter 1, the art curriculum planning process requires that we pay attention to the nature of art, to appropriate conceptions of children and their abilities to learn, and to the values of society.¹ Curriculum planners in different states or provinces will be influenced and guided by the values set forth by their respective state frameworks. Within a state, different school districts will shape their state's framework to meet local values, needs, and resources. Within school districts, individual schools will apply their own guidelines according to their perceived needs, and finally, each teacher will adapt all of the prior educational guidance as he or she sees fit, in the context of the needs and interests of students.

Winslow Homer, *The Country School* (1871). The schoolroom is a familiar scene for children of every generation. Early American artist Winslow Homer created many works depicting childhood experiences, including this informative view of a one-room school in nineteenth-century New England.

It is difficult, if not inappropriate, to discuss curriculum without referring to instruction and evaluation. The planned curriculum is intended to be implemented through the teacher's direction and instruction. Art curriculum planners must be aware of the realities of the classroom, including the age levels and abilities of children, requirements and duties placed on the teacher by the school, and

relationships between the art curriculum and the rest of the school curriculum. Curriculum developers also must consider relationships among the written curriculum, instruction and learning in the classroom, and evaluation of students' progress.

INFLUENCES ON CURRICULUM DECISION MAKING

Readiness of Learners

The subject content of a balanced art program can accommodate learners of any age, personality type, or experience. Curriculum writers need to recognize that just as no two children are exactly alike, so also do classes or groups of children differ. The written curriculum should provide for differences, allowing teachers to adapt activities to the differences in individuals and groups. The capacities of the children to learn will obviously influence the art program. and variations in intelligence may affect art production as well as general learning about art. Slow learners in other subjects are often also slow to profit from art activities, and the art curriculum must be flexible enough to accommodate such differences. Curriculum planners must also consider fast learners and should provide extensions of the regular activities for those who are ready to move ahead or work more in depth. The needs, capacities, and dispositions of the children demand diversification of materials to be used, problems to be solved, and concepts to be introduced and reinforced.

Values of Society

The values of the larger society, along with local community values and those expressed within school systems, influence curriculum planning. As noted in Chapter 1, art education in the United States was initiated for the purpose of improving this country's ability to compete internationally in business and industry. Since that time we have seen national and international events and trends assert their influence on American education. The following current examples of society's values are often mentioned in discussions of education:²

- 1. The explosion of the Internet as a worldwide interactive source for information and a resource for research
- 2. Concern for safety in schools

- 3. Renewed emphasis on the so-called basics of education: reading, writing, mathematics, and science
- 4. Concern that American education aims too low and does not teach students to develop more complex levels of thinking
- 5. A desire to recognize and sustain the contributions of other cultures and their legitimate connections to Western ideas and to each other

Sometimes the complexity of issues that impinge on education is ignored, and simplistic slogans or panaceas are offered to the lay public by reformers in place of sound proposals with sufficient financial support for implementation.

Curriculum planners need to be up-to-date with respect to educational trends and value issues in society. Curriculum writers can contribute significantly toward educational improvement through the content and activities they place in the curriculum. For example, art curriculum planners currently are very aware of the need to provide children with knowledge and understanding of visual culture as well as of traditional fine arts.

Thinking Skills in the Art Curriculum

Although considerable variation occurs in what different psychologists and educators mean when they refer to more complex levels of thinking, Lauren Resnick and Leopold Klopper have developed a brief set of characteristics that we can apply to art curriculum and instruction.³ Through art education, students can become engaged in these types of thinking:

- 1. Thinking that is *nonalgorithmic*—that is, a path of action not fully specified in advance
- 2. Thinking that tends to be *complex*, in which the total path is not "visible" (mentally speaking) from any single vantage point
- 3. Thinking that often yields *multiple solutions*, each with costs and benefits, rather than unique solutions
- 4. Thinking that involves *nuanced judgment* and interpretation
- 5. Thinking that involves the application of *multiple criteria*, which sometimes conflict with one other
- 6. Thinking that often involves *uncertainty*—that is, not everything that bears on the task at hand is known
- 7. Thinking that involves *self-regulation* of the thinking process, where students can consider their progress as they work on a problem or endeavor

- 8. Thir king that involves *imposing meaning*, finding structure in apparent disorder
- Thinking that is *effortful*—that is, considerable mental work is involved in the kinds of elaborations and judgments required

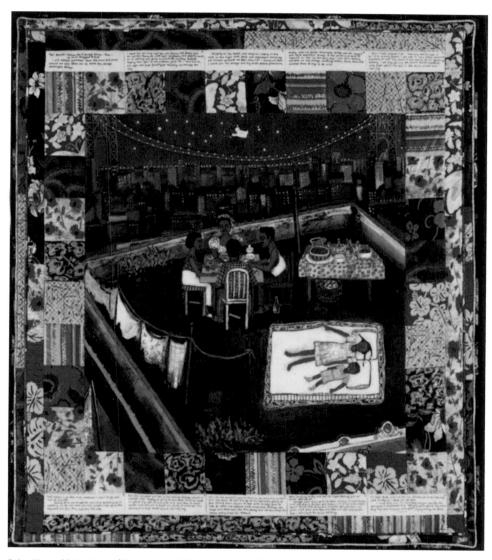

Faith Ringgold, *Tar Beach* (*Woman on a Bridge Series, Part I*) (1988). Acrylic on canvas, bordered with printed, painted, quilted, and pieced cloth, $74^{5/8''} \times 68^{1/2''}$. Through her use of quilts as a foundation for her work, Faith Ringgold raised questions about supposed hierarchies in art that relegated utilitarian objects to a lower status. Ringgold also wrote and illustrated a children's book on the theme of *Tar Beach*, the rooftop retreat for her family during the hot summer nights of her childhood in the city.

When we consider the range of activities that children participate in with a balanced, comprehensive art curriculum, we can recognize art as a school subject that encourages more complex levels of thinking. For example, when children apply a phased approach to art criticism. involving description, analysis, interpretation, and informed preference, they are involved in *complex* mental activity with *multiple* potential solutions requiring nuanced judgment (see Chapter 12 on art criticism). When children apply what they have learned about color, composition, proportion, and distortion to the creation of a landscape painting that expresses a mood, they are involved in a nonalgorithmic activity with multiple criteria requiring self-regulation. When children are old enough to discuss and debate basic questions about art, such as the puzzles described in Chapter 14 on aesthetics, they might be engaged in several types of thinking, including effortful thinking involving a good deal of uncertainty.

Much of the discussion of the thinking curriculum in general education is focused on such subjects as language arts, science, and mathematics, with relatively little attention paid to the potentials in the art curriculum. John Dewey recognized the cognitive requirements of making and evaluating art.

To think effectively in terms of relations of qualities is as severe a demand upon thought as to think in terms of symbols, verbal and mathematical. Indeed, since words are easily manipulated in mechanical ways, the production of a work of genuine art probably demands more intelligence than does most of the so-called thinking that goes on among those who pride themselves on being "intellectuals."⁴

Nearly 60 years later, such writers as Elliot Eisner and Arthur Efland continue to emphasize the cognitive dimensions of art and the existence of multiple intelligences that children and adults bring to bear on developing their understandings of the world.⁵

The Community Setting

Curriculum planners must respect local social issues and values. For example, an art curriculum developed within a school district that serves a primarily Latino community in east Los Angeles might differ significantly from an art curriculum tailored to the needs and interests of students in rural Kansas, northern Minnesota, or urban Philadelphia. Teachers, administrators, and curriculum planners should be aware of local issues that might be sensitive, such as sex education, religious issues, ethnic values, and such specific topics as nudity in art. Michelangelo's David and Botticelli's Venus may not be welcome in all communities, for example, and curriculum planners should be aware of community mores and standards. Although these two artworks are considered by many experts to be masterworks of Western culture and might be counted essential for cultural literacy in some schools, because of their use of nudity they might be rejected in other communities. Knowledgeable curriculum planners realize that the tremendous range of art content makes the omission of particular artworks a relatively minor problem. There is much more of value to teach than class time available, and excellent art curricula can be developed without nude figures or other problematic issues, in recognition of local standards.

Knowing what to include and develop in art curricula is at least as important as knowing what to avoid. Locally developed art curricula can take advantage of local resources, such as architecture, museums, galleries and artrelated industries and businesses, and local experts in the many occupations related to the visual arts.

Sometimes the general character of the community will influence the materials used in an art program. In Oregon, the authors observed a far greater use of wood in art programs than in Miami, where sand casting was popular. Communities such as New Orleans, where there is a welldefined interest in local history, might again influence some of the activities in the art program. In some communities, ethnic groups still maintain traditional arts and crafts of which they are rightfully proud.

The School Setting

The school setting greatly affects the art program. In most school districts, the board of education, or school board, is responsible for establishing school policy, for designating the curriculum, and for overseeing the expenditure of funds to run the district. The board hires a superintendent to carry out board policy and to administer the school program. The superintendent usually hires central office staff and often selects principals for individual schools in the district. In this way the community is actually responsible for the school curriculum but often relies on education professionals such as the superintendent for counsel in decision making. It should be noted, however, that the superintendent usually serves at the pleasure of the board of edu-

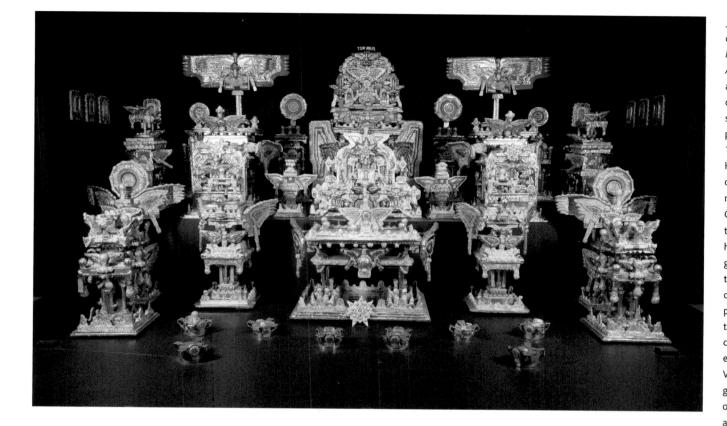

cation, so the real power resides with the elected representatives of the community. The relationship of principals to superintendent is important for art educators to note. Most often the principals serve at the pleasure of the superintendent and take cues from their superior with respect to the relative value of various components of the curriculum.

What this established system means in practice varies, of course, from one district to the next, but certain facts are worth noting. First, art usually will not find a significant place in the curriculum unless the board of education formally indicates that it will be taught. Second, even if the board of education formally establishes art as a regular subject, the superintendent might neglect its implementation. This requires careful attention by the board, who might not realize that the art curriculum is not being well implemented.

Third, even if the superintendent indicates that art is to be implemented as directed by the school board, this will not occur in all schools if principals are not convinced that regular instructional time should be spent on art education. Full implementation will usually occur only when the superintendent reviews and evaluates art education with the same attention given to mathematics, language arts, and social studies.

The place of art in the school setting is influenced as well by the facilities and teaching resources provided for art instruction. Is regular school time set aside for art instruction? Does the school have an art room with the necessary sinks and display and storage spaces? If art is taught in regular classrooms, what provisions are in place to accommodate a comprehensive art program? Are sinks available? Is storage space available so student work can be set aside and worked on over several periods of instruction? Are adequate funds available for art supplies? Where are art materials stored? Are slide projectors and video players readily available for art instruction? Does the library hold an adequate array of art books and magazines? Are art prints and other visual support materials available for art instruction?

James Hampton, The Throne 341 of the Third Heaven of the Nations Millennium General Assembly (c. 1950-64). Gold and silver aluminum foil. colored kraft paper, and plastic sheets over wood furniture, paperboard, and glass, 180 pieces, $10^{1/2'} \times 27' \times 14^{1/2'}$. James Hampton was a black veteran of World War II who worked for many years as a janitor for the General Services Administration in Washington, D.C. He had an artistic calling that gave him a secret life: Over the years he collected castoff furniture and government property and fashioned altars, thrones, offertory tables. crowns, and lecterns, all covered with silver and gold foil. When he died, he left a rented garage full of these wonderful objects, which were immediately recognized as inspired folk art. A tribute to the irrepressible creative force felt by all artists, this work is permanently installed in the National Museum of American Art.

CHAPTER 18 · CURRICULUM

Is there a written art curriculum with suggested evaluation procedures and instruments? Do teachers and administrators accept and respect art as a regular subject in the curriculum? The National Art Education Association (NAEA) has published a guide for administrators with similar questions that includes recommended practices and resources to assist interested administrators who wish to implement strong art programs.⁶

WHO DESIGNS THE ART CURRICULUM?

Several strategies exist for planning and implementing art programs, with wide variations of these approaches from one school district to another. The major issue is one that has been discussed in other chapters: Who shall teach art? And the extension of this question: Who shall plan the art curriculum? This issue refers basically to two alternatives the art program is planned and taught either by regular classroom teachers or by certified art specialists.

The Art Supervisor

The art supervisor is an art specialist with administrative responsibilities, usually on a districtwide basis. Many art supervisors have administrative training and credentials. The responsibilities of art supervisors, known in some districts as art coordinators, usually include overseeing implementation of the art curriculum across the district, managing district stores of art supplies, ordering resource materials for art instruction, providing in-service education for teachers of art, and periodically overseeing the review and revision of the district art curriculum. Art supervisors often have more responsibility and authority with respect to the elementary art curriculum than with secondary art education. This person usually provides leadership regarding art curriculum issues, often in consultation with art teachers, classroom teachers, and interested community members.

When classroom teachers teach art, the art supervisor has the challenging task of overseeing art curriculum implementation by nonspecialists. The written curriculum becomes more essential, and in-service instruction by the supervisor is often focused on basic principles of art and art teaching. The supervisor will likely be able to demonstrate art instruction only in selected classrooms and will of necessity rely on classroom teachers to teach art on a regular basis. When elementary art specialists teach art, the role of the art supervisor is changed to that of providing support for colleagues with art expertise. This also significantly changes the requirements for the art curriculum. If classroom teachers teach art, the art curriculum is addressed to the levels and needs of this group, and the curriculum development process will involve classroom teachers to a large extent. An art curriculum developed for art specialists might be less prescriptive and more flexible, allowing for the subject expertise of the art specialists. The curriculum might also assume more knowledge and deal with sophisticated materials and processes not recommended for classroom teachers.

The Elementary Art Specialist

Many school districts employ certified art specialists to teach art in elementary classrooms. In some regions of the country, especially in several Eastern states, art specialists provide most art instruction. In other regions, especially in some Western states, art instruction is often the responsibility of regular classroom teachers, sometimes under the direction of an art supervisor.7 The NAEA recommends that all children receive art instruction from certified art teachers, who, because of their education and training, are able to provide the highest-quality art instruction. Art teachers are the key people to involve in any curriculum decisions. They generally have a background of training in the fundamentals of curriculum planning and development and, due to their teaching experience, knowledge of art, and familiarity with children of different age levels, are most valuable participants in curriculum development undertakings.

The Classroom Teacher

When elementary art specialists are not available, the responsibility to teach art falls on classroom teachers. Most elementary classroom teachers are not certified as art specialists, and many do not have an extensive background in art. In this situation the guidance provided by a sound written art curriculum is of great importance, along with professional in-service support from an art supervisor whenever possible. A classroom teacher with little art background, no written curriculum, and no professional support from a certified art specialist has little chance to provide children with the type of art program recommended in this book. However, when an art curriculum, instructional materials and resources, and professional support are available, many classroom teachers are able to implement a basic art program.

Classroom teachers can be valuable consultants for art curriculum planning, because they know the general curriculum and the characteristics and needs of their students. They can give advice that will assist planners in correlating art curriculum with other subjects, themes, or periods to be studied in the general curriculum. When art specialists teach art, the classroom teachers are the ones who are able to reinforce, support, and correlate art learning with other subjects.

Student Participation in Curriculum Development

Although research indicates that students often have very little to say about curriculum development, this need not be the case. Students are the ultimate recipients of the art curriculum, and their participation at some levels can provide assurance that curriculum writers are at least on the right track. This does not mean that first- and second-grade students are able to tell professional educators what ought to be taught and how it ought to be organized. Rather, it means that students of various age levels can be consulted profitably at several stages of the curriculum development process. For example, children can be asked to try curriculum sequences and express their opinions. Children can be polled for their interests in current events, personalities, music, and other parts of the popular culture, and these interests can be considered as starting points for art instruction. Children can view proposed art reproductions, can give their responses to particular artworks, and can provide curriculum writers with a running assessment of the activities they are planning. In brief, children can provide a reality check for curriculum developers who might be tempted to become pedantic, grandiose, and too academic in their writing and planning. This process can also serve as a form of evaluation.

School District Administrators (Directors of Curriculum)

Most midsize to large school districts employ administrators who are responsible for curriculum development and instruction across all subjects. As has been mentioned, the board of education makes curriculum policy and the superintendent is hired to carry out policy. The superintendent often appoints an assistant superintendent for curriculum and instruction and sometimes a director of curriculum. The director of curriculum for the district works with subject-ærea curriculum specialists, such as the art coordinator or art supervisor, when these positions are available.

Many districts have a regular cycle for curriculum evaluation, revision, and implementation. This means that the mathematics curriculum will be reviewed every so many years, and changes in the program will be implemented through regular in-service education of teachers. When art is considered a regular part of the school curriculum, it should have a place in this cycle and should be the focus for in-service education. If the art program is not part of the regular review and implementation process, it cannot be considered as a basic subject in the school curriculum.

Who should design the art curriculum? We can say that all the above should be involved. Certainly art curriculum review should be part of the regular cycle supervised by top-level district administrators.

Strategies for Art Curriculum Implementation

As if issues of art curriculum and instruction were not sufficiently complex, school districts around the country have developed a wide variety of means for delivering art instruction to children. Each of these strategies for implementation of the art curriculum has implications for curriculum development. The following sections review a few of these implementation strategies.

THE ART TEACHER IN AN ART ROOM

The ideal situation for many elementary art teachers is to work in their own art room and to meet the various grade-level classes one at a time according to a regular schedule.⁸ This means that the art teacher can meet each child for an art lesson once each week, allowing for curriculum sequence and articulation between grade levels. Regular scheduling means that in-depth activities can be undertaken; working in an art classroom means that adequate storage, tools, materials, audiovisual equipment, art prints and slides, and such items as ceramics kilns can be made available. This implementation strategy allows for a full, balanced art curriculum written for use by art specialists. If the elementary schools are small, the art teacher might work in two schools. Assuming that the art teacher teaches 25 art periods each week and classes average 25 students, the art teacher would have 625 pupil contacts.

THE ITINERANT ART SPECIALIST

Many school districts employ itinerant, or traveling, art teachers. Working within regular classrooms rather than in an art room limits these art teachers significantly, especially if classrooms are not equipped with sinks. This "art on a cart" approach means that the art teacher will move from room to room, bringing the needed art materials and teaching resources on a cart or other conveyance. Art projects to be worked on over several art periods will be stored in the classroom. Scheduling and numbers of pupil contacts can be identical to the strategy with an art room. The major limitations for curriculum are imposed by the lack of a fully equipped art room and by the amount of materials the teacher can move from room to room.

Unfortunately, in some school districts this strategy is misused in the name of providing art instruction for all students. Sometimes itinerant art teachers are asked to travel by automobile to two or more schools, further limiting the program that can be offered to children. In some situations, art is offered twice a month or less, and the number of pu-

This is a single panel of a long mural created by two Israeli boys working as a team. The theme of their work is obviously related to military action. Eventually the work extended more than 20 feet and was exhibited in the school hallway.

pil contacts increases beyond the boundaries within which any meaningful teacher-student relationships might be established. When instructional time for art falls below the baseline of one lesson a week, the possibility of implementing a comprehensive, balanced program diminishes significantly. It is very difficult, because of the length of time between art lessons, for teachers to engage students in art activities that require more than one class period. All these limitations restrict the type of art curriculum that can be reasonably implemented.

ART TEACHERS AND CLASSROOM TEACHERS

Some school districts, operating on the principle of local curriculum decision making within each elementary school, employ more than one strategy. In some cases elementary principals and faculties are given the option of having two curriculum area specialists visit their schools. They are asked to choose among physical education, music, and art specialists, and the classroom teacher will be responsible for teaching the remaining subject. In such districts, we find some schools in which art specialists teach art and other schools in which classroom teachers teach art. Given the variations within each of these implementation strategies, this situation significantly challenges art curriculum planners.

Two Israeli boys worked together for hours on their project. How does the teacher organize class time for long-term projects? How often do students have opportunity to work in depth with their ideas for art?

COOPERATIVE ART TEACHING

Another strategy for implementing art curriculum attempts to utilize the expertise of both art teachers and classroom teachers. Under the reasonable assumptions that art specialists are better prepared with respect to art knowledge and techniques and that classroom teachers know their students best and have opportunities to integrate art with other subjects, some districts engage art teachers and classroom teachers in a cooperative strategy. To initiate an art activity, the art specialist visits the classroom and teaches a lesson. The art teacher provides the art expertise required for introducing the lesson and leaves a clearly expressed assignment for students to complete under the direction of the classroom teacher. The classroom teacher remains in the classroom and assists the art teacher with the lesson. at the same time noting the direction of the lesson and observing the assignment given to students.

The classroom teacher is then responsible for conducting the art lesson the following week and for following up on what the art teacher initiated. The classroom teacher can also innovate and enrich what has been started according to her or his own background and interest in art and can

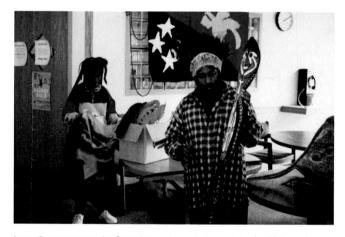

Larry Santana, an artist from Papua, New Guinea, visited a fifth-grade class through an invitation from a cultural anthropologist who taught at a local college. Students researched the art of New Guinea before the artist's arrival. During the session with Mr. Santana, they learned about conventional New Guinea treatment of animals, decorative art, and symbols in the work of indigenous artists. The culminating activity for students was creation of a mural using animal forms and symbols related to the art of New Guinea.

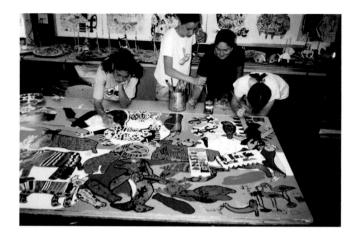

Students worked on $4' \times 8'$ panels of plywood and used colored permanent markers for details on enamel paints. They improvised and interpreted ideas from the artist's visit to create the large mural.

integrate and relate the art content with other subjects as opportunities arise. This strategy, when well implemented, provides greater opportunity for the integration of art into the general curriculum.

ART SUPERVISION

This strategy involves classroom teachers implementing the art curriculum under the direction of and with support from a certified art specialist, the art coordinator. Classroom teachers teach art on a regular basis to their own students and integrate art with the rest of the curriculum. This strategy works best when teachers have access to a clearly written basic art curriculum with support materials that minimize the time required for lesson preparation. When the district employs an art supervisor, or director of art, to support the classroom teachers, this strategy becomes much more effective. The art supervisor orders art supplies and teaching support materials, demonstrates particular art lessons by request in various teachers' classrooms, provides in-service training in art education, and supervises the implementation of the art curriculum.

The art supervisor may also screen applicants for new teaching positions, review the progress of teachers without tenure, test and order supplies, serve on district curriculum committees_ and generally provide leadership for the art program.

The art supervisor is also called upon to prepare and defend the art budget to the school committee, to speak at PTA meetings, and to keep abreast of current thinking and practice in *c*rt education. The assigned responsibilities of British artist Hugh O'Donnell

conducts intensive, one-day

drawing workshops for multi-

age groups. The students immerse themselves for hours in

developing ideas taken from

small cross sections of fruits

and vegetables, beginning

small and ending on a large

scale. This is an example of an

extension of the art curriculum

beyond regular school hours.

art supervisors vary from system to system, as does the title of the position.

KEY DECISIONS IN PLANNING AN ART PROGRAM

District-level curriculum planners have a number of important decisions to make before actually formulating an art curriculum. They need to discuss and decide on issues related to the philosophy of art education, organizational schemes, balance of art learning, scope and sequence of art content, student participation in curriculum development, and integration of art education with other subjects in the curriculum.

School District Philosophy

Most school districts have produced documents that indicate, however briefly, the goals of education for their schools and their children. State departments of education usually have similar documents with broad statements of

values and the worth of education. Individual subject curricula should relate to and support the state or district statements of educational philosophy. The field of art education has developed such statements as well, referring specifically to the contributions that art learning can make in the lives of children. Chapters 1 and 2 discuss the rationales and philosophical values of art education.

A statement of philosophy is an essential beginning for the development of a district art curriculum. It can provide a very general type of guidance and can be referred to when difficult issues arise and resist resolution. The role of art education in the general curriculum can be established by relating the art rationale to the district goals. This relationship can assist board members and administrators who might not be entirely sure of the value of art education.

A Balanced Art Program

"We know from long experience that no one can claim to be truly educated who lacks basic knowledge and skills in the arts" [emphasis in original].9 This view recommends a balanced curriculum that derives its content from the art disciplines. This position is widely held among art educators and other art professionals as well as among many leaders

This elementary-school student uses a brush, along with black ink and oil paint sticks, as she works on her large, organic-based drawing in O'Donnell's "Growing Things™ Workshop." Wearing gloves avoids obvious problems with permanent art media.

in general education. The National Standards for the Visual Arts list six broad content standards: $^{\rm 10}$

- 1. Understanding and applying media, techniques, and processes
- 2. Using knowledge of structures and functions
- 3. Choosing and evaluating a range of subject matter, symbols, and ideas
- 4. Understanding the visual arts in relation to history and cultures
- 5. Reflecting upon and assessing the characteristics and merits of their work and the work of others
- 6. Making connections between the visual arts and other disciplines

The National Standards are intended for secondary education as well as for elementary levels, and the basic ideas are similar. A curriculum that attends significantly to historical knowledge, to analysis and evaluation of artworks,

Wolf Kahn, *In a Red Space* (1938). Oil on canvas, $52'' \times 57''$. The United States received many immigrants who fled the oncoming European war in the late 1930s and early 1940s. Separated from his family as a young boy, Wolf Kahn made his way from Germany to England, then on to New York City. Kahn exhibits the sensitivities of painterly abstraction in his striking landscapes. Above all, color plays the key role in Kahn's paintings. How might you use Kahn's work as a resource for teaching?

to art concepts and vocabulary, and to accomplishment in the production of art in several media is a balanced art curriculum. Art curriculum planners need to decide if the art curriculum will be balanced or if it will emphasize a narrower range of art learning.

SCOPE AND SEQUENCE

The term *scope* refers to the extent and depth of content coverage and *sequence* refers to decisions about the order in which learners encounter content. Scope and sequence documents address such questions as these: Will the children learn about African art? If so, during what grade level? A balanced art curriculum requires extensive planning so children will learn as widely and deeply about art as instructional time allows. Decisions of scope will determine which historical periods children will study during their elementary-school years, which different art modes and media they will experience, which cultures they will learn about, and which vocabulary of terms and concepts they will master.

Sequence is one of the keys to cumulative learning. Learning activities organized in sequences that build on previous learning help children develop from naïve understandings to sophisticated knowledge. Curriculum sequences can occur within a single lesson, can develop from lesson to lesson in a single unit, and can be written across entire terms or grade levels. Sequences of activities can be written and placed within a grade level that will take children from simple beginnings in their use of color to more and more complex understandings and applications in their own art production. Curriculum developers will need to deal with issues of content scope and sequence and to decide how they will utilize these ideas in the art curriculum.

Published Art Curricula

As the field has moved in the direction of balanced, comprehensive art programs, the role of planned, written art curricula has gained in significance. Publishers of educational materials have developed a wide range of art resource materials, including several series of elementary art curricula that provide local curriculum planners with some options. School districts can choose to *adopt* a published art curriculum and *adapt* it to local goals and resources. This process requires an assessment of the available curricula, trial teaching in classrooms, analysis of content and activities, and a determination of the match between commercial curricula and state or district art guidelines. It usually involves a committee that reviews, tries, and selects a curriculum that is then recommended to the board of education for adoption. When adoption is accomplished, materials are developed to assist teachers to adapt the commercial curriculum to the specific goals of the local schools. This might mean suggested sequences of lessons, the addition of lessons written locally, the development of supplementary teaching materials, and designation of vocabulary and lists of artworks to be studied at each grade level. Prepared curricula, in other words, should be adapted for local needs.

Many districts choose to develop their own art curricula, sometimes based on the belief that teachers are more likely to enthusiastically teach what they have a stake in through their own efforts. The issue of cost is an important one. District leaders who believe that commercial art curriculum materials are too costly and for that reason choose to develop their own might be disappointed because the process of developing an art curriculum is a lengthy, timeand energy-consuming task. And when the curriculum is ready for implementation, released-time in-service support is always required for adequate results. This requires longterm administrative and financial support.

CORRELATING ART WITH OTHER SUBJECTS

Many new art programs reflect two major choices: (1) integration within the various arts and (2) integration of art with academic subjects. The conscious seeking of relationships among separate disciplines is assumed to be educationally desirable in any discussion of art beyond its customary function. The visual arts all involve perception, emotion, imagination, and the creative processes—a love of manipulation (of both forms and materials), a delight in sensations, and considerable pleasure in both the contemplation and the creation of structured experiences.

It is precisely because of these shared characteristics that art is so suitable as an adjunct to other activities. The major interest in correlating art with the general curriculum lies in its integration with academic subjects. Before we examine this direction, however, let us look at a few examples of the way art is employed in the first two areas mentioned.

Relationships within the Arts

In a situation in which the arts relate in a broad context, some principle or concept is selected, because it is a part of the artistic experience and, at the same time, exists separately from a particular art category. Let us take one concept that many artists face at various times in their careers—*improvisation*—and examine its possibilities as a "connector" among several art forms. Improvisation is borrowed from the professional training of actors and works well with students of any age.

As a rule, improvisations do not allow any preplanning. They are spontaneous acts created from moment to moment, using some stimulus in the immediate situation as a point of departure. Improvisations always call on the inventiveness of the participants, thus developing such attributes as spontaneity, fluency, and imagination. Participants in improvisational situations learn to respond to the moment at hand and to trust in their ability to embellish, expand, and develop an idea. Examples of improvisation from the arts can be compared and discussed, perhaps with examples from improvisational theatre, modern dance, jazz music, and abstract expressionist art (action painting). Students will note that an expressive vocabulary in an art form is a prerequisite for improvisation.

Although the arts lend themselves to many styles of related instruction, teachers must learn to distinguish between forced and natural ways of connecting one experience to another. If the planning for sequences of activities can be shared by two or more arts specialists, the pooling of ideas can lead to rich possibilities for arts experiences. One arts area can provide motivation for another and so on, creating a sequential flow of activities. Exercises can free the body and attune it to movement to music, which in turn can set the stage for a more formalized dance experience. Because no dance occurs without rhythm, exploration and creation of rhythmic patterns can lead to creating soundmaking instruments. Rhythm can also be translated visually into large-scale drawings based on principles of conducting (imagine holding a brush instead of a baton). Making a spontaneous graphic record of a musical experience can then provide the basis for more thoughtful works, developed with care at the student's own pace rather than that of the music.

Experiences in related arts can also be connected through grouping activities around some common element.

For example, observation is a skill that actors use in studying characteristics of various kinds of people (toddlers and very old people have their own way of walking, for example, hesitant, halting, insecure). Such observation helps in the actor's creation of a character. Artists use their powers of observation as a means of memory development and analysis of form. Memory can be developed, as can visual acuity; many kinds of artists store and call on recollected experience. The actor must learn the lines of King Lear, the pianist commits musical scores to memory before a concert. the dancer must recall dozens of minute bodily movements within fixed time frames, and the artist develops a mental storehouse of images. Improvisation is part of every actor's training, and the painter who develops an image from each preceding stage without any preplanning or the jazz trombonist who picks up cues from what the clarinetist is playing is also improvising. These are three of the many shared characteristics of the arts that suggest activities.

Social Studies

Many of the claims art teachers make for their subject are parallel to goals in other subject areas. A group of social studies specialists specified the goals for which they teach. Their choices indicate some obvious analogies to art. Listed next are seven points they felt were vital for any current social studies program. These assumptions may be similar to those made for an art program, but the teacher should be cognizant of the art program's unique features, as the comments in parentheses indicate.¹¹

- 1. Humanity in relation to the natural environment and the cultural environment is a proper subject for the elementary-school social studies curriculum. (This is also proper subject matter for art activities.)
- 2. Contrast is a powerful pedagogical tool: Look at unfamiliar cultures to understand one's own; look at animal behavior to understand what characteristics humans and animals have in common and what differentiates them. (The art teacher utilizes the contrasts found in works of art to reinforce learning in criticism and appreciation. Polarities of style and technique are stressed to heighten the child's perceptions of likenesses and differences in artworks.)
- 3. "Ways of knowing" are important, such as the way of the anthropologist, the archeologist, and others.

("Ways of knowing" in art implies understanding not only the functions of critic, historian, and artist but also the kinds of "knowing," perceiving, and experiencing that differentiate the painter from the sculptor, the architect from the potter.)

- 4. Studies in depth provide a thorough foundation and a point of reference around which later learnings may cluster. (An art program that included in-depth studies would give a great deal of time to a few selected concepts deemed important, such as drawing, color relationships, or Japanese pottery, rather than skip to a different activity each week without making any connections among the activities.)
- 5. Discovering how things are related and discovering how to discover are the ends of learning; the end should not be just mastery of the subject matter. (Discovery is a part of the process in art as well. Sensitive teachers are aware of the importance of the changes that may

These simulated Egyptian fresco paintings on low, carved relief were done by drawing the faces on slabs of plaster of paris. The lines were incised with a sharp tool and the faces painted in tempera. Sandpaper was then lightly applied to contribute to the appearance of age. The thinner the paint is, the more delicate the colors are. This activity was part of a class unit on ancient Egypt.

occur when children are taught for discovery as well as for adult-inspired goals.)

- 6. The students are participants; they can be selfmotivated inquirers rather than passive receivers. (The taped dialogues transcribed in this book testify to the value of interactions between teacher and pupil in discussions of art activities.)
- 7. Students should find their own meaning in the material, some of which should be the "raw data" of creative studio experiences and original works of art, be they buildings, paintings, or craft objects.

The seven points have been included here to emphasize the need for art teachers to define the special nature of art, even when art appears to be close to other subjects in its ultimate objectives.

Peter Minshall, designer, *Fly, Fly, Sweet Life*, from *Papillon* (1982 Trinidad Carnival). Caribbean festival arts are perhaps the most integrated of art forms, incorporating dance, costume, music, and the visual arts with literary themes, legends, and stories. Designers appropriate art from an unrestricted selection of world cultures and combine art traditions with the most contemporary images and materials. In this work, the dancer's wings feature the image of Marilyn Monroe created by Andy Warhol, in the guise of Botticelli's famous *Venus* from fifteenth-century Italy. The theme of "butterfly" is mirrored in the work's title.

A primary teacher in an urban environment integrated art and social studies on the theme of migration, featuring the migrations of black people from the Southern states to Northern states before, during, and after the Civil War. She focused on the paintings and collages of Romare Bearden, using such concepts and vocabulary as "urban," "rural," "migration," "collage," "texture," and "contrast." She played blues and jazz music that described the period, including music composed by Bearden. As they studied the life and times of the artist, students viewed, analyzed, and discussed Bearden's works in relation to these concepts and learned in a vivid way about history, culture, and art.¹²

A sixth-grade teacher organized an art unit on the theme of the Caribbean, with emphasis on the Carnival festival and the festival arts of music, dance, and costume, all in conjunction with the museum exhibition of the Caribbean Festival Arts, which traveled across the country to several museums in urban centers. Building on earlier art units on textile design, batik, and masks, this teacher engaged his students in a community celebration based on the Carnival festival, with steel drum music, Caribbean foods, dancing, and costumes made by students. The entire school and parents were invited to a community celebration. Students were introduced to an unusual type of art, saw videotapes of festival costumes and dancing available from the museum, noted the multicultural dimensions of the celebration, and enjoyed a vivid, memorable experience that integrated the arts in a natural and spontaneous manner.

Language Arts

Experiences in criticism create natural allies between writing and art. Thought processes are clarified when ideas are written as well as voiced. The method of wedding language to art is to encourage a "visual narrative" approach, wherein one activity reinforces the other, using stories as a basis for sequences of drawing involving characters in specific settings.¹³ This is a natural alliance, because most children begin schooling with their imaginative skills developed through listening and looking at books, as well as through having consumed countless hours of television. Teachers use myths, poetry, artworks, folk tales, and other literary sources as a basis for children's artwork.

Generally, stories and poems may encourage children

in the symbol-making or later stages of expression to make two- and three-dimensional illustrations. One very natural way to relate language, art, and imagination is to ask children to write about what they have drawn. If the subject is selected with care (such as "Machines Designed to Perform Unusual Tasks"), then the interplay between idea and image grows dramatically. Children can speak and write about things they may not draw, and vice versa. Combining the two can enhance the development of both linguistic and graphic forms.

One study demonstrated that students can attain higher levels of achievement in reading and writing in the middle grades when narrative drawing was used regularly.¹⁴ The teacher began by asking her students to draw the answers to such questions as, "How many kinds of people can you draw?" and "How many kinds of movement and emotions can you draw?" These activities took place before the students created a plot for the characters drawn. Such experiences made it easier to write about sequences of events. Because writing is increasingly stressed on all levels of instruction, children, particularly in the upper grades, should be encouraged, once familiarized with the critical process, to write on the descriptive and interpretative stages (see Chapter 12 on art criticism).

Art and Multicultural Understanding

In a democratic society made up of people from every part of the world, it is most appropriate that education in the United States respect contributions of excellence from many cultural sources. The arts provide the most vivid and vibrant means to understand any culture and to reveal its most significant meanings. The visual arts in particular provide our greatest insights into cultures of the past and the present. For these reasons, art education is a focal point whenever multicultural education is discussed.¹⁵

The term *multicultural* has been used so broadly in discourse about education that clear definition has eluded the education profession. Over the past decades, "even the designation itself has been used to denote terms, such as multiethnic, multiracial, cross-cultural and gender-balanced, as well as representations of global religions, or all age and socioeconomic groups." Roger Tomhave provides some clarity with his discussion of six recognizable emphases for multicultural education.¹⁶ The following are the most relevant for this discussion: *Cultural Separatism:* A large infusion of one particular subculture may lead to enough economic and political power for the group to practice cultural separatism. The ethnic school is a "folk school" that disseminates ethnic customs, traditions, and languages that a particular group cherishes and finds worthy of transmission to later generations.

Social Reconstruction: This approach is concerned not only with ethnic and racial perspectives but also with matters of Eurocentrism, sexism, and classism. Sociopolitical change amounting to a restructuring of society is the goal and valued outcome of this approach. Education in art becomes part of or subordinate to the goal of social change.¹⁷ The desire for social change is one of the characteristics of postmodernism (see Chapter 2).

Cultural Understanding: Without losing the ideal of achievement in the present democratic educational system, we can accommodate the concerns of various ethnic groups and also gain appreciation of, respect for, and acceptance of diverse cultures' contributions to the human condition. Attempts

When teachers prepare students for a story, they reach back to an ancient mode of communal sharing. Love of narrative exists in all cultures, and television, film, and theatre all draw upon our fascination with good tales well told.

are made to translate multicultural theory into multicultural practice.

Although each approach is valid within some settings, the one that seems most useful for general art education is the "cultural understanding" view, which seeks to foster appreciation and acceptance of diverse cultural contributions. Other approaches might serve within local communities with particular circumstances that warrant a more specific focus.¹⁸

Art and Nature

Although such artists as John James Audubon and Leonardo da Vinci were able to bring art and science into proximity, scientific drawings and artistic expressions differ in intent. A scientific drawing is an exact statement of fact, allowing no deviation from the natural appearance of an object.

Elements of grammar can serve as sources for art. In this case, students selected randomly from a group of nouns, adjectives, verbs, and prepositions to produce this sentence: "Many cowboys jump blue ghosts in the forest." The problem was to incorporate all the words into one drawing.

For children, natural objects evoke feelings and hold meanings that go beyond a scientific statement. The objects in the science corner of the classroom, such as fossils, shells, and rocks, can provide the basis for invention as well as for scientific study. Studying the natural world satisfies the curiosity of both artist and scientist (see Leonardo's notebooks). The studios of many artists, for example, that of Georgia O'Keeffe, are filled with specimens of rocks, bones, and other natural objects.

Most elementary-school children, of course, are incapable of drawing with scientific accuracy. This does not mean that they should not be exposed to natural objects or that they should not use them for expressive purposes. On the contrary, flowers, birds, seashells, fish, and other animals, as stated previously, may be used with excellent effect in art. Any natural object may be employed as the basis of design, provided the children are also given freedom to depart from the scientific form they observe. The fact that this freedom is allowed does not retard the children's growth in scientific knowledge.

A correlated art-science project could work as follows for the fifth and sixth grades. The first step would be an *observational phase*, in which students would be asked to draw as carefully as possible an object or specimen, such as bones (skeleton segment), fossils embedded in stone, flowers, or cellular forms viewed through a microscope. The second step, the *design phase*, would involve using the drawing in one of the following ways:

- Fill in areas within outlines with flat tones based on a color theory.
- Blow up the drawing to 10 times the original size, and turn it into a hard-edge-style painting.
- Move a piece of tracing paper over the original, allowing shapes to overlap. Fill in with textured pen-and-ink patterns, a color scheme, or a number of shades of one color.
- Select a section for a small linoleum print, and make a repeat pattern.

In such a sequence, the student moves from observation to design judgment and, in making the print, comes to understand how artists use natural forms as a basis for applied design. The entire sequence may take up to four or five class sessions, but it allows the student to "live with" one problem for an extended period of time.

Music

Music and art lend themselves to several types of correlation. As an indirect correlation, a background of music playing is often valuable to children while they are drawing, painting, or working in three dimensions. The music appears to influence the children's visual output in a subtle fashion.

The teacher may arrange direct correlations between music and art for children at any level in the elementary school. Music with a pronounced rhythmic beat and melodic line may be used as a basis for drawing nonobjective patterns.

Music depicting a definite mood may also lead to some interesting artwork, especially in the fifth and sixth grades. Before playing the piece, the teacher usually discusses the mood of the selection. After hearing the music, the class may discuss possible combinations of colors, lines, and other elements of design to express the mood pictorially. Work then begins, possibly in soft chalk or paint, with the music playing in the background.

Classical music with a literary theme may also assist in developing noteworthy picture making by pupils in the symbol-making or later stages of expression. The teacher gives the outline of the story, plays excerpts from the music, and from time to time draws attention to passages depicting specific events in the narrative.

Varieties of pop, rock, and jazz can be used with equal effectiveness. The teacher can use a wide range of classical and contemporary music to motivate artwork. And students can study CD covers as a popular art form that links the mood and beat of music to visual experience. Musical selections from such cultures as Spanish, African, West Indian, Scottish, or Native American can add interest and variety to this type of experience, especially in conjunction with study of art and culture. Music teachers can be particularly helpful in choosing appropriate works.

Mathematics

As soon as a child is capable of using a measured line, mathematics may begin to enter into some of the child's artwork. Such activities as building model houses, making costumes for puppets, or constructing puppet stages lend themselves to this correlation. Studying the history of art provides ample examples of uses of mathematics, especially geometry. Mathematical foundations exist for some of the great monuments of the world, such as Egyptian pyramids; prehistoric Native American rock art that marks solstices; Mayan art, calendars, and architecture; and Stonehenge. The ancient Greeks, for example, used the golden mean in architecture and art. Geometry has been applied by contemporary artists who use linear patterns on their canvases to establish balance and centers of interest in their compositions. The geometric works of Piet Mondrian, M. C. Escher, and op artists Bridget Riley and Victor Vasarely all are examples of creative variations on strict mathematicsbased themes.

Some teachers have attempted to combine the two fields by having the children work during art sessions with mechanical drawing tools, such as compasses, triangles, and T-squares, to devise geometric designs. If this type of work

As part of a unit on the history of their village, a class in an English primary school first created a photo essay of their community based upon the architectural styles that made up the village of Cavendish. Because the school had no art specialist, the project was carried out by an itinerant art teacher in collaboration with the classroom teachers.

for picture making need not constrict the child's imagination as evidenced in these portraits of Queen Isabella and King Ferdinand by second and fifth graders in Clark County, Georgia.

The use of historical sources

is largely mechanical and hence not particularly expressive, there is little reason to recommend it. However, because children do enjoy the clarity and precision that designing with drafting tools provides, in many situations the teacher may establish creative and aesthetic standards to make the design activities worthwhile. These tools might be combined with work in any number of techniques—crayon and pencil drawing, painting, crayon resist, and etching, among others.

Problems of Correlation

The teaching of art has, of course, been affected by both the correlation of subjects and their fusion in the curriculum. In certain circumstances art education has benefited from the grouping of areas of learning; in other circumstances, however, it has suffered.

The four arts-education professional associations are concerned that each art discipline receive sufficient place in the school curriculum and that regular instruction in the arts not be diffused through the guise of curriculum integration. In a joint statement, the associations representing theatre, music, dance, and the visual arts indicated their belief that

when appropriate, instruction in the arts may be used to facilitate and enrich the teaching of other subject matter. The arts must maintain their integrity in the curriculum and be taught for their own sake as well, rather than serving exclusively as aids to instruction in other disciplines. The use of the arts as an instrument for the teaching of nonartistic content should in no way diminish the time or effort devoted to the teaching of each of the arts as distinct academic disciplines in their own right.¹⁹

Correlation or integration need not debase an authentic art experience, but art teachers always must maintain the primacy of their responsibility to teach art. If attempts to integrate art across the curriculum avoid the pitfalls of losing time allocated for regular art instruction, they are often very successful. In addition to the values of intrinsic goals for art education are significant benefits for the pupils and for the entire school program.

ORGANIZING AND WRITING ART CURRICULUM

Approaches to Curriculum Development

The shaping of any curriculum must begin by establishing a direction. Although curriculum planners may bring to this problem some knowledge of art, of children, and of sound educational practice, the content of the curriculum begins to take form when they use all their knowledge and experience as a basis for setting down what they hope to accomplish in terms of art goals and objectives.

Ralph Tyler, in his brief-but-classic essay on curriculum planning, cites four questions that are generally accepted as a reasonable place to begin:²⁰

- 1. What educational purposes should the school seek to attain?
- 2. What educational experiences can be provided that are likely to attain these purposes?
- 3. How can these educational experiences be effectively organized?
- 4. How can we determine whether these purposes are being attained?

The "purposes" to which Tyler alludes may also be viewed as goals, and his "experiences" as the vehicles by which goals or purposes are attained. In many cases the new art teacher is presented with a written curriculum or guide prepared by a committee of teachers. The new teacher may not be prepared to carry out all the activities suggested and, in such cases, searches for ways to accommodate the curriculum. Even though teachers are expected to teach from the school or district art curriculum, it is good practice for them to expend the effort needed to create their own applications.

School districts have two basic options for curriculum development in any subject area: they can purchase a commercial curriculum and adapt it to local needs, or they can develop their own curriculum using district personnel and,

 ← Children can learn from other children through the growing number of exchange programs. These examples of the Bo Train Circle game are from Sierra Leone and are part of an exhibition organized by the Foster Parents Plan Pro- gram on understanding the third world through art. (Com- pare with circle games in Chapter 3.)

This painting of the circle game demonstrates the student artist's advanced ability to handle space. The closer figures are larger; the group surrounds a circular space on the ground; and the more distant figures, houses, and other objects are placed higher on the picture space.

possibly, consultants. Regardless of which choice is made, teachers will make many curriculum decisions and will ultimately shape the curriculum to their own personal teaching styles and their own classroom situation. It is important for professional teachers to develop skills in understanding and creating curriculum if for no other reason than to gain greater appreciation for the many curriculum decisions they and others will make during each school year.

Curriculum writing is a complex undertaking with several levels of decision making. The first level appears as soon as instructors begin to organize a curriculum and must decide on an approach to the task. M. Frances Klein describes four distinctive approaches that appear in theory and practice.²¹

Traditional Approach: Processes reflect a scientific, reductionistic, linear, and rational approach to curriculum development. This position emphasizes the role of organized subject matter, often in the form of disciplines. The outcomes desired deal primarily with predetermined, logically organized skills or bodies of knowledge that all students are to learn and with the development of their intellectual capacities.

Emphasis on Self-Understanding: Value is placed on development of the individual pupil and creation of personal meaning in learning. Organized subject matter is important only insofar as each student affirms its relevance to him or her. Reflection on the personal meaning of content and experience by each student is highlighted. Learning is viewed as holistic, not as hierarchical discrete tasks within specific domains of human behavior.

Emphasis on the Role of the Teacher: The teacher is a very powerful influence on what students learn. Teachers develop practical knowledge and wisdom about curriculum as they make myriad classroom decisions daily. Teachers should be supported in their role as curriculum developers.

Emphasis on Society: The intent of the curriculum is to help build a better society and to improve human relationships to foster social change through the strong involvement of the surrounding community. Emphasis is placed on the interaction of societal norms, values, and expectations with curriculum and schooling. Organized content fields in the form of the disciplines are important to the extent that they can be brought to bear on issues and problems under study.

Probably no single approach in curriculum will do all that we expect from our schools in helping students grow and develop today and prepare for their lives in the twenty-first century.

As the curriculum development process unfolds, general decisions about content must be confronted. What modes of art making will students experience? What artists, cultures, and artworks will be studied? Will there be a balance of artworks according to gender?²² What questions and issues in art will be discussed? What skills of creation and response to art will be learned? And what structure will be used to organize this material? All these decisions and more will be made during the planning process for a single grade level. If the curriculum project includes several grades, the process is even more complex, because content from each grade level must be related and articulated with the grades above and below. Usually, it is best to organize content in very general ways for yearly plans so individual teachers have appropriate latitude for decision making within their classrooms.

Organizational Categories for Art Curricula

Several ways to organize art curricula deserve the attention of curriculum writers. Many art curriculum guides and curricula have been organized on the basis of the elements and principles of design. Another traditional organizing scheme uses modes of art production. The changing paradigm for art education, however, has caused art educators to consider additional categories suggested by art history, criticism, visual culture, and aesthetics. Following are brief lists of topics or categories that might be considered for organizing art curriculum content.

ELEMENTS AND PRINCIPLES OF DESIGN

Units of instruction might be organized according to

line	space	composition
shape	unity	movement
color	harmony	contrast
texture	rhythm	pattern

ART MODES AND MEDIA

Units of instruction might be organized according to

drawing	architecture	newer media
painting	ceramics	installation art
printmaking	photography	video/computer art
sculpture	graphic design	environmental art

PERIODS OF WESTERN ART HISTORY

Units of instruction might be organized according to

prehistoric art art of the ancient world art of the Middle Ages medieval art

art of the Renaissance baroque art modern art postmodern art

ART FROM VARIOUS CULTURES

Units of instruction might be organized according to

art of China contemporary art art of Africa American art art of Italy, Spain, or France African American art Native American art

THEMES

Units of instruction might be organized according to

art and ecology art and technology the westward movement mythology and art art and power

art in advertising images of men images of women art and worship the artist as social critic

AESTHETICS TOPICS

Units of instruction might be organized according to

purposes and functions of art art versus nature beauty in art what constitutes art the artist's intent

the creative process quality in art

LANDMARK ARTWORKS

Units of instruction might be organized according to

Egyptian pyramids Michelangelo's Sistine Chapel ceiling the Taj Mahal Marisol's The Last Supper Leonardo da Vinci's Mona Lisa Hokusai's The Great Wave Rodin's The Thinker Van Gogh's The Starry Night Picasso's Guernica The Great Mosque at Cordoba Faith Ringgold's Tar Beach Georgia O'Keeffe's Black Hollyhocks Ansel Adams's Yosemite Valley

Notre L'ame cathedral Frank Lloyd Wright's Fallingwater Maya Lin's Vietnam Veterans Memorial Frank Gehry's Guggenheim Museum, Bilbao

FUNCTIONS OF ART

Units of instruction might be organized according to

spiritual and religious art art to convey power and authority art as a fcrce for social reform decorative art

ART STYLES

art as narrative art for celebration art as personal expression design for human needs art and visual culture

Units of instruction might be organized according to

Egyptian figures baroque style rococo style impressionism cubism surrealism

abstract expressionism pop art African Benin Chinese Ming American colonial German expressionism "Water Ox" by Cathlen (Navajo), age 8, tells a story from her Navajo heritage in this delicate watercolor. She wrote, "The men are telling Water Ox that they want water in their land. Water Ox makes it rain and makes trees grow. He changes color. Water Ox is mad because the men interrupt him. He changed to a dark color. And then Water Ox told them that he could make it rain."

This is a scene from the Revolutionary War depicting a British raid on Martha's Vineyard in 1778. The local people lost 600 cattle and 3,000 sheep to British soldiers who sailed into the harbor. Third graders studied the event, known as Gray's Raid, in their history curriculum with support from the local historical society. This painting is by Joshua, age 8.

This painting is by Willett, age 8. The two versions of Gray's Raid were created by two boys who sat side by side as they worked on their pencil, pen, and watercolor paintings. These paintings show how children influence each other, yet their artwork remains unique and individual. They are also examples of unique responses to the same assignment, a prime characteristic of art education. See a third version of Gray's Raid from the same class by Bo, age 8, in Chapter 3.

ARTISTS

Units of instruction might be organized around landmark artists, particularly if their work reflects periods of change or possesses some element of personal history or artistic content interesting to children.

Pablo Picasso Romare Bearden Georgia O'Keeffe Frank Lloyd Wright Maya Lin Frederic Remington Frida Kahlo Judy Chicago Mary Cassatt Anselm Kieffer Rembrandt van Rijn Alan Hauser

A balanced art curriculum can be organized on the basis of any of the schemes listed and on the ways they interact. For example, if the elements of design are selected, students can study artworks that exemplify different uses of line or specific artists well known for their mastery of color. They can investigate the history of color usage in Western art and note the technological advances in the development of natural and artificial pigments. Students can study color symbolism found in different cultures in relation to color meanings in contemporary American society. Students can develop skills in the use of line, shape, and color in their own artwork as a result of instruction and of observation of the works of other artists. Likewise, any of the category systems listed can be cross-referenced to art content from aesthetics, art history, art criticism, and art production. The organizational category usually assures emphasis on its topic.

The Yearly Plan or Course Outline

The main purpose for a broad outline of content and activities is to provide the art teacher with an overview of the entire term or year. This will assist the teacher to develop stronger sequential learning, to build on prior learning, to integrate across the curriculum, and to better use class time. One way for teachers to get their thoughts on paper is to use a matrix as a graphic guide for sorting ideas. The matrix is simply a grid that indicates where key issues intersect. Table 18-1 provides an example, showing several units of a sixth-grade yearly plan outlined in matrix form.²³

Unit Plans

The unit plan outline is similar to a yearly plan but with more detail. A unit plan is a series of lessons organized on a single theme, topic, or mode. The unit plan should provide the teacher with a concise overview of the unit, including information about artworks, art materials, and special preparations that need to be considered. The unit should be organized to emphasize sequences of learning activities. Units vary in length from a few lessons to an in-depth sequence of lessons on a topic that might last as long as six weeks. Following is a sample unit outline for upperelementary grades. The unit consists of four lessons estimated to require six class sessions for completion. It is organized as a sculpture unit.

	Unit Title: Coiled Clay	Unit Title: Painting People and Objects	Unit Title: Graphic Design— Imagination and Influence
Art-Making: Topics and Processes	Media and materials: ceramic clay, clay equipment and tools, glazes Processes and skills: coil and slab construction, building with a sup- port mold, burnishing, clay slip for decoraticn, firing pots Write description of coil construc- tion process Discuss coil techniques of several cultures Learn to work in style of South- western Pueblo potters	Media and materials: tempera, watercolor, acrylics, oil pastels, inks, marking pens Processes and skills: drawing and painting skills from previous units, still life from several vantage points, combining versions of still life in a collage, painting expressive face and posed figure	Media and materials: marking pens, commercial letters, computer Processes and skills: analyze design problem and develop solutions; communicate effectively with combined words and images; cre- ate package design; create poster of book cover; illustrate literary work, social issue, or personal experience
Art Criticism: Topics and Processes	 Study coil pottery from several cultures Study symbols used by traditional Pueblo potters Interpret meaning of contemporary ceramic sculptures Judge quality of pots according to construction and decoration techniques Critique student pots and sculptures 	Analyze painting and collage tech- niques in cubist still life Interpret paintings of human faces and figures Describe in writing moods or emo- tions in paintings of faces Discuss and interpret student paintings Mount display of student paintings	Interpret meanings of international symbols Judge quality of graphic designs Examine design of common food and household packages Recognize influence of graphic design on consumer decisions Write critique and interpretation of an illustration
Art History/Culture: Topics and Sources	Learn about: traditional Pueblo, Ma- yan, and African ceramic works; con- temporary Pueblo and European- American pottery Study lives and works of selected potters and ceramic sculptors	Learn about: historical Dutch and Flemish paintings; modern Spanish, Mexican, Native American, and European-American paintings Study still life and figure as tradi- tional subjects for painting Study lives and works of specific artists Analyze figure paintings for pose, costume, theme, mood, and setting Analyze and discuss various mean- ings of realism in painting	Learn about: careers in design and commercial art; contemporary design of packages, book covers, posters; computer graphics Study historic role of graphics for communication Study lives and works of selected graphic artists Recognize and value skills of graphic artists (continued)

360

	Unit Title: Coiled Clay	Unit Title: Painting People and Objects	Unit Title: Graphic Design— Imagination and Influence
Aesthetics: Topics and Questions	Investigate questions: How can scholars interpret meaning and quality of art objects from pre- historic times? Should beautifully designed and decorated functional pots be con- sidered art or craft?	Investigate questions: Must art reflect nature? Can abstract art convey meaning? Can an artist change styles and retain his or her individuality?	Investigate questions: What is the relationship between fine arts and applied arts, such as graphic design and illustration? Can a poster or book cover be a work of art?
	Should contemporary Native Ameri- can potters copy ancient designs or invent new symbols?		
Evaluation: Assessing Student Progress in Specific Activities	Coil construction techniques	Worksheet on expressive faces	Package design
	Technique for clay figure with at- tention to figure gesture and free- dom of attitude Essay on Southwestern Native American potter Display and discussion of student work	Multistage painting/collage process Quiz on slides and related information Still-life painting	Illustration Poster or book-cover design Report on works of graphic desigr viewed on television
		Painting of expressive face Painting of posed figure	Paragraph explaining example of graphic design Effective communications through
	Written review of ceramic sculpture display Identify ceramic works from slides	Essay on expressive purpose of own painting Display, discussion, and evaluation of student work	enective communications through design Problem-solving techniques expressed through design

Lesson Plans

The planning process discussed here is most appropriate for curriculum lessons and units that will be shared with other teachers, probably as part of a district art curriculum. When planning exclusively for their own classes, teachers quickly develop shorthand versions of their plans. The unit plan shown constitutes one of the columns in the yearly plan matrix. In turn, curriculum units are made up of a series of lesson plans. The lesson plan that follows is an example of the type of detailed version that provides sufficient information so experienced teachers could prepare and teach the lesson. It also provides background materials on the artists, artworks, and historical/cultural contexts intended to save teachers time and to assist them to enrich the lesson.

Following is a sample lesson plan using these categories, with each one filled in to demonstrate how a complete lesson plan appears. Not included are the background materials for the teacher, with handouts on selected topics for students. Slides or other art reproductions should be included with the lesson to allow the teacher to implement it. Providing such detailed plans, art reproductions, and written background materials need not reduce a teacher's autonomy. Teachers typically make choices about which ideas and materials they will use, which they will bypass, and what additional materials of their own they wish to introduce to their students. Providing complete lesson plans simply increases the choices available to the teacher.

This lesson plan is one of the lessons from the sculpture unit outlined in the sample unit plan shown earlier. The detailed information for the teacher under the heading "Instruction" provides the sense of the lesson and the types of interactions a teacher might have in discussions with students. On reading this material, an experienced teacher will understand where the lesson is headed and why and will translate the essence of the lesson into his or her own language, making decisions on the level of concept and language, knowing prior instruction students have received, perceiving students' capabilities and interests, and understanding his or her own situation regarding the many variables of a classroom, such as time available, class size, and room facilities. The teacher always makes the most important curriculum decisions at this level. The purpose of good curriculum is to make the teacher's job easier, the instruction richer, and the learning climate more engaging.

Educational Objectives

Some art educators believe that because art learning is primarily divergent and creative, specified objectives set by the teacher are not appropriate. Some suggest that naming objectives might distract teachers from following students' interests. Others wish to state objectives in terms of the classroom activity or experience rather than in terms of what students will learn, suggesting that it is not possible to anticipate and specify all these outcomes. The most detailed approach is associated with behaviorist psychology and focuses on observable behaviors as desirable outcomes of learning activities. Outcome-based education (OBE) systems relate closely to behaviorist thinking.

In current educational practice, all these approaches are used. Sometimes entire school districts adopt particular approaches to writing educational objectives, and they are often related to the plan for assessing student progress (see Chapter 20 on assessment). More often there may be no specific guidance for teachers, who are encouraged to use whatever method for writing objectives that suits them. We will discuss briefly the components of performance objectives. After developing the ability to view learning outcomes in terms of student behaviors, teachers will not find it difficult to adapt their approach to objectives to meet local requirements or personal preferences.

Grade 6 UNIT TITLE Sculpture: Materials with Messages

OVERVIEW

In this unit students are introduced to a number of monuments of world sculpture followed by focus on the works of six contemporary Japanese sculptors and two prominent British sculptors. Students will analyze and interpret several sculptures, ciscuss different purposes for sculpture, and create two sculptures, one made from natural materials and one carved from a relatively soft material.

UNIT OBJECTIVES

- 1. Students will engage in historical research and report their findings. They will study materials about contemporary Japanese sculpture and the work of two British sculptors, Barbara Hepworth and Henry Moore.
- 2. Students will practice interpreting feeling and meaning from sculpture. They will respond to slides and pictures of sculpture from various times and places.
- 3. Students will create two sculptures based on different views of art.
- 4. Students will ponder and discuss differences in purpose and function of sculpture from a range of cultures and times.

MATERIALS FOR PRODUCTION

- 1. Notebooks and sketch pads for sketches and ideas
- 2. Collection of natural materials, such as sand, stones, dirt, cotton, wood in various forms, rope, cardboard, papers, and others stored in plastic buckets or bins
- 3. Modeling clay

RESOURCES

- 1. Art books and pictures of sculptures from around the world
- 2. Slides of designated works by Japanese and British sculptors

ASSESSMENT OPTIONS

- 1. Written response to designated sculptures
- 2. Brief papers on sculpture topics
- 3. Assessment of quality of student sculptures, including their records of the process in notebooks and sketch pads

Grade	# n Title		
FOCUS		INTRODUCTION	
Statement of the generalization about art emphasized in th		An introductory paragraph on the topic of the lesson	
lesson		INSTRUCTION	
OBJECTIVES Students will:		Explicit step-by-step guidance for the teacher, including rationales for practice as needed	
2.		2.	
RESOURCES		EVALUATION	
Audio and visual instructional aid sources	ls and other teaching re-	Suggested assessment strategies that correlate directly with the lesson objectives	
• • TIME X class session(s) MATERIALS AND PREPARATION		1.	
		2.	
		BACKGROUND	
		Written materials for teachers' use	
		Art in Context (art history/culture)	
List of materials and tools students u		Art and Meaning (art criticism)	
and preparation tasks for the teach	ier	Creating Art (art making)	
		Questions about Art (aesthetics)	

A performance objective is usually stated as a declarative sentence in terms of observable student behavior or performance: for example, "The student will select, discuss, draw, write . . ." and so on. In the case of a single activity, such as centering clay, the objective is specific; in the case of a sequence of activities, such as doing a research paper or making an animated video, the objective is broader. It is also possible to set an objective for a group: for example, "The class will conduct the cleanup period without teacher intervention." In developing performance objectives, program planners consider the following elements:

1. *Identification of the individual or group* that will perform the desired behavior.

- 2. *Identification of the behavior* to be demonstrated through the product to be developed. The behavior should be described, as precisely as possible, in terms of an *action* that can be followed; or similarly, the product should be described precisely as an *object* that can be observed.
- 3. *Identification of the primary conditions* under which the performance is expected to be measured. These might include restrictions placed on the project during the performance of specified tasks.
- 4. *Establishment of the minimum level of acceptable performance.* This step is the critical phase and the one that poses the most problems. What is the criterion for success? How will it function in evaluation?

LESSON 1 Contemporary Japanese Sculptors

FOCUS

Some sculptors emphasize inherent qualities of materials to express ideas and feelings. They believe that direct response to natural materials is aesthetically powerful.

OBJECTIVES

Students will do the following:

- 1. Study artworks by contemporary Japanese sculptors
- 2. Make a list of materials and elements used by the sculptors in their work
- 3. Formulate several ideas or values that seem to be expressed by the Japanese artists
- 4. Make a list of materials available for students' own sculpture projects

RESOURCES

- Slide Related Effects S-90LA, by Ebizuka
- Slide Untitled, by Tokushige
- Slide Range of Mountains, by Toya
- Slide Silence, by Tsuchiya
- TIME

1 class session

MATERIALS AND PREPARATION

• Students will use paper and pencils to take notes for their notebooks and to make lists of materials.

INTRODUCTION

Japanese sculptors of today combine Western and international understandings and techniques for making art with traditional Japanese cultural values. The notion that natural materials have intrinsic aesthetic value and "life" to be experienced by the sensitive viewer is central to the work of these artists. Students will investigate these values by viewing and discussing sculptures by these artists and by creating their own sculptures with materials available locally. The scale of student work will be limited only by local available space and materials.

INSTRUCTION

- 1. Show slides of works by contemporary Japanese sculptors, and discuss the materials used by the artists. Most materials are evident in the work, but others are mentioned in the background materials. Make a list of materials on the chalkboard as they are identified through class participation.
- 2. Discuss the list of materials, and help students realize that all are natural materials and elements (water and fire). The metals are minerals that have been processed by fire.
- 3. Tell students that you will show all slides again, mentioning titles and approximate size of the sculptures, and ask them to speculate about what messages the artists are attempting to convey in their work. Assist students to note the artists' respect for natural materials, especially wood; the lack of representation of figures or objects; and the large size of many of the works.
- 4. After students have speculated about meanings expressed by the sculptural pieces, write the names of the Japanese artists on the board and read selected statements from the background materials. Select statements that reveal the artists' purposes and ideas central to their work.
- 5. Ask students to formulate ideas expressed by the artists and make a list of these ideas or values. You might dc this as a class discussion, or ask students to work in small groups and share their lists in class discussion. You might develop such ideas as these:
 - a. There is beauty in human engagement with nature.
 - b. Artists work with natural materials to express their "inner being."
 - c. The artists' work is about natural themes: growth and change, creation and destruction, life and death.
 - d. Artists must understand and be sensitive to the inherent properties of their materials.

(continued)

LESSON 1 (continued)

- e. Trees and other natural materials have their own personality and character.
- f. Artists leave expression to the materials rather than impose their will on the materials.
- 6. After discussing these ideas and others, tell students that they will work in small groups to organize materials and create sculptures based on the Japanese sculptors' ideas and sensitivities. Ask students to make a list of materials that are available locally for their use in this project. Make plans to begin collecting materials to bring to school at the site of your project. Note: The availability of materials will depend on your local setting (city, rural, desert, mountain, and so on). Keep in mind that found materials can be used as well as pure materials, such as sand, rocks, and dirt.

EVALUATION

- 1. Show the Japanese sculptures again, and ask students to write a paragraph about ideas or values expressed in the works. Collect the paragraphs, and assess levels of individual students' understandings of the main ideas discussed in class.
- 2. Were students able to identify and list materials used by Japanese sculptors?
- 3. Ask students to work in groups to brainstorm materials they might collect and use in their sculptures.

BACKGROUND

Contemporary Japanese Sculptors (Written materials about the artists and about Japanese culture and tradition as well as quotes from the artists follow.)

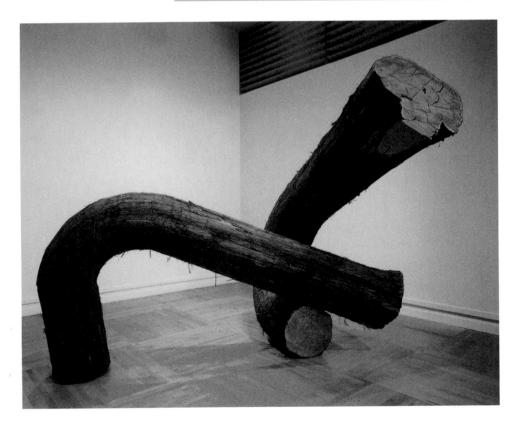

5. *Establishment of the means of assessment,* which will be used to measure the expected performance or behavior. What forms will assessment take? Checklists, informal observations, anecdotal records?

One benefit in understanding these requirements is that teachers might become much clearer in their thinking when writing curriculum as they focus sharply on exactly what they intend and how they will know when and if students are able to accomplish it.

Obviously, planning a program can be arduous and time-consuming if teachers feel they must do the entire job themselves rather than consult existing models. Most

◄ Chuichi Fujii, Untitled (1985), Japan. Japanese cypress, 118" high, 145³/₄" wide, 114¹/₄" deep. The artist used his own secret process to bend these massive logs and endow them with apparent latent energy. Like fellow Japanese sculptors, Fujii conveys a respect for the inherent qualities of natural materials. Rather than impose his own vision upon the wood by carving it to resemble a figure or object, the artist maintains the natural character of the tree. How would such a work provide the basis for an art activity? What sorts of materials might be used? How does this work by a contemporary Japanese artist relate to Japanese traditions such as the design of gardens? teachers, in any case, will not be expected to plan entire programs on their own. The suggestions described are intended as a brief introduction for readers who suddenly find themselves on a team required to produce a total art program in depth and detail.

The idea of approaching art instruction in a disciplined

manner may seem rather extreme to the teacher who feels that art lies beyond careful planning. But every teacher, regardless of philosophy or subject, must face the results of his or her instruction, and planning for art simply requires that the instructor consider the results before beginning to teach.

NOTES

- 1. Ralph Tyler, *Basic Principles of Curriculum and Instruction* (Chicago: University of Chicago Press, 1950).
- Lois Petrovich-Mwaniki, "Multicultural Concerns in Art Education," *Translations: From Theory to Practice* 7, no. 1 (Spring 1997).
- 3. Lauren Resnick and Leopold E. Klopper, *Toward the Thinking Curriculum: Current Cognitive Research* (Alexandria, VA: Association for Supervision and Curriculum Development, 1989).
- 4. John Dewey, Art as Experience (New York: Capricorn, 1958), p. 46.
- Elliot W. Eisner, Cognition and Curriculum Reconsidered, 2d ed. (New York: Teachers College Press, 1994); and Arthur Efland, Art and Cognition: Integrating the Visual Arts in the Curriculum (New York: Teachers College Press, 2002).
- Elementary Art Programs: A Guide for Administrators (Reston, VA: National Art Education Association, 1992).
- National Center for Education Statistics, Arts Education in Public Elementary and Secondary Schools: 1999– 2000, NCES 2002-131 (Washington, DC: U.S. Department of Education, 2002).
- 8. Art Education in Action, Tape 3: "Making Art, Episode B: Integrating Art History and Art Criticism," Evelyn Pender, art teacher, videotape (Los Angeles: Getty Center for Education in the Arts, 1995).
- Music Educators National Conference (MENC), National Standards for Arts Education: Dance, Music, Theatre, Visual Arts (Reston, VA: MENC, 1994), pp. 5, 50–51.
- 10. Ibid.

- 11. The list of goals is taken from *Curriculum Study Group: Social Studies* (Newton, MA: Newton Public Schools, 1992).
- 12. Art Education in Action, Tape 4: "Art History and Art Criticism, Episode B: Art Informs History," Ethel Tracy, second-grade teacher, videotape (Los Angeles: Getty Center for Education in the Arts, 1995).
- Janet L. Olson, Envisioning Writing: Toward an Integration of Drawing and Writing (Portsmouth, NH: Heinemann, 1992).
- 14. Ibid.
- 15. Minuette Floyd, "Multicultural Understanding through Culturally and Personally Relevant Art Curricula," Parts 1 and 2, NAEA Advisory (Reston, VA: National Art Education Association, 1999); and Elizabeth Manley Delacruz, "Multiculturalism and Art Education: Myths, Misconceptions, Misdirections," Art Education 48, no. 3 (1995): 57–61.
- Roger D Tomhave, "Value Bases Underlying Conceptions of Multicultural Education: An Analysis of Selected Literature in Art Education," *Studies in Art Education* 34, no. 1 (Fall 1992): 48–60.
- Patricia L. Stuhr, "Multicultural Art Education and Social Reconstruction," *Studies in Art Education* 35, no. 3 (1994): 171–78.
- 18. Bernard Young, ed., Art, Culture and Ethnicity (Reston, VA: National Art Education Association, 1990).
- Consortium of National Arts Education Associations, "Joint Statement on Integration of the Arts with Other Disciplines and with Each Other," *NAEA Advisory* (Reston, VA: National Art Education Association, 1992).

- 20. Tyler, Basic Principles, chap. 1.
- M. Frances Klein, "Approaches to Curriculum Theory and Practice," in *Teaching and Thinking about Curriculum*, ed. James T. Sears and J. Dan Marshall (New York: Teachers College Press, 1990), pp. 3–14.
- 22. Renee Sandell, "Feminist Concerns and Gender Issues

ACTIVITIES FOR THE READER

- 1. Describe in some detail the significant planning decisions that must be made in an art program developed in the following situations: (a) a sixth-grade classroom in a new, wealthy suburb of a large city; (b) a thirdgrade classroom in a temporary school for the children of construction workers in an isolated part of North Carolina; (c) a mixed-grade classroom (first through fourth grades) in a mission school for Native Americans located in New Mexico.
- 2. Describe how you would constructively handle a situation in which your principal was more interested in having an art program based on a rigid approach of outdated concepts than on a contemporary, creative approach. Choose a classmate, and do some improvised role-playing on the subject.
- 3. You are elected chairperson of an eight-person ad hoc committee in a city school system to submit ideas to a central authority for the improvement of the art program. You are expected, furthermore, to select the eight members of the committee. State the kinds of

in Art Education," *Translations: From Theory to Practice* 8, no. 1 (Spring 1999).

23. This matrix outline and the following unit and lesson plans were derived from Kay Alexander and Michael Day, *SPECTRA Art Program*, *K*-8 (Palo Alto, CA: Dale Seymour Publications, 1994).

people you would choose. Describe the agenda you

- would draw up for the first hour-long meeting.
 Because of negative associations with a previous art program, your fifth-grade pupils do not seem interested in helping you develop an art program. Describe how you might improve matters.
- 5. Improvise the conversation you might have with a parent who thinks teaching art is a waste of taxpayers' money, which should be used for "more important fundamentals." Try this conversation with various types of parents: professionals, lower-middle-class factory workers, and local shopkeepers.
- Plan a sequence of six art activities for the middle grades, all based on a theme of your choice. Try one unit for a limited budget and one for a generous budget.
- 7. Review the section on "Thinking Skills in the Art Curriculum," and determine what art activities are suggested by the styles of thinking listed.
- 8. Plan a lesson of your choice, using the example prepared on "Contemporary Japanese Sculptors."

SUGGESTED READINGS

- Alexander, Kay, and Michael Day. *Discipline-Based Art Education: A Curriculum Sampler*. Los Angeles: Getty Center for Education in the Arts, 1991.
- Banks, James A. Cultural Diversity and Education: Foundations, Curriculum, and Teaching. 5th ed. New York: Allyn and Bacon, 2005.
- Day, Michael, and Getty Center for Education in the Arts. "Viewer's Guide." *Art Education in Action.* Santa Monica, CA: Getty Center for Education in the Arts, 1995.
- Deasy, Richard J., and Harriet M. Fulbright. "The Arts' Impact on Learning: The Evidence Is In, and It's Positive." *Education Week* (January 2001): 34, 38.

- Dorn, Charles. *Mind in Art: Cognitive Foundations in Art Education.* Mahwah, NJ: Lawrence Erlbaum Associates, 1999.
- Efland, Arthur. Art and Cognition: Integrating the Visual Arts in the Curriculum. New York: Teachers College Press, 2002.
- Efland, Arthur, Kerry J. Freedman, and Patricia L. Stuhr, eds. *Postmodern Art Education: An Approach to Curriculum*. Reston, VA: National Art Education Association, 1996.
- Eisner, Elliot. *The Arts and the Creation of Mind*. New Haven, CT: Yale University Press, 2004.

- ——. Cognition and Curriculum Reconsidered. 2d ed. New York: Teachers College Press, 1994.
- ———. The Kind of Schools We Need: Personal Essays. Portsmouth, NH: Heinemann, 1998.
- ——. Re-Imagining Schools: The Selected Works of Elliot Eisner. New York: Palmer Press, 2005.
- Erickson, Mary, and Bernard Young, eds. *Multicultural Artworlds: Enduring, Evolving and Overlapping Traditions*. Reston, VA: National Art Education Association, 2000.
- Gelineau, Phyllis. Integrating the Arts across the Elementary School Curriculum. Belmont, CA: Wadsworth Publishing, 2003.
- Henry, Carole, and National Art Education Association. Middle School Art: Issues of Curriculum and Instruc-

tion Reston, VA: National Art Education Association, 1996.

- McFee, June King. Cultural Diversity and the Structure and Practice of Art Education. Reston, VA: National Art Education Association, 1998.
- Smith, Falph, ed. Readings in Discipline-Based Art Education. Urbana and Chicago: University of Illinois Press, 2000.
- Stewart, Marilyn G., and Sydney Walker. *Rethinking Curriculum in Art.* Worcester, MA: Davis Publications, 2005.
- Winner, Ellen, and Lois Hetland. "Does Studying the Arts Enhance Academic Achievement?" *Education Week* (November 2000): 46, 64.

WEB RESOURCES

- Association for Supervision and Curriculum Development (ASCD): http://www.ascd.org/. Provides professional development and support in curriculum creation and implementation. Provides a wide array of education information services.
- CRIZMAC, Art & Cultural Education Materials: http:// www.crizmac.com/. Publishes curriculum materials. An excellent source for multicultural art resources.
- Crystal Productions, Art Education Resource Materials for Elementary, Secondary, and College: http://www .crystalproductions.com/catalog/index.php
- Davis Publications: http://www.davisart.com/. Publisher of art curriculum, books, images in every format, posters, videos, and CD-ROMs and other resources for art and elementary-school teachers.
- Department of Education, "Summary Statement: Education Reform, Standards, and the Arts: What Students Should Know and Be Able to Do in the Arts," *National Standards for Art Education:* http://www.ed .gov/pubs/ArtsStandards.html
- The National Art Education Association (NAEA): http:// www.naea-reston.org/. Professional support and resources for art teachers and administrators. Provides links to state organizations and commercial art suppliers.
- National Endowment for the Humanities, *EDSITEment:* http://www.edsitement.neh.gov/. Brings together the

top humanities websites, lesson plans, and other useful teacher resources. Growing database of online lesson plans and other links. Excellent search ability provided for the site.

- SBC, Knowledge Network Explorer, *Blue Web'n:* http:// www.kn.pacbell.com/wired/bluewebn/about.html. An online library of Internet sites categorized by subject, grade level, and format. The site is well designed and features links to quality resources, lessons, and tools for art teaching and technology. The Hot Lists are interesting and helpful.
- University of North Texas, North Texas Institute for Educators on the Visual Arts, *Curriculum Resources:* http://www.art.unt.edu/ntieva/artcurr/index.html. The North Texas Institute creates comprehensive art curriculum materials for use by art and classroom teachers, including art historical, cultural, and critical content as well as production activities. These materials are adaptable for different grade levels and teaching styles.
- Virtual Curriculum, Elementary Art Education: http:// www.teachingarts.org/. Designed for teachers and art educators of elementary-age children. The lessons include concepts, objectives, vocabulary, materials, procedures, and evaluation. Links are provided to museums and other related resources.

CLASSROOM ORGANIZATION AND EXHIBITION OF STUDENT WORK

The art room is . . . the teacher's canvas on which ideas are showcased, the curious are challenged, and responses are invited.

—George Szekely, "Visual Arts"

To conduct an art program successfully, the teacher must often plan alterations and additions to the basic classroom provided. In this chapter we will discuss some of the ways a general classroom may be modified to accommodate pupils engaged in artwork. Some attention will be given also to the planning of an art room, if such a separate room is available. We will deal first with the physical equipment and functional arrangements for art activities in different types of rooms. In the second half of the chapter, we will discuss the display of student artwork. Many of the problems that arise from the task of reorganizing a room for art are unique to the particular situation. The size and shape of a room, the number of children in a class, and the types of activities in the program all will modify the arrangements to be made. Making suitable physical arrangements for art, therefore, presents a challenge that in the long run only the teacher can satisfactorily meet.

PHYSICAL REQUIREMENTS OF THE CLASSROOM

A classroom in which art is taught requires physical provisions for storing equipment and supplies, preparing supplies for the class, and setting out the supplies for current work. The room should accommodate slide or digital and overhead projectors and a video monitor, as well as the display of large art prints. After children learn where supplies are stored and how to move so they do not get in one another's way (all of which they learn through discussion with the teacher and subsequent practice), they must have suitable places to work. Drawing and painting are quiet activities; cutting and hammering are more active. Papers for

This U.S. student is proud of her work on exhibit and interested in the output of her class peers. Note the paired variations of the same head drawings and the large size of the work.

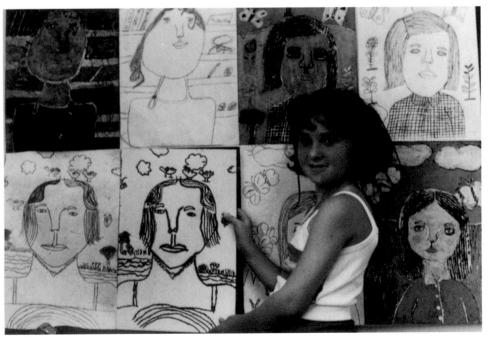

drawing and painting are usually much larger than those for writing, so surfaces to accommodate them must be larger than most school desks. A drawing board is necessary. Drying unfinished or completed work, storing unfinished work, and displaying work also require their own spaces. These requirements suggest the following furniture:

- 1. A storage cupboard with some adjustable shelves, the latter at least 8 inches wide for small items and at least 18 inches wide for larger items. The outside dimensions of the cupboard will, of course, be determined by the floor and wall space available.
- 2. Two tables, preferably at least 5 feet long and 30 inches wide, one to be used largely by the teacher in arranging and displaying supplies and the other for children's group work.
- 3. A sink, or a stand for pails of water. The sink should have at least two faucets to hasten the cleanup activity.
- 4. A drying shelf or battery of shelves near a source of heat. The shelf should be about 12 inches wide and as long as space permits. Shelves can also be placed over windows, because this space is rarely used.
- 5. Some display facilities, such as cases and bulletin boards.
- 6. Some markerboard space—but not so much as to displace needed display areas.
- 7. Blackout drapes, projectors, and screens for showing slides and videos and for overhead projection.
- 8. Storage for art prints, slides, and other art resource materials.
- 9. Walls that can accommodate pushpins.
- 10. Drying racks for wet works (paintings and prints) in progress.

BASIC SUPPLIES AND EQUIPMENT

Although each type of art activity demands particular tools and equipment, and sometimes special room arrangements, the following list of tools and supplies seems basic to nearly any art program. Miscellaneous supplies and equipment, such as scissors, thumbtacks, masking tape, and a paper cutter (18-inch minimum), are not listed because they are part of general equipment for other subjects. Craft materials are not listed because they vary so much with each teacher. Paper cutters are potential hazards and require instruction on their use.

- 1. *Brayers:* Available in a variety of widths from 3 to 8 inches. Soft rubber rollers are recommended, and a set for one class can service the entire school.
- 2. *Brushes:* For painting larger areas—flat, hog-bristle, 1/4-inch to 1-inch wide; for painting detailed sections—pointed, sable, large (size 6 or 7) paste brushes.
- 3. *Chalk:* Soft; 10 or 12 colors plus black and white; dust-less preferred.
- 4. Crayons: Wax; soft; 10 or 12 colors plus black and white.
- 5. Oil crayons: Often known as oil pastels.
- 6. Pens: Felt-tip marking pens.
- 7. *Drawing boards:* About $18'' \times 24''$; soft plywood at least "BC" grade (that is, clear of knots on at least one side); Masonite, composition board (optional).
- 8. Erasers: Artgum type.
- 9. *Inks*: Black drawing ink; water-based printing inks in tubes for block printing.
- 10. *Printing surfaces:* Linoleum is traditional but may be too difficult for younger children. A number of good alternative surfaces are available in art supply catalogs.
- 11. *Tempera paint:* Liquid in pints or powder in one-pound containers (white, black, orange, yellow, blue, green, and red as basic; magenta, purple, and turquoise as luxuries; probably twice the quantity of black, white, and yellow as of other colors chosen).

Tempera paints have been the traditional mainstay of painting activity. Acrylic paint is now priced competitively with tempera and should be considered for its distinguishing properties: It is waterproof and therefore ideal for interior and exterior wall murals murals on paper can be rolled up without flaking. It will adhere to any surface—clay, wood, glass, and so on. When it is applied thickly, objects can be embedded into it; when thinned with water, it can serve as a substitute for watercolor.

- 12. *Watercolor paint:* Secondary-color selections are preferable.
- 13. *Paint tins:* Muffin tins, with at least six depressions; baby-food jars and frozen-juice cans may also be used.
- Paper: Roll of kraft (brown wrapping), about 36 inches wide; or "project roll," 36 inches wide; white and manila, 18" × 24", cream and gray, 40 pound; colored construction, 12" × 18"; colored tissue; newsprint, 18" × 24".
- 15. Paste and glue: School paste, in quarts; powdered

wheat paste for papier-mâché; white glue for wood joining (thinned, it works well as an adhesive for colored tissue).

- 16. Pencils: Drawing; black, soft.
- 17. *Printing plates:* Glass trimmed with masking tape for inking brayers.
- 18. Firing clay: Minimum of 3 pounds per child.
- 19. *Slide or digital and video projectors:* This equipment should be available.
- 20. Collection of art prints, postcards, and other reproductions.
- 21. Filing cabinet: For item 20.
- 22. *Art books and magazines:* These should be available in the art room or the library.
- 23. *Recycled materials:* Bottles, heavy cardboard, newspapers, wood scraps, corks, string, containers, buttons, and so on organized in containers.

CLASSROOM ARRANGEMENTS

A Primary-Grade Classroom

The teacher's preparation of art materials for young children is often quite different from that for the upper grades. Older children can usually select art materials for themselves, but the primary teachers must, at least at the beginning of the school term, arrange sets or groupings of materials. These vary greatly in the number of items they contain. For example, for crayon drawing, children need only six crayons and a sheet of manila paper each. For painting, they require perhaps aprons or parents' old shirts, a sheet of newspaper or oilcloth to protect the painting surface, two brushes and a sheet of newsprint each, paint cloths, and some liquid colors.

From a necessarily large and convenient storage space, the teacher selects materials and places them on a long table, cafeteria style. Crayons may be put on a paper plate and set on the sheet of paper. The teacher may assemble the painting kit in discarded "six-pack" cartons, on a metal or plastic tray, or on a wooden work board. The paint should not be included at this point, because children could spill it as they transport the kit to the place where they will be painting. Paint and any other "dangerous" materials should be placed in the work area ahead of time in broad-based containers (jars or milk cartons). The following suggestions may be helpful in storing tools and supplies so they will be ready for distribution:

- 1. Place brushes and pencils in glass jars, with bristles and points up. Blocks of wood with holes bored in them, each hole large enough to hold one item, provide another convenient way of arranging brushes. This manner of storage also allows the teacher to make a quick visual check for missing brushes.
- 2. Separate crayons according to colors. Store only one color in each container, which might be a milk carton or a cigar box.
- 3. Roll moistened clay into balls, and place them in a large lidded earthenware jar or plastic bags to keep in the moisture.
- 4. Cut paper to size, and arrange it on a shelf in piles according to size and color.
- 5. Separate paper scraps according to color, and save them in small cartons or folders.
- 6. Store paste in covered glass jars. After paste has been mixed for use, the teacher should place it on disposable paper plates or simply on pieces of cardboard.
- 7. Spread oil or Vaseline on the rim or cap of a jar in which tempera is stored so the paint will not harden and the cap can easily be removed.

It is fortunate that the furniture in most primary rooms is movable, because floors provide an excellent work area for art. If the floor is covered with heavy linoleum or linoleum tile, it is necessary to set down only a thin protective covering, such as oilcloth, plastic sheets, or wrapping paper, before work begins. Tables are often used for drying three-dimensional projects.

Because it is desirable for all children eventually to learn how to procure and replace equipment and supplies for themselves, the room should be arranged so children can perform the task easily.¹ In the primary grades, as elsewhere in the art program, the cafeteria system is useful. Children must develop the ability to obtain and replace art materials according to a plan that they themselves help determine. The teacher should discuss with children the necessity of learning these skills. However, in the primary grades the children will usually follow plans willingly and treat the routine as a game. The game can even include a rehearsal or drill of the routine.

A General Classroom

Many contemporary school plans give considerable thought to suitable accommodation for art activities in general classrooms. A description of the special provisions for art in the general classroom is offered here primarily for those teachers who are provided with a reasonably liberal budget for the furnishing of their art facilities.

In most classrooms desks can be easily arranged to suit the studies in progress. Movable desks are a great convenience for drawing and painting, because they allow a pupil to use a drawing board without interfering with other children. Clusters of desks may be arranged so large flat areas of working space are available for group activities.

In some contemporary classrooms, an entire wall is provided with fixtures that facilitate the teaching of art. These can include a counter covered with Formica or some other suitably processed material, built from wall to wall. This counter houses probably the most important single convenience for art activities—a large sink supplied with hot and cold water. Below the counter are several storage cupboards equipped with adjustable shelves and swinging doors, where all expendable supplies may be stored. A second row of cupboards is suspended about 12 inches above

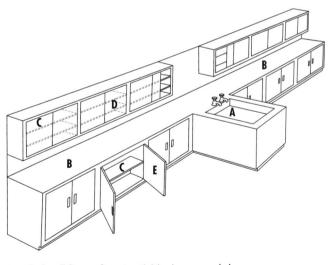

A typical wall fixture for art activities in a general classroom.

- A. SinkB. Counter
- D. Sliding doorsE. Swinging doors
- C. Adjustable shelves

the counter. These cupboards also have adjustable shelves, but the doors are of the sliding variety so pupils will not bump their heads on them when open. Additional supplies or the pupils' unfinished work may be kept in this storage space. Electrical outlets are frequently provided at convenient intervals along the counter. The whole assemblage, which substantially resembles a work unit in a modern kitchen, occupies relatively little floor space. Sometimes an additional work counter is provided along part of the window wall; more cupboards may be built below this counter.

Because the teacher in a general classroom requires a relatively large expanse of chalkboard, it is sometimes difficult to find sufficient space to display art. This is often provided, however, on the side wall to the rear of the room and on two walls above the chalkboards, where a wide strip of tackboard is fastened. However, because even these areas are usually insufficient for display purposes, many new schools are being equipped with display boards and cases in the main halls of the building.

The Art Room

In today's educational world, budgets are not always large enough for accommodating a separate art room in a new school, although this is recommended by the National Art Education Association (NAEA). If not all the ideas set forth in this section can be adopted, perhaps some of them may be employed as the teachers gradually improve the working conditions in their school. Ideally, the art specialist is consulted when a new school or new addition is planned.

DESIGN

An art room should be placed near a service entrance on the main floor of a school building, for convenience in delivering supplies and equipment. In junior high and middle schools, it is preferable also to have the room situated reasonably close to industrial-arts shops so pupils may conveniently move from one room to another to use special equipment.

According to standards developed by the NAEA, because student art projects and materials may be bulky and rooms must fulfill multiple purposes for contemporary art programs, art rooms need to be larger than general classrooms.

NAEA recommends 55 square feet per student, not

including storage, kiln rooms, and teacher's office, and a maximum pupil-teacher ratio of 28:1. This leads to an art room covering 1,540 square feet, excluding auxiliary space. NAEA recommends 400 square feet for the storage room, 45 square feet for the kiln room, and 120 square feet for the teacher's office.²

Lighting in an art room is of the greatest importance. Natural north lighting is recommended whenever possible. Preferably, the lights should be set flush with the ceiling, with the exception of spotlights for important displays. Unless the room has a daylight screen, the windows should have blackout curtains to control lighting. In all matters pertaining to both artificial and natural lighting, architects and lighting engineers should be consulted. Many excellent materials and arrangements are available, including directional glass bricks, opaque louvers, clerestory lighting, and various types of blinds.

The efficient use of space around the walls should also be considered. Along one of the shorter walls, there might be storage rooms jutting into the room. Two storage areas are desirable: one to house a stock of expendable art materials and the other to store the pupils' unfinished work. Each storage room should be fitted with as many adjustable shelves as convenient. Because the shelves may rise to a considerable height, there should be at least one lightweight stepladder available. The outside walls of these storage rooms, facing the classroom, can be covered with tackboard. The long wall area opposite the windows should for the most part be faced with tackboard running from about 30 inches above the floor up to the ceiling. An area of about 20 square feet, however, should be reserved for a chalkboard. Space might be provided for counters and cupboards

The sink may be located on this long side of the room. Its position should be reasonably central, and it should be accessible from at least three directions (see the floor plan in the diagram). It may be placed in a separate cabinet so the pupils can approach it from all directions, or it may be placed at the end of a counter running at right angles from the wall toward the center of the room. However arranged, the sink should be large, deep, acid resistant, and equipped with hot- and cold-water taps. Clean-out traps should be fitted, and all plumbing leading from them should also be acid resistant.

Along the entire wall at the end of the room and op-

posite the storage rooms, storage cupboards might alternate with glass-enclosed display cases. These cases should be provided with adjustable glass shelves and illuminated with hidden or indirect lights.

Beneath the windows, a work counter might run almost the full length of the room. Below the counter, storage cupboards could be constructed, or the space might be left open to house tools. Jutting out at right angles might be a series of small counters for delicate work. Each small counter, perhaps collapsible, should be provided with a stool of convenient height. An area might be set aside for the teacher's desk and files.

The placement of electrical outlets is a task for an expert who understands electrical loads, but the teacher must be sure that outlets are placed in correct locations for their use. In addition to outlets for ceramic and enameling kilns and service outlets in general, there should be an outlet for an electric clock. The pupils should always be aware of how much time is available to begin certain phases of their work or to start cleaning up toward the end of the art period.

FURNISHINGS

Certain equipment should be placed in convenient relation to the arrangements around the walls. Such items might include an electric kiln with a firing area of not less than 3,000 cubic inches, a pullout storage bin for clay, a storage box for keeping clay damp, and a spray booth. The clay-working area should be located near the sink. A filing cabinet for storing catalogs, folders containing information about the students, and miscellaneous items useful to the teacher should be placed near the teacher's desk.

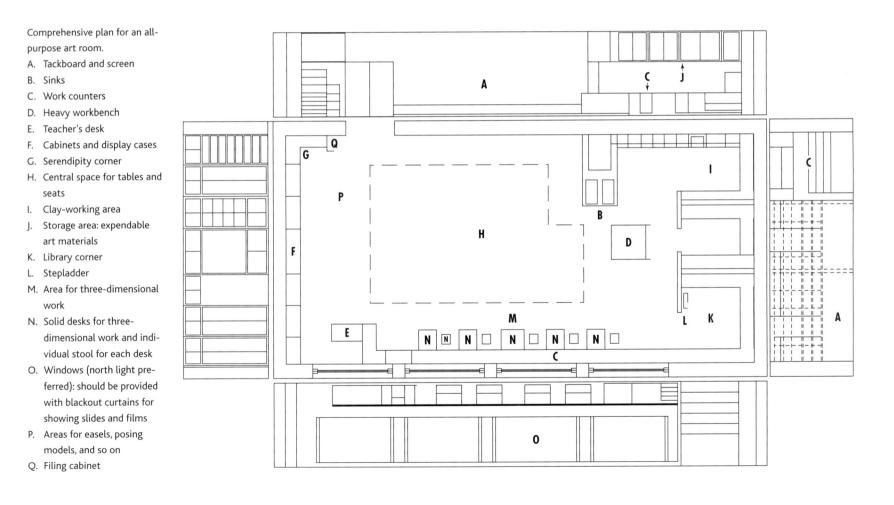

Furniture for the art room must be chosen with care. Suitable art desks come in a variety of designs, but a desk with low shelves on which the pupils may place schoolbooks would have optimum utility. For seating, chairs, stools, and benches are all useful. One or two carpenter's benches, as well as desks for drawing and painting, should be provided. The benches should be supplied with vises and have storage space beneath them for tools and other equipment.

The colors used to decorate the art room must be carefully planned. Bright colors are generally to be avoided because they "rebound" and confuse a painter. Tints or neutral colors such as pale grays or off-white are recommended for the walls and ceiling. The ceiling should be lighter in tone than the walls. The floor should be neutral but mottled. In general, color in an art room must not interfere with the color work in progress, and it must serve as background for the displays of the children's work.

Before an elaborate art room of the type described can be set up successfully, much study must be given to the problem. Particular attention should be given to the grouping of furniture and equipment to avoid overcrowding in any one part of the room and to locate in an area everything necessary for any one type of work. Obviously, an art room entails costly construction, and whatever arrangements are made, good or bad, are likely to be in use for a long time. One example to study is the accompanying comprehensive plan for an all-purpose art room.

CREATING A LEARNING ENVIRONMENT

Equipment, facilities, and storage have been considered thus far, but functions other than purely practical ones are also essential. The art room should be an environment for learning about art as well as an assembly of hardware. It must contain many stimuli; it must be a place for sensory excitement; it is also the child's link with the world outside the classroom.³ Here, before painting a favorite animal, a child may have access to slides, paintings, or photographs of animal life. One day the teacher may bring in a live puppy, kitten, or turkey to study. At times the art room may resemble a science laboratory as the teacher attempts to acquaint the children with intricate or hidden forms of nature. The room should be visually appealing with art visuals and other interesting displays connected with the art curriculum.

A corner of the room might be reserved for research and supplied with art books, well-illustrated children's books, magazines on a suitable reading level, file material, CVDs, and videos. Another part of the room might be set aside as a "serendipity corner"—a place for interesting and unusual things to draw. Each teacher creates a unique classroom environment that serves to attract students' interest and support art learning

One way to create a learning environment in the art room is to have the children themselves design portions of the room. The teacher who thinks of the child as entering a studio of visual delight—a place for looking, feeling, shaping, and forming—will have some idea of what the art room or even a section of the classroom might be. The moment a child enters should be one of happy anticipation. The art room is a space where creative things happen; it should be the most attractive place in the child's school life.

WHY EXHIBIT CHILDREN'S ART?

From the art program come tangible visual results of the learning experience: the art programs unique within the school curriculum with truly visible results that can be exStudents gather around one of the large tables in this Hong Kong art room. The room organization includes bookshelves, chalkboard, exhibition areas with student work on display, screen for projections, and easily movable seating. This is a large art room for a middlelevel school. The art teacher, Leung Chi Fan, has invited a local artist whose drawings of people riding the subway system provide the theme for a curriculum unit.

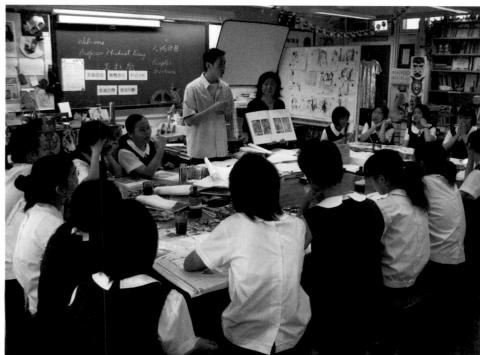

hibited over a prolonged period. Art lends itself to display, which serves as the final communicative stage of the creative process.

One reason for displaying art is simply that the results of children's artistic acts are usually worth observing for their aesthetic qualities. Children's art is often so attractive that it should be brought forth for people to see and enjoy. The display of children's art is also an effective teaching device. One common method of display is to group the work according to topics or themes. When 25 or more pupils in a class present their reactions to one theme, it is highly educative for all to observe those reactions. If art is suitably taught, no two children will make identical statements about an experience. As they view and discuss the artwork of fellow students, the children may gain a broader insight into the topic as a whole.⁴

The display of children's art tends to develop certain desirable attitudes toward the school. When young children see their artistic efforts on display, they tend to sense a oneness with the group. Their participation brings out a feeling of belonging, which often increases the fullness of subsequent participation.

Children's art on display also has its decorative purposes. The classroom is usually a barren place when the teacher enters it before the beginning of the school year.

Likewise, the halls of many schools are dull, institutional places until suitable decorations have been arranged. The artwork of children humanizes the character of a school building.

More and more, schools are serving as institutions of learning by day and as community centers by night. Parent– teacher groups, night-school classes (in which, among other subjects, art may be studied), and other meetings of interest to members of a community are causing greater numbers of adults to visit the schools than ever before. This is desirable, because it provides the school with an opportunity to show the public what is being done with taxpayers' money. Furthermore, it presents an opportunity to arouse or maintain public interest in education in general and art education in particular.

Art displays operate on three different levels: the classroom, the school, and the community. In the classroom or art room, display is linked closely to instruction and also enhances the environment. In the school and community, however, it should be used to alert viewers to the nature and goals of the art program. Student work should be presented with labels conveying such information as the student's name, school, teacher, and grade; the title of the piece; and—most important—the concept, goal, or unit to which the work is related. In some cases, as in exhibiting the results of a curriculum unit, it is advisable to provide background material in the form of a written introduction. If a lesson is related to art history, reproductions of the artist's works might be included. Exhibitions should be viewed as a way of educating the public.

SELECTING WORK FOR EXHIBIT

Probably the first question in the teacher's mind when exhibiting art is how to choose the work. The criteria for selection should be both pedagogical and aesthetic. Although children will find interest in the art output of others, they are also interested in their own work and are usually proud of it. This means that every child in a class sooner or later during the school term should have some work on display. Because space is limited in a classroom, pupils cannot expect their work to appear very often, but they will accept this fact if they feel that their chances to have work displayed are equal to those of others.

As children mature, they develop an ability to appraise the standards of both their behavior and their artistic output. When children realize that their output has not reached

Administrators can play a critical role in the life of an art program. This Australian principal gives students house paints so that they can create large-scale artwork to be attached to exterior walls of the school. an accustomed standard, displaying their work would in all likelihood be an embarrassment to them. Before a particular child's work is displayed, therefore, a teacher would do well to consult with the child.

If work for display is chosen with these ideas in mind, the child of exceptional ability will not create the problems of selection that might otherwise occur. It would be discouraging for the members of the class to see a more gifted child's work repeatedly occupying a major portion of the displays to the partial exclusion of the work of others. The gifted child exhibits a range of success just as everyone else does. This being the case, only the most significant items of that child's expression need appear on display.

The teacher will not have to save all the artwork of every pupil during the school year to summarize the general progress of each child. Although some of the work may be kept in a portfolio for reference, the teacher will be able, for the most part, to remember each child's earlier performances. More teachers are using digital cameras and computers to record the progress of each child. Some send a CD record of each child's work to the parents at the conclusion of the school year.

In general, it is suggested that the farther the display is removed from the classroom, the more selective should be the process of choosing the works to be displayed. When children's art goes to the front hall or to some location in the community, each piece should be selected as a representative of student learning in the art curriculum. In the classroom, the work of the entire class should be displayed.

ARRANGING EXHIBITS IN THE CLASSROOM

Displaying Two-Dimensional Work

The display areas should not be overcrowded. Ideally, each piece should be set apart and mounted in some way. Mounts should be chosen so their color unifies the display but does not conflict with the colors used in the drawings and paintings themselves. Grays, browns, and sometimes black are usually suitable colors for mounts. White is also recommended, because it flatters the picture and gives a clean look to the exhibit. When the display panels are made of soft wood, cork, or composition board, both mount and picture may be most conveniently fastened to the display area by a gun-type wall stapler or clear-headed pushpins. Thumbtacks should be avoided because they distract the viewer's attention from the work.

Mounts or frames may be devised in a number of ways and with several materials. The simplest, cheapest, and, many think, most attractive method of mounting is to attach a sheet of newsprint, paper, or cardboard to the dis-

Displays need not be limited to completed works; they can also present processes and involve parents in the subject or media in the exhibits.

play board and to fasten on this a drawing or painting having smaller dimensions. This method can result in a variety of effects by altering the proportion of background to picture. Mounts need not be wide. Even a 1-inch border with a 2-inch lower border can be effective, as long as it leaves room for a label.

When a display is arranged, a title is usually required. Titles, of course, become part of the general design of a display. The students may produce a title in two dimensions with lettering pens and india or colored inks and felt-tip pens. Attractive background papers of contrasting color or texture help make titles particularly arresting. Computergenerated titles have become popular, as has the use of calligraphy (often with special pens).

The simplest and most common arrangement of pictures on a display panel is one that follows the rectangular shape of the board. The pictures are hung so their edges are rowest. A square panel calls for even margins at top and sides, with a wider margin at the bottom for information

parallel to those of the board. More often than not a formal balance is achieved, so the viewer's attention will be attracted equally around imaginary central axes of the board. The margins established between the picture frames and the outside edges of a display panel that is horizontal should be such that the bottom margin is widest, the top narrowest, and the width of the sides in between. In a vertical panel, the traditional proportions to be observed reverse the proportions of sides and top: the bottom is the widest, the top is second in size, and the sides are the nar-

This display board includes a variety of visuals, including student work in two dimensions and three dimensions, newspaper clippings, an exhibition poster, a poster for students, notes, and other items. Although content for the display is disparate, the basic composition of background colors adds structure to the overall design.

regarding the work. These classic arrangements are safe; and by using them, one may tastefully display any group of pictures.

If display panels are not available, it may prove difficult to exhibit works of art in the school hall. Curls of masking tape on the back of pictures are often used to attach flat work to such surfaces, but this is far from ideal because of the expense involved and the tendency of pictures to slip. Two permanent solutions are strips of cork bolted to the wall and/or framed 4' imes 8' sheets of composition board or any other material that takes staples and pins. Avoid Masonite for this reason. Masonite pegboard, however, is excellent, because bent metal hooks can be inserted to hang shelves, puppets, and other three-dimensional objects.

As each display is added, it must be considered in relation to whatever displays are already on view. In general, it is wise to restrict displays to those areas especially designed for them. Markerboards, chalk ledges, and windows are functional parts of the classroom whose efficiency is impaired by displays of art.

Here are some other points the teacher might keep in mind when setting up bulletin-board displays and exhibits:

- 1. A bulletin board has somewhat the same function as a poster. Both must capture attention, provide information, and present a unified design through pleasing relationships of textures, masses, subject matter, and lettering.
- 2. Pins with clear plastic heads are the best fasteners, metal pins next, and tacks last. Staples may be used if a staple remover is available.
- 3. Background spaces should be uncluttered, to give the eve a rest.
- 4. Respect the eye level of the viewer. A good average height is 5 feet, 6 inches.
- 5. Avoid extreme "artiness," such as complicated diagonal arrangements.
- Bulletin-board exhibits should seldom be on display 6. for more than two weeks. There is no disgrace in occasionally having a blank display area.
- 7. If possible, use a well-lighted area for the display.
- Usually tops or sides of pictures should be aligned for 8. consistency and order.
- When "going public," avoid supermarkets and other 9. busy environments that distract from the exhibit. Local libraries, banks, and store windows are good candidates for exhibitions of school art.

- 10. Avoid large groups of objects that are too similar in either size or subject. Twenty drawings or paintings of different sizes can maintain variety within themselves.
- 11. Occasionally, break up displays with a sudden shift of scale. It can be quite exciting to have the usual $12'' \times 16''$ or $16'' \times 24''$ works set off against a lifesize painting or mural.
- 12. Some works are "quieter" (lower key, smaller scale, less obtrusive) than others. A group of quiet paintings fares better than a row of loud ones, which tend to cancel out one another's effectiveness. Try alternating works of contrasting character.
- 13. Statements by students or teachers or Polaroid photographs of a class in action can add diversity and a documentary effect. The life of the classroom can be brought into the exhibition.
- 14. Nothing is more barren than a blank wall when the public has become accustomed to a surface filled with art. Leave the walls empty for at least a week before putting up the next show. A never-ending exhibit ends up as pure decoration, and after a while the public may take it for granted.
- 15. Examine the public relations potential within your community. Your local newspaper or TV station might provide coverage of a student exhibition.

Displaying Three-Dimensional Work

Many classrooms are not equipped with display cases for three-dimensional artwork. It is frequently necessary, therefore, for the class to improvise other means of display. If space is available, a table may be placed directly in front of a display board. The three-dimensional objects may then be set on the table, and descriptions of the work or related two-dimensional work may be pinned to the board.

The objects should be arranged according to their bulk and height. Obviously, the largest and tallest objects will have to be placed well in the background so smaller objects

► The ceramics room in this middle-level school is a small room connected to the larger art room. Storage shelves are necessary for drying ceramic pieces and keeping them safe in their fragile state before firing. Potters' wheels are stored here along with aprons for students to use while working with clay. Fired and glazed student work is displayed on the metal table on a regular basis, ready for exhibition in other display cases near the principal's office and in other locations around the school.

◄ The teacher has reserved this section of the art classroom for an aesthetically pleasing exhibit free from the clutter that inevitably gathers in the typical art room. Although carefully designed and maintained, this quiet corner is functional as well, with crayon pastels ready for use, drawers for storage of papers and art reproductions, exhibition room for student clay projects, the teacher's telephone, clock, and other items.

will not be hidden. Some groups of objects, particularly modeled or carved forms and pottery, will demand the use of pedestals. The pedestals, which can be made from boxes or blocks of wood, may be painted or covered with textiles. By placing a sheet of heavy glass over one or more of the pedestals, it is possible to arrange a convenient series of shelves of varying heights. Ceiling space can be utilized in many unusual ways, particularly for mobiles and kites. Caution should be used, however, in hanging objects from the ceiling, for certain ceiling surfaces and lighting fixtures must be treated with care. Consult custodians and principals before hanging anything from a ceiling.

Teaching

Because the display of art is an art activity in itself, it is highly desirable for children to take part in it. Even a 6year-old can see how much better a drawing looks when it

A large zigzag display in a school gymnasium. Activities that normally take place in the gym must be rescheduled to accommodate the exhibit. Moreover, setting up such an exhibit may involve a good deal of the teacher's time and energy, even though the exhibit itself may be on display for only a short time. Pat Renick, designer.

is mounted and displayed. A simple act such as this can establish the connection between design and order in a young mind. Moreover, display techniques may lead to excellent group endeavors. Kindergarten is not too soon for children to begin this work. Kindergarten children may participate in quasi-group activities in which individuals bring their work to some central area for display.

The teacher should encourage pupils to experiment with new ways of displaying their art. One method is to have members of the class report on any outstanding display techniques observed in store windows or elsewhere. Another method is to have the teacher from time to time arrange children's work, demonstrating some new ideas for display.

ARRANGING DISPLAYS OUTSIDE THE CLASSROOM

The problems arising from displays arranged in the halls or elsewhere in a school are little different from those related to classroom exhibits. More people and examples of work are involved, of course, so organizational problems are intensified.

Media and Techniques

School architects should give attention to display possibilities. It is not unusual for some elementary schools to have display cases or gallery-type walls designed adjacent to the principal's office.

If no gallery space is available, school authorities may be expected to provide suitable panels. When the panels or cases are being installed, those responsible for the installation must remember to arrange suitable lighting.

On occasion the school may need additional display facilities. Many extra panels might be required on "Parents' Night," for example, when the school wishes to make an exceptional effort to interest the community. The design of panels for extra display facilities has become almost standard. The panels consist of sheets of building board, usually measuring from $4' \times 4'$ to $4' \times 8'$, with legs bolted to either end. The legs are usually in the form of inverted Ts, but other ingenious and attractive designs are to be seen. For three-dimensional displays, a boxlike construction having shelves takes the place of a panel.

A second type of portable display board has been designed for space saving and quick assembly. It consists of panels of building board and sturdy legs with slots cut into two adjacent sides. The panels are fitted into the slots to form a zigzag effect that is pleasing and practical. The panels are made secure by lashing the legs together with cord at the top and bottom of the panels.

Another portable display unit requires $2'' \times 2''$ wooden rods slightly more than 5 feet in length, with holes bored at approximately 30-inch intervals. These rods will receive 1-inch dowels, on which hang metal rings attached to the pictures. The placement of the holes on the rods determines how the units may be angled so the flow of traffic can be controlled.

THE EXHIBITION AS COMMUNITY EDUCATION

The subject matter of art exhibits for parent and community groups may be different from that of displays for children. Parents and other adults are interested not only in the work as such but also in the objectives and instructional contexts of the work shown.⁵ We should remember that for many adults, the comprehensive program of art in schools today is completely different from the art education they received in their youth. Although ignorance of the contemporary program sometimes leads to disapproval, parents are generally quick to react favorably to present-day trends in art education once they understand the goals and content of the program.

For parents, subjects of exhibitions of children's art might emphasize the instructional implications of the art activities. Display written commentary next to artworks when a problem of critical reaction or art history is involved. Themes of exhibitions may dramatize the overall structure of the art program or a single aspect of it. The following are a few sample topics that have proved satisfactory for "Parents' Night":

The Art Program: A Grade-Level Approach Looking at Nature Personal Development through Art Variety in Artistic Expression Group Work in Art

Learning from Other Artists Art and Visual Culture Art from Other Cultures, such as Asia or the Middle East Arts of Today

For each exhibition, brief but effective signs should be made to emphasize the points demonstrated by the children's work. Each show, moreover, should have a clearly marked beginning; a logical sequence of ideas throughout the body of the exhibition; and a short summary, either written cr pictorial, or both, at its close. The exhibit is more than another chore for the teacher. It is the most dramatic means of communicating the teacher's role in the school to the administration, to other teachers, and to the community.

Rarely has there been a more impressive place to set up a display of children's art than in one of the main galleries of the Hermitage Museum, St. Petersburg. The work comes from special children's art classes in the museum.

- Art Education in Action, Tape 3: "Making Art, Episode B: Integrating the Art Disciplines," Sandy Walker-Craig, elementary teacher, videotape (Los Angeles: Getty Center for Education in the Arts, 1995).
- 2. MacArthur Goodwin, ed., *Design Standards for School Art Facilities* (Reston, VA: National Art Education Association, 1993).
- 3. Frank Susi, "Preparing Teaching Environments for Art Education," *NAEA Advisory* (Reston, VA: National Art Education Association, 1990).
- 4. *Art Education in Action*, Tape 3: "Making Art, Episode A: Integrating Art History and Art Criticism," Evelyn Pender, art teacher, videotape (Los Angeles: Getty Center for Education in the Arts, 1995).
- 5. Kelly Bass, Teresa Cotner, Elliot Eisner, Tom Yacoe, and Lee Hanson, *Educationally Interpretive Exhibition: Rethinking the Display of Student Art* (Reston, VA: National Art Education Association, 1997).

ACTIVITIES FOR THE READER

- 1. Describe the various criteria used by teachers you have observed to select children's artwork for display. Appraise each criterion according to its educational effects on the children concerned.
- 2. Study and compare the display techniques you have observed in various classrooms.
- 3. Sketch in pencil or crayon some plans for a display of five pictures. Select the plan you like best, and use it in an actual panel display.
- 4. Repeat number 3, this time including at least 12 pictures.
- 5. Make some plans for the display of 5 to 15 pieces of student pottery. Make sketches, and select the plan you like best.
- 6. List some subjects for an art display to be used in the main entrance of a school on "Parents' Night." The entrance hall is about 25 feet long and 12 feet wide. Af-

ter selecting the subject that most appeals to you, indicate in detailed sketches (a) the type and position of the display panels, (b) the number of and subject matter of the pictures or three-dimensional objects, (c) the captions to be used, and (d) the route visitors should follow to view the exhibition.

- 7. Collect a number of boxes of varying sizes, and arrange them so that when covered with one piece of cloth, they provide an attractive setting for ceramics, sculptures, or other three-dimensional objects.
- 8. As part of a field experience, such as a visit to an art classroom, gifted program, or art museum, work with colleagues to mount a display demonstrating what was learned and encountered on the trip. Take photographs of the completed display, and make a journal entry about its effectiveness in the classroom.

SUGGESTED READINGS

Bass, Kelly, Teresa Cotner, Elliot Eisner, Tom Yacoe, and Lee Hanson. *Educationally Interpretive Exhibition: Rethinking the Display of Student Art.* Reston, VA: National Art Education Association, 1997.

Evertson, Carolyn M., Edmund T. Emmer, and Murray E.

Worsham. Classroom Management for Elementary Teachers. 5th ed. Boston: Allyn and Bacon, 2000.

Seefeldt, Carol. Creating Rooms of Wonder: Valuing and Dis-

Qualley, Charles A. *Safety in the Artroom.* Worcester, MA: Davis Publications, 1993.

playing Children's Work to Enhance the Learning Process. Beltsville, MD: Gryphon House, 2002.

- Spandorfer, Merle, Deborah Curtiss, and Jack W. Snyder. Making Art Safely: Alternative Methods and Materials in Drawing, Painting, Printmaking, Graphic Design, and Photography. New York: Van Nostrand Reinhold, 1993.
- Susi, Frank Daniel. Student Behavior in Art Classrooms: The Dynamics of Discipline. Teacher Resource Series. Reston, VA: National Art Education Association, 1995. Szekely, George. "Visual Arts." Visual Arts Teacher Re-

source Handbook: A Practical Guide for Teaching K–12 Visual Arts, John A. Michael, ed. (Milwood, NY: Kraus International Publications, 1993).

- Weinstein, Carol Simon, and Andrew J. Mignano. Elementary Classroom Management: Lessons from Research and Practice. 2d ed. New York: McGraw-Hill, 1997.
- Zuk, Bil, and Robert Dalton, eds. *Student Art Exhibitions: New Ideas and Approaches*. Reston, VA: National Art Education Association, 2001.

WEB RESOURCES

The Art & Creative Materials Institute (ACMI), *Safety— What You Need to Know:* http://www.acminet.org/. ACMI is a nonprofit association of manufacturers of art, craft, and other creative materials. Since 1940, ACMI has sponsored a certification program for children's art materials, certifying that these products are nontoxic and meet voluntary standards of quality and performance. The website lists all the art products that are certified as safe for children by ACMI and provides information about art materials. Office of Environmental Health Hazard Assessment, *Guidelines for the Safe Use of Art and Craft Materials:* http://www.oehha.ca.gov/education/art/index.html. This website, maintained by the state of California, provides a section devoted to the use of art and craft mater:als by children, including some that may have health risks. The site provides information and criteria for evaluation, selection, and use of art supplies and addresses other environmental problems associated with art classrooms.

ASSESSING STUDENT LEARNING AND ACHIEVEMENT

An effective art assessment program enables the art educator to diagnose student strengths and weaknesses early and on a regular basis, to monitor student progress, to improve and adapt instructional methods in response to assessment data, and to use information about students individually and as a group to manage the classroom more effectively.

-Donna Kay Beattie, Assessment in Art Education

Art teachers, like their colleagues across the curriculum, are asked to take full responsibility for assessment of learning in their classrooms. Art in today's schools is a subject for all students. All students can study, practice, learn, and understand art as an essential part of their general education. Art teachers at all instructional levels are expected to develop expertise in assessment as part of their professional preparation. Their understanding of assessment in art education should be commensurate with their competencies in curriculum and instruction. Indeed, these three areas of teaching expertise must be fully integrated in practice.

The arts contribute unique perspectives within the field of educational assessment. By their very nature, products created in the arts can be seen, heard, and viewed in their particular forms. In the visual arts, teachers have access not only to finished works by students but also to the record of procedures used in their creation with various media and through assorted processes such as sketches, plans, notebooks, and portfolios, all part of the rich heritage of art. Art educators have at their command an array of assessment strategies much more meaningful than the traditional paper-and-pencil tests so prevalent in schools.

As often as possible, assessments in art should include actual performances in the forms of created artworks, essays and critical responses, interpretations and evaluations of works of art, and other educationally appropriate tasks. Assessments are, as often as possible, fully integrated with and consistent with national, state, and local standards; the art curriculum; and the instructional strategies employed by teachers.

Although most art educators will probably agree that assessment is a necessary component for responsible education, it might be the least well-developed and most misunderstood part of art education. In this final chapter, we will discuss assessment terminology, principles of assessment, and types of assessment; provide examples of devices and applications; and attempt to dispel some potential misunderstandings about assessment of art learning.

DEFINING TERMS

As we approach assessment, it is useful to review terminology commonly used in this important arena. Recent developments in the field of assessment have contributed to an increase in the number of assessment-related terms teachers should know and understand.

The term assessment is frequently used interchangeably with the term evaluation. However, the terms have acquired important subtle differences. Assessment is a kind of "temperature taking." Assessment is "the method or process of gathering information about people, programs, or objects for the purpose of evaluation. Effective assessment techniques can improve classroom instruction, empower students, heighten student interest and motivation, and provide teachers with ongoing feedback on student progress."1 Assessment evidence can also provide meaningful information helpful in evaluating the effectiveness of curriculum, instructional methods, and teachers' performances. Evaluation involves a summing-up process in which assignment of a judgment about the overall worth, quality, merit, or value of the object being evaluated results. Evaluation includes carefully examining the array of factors that contribute to the creation of the product and synthesizing them into the final judgment.

Assessments are generally clustered into three categories, including standardized, authentic, and alternative. *Standardized assessments* involve the standardization of content, method of administration, and creation of norms. Standardized test or item content examines knowledge

Jasmine, age 7, created this multimedia self-portrait in "My Trip to New York." The attention to details, such as the pattern on her clothes and the folds in Liberty's robes, make this work unusual and interesting.

common to a large population. Such content has been scrutinized for its relevance, clarity, and appropriateness. The method of administration is fixed to include explicit directions, set time limits, and instructions. The intent of providing uniform methods of administration is to "level the playing field," or to create equivalent conditions under which all subjects can generate responses on standardized tests. The creation of norms is based on the actual performances of groups of people. Norms facilitate interpretation of scores on the tests by permitting comparisons of test performances of groups or individuals with the cumulative performances of other groups or individuals who have taken the same tests. Authentic assessments are those assessments that are performance based and include real-life decisions and behaviors like those of professionals in the discipline. Authentic assessments might resemble tasks in which artists, art historians, art critics, or aestheticians may routinely engage. Authentic assessments focus on the ability to use relevant knowledge, skills, and processes for solving open-ended problems during meaningful tasks. By contrast, alternative assessments are generally nontraditional and teacher mediated. Typically, they do not include traditional paper-and-pencil item formats, and they may not mimic knowledge, skills, or processes of professionals in the discipline. Although different from authentic assessments in structure and design, alternative assessments enable students to express their knowledge in ways that may be challenging as well as meaningful to them. Alternative assessments may include measures such as games, puzzles. worksheets, and checklists.

Assessments, whether standardized, authentic, or alternative, can take place at various times. Formative assessments occur during the period in which creation of art products occurs. Formative assessments are conducted for the purposes of diagnosis, revision, description, or comparison. Teachers can gain a sense of the problem-identification and problem-solving processes used by students at various stages in the creation of their art products. Formative assessments enable teachers to establish a record of the evolution of students' art products and understand factors that influenced their creation. Summative assessments are conducted after completion of the creative process or activity. Summative assessments permit teachers to judge the final product of the activity. Summative assessments can be conducted to verify, predict, or validate the product or activity. They enable teachers to acquire understanding of the achievement or learning levels of students as displayed in

the culmination of their final products. Summative assessments are limited in that they rarely reveal information about the thought processes or creative experimentation involved in creation and evolution of the final products.

Testing is commonly associated with assessment. A *test* is an instrument or systematic procedure involving a series of questions (or exercises or other means of measuring the skills), knowledge, intelligence, capacities, behaviors, or aptitudes of an individual or group. It is of importance for tests to be designed to measure students' acquisition of specified knowledge, skills, or processes taught in the classroom. Testing may involve use of standardized measures or tests made by teachers

Development of rubrics is useful for some assessment needs. A *rubric* is a means of evaluating students' products or performances. Rubrics include a listing of specific criteria related to the activity or product and a value scale to indicate the relative level or quality of the performance or product for the criteria. Rubrics enable teachers and students to identify students' particular strengths or deficiencies relative to each criterion. Aggregate scores are useful for identifying areas of strength in students' performances, enabling teachers to maintain or build upon them.

The concepts of validity and reliability are central to the theory and practice of assessment. *Validity* is the measure of how well a test or assessment matches the function for which it is being used. If an assessment lacks validity, the information it provides is useless. Valid assessments must include a representative sample of what was taught. They must also involve a level of intellectual complexity that will provide profiles of varying levels of achievement among students. *Reliability* is the degree to which an assessment can consistently measure whatever it has been designed to measure. However, a measure can be reliable without being valid, but an assessment cannot be valid unless it is reliable.

INFORMAL ASSESSMENT

We regularly make value judgments about many aspects of schooling, ranging from the quality of textbooks to the adequacy of school facilities or the behavior of individual students. Most assessment is accomplished informally. On entering the classroom, for example, the teacher notices the room temperature, the lighting, and the arrangement of furniture. The teacher assesses the situation and makes the necessary changes. As the students enter the room and the class period progresses, the teacher makes numerous quick assessments of the students, noting who is engaged in activity and who is not, and adjusts teaching strategies accordingly. The teacher speaks quietly with a student, moves on quickly to a restless group, demonstrates a technique, offers words of encouragement, chastises mildly, and so on, as each situation warrants—all the while noticing in what ways students are encountering difficulties in their work and formulating changes in the plans for tomorrow's activity.

FORMAL ASSESSMENT

Formal assessments are devised to gain important information for educational decision making, decisions ranging from assignment of student grades to program revisions to school policy changes. We will discuss a variety of means for conducting formal assessments of pupil progress, including traditional tests and more authentic devices such as portfolios.

Verification of student learning is the reason for most formal assessment in schools, and because a report of student progress is usually required, this form of evaluation holds a high priority. The basis of appraisal of a pupil's progress in any area of learning often can be found in the objectives of that area. Well-stated objectives can reflect not only the specific contributions the subject has to offer but also the philosophical foundations and educational practices of the school system. An appraisal of the progress of any pupil involves a judgment of the efficacy of the school system in general and of the teacher's endeavors in particular.

Assessment and instruction are both guided by the educational goals and objectives of those who educate (see Chapter 1). Assessment must be made compatible with objectives, and results should be reported in ways meaningful to those who receive them.² Five basic questions can be asked about any system of evaluation:

- WHO will do the evaluation? Teachers? Pupils? Some outside agency?
- WHAT is being evaluated? Attitudes? Curriculum content, such as skills, knowledge, or processes?
- WHO will be evaluated? Elementary-school children? Teachers? Special students?
- WHAT is the range of the evaluation? Pupil? Class? Course? Entire school? Art program?

And finally, perhaps the most difficult:

• WHAT is the purpose or function of the assessment?

In studies in which art teachers identified their use of assessments, Robert Sabol reports that art teachers assess for these reasons: 3

- 1. Grade student achievement
- 2. Provide feedback from students
- 3. Provide instructional feedback to students
- 4. Evaluate curriculum
- 5. Set goals and standards
- 6. Diagnose students' needs
- 7. Evaluate their teaching
- 8. Identify strengths and weaknesses of the art program

For this discussion we refer to assessments that teachers conduct for their own students, classrooms, and curricula and not to the work of professionals. This discussion is intended to assist teachers with the practical problems of assessing both their own work and that of their students.

Concerns about Assessment in Art Education

The use of educational assessment distinguishes between what is traditional and what is contemporary in art education. Art educators in the past were concerned that formal assessment might discourage children from learning and progressing in their own creative production.⁴ The assessment process might place too much emphasis on children's art products and inhibit their expressions of personal feelings. These concerns have been expressed most prominently in relation to art programs that are nearly exclusively dedicated to children's work with art media. Sabol reports additional concerns that include the belief that assessments control the curriculum rather than provide indications of its effectiveness. Art teachers are concerned about the lack of uniform performance standards, guidelines, procedures, and assessment tools. Other concerns include the inability of assessments to measure a broad range of learning, lack of teacher knowledge and training about assessment, and the amount of time taken away from studio production.⁵

Few educators would disagree with these concerns about assessment, which must always serve to improve education rather than detract from it. Assessment should not be arbitrary, nor should it discourage children from learning and progressing in their understanding of art. Overemphasis on children's art products should be avoided, and the processes of learning and creating are of utmost importance. Such devices as tests should not dominate the art curriculum, influencing teachers to teach for test results. Such negative aspects are not the inevitable results of educational assessment and are certainly not related to uses within a responsible, comprehensive art program. Assessment can be unobtrusive and interesting for students and, in some instances, a part of learning activities.

Positive Effects of Assessment in Art

Assessment in art education has contributed a number of positive effects. Because of its widespread use in all disciplines, assessment has become commonplace in the art classroom; and students, parents, and administrators have come to expect assessment in art classrooms. In a recent study, art teachers reported that assessment accomplishes the following:⁶

- 1. Makes students more aware of the goals for the program
- 2. Provides feedback for students and teachers about learning and shows growth
- 3. Helps students better understand assignments and improve their work
- 4. Motivates students and provides accountability for students
- 5. Provides credibility for the art program
- 6. Indicates whether goals and objectives for the program are being met
- 7. Improves students' self-esteem
- 8. Improves teaching and makes teachers more introspective
- 9. Improves students' understanding of their grades
- 10. Increases respect from administrators

ASSESSMENT OF STUDENT PROGRESS IN ART

As with other school subjects, many factors influence the progress of students as they study art. Following are some of the questions that assessment might assist teachers to answer:

- 1. Are students enjoying a positive experience in class? Is the learning environment compatible with the goals for learning?
- 2. Are changes in the pace of learning needed? Is a shift in instructional strategy warranted? What about grouping of students versus individualized learning projects?
- 3. What are students learning? How does this relate to pricr expectations for the class? How does this relate to prior performance by the students? And to students' own expectations? How is students' learning reflective of national and state standards?
- 4. How can the teacher become more effective? How can sound judgments about student progress be made?
- 5. How can the teacher communicate with students about their strong and weak points in art? How can the teacher communicate the accomplishments of students to other teachers, school administrators, and parents?

A Balanced Program of Assessment

Assessment conducted as the school term unfolds can be used for two purposes: first, as feedback about the art class and how things are progressing; and second, as a basis for end-of-term decisions. Teachers should engage in ongoing collection of information to assist in decision making related to these purposes. Reflective teachers review the relative successes of the curriculum and their instructional methods at various junctures during and after the school term. They are equally willing to modify curriculum and instructional methods to better suit the educational needs of students, goals of the program, or requirements from the state.

Assessment of student learning may also assist teachers in making summary statements about student accomplishments and the relative success of the class. At the conclusion of the school term, often some type of final assessment is conducted to certify student learning and to diagnose areas of the curriculum that might need extra emphasis in the future. This might include a wide range of assessment devices, including final examination checklists, portfolio reviews, and personal interviews. Often, at this time, teachers are required to report on each student's success in accomplishing the goals and objectives of the curriculum by assigning a letter grade or by providing a more descriptive analysis of the student's work. The teacher can draw on all the information obtained during the school term as well as on postinstructional assessments to prepare this report.

A balanced plan of assessment will provide teachers with appropriate and useful information that will assist them in making sound decisions about individual students, the curriculum, and the overall art program.

Some Guiding Principles for Assessment in Art

The prospect of assessing the creative artwork of children is a concern to many teachers. Before discussing this topic, we offer several broad assessment principles that we hope will make the teacher's task easier and more acceptable.

- 1. As in all areas of art learning, assessment should be closely related to instruction. This means that teachers can expect children to learn what is taught and that they should focus assessment on those skills and understandings that children have had a fair opportunity to learn. In order for this to successfully happen, there should be a good match between what is to be learned, the learning process involved, and the content and format of assessments. Assessment of student progress then becomes more a measure of the teacher's abilities to foster learning than a means to distinguish students' strengths and weaknesses.
- 2. Creativity and expressiveness are difficult to assess with reliability. We seldom attempt to assess students' creativity or expressiveness. More often, assessment is focused on what students have learned as a result of instruction. Students' creative and expressive efforts should always be encouraged, whether or not we are able to measure their progress.
- 3. Students who do not exhibit great natural ability in making art still will be able to succeed because of the diversity of a comprehensive art program. Students who appear to have natural abilities for making art will be rewarded for their efforts but will need to make progress in the other areas of learning as well.
- 4. Part of instruction in art making deals with clear-cut skills, such as knowledge of color theory resulting in abilities to mix the hues, change color value and intensity, and identify cool and warm hues. Children can learn to apply technical skills and principles associated with any art medium. Successful curriculum in art provides activities that require students to demon-

strate their knowledge of content and of the skills and processes needed to create art products.

- 5. In evaluating student performances, consistent, fair, stable, and reasonable standards and criteria should be applied. It is important for students to understand the criteria by which their work will be evaluated. Such knowledge can help students focus their work more effectively and make better use of their time. The teacher's evaluations of students' products must be uniform and constant, and students must have a real sense that the process is fair.
- 6. Teachers should attempt to give students a variety of activities to demonstrate their understanding and skills of content that was taught. Moreover, using multiple methods of assessment provides a more comprehensive, informative picture of what students know and can do than a single assessment does.

When the art program focuses on the learning of art knowledge and skills, students soon realize that art can be taught and can be learned, just as other subjects in school. If children can learn and practice, they can make progress toward clearly defined, understandable goals. When finished art products reflect the intended learning, the reasons for their excellence can be pointed out, discussed, and related to classroom instruction. As they can with other subjects in the curriculum, students in art can begin with whatever aptitude is given and can progress at faster or slower rates according to their individual motivation and application. The notion that art is only for the few "talented" stars will soon be dispelled, and the idea that art learning is for everyone will be reinforced.

Many assessment problems in the area of art production are alleviated when teachers realize they have different instructional purposes at different times and that different assessment procedures are appropriate according to the specific instructional purpose. For example, when instructional goals call for the learning of specific production skills, assessment can be equally specific. Teachers can readily learn if students are able to overlap objects to represent space, make a graded watercolor wash, or construct a coil clay pot that will hold water. Students' progress in such skills can be assessed, students and teachers can discuss results, and students can learn how to improve.

Not all learning in art falls into this clear-cut relationship between instruction and assessment, however, and

"Self-Portrait," by Tyler, age 10, is a whimsical work with an unusual cropping of the upper head, probably influenced by photography. The facial expression is achieved with minimal lines, and the background is enlivened with colors and shapes.

time should be maintained for art activities with no specified outcomes other than student participation in the process. For example, students who are given access to watersoluble printing inks, brayers, and a container of various objects that can be used to print are asked to explore the possibilities of the medium. The educational expectation is that the children will learn individually and from one another some of the properties and possibilities of the medium. The appropriate educational assessment would be to note students' participation, the level of serious engagement, the sharing of discoveries, and the quality of the learning environment in terms of noise, activity, and attention to the task.

▲ Tamrah, a fifth-grade student, made this frontal portrait with mixed media using the sgraffito technique, scratching through an application of dark crayon to a precolored background. The clearly delineated objects and flat color areas recall Egyptian murals.

The three very different self-portraits were created by students of similar age. Each must be assessed within the context of the art class and the requirements of the assignment, if any were given. Questions that might apply to self-portrait assignments: Did the student make a selfportrait? Is the student pleased with the result? What changes would improve the next try at this type of work? What has the student learned from the experience? How does the work relate to specific criteria (if any) given with the assignment? Does the work meet technical expectations based on instruction and practice? Is the work unique, creative, expressive? Does the work express the personality or appearance of the artist? Comparison of the three selfportraits raises questions of the effects of media on expression and emphasizes again the happy truth that students in art can answer the same question with a wide variance of equally valid answers.

Another fifth-grade student used a block-print technique with black ink on white paper for this self-portrait in which she has included her animal friends.

It would be inappropriate to assess this art activity by testing the children on specific information or skills that might have been discovered by some but that were not presented to all. It would be inappropriate to assess this activity by collecting the results of their experimentation and judging them for aesthetic quality.

Teachers often find themselves faced with the challenge of evaluating not only their students' products but also the actions or behaviors that may not be evident in the products students create. Such behaviors are often clustered under broad headings such as "citizenship," "classroom interaction," "character development," "behavior," and other locally identified designations. These behaviors may be related to the socialization of students or to their individual or group working habits. These behaviors generally play an important role in aiding or restricting learning. Art teachers often include evaluation of students' behaviors in the overall assessment of learning in the classroom. Some school districts require teachers to provide separate grades or reports about students' behaviors, whereas others permit teachers to factor them into the overall grade or evaluation report. Research reveals that art teachers routinely focus some portion of student assessment on these characteristics:7

- 1. Effort
- 2. Problem-solving ability
- 3. Improvement or growth
- 4. Classroom behavior
- 5. Self-motivation
- 6. Turning in assignments on time
- 7. Use of previous knowledge or skills
- 8. Reflection or thoughtfulness (metacognition)
- 9. Critical thinking or analytical ability
- 10. Decision making, reasoning, or use of logic
- 11. Synthesis of ideas
- 12. Behavior in groups

Evaluations of these behaviors are generally the product of teachers' "professional judgment." Teachers judge the quality, degree, and appropriateness of these behaviors based on observation or informal record keeping. Teachers' comparisons of an individual student's actions with those of whole classes or developmental-level expectations are used to arrive at these judgments. In some cases discussions with students, journaling, audio- or videotaping, and various other data-collection methods can support teachers' evaluations of these behaviors.

Perhaps the principal focus of assessment in the art classroom is on the products students create. Traditionally, these products have included an assortment of studio creations in the various visual arts. However, with the current emphasis on aesthetics, art criticism, art history, and visual culture, the range of student products has expanded significantly. It is not unusual for students to discuss, critique, or debate works of art; to write about their artwork, the work of artists, or art from contemporary culture; to read about works of art, art periods, or art forms; or to learn about art and exhibit knowledge gained from these and additional modes of learning traditionally used in other disciplines. Evaluating such products, which may occur in written as well as oral form, requires identification of assorted criteria that may not be useful or even appropriate when evaluating studio products. Evaluating discussions, journals, research reports, in-class presentations, and other non-studio-based products requires that teachers focus on many aspects of student learning.8 It has become of increasing importance for teachers also to evaluate the literacy skills evident in students' written and oral products. Teachers may find themselves confronted with the task of evaluating English usage and grammar in these products. Teachers should keep in mind that although such evaluation may be outside the discipline of art education, it provides teachers with additional input about students' understanding and learning in art, while reinforcing learning in other disciplines.

Having knowledge of various means of assessment, including paper-and-pencil tests, observations, interviews, discussions, questionnaires, attitude measures, portfolios, and other ways to gather information about levels of student learning, and understanding how and when to use them are important for all teachers. In the following section, we present a number of examples to illustrate assessments of differing types of learning that occur in the art classroom.

Some instructional activities will foster individual expression, experimentation, and exploration; others will focus on precise technical skills; and still others will call for students to apply art concepts and skills to produce finished works appropriate to their age level and reflective of the art instruction that has taken place up to that time. A comprehensive art program will include a variety of instructional purposes and various assessment devices. When students are assessed according to their participation, their successful completion of specific tasks, and the quality of their completed artwork, the teacher has a valid basis for

EVERYONE NEEDS TO CARE, A DRAWING LESSON

Children in second grade are shown paintings by Mary Cassatt, Auguste Renoir, and Nicholas Vasilieff, all on the theme of persons caring for pets. After discussing the artists and analyzing content of the paintings, the children are asked to make a drawing of themselves with a pet or object for which they care, such as a doll or toy. The teacher intends that students will "make a connection between their own feelings for something and similar feelings that can be found expressed in works of art." Assessment is focused on the extent to which pupils are able to:

- a. recognize the theme of caring in paintings;
- b. verbalize connections with their feelings and those expressed in the paintings; and
- c. make a drawing that indicates the theme of caring.

Assessment devices in this lesson included class and small-group discussions and teacher's observation of each child's drawing.*

*Mary Lou Hoffman-Solomon and Cindy W. Rehm, "Art Touches the People in Our Lives," in *Discipline-Based Art Education: A Curriculum Sampler*, ed. Kay Alexander and Michael Day (Los Angeles: The Getty Center for Education in the Arts, 1991), pp. A3–A31.

assigning grades as well as for diagnosis and suggestions for improvement.

ASSESSMENT OF LEARNING IN ART CRITICISM

As we discussed in Chapter 12, students in a balanced art program will view many works of art and visual culture, respond to them in depth, and discuss and write about them. They will learn approaches to art criticism, such as the phased approach of description, analysis, interpretation, and informed preference. They will critically examine samples of visual culture and discuss social issues and values embedded in images. Assessment within some parts of the critical domain of art learning is obvious. For example, teachers can determine when students might be able to apply such concepts as visual balance, distortion, and emphasis in their descriptions and analyses of artworks. Teachers can note students' progress in analysis of design and advertising and students' understanding of their intent and influence. Teachers can assess students' progress in developing plausible interpretations of particular artworks and their abilities to support them with good reasons.

Teachers can ask if the children are able to see and understand how artists control and manipulate their media to achieve the desired effects and meanings. In all instances, the levels of instruction and the means of assessment must be suited to the age levels and abilities of the children.

Finding ways to assess children's critical understandings and skills can challenge the teacher's ingenuity. Teachers strive to ask the most meaningful questions about stu-

Diego Rivera, Agrarian Leader Zapata (1931). Teachers can gain insight into children's learned abilities to describe. analyze, and interpret artworks through their spoken and written comments. As children view this fresco, how do they explain the fallen man, his drawn sword, and the beautifully appointed, but riderless. white horse? How do they interpret the tool in the central figure's hand, his placement in front of the fallen figure, and his hold of the horse's rein? From their study of art history, what do children know about the white clothing of the men in the picture, their tools, hats, and the agricultural setting suggested on the right side of the painting? Who are these men, and what is happening? What is the social theme of the painting? What do children know about Rivera, events in Mexico that he depicted, and the fresco process?

Katsushika Hokusai, *The Great Wave*, from *Thirty-Six Views of Mt. Fuji*, Tokugawa period (c. 1823–29). Woodblock print, $14^{3}/4''$ wide. This is one of the few traditional Japanese artworks that has become so well known in the United States that it can be used as a recognizable source in the works of other artists. dents' progress and devise means to gather information in response to these questions. Teachers can collect evidence of children's understandings about purposes and functions of art. They can seek to learn more about their students' knowledge of and recognition of religious, political, and social themes in art, such as in Michelangelo's *Pietà*, Diego Rivera's *Agrarian Leader Zapata*, James Flagg's classic recruiting poster "I Want You," Maya Lin's *Vietnam Veterans Memorial*, and Judy Chicago's *The Dinner Party*. Teachers will use various methods to assess learning activities that integrate content from the art disciplines.

Teachers also need to attend to larger questions about children's progress. Is the art program assisting students to respond more fully to works of art and to derive satisfaction in the process? What evidence can the teacher find to inform this question? What evidence can the teacher find that students are developing positive attitudes toward art? Is instruction leading the children to richer and deeper encounters with art and to a broader and deeper understanding of the purposes and functions of art and visual culture in the lives of human beings? Do the children use valid reasons to inform their art preferences? Do the children seem to enjoy these activities? Several of the methods for assessment discussed in this chapter might assist teachers to answer such questions.

McRay Magleby, *Wave of Peace* (1985). Serigraph poster, $26'' \times 40''$. American graphic artist McRay Magleby made significant changes in Hokusai's *Great Wave* to create a different message in his *Wave of Peace*.

ASSESSMENT OF LEARNING IN ART HISTORY

Art historical learning includes a broad range of topics. Indeed, it would be possible to study much of the history of the world simply through the study of art history. The amount of information and the level of detail in which it is available are nearly overwhelming, making selection of curriculum content a major task.

As noted in Chapter 13, much teaching in art history can be done in a visual rather than in a verbal mode, with visual displays of the artworks and styles of art from various eras and cultures. Topics from art history can be related directly to the interests of children, because the great themes of human experience are available in visual form in the art of the past and present. Reproductions, pictures, slides, videos, CDs, DVDs, magazines, and books about art are readily available.

Assessment methods can be tailored to complement the teacher's instructional approaches. If instruction is intended to assist children to recognize the characteristics of Chinese art, then the assessment should be as general as the instructional goal. For example, the teacher might show the children a series of images of artworks from various cultures and ask them to designate which works are from China. If the children are unable to do this, perhaps the instruction needs to be revised. When instruction in art history is precise in terms of specific information to be learned by students, then traditional objective tests might be appropriate, including identification of specific artworks by artist or style, period or country. When art history is taught to assist children to understand and appreciate the contributions of other cultures and art from different times, assessment must be linked to those purposes. Attitude and preference measures are often as useful in this domain as objective measures.

ASSESSMENT OF STUDENTS' PROGRESS IN AESTHETICS

A balanced art program includes content derived from the discipline of aesthetics, or philosophy of art. Aestheticians deal with many interesting questions that are raised whenever people begin to talk about art. Even young children ask such questions as "Why is this object art and that object is not art?" Aestheticians examine fundamental conceptions of art, beauty, quality in art, and judgments about art.

Aesthetics questions are often integrated within learning activities that involve other art disciplines. Assessment of student achievement in the domain of aesthetics will depend, as always, on instructional goals and strategies. Some assessment strategies will focus on the use of language by children as they read, discuss, and write about the basic questions identified with aesthetics. They will be asked to contemplate the nature of art and to justify their conclusions at levels appropriate for their ages. Children in middle grades, as an example, should be able to demonstrate the difference between art and nature by comparing a photograph of a tree to a painting of a tree and an actual tree.

THE GREAT WAVE, AN ART CRITICISM ACTIVITY

This assessment form is part of a lesson for upper-elementary students in which they learn to use formal analysis as a means to interpret content in paintings. They are asked to make detailed comparisons of two paintings, one a modern revision of the earlier work. This device can provide the teacher with evidence of each pupil's understanding of formal analysis and ability to interpret meaning in two contrasting works. At the same time, this is a learning activity for students.*

THE GREAT WAVE

Compare Katsushika Hokusai's *The Great Wave* and McRay Magleby's *Wave of Peace*. Use the back of this sheet for the last answer and if you need more room for the others.

<i>The Great Wave</i> by Hokusai 1. Color: sky	<i>Wave of Peace</i> by Magleby Color: sky
water	water
whitecaps	whitecaps
other color	other color
2. Share of wave:	Shape of wave:
3. Use of line:	Use of line:
4. Use of texture:	Use of texture:
5. Format:	Format:

- 6. List ways in which Magleby simplified Hokusai's picture.
- 7. Do the two artworks express the same feeling or idea? If not, how are they different?
- 8. Which artwork is more interesting to you? Why?

*Kay Alexander and Michael Day, SPECTRA Art Program, K–8 (Palo Alto, CA: Dale Seymour Publications, 1994), pp. 48–61.

Upper-grade students might be asked to give three reasons for supporting or rejecting a philosophical position (for example, "The purpose of art is to create works of beauty").

METHODS FOR ASSESSMENT OF STUDENT PROGRESS IN ART

Assessment has been a central topic in the discourse of general education reform since the turn of the century. A number of highly visible initiatives have come forward, including President George W. Bush's No Child Left Behind legislation; President Bill Clinton's education agenda, Goals 2000: Educate America; the *National Standards for Arts Education;* standards for art education published by the National Board for Professional Teaching Standards (NBPTS); the 1997 report of the National Assessment of Educational Progress in the Arts; and publication of NAEA's *Standards for Art Teacher Preparation.*⁹ All these publications and projects view educational assessment as an integral compo-

Forgia O'Keeffe at Ninety. Who is this person? What is her place in art histor? Why is she portrayed with

Georgia O'Keeffe at Ninety. Who is this person? What is her place in art history? Why is she portrayed with bleached ani mal bones? Evaluation of cultural and historical learning goes far beyond names, dates, and titles. Teachers can learn from their students how well they understand the roles of artists, how artworks are regarded by scciety and by art experts, and what artists have contributed to the world through their work. Study of the life of Georgia O'Keeffe will lead children from the bustle of her early career in New York City and her association with other, now-famous, artists to her secluded and productive life in New Mexico.

nent of education reform. Leaders in art education have been energetically involved in these initiatives, which will affect the content and quality of education on a large scale.

The most prominent means, traditionally, for conducting assessments has been in the form of standardized tests with multiple-choice and true-or-false items. Limitations of paper-and-pencil testing, which many view as too narrow and too readily biased, have motivated educators to develop alternative forms of assessment. Interest in alternative assessment crosses subject content boundaries, and discussions often focus on such items as exhibits, experiments, journals, and portfolios. Alternative assessments require students to generate rather than to choose a response and to "actively accomplish complex and significant tasks, while bringing to bear prior knowledge, recent learning, and relevant skills to solve realistic or authentic problems."¹⁰ Alternative or performance assessments of student learning include the following:¹¹

- 1. Evaluating students on tasks that approximate disciplined inquiry
- 2. Considering knowledge and skills holistically rather than in fragmented parts
- 3. Valuing student achievement in and of itself and apart from whether it is being assessed
- 4. Attending to both processes and products of teaching and learning
- 5. Educating students to assess their own achievement in consort with assessments of others
- 6. Expecting students to present and defend their work orally and publicly

These criteria for alternative assessment are relevant for assessment in art education. In fact, the concept of portfolios of student work collected over time has a long history in the visual arts and has been recognized within other disciplines (see the section "Portfolio" later in this chapter).

A comprehensive art curriculum involves much visual and verbal content and includes the creative production of students. Following are some examples of traditional and alternative strategies for assessment of art learning.

Observation

The task is for the students in the class to explore the properties of clay in preparation for learning some of the traditional forming techniques. The teacher observes that most of the students are engrossed in the task and seem to be ex-

DIDACTIC DISPLAY, ART HISTORY CONTENT

Fifth-grade students participated in a series of art lessons on the painting traditions of still life, landscape, and figure during which they studied works by various artists from several cultures. They also created their own paintings on each topic. This final assessment is a display activity in the school hallway, with the students assigned to convey what they learned visually to the rest of the school. To do this, students had to accomplish the following:

- 1. Select reproductions of paintings exemplifying the concepts of still life, landscape, and figure
- 2. Make labels denoting these concepts as well as basic information such as title, artist, medium, date, size, and a brief statement about each work
- 3. Select and mount examples of their own paintings, also according to categories with labels and statements by each student artist
- 4. Mount the exhibition with the teacher's (and volunteer parents') assistance

Assessment involves observation of the display itself and how well it meets the assignment. The teacher also evaluates cooperation, quality of writing, and sense of accomplishment and pride exhibited by students.

perimenting with the clay: pinching, rolling, stamping, and marking the clay. Several students appear reticent and seem to need the teacher's attention and encouragement.

Interview

The teacher is interested to learn why a boy in the class consistently has trouble with drawing. The teacher talks to the boy privately in a corner of the room, trying to learn more about the apparent problem. Or the teacher wishes to learn more about what the students know about how the works of art are made, how artists work, and how they are educated. The teacher talks with groups of five or six students, showing them a reproduction of a painting and asking them pertinent questions. The teacher may create a list of questions to ask students prior to the interview or spontaneously generate questions.

Discussion

The teacher wishes to know more about the students' responses to art and their interpretations of what is acceptable as art. The teacher leads a class discussion on a series of reproductions of paintings he or she shows to the students. Each painting shown is more abstract than the previous one. Discussion questions may be open ended, and the teacher is careful to require students to support interpretations they make with thoughtful responses.

Georgia O'Keeffe, *Red Hills and Bones* (1941). Oil on canvas. Historical background about the life of artist Georgia O'Keeffe can help students understand this painting. They can associate the painting of bleached animal bones and the barren red earth with the photograph of the artist. Such learning and associations can be applied in students' own art production as they select subjects or techniques suggested by the study of an artist's life and works. Teachers might assign students to make a painting in homage to a particular artist as an evaluation device, displaying the students' knowledge and understanding of the artist and her or his works.

The teacher distributes tempera paints in the primary hues, black, and white to the children, along with the necessary brush and water. After distributing a sheet of paper divided into six rectangles, the teacher asks the children to mix and paint in the respective spaces orange, green, violet, yellow green, brown, and light blue. Or the teacher gives each child a washable marker and a laminated reproduction of a still-life painting. The students are asked to circle the main centers of interest and to place a plus sign on the positive spaces and a minus sign on the negative spaces.

Carlos Almarez, *Greed* (1982). What is the theme of this painting? How can you support your interpretation? How would you characterize the stance of the two animals? What feelings does the artist arouse through his choice of colors? Describe the colors in terms of hue, value, intensity, and relationship. How does this painting compare with Georgia O'Keeffe's painting of red hills and animal bones? How does the mood of Almarez's painting compare with the mood of O'Keeffe's? Which do you prefer, and why? Teachers can formulate such questions as these and engage children in response to them through various evaluation devices, such as questionnaires, discussions, essays, interviews, and creative art production.

I'M ON VIDEO, A LESSON ON SELF-PORTRAIT

The lesson is on the concept of self-portrait in art. Students view many examples from traditional and contemporary art and make a self-portrait collage using pictures, symbols, and images of any kind that would best express their looks, preferences, or personality. The finished collages are displayed, and the teacher shows a videotape featuring each student outside school in a characteristic setting or activity (the videotape is made with the cooperation and signed permission of parents and other students).

As a peer assessment on a single criterion, the class is asked to match the student depicted in each video segment with his or her self-portrait, noting the relative effectiveness of each collage as a self-portrait and giving reasons for their statements.

Checklist

As the teacher leads discussions of artworks from time to time in the classroom, he or she marks the class roster by the names of those students who participate. The teacher encourages and invites responses from those who have not participated. In another example, the teacher keeps a list of the several drawing exercises for the drawing unit and checks off accordingly as each student completes the exercise satisfactorily.

Questionnaire

The teacher administers a questionnaire that assesses student learning about architectural styles from various cultures and about the reasons for the development of each style. Or students are required to answer a questionnaire about the details of the copper enameling process. Each student must score 100 percent correct on the technical questionnaire, which includes items on hazards and safety precautions, in order to begin work with actual materials.

Test

The teacher administers a multiple-choice and short-answer objective test with questions from several units of study completed during the school term, including items in the aesthetic, critical, historical, and productive domains of art learning.

Essay

The teacher asks students to write about a sculpture, considering the appropriate level of writing ability for the grade level. Students are to use the skills of art criticism that they have practiced several times in class as a large group and in small discussion groups.

Visual Identification

The teacher shows the students images of artworks by artists they have studied in class. The students are to identify the work by artist, by style, or according to other categories they have practiced in class.

Attitude Measurement

The teacher is interested to know how students are responding to the new approach to art education that includes talking and writing about visual culture as well as making art objects. In addition to talking to individual students and holding discussions with the entire class, the teacher develops and administers a questionnaire that asks for students' feelings about specific learning activities that they have completed.

Portfolio

Students' artwork, exercises, written assignments, notes, class handouts—virtually all of what they have produced as they study art—are saved in a folder. Periodically, the teacher reviews this work with each student individually and discusses the student's learning, progress, and aspirations in art.

Judgment of Student Work

When art programs are studio centered, many teachers assume that the basis for evaluation and grading is the teacher's judgment of the quality of students' art products. Art teachers are aware of the biases and inconsistencies likely to occur as they attempt to render judgments, and they might prefer to avoid evaluation. The making of judgments about art, however, is one of the major aspects of art criticism, which is integral to a balanced art program.

Art teachers are able to make judgments of aesthetic quality with respect to their students' artworks in appropriate contexts. Teachers who have taught specific art skills, principles, and understandings and who have implemented a balanced program of assessment using a variety of evaluation tools will gain confidence in making judgments of students' artworks. As an example, the curriculum has taken students through a series of learning activities focusing on the use of basic color theory, composition, and basic drawing skills. The teacher judges the completed paintings according to aesthetic criteria and evidence that students applied the concepts they studied.

Standardized Art Tests

Techniques for assessment range from the most formal test to the most informal conversation with a child. Since the heyday of standardized testing several decades ago,¹² the trend in testing for art ability has been toward specific ends-that is, tests have been designed by teachers or research workers to arrive at limited kinds of information. Tests may be designed for a number of purposes, but in all cases they represent a judgment of the adequacy of behavior as compared to a set of educational objectives. Any test is a reflection of what a teacher considers important in a student's behavior, studio processes, skills, and knowledge about art. The test may be formal or informal, and it may just as easily precede instruction in the form of a diagnostic device as it may follow the instructional period to measure a student's gain. In any case, the test is but one technique among many to gauge the kind and quality of change in the student.

Formal Tests Devised by the Teacher

On many occasions, the classroom teacher composes tests. Such tests cften can be useful, provided the teacher understands their significance. Sometimes the teacher may wish to use a test to discover whether or not the pupils have grasped some part of the art program. For example, it may be helpful to present a few questions based on the pupils' knowledge of a specific medium, of facts surrounding an artist's life, or pupils' abilities to interpret examples of art or visual culture. For these purposes, teachers can develop several types of test items: true-false, short answer, multiple choice, or fill-in-the-blanks.

It should be noted that often the easiest test items

Long-term performance: Financial markets have their ups and downs, but your objectives stay the same. So you need a bank with the ability to react quickly while keeping a long-term perspective. For over 150 years our clients' confidence in our capabilities has made us one of the world's largest fund managers. In short, we can provide the performance you demand – now and in the future.

Private Banking is 💥 UBS

For more information about our services please contact us at: www.ubs.com/privatebanking or send us your business card: UBS AG, Hanspeter A. Walder, New York Branch, 10 East 50th Street, New York, New York 10022, tel.: (212) 574-3293.

to compose are technical questions that tend to be trivial compared with the goals of developing personal expressiveness and artistic creativity. The most significant educational objectives are often the most complex and the most difficult to evaluate appropriately. Teachers can develop

VIDEO AND ADVERTISING, A UNIT ON GRAPHIC DESIGN

The unit is on graphic design as advertising in magazines and on television. During the unit, children create their own design for a product and make an illustration for a story. To help students recognize the pervasiveness of advertising and begin to make judgments of quality and motive, the teacher asks them to watch a 30-minute television program she has taped. They are to take notes on uses of graphic design for the television program and in the commercials. The teacher assesses students' abilities to note lettering, layout, illustrations, animation, and computer graphics as they observe the videotape.

As a follow-up or alternative to this assessment, the teacher hands out a collection of popular magazines and asks each student to select what he or she considers a high-quality example of graphic design, package design, or illustration. Students are to cut out the image, paste it on a sheet of paper, and write a paragraph about how the image was created and about their reasons for selecting it as a good example. The teacher is able to assess students' understandings of graphic design and their abilities to make and support judgments of quality.

▲ Ad from *The New Yorker* (no title), advertisement for UBS. Many ideas, conceived on the fine art level, are eventually appropriated by graphic designers. A postmodern sensibility in this advertisement can be seen in its use of ambiguous relationships among objects—a swimmer, recessive layers of space, and a sunset. Viewers ask, "What does this have to do with banking?" The advertiser assumes that any viewer who asks such a question has a better chance of remembering the product (a banking service) than someone who glances at the ad and turns the page.

their own creative strategies for assessment that meet the unique needs and requirements of their students, the art curriculum, and the school setting. For example, Beattie lists 59 assessment strategies for art education.¹³

Informal Assessments

THE ANECDOTAL METHOD

Another assessment device, known as the *anecdotal method*, is also valuable. With this method the teacher periodically jots down observations about each child, based on the questions in the three categories of criteria. A cumulative record of such specific reactions may become a reliable index of a pupil's progress. It at least furnishes the teacher and the pupil with some concrete evidence of strong and weak points in the pupil's art learning conduct.

As an example, opposite some of the items of a performance checklist, the following remarks might be set down for a 6-year-old child in first grade:

THE STUDENT:	COMMENTS:
 Was able to use the con- cepts of contrast and texture in describing a painting by Mary Cassatt 	"Seemed to be very inter- ested in looking at the painting. Good attention span."
2. Participated in class discussions of art reproductions	"Indicated a special inter- est in African masks. Made very perceptive remarks about the feeling qualities of the masks. Referred to one of the library books on African art."
 Participated in group activity of sorting art postcards according to multicultural themes 	"Had some difficulties with sharing and cooperating in group activities. Needs special help to work with group."
 Completed line draw- ings done in response to Japanese print and Pollock painting 	"Was not clear about pur- pose for this activity at first. Was pleased when the drawings were displayed and discussed."
The teacher also might	consider commenting from

The teacher also might consider commenting from time to time after periodic examination of portfolios. A checklist might be used as a guide in writing these comments but need not be referred to item by item. Such records give general, overall impressions of a large body of work. The following are examples of notes about children that a teacher might write for a personal file.

John A. (6 years, grade 1): John uses a variety of personal experiences in his pictures, and he is certainly getting along well lately in trying to develop symbols of houses. It is strange, however, that his work seemed to deteriorate last week. He works hard, though, and participates well in a group.

Roberto L. (11 years, grade 6): He shows himself to be a sensitive child, and his writing about several sculptures from the museum field trip reflects his feelings. He seems to be fascinated by seeing actual sculptures and especially enjoys the painted wood sculptures of Louise Nevelson. His handwriting is improving but sometimes is barely legible. His art vocabulary is excellent for his age group.

Betty McM. (10 years, grade 5): Betty continues to be careless and untidy; her paints are in a mess, her drawings all thumb marks, her brushes unwashed. As stage manager of our play, however, she worked well. She seems to be more at home with sculpture than she is in drawing and painting. Her last sculpture in clay was quite vigorous. She likes to explore new materials and last week brought to school some wood for carving.

The data derived from checklists and other notations will greatly assist the teacher in appraising a pupil's progress, but it is also necessary to keep a file of the child's actual art production for periodic study and comparison with the written notations. Usually lack of space prevents the teacher from keeping any but the flat work.

These methods of assessment allow the teacher to summarize the child's progress in only the most general of terms. Once made, however, such a summary will prove valuable to the teacher in making progress reports to parents and others interested in the child's welfare.

Tools for Assessment of Student Progress in Art

Following are some examples of assessment tools that reflect the methods discussed in the preceding section.

REPORTING PROGRESS IN ART

Every school system reports to parents or guardians concerning their children's progress. This is one of the traditional and necessary functions of a school. Regarding the Teachers can use this type of schedule with middle-grade children. The teacher conducts the interview on a recent project, uses the schedule for notes as appropriate, and keeps the schedule for future reference as the term progresses.

	SAMPLE INTERVIEW SCHEDULE				
Stu	dent			Grade level	
		Yes	No	Comments	
1.	Did you know what you wanted to do before you began working? What was it?				
2.	Did you change your way of thinking while you were working? Why?				
3.	When things went right, did you know why?				
4.	When things went wrong, did you know why?				
5.	Did you discover anything unusual or special while you were working?				
6.	Did you solve your problem/theme satisfactorily?				
7.	Is there a part you would like to change?				
8.	Did you enjoy working on this piece even if you did not solve all your problems?				
9.	Would you like to do something like this again? Why?				
10.	Now that you are finished, are you pleased about what you have accomplished? Why?				
Sou	rce: This assessment device was developed by Donna Ka	v Reattie Brigh	am Young University		

This is an example of a rating scale for art production focused on specific criteria of performance taught as part of the teacher's instruction.

STIPPLE DRAWINGS SAMPLE RATING SCALE

Student _

Date

DIRECTIONS: Listed below are assessment criteria related to performance in art production (studio activities). Under each are the numbers 1 to 5, which stand for the following:

- 1. In this respect, the performance ranks below most of the performances you have known.
- 2. In this respect, the performance is only fair in comparison with other performances you have known.
- 3. In this respect, the performance is competent and compares well with the average performances you have known.
- 4. In this respect, the performance is well above the average of performances you have known.
- 5. In this respect, the performance is one of the most outstanding performances you have known.

Rate the quality of the performance by circling the number that indicates the category that best describes your judgment on each item.

ARTISTIC ABILITY

1.	The pupil's technic	cal skill in rei	ndering stron	g contrasts in	n value (deep bla	acks and white highli	ghts)
	1	2	3	4	5		
2.	2. The pupil's technical skill in handling gradation or chiaroscuro in the stipple technique						
	1	2	3	4	5		
3.	The pupil's technic	cal skill in ac	curately rend	ering the sul	oject matte:		
	1	2	3	4	5		
4.	4. The pupil's technical skill in handling the medium of stipple						
	1	2	3	4	5		
5.	5. The pupil's skill in creatively interpreting the theme						
	1	2	3	4	5		
Sou	rce: This assessment dev	vice was develo	ped by Donna	Kay Beattie, Bi	righam Young Unive	ersity.	

mechanics of reporting to the parents, several points must be kept in mind. First, the method of reporting must be easily understood by all parents. Any report that makes use of complicated symbols or what is considered by some to be highly professional language (and by others to be an undesirable "pedagese") will not be appreciated by most parents. Second, the report should reflect the objectives and practices of the art program and should attempt to comment on the child, both as an individual and as a member of a group. Third, any good report should, of course, be as accurate and fair as a teacher can make it. Fourth, from the teacher's point of view, the system of reporting should not demand a disproportionate amount of clerical work. Teachers should be able to substantiate claims they make

Judy Pfaff, Voodoo (1982). Collage, $98'' \times 60''$. The mood, action, or feeling of a nonobjective work of art, such as this large piece by contemporary artist Judy Pfaff, can be discussed and interpreted by children who have learned fundamentals of formal analysis.

> in these reports with objective evidence gathered during assessments. Teachers should keep records of events and examples of students' responses to use as illustrations in explanations or conversation with parents or guardians and administrators to support evaluations included in the report.

> Two of the best means of reporting available to teachers of art are *progress reports* and *narrative reports*. The progress report is based on the use of check marks, symbols, or

Before doing this worksheet, students discussed many artworks and attempted to find words that described their content or feeling. The teacher showed a slide of the large, very bright, nonobjective collage by Judy Pfaff and asked students to respond on this form.

VOODOO by Judy Pfaff

Study *Voodoo* by Judy Pfaff. Circle the words that you think describe the collage.

soft	hard	curved	straight
jagged	blurred	angular	smooth
rough	thin	thick	blended
active	horizontal	dead	rising
drooping	intertwined	friendly	alive
bright	dull	dark	light
layered	confused	organized	jittery
calm	nervous	simple	restful

Write additional words that you think describe the artwork.

What do you think you would feel if you were standing in front of the actual work, which is about 8 feet high and 5 feet wide?

Based on the words you circled and wrote, what mood, idea, or feeling do you think is conveyed by this work?

This worksheet can be used with small cooperativelearning groups or as an individual response. Its content refers to a particular painting by Winslow Homer, *The Fog Warning*, which students discussed in class. It also refers to a critic's written interpretation of the painting, which was given to each student and discussed in class. Students respond not only to the painting but also to the critic's writing about the painting.

THE FOG WARNING WORKSHEET

Read Henry Adams's commentary about Homer's painting, and answer the following questions, providing reasons and explanations.

- 1. How does Homer direct our attention to the tiny sailing ship in the distance? [fisherman's gaze, tail of fish points, whitecap points]
- 2. Why did Homer show the man holding the oars out of the water?
- 3. How does the viewer know the fog is moving from right to left?
- 4. Why does Adams think the rower is in danger? What are the signs of danger? [fog advancing, ship moving away, rower misdirected, big waves]
- 5. In what ways could the rower's experience be like our everyday lives? [we lose sight of goals, become disoriented, feel as if our troubles are like a fog bank, need to realign our course, need to work hard to reach a goal]
- 6. Do you think Adams's interpretation of the painting makes good sense? Why or why not? Explain.

letters. Often only two marks are used—S for satisfactory and U for unsatisfactory. Sometimes the letter O may be employed to signify outstanding progress. The teacher can make subheadings according to content categories (art history, art making), personal behaviors (initiative, social development), or other topics. The parent would then expect to find either S, U, or O opposite each of these subheadings. This system appears to be theoretically sound for reporting art, in that it is based on each child's individual progress rather than on progress in comparison with other pupils.

A teacher might, with the parents' consent, wish to make an initial report to them verbally during a short conference. This method tends to be time-consuming, but because of its flexibility it has some obvious advantages over written reports. It demands, of course, that the teacher have some ability to report both positive and negative aspects of a child's efforts without arousing the wrath of a parent. No teacher, furthermore, can afford to arrange an interview of this type without first being fully prepared. Parents should be informed of their children's special educational needs. Of course, if the child is gifted, the teacher should make the parents aware of this, so the child can gain support that might otherwise be lacking without this knowledge. Many parents are completely unaware of their childrens creative abilities in art making or in the other domains of art.

Often the best type of reporting goes on during the academic term, when teachers send items home with students, such as a summary of an art unit with objectives and content, samples of student work with teacher's comments, invitations to exhibits of student work, and other items that convey to parents what the art program is about and what their children are learning. For parent conferences, nothing is as helpful or impressive as a complete portfolio that displays the child's progress and learning. Some teachers use the technologies of video, computers, CD-ROM,

Winslow Homer, *The Fog Warn-ing* (1885). Oil on canvas, 30" \times 48". Historical knowledge and the writing of critics can assist teachers and children to interpret meaning in works of art. This work can be interpreted as a metaphor for the human struggle with nature and the task of facing adversity against great odds.

This student worksheet was developed for upper-elementary students who studied the concept of metaphor in art, as distinct from literal representation. For example, what symbols and metaphors can students discover in Earl Keleny's humorous painting Obesity in Men Linked to TV Viewing (see p. 194)?

METAPHOR AND MEANING

Study the artwork your teacher shows. Fill in the lines below to identify the artwork. Then, describe the literal content of the work and the metaphorical meanings of the work in the spaces provided.

т	1 .	. 1		
	11	tl	0	
	11	ш	C	

Artist Culture or Style _____ Date _____ Media _____

Literal Content

Metaphorical Meanings

Based on the content and possible metaphors you have described, write a brief statement about the meanings of this artwork. Use the back of this sheet.

and digital cameras to record and organize visual images of students at work and students' artwork. For example, one compact disc can store a student's art production from 13 years of schooling. In addition, teachers who have used a comprehensive approach to assessment will be able to communicate very specifically to students and parents regarding each pupil's strengths, accomplishments, and areas where improvement is possible. Far from becoming a "chore" for teachers, assessment can be a most rewarding

Oath Taker, nail figure, Congo (1875–1900). Understanding the cultural context in which works are created and the functions of artworks in societies can help us appreciate artworks from other times and places. Works of art such as *Oath Taker* can help dispel cultural stereotypes and expand children's understanding of the diversity cf world art.

integral part of the art program; and teachers can gain a great deal of personal satisfaction because they have the ability to communicate so clearly and effectively to students, parents, and school administrators about the progress of each student.

Oath Taker is an African wooden figure regarded by Congo peoples of western Africa as a source of healing and as a judge for ending disputes or attending to civil matters, such as divorce. The nails in the figure mark specific oaths or contracts made by supplicants and are similar in function to signatures on legal documents in contemporary Western society. Children work in groups to discuss the questions then report to the entire class. Note that questions relate to art history, art criticism, and aesthetics.

OATH TAKER WORKSHEET

View and analyze Oath Taker, learn about its cultural context, and answer the following questions, explaining your answers:

- 1. An *nkisi n'kondi* sculpture, such as Oath Taker, is used within Congo cultures for what purposes?
- 2. Why were nails and blades driven into the wood of the sculpture? How does this relate to the legal system of this society?
- 3. What have you learned about the culture of Congo peoples?
- 4. In what ways has knowledge about Oath Taker and its cultural role influenced the way you view the sculpture? Do you understand it better? Do you like it more? Less? What has made a difference for you?
- 5. Do you think it is appropriate to exhibit an object such as Oath Taker out of its original context in an art museum in the United States? Explain your answer.
- 6. Can people of other cultures who do not use sculptures this way enjoy looking at Oath Taker? Why or why not?
- 7. Discuss your response to *Oath Taker*. Do you like it? Do you think it is a good work of art? What feeling do you think it conveys? Would you like to see the original? Explain your answers.

Source: Kay Alexander and Michael Day, *SPECTRA Art Program*, *K*–8 (Palo Alto, CA: Dale Seymour Publications, 1994), pp. 48–61.

This assessment device features open-ended statements that children are asked to complete. It is especially useful for eliciting comments that might not be forthcoming on a form that requires only correct answers to specific content questions.

PAINTING REVIEW

Complete the following statements.

- 1. My favorite painting studied in the two painting units was
- 2. I like this painting best because
- 3. The most important thing to remember about painting is
- 4. In order to understand a painting, a person needs to
- 5. Paintings are best when they
- 6. Albert Bierstadt was best known for
- 7. I thought Jean-Michel Basquiat's painting was
- 8. Representational painters tried to
- 9. The abstract expressionists tried to
- 10. In studying painting, I learned it really doesn't matter that

Students are given a case-study problem in aesthetics and are asked to analyze different reasons associated with debate of the issue and to rate the quality of reasons given in support of particular views.

EVALUATING REASONS

Citizens in Allentown are debating whether the city should give money to artists to erect sculpture in the park again this summer. Last year, artists submitted slides of their work and drawings and plans for the sculptures they intended to make. A group of citizens, some of whom were art critics, artists, and art teachers, decided which artists would receive money to help pay for materials. The 10 sculptures were put into the park, where they remained for one month, including the Fourth of July weekend.

Here are some of the comments offered in the discussion. Tell whether you think the comments include good or not very good reasons. Be prepared to tell members of a small group of classmates why.

1. We should not give artists money to erect sculpture in the park again this year. Artists make art, but they can't tell us what to like and what not to like.

GOOD _____ NOT VERY GOOD .

2. Over time, the great artists will stand out. Even though van Gogh wasn't popular in his own time, his work is very valuable today. We should wait until an artist is accepted as really great before we put his or her work in the park. Not one of the Allentown artists has been recognized as really great, so we should not give any of them money to put their sculptures in the park.

GOOD _____ NOT VERY GOOD ___

3. Some art is really good today, even though the artists aren't well known by most people. The art people who selected the sculptures know what art is the best, so we should put the sculptures in the park and learn about what the experts say is good, even though we don't like it much.

GOOD _____ NOT VERY GOOD

4. There are two kinds of art—art for galleries and museums and art for public places. The art for public places ought to be art that everybody likes. In Boston, a sculpture of Mrs. Mallard and her ducklings (from the children's book *Make Way for Ducklings*) was put near the Public Garden lagoon where, in the story, Mrs. Mallard and her ducklings go swimming. All art in public places ought to be like this—art that everybody likes. No artist should be given money unless the sculpture will probably be liked by everybody.

GOOD _____ NOT VERY GOOD _

- 5. All art in public places should be art that looks like something we all recognize. It should never be abstract art. GOOD ______ NOT VERY GOOD ______
- Because they are putting the sculpture in the park, it should blend in with the natural surroundings. Only give money to the artists who will make sculpture to blend in with nature.
 GOOD ______ NOT VERY GOOD
- Art in the park should not blend with the surroundings. It should stand out so that everybody can see that it is art in the park. This way, they will see it and try to understand it. Maybe they might even learn to like it. GOOD ______ NOT VERY GOOD ______
- 8. Art belongs only in museums and galleries. Keep it out of the park! GOOD ______ NOT VERY GOOD

Source: This assessment device was developed by Marilyn Stewart, Kutztown State University

- Donna Kay Beattie, Assessment in Art Education, Art Education in Practice Series (Worcester, MA: Davis Publications, 1997), p. 2.
- Michael Day, "Evaluating Student Achievement in Discipline-Based Art Programs," *Studies in Art Education* 26, no. 4 (1985): 232–40.
- F. Robert Sabol, "The Assessment Context," in Assessing Expressive Learning, ed. Charles M. Dorn, Stanley S. Madeja, and F. Robert Sabol (Mahwah, NJ: Lawrence Erlbaum Associates, 2004), p. 14.
- 4. See any of the editions of Viktor Lowenfeld and Lambert Brittain, *Creative and Mental Growth*, 8th ed. (New York: Macmillan, 1988).
- 5. F. Robert Sabol, "The Assessment Context," p. 14.
- 6. Ibid.
- 7. Ibid.
- F. Robert Sabol, "Development of Visual Arts Talent in Adolescence," in *Secondary Gifted Education*, ed. Felicia Dixon and Sidney M. Moon (Austin, TX: Prufrock Press, 2006).
- G. W. Bush, "No Child Left Behind" (Washington, DC: U.S. Department of Education, 2002); W. J. Clinton, "President's Call to Action for American Education in the Twenty-first Century," *State of the Union Address* (Washington, DC, February 4, 1997); Consor-

tium of National Arts Education Associations, National Standards for Arts Education: What Every Young American Should Know and Be Able to Do in the Arts (Reston, VA: Music Educators National Conference, 1994); National Board for Professional Teaching Standards (NBPTS), Standards for National Board Certification: Early Adolescence through Young Adulthood/Art (Washington, DC: NBPTS, 1994); National Center for Education Statistics, The NAEP 1997 Arts Report Card, OERI, NCES 1999-486 (Washington, DC: U.S. Department of Education, 1998); and Carole Henry, ed., Standards for Art Teacher Preparation (Reston, VA: National Art Education Association, 1999).

- 10. John Herman, Pamela Aschbacher, and Lynn Winters, *A Practical Guide to Alternative Assessment* (Alexandria, VA: Association for Supervision and Curriculum Development, 1992), p. 2.
- 11. Enid Zimmerman, "Assessing Students' Progress and Achievements in Art," *Art Education* 45, no. 6 (November 1992): 16.
- 12. For a discussion of standardized art tests, see Gilbert Clark, Enid Zimmerman, and Marilyn Zurmuehlen, *Understanding Art Testing* (Reston, VA: National Art Education Association, 1987).
- 13. Beattie, Assessment in Art Education.

ACTIVITIES FOR THE READER

- Describe some situations in which the art program reflects the educational outlook of (a) a school principal,
 (b) a school board, and (c) a community.
- 2. Devise some test items in art as follows:
 - a. A true-false type to test third-grade pupils' knowledge of handling clay
 - b. A recall or completion type to test fourth-grade pupils' knowledge of color mixing
 - c. A multiple-choice type to test sixth-grade pupils' knowledge of art history
 - d. A matching-items type to test fifth-grade pupils' ability to use a mixed-media technique
 - e. A recognition type to test sixth-grade pupils' knowledge of art terms

- 3. Make checklists for (a) appreciation of sculpture by sixth-grade pupils and (b) skills needed by fourth-grade pupils when doing art criticism.
- 4. Over a period of two weeks, study the art output of a group of 10 children, and write a paragraph of not more than 50 words for each child, summarizing their progress.
- 5. Describe any results, either good or bad, that you have observed as a result of competitive marking of children's art. How do those who have received a poor grade react?
- 6. Make a checklist of items that would reflect the attitudinal change of the principal and faculty with respect to the art program.

7. Review the works by artists in this book, and select three that would make good subjects for a pictorialanalysis exercise involving the use of an overlay of trac-

ing paper. Can these exercises be assigned according to grade level or experience of children?

SUGGESTED READINGS

- Beattie, Donna Kay. *Assessment in Art Education*. Art Education in Practice Series. Worcester, MA: Davis Publications, 1997.
- Clark, Gilbert A., Enid Zimmerman, and Marilyn Zurmuehlen. *Understanding Art Testing*. Reston, VA: National Art Education Association, 1987.
- Dorn, Charles M., Stanley S. Madeja, and F. Robert Sabol. Assessing Expressive Learning. Mahwah, NJ: Lawrence Erlbaum Associates, 2004.
- Eisner, Elliot W. "Evaluating the Teaching of Art." In *Evaluating and Assessing the Visual Arts in Education: International Perspectives*, ed. Doug Boughton, Elliot W. Eisner, and Johan Ligtvoet, pp. 75–94. New York: Teachers College Press, 1996.
- Gardne-, Howard. "The Assessment of Student Learning in the Arts." In *Evaluating and Assessing the Visual Arts in Education*, ed. Doug Boughton, Elliot Eisner, and Johan Ligtvoet, pp. 131–55. New York: Teachers College Press, 1996.
- Montgomery, Kathleen. Authentic Assessment: A Guide for Elementary Teachers. New York: Longman, 2001.
- National Center for Education Statistics. Arts Education: Highlights of the NAEP 1997 Arts Assessment Report Card. The Nation's Report Card. Washington, DC: National Center for Education Statistics, 1998.

WEB RESOURCES

- Education Commission of the States (ESC): http://www .ecs.org/. Contains an assessment component that is designed to help educators understand how assessment can improve education. Assessment models for No Child Left Behind (NCLB) are included. The site provides information about grants
- National Assessment of Educational Progress, The Arts Subject Areas: http://nces.ed.gov/nationsreportcard/ arts/. Reviews the development, administration, and findings of the NAEP in the arts and includes other resources on arts assessment.
- North Central Regional Educational Laboratory, *Assessment:* http://www.ncrel.org/sdrs/pathwayg.html. Contains substantial information and practical guidelines. A search tool is provided that enables one to design a path of inquiry. Furnishes links to websites containing supporting resources.
- Thirteen Ed Online: http://www.thirteen.org/edonline/. Public television's web service for teachers was devel-

oped by Thirteen/WNET New York. This free service provides lesson plans, classroom activities, and assessment workshops.

- U.S. Department of Education, National Center for Education Statistics (NCES): http://nces.ed.gov/. NCES collects and reports information on the academic performance of the nation's students. The primary focus of this assessment is what American elementary/secondary students know and can do in academic subjects. Organized to provide data and information about NCES's surveys and assessments. Data on state or local school districts can be accessed.
- U.S. Department of Education, Student Achievement and School Accountability Programs: http://www.ed.gov/ about/offices/list/oese/sasa/index.html. A site aimed to help classroom teachers understand accountability standards and assessment programs.

A HISTORICAL FRAMEWORK FOR ART EDUCATION: DATES, PERSONALITIES, PUBLICATIONS, AND EVENTS

- **1749** Benjamin Franklin advocates art instruction in the school curriculum for its utilitarian functions, thus establishing himself as a precursor of the Massachusetts drawing provision of 1870.
- **1761** Jean-Jacques Rousseau, *Emile*. Revolutionary (for its time), *Emile* stresses the nature and interests of children as a basis for education. Through his influence on succeeding educators, Rousseau sets the stage for childcentered approaches.
- 1746–1822 Johann Pestalozzi follows Rousseau's theories and anticipates those of Frederick Froebel as a member of the triumvirate who set the stage for the Child Study Movement through their interest in the use of objects, the function of physical activity in the process of learning, the rejection of severe discipline, and above all, respect for the child as an individual, whose development is viewed in context rather than considering the child a flawed adult.
 - **1816** Johann Friedrich Herbart, a German psychologist who attempts to systematize the ideas of Pestalozzi in *ABC* of Sense Perception.
 - **1827** A course in drawing is offered to students of Boston English High School.
- 1834–1839 Bronson Alcott begins the Temple School in Boston, employing drawing as an adjunct of the imagination, one of three major areas of mental activity.

- 1835–1850 Friedrich Froebel develops his ideas in his Garden of Children (kindergarten) school, devising curricula based on play and on the use of "gifts" designed to develop mathematical and aesthetic relationships through the use of objects, such as woolen balls, geometric forms, and drawing on slate.
 - 1839 Horace Mann, while secretary of the Massachusetts Board of Education, visits Germany to study the teaching of drawing. He is particularly impressed by one teacher, Peter Schmidt, and publishes Schmidt's lessons. Mann views drawing as a source of pleasure, as well as leading to a vocation. G. Stanley Hall also visits Germany, but unlike Mann, studies psychology instead of drawing. When Hall develops the idea that is to grow into the Child Study Movement (late 1800s), a marriage between psychology and art education is begun. Harvard's Project Zero reflects the enduring nature of this partnership.
 - **1849** William Minifie teaches drawing in the Boys High School in Baltimore, and like Benjamin Franklin, Walter Smith, and William Bentley Fowle, uses a "scientific" sequential approach to carry out his belief in drawing as a practical and useful skill.
 - 1860 Wm. Bradley Co. founded in Springfield, Massachusetts. Manufactured Froebel's educational materials known as "Gifts."
 - 1861 Philosopher and educator Herbert Spencer makes a case for art education in his essay "What Knowledge Is of Most Worth?"

- The Oswego Movement of the Oswego, New York, 414 by 1870 Normal School, following the lead of the Kindergarten Movement, stresses the use of instructional "objects," such as charts, cards, picture sets, blocks, specimens in glass, textiles, and maps, in the classroom. Although intended for general education, the implication of "objects" for art education becomes clearer over time. Related to this are the "type forms" or geometric models of spheres, cones, cubes, pyramids-those basic pure forms Cézanne referred to as the structural components of natural form. Type forms are formally introduced to art education students at the Pratt Institute in 1886. The dominant figure at Oswego is Herman Krusi, whose books on drawing influence classroom teachers.
 - **1870** Elizabeth Peabody, a former teacher in the Temple School, publishes *A Plea for Froebel's Kindergarten as the Primary Art School*, advocating drawing as a major component of kindergarten instruction.

Massachusetts passes the Drawing Act, making drawing instruction mandatory in towns with populations of 5,000 or greater.

- 1871 Walter Smith of England is invited to the Massachusetts Normal Art School by the state to help teachers fulfill a new state requirement for the teaching of drawing to prepare students to function as draftspersons and designers. He becomes director of what is now Massachusetts College of Art.
- 1880s Beginning of Child Study Movement.
- **1883** The National Education Association (NEA) creates a department of art education, and Carrado Ricci writes the first book on child art, *L'arte dei bambini*.
- mid-1880s Fowle publishes the *Common Schools Journal*, introducing the monitorial system—training students to teach other students. Fowle stresses the use of maps and chalkboards and eliminates corporal punishment. Fowle writes more than 50 books on all phases of education and translates a European text on drawing.
 - **1888** Bernard Perez, *L'art et la poésie—chez l'enfant*, a poetic approach to child art (France).

- **1890–1905** Study of child art accelerates, and James Sully (Great Britain) in his *Studies in Childhood* pioneers study of developmental stages in art.
 - **1892** James Sully, *Investigation on Childhood*. Sully charts three stages of artistic development and is first to use the term *schema* (Great Britain).

In Boston, art appreciation is introduced into the schools, and Earl Barnes, first psychologist to "discover" child art, publishes *Art of Little Children*.

- **1893** Color Instruction: Suggestions for a Course of Instruction in Color for Public Schools by Louis Prang, Mary Dana Hicks, and John S. Clark is published.
- **1895** Louise Maitland is the first woman to write on child art ("Children's Drawings") for the *Pacific Education Journal*.
- **1899** The NEA appoints a committee to report on the teaching of drawing in the public schools. The report stresses art appreciation, development of the creative impulse, the use of perceptual training for representational drawing, drawing as a vocational preparation, and the rejection of the use of public schools for the training of professional artists.

The Teacher's Manual (Part IV) of the eight-volume Prang series of art instruction is designed to serve class-room teachers, using such consultants as Winslow Homer, Arthur Dow, and Frederic Church to develop curricula in aesthetic judgment, art history, nature drawing, perspective, decoration, design, and paper construction.

New Methods in Education by J. Liberty Tadd is published. Tadd, the director of the Public School of Industrial Arts in Philadelphia, is the first American art educator whose influence is felt in Europe

Composition by Arthur Wesley Dow is published.

1901 The publication of *The Applied Arts Book*, edited by James Hall, promotes "projects and activities" that are to lead art teachers away from the "scientific" method of Walter Smith. A Massachusetts Normal Art School graduate, Henry Turner Bailey, is appointed editor of the newly titled *School Arts Book*.

- 1904 Franz Cizek, an Austrian artist/teacher, begins his children's classes at the Vienna School of Applied Art. Cizek rejects the idea of realistic drawing and instead draws on the personal reactions, memories, and experiences of students. The pictorial results are so impressive that art educators from the United States come to study his methods. One observer (Thomas Munro of the Cleveland Museum) comes to the conclusion that the consistently high quality of student work is attributable to the structured nature of Cizek's teaching, a contradiction of which Cizek may not have been aware.
- **1904–1922** Arthur Wesley Dow becomes the major spokesperson for the importance of composition or structure of art, what is now referred to as the elements and principles.
 - **1905** George Kerschensteirner, *Die Entwicklung Der Zeichnerischen Begabung*, a superintendent of schools and an art supervisor who has collected a half-million drawings from the children of Munich, stresses freedom from teacher intervention, and is an early advocate of the use of the imagination.

The University of Breslau, Poland, offers the first seminar on the psychology of children's art.

1908 *Kind und Kunst* (Child and Art), the first periodical devoted to child art, is published.

First symposium on picture study convened by Henry Turner Bailey for supervisors in major cities.

- **1911** The *Encyclopedia of Education* includes the first article on art education.
- 1912 Fifty art supervisors are working in New York City.

Walter Sargent (University of Chicago), in his book *Fine and Industrial Art in the United States*, stresses the need to respect the child's needs, interests, and desires to create art, calling attention to the uneven course of progress in a child's ability to draw and recommending the study of conventions established by artists as a means of developing ability in drawing. Some of Sargent's ideas have reemerged today.

1914 Max Verworn, *Ideoplastic Art*, stresses the uses of art for the cultivation of sensory experience in education (Germany).

Teachers College, Columbia University, grants the first 415 Ph.D. in art education.

- **1917** Walter Krotzsch, *Rhythmus Und Form in Der Freien Kinderzeichnung*, makes the first argument for studying the processes as well as the products of creation among children (Germany).
- **1919** Pedro J. Lemos succeeds Henry Turner Bailey as editor of *School Arts Book*, currently published as *SchoolArts* magazine. Over time *School Arts* moves closer to serving art teachers as well as elementary classroom teachers.
- 1920s As John Dewey's ideas begin to merge with those of other child-centered educators, the era of progressive education grows, lasting until the demise of the movement in the 1930s, during which time the public schools attempt to apply ideas that have had greater success in private schools. The progressives are committed to unit or project learning and the integration of subjects. "Creative expression" becomes a catchphrase of the movement and continues to be used, although with less regularity. Because the teacher's responsibility is to provide materials and to foster an environment conducive to freedom and exploration, the content of art is not deemed important. One consequence of emphasis on the child rather than on art is a decline in gains made by the Picture Study Movement. Many of the progressives' ideas will resurface in the 1960s in the books of such "radical" critics as John Holt.
- **1920–1930** The Picture Study Movement thrives as an antecedent of the current discipline-based art education movement. Encouraged by advances in printing technology and the use of color reproductions, educators now take art appreciation seriously as part of a balanced program. The goals of appreciation lie on the moralistic as well as the aesthetic side as sentimental narrative works take precedence over contemporary European exemplars. Pictorial images are regarded as natural vehicles for transmitting society's most dearly held values (patriotism, family, religion, and so on).
 - **1924** Belle Boas publishes *Art in the Schools,* advocating art appreciation through an applied arts philosophy. Margaret E. Mathias publishes *The Beginnings of Art in the Public Schools.*

- **1925** The Carnegie Corporation supports a report on the role of art education prepared by the Federated Council in its call for greater content in art.
 - **1926** Gustav Britsch, "Theory of Child Art," a systematic theory of the developmental aspects of the art of children, provides a basis for Henry Schafer-Simmern's book (1948, Germany).

Florence Goodnough, Measurement of Intelligence by Drawings.

1927 Margaret Naumburg, *The Child and the World; Dialogues in Modern Education; in 1947, Studies of the "Free" Art Expression of Behavior Problem Children and Adolescents as a Means of Diagnosis and Therapy.*

The NEA, in its annual meeting in Dallas, Texas, recognizes art as fundamental in the education of children.

- **1932** *The Teaching of Art* by Margaret Mathias is published, contributing to the growth of serious literature in art education.
- The Owatonna Art Project in Minnesota creates an art 1933 program that falls not only within the responsibility of the school system but also responds to the needs of the citizenry, promoting and advising on home decoration, art in public places, landscaping, and even window display, thus demonstrating that art can be public as well as private and personal as well as utilitarian, and that art teachers are capable of raising the general aesthetic level of an entire community. One of the teachers is Edwin Ziegfeld, later to become the first president of In-SEA; head of the department of art education at Teachers College, Columbia University; and author of Art Today. The Owatonna Project loses its impact at the onset of World War II but retains its importance as a historic landmark in art education.

While Owatonna is getting underway, teachers from Germany's Bauhaus, an art academy that significantly influenced American art and art education, escape from Hitler and arrive at Black Mountain College in North Carolina, led by the painter Josef Albers. By the time the Bauhaus has to move to a more permanent setting at the Institute of Design in Chicago, the ideas begun in Germany begin to exert an influence in the curricula of a growing number of American art programs

- **1937–1940** During this period three émigrés from Hitler's Europe arrived in the United States: Henry Schaefer-Simmern, 1937; Viktor Lowenfeld, 1939; and Rudolf Arnheim, 1940. They dealt with issues of developmental theory in art, the influence of Gestalt psychology, and processes of visualization and perception.
 - **1938** Leon Loyal Winslow, director of art for Baltimore City Schools, publishes *The Integrated School Art Program*, demonstrating a need and method for using art as a catalyst for learning academic subjects.
 - **1940** Natalie Robinson Cole's *Art in the Classroom* reaffirms the importance of creative expression and is one of the few books to deal with the subject from a personal point of view. (Seonid Robertson's *Rose Garden and Labyrinth* is a good example of how an English art educator worked in this limited genre.)
 - **1941** Edwin Ziegfeld with Ray Faulkner, *Art Today: An Introduction to the Visual Arts.* With Mary Elinore Smith, *Art for Daily Living: The Story of the Owatonna Art Education Project* was published in 1944.
 - **1942** Victor D'Amico's *Creative Teaching in Art* states the case for the nature of creativity, moving closer to the artist as model. Creates a laboratory to carry out his ideas and to exercise his power as a creative, charismatic teacher.
 - **1943** Herbert Read, a British poet, philosopher, and critic, publishes *Education through Art*. Like Lowenfeld and Dewey, Read sees aesthetic education as the logical center for education in general. He inventories European and British developmental theories and endows his ideas with a wide frame of references from art, psychology, and philosophy.
 - **1946** Wilhelm Viola, *Child Art*. Forty-two years after Cizek began his classes in Vienna, Viola publishes his recollections of Cizek's classes.
 - 1947 Viktor Lowenfeld's major work, Creative and Mental Growth, is published. Lowenfeld reorganizes the

threads of developmental study of child art begun in Europe and relates these to the formation of personality. The authoritative and comprehensive nature of the book establishes it as a classic of enormous influence both here and abroad.

The National Art Education Association (NAEA) is founded, adding three geographical regions to the existing Eastern Arts Association.

1948 Marion Richardson, Art and the Child (Great Britain).

Henry Schafer-Simmern, *The Unfolding of Artistic Activity*, discusses the title of his book in relation to his work with special groups, such as the aged and mentally retarded. Relies on Britsch's work (1926) as a basis for his theory of artistic development.

- **1950** Creativity is taken seriously by the psychological community, and numerous research studies are conducted to analyze the creative personality. J. P. Guilford, president of the American Psychological Association, calls the attention of his colleagues to a hitherto neglected area embraced previously by art educators in the progressive era.
- **1951** The International Society for Education through Art (InSEA) is founded by UNESCO in Bristol, England, with the guidance of Sir Herbert Read. The purpose of InSEA is to provide within an international framework periodic forums for art educators interested in the philosophy, objectives, curricula, and methodology of art education. Tri-yearly meetings are held on a national and regional basis.

Florence Cane, *The Artist in Each of Us.* Cane's book bridges art therapy and the talented child through a series of case studies.

Mildred Landis, *Meaningful Art Education*, a textbook based on Dewey's theories.

Rosabelle MacDonald (Mann), Art as Education.

1956 Thomas Munro's *Art Education, Its Philosophy and Psychology* is the first scholarly attempt by a museum-based educationalist and aesthetician to focus attention on art education. **1957** The Soviets launch *Sputnik*, an event that establishes 417 their lead over the United States in space technology and provokes a reevaluation of American education, beginning with science and mathematics and attempts at curricular reform.

Miriam Lindstrom, Children's Art: A Study of Normal Development in Children's Modes of Visualization.

- **1958** Congress passes the National Defense Education Act to encourage a reevaluation of curriculum, primarily in the "defense-related" subjects of math, science, and foreign languages. Art education receives limited funding, along with other academic subjects.
- **1959** Blanche Jefferson's *Teaching Art to Children* is published.
- **1960–1970** The "greening" or consciousness raising of the United States before the end of the Vietnam War results in an awareness of the diversity of American ethnic groups and of the environment and an acceleration of interest in technology and collaborative projects in art education.
 - **1961** *Preparation for Art* by June King McFee provides a significant shift toward the importance of perceptual and environmental issues in planning curriculum.

President John F. Kennedy's Science Advisory Committee recommends that the arts be included in educational reform.

- **1962** Manuel Barkan's article "Transitions in Art Education: Changing Conceptions of Curriculum Content and Teaching," published in the *Art Education Journal of the NAEA*, marks the initial stage of a movement toward increased emphasis on art content in art education. This period is also a time of openness toward newer media, borrowed from the revolution of youth culture occurring in higher education. It parallels the more conservative rational methods of the accountability movement, which represents mainstream thinking in all areas of education.
- **1965** The publication of *Art Education: The 64th Yearbook of the National Society for the Study of Education,* an anthology of essays by leaders in art education, serves as a status report on U.S. art educators. This book should be compared to the fortieth yearbook, published some

30 years earlier. A later, if somewhat briefer, effort is the *Report of the NAEA Commission on Art Education* (1977).

Federal support of the arts in education grows with the passage of the Elementary and Secondary Education Act (Title V), which strengthens the role of art supervision at the state level.

Congress establishes the National Endowment for the Arts.

The "Seminar in Art Education for Research and Curriculum Development," held at Penn State University, is the first conference to bring together artists, critics, historians, philosophers, and art educators in an attempt to reevaluate the nature of the curriculum in art education.

- **1966** *Journal of Aesthetic Education*, edited by Ralph Smith, is published.
- **1967–1976** The Central Midwestern Regional Education Laboratory (CEMREL), with Stanley Madeja as director, is the first government-funded project to develop a curriculum ("Through the Arts to the Aesthetic") and to support materials in consultation with artists, historians, critics, and aestheticians.
 - **1968** University City in St. Louis, with the support of the JDR III Fund and under the direction of Stanley Madeja, creates a model for an "arts infusion" curriculum to address the question, "Can the arts be made integral to the general education of every child from kindergarten through high school?" (Kathryn Bloom, Director, JDR III)

Under the direction of Elliot Eisner, the Kettering Project at Stanford University develops a comprehensive elementary art curriculum based on art content. The curriculum is later adopted by the state of Hawaii.

1968–1979 Kathryn Bloom directs the Arts in Education Program for the JDR III fund for "all of the arts for all of the children." Laura Chapman refers to the role of the new bureaucracies as the "deschooling" of art education because of the stress laid upon extra school considerations: the use of noncertified art teachers, liaisons with community agencies, and art councils, all of which can tend to weaken rather than strengthen art education in the classroom.

1969 The National Assessment of Educational Progress (NAEP) assesses the state of art education from a national perspective.

Mary Rouse and Guy Hubbard of Indiana University write *Meaning*, *Method*, *and Media*, the first commercially available elementary art curriculum.

- **1970** Advanced placement in studio art and art history is offered for high-school students interested in credit in institutions of higher education.
- **1972** *Educating Artistic Vision* by Elliot Eisner is the first of many influential books by the author.
- **1973** The Alliance for Arts Education is formed through a mandate of the John F. Kennedy Center. The JDR Arts in Education Program and the National Endowment for the Arts support numerous projects, including the Artist-in-Schools program.

The National Assessment of Educational Progress in art (NAEP) is conducted at the request of the U.S. Office of Education. This study examines the knowledge, skills, and attitudes regarding art of 9-, 13-, and 17-year-olds, using the objectives of art education as a basis of investigation. Brent Wilson is the major investigator.

- 1974 Art and Visual Perception by Rudolf Arnheim.
- **1978** A second NAEP in art is conducted but without an analysis of data. A third assessment is planned for 1996.
- **1981** A program on the gifted and talented in art is held at the NAEA convention in Chicago. This is to a large degree art education's response to a general interest in children with special needs and leads to a number of publications and conferences in art education as well as new programs for children and adolescents.
- **1982** The Getty Center for Education in the Arts is created as one of the Getty Trust's seven units. Headed by Leilani Lattin Duke, the Getty Center offers support for discipline-based art education in the public schools

through a program of research, publications, conferences, grants, and regional institutes.

Laura Chapman publishes *Instant Art, Instant Culture,* an independent view of art education policy that includes survey reports and recommendations for future practice.

- **1984** Dwaine Greer introduces the term *discipline-based art education* in an article in *Studies in Art Education*.
- **1987** *Excellence in Art Education: Ideas and Initiatives* by Ralph Smith is published.
- **1988** The National Endowment for the Arts publishes *Towards Civilization: A Report on Arts Education,* which attempts to reveal the status of the arts in education in the United States. It recommends that the NAEP be reinstated.
- **1990** *America 2000,* a status report on education in the country, is issued by U.S. governors and President George H. W. Bush. After initial failure to mention the arts and the resultant protest, the report includes arts in national goals statements.
- **1991** The National Board for Professional Teaching Standards (NBPTS) is formed in order to offer recognition for exemplary or accomplished secondary teachers, art included. Recognition for elementary teachers follows later.
- **1994** National voluntary standards in the arts are developed by the national arts education associations (Dance, Music, Theatre, and the Visual Arts) in conjunction with a movement for standards in all areas of the school curriculum.

In the largest art education reform initiative in history, six art education institutes established since 1988 in Florida, Minnesota, Nebraska, Ohio, Tennessee, and Texas by the Getty Center for Education in the Arts support discipline-based art programs in more than 200 school districts in 15 states, reaching close to a million students in kindergarten through twelfth grades. The institutes are based on findings from the Los Angeles Getty Institute for Educators on the Visual Arts (1982–1989), which served 1,300 teachers in 419 21 school districts in the Los Angeles area.

- **1996** Secondary art teachers become National Board Certified (NBC). By 1999 there are nearly 100 NBC art teachers in states across the country. National Board Certification is expected to become available for elementary art teachers in 2000.
- **1997** The second National Assessment of Educational Progress in the visual arts employs a wider range of assessment items, following national developments in educational evaluation that feature authentic approaches to assessment.
- **1998** Leilani Lattin Duke resigns as director of the Getty Center for Education in the Arts. Getty art education programs are significantly reduced.
- **1999** NAEA publishes *Standards for Art Teacher Preparation*, a document that discusses requirements for quality art teacher education programs, preparation of faculty, and knowledge and skills new art teachers will need as they enter the teaching profession.
- **2000** The Creativity Movement celebrates its fiftieth anniversary.

National Board Certification becomes available for elementary art teachers. Many states and local school districts recognize NBC teachers with financial incentives and advanced assignments.

- **2000–2007** Visual culture in art education becomes a significant topic in the professional discourse. A proposal to change the field of art education to "visual culture art education" is widely debated.
 - **2001** The federal government's sweeping education initiative No Child Left Behind is introduced to the education systems of the 50 states.
 - **2004** No Child Left Behind receives serious criticism and resistance from a number of state legislatures. Art educators are concerned that the national program of high-stakes testing in reading and mathematics will cause school boards to deemphasize art education.

PROFESSIONAL RESPONSIBILITY AND PROFESSIONAL ASSOCIATIONS

We all agree that teaching is not just a job and that preparing future generations of citizens for their place in society is the most important work that we can do. Dedicated teachers who view education as a career recognize their responsibilities as professionals. As citizens in our communities, as well as professional educators, we are often called upon to provide assistance and guidance in developing and maintaining sound programs of education for children and young people. Because of our education and experience as teachers, we have much to offer our communities and many insights about education that are not available to average citizens from other walks of life.

We find that we face several responsibilities as professional teachers. First, we have an obligation to gain the best preparation for teaching by excelling in our undergraduate education so that we will have much to offer our students. As in-service teachers we should keep up with change and innovation in our subject areas, as well as with the issues and trends of education as a field and the place of education in our communities and in society. Like professionals in law, medicine, business, and cther fields, we should be active in our professional associations, subscribe to our professional journals, and participate in the educational issues of the day to assure that the children receive the best education that we know how to provide.

If we, as teachers, are to model for our students the excitement of learning and the values and benefits of education, we must be active learners in our own right. We should collect, keep, and add to a professional library of important works in our field. We should be active learners by participating in and enjoying the subject area of our teaching expertise. For teachers of art this means that we seek opportunities to visit art museums and galleries, read the current art books and periodicals, and take time to express our ideas and feelings through our own art production. The excitement and joy that we gain through our participation in and appreciation of art will be conveyed directly to our students. There is no substitute for our own enthusiasm and participation in the life of the mind. Students cannot be fooled; they seem to know which of their teachers are genuine in their advocacy of learning and education.

Too often, teachers feel isolated from their colleagues, as they spend nearly their entire working days with their young students. Like professionals in other fields, teachers need time and opportunities to share ideas and values with their colleagues. Active membership in local, regional, and national professional associations provides many such opportunities. The following list is provided to encourage interested teachers to participate as professionals, to learn from their colleagues, and to become leaders in the advocacy of sound education for all children and young people.

Professional Organizations

International Society for Education through Art (InSEA) Cheng-Feng Kao 1, Ai-Guo West Road Taipei Taiwan ROC cfkao@tmue.edu.tw www.insea.org

National Art Education Association (NAEA) 1916 Association Drive Reston, VA 20191-1590 703-860-8000 www.naea-reston.org United States Society for Education through Art (USSEA) Dr. Alice Arnold, President arnoldm@mail.ecu.edu contact Dr. Mary Stokrocki http://www.public.asu.edu/ %7Eifmls/ussea

Canadian Society for Education through Art (CSEA) CSEA National Office Faculty of Education, Queen's University A321 Duncan McArthur Hall Kingston, ON, K7L 3N6 Canada Fax: 613-533-2331 www.csea-scea.ca

These professional organizations offer links to many other state, provincial, and public arts organizations on their websites.

COMMERCIAL RESOURCES

A few of the many reliable providers of resources for teaching art available online.

American Art Clay Company 6060 Guion Road Indianapolis, IN 46254 http://www.buyamaco.com/

Art Visuals

P.O. Box 925 Orem, UT 84059-0925 801-226-6115 www.members.tripod.com/ ~artvisuals

Binney & Smith Inc. 1100 Church Lane Easton, PA 18044-0431 800-CRAYOLA http://www.binney-smith.com Crayola: http://www.crayola.com

Chroma, Inc. 205 Bucky Drive Lititz, PA 17543 800-257-8278 www.chroma-inc.com

CRIZMAC

P.O. Box 65928 Tucson, AZ 85728-5928 800-913-8555 www.crizmac.com

Crystal Productions

P.O. Box 2159 Glenview, IL 60025 http://www.crystalproductions .com/ Davis Publications, Inc. 50 Portland Street Worcester, MA 01608 800-533-2847 http://davispublications.com/

Dick Blick Art Materials P.O. Box 1267 Galesburg, IL 61402 800-447-8192 www.dickblick.com

Glencoe/McGraw-Hill 1221 Avenue of the Americas New York, NY 10020 800-334-7344 www.glencoe.com

Liquitex: http://www.liquitex.com

Nasco Arts and Crafts 4825 Stoddard Road P.O. Box 3837 Modesto, CA 95352 800-558-9595 www.nascofa.com

Sanford

2711 Washington Boulevard Bellwood, IL 60104 800-323-0749 www.sanfordcorp.com Sax Arts & Crafts 2405 South Calhoun Road New Berlin, WI 53151 800-558-6696 http://www.saxarts.com/

SRA/McGraw-Hill 8787 Orion Place Columbus, OH 43240 http://www.sra-4kids.com/ Triarco Arts & Crafts

2600 Fernbrook Lane Suite 100 Plymouth, MN 55447 http://www.triarcoarts.com/

Universal Art Images

8450 South Tamiami Trail Sarasota, FL 34238-2936 800-326-1367 www.universalcolorslide.com

SAFER MATERIALS FOR ELEMENTARY-SCHOOL ART

Photography

Photochemicals

- Use digital cameras.
- Use Polaroid cameras, without transfer manipulation.
- Send film out to be developed.
- Do sungrams with blueprint paper and sunlight.
- Do photocopier art.

Textiles and Fiber Arts

- Synthetic Dyes
 Use vegetable dyes (spinach, tea, onion skins, and so on) or food dyes.
 Synthetic Fibers
 Use fibers that have not been treated with formaldehyde sizings.
 - Use leftover textile scraps for stuffing pillows or soft-sculpture projects.

Printmaking

- Screen Printing Use CP/AP water-based inks.*
 - Use cut paper stencils.
- *Relief Printing* Do linoleum cuts instead of woodcuts.
 - Use CP/AP water-based inks.

Sculpture

- *Modeling Clays* Use premixed clay or CP/AP modeling materials.
- Papier-Mâché
 Use black-and-white newspaper with CP/AP pastes or CP/AP instant papiermâché made from cellulose.

Painting and Drawing

Paints	 Use CP/AP watercolors, tempera, and
	acrylic paints, not adult paints.

- *Scented Markers* Do not use, because they teach children to smell and eat art materials.
- Permanent Markers Use CP/AP water-based markers.
 - *Pastels* Use CP/AP oil sticks, crayons, chalks, and colored pencils.
 - *Spray Fixatives* Use CP/AP clear acrylic emulsion to fix drawings.

Woodworking

- Woods Use only common soft woods.
- Glues Use CP/AP glues.
- Paints Use CP/AP water-based paints.

Ceramics

- Clays Use only wet, premixed clays.
- White Clays Use only talc-free clays.

* CP/AP refers to the Certified Product (CP) or Approved Product (AP) seal of the Art & Creat.ve Materials Institute (www.acminet.org).

- Glazes Paint finished pieces with acrylics or tempera instead of glazing.
 - Use premixed liquid glazes, not powders.

Metalworking

- Jewelry
- Use bent-metal wire instead of soldering. Stained Glass • Use colored cellophane and black paper to
 - imitate colored glass and lead came.

Commercial Arts

- Do not use, because they teach children to Scented Markers smell and eat art materials.
- Use CP/AP water-based markers. Permanent Markers
 - *Rubber Cement* Use CP/AP glues for collage.

This page constitutes an extension of the copyright page. We have made every effort to trace the ownership of all copyrighted material and to secure permission from copyright holders. In the event of any question arising as to the use of any material, we will be pleased to make the necessary corrections in future printings. Thanks are due to the following authors, publishers, and agents for permission to use the material indicated.

Cover

"Cultural Mountain" by Rolland D. Lee (Navajo), age 12. From *A Rainbow at Night: the World in Words and Pictures by Navajo Children* by Bruze Hucko (Chronicle Books, 1996). For more information contact Bruce Hucko at bhucko@frontiernet.com.

chapter 1

facing page 1 Courtesy of the author; 2 (left) Photograph © 1996 Ben Mara, Ben Mara Photography, Inc.; (right) American Museum of Natural History; 3 (top) Portland Art Museum, Portland, Oregon. Gift of the Friends of the Museum; (bottom) Instituto de Cultura de Tabasco, Direccion de Patrimonio Cultural, Museo Regional de Anthropologia "Carlos Pellicer Camara." Photo commissioned by the Metropolitan Museum, Encuadre: Gerardo Suter-Lourdes Almeida; 4 Photographs by Val Brinkerhoff; 5 (left) Courtesy of the artist; (right) Courtesy of the artist; 6 Courtesy of the author; 13 Courtesy of the Huntington Library, Art Collections and Botanical Gardens, San Marion, California; **14** Courtesy of the author; **15** Courtesy University of California Press.

chapter **2**

24, 26 Courtesy of the author; 27 (top right) Courtesy of Creators Syndicate; (bottom right) Courtesy of the Metropolitan Museum of Art, New York; 28 Courtesy of the artist; 29 Courtesy of the author; 31 Albright-Know Art Gallery, Buffalo, New York. Gift of Seymour H. Know, 1956. Copyright 2007 Artists Rights Society (ARS), New York; 34 (left) Solomon R. Guggenheim Museum, New York, Purchased with funds contributed by the International Director's Council and the Executive Commitee members. 2001.70. Copyright The Solomon R. Guggenheim Museum, New York; (right) Courtesy of the artist. Andy Goldsworthy Studio, Penpont (near Thornhill), Durmfriesshire, Scotland, UK; 35 Courtesy of Ronald Feldman Gallery; 36 Dia Foundation for the Arts, Corrales, New Mexico.

chapter 3

42, 44, 46, 47, 48, 49, 50, 51, 52 Courtesy of the author; 53 Courtesy of Crayola "Dream-Makers"; 54, 55, 56 Courtesy of the author; 57 From Sylvia Fein, *Heidi's Horse* (Pleasant Hill, CA: Axelrod Press, 1984); 58 Courtesy of the author; 59 From *A Rainbow at Night: The World in Words and Pictures by Navajo Children* by Bruce Hucko (Chronicle Books, 1996). For more information contact Bruce Hucko at bhucko@frontiernet

.net; 60 Courtesy of Crayola "Dream-Makers"; 61 (left) Courtesy of the Massachusetts Historical Society; (right) 62, 63, 64 Courtesy of the author.

chapter 4

68, 70, 73, 77, 78 Courtesy of the author; 80 (left) Viktor Lowenfeld, *Creative and Mental Growth* (New York: Macmillan Company, 1947); 80 (right) Courtesy of the author.

chapter 5

84, 86, 87 Courtesy of the author; 88 Courtesy of Crayola "Dream-Makers"; 89, 90, 91, 92, 93 Courtesy of the author; 94 Courtesy of Crayola "Dream-Makers"; 94, 95 Courtesy of the author; 96 From Jean Gould, *Winslow Homer: A Portrait* (1962). Courtesy of Dodd Mead; 97 Courtesy of Crayola "Dream-Makers"; 98 Courtesy of the author.

chapter 6

102, 104, 105, 106, 107, 108, 109, 111, 112, 113 Courtesy of the author; **114** (left) © 1994 UNICEF. Reprinted with permission of Harper-Collins; (right) Courtesy of the author.

chapter 7

118, 121 Courtesy of Crayola "Dream-Makers";122, 123 (left and right) Courtesy of the author;124 Copyright of the artist. Courtesy Rena Bran-

sten Gallery, San Francisco, CA; **125** The Georgia O'Keeffe Foundation. © 2007 Artists Rights Society (ARS), New York; **126** (left) Courtesy of the Bernice Steinbaum Gallery, Miami, FL; (right) Courtesy of the author.

chapter 8

130 Maryland Institute College of Art: 132 Courtesy of the author; 133 The Metropolitan Museum of Art. New York: 134 (top) The Metropolitan Museum of Art, New York: (bottom left and bottom right) Maryland Institute College of Art; 135 Smithsonian American Art Museum, Washington, DC. Gift of Herbert Walde Hemphill Jr. Museum purchase made possible by Ralph Cross Johnson. Art Resource, New York; 136 (top left and bottom right) Courtesy of the author: 138 (top and bottom) Courtesv of the author: 139 Whitney Museum of American Art. Purchase, with funds from the Louis and Bessie Adler Foundation, Inc., Seymour M. Klein, President, the Gilman Foundation, Inc., the Howard and Jean Lipman Foundation, Inc., and the National Endowment for the Arts 79.4 © The George and Helen Segal Foundation. Licensed by VAGA, New York; 140 (top right) Smithsonian American Art Museum, Washington, DC, Art Resource, New York; (bottom left) ©2007 Jerry Jacka; (bottom right) The National Museum of Women in the Arts, Washington, DC, gift of Wallace and Wilhelmina Holladay; 141, 142 (left and right), 143 (top and bottom). Courtesy of the author: 145 (left) ©1981 Robert Arneson. Licensed by VAGA, New York; 145 (right), 146 (left and right) Courtesv of the author.

chapter **9**

150 Courtesy of the author; 152 (left) Courtesy of the author; (right) Courtesy Museum of Art, Brigham Young University. All rights reserved; 153 (left and right) The National Museum of Women in the Arts, Gift of Wallace and Wilhelmina Holladay; 154 Courtesy of the author; 156 Copyright of the artist; 156, 157 (left, center, and right), 158, 159 (left and right), 160, 161, 162 (left and center) Courtesy of the author; 162 (right) Courtesy of Crayola "Dream-Makers"; 163 (top left) Solomon R. Guggenheim Museum, New York, purchased with funds contributed by Elaine and Werner Dannheisser and The Dannheisser Foundation, 1982, 82.2912. Photograph by David Heald. © The Solomon R. Guggenheim Foundation, New York; (top center, top right, bottom right) Courtesy of the author.

chapter 10

166 Maryland Institute, College of Art, Decker & Meyerhoff Galleries 168 TopFoto/The Image Works; 169 (left) Andrea Mohin/The New York Times; (right) Wolfgang Volz/Redux Pictures; 170 © 1980 by Sandy Skoglund. Collection of the artist; 171 © Cirdy Sherman; 173 © 1983, 2000, David Hockney; 174, 175, 176 (top and bottom), Courtesy of the author; 177 Los Angeles County Museum of Art. © 1993 Museum Associates, Los Angeles County Museum of Art. Gift of the Arm Museum Council. All rights reserved; 178, 179 Courtesy of the author.

chapter 11

182, 184 Courtesy of the author; 185 © Bildarchiv Preussischer Kulturbesitz, Berlin; 186 © Pitseolak Ashoona, 1969. Reproduced with permission of the West Baffin Eskimo Cooperative, Ltd., Cape Dorset, Northwest Territories, Canada; 188 (left) Courtesy of the author; (right) Courtesy of Crayola "Dream-Makers"; 190 Courtesy of the author; 191 From Ronald Bernatt and E. S. Phillips, *The Australian Aboriginal Heritage*; 192 Courtesy of the author; 193 Courtesy Julie Saul Gallery, New York; 194 Courtesy of the artist; 195 Photo by the author; 196, 197 Courtesy of the author.

chapter 12

200 Courtesy of the artist; 202 (left) Courtesy of the artist; (right) National Museum of American History, Smithsonian Institution. Art Resource, New York; 206 (left) The Museum of Modern Art, New York. Given anonymously. Art Resource, New York; (right) Courtesy of the artist; 208 Courtesy of the artist; 209 Copyright 2002 Guerrilla Girls, Inc. Courtesy of www.guerrillagirls.com; 210 (left) Copyright 2003 Judy Chicago. ACA Galleries, New York. Copyright 2003 Artists Rights Society (AF.S), New York; (right) Cover from *Mixed Blessirgs: Art in a Multicul*-

tural America by Lucy R. Lippard, Copyright 425 2006. Reprinted with permission of The New Press, an imprint of W. W. Norton, New York, NY: 211 Copyright 2007 Jenny Holzer. Artists Rights Society (ARS), New York. Courtesy of the Solomon R. Guggenheim Museum, New York; 212 The Museum of Modern Art. New York. Art Resource, New York; 214 (top left) Courtesy of the Huntington Library. Art Collections and Botanical Gardens, San Marino, California; (top right) Los Angeles County Museum of Art; (bottom left) National Gallery of Art, Washington, D.C. Collection of Mr. and Mrs. Paul Mellon. © 2000 Board of Trustees, National Gallery of Art. Washington, DC: (bottom center) Albright-Knox Art Gallery, Buffalo, NY, Bequest of A. Conger Goodvear, 1966, Copyright Banco de Mexico, Diego Rivera & Frida Kahlo Museums Trust, Av. Cinco de Mayo No. 2, Col. Centro del Cuauhetemoc 06059, Mexico, DF. Copyright 2007 Artists Rights Society (ARS). New York; (bottom right) Bernice Steinbaum Gallery, Miami, Florida; 215 Collection of Madison Art Center, Madison, Wisconsin. Purchase through NEA grant with matching funds from Madison Art Center members. Licensed by VAGA, New York; 216 (left) Courtesy of the author; (right) © 2006 Morla Design, San Francisco; 217 Courtesy of the author; 219 National Museum of American Art, Smithsonian Institution, Washington, DC. Art Resource, New York.

chapter 13

224 Photograph by Val Brinkerhoff: 226 Photo © Nippon Television Network 227 Aegyptisches Museum, Staatliche Museum zu Berlin, Berlin Germany. Bildarchiv Preussicher Kulturbesitz/ Art Resource, New York; 228 Museum purchase, 85-1-11. Eliot Elisofon Photographic Archives. National Museum of African Art, Smithsonian Institution, Washington, DC. Photo Franko Khoury; 229 Museum of Fine Arts. Boston. Bridgeman Art Library; 230 (left) The Detroit Institute of Arts, Founders Society Purchase with funds from the Gerald W. Chamberlin Foundation, Inc., Mr. and Mrs. Charles M. Endicott. Photograph © 1988 The Detroit Institute of Arts; (right) Minneapolis Museum of Art (83.80). The Centennial Fund: Gift of funds from Mr. and Mrs. Donald C. Dayton; 231, 232 (left) Photo-

graph by Val Brinkerhoff; 232 (right) Photo Re-426 searchers. Inc.: 235 Reproduced by courtesy of the Trustees, The National Gallery, London; 236 The Metropolitan Museum of Art, New York. Gift of Cornelius Vanderbilt, 1887; 237 Museum of Modern Art, New York. Bequest of Lillie P. Bliss. Art Resource, New York. Copyright 2003 Estate of Pablo Picasso. Artists Rights Society (ARS), New York; 238 Young People's Art Studies, Maryland Institute College of Art. Ruth Aukerman, teacher: 239 Chicago Historical Society: 240 The Metropolitan Museum of Art. Gift of Several Gentleman, 1911; 241 The Museum of Fine Arts, Houston (84.199). Museum purchase with funds provided by the Museum Collectors; 242 (left) National Museum of American Art, Smithsonian Institution, Washington, DC. Art Resource, New York; (right) Wadsworth Atheneum, Hartford, the Ella Gallup Sumner and Mary Catlin Sumner Collection Fund; 244 (left) The Philadelphia Museum of Art. The Louise and Walter Arensberg Collection, 1950. Art Resource, New York, Copyright 2007 Artist Rights Society (ARS), New York/ADAGP, Paris/ Estate of Marcel Duchamp; 244 Time and Life Pictures/Getty Images; 245 Lent by the Department of the Interior Museum, National Museum of American Art, Smithsonian Institution, Washington, DC. Art Resource, New York; 246 Courtesy of the author; 247 Israel Museum; 248 (right) Copyright 1990 The New Yorker Magazine, Inc. Reprinted with permission. All rights reserved; (left) Courtesv of the author: 249 (left) Courtesv of the Pavel Zoubok Gallery, New York; (right) Kunsthistorisches Museum, Vienna. Erich Lessing/Art Resource, NY.

chapter 14

256 Museo Nacional Centro de Arte Reina Sofia, Madrid, Spain. Erich Lessing. © 2006 Estate of Pablo Picasso/Arts Rights Society (ARS), New York. Photograph John Bigelow Taylor/Art Resource, NY; 258, 259 Photo by Val Brinkerhoff; 260 Estate of the artist. © 2006 Artists Rights Society (ARS), New York; 262 Louvre Museum, Paris, France. Scala/Art Resource, NY; 264 (top) Courtesy of the author; (bottom) Museum of Fine Arts, Boston. Bequest of John T. Spaulding; 265 Galleria degli Uffizi, Florence, Italy. Scala/ Art Resource, NY; 266 (left) The Detroit Institute of Arts, Founders Society. Purchase with funds from the Detroit Edison Company. © Romare Bearden Foundation, New York, NY. Photograph © 1990 The Detroit Institute of Arts. Licensed by VAGA, New York; (right) Hampton University Museum, Hampton, Virginia; 267 Museo Nacional Centro de Arte Reina Sofia, Madrid, Spain. Erich Lessing. © 2003 Estate of Pablo Picasso. Arts Rights Society (ARS), New York. Photograph John Bigelow Taylor/Art Resource, NY: 268 Indiana University Art Museum. Photograph by Michael Cavanagh and Kevin Montague. © 2006 Estate of Stuart Davis. Licensed by VAGA, New York; 269 (left) Maryland Historical Society, Fred Wilson, artist/curator; (right) Brookgreen Gardens, Murrells Inlet, South Carolina; 270 (left) University Art Museum, University of California at Berkeley, purchased with the aid of funds from NEA and selected by the Committee for the Acquisition of Afro-American Art; (right) Courtesy Bernice Steinbaum Gallery, Miami, FL; 272 © Dorothea Lange Collection. The Oakland Museum of California, City of Oakland. Gift of Paul S. Taylor; 273 Photo by Michael Day; 274 AP/Wide World Photos. Inc.

chapter 15

280 Topham/The Image Works; 282 (left) Electronic Arts Intermix (EAI), New York; (right) U. S. Census Bureau; 283 © 2006 Margaret Courtney-Clarke; 284 Copyright Aardman Animations, Ltd., 2006; 285 Id Software, Mesquite, TX; 286 Publisher: Parkett, Zurich and New York; Manufacturer: Marmet, Tokyo; edition of 99. The Museum of Modern Art, New York, Linda Smith Goldstein Fund. ©1998 Mariko Mori/Art Resource, NY; 287 Davis Art, Worcester, MA; 288 (left and right) Courtesy of the author; 289 Topham/The Image Works; 290 The Everett Collection; 292 (right) Courtesy of the artist; 293 Courtesy of the author.

chapter 16

296, 298, 299 (top and bottom), **301** Courtesy of the author; **307** Smithsonian American Art Museum, Washington, DC. Art Resource, New

York. Licensed by VAGA, New York; **309**, **313** Courtesy of the author.

chapter 17

316, 318, 319, 320, 321 Courtesy of the author; **323** (top) Palacio de Bellas Artes, Mexico City, DF, Mexico. Schalkwijk/Art Resource, NY. Diego Rivera & Frida Kahlo Museums Trust, Av. Cinco de Mayo No 2, Col. Centro del Cuauhetemoc 06059, Mexico, DF. © 2006 Artists Rights Society(ARS), New York; (bottom) AXA Gallery, Equitable; **324** Courtesy Judith F. Baca; **325, 326** (left and right), **328, 329, 332**, **333** (right and left) Courtesy of the author.

chapter 18

336 Courtesy of the author; 338 St. Louis Art Museum; 339 Solomon R. Guggenheim Museum, New York. Gift of Mr. and Mrs. Gus and Judith Lieber, 1988. 99.3620. Photograph by David Heald © The Solomon R. Guggenheim Foundation, New York; 341 Smithsonian American Art Museum, Washington, DC. Art Resource, New York: 344 (left and right), 345 (left and right), 346 (left and right), Courtesy of the author: 347 Ameringer & Yohe Fine Art 349 Courtesy of the author; 350 The Saint Louis Art Museum 351 Courtesy of the author; 352 Courtesy of the author; 353 Photo by Neil Jacobs, Courtesy of the author; 354 Courtesy of the author; 355 (top and bottom) Courtesy of the author: 357 From A Rainbow at Night: the World in Words and Pictures by Navajo Children by Bruce Hucko (Chronicle Books, 1996). For more information contact Bruce Hucko at bhucko@frontiernet.com; 358 (top and bottom) Courtesy of the author; 364 Courtesy of the artist.

chapter 19

368, 370, 372, 374, 375, 376 Courtesy of the author; 377 Elizabeth Safer, Museum of Modern Art, Liechtenstein. Courtesy of the author; 378 Courtesy of the author; 379 (top and bottom) Courtesy of the author; 380, 381 Courtesy of the author.

chapter 20

384 Courtesy of the author; 386, 391 (top left) Courtesy of Crayola "Dream-Makers"; 391 (top right and bottom right) Courtesy of the author; 393 The Museum of Modern Art, New York. Photograph © 2006 The Museum of Modern Art, New York. Art Resource, NY. Diego Rivera & Frida Kahlo Museums Trust, Av. Cinco de Mayo No 2, Col. Centro del Cuauhetemoc 06059, Mexico, DF. © 2006 Artists Rights Society(ARS), New York; **394** (left) Museum of Fine Arts, Beston, Spaulcing Collection; (right) Courtesy of the artist; **396** Malcolm Varon, New York. © 1985, 2000, 2006; **397** Philadelphia Museum of Art, The Alfred Stieglitz Collection. Copyright 2006 Artists Rights Society (ARS), New York; **398** Collection of John and Lynne Ple-

shette; 400 Courtesy UBS, New York, NY; 427 404 Albright-Knox Art Gallery, Buffalo, NY. Edmund Hayes Fund, 1982; 405 Museum of Fine Arts, Boston; 407 The Detroit Institute of Arts, Founders Society Purchase, Eleanor Clay Ford Fund for African Art. Photograph ©1998 The Detroit Institute of Arts.

INDEX

Page numbers in **bold** indicate an illustration.

A

A201 Recall (Ferrara), 5 aboriginal bark paintings, 191-192 abstract expressionism, 31, 240 actual space in design, 189 advertising deconstructing, 291-292 graphic design and, 400 package design project, 287 aesthetics assessment of students' progress in, 395-396 balance and, 191-192 beauty and art, 259-263 censorship and art, 271-273 children's beliefs about art, 261 controversies about, 273-274 defined, 259 expressionism and, 267-268 fallacy of artistic intention, 269-270 forgeries and, 274 formalism, 268 inquiry and structured discussion for teaching, 274–276 knowledge and art, 264-265 material values and art, 270-271 media and, 265-266 mimesis and, 266-267 nature and art, 263-264 notion of aesthetic response, 3 politics and, 271 questions on, 257-258, 263 semiotic theory and, 36 teaching methods, 261-263, 274-276

western society and art, 270-274 See also design African art, 2, 228-229, 283, 345, 407 Agrarian Leader Zapata (Rivera), 393, 394 Alabama Wall (Christenberry), 219 Albers, Josef, 239 Algonquin, 234 Almarez, Carlos, 398 Altdorfer, Albrecht, 234 America history of art in, 238-239 Native art (see Native American art) American Artist, 329 American Association on Mental Retardation, 74 American Psychological Association, 17 analogous colors, 188 Anasazi, 233, 258 ancient world Africa, 228-229 Asia, 229-230 Egypt, 227-228 near East, 228 prehistoric art, 227 Anderson, Richard, 268 Anderson, Tom, 34, 208, 285 anecdotal method of assessment, 401 Angel Departing from the Family of Tobias (Rembrandt), 152 Anguissola, Sofonisba, 234 Anthony, Peter (Sky Eagle), 2 Anuszkiewicz, Richard, 240 applied arts. 3 The Arc (Association of Retarded Citizens), 75 architectural design, 195-197 Architectural Site 10 (Kasten), 193

Arch of Constantine, 231 Armory Show (NY, 1913), 239 Arneson, Robert, 145 Arnheim, Rudolf, 7, 43, 50, 51 art and nature aesthetics and, 263-264 curriculums and, 352 Art and Visual Perception (Arnheim), 7 Art: A Personal Journey, 286 art appreciation and criticism asking what qualifies as art, 213, 215 assessment of learning in, 393-394, 395 components in understanding art, 202-203 composition, 213 descriptive level of analysis, 205 formal analysis, 205 instruments of engagement and evaluation, 212-213 interpretation, 205-206 judgement and informed preference, 206-208 learning from art critics, 208-209 museums and galleries use, 217-220 past versus present teaching methods, 204 picture walls. 215–216 postmodern perspectives, 203 pre- and post-preference instrument, 215 sorting and matching, 215 statement matching, 213 studio involvement in teaching, 203-204 suggestions for study, 211–212 teaching aids, 216-217 teaching methods, 203-208 working with language, 210-212 Art as Experience (Dewey), 192 art assessment programs. See assessing students

art education balanced program goal, 27-30 basic beliefs. 18 the Bauhaus and 16 brain research and, 11 Cizek's view of artistic expression, 14-15 concerns about assessments, 388-389 content of art and. 17-18 creativity and, 16-18 cultural understanding and *[see* modernism; postmodernism) curriculums in (see curriculums) early influences on. 6 education development, 13-14 historical development of. 13-14 influences of art teachers, 15–16 Owatonna Project, 16 rationale for art in schools, 26 recognition of a need for in U.S., 13-14 role in general education, 25-27 social values in. 317-318 societal values and, 12 viewed as essential, 13 visual culture in (see visual culture) See also learning theory; teaching methods Art for Daily Living (Ziegfeld), 283 art games, 329-331, 332-333 art history in America, 238-239 ancient world, 227-230 assessment of learning in, 394-395 baroque, 234 changing face of, 241-243 classical European, 230-231 color and painting, 124-125 colors in paintings and, 124–125 contemporary art, 239-241 content overview, 226-227 dramatization activities, 249-250 methods of inquiry, 245-247 middle ages, 231-234 modern art, 235-238 murals and, 322-324 postmodern art, 235-238 reading about, 248 Renaissance, 231, 234 teaching methods, 243-245, 246-250 Art in Action. 35 Art in America, 241, 329 artistic development. See children's artistic development

artistic giftedness. See gifted and talented learners ARTnews, 241, 329 Art of Painting, The (Vermeer), 249 Art Today: An Introduction to the Visual Arts (Ziegfeld), 283 Ash Can school, 239 Ashoona, Pitseolak, 186 Asia, 229-230 assemblage, 133 assessing students anecdotal method 401 balanced program goal, 389-390 concerns about in art education, 388-389 devices for, 402, 403, 406-409 evaluations of student behaviors, 392 formal assessment, 388 informal assessment, 387-388 of learning in art criticism. 393-394 of learning in art history, 394-395 methods for, 396 positive effects of, 389 principles for, 390-393 progress in aesthetics, 395-396 reporting progress in art, 401, 403-405. 407 strategies for, 396-401 terminology, 386-337 usefulness of feedback, 389 Association of Retarded Citizens (The Arc), 75 Assyrians, 228 attitude measurement and assessing students. 399 Audubon, John James, 352 Australia, 233 authentic assessments, 387 autism, 72. See also special needs learners Autobiography (Pindell) 242 Ayers, William, 297 Aztecs, 233

B

Babylonians, 228 Baca, Judy, 324 background, 189 balance in design, 191–192 *Banjo Lesson, The* (Tanner), **266** Barkan, Manuel, 16, 204 baroque art, 234 Barrett, Terry, 32, 201, 290–291

Bar Willows and Distant Mountains (Yuan), 229 429 baseline, 54 Baselitz, Georg, 240 Basquiat, Jean Michel, 64, 242 Bath. The (Cassatt), 153 Bauhaus, 16 Bearden, Romare, 215, 242, 266, 350 Beattie, Donna Kay, 385 beauty and art, 259-263 Beetle n' Wedge (Homer), 96 behavioral psychology, 7 Benin people, 229 Benton, Thomas Hart, 322, 323 Bierstadt, Albert, 239 Biggers, John T., 307 Bilbao Museum (Gehry), 258 bird's-eye views in children's drawings, 54 bisque firing/bisqueware, 145 Blandy, Doug, 81 blowups, 328-329 Blue Poles (Pollock), 270 Boas, Belle, 16 bodily kinesthetic intelligence, 9 bone-dry state of clay, 145 Bonheur, Rosa, 235, 236, 267 Bot Fighters, 285 Bo Train Circle game, 355 Botticelli, Sandro, 234, 264-265, 265, 340 box sculptures with paper. 135-137 Bover, Ernest, 26 Boy with a Pipe (Picasso), 270 brain research and learning theory, 8, 10-11 Braque, Georges, 124, 237 Bravo, Claudio, 240 Breakfast in Bed (Cassatt), 214 Breton, André, 237-238 Broudy, Harry, 25 Brueghel, 234 brushes. See paintbrushes Buddhism, 229 Burke, Chris, 75 Burton, Judith, 48 Bush, George W., 10, 396 Butterfield, Deborah, 189 Byzantine art, 231

C

Calder, Alexander, 271 Camara, Silla, **283** Cambodian art, **4** cameras used for art, 177. See also photography Canadian Museum of Civilization, 234 Canadian Society for Education through Art (CSEA), 18 canon of works. 32 Caravaggio, 234 careers in the applied arts, 194 in architecture, 196 Caribbean Festival Arts, 350 Carroll, Karen, 99 carving, 133 Cassatt, Mary, 124, 153, 214, 239 Catlin, George, 239 cave paintings, 2-3censorship and art, 271-273 ceramic clay activities, 144 displaying, 379 finishing processes, 146-147 invention of containers and, 2 media and techniques, 140-142 pottery, 144-146 teaching methods, 142-143, 147 types of uses, 132 Ceremonial Art Honoring Service Workers (Ukeles) 35 Cézanne, Paul, 236-237 Chagall, Marc, 237, 322 chalk, 105. See also specific topics under media and techniques Chapman, Laura, 33, 204 Chapter 766 (Federal law, U.S.), 71 charcoal, 97, 105. See also specific topics under media and techniques Chartres cathedral, France, 231 checklists and assessing students, 398 Chen Ming-Te, 292 Chiang Hsiu-Chi, 292 chiaroscuro. 125, 187, 234 Chicago, Judy, 12, 92, 209, 210, 394 Chihuly, Dale, 214 children's artistic development adult artists' emulation of children's art, 64-65 children's conceptions of art, 63-64 children's nature as learners, 6 criticisms of stage theory, 45 emotional lives depicted in, 45 influences of visual culture, 44 manipulative stage, 47-50

preadolescent stage, 59-60 pre-school depictions of art, 44 reasons children make art, 60-63 schema use, 56, 58-59 stage theory overview, 46-47 stereotypes use, 58-59 symbol-making stage, 50-59 therapeutic value of art, 63 Chimu culture, 233 Chinese art, 3, 141, 152, 229 Chirico, Giorgio di, 237 Christenberry, William, 219 Christian art, 231 Christina's World (Wyeth), 212, 212, 213 Christo, 169-170, 169, 248 Chung, Sheng Kuan, 291 Church, Frederic, 239 cigarette ads. 291-292 Civil Rights Memorial (Lin), 274 Cizek, Franz, 14-15, 16 Clark, Gilbert, 85 classroom organization design of the art room, 373-374 furnishings in an art room, 374-375 for general classrooms, 372-373 learning environment creation, 375 physical requirements, 370 for primary grades, 371-372 supplies and equipment, 370-371 See also displaying students' art; teaching methods clay. See ceramic clay Claymation, 284 Clemente, Francesco, 240 Clinton, Bill, 396 Close, Chuck, 155, 240 clothing, cultural relevance of, 2 cognitive development stages, 7 coil methods in pottery, 144, 145, 145 Coles, Robert, 114 collaborative art activities art games, 329-331, 332-333 group activities, 319-320 murals (see murals) puppetry, 320-322 social values in art education, 317-318 teachers' role, 318-319 collography, 160-161 color awareness development, 122–126 children's use of, 53

hue manipulation, 123 painting and, 124-125 teaching about, 121-122 wheel, 188 color in design art history and paintings and, 124-125 complexity and power of, 186, 187 function of, 186-187 terminology, 187-189 Colosseum, Roman, 231 Commentary Islands, 35 complementary colors, 187-188 computers aesthetics and, 265-266 as a medium, 98, 110-111 printmaking and, 153 technology and teaching methods, 308-309 uses in art, 168-169, 178-179 visual culture and, 284 Constable, John, 235 containers as functional art, 2 contemporary art art history and, 239-241 visual culture and, 290 See also modernism: new media: postmodernism contour-line drawing, 108-110 Convergence (Pollock), 31 cool colors, 188 copiers used for art, 174-175 Cordoba mosque, Spain, 231 Courbet, Jean, 236, 266 crayons for drawing, 97 in manipulative stage, 104-105 for rubbings, 153-154 See also specific topics under media and techniaues Creative and Mental Growth (Lowenfeld), 16, 17 Creative Teaching in Art (D'Amico), 16 creativity and art education, 16-18 Cree, 234 criticisms of art. See art appreciation and criticism CSEA (Canadian Society for Education through Art), 18 cubism, 237 cultural separatism, 351 cultural understanding of art, 351-352. See also modernism; postmodernism

430

curricula

art and multicultural understanding and. 351-352 art and nature and, 352 art supervision, 345-346 attitudes towards art and, 12-13 balanced program goal, 346-347 classroom teacher and, 342-343 community setting and, 340 cooperative art teaching, 345 correlation problems, 354-355 defined, 337-338 design of, 342-343 development approaches. 355-356 district administrators and, 343 educational objectives, 361-365 elementary art specialist and, 342, 343-344 implementation strategies, 343–346 influences on, 338–342 integrating into elementary curriculum, 29-30 Japanese sculptors lesson example, 363-364 language arts and, 350-351 lesson plans, 360-361 mathematics correlated to art, 353-354 music correlated to art, 353 organizational categories, 356-358 outcomes of quality programs, 27-29 planning decisions, 346-348 planning process, 338 published art curricula, 347-348 readiness of learners and, 338 relationships within the arts, 348-349 school district philosophy and, 346 school setting and, 340-342 scope and sequence in, 347 social studies and, 349-350 societal values and, 338-339 student participation in development of, 343 thinking skills taught, 339-340 unit plans, 358 visual culture in, 286–288 yearly plan, 358, 359-360

D

dada movement, 237 Dalí, Salvador, 237 D'Amico, Victor, 16 Danto, Arthur, 210 Darius, King, 228

Daumier, Honoré, 236, 259 David (Michelangelo), 340 David, Jacque-Louis, 235, 236 da Vinci. See Leonardo da Vinci Davis, Stuart, 268 deaf-blindness, 72. See also special needs learners deafness, 72. See also special needs learners Death of Socrates, The (David), 235 deconstruction, 33, 36, 291-292 decoration used to convey meaning, 2-3Deem, George, 249 Degas, Edgar, 153, 154, 214 de Kooning, Willem, 239, 240 Delacroix, Eugène, 235 De Maria, Walter, 36, 170 Derain, André, 237 design architectural, 195-197 careers in the applied arts, 194 color, 186-189 elements overview, 184-185 in the entertainment media, 194-195 form and, 184 graphic, 194 implications of the process, 192-193 line. 185-186 mass, 186 meaning of the word, 183-184 principles of, 185, 190-192 shape, 186 space in. 189-190 texture in. 189 uses of, 193-194 See also aesthetics Demoiselles, Les (Picasso), 237, 237, 240 development, artistic. See children's artistic development Dewey, John, 6, 12, 31, 61, 192, 340 Dial, Thornton, 287, 288, 290 Diamond, Marian, 11 Diary: December 12, 1941 (Shimomura), 242 Diary of John Quincy Adams. The. 61 Dinner Party, The (Chicage), 12, 209, 210. 394 directive method of teaching, 298 disabled students. See special needs learners Disasters of War (Goya), 261 Discobolus, 230 discovery method of teaching, 298 discussion and assessing stucents, 397

Disney Concert Hall (Gehry), 288 displaying students' art involving students in. 380 outside the classroom, 380-381 for Parents' Night, 381 reasons to display, 375-376 selecting work to exhibit, 376-377 three-dimensional work, 379-380 two-dimensional work, 377-379 See also classroom organization; teaching methods Dissanavake, Ellen, 1 Docter, Peter, 290 Dow, Arthur Wesley, 15, 15 Down syndrome children, 71, 74, 75 dramatization activities, 249-250 drawing composition approached through form and idea, 111 contour-line drawing approach, 108-110 goals of, 107 manipulative stage, 104-105 memory abilities and, 112-113 mixed media methods. 110-111 narratives and storytelling. 113-115 preadolescent stage, 105-111 purpose in encouraging in preschool children. 104 resist techniques, 110 sources of observation, 107-108 symbol-making stage, 105 techniques for improving skills, 108 Duchamp, Marcel, 244, 288 Dunn, Phillip, 308 Dürer, Albrecht, 234 dustless chalk, 105

Ε

Eakins, Thomas, 239 early childhood education, 6. See also learning theory Easter Island, 4, 233 ecological themes in art, 328 Education through Pictures (Farnum), 16 Efland, Arthur, 340 Egypt, 227–228 Egyptian art, **134**, **349** Eisner, Elliot, 8, 17, 47, 285, 337, 340 elementary art specialist, 342, 343–344 Elisofon, Eliot, **244** emotional disturbance, 72. See also special needs learners English as a second language (ESL), 71 engobe, 146 the Enlightenment, 30 entertainment media and design, 194-195 Escher, M. C., 353 essays and assessing students, 399 Estes, Richard, 189, 240 European art, 230-231, 235 evaluation, 386, 387, 392, 409. See also assessing students expressionism abstract, 31, 240 aesthetics and, 267-268 defined, 238 expressive concepts and stages of development, 49 Eyck, Jan van, 234, 235

F

432

Fallingwater (Wright), 239, 239, 258 Family, The (Grigsby), 206, 207 Farnum, Royal B., 15, 16 fauvists, 237 faxes used for art. 174 Feldman, Edmund, 186 felt-tip pens. 104–105. See also specific topics under media and techniques Female Figure (Maillol), 260 feminism movement in art, 209 postmodernism and, 33 Ferrara, Jackie, 5 Fighting Stallions (Huntington), 269 figure-ground relationship, 190 fine arts. 3 Fish, Janet, 240, 241 Flagg, James M., 202, 394 Fly, Fly, Sweet Life (Minshall), 350 Fog Warning, The (Homer), 405 foldover view in children's drawings, 54, 55 folk arts, 3 foreground, 189 forgeries, 274 formal assessments, 399-401 formalism, 268 formative assessments, 387 form in design, 184 Foster Parents Plan Program, 355

Fountain (Duchamp), 288 Francis, Sam, **202** Frankenthaler, Helen, 111, 187 Freedman, Kerry, 281 French Academy, 235 Fröbel, Friedrich, 6 Fuiji, Chuichi, **364**

G

Gablik, Suzi, 208-209 Gaither, Joan, 208, 209 Galeano, Eduardo, 26 games, art, 329-331. 332-333 games, instructional. See collaborative art activities Garden of Eden. The (Schapiro), 126 Gardner, Howard, 8, 9, 45, 90 Gardner's Art through the Ages (Mamiya), 241 Gates. The (Christo and Jeanne-Claude), 169-170, 169, 248 Gauguin, Paul, 236 Gehry, Frank, 195, 258, 288 Gentileschi, Artemisia, 234 Géricault, Théodore, 235 Germany's Children Are Starving (Kollwitz), 185 Gestalt, 7 Ghirlandaio, Domenico, 261-263, 262 Giclée print, 175 gifted and talented learners activities for, 95-97 artists' remembrance of their pasts, 92-93 case histories of gifted students, 91-92 characteristics of artistically gifted children, 88 - 91identifying gifted children, 87-88, 93 media for drawing and painting, 97-98 special arrangements in art for, 94-95 teaching methods for, 98-99 Giovanni Arnolfini and His Bride (van Eyck), 234, 235 Giovanopoulos, Paul, 28 glaze, 187 glaze firing, 145 Goals 2000: Educate America, 396 Gogh, Vincent van, 124, 236, 270 Goldsworthy, Andy, 34, 35, 172 Golomb, Claire, 52 Goodman, Nelson, 26 gothic cathedrals, 231

Gova, 259, 261 Grand Canvon of the Yellowstone (Moran), 245 graphic design, 194, 400 Grav's Raid, 286, 358 Great Wall of Los Angeles (Baca), 324, 324 Great Wave. The (Hokusai), 394, 395 Greece, 230 Greed (Almarez), 398 Greenberg, Clement, 203 greenware, 145 Grigsby, Eugene, Jr., 206, 207 Grocery (Chen), 292-293 Guay, Doris, 71, 77 Guernica (Picasso), 12, 267, 329 Guerrilla Girls, 209, 209, 291 Guggenheim Museum (Wright), 195, 271 Guilford, J. P., 17 Gvotaku, 163

Η

Haftmann, Werner, 237 Hampton, James, 341 handicapped students. See special needs learners Haozous, Robert, 242 Harunobu, Suzuki, 153 Heap of Birds, Edgar, 241 hearing impairment, 72. See also special needs learners Hegel, Georg, 275 Heller, Jules, 151 Heller, Nancy, 241 Hepworth, Barbara, 186 Herbart, Johann Friedrich, 6 Hinduism, 229 Hispanic American artists, 322 history of art. See art history Hockney, David, 124, 173, 174 Hofmann, Hans, 125, 239 Hokusai, Katsushika, 230, 394, 395 Holzer, Jenny, 211, 241 Homer, Winslow, 96, 239, 338, 405 Hopis, 233, 234 Hopper, Edward, 263, 264 Horse Fair, The (Bonheur), 235, 236 Horsemen, 230 How Much Longer? (Gaither), 208, 209 hue. 187 Huntington, Anna Hyatt, 269 Hurwitz, Al, 332, 333

Hurwitz, Michael, 5 hyperreality, 37

I Dream of Peace: Images of War by Children of Former Yugoslavia, 114 illusionistic, 266 impressionists, 236 improvisation, 348 In a Red Space (Kahn), 347 Incas, 233 Incredibles, The, 289 India, 229 Individual Educational Program (IEP), 75 Individuals with Disabilities Education Act (IDEA), 70 Ingram, Jerry, 282 Ingres, Jean-Auguste-Dominique, 236 Inhelder, Barbel, 7 instructional games. See collaborative art activities intaglio process in printmaking, 152 Integrated School Art Program, The (Winslow). 29 intelligence quotient (IQ), 8, 10 intensity, 187 intentional fallacy in art, 269-270 International Society for Education through Art (InSEA), 18 Internet and teaching art, 308 interpersonal intelligence, 9 interviews and assessing students, 397, 402 intrapersonal intelligence, 9 Irises (van Gogh), 270 Islamic art. 231–233 "I Want You" (poster), 202, 394

Japanese art, **15**, **153**, 229, **364** Japanese sculptors lesson example, 363–364 Javits Gifted and Talented Education Act, 87– 88 Jeanne-Claude, 169, **170**, 248 Jencks, Charles, 30 Jensen, Eric, 11 Jimenez, Luis, 242 Joe, James, 242 Johns, Jasper, 240 judgment of students' work, 399

___K

Kahlo, Frida, 214, 238, 242 Kahn, Wolf, 347 Kandinsky, Vasily, 238 Kant, Immanuel, 275 Kara (Fish), 241 Kasten, Barbara, 193 Kaufman House (Wright), 239, 239 Keleny, Earl, 194, 406 Keller, Helen, 69 Kieffer, Anselm, 240 Kiitsu, Suzuki, 230 Kinkade, Thomas, 287 Kläger, Max, 74 Klee, Paul, 64, 65, 237 Klein, M. Frances, 356 Kleinbauer, Eugene, 245 Kleiner, Fred. 241 Klopfer, Leopold, 7, 339 knowledge and art, 264-265 Kollwitz, Käthe, 185, 238 Koons, Jeff, 195 Koran, 232 Korzenik, Diana, 13 Kruger, Barbara, 241, 291

Lange, Dorothea, 272 Langer, Susanne, 74 language arts and art curriculum, 350-351 Laocoön Group, 230 Larson, Gary, 26, 27 Last Supper (Leonardo da Vinci), 322 Lawrence, Jacob, 242 learning theory brain research and, 8, 10-11 levels of thinking, 29 multiple intelligences, 8, 9 philosophy and psychology, influence on, 6 - 7societal values and, 11-13 views of the learner, 7 See also art education; teaching methods leather-hard state of clay, 144 Leonardo da Vir.ci, 234, 322, 327, 352 Leung Chi Fan, 375 Leutze, Emanuel, 26, 27, 329 levels of thinking, 29 Liberation of Aunt Jemima, The (Saar), 270

Libyan Sibyl (Michelangelo), 226 Lichtenstein, Rov. 240 Lighthouse and Building (Hopper), 264 Lightning Field (De Maria), 36, 170 Lin, Maya, 242, 272, 273, 274, 394 linear perspective, 125, 189-190 line in design, 185–186 linguistic intelligence, 9 linoleum and woodcut printing collography, 160-161 media and techniques, 157-158 mixed media methods, 161 reduction process, 160 teaching methods, 158-160 Lippard, Lucy, 26, 34, 209, 210, 242 Little Dancer (Degas), 214 Liu, Hung, 124 Lives of the Artist (Vasari), 225–226 logical-mathematical intelligence, 9 London, Peter, 317 Lowenfeld, Viktor, 12, 16, 17, 45, 80 Luna, James, 242

Μ

Machida, Margo, 242 Magleby, McRay, 394, 395 Magritte, René, 237 Maillol, Aristide, 260 Mamiya, Christin, 241 Man, Controller of the Universe (Rivera), 323 Manet, 236 manipulative stage in development concepts learned during, 49 defined, 46, 47-48 drawing and, 104-105 enduring nature of, 50 importance of naming, 49-50 progression in abilities, 48 significance of scribbling, 47 Maori people, 233 Mapplethorpe, Robert, 271 Marcel Duchamp (Elisofon), 244 Martinez, Maria, 29, 140, 242 Marxism, 33 Maslow, Abraham, 7 Massachusetts Normal Art School, 14 mass in design, 186 mathematics correlated to art, 353-354 Mathias, Margaret, 16 Matisse, Henry, 65, 236, 237

434 Ma

Mayans, 233 McFee, June King, 17 Mecca, 231 media and techniques aesthetics and, 265-266 classroom supplies and equipment, 370-371 clay modeling, 140-142, 146-147 displaying students' art, 377-381 for drawing 110-111 freestanding forms of sculpture, 137-138 for gifted and talented learners, 97-98 group activities, 319-320 linoleum and woodcut printing, 157-158 manipulative stage, 104-105 methods of mixing media, 110-111 monoprints, 154-155 murals, 324-327 paint, 120-121 potato and stick printing, 156-157 pottery, 144-146 preadolescent stage, 110-111 puppetry, 320-322 sculpture, 132-134 for special needs children, 77-78 stenciling, 161-163 symbol-making stage, 105 technology use and, 175-176 See also new media Megatron (Paik), 282, 288 Meier, Norman, 88-89 memory game, 111 Mendieta, Ana, 242 mental retardation, 72, 74-75. See also special needs learners Mexican art, 3, 4, 319, 322 Michelangelo, 226, 234, 273, 322, 340, 394 middle ages Christian art, 231 Islamic art, 231-233 Oceania, 233 pre-Columbian art, 233-234 middle ground, 189 Migrant Mother (Lange), 272 Milbrandt, Melody, 285 Millet, Jean-François, 236 mimesis, 266-267 Minshall, Peter, 350 Miró, Joan, 237 Mitchell, Joan, 240

Mixed Blessings (Lippard), 209, 242 modeling, 133, 144 modern art, 235-238 modernism attributes of modern art included in, 32 basic tenets, 30 belief in autonomy of the artwork, 32 canon of works, 32 central beliefs, 31 defined, 31 faith in science and, 30 formalism, 32 theory of historical progress in art, 31 view of social progress and art, 31-32 Mondrian, Piet, 353 Monet, Claude, 187, 236 monoprints media and techniques, 154-155 teaching methods, 155-156 Monroe, Marilyn, 350 Moore, Henry, 186 Moran, Thomas, 245 Mori, Mariko, 286 Morisot, Berthe, 236 multiculturalism, 33, 34 multicultural understanding and art, 351-352 multiple intelligences theory, 8, 9, 90 murals art history and, 322-324 blowups, 328-329 ecological themes. 328 media and techniques, 324-327 pictures of, 26 subject matter, 325-327 tableau projects, 327-328 teaching methods, 327 museums and galleries art appreciation and criticism and, 217-220 field trips. 305-306 use for teaching art, 77 musical intelligence, 9 music correlated to art, 353 Muslims, 231-233

N

Nadin, Mihai, 167 naïve artists, 64–65 narratives and storytelling through drawings, 113–115 National Art Education Association (NAEA), 18, 35, 342, 373, 396 National Assessment of Educational Progress in the Arts, 396 National Association of Schools of Art and Design (NASAD), 289 National Board for Professional Teaching Standards (NBPTS), 396 National Center for Education Statistics (NCES), 13 National Endowment for the Arts, 271 National Museum of the American Indian, 234 National Society for Education in Art and Design (NSEAD), 18 National Standards for Arts Education, 25, 27, 396 National Standards for the Visual Arts, 347 Native American art, 2, 29, 233, 234, 258, 282, 332, 357 naturalism, 266 naturalistic intelligence, 9 nature and art aesthetics and, 263-264 curricula and, 352 Navajos, 233, 234 near East, 228 Nefertiti (queen), 227 neoclassical movement, 235 neoexpressionism, 240 Neolithic period, 227 Neshat, Shirin, 34 Nevelson, Louise, 92-93 New Guinea, 233 new media examples, 168-169 response to contemporary art, 171-172 self-portraits galleries and, 171 technology-based (see technology) See also media and techniques New York Artist in Studio (Deem), 249 New Yorker, The (magazine), 400 New Zealand, 233 Nike of Samothrace, 230 No Child Left Behind, 7, 396 Nochlin, Linda, 209 Noguchi, Isamu, 242 nonobjective art, 238, 240 nonrepresentational art, 238 Notre Dame cathedral, 231 Nude Descending a Staircase (Duchamp), 244

0

Oath Taker, 407 Obesity in Men (Keleny), 194, 406 objectivists, 260 observation and assessing students, 396-397 Oceania, 233 O'Donnell, Hugh, 346 oils and acrylics, 97. See also specific topics under media and techniques Oiibwa, 234 O'Keeffe, Georgia, 119, 125, 352, 397 One Room School (Homer), 338 op art, 240 organizing a classroom. See classroom organization Oriental Poppies (O'Keeffe), 125 Orozco, José Clemente, 205, 206, 206, 319 orthopedic impairment, 72. See also special needs learners Osage Orange (Smith), 214 Owatonna Project, 16, 283

P

package design project, 287 Paik, Nam June, 177, 242, 282, 288 paintbrushes, 120, 122 painting art history and color, 124-125 color awareness development, 122–126 communicating concepts, issues, and ideas, 125 - 126Giclée paint, 175 manipulating hues, 123 media and techniques, 120-121 oils and acrylics. 97 paint for murals, 325 study of masses and shapes, 124-126 teaching methods, 121–122 techniques for exploring, 123-124 paleolithic art, 227 Pantheon, 231 paper box sculptures, 135-137 freestanding forms of sculpture, 137-138 See also specific topics under media and techniques paper stop out method, 155 papier-mâché, 137-138

Paradise (Tolson), 135 Parsons, Michael, 183 Passage (Neshat), 34 pencils, 104-105. See also specific topics under media and techniques pens, felt-tip, 104-105. See also specific topics under media and techniques performance and assessing students, 398 Persians, 228 Pestalozzi, Johann, 6 Pfaff, Judy, 184, 404 photography activities for children, 171 cameras used for art, 177 historical development of, 168 photo-realism, 240 Polaroid camera use 173 photo-realism, 240 Piaget, Jean, 7, 45 Picasso, Pablo, 12, 65, 111, 237, 240, 267, 270.329 pictorial composition approached through form and idea, 111 memory abilities and drawing, 112-113 pictorial space in design, 189 Picture Study Movement, 16 Pietà (Michelangelo), 273, 394 pinch methods in pottery, 144 Pindell, Howardena, 242, 242 plaster of paris, 139-140 plasticene, 144 Plato, 192, 266, 271, 275 pointillism, 248, 249 Polaroid cameras, 173 politics and art. 271-273 Pollock, Jackson, 31, 211, 240, 269, 270, 323 Polvnesia, 233 pop art, 240 popular arts, 3 portfolios and assessing students, 399 Portrait of an Old Man with a Young Boy (Ghirlandaio), 261-263, 262 Portrait of George (Arneson), 145 postimpressionists, 236 postmodernism community and social values and, 35 deconstruction, 36 era of, 240-241 feminism and, 33 history of, 235-238

hyperreality, 37 Marxism and, 33 multiculturalism, 34 perspectives on, 203 semiotics, 36 themes in. 32-33 theory in art education, 33 Postmodern Perspectives (Risatti), 203 poststructuralism, 33 potato and stick printing, 156-157 pottery, 144-146 preadolescent stage of development color awareness development, 122-126 described, 46, 59-60 mixing media, 110-111 sources of observation for drawings, 107-108 understanding of space, 106 pre-Columbian art, 233-234 prehistoric art, 227 Preziosi, Donald, 225 primary colors, 187 Primavera (Botticelli), 264-265, 265 printmaking appropriateness for children, 153 invention of, 152 linoleum and woodcut, 157-161 monoprints, 154-156 potato and stick printing, 156-157 processes used, 152-153 rubbings, 153-154 stenciling, 161-163 styrofoam, 157 projections used for art, 176-177 proportion in design, 191 public funding of the arts, 271-273 public schools. See curriculums Pueblo people, 234 puppetry, 320-322 Puppy (Koons), 195

Q

questionnaires and assessing students, 398 *Quilting Time* (Bearden), **266**

R

Radioactive Cats (Skoglund), 170, 171 Rain, Steam, and Speed (Turner), 235 Rainbow (Smith), 270 436 Raphael, 234

rating scale for assessing students, 403 Rauschenberg, Robert, 163, 288 Rauscher, Frances, 10 Read, Herbert, 192 realism, 235, 241 Red-Figure Volute Krater, 230 Red Hills and Bones (O'Keeffe), 397 reduction process, 160 Reeds and Cranes (Kiitsu), 230 relational concepts and stages of development, 49 relativists. 260 reliability, 387 relief process in printmaking, 152 Rembrandt van Rijn, 152, 154, 163, 187, 234 Remington, Frederic, 239, 240 Renaissance, 231, 234 Renoir, Auguste, 206, 236 resist techniques, 110 Resnick, Lauren, 7, 339 rhythm in design, 191 Riley, Bridget, 240, 353 Ringgold, Faith, 93, 111, 242, 339 Risatti, Howard, 203, 210 Rivera, Diego, 242, 319, 322, 323, 393, 394 Robie House (Wright), 239 Rocking Pot (Voulkos), 140 Rockwell, Norman, 290 rococo style, 234 Rogers, Carl, 7 Roman art, 231 romanesque architecture, 231 romanticism, 235 Rosenberg, Harold, 203 Rosenberg, Lily Ann, 325 Rousseau, Jean-Jacques, 6 rubbings, 153-154 Rubins, Nancy, 173 rubric, 387. See also assessing students Running Fence (Christo and Jeanne-Claude), 169 Russell, Charles, 239

S

Saar, Bettye, 270 Sabol, Robert, 388 Santana, Larry, 345 San Vitale church, Italy, 231 Sargent, Walter, 15

"Save Our Earth" (poster), 216 Schapiro, Miriam, 126 schema use in children's drawings, 56, 58-59 Scholder, Fritz, 242 schools and art education. See curriculums Scrabble Game, The (Hockney), 173 scratchboard technique, 110 scribbling and artistic development, 47 Scull, Ethel, 168 sculpture box, with paper, 135-137 freestanding forms from paper, 137-138 modes of forming and construction, 132-134 in plaster of paris, 139-140 teaching methods, 136, 137, 140 Seaform (Chihuly), 214 secondary colors, 187 Segal, George, 139 Seim, Sharon, 328 Self-Portrait (Rauschenberg), 288 self-portraits, 171, 391, 398 Self-Portrait with Monkey (Kahlo), 214 semiotics, 33, 36 "Sensations," 271 Serenade (Bearden), 215 Serra, Richard, 271 Serrano, Andres, 271 Seurat, Georges, 248 7-Eleven, 292 sgraffito, 146-147 shades, 187 shape in design, 186 Shapiro, Carolyn, 160 Shatz, Carla, 10 Sherman, Cindy, 171, 172 Shimomura, Roger, 242 Shotgun, Third Ward #1 (Biggers), 307 Silva, Pedro, 328 Sinan, 232 Sioux, 233 Siqueiros, David Alfaro, 319, 322 Sistine Chapel, 226, 322 Skinner, B. F., 7 Skoglund, Sandy, 170, 170 slab methods in pottery, 144, 146 Smith, David, 271 Smith, Jaune Quick-to-See, 214, 242, 270 Smith, Walter, 12, 14, 15, 16 Smith, William, 271 Smithson, Robert, 170

soap-eraser printing, 156 social dimension in art education. See collaborative art activities social realism, 266 social reconstruction, 351 social responsibility and postmodernism, 35 social studies and art curriculums, 349-350 social values and postmodernism, 35 social values reflected in art education, 11-13. 317-318, 338-339 Socratic method of teaching, 259, 298 Soldiers from Pit 1, 141 On Southern Plains (Remington), 240 space children's use of symbols and, 53-56 in design, 189–190 studying through painting, 124-126 spatial intelligence, 9 special needs learners contributions of art to, 73-74 criteria for mental retardation, 74-75 definitions of disability terms, 72 federal legislation for, 70 group activities strategies, 79 history and criticisms exposure, 78 inclusion in regular classrooms, 70-71 media and techniques, 77-78 museums use, 77 non-intellectual/developmental disabilities, 79 - 81popular subject matter for art, 76 progression through stages, 75, 76 strategies for teaching, 76-77 teacher qualities needed, 76 teaching approach, 75-76 therapeutic aspects of art education, 74 speech or language impairment, 72. See also special needs learners Spiral Jetty (Smithson), 170 stage theory of development criticisms of, 45 manipulative stage, 47-50 overview. 46-47 preadolescent stage, 59-60 symbol-making stage, 50-59 standardized assessments, 386, 399 Standards for Art Teacher Preparation, 396 Standing Glass Fish (Gehry), 288 Star Doll (Mori), 286 Steele, Bob, 74, 103 Stella, Frank, 184

stencil process in printmaking, 152-153, 161-163 stereotypes use in children's drawings, 58-59 Stewart, Marilyn, 36, 257 stick and potato printing, 156–157 stimulus-response theory, 6-7 storyboards, 177 structuralism, 33 styrofoam, printmaking, 157 Suleimaniye Mosque, Turkey, 232 Sullivan, Louis, 238-239 Sumerians, 228 summative assessments, 387 A Sunday Afternoon on the Grande Jatte Seurat), 248 Sunday in the Park with George, 248, 249 surface process in printmaking, 152 surrealism, 237-238 Surrounded Islands (Christo and Jeanne-Claude), 169 Swing Landscape (Davis), 268 Sylwester, Robert, 11 symbol-making stage in development age-range, 46, 50 drawing and, 105 early symbolic behavior, 44, 51 increasing sophistication in drawings, 51-52 relating of symbols to an environment, 52 schema and stereotypes, 56, 58-59 storytelling using, 52–53 typical themes, 53 use of space, 53-56 use of undifferentiated symbols, 50-51Szekely, George, 369

tableau projects, 327–328 Taj Mahal, India, **232** talented children. *See* gifted and talented learners Tanner, Henry Ossawa, 242, **266** *Tar Beach* (Ringgold), **339** teaching methods aesthetics, 261–263, 274–276 art appreciation and criticism, 203–208 art history, 243–245 assignments, 303–304 audiovisual presentations, 304 ceramic clay, 142–143, 147 computers as a medium, 308–309

contexts for art teaching, 299 demonstrations, 303 discussion, 307-308 dramatization, 306-307 field trips, 305-306 first session planning, 311-312 games, 305 for gifted and talented learners, 98-99 group activities, 304-305 guest speakers, 306 individual work, 304 lectures, 304 linoleum and woodcut printing, 158-160 maintaining a learning environment, 302-303 materials and tools selection, 309 methodology, 298-299 monoprints, 155-156 motivation for art making, 301-302 murals, 327 painting, 121-122 phases of instruction, 312-314 range of methods, 302 reports, 305 sculpture, 136, 137, 140 setting the stage, 300-301 sources of art, 301 specialist versus generalist teachers, 299-300 special needs learners, 76-81 teachers' role in collaborative art activities, 318-319 teacher talk, 309-311 technology and, 308-309 visual displays, 307 See also art education; classroom organization; learning theory Tea Cup Desk (Hurwitz), 5 technology art from everyday objects. 174 cameras used for art, 177 computers as a medium, 168-169, 178-179 copiers used for art, 174-175 faxes used for art, 174 medias used for instruction, 175-176 photography, 168 projections, 176-177 storyboards, 177 teaching aids, 216-217 teaching methods and, 308-309 video, 177-178 See also new media

tempera, 120, 122 tension in design, 190 tertiary colors, 187 tests and assessing students, 399 texture in design, 189 Thorndike, E. L., 6 Throne of the Third Heaven (Hampton), 341 Through Art to Creativity (Barkan), 16 Tilted Arc (Serra), 271 tint, 187 Tlingits, 234 Tolson, Edgar, 135 Tolstoy, Leo, 258, 267 Tomhave, Roger, 351 totem poles, 234 Toulouse-Lautrec, 153, 259 traumatic brain injury, 72. See also special needs learners Tribute in Light, 168 trompe l'oeil, 266 Tuesday (Wiesner), 177 Turkish art. 4 Turner, J. M. W., 235 TV and visual culture, 283 Tyler, Ralph, 355

U

Ukeles, Mierle, **35** *Umbrellas* (Christo and Jeanne-Claude), 169 United States art history in, 238–239 Native American art (*see* Native American art) unity in design, 190–191 Unkei, 230 *Untiled* (Fujii), **364** *Untiled* (Fujii), **364** *Untiled* (Holzer), **211** *Untiled* (Rauschenberg), **163** *Untiled Film Still* #5 (Sherman), **172**

Valadon, Suzanne, 236 validity, 387 value, 187 Vasarely, Victor, 353 Vasari, Giorgio, 225–226 Venus (Botticelli), 340 Venus de Milo, 230 Venus II (Giovanopoulos), 28 Venus of Willendorf, 227 Vermeer, Jan, 249 Video Flag Z (Paik), 177 video games, 285 video used for art, 177-178 Vienna School of Applied Arts, 14-15 Vietnam Veterans Memorial (Lin), 272, 273, 394 Viola, Bill, 287 visual arts content standards, 347 defined, 3 nature of, 2-5 visual culture as a subset of, 289-290 visual concepts stage of development, 49 visual culture advertising deconstruction, 291-292 applied arts and, 286 in art curriculum, 286-288 art versus, in education, 285-286 children's artistic development influenced by, 44 contemporary art and, 290 corporate influence in the community, 292-293 denotations and connotations interpretation, 290-291 described, 281-282, 285 discourse about, 283 history in art, 283-284 package design project, 287 rationale for including in art education, 282-283

438

relevance to art education, 288–289 as a subset of visual art, 289–290 teaching approaches, 284–285 visual fluency, 90 visual identification and assessing students, 399 visual impairment including blindness, 72. *See also* special needs learners *Voodoo* (Pfaff), **404** Voulkos, Peter, 131, **140**

W

Walk, Don't Walk (Segal), 139 WalkingStick, Kay, 242 Wallace and Gromit, 284 Warhol, Andy, 168, 240, 350 warm colors, 188 Washington Crossing the Delaware (Leutze), 26, 27, 329 "Washington crossing the street" (Larson), 26, 27 Washington Monument, 272 watercolor gifted children's use of, 97-98 use in teaching, 121–122 Wave of Peace (Magleby), 394, 395 Weiss, Howie, 134 Western European thought. See modernism Western society and art, 270-274 wheel, color, 188 Whistler, James McNeil, 239 Wiesner, David, 177

Wilson, Brent and Marjorie, 15, 53
Wilson, Fred, 242
Winslow, Leon Loyal, 29 *Winter Camp Scene* (Ashoona), 186
Wölfflin, Heinrich, 245
women artists, 241 *Women Artists: An Illustrated History* (Heller), 241 *Women with Mirror* (Harunobu), 153
woodcut printing. *See* linoleum and woodcut printing
World War II, 239
Wright, Frank Lloyd, 239, 239, 258, 271
Wyeth, Andrew, 111, 212, 212, 213

X

X-ray views in children's drawings, 54

Y

Yellow Elm Leaves Laid over a Rock (Goldsworthy), **34**, 172 Yoruba people, **228**, 229 Yuan, Ma, **229**

Ζ

Zapatistas (Orozco), 205, 206, **206** Ziegfeld, Edwin, 283 ziggurats, 228 Zimmerman, Enid, 85